Parallel Visions

Modern Artists and Outsider Art

Parallel Visions

Modern Artists and Outsider Art

In 1912 Paul Klee declared that the art of the mentally ill, among other forms of marginalized expression, "really should be taken far more seriously than are the collections of all our art museums if we truly intend to reform today's art." What Klee and a host of modern artists—including Max Ernst, André Breton, Salvador Dalí, Jean Dubuffet, Alfonso Ossorio, and Claes Oldenburg—found most fascinating and instructive about the art of "outsiders"—those self-taught individuals, sometimes mentally disturbed, who compulsively create while isolated from mainstream culture—was the sincerity, depth, and power of their unadulterated, unmediated expressions.

Parallel Visions: Modern Artists and Outsider Art, an exhibition and catalogue produced by the Los Angeles County Museum of Art, brings to light the considerable influence that outsider art has had on the development of twentieth-century art. Tracing this phenomenon of influence through five successive generations of modern artists, *Parallel Visions* connects the bold, elemental expressions of some of the artistic luminaries of the twentieth century with the work of their lesser-known, but likewise estimable, counterparts. This volume features brief, poignant biographies of the thirty-four outsider artists whose work is contained in the exhibition, such compulsive visionaries as Adolf Wölfli, who, though confined to Waldau Psychiatric Clinic in Bern for thirty-five years, managed to produce, in the opinion of Breton, "one of the three or four paramount bodies of work of the twentieth century"; Aloïse, who manifested her romantic longings for Kaiser Wilhelm in brilliantly colored drawings; Karl Brendel, who, after five years in an asylum, began to model figures from chewed bread and soon after began to sculpt in wood; Ferdinand Cheval, a postman who, with no schooling in architecture, built an incredible dream palace out of the stones he collected on his postal rounds; Hélène Smith, a medium who produced beautiful books and

(continued on back flap)

Modern Artists and

Parallel Visions

Maurice Tuchman and Carol S. Eliel

with contributions by

Barbara Freeman

and

Russell Bowman

Roger Cardinal

Sander L. Gilman

Mark Gisbourne

Reinhold Heller

John M. MacGregor

Donald Preziosi

Allen S. Weiss

Jonathan Williams

Sarah Wilson

Outsider Art

LOS ANGELES COUNTY MUSEUM OF ART

PRINCETON UNIVERSITY PRESS

This book was published in conjunction with the exhibition *Parallel Visions: Modern Artists and Outsider Art.* Organized by the Los Angeles County Museum of Art, the exhibition was made possible through the generosity of Shiseido Co., Ltd., the National Endowment for the Arts, the Frederick R. Weisman Art Foundation, Gale Hayman, and Nissha Printing Co., Ltd. The exhibition is supported by an indemnity from the Federal Council on the Arts and the Humanities.

Exhibition Itinerary

Los Angeles County
Museum of Art
October 18, 1992–
January 3, 1993

Museo Nacional
Reina Sofía, Madrid
February 11–May 9, 1993

Kunsthalle Basel
July 4–August 29, 1993
The installation at the
Kunsthalle Basel was made
possible by the generosity
of Bank Heusser.

Setagaya Art Museum,
Tokyo
September 30–
December 12, 1993

Copublished by
Los Angeles County
Museum of Art
5905 Wilshire Boulevard
Los Angeles, California
90036
and
Princeton University Press
41 William Street
Princeton, New Jersey
08540-5237

*Library of Congress
Cataloging-in-Publication
Data*

Tuchman, Maurice.
Parallel visions : modern artists and outsider art / Maurice Tuchman and Carol S. Eliel ; with contributions by Barbara Freeman . . . [et al.].
p. cm.
Catalog of an exhibition organized by the Los Angeles County Museum of Art, and held October 18, 1992–January 3, 1993.
Includes index.
ISBN 0-87587-165-8 (LACMA : cloth).—ISBN 0-87587-166-6 (LACMA : paper).—ISBN 0-691-03213-0 (Princeton : cloth).—ISBN 0-691-00039-5 (Princeton : paper)
1. Art, Modern—20th century—Exhibitions.
2. Art and mental illness—Exhibitions. 3. Art brut—Exhibitions. I. Eliel, Carol S., 1955– .
II. Los Angeles County Museum of Art. III. Title.
N6487.L64L678 1992
709'.04'007479494—dc20
92-11360
CIP

Note to the Reader
Figure captions for works that appear in the exhibition provide only artist's name, title of work, translation of the title (if necessary), and year the work was created (if known). Additional information about each artist (country of origin and activity, life dates) and each work (medium, dimensions, and owner) can be found in the Checklist of the Exhibition (see PAGES 308–23). This additional information is provided in figure captions for works not included in the exhibition.

Unless otherwise indicated, measurements of two-dimensional works of art are given as height by width; three-dimensional, as height by width by depth.

Foreign words and phrases are italicized upon first mention within each essay and thereafter appear unitalicized. Titles of works and of books always appear italicized in their original language and, upon first mention within each essay, are followed by a translation.

Contents

Forew
ord

Foreword

EARL A. POWELL III
Director
Los Angeles County Museum of Art

Neither childish behavior nor madness are insulting words. . . . All this is to be taken seriously, more seriously than art of the public galleries, when it comes to reforming today's art.

There are two significant implications in Paul Klee's words of 1912: first, that the art of the insane would be important for the development of twentieth-century art; and second, that its importance was likely not to be fully aired.

As this exhibition and catalogue demonstrate, the art of the insane and of self-taught visionaries—collectively, the art of compulsive visionaries—has indeed been a crucial strain underlying the development of mainstream art throughout this century. Though resistance to the productions of these so-called outsiders remains high, their work has finally begun to receive the serious attention it deserves.

Parallel Visions: Modern Artists and Outsider Art carries on the Los Angeles County Museum of Art's tradition of presenting provocative and innovative exhibitions of twentieth-century art. We owe our gratitude to Maurice Tuchman, senior curator of twentieth-century art, and Carol S. Eliel, associate curator of twentieth-century art, who, with the assistance of Barbara Freeman, have unearthed for us several of the lesser or unknown roots of modern art. We are also grateful to the many scholars outside the museum who contributed their ideas, in particular those who provided essays for this volume.

We would like to express special thanks to Shiseido Co., Ltd., for their generous support of *Parallel Visions*, as well as to Frederick Weisman for his crucial early support through the Frederick R. Weisman Art Foundation. We are also grateful to Gale Hayman for her foresighted support of this exhibition and to Nissha Printing Co., Ltd. We are likewise indebted to Maria de Corral, director of the Museo Nacional Reina Sofía in Madrid; Thomas Kellein, director of the Kunsthalle Basel; and Seiji Oshima, director of the Setagaya Art Museum, Tokyo. The support of our institutional colleagues quite literally was essential to the realization of the exhibition. In addition, we are particularly pleased to have received an important grant from the National Endowment for the Arts for *Parallel Visions*.

Lenders to the exhibition, who are listed elsewhere in this catalogue, have kindly agreed to part with treasured works from their collections for an extended period of time. To them we offer our thanks for making this exhibition possible.

It is gratifying to present an exhibition as stimulating and provocative as *Parallel Visions*; we are proud to offer an international audience the opportunity to share in this experience.

=

Introduction

MAURICE TUCHMAN

Parallel Visions: Modern Artists and Outsider Art, conceptualized as a sequel to the museum's historic *The Spiritual in Art: Abstract Painting 1890–1985*, draws upon several of the essential experiences we encountered in the organization and execution of that 1986 exhibition. In *The Spiritual in Art* we sought to demonstrate that the genesis and development of abstraction came out of the artists' deep involvement with the mystic and occult realms. Critical to the success of that earlier research effort was finding persuasive evidence to support the claim that all ninety-five artists in the exhibition were so involved. One way to demonstrate this point was to present key texts from the artists' personal libraries: 125 books owned by figures from Edvard Munch through Wassily Kandinsky, as well as by many living artists, were displayed in numerous vitrines throughout the exhibition space. In the catalogue we documented each artist's "spiritual" biography, and in the introduction and in many of the commissioned essays we focused on key moments in the lives of the exhibiting artists that reflected their attraction to this "other mode" of perception. We were not overly concerned to prove that myriad stylistic nuances could be precisely tracked to images in esoteric texts. Nevertheless throughout the show and the book there were regular appearances of startlingly premonitory imagery; for example, Robert Fludd's 1520 "black square" etching and Kasimir Malevich's painting of the same image four centuries later. More central to our thesis than these striking comparisons, however, was the inescapable weight of documentary evidence invariably tying abstract painters to mystical preoccupations at precisely the time when their abstraction emerged. Our presentation had the effect then of serving as a reinterpretation of a historical body of work that appeared to mean other than it once did; in the re-viewing of a lineage of artists from Piet Mondrian and František Kupka to Jackson Pollock and Jasper Johns greater resonance, intention, emotion, and "spirituality" could be seen.

The focus of *Parallel Visions*, a research project of comparable scope, is on the modern artists drawn to, and influenced by, the art of "outsiders," or, as we refer to them, compulsive visionaries. These outsiders have usually been self-taught individuals, sometimes mentally disturbed, who have created their work while isolated generally from mainstream culture and particularly from the complex infrastructure of the art world, that is, from the galleries, museums, and universities with which mainstream artists are regularly associated.

In developing the exhibition and catalogue for *The Spiritual in Art* we enjoyed a striking richness of research materials: the body of literature on and by mystics is vast, and the history of the nexus between art and spiritual philosophy was ripe for study. Such was not the case with *Parallel Visions*: only scanty material exists on the linkage between modern art and the art of outsiders; also, the art-historical attention paid to the works of outsiders has been inadequate. The endnotes accompanying the twelve essays commissioned for this catalogue will yield to the interested reader a fair account of the state of knowledge in this field. The paucity of art-historical writing may also suggest the nature and scope of the challenge that faced us in embarking on this project—a challenge made even more daunting by the scarcity of explorations into the methodologies of influence in art history.

As cultural and literary studies in general have in recent years broadened their purview to include numerous creative expressions outside the main-stream, the time seemed ripe to consider twentieth-century art in a similar light. In reaction to the rise of conceptualism and other strategy-oriented art movements more than two decades ago, authen-ticity and emotional sincerity have been increasingly appreciated in art. This factor underlies the grow-ing regard for artistic expressions from cultures outside the dominant Euro-American traditions.

We examined a tremendous amount of material during the conceptual stages of *Parallel Visions* before establishing the present roster of forty professional painters and sculptors and thirty-four outsiders. The array of art we originally considered included children's, shamanic and voodoo from tribal Africa, Oceanic and Haitian, Australian aboriginal bark and acrylic painting and artifacts, graffiti, the environmental "sculptures" of French and American builders especially in the early part of this century, and, of course, the art of self-taught, completely alienated persons, who have often been isolated in mental hospitals. (The exhibition *Naivety in Art* at the Setagaya Museum, Tokyo, in 1986 attempted to synthesize all these forms of expression.) Ultimately, following the leads provided by the experiences of modern artists with these materials, we came to focus increasingly on a specific lineage of modern Western artists and on their relationship with the work of compulsive visionaries in particular.

Through our research we identified a certain restricted range of expression among the outsiders that has intrigued five successive generations of artists in the twentieth century. That range of expression includes the following: a distinct compulsiveness, a visionary tone, a fusion of edgy uncertainty and anxiety with a firm certitude, a sense of exorcism, and the need and intent to get it out and place it down and to grasp and anchor the ephemeral. Such expressiveness verges on the hallucinogenic; it grapples with the unknowable; it does not—as is often the case with folk art—affirm the status quo.

With *The Spiritual in Art* we intended to reveal that the development of abstraction was hardly thinkable without the transfusion of mystical experience; with *Parallel Visions* we intended similarly to reveal that the bold, elemental, figurative expressiveness characteristic of much twentieth-century art is due in part to the appreciation and influence of the art of compulsive visionaries. We have tried to locate the most powerful, albeit the most unsettling, of these works; in many cases we were led by known artists (either personally or through their writings) directly to specific paintings and drawings. The appearance of occult books in the libraries of the "spiritual-abstract" painters has its analogy in *Parallel Visions* in the remarkable collections of outsider art put together by modern artists, for example, Jean Dubuffet's spectacular Collection de l'Art Brut, the focused and intense collections of many Chicago artists, Arnulf Rainer's in Vienna, and those of younger contemporary artists such as Donald Baechler and Andy Nasisse.

The lineage of outsider-influenced modern artists in *Parallel Visions* runs from Paul Klee to Gregory Amenoff. Klee's interest in outsider productions can be traced to 1912, when, in a review of a Der blaue Reiter (The blue rider) exhibition, he urged the public to take the art of children and the mad seriously.[1] He also found confirmation of his own creations in the works collected by Dr. Hans Prinzhorn and reproduced in his book *Bildnerei der Geisteskranken* (Artistry of the mentally ill), 1922, which was in circulation at the Bauhaus.[2] In these works Klee discerned "depth and power of expression. . . . Really sublime art. Direct spiritual vision."[3] Alfred Kubin visited the Prinzhorn Collection in Heidelberg in 1922 and wrote, "I was touched by the secret regularity of the work, we admired these wonders of the artists' minds that come from the depth outside all thoughtful thinking and make you happy just looking at them."[4] The work of an outsider artist

like Louis Soutter was appreciated by Le Corbusier (his cousin) because "through him we can see inside a man."[5] Dubuffet assigned to outsider works, which he labeled *art brut* (raw art), all the characteristics that one should expect of "high," "serious" art: "burning mental tension, uncurbed invention, and ecstasy of intoxication, complete liberty." Rainer wrote that he is "interested in those moments that are innovative. The mentally ill [artists] have discovered much for art, things that [mainstream] artists would not have thought of."[6] Richard Lindner, in a conversation with Stephen Prokopoff, claimed that viewing the Prinzhorn Collection had been the most important artistic experience of his life.[7]

Decades after Dubuffet's ground-breaking assertion that art brut was to be preferred over the cultural arts, Roger Cardinal sought to further define art brut and settled on the term *outsider art* for his book published in 1972.[8] In a letter to Seymour Rosen, Cardinal recounted his odyssey in search of usable terminology:

Many terms have been used which allude to the creator's social or mental status—isolate art, maverick art, outsider art, folk art, visionary art, inspired art, schizophrenic art. This seems unsatisfactory in as much as not every creator we want to recognize fits so readily into a social or psychological category. I feel strongly that to label works in a way that stresses the eccentricity or oddness of their maker tends to divert attention from aesthetic impact onto the biographies. . . . One could look at the factor of artistic independence as of central importance. Self-taught art, autodidact art, untutored art, idiosyncratic art, original art, "All Their Own" (Wampler), "Outlaw Aesthetics" (Schroeder), estranged art, "Anti-cultural Positions" (Dubuffet), the Art of the Artless (a title I once toyed with), Unfettered Art, Breakaway Art, Unmediated Art, Art without Precedent or Tradition (subtitle of the 1979 "Outsiders" show)—but none of these is quite incisive enough.[9]

Parallel Visions is certainly not the first time outsider productions have been shown in a museum. A selection of watercolors originally from the Prinzhorn Collection, other artworks made by mentally ill patients from the collections of Paul Eluard and André Breton, and photographs of Ferdinand Cheval's tomb and his *Palais idéal* (Ideal palace) were presented in the *Fantastic Art, Dada and Surrealism* exhibition at the Museum of Modern Art in 1936. One of these same objects from Breton's collection was exhibited in the *International Surrealist Exhibition* at the New Burlington Galleries in 1936. In 1945 Dr. Gaston Ferdière organized the first exhibition of psychotic art to be held in a museum, the Musée Denys Puech. Dubuffet's collection was first exhibited in a museum at the Musée des Arts Décoratifs, Paris, in 1967. *Outsider Art* at the Hayward Gallery in London in 1979 attracted much notice. Outsider works have been exhibited more than once at the Setagaya Museum, which will also present this exhibition. In 1989 the Museum van Hedendaagse Kunst in Ghent exhibited *Open Minds*, a large, somewhat random assemblage of both insider and outsider works. But *Parallel Visions* is the first exhibition to investigate systematically the linkage between the works of compulsive visionaries and mainstream artists. Also, apart from the Collection de l'Art Brut in Lausanne, never before have so many outsider works been seen together. Furthermore insider and outsider works in *Parallel Visions* will be displayed in such a way as to underscore our assertion that all of them are equally valid as art, that they are all, in fact, strong visual statements, aesthetically challenging and intensely involving. It must be emphasized that only those outsiders whose work has been known to modern artists are included in the exhibition. Therefore this is not a comprehensive or encyclopedic view of the art of outsiders but rather of those figures whose works have entered into the dialogues of twentieth-century art history.

The observer of modern art may perhaps wonder about the exclusion from this project of an artist whose career and life seem to anticipate or herald the phenomena under examination in *Parallel Visions*—Vincent van Gogh. For the general art-viewing public, van Gogh perhaps represents the quintessential "mad" artist. But because he was a professional artist who from the onset of his career yearned to make art that would change the world, he does not qualify as an outsider by our standards. His psychological instability was never the basis of his creative expression nor was his influence premised primarily on this instability. Furthermore, as we have determined to focus only on professional artists, "insiders," who were drawn to expressions of people who made "raw" work, productions that reflect little or no cultural indoctrination, van Gogh could not be included in this exhibition. He did not consciously look for inspiration in the work of outsiders, but was, in fact, devoted to the history of art and hoped to become a part of it.

Dubuffet called art brut *anticultural*, but perhaps *acultural* is a more accurate description of works made in almost complete alienation from society. Many well-known artists may appear to be outsiders due to their alienation; however, alienation alone does not constitute outsiderness. For those professional artists who fell into illness and became estranged from society—as in the remarkable cases of Carl Frederik Hill in the 1890s, Soutter in the 1930s, and Antonin Artaud in the 1940s—we show the work these artists made *when they fell outside. This* work, not their more academic and professional art, was inspirational for modern artists and remains influential today.

The eighty-year tradition of modern artists finding revelation in the unadulterated, unmediated expressions of untaught visionaries continues with the young professional painters and sculptors emerging today. This tradition, commencing around 1912, may be seen to be the precise counterpoint to the ratiocinative, philosophical tradition in twentieth-century art. Artists who turn to outsiders derive inspiration from an element in

visionary art, "a feeling like the work came *through* the artist more than from them," according to Nasisse, allowing the artist in making art to experience "a feeling of surprise when the work is done."[10] Today's viewer of contemporary art and of outsider art places a premium on values of genuineness, vivid presence, raw strength, and above all a sense of unqualified and felt intention in works of art. This viewer responds to work that is, as it was for Klee, in touch with "fundamental forces," work that "gives voice to doubts," and allows "the most precious kind of confirmation" of one's individuality.[11]

∎

Notes

1
Paul Klee, *Diaries of Paul Klee, 1898–1918* (Berkeley: University of California Press, 1964), 266.

2
Hans Prinzhorn, *Bildnerei der Geisteskranken* (Berlin: Springer, 1922; reprint, Berlin: Springer, 1968), and in English as *Artistry of the Mentally Ill: A Contribution to the Psychology and Psychopathology of Configuration,* trans. Eric von Brockdorff (New York: Springer, 1972).

3
Felix Klee, *Paul Klee* (New York: Braziller, 1962), 183.

4
Alfred Kubin, "Die Kunst der Irren," *Das Kunstblatt* 6, no. 5 (May 1922): 185-88; reprinted in Kubin, *Aus Meiner Werkstatt* (Munich: Nymphenburger, 1973), 13–17. Translated by Grete Wolf.

5
Le Corbusier, "Louis Sutter [sic], l'inconnu de la soixantaine," *Minotaure* 3, no. 9 (1936): 62.

6
George F. Schwarzbauer, "Das Sammlerporträt," *Kunstforum International*, no. 26 (February 1978): 225. Translated by Grete Wolf.

7
Stephen Prokopoff, "The Prinzhorn Collection and Modern Art," *The Prinzhorn Collection: Selected Work from the Prinzhorn Collection of the Art of the Mentally Ill*, exh. cat. (Champaign, Illinois: Krannert Art Museum, University of Illinois, 1984), 18.

8
Roger Cardinal, *Outsider Art* (New York: Praeger, 1972).

9
Letter dated January 5, 1987.

10
Nasisse, in a letter to the author, March 27, 1991.

11
James Smith Pierce, "Paul Klee and Karl Brendel," *Art International* 22, no. 4 (April–May 1978): 8, 20.

13

Eyes
Outsi
de
and
Eyes
Insid
e

Eyes
Outside
and
Eyes
Inside

Jonathan Williams

What delights me is an exhibition that ranges all the way from Paul Klee, of Münchenbuchsee, Switzerland, to J. B. Murry, of Sandersville, Georgia. That's a fur piece. I try to imagine Klee, living out his days on a farm in the country in Glascock County, Georgia. No James Ensor, no Odilon Redon, no Aubrey Beardsley, no Alfred Kubin; no Christian Morgenstern and Joachim Ringelnatz ("humor is the stud that keeps the collar from flying apart"); no Walter Gropius or Wassily Kandinsky or Lyonel Feininger or Bauhaus; no Mozart or Maurice Ravel. No nuthin, except corn pone and Hoppin' John, pot licker, pig grease, watermelon, and well water. Yet Murry, whose diet (nutritionally and culturally) was restricted to this for all of his eighty years on this earth, is not a "dumb" artist. His work is not impoverished, it is absolutely extraordinary. Klee would be the first to say it.

My life in the arts has been peripatetic and curious, and it is, *possibly*, instructive for me to suggest to you how I found the path from Klee to Murry. I got an early start, being lucky enough to be brought up in Washington, D.C., at a good school (St. Albans). The Phillips Memorial Gallery was fifteen minutes away. By the time I was fourteen, I knew about Redon, Arthur Dove, Albert Pinkham Ryder, Augustus Vincent Tack, Pablo Picasso, and Klee. Max Ernst I first found at Caresse Crosby's gallery on Q Street, in a show called *The Temptation of St. Anthony*. Salvador Dalí and Pavel Tchelitchew, in New York, came a few years later during my short stay at Princeton. With tutelage from Ernest DeWald and visiting Alfred Barr, I sought out Feiningers and Klees at the galleries of Curt Valentin and Henry Kleemann. It is amazing to recall that a small Klee watercolor could be purchased for $500 and a big Feininger oil for $2,000 in 1947.

There's something Klee wrote in 1919 that I copied into an old notebook: "Let art sound like a fairy tale and be at home everywhere. Let it work with good and evil as do the eternal powers. And to men let it be a holiday, a change of atmosphere and point of view, a transfer to another world which presents a diverting spectacle so that they may return to everyday life with renewed vitality." How strangely "egalitarian" that sounded to my Blue Ridge Mountain ears. Likewise, this passage from that vigorous Catalan, Señor Picasso: "The artist is a receptacle for emotions, regardless of whether they spring from heaven, from earth, from a scrap of paper, from a passing face, or from a spider's web. That is why he must not distinguish between things. *Quartiers de noblesse* do not exist among objects."

Having dropped out of Princeton, I have spent forty years dropping out of what is called American Life (a.k.a. Generic Schlepp). A chronic case of agoraphobia (fear of the marketplace) hit me early, so I fled from the art coteries and from the faculty club and the country club. I wrote poems that were too funny and too serious (all at once) for anybody to bother with; and I published books that could not be sold to a nation of dumbed-down mammonites. I went off to live in the mountains like some pumpkin-headed, epicurean fool. "Buddha says: 'None of the world is good.' I am fond of my hut." That is Kamo no Chōmei, in his book *Hōjōki*, describing his abandonment of the pestilential Japanese society of the year 1212. Peering over valleys to the Nantahala Mountains and to the Great Smoky Mountains, I listen to Vladimir Horowitz and Earl Scruggs with equal delight. And spend as much time watching baseball as reading early Taoist texts. It's good to be a nobody in a nowhere country. Artists—insiders and outsiders—are like the rest of us demotic folk: *celestial* and *chthonian*.

Poets talk a lot of trash, why should I be an exception? One peers into the magic screen of the Apple/Mac, and it's no problem getting absolutely all the words you want in there, frontwise not edgewise. The point I want to make is that *Parallel Visions* mixes many streams, many makers of art,

and we finally see that there *really* are no quartiers de noblesse. Some of us once thought that nobility was limited to the aristocratic world of a Rainer Maria Rilke. At the beginning of the road, I wrote down his words: "Works of art are of an infinite loneliness and with nothing to be so little appreciated as with criticism. Only love can grasp and hold and fairly judge them." So, we ask the urbane to despise not us hicks and isolatos. Art's as bad in the country as it is in town, but not always. "Everything has its vermin," as Uncle Will Blake put it one day. What wonders remain for revelation in our flensed times? Münchenbuchsee to Sandersville, keep your eyes open! *Parallel Visions* belongs in your knapsack.

Let me end with a down-home story. Dilmus Hall (1900–1987) was an oracular little man who enjoyed jivin' with the white folks who kept coming by to see his yard art on the west side of Athens, Georgia. Dilmus was a "simple" soul and, somehow, late in life he made some of the most magical little sculptural tableaux of any artist in the twentieth century. I've seen four crucifixion scenes (made out of wood, wax, chewing gum, clay, and bits of cloth and paint) that are absolutely overwhelming—overwhelming in the ways that Giotto, Matthias Grünewald, and Francis Bacon can be. Klee and Rilke would have loved him, and so will you when the work gets out into the world. I made a poem from some words he said to me the last time I visited with him:

you have eyes
outside
and eyes
inside

your heart
is full of eyes

to communicate
you put the two

together
amen!

=

Moral Influence and Expressive Intent:

A Model of the Relationship between Insider and Outsider

CAROL S. ELIEL

Surprisingly, for those in a discipline preoccupied with tracking influence—of one artist on another, one period on another, one civilization on another—art historians have rarely considered either the potentialities or results of influence. Various exhibitions have been organized to investigate correlations between disparate types of art, yet these have gone only so far as to consider such relations in static, formal (that is, stylistic) terms rather than continuing to consider the dynamics of such contacts, the ways in which they are absorbed and transmuted. This was evident in *The Great Wave: The Influence of Japanese Woodcuts on French Prints* (Metropolitan Museum of Art, New York, 1974), *Japonisme: Japanese Influence on French Art 1854–1910* (Cleveland Museum of Art, 1975), and *"Primitivism" in Twentieth-Century Art: Affinity of the Tribal and the Modern* (Museum of Modern Art, New York, 1984). The types of art exhibited have varied widely, but the conceptual models for these exhibitions are of a type. Specific correspondences—in these exhibitions the formal influences of particular non-Western artists or art forms on particular Western artists—are established, for example, between Andō Hiroshige and Edouard Manet, Katsushika Hokusai and Edouard Vuillard, Kitagawa Utamaro and Edgar Degas, Zuni wood figures and Paul Klee, Tusyan (Upper Volta) masks and Max Ernst, Iberian carved heads and Pablo Picasso. The list seems endless and is endlessly fascinating in terms of what it can tell the viewer about the formal genesis of late nineteenth- and twentieth-century Western art. What such comparisons do not elucidate, however, are the Western artists' thoughts about and understanding of the non-Western works. As art historian George Kubler stated in *The Shape of Time*, "We are discovering little by little all over again that what a thing means is not more important than what it is;

that expression and form are equivalent challenges to the historian; and that to neglect either meaning or being, either essence or existence, deforms our comprehension of both."[1]

The Great Wave, Japonisme, and *"Primitivism" in Twentieth-Century Art* focused on form to the exclusion of expression. They did not address such questions as whether Western artists were aware of the social functions of the non-Western works or, more specifically, whether they distinguished between decorative and ritual objects or whether they perceived the populist character of Japanese prints. Most importantly, did such understanding (or lack thereof) affect the dynamic influence of this non-Western art on Western art? Perhaps only stylistic aspects (in Kubler's terminology, aspects of form) of non-Western art were absorbed, while its essence (its expression) remained untapped.

In recent years such models for the comparison of disparate types of art have been criticized as demeaning to both the party influenced ("unoriginal") and the party exerting the influence ("exploited"). The most apposite model of influence for us is the one enunciated by Harold Bloom in his study of literary methodology, *The Anxiety of Influence.* "Poetic influence," he maintained, "need not make poets less original; as often it makes them more original. . . . The profundities of poetic influence cannot be reduced to source-study . . . to the patterning of images."[2] That is, far from diminishing an artist, influence may enhance his or her creativity. Influence, furthermore, should not be regarded solely as stylistic, or formal, in nature. In *Parallel Visions* we attempt to explicate a different model of influence,

demonstrating what the artist Gregory Amenoff has called the "moral influence" of outsider artists on twentieth-century art.[3] The outsiders' "sense of focus," their "intensity," and their "lack of guile" are what appeal to mainstream artists, rather than "any given style or subject."[4]

As Maurice Tuchman explains in his introduction to this volume, *Parallel Visions* as originally conceived would have defined outsider art rather broadly; initially considered for inclusion were Haitian art, aboriginal art, children's art, and graffiti as well as the work of mentally disturbed and self-taught visionaries. Many of this century's insider artists have been influenced by all sorts of art outside the Western cultural mainstream. Yet to organize an exhibition of insider artists in some way inspired by the work of *any* outsiders would be broad to the point of pointlessness. Instead, as our preparatory research continued, it became apparent that numerous insiders have looked to outsider art not necessarily for stylistic inspiration but for a model of the maker's role and the expressive potential of the creative act. Who are these insiders? we asked ourselves. Who are the outsiders? And what is the relationship between them? By answering these questions specifically, then extrapolating generally, we can posit a model for the structure of the exhibition.

In studying the work of twentieth-century insiders and speaking with many of them, we became aware that the influence of outsiders touches much more than, or something other than, the formal, or stylistic, realm. For example, in formulating his paranoiac-critical method, Salvador Dalí hoped that he could arrive at a "spontaneous method of irrational knowledge based upon the interpretative-critical association of delirious phenomena."[5] He hoped, in other words, to achieve an irrational quality in his own work that would approximate the hallucinatory quality of works created by the mentally disturbed. The resulting work need not resemble the work of a deranged

18 ELIEL Moral
 Influ
 ence
 and
 Expre
 ssive
 Inten
 t

person but would reflect what Dalí perceived to be the same creative impulse. Dalí's double imagery (see FIGURE 80), for example, mirrors the same search for subject as August Neter's (see FIGURE 79). Similarly Ray Yoshida does not seek to recreate the look, or style, of Joseph Yoakum's visionary landscapes, though he is touched by the animism with which Yoakum imbued his scenes and strives to create a similar animistic quality in his own work.[6] Just as the rocks, clouds, trees, and water of Yoakum's *Mt. Mauna Kea* (see FIGURE 128) or *Mt. Elberst* (see FIGURE 124) lick and swirl like organic entities, so too the surface of Yoshida's *Froggy* (see FIGURE 126) bristles with energy, and the elements of *Partial Evidences II* (see FIGURE 127) emerge from the ground like germinating seeds.

Christian Boltanski speaks of the timelessness and the powerful emotional attraction of outsider art, which he emulates in his own work. Like the compulsive visionaries of Jean Dubuffet's art brut collection (which he first saw in 1967 and so admires), Boltanski often works with such commonplace materials as rags and light bulbs to make objects that, while not derivative of the history of art stylistically, do nonetheless have a striking emotional impact.[7] *Reliquaire* (see FIGURE 208), with its ghostlike photo blowups of French schoolchildren of the 1930s, eerily lit and presented to the viewer like an altar, evokes feelings of nostalgia and sorrow that are undefined but strong.

What emerged from our lengthy consideration of the work of many artists, both insiders and outsiders—many more than we ultimately included in *Parallel Visions*—is a model of intentionality. The insiders we selected look not to the styles of the outsiders in the exhibition but to their expressive intent. This expressive intent is shaped not by external forces but seemingly by internal necessity.

As critic James Yood has commented, "Free from hypocrisy, free from greed and envy, free from cruelty and lust, free from the ego, it is they [outsider artists] who are natural, direct and *authentic*: their actions spring from need, not ambition, and from a mind which is conscious and unconscious at the same moment."[8]

Six essays in this volume chronicle the contacts between insiders and outsiders during the twentieth century. Such contact occurred in a number of ways: insiders are known to have looked at published reproductions of the work of outsiders, to have seen collections or exhibitions including this work, and to have collected the work themselves. In only a handful of cases was the contact between mainstream artist and compulsive visionary a personal one (and even then rarely a close personal relationship), indicating that such relationships have been based not on a cult of personality but on the expressive power of images.

The expressive power of outsider images is not to be underestimated. It is worth noting that *Parallel Visions*—which, as Tuchman has pointed out, developed in response to an exhibition devoted to the genesis of *abstraction*—is largely a show of *figurative* art. Until the 1970s and 1980s, with the rise of postminimalism, postmodernism, and other critical stances, abstraction was generally considered the prevailing vocabulary of mainstream twentieth-century art. The imagery of outsider art is almost exclusively figurative; the strength of these images has provided a powerful impulse for the insider artists in *Parallel Visions* to work in a figurative vein. For example, art brut validated Dubuffet's impulse to create figurative art in the 1950s, a decade marked by the prominence of abstraction. Interestingly the insider creating the most purely abstract images in the exhibition, Amenoff, works at a time when figuration is again fashionable in the mainstream art world; it is as if the "moral influence" of outsiders allows insiders to go against the stylistic grain, whatever that grain may be.

Because the influence *Parallel Visions* considers is not primarily formal, the traditional art-historical models of influence could not provide a suitable underlying structure for the exhibition. It was thus a difficult task to determine the appropriateness of the inclusion of artists in the exhibition. However, as we demonstrate, the influence of the art of compulsive visionaries on twentieth-century mainstream art clearly exists and can be documented. Based on these many points of intersection between insider and outsider art, we have constructed a new model of influence for *Parallel Visions*.

=

Notes

1
George Kubler, *The Shape of Time: Remarks on the History of Things* (New Haven: Yale University Press, 1961), 126.

2
Harold Bloom, *The Anxiety of Influence* (Oxford: Oxford University Press, 1973), 7.

3
Amenoff referred to "moral" as opposed to stylistic influence at a scholars' conference held February 19, 1990, in New York City, during the planning stages of this exhibition.

4
Ibid.

5
Salvador Dalí, *Conquest of the Irrational* (New York: Levy, 1935), 15; quoted in James Thrall Soby, *Salvador Dali*, exh. cat. (New York: Museum of Modern Art, 1941), 16.

6
Yoshida, in conversation with the author in Chicago, February 7, 1991.

7
Boltanski, in conversation with the author in Paris, November 4, 1989.

8
James Yood, "Martin Ramirez: Madness and Arcadian Dream," *New Art Examiner* 14, no. 2 (October 1986): 25, quoted in Ken Johnson, "Other Vision: The Art of Roger Brown," *Arts* 62, no. 4 (December 1987): 62.

Biographies of Outsider Artists

Barbara Freeman

Aloïse (Aloïse Corbaz)

Lausanne, Switzerland, 1886–1964, Gimel, Switzerland

Principal References

Bonfand, Alain, et al. *Aloïse.* Exh. cat. Rochechouart, France: Musée d'Art Contemporain de Rochechouart, 1989.

Porret-Forel, Jacqueline. "Aloïse et son théâtre." *L'Art brut*, fascicle 7. Paris: Compagnie de l'Art Brut, 1966, 23–89.

Schmidt, George, et al. *Though This Be Madness: A Study in Psychiatric Art.* London: Thames and Hudson, 1962, 59–69.

When Aloïse was eleven years old, her mother died of heart disease, which left the six Corbaz children in the care of their often brutal father. Aloïse, a zealously assertive and pretty girl with long red hair, aspired to be an opera singer and took music lessons from the organist of the Lausanne cathedral. When she graduated from school at the age of eighteen, however, she gave up her operatic ambitions and, like her sisters, went to a professional sewing school.

In 1911 Aloïse went to Germany and worked as a private teacher for the three daughters of Kaiser Wilhelm's court pastor. Living in Potsdam in the imperial splendor of the Château Sans Souci, she became infatuated with the kaiser. The impending war forced Aloïse to return to Switzerland in 1913. Her odd behavior—neglecting personal appearance, withdrawing from interpersonal contacts, composing fanatical religious tracts and on one occasion an ardent love letter to the kaiser, fits of agitation, and delusions of grandeur and persecution—led family members to commit her to the Hôpital Psychiatrique Universitaire de Cery in 1918.

Transferred in 1920 to the asylum of La Rosière at Gimel for chronically ill patients, where she was to spend the remainder of her life, Aloïse produced inspired writings and manifested her romantic longings for Wilhelm in brilliantly colored drawings. At La Rosière she led the life of a dependable inmate, ironing daily for the sisters, and an imaginary life in which she was pope, prophetess, suffering mother, temptress, and lover.

In the early years of her hospitalization Aloïse drew secretly on scraps of paper. Encouraged from 1936 on by the hospital director, who provided her with paper and colored pencils, Aloïse produced erotic drawings reflecting her opulent world of dreams and her identification with great tragic lovers of the past. In the 1940s Aloïse created larger and more dynamic drawings abundant with symbolism. Her vertical friezes teemed with decorative elements surrounding voluptuous figures of queenly women, whose breasts were commonly transformed into flowers and whose wombs often metamorphosed into baskets of fruit.

Never losing her youthful love of opera, to which she often alluded in her poetry and in the titles of her drawings, Aloïse, whose speech was virtually unintelligible, was periodically heard by staff and patients at La Rosière singing Verdi arias.

=

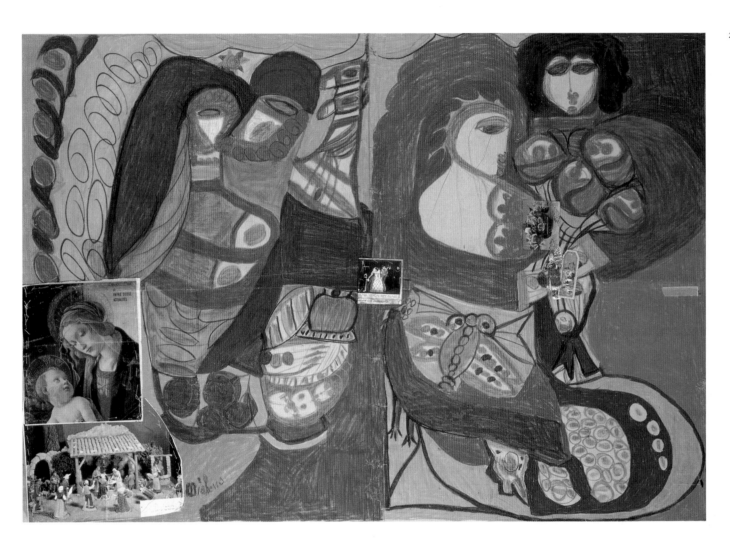

: I :
Aloïse (Aloïse Corbaz)
Mickens

Antonin Artaud

Marseilles, France, 1896–1948, Ivry-sur-Seine, France

Principal References

Antonin Artaud: Dessins. Exh. cat. Paris: Musée National d'Art Moderne, Centre Georges Pompidou, 1987.

Mèredieu, Florence de. *Antonin Artaud: Portraits et gris-gris.* Paris: Blusson, 1989.

Thévenin, Paule, and Jacques Derrida. *Antonin Artaud: Dessins et portraits.* Paris: Gallimard, 1986.

Poet, playwright, actor, theoretician, and artist, Antonin Artaud knew illness throughout his life. At five he survived a near-fatal attack of meningitis, and at nineteen, beset by depression and headaches portending the onset of lifelong mental problems, he was sent to the first of what would become a series of nursing homes and mental asylums. In 1920, after two years of treatment in a Swiss nursing home specializing in nervous disorders, where he learned to draw, Artaud settled in Paris to pursue literary ambitions. Once there, fascinated by the stage, Artaud embarked on an acting career with Charles Dullin's Théâtre de l'Atelier, one of the most progressive theatrical troupes of the era.

Aligning himself with the surrealists in 1924, Artaud edited and contributed articles—including "Lettre aux médecins-chefs des asiles de fous" (Letter to the medical directors of lunatic asylums)—to the journal *La Révolution surréaliste* and was active in the Bureau de Recherches Surréalistes. After a break with the surrealists in 1926, Artaud, in collaboration with Roger Vitrac and Robert Aron, founded the short-lived Théâtre Alfred Jarry. Despite surrealist activities, constant work in the theater, deteriorating health, and drug addiction, Artaud wrote zealously and continued to draw throughout the decade.

Undaunted by the failure of the Théâtre Alfred Jarry, Artaud established the Théâtre de la Cruauté (Theater of cruelty) in 1933. Assailing bourgeois theatrical convention with a combination of gesture, unusual scenery, sound, and lighting intended to shock the spectator, he attempted to awaken his audiences to the cruelty inherent in life. The failure of the company led him to abandon theatrical activity.

Fascinated by mysticism, Artaud traveled in 1936 to the Sierra Madre mountains of northern Mexico, where he lived for the better part of a year with the Tarahumara Indians, practicing their tribal ceremonies and peyote rituals. Exhausted by this experience but determined to continue his search for the aura of magic and legend, Artaud set out on an ill-fated trip to Ireland in the summer of 1937. Without funds and in a frenzied state he sought refuge at a Dublin Jesuit college. Denied entry, he hammered at the door and created such a ruckus that he was jailed, then released after six days only on condition that he leave the country. Aboard the boat home he was straitjacketed after threatening to harm himself and others. Upon his arrival in France he was certified mad and placed in the first of four mental institutions, where he remained for the ensuing nine years.

During Artaud's early confinement he was withdrawn, refusing to draw, write, or receive visitors. In 1943 Robert Desnos and Paul Eluard were successful in securing Artaud's transfer to the care of Dr. Gaston Ferdière, director of the psychiatric hospital at Rodez, whose course of treatment included electroshock therapy (the need for which has been bitterly disputed). At Rodez, Artaud began anew his life as a creative artist. His graphic depiction of the anguish of insanity served to discount the surrealists' romanticization of madness.

Frequently depicting coffins, gallows, nails, bones, and isolated body parts, Artaud referred to his drawings as documents and sensations, ascribing to them curative and magical functions. In his portraits faces often appear like totems, superimposed with text. Artaud claimed that his drawing, like his drama, sought to "rediscover lost worlds that no language can interpret."

At the war's end Artaud's friends arranged for his release from Rodez to a nursing home on the outskirts of Paris, where he continued to write and draw until his death from cancer at age fifty-two.

=

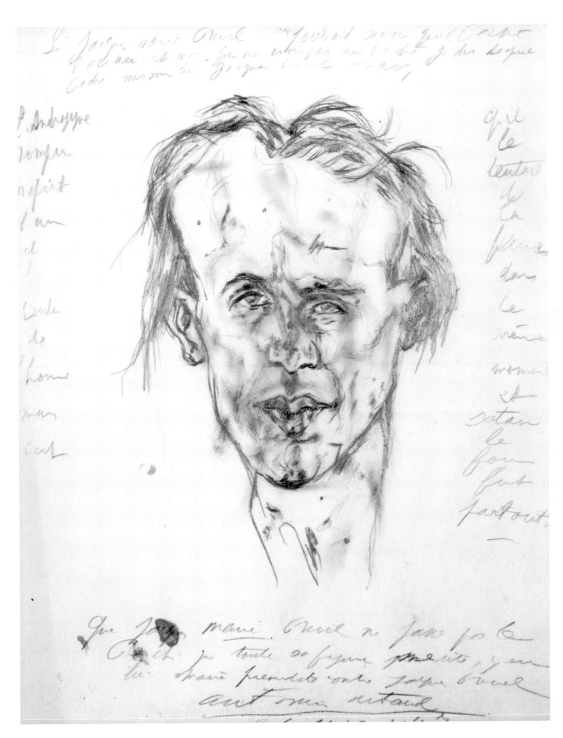

: 2 :
Antonin Artaud
Portrait de Jacques Crevel
(Portrait of Jacques Crevel), 1947

26 FREEMAN Biogr
aphie
s of
Outsi
der
Artis
ts

Karl Brendel (Karl Genzel)

Mühlhausen, Germany, 1871–1925, Eickelborn, Germany

**Principal
References**

Cardinal, Roger. *Outsider Art.*
New York: Praeger, 1972,
158–60.

Prinzhorn, Hans. *Artistry
of the Mentally Ill: A
Contribution to the Psychology
and Psychopathology of
Configuration.* Trans. Eric
von Brockdorff. New York:
Springer, 1972, 96–130.

Dr. Hans Prinzhorn discovered the sculptor Karl
Brendel and his work in the Eickelborn asylum in
1920. Brendel is the only sculptor to be presented in
Prinzhorn's *Bildnerei der Geisteskranken* (Artistry of
the mentally ill), 1922; in that book there are more
illustrations of Brendel's work than of any other
artist's: twenty-four sculptures and eight drawings.

One of eight children, Brendel was, by his own
account, a lively and affectionate child and capable
student. He attended school from the age of six
until graduating at fourteen, after which he learned
the craft of bricklaying. He married in 1895 and
had a family. From 1892 until his hospitalization
in 1907 he was in constant conflict with the law and
imprisoned twelve times for such crimes as assault,
libel, procuring, property damage, and resisting
arrest. During one of these incarcerations his wife
divorced him.

In 1906 Brendel began to manifest signs of
mental illness, and the following year, suffering
from auditory and visual hallucinations, he was
admitted to the Eickelborn asylum. In 1912, after
five years of hospitalization, he began to model
figures from chewed bread. Encouraged by a
physician, Brendel was given wood to sculpt.

In his earliest works Brendel carved flat reliefs,
often with patterned borders. Later he created
imaginative gargoylelike animals and complex
sculptures with incongruously juxtaposed motifs.
Many of his figures embody both male and female
characteristics. This is true even of his representa-
tions of Christ, with whom Brendel identified. He
often worked in very hard woods, some of which
he painted or varnished. His method was spontane-
ous; he had no interest in using models. Regarding
his process, Brendel once said, "When I have a
piece of wood in front of me, a hypnosis is in it—if
I follow it something comes of it, otherwise there
is going to be a fight."

=

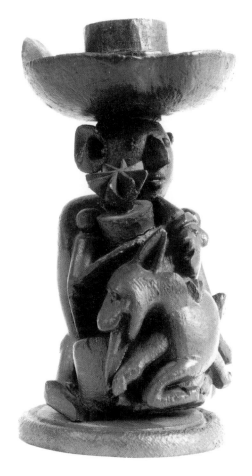

: 3 :
Karl Brendel (Karl Genzel)
Untitled (Figure with hat), c. 1920

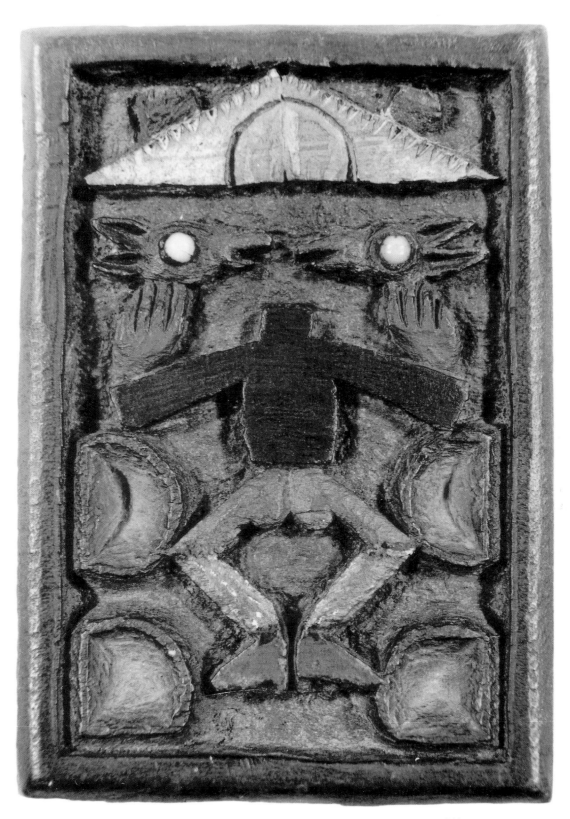

: 4 :
Karl Brendel (Karl Genzel)
Untitled

Carlo (Carlo Zinelli)

San Giovanni Lopatoto, Italy, 1916–74, Verona, Italy

Principal References

Andreoli, Vittorino. "Les Dernières Années de Carlo." *L'Art brut*, fascicle 11. Lausanne: Collection de L'Art Brut, 1977, 77–85.

Andreoli, Vittorino, et al. "Carlo." *L'Art brut*, fascicle 7. Paris: Compagnie de l'Art Brut, 1966, 5–94.

Bader, Alfred, and Leo Navratil. *Zwischen wahn und Wirklichkeit: Kunst, Psychose, Kreativität*. Lucerne: C. J. Bucher, 1976, 231–33.

The fourth of seven children, Carlo, an introverted child, was only nine years old when he was separated from his family and sent to work as a farm laborer. Rural life having strengthened his solitary inclinations, Carlo found his move to Verona at fifteen to become a butcher's apprentice quite disconcerting. It was in Verona, where he lived until conscripted into the army in 1936, however, that Carlo developed an interest in music and painting. During his military service the first signs of his mental disturbance appeared. In a state of confusion and anxiety brought on by the shock of war, Carlo attacked his captain and was discharged after being examined at a military hospital in 1941. In the years following the war he was increasingly incapacitated by a persecution complex, terrifying visual hallucinations, and speech disorders, and in 1947 family members committed him to the San Giacomo Psychiatric Hospital in Verona.

In 1957, two years after Carlo began drawing graffiti on the hospital walls with a brick, San Giacomo, at the instigation of the Scottish sculptor Michael Nobel, set up the Studio for Artistic Expression. In this creative environment Carlo painted every day for the next fourteen years. Using a fine brush, he drew plants, animals, boats, and houses, but his predominant motif was a stereotyped mechanical human figure drawn in profile. Around 1962 he began adding stripes of pure color to his paper before superimposing figures. To his silhouetted, repetitive forms, painted in a calligraphic style, Carlo eventually added a profusion of letters and words. The words, however, were nonsensical, reflecting the artist's inability to use language.

In 1971 San Giacomo was closed, and Carlo was transferred to its replacement, the newly built Marzana Psychiatric Hospital in Verona. Devastated by the loss of the old studio, Carlo painted only sporadically. Not long after his transfer, the new hospital too was closed, and after twenty-four years of confinement Carlo was released to a family who did not have the means or desire to care for him. In 1974 he died of tuberculosis.

∎

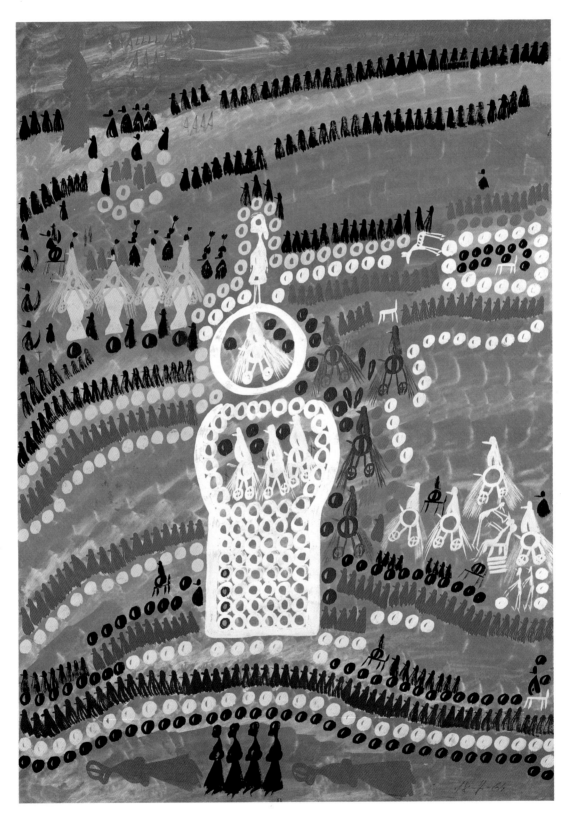

: 5 :
Carlo (Carlo Zinelli)
Untitled (verso; see FIGURE 238)

30　　　　　　　　　　　　FREEMAN　　　　　　　　B i o g r
　　　　　　　　　　　　　　　　　　　　　　　　a p h i e
　　　　　　　　　　　　　　　　　　　　　　　　s　o f
　　　　　　　　　　　　　　　　　　　　　　　　O u t s i
　　　　　　　　　　　　　　　　　　　　　　　　d e r
　　　　　　　　　　　　　　　　　　　　　　　　A r t i s
　　　　　　　　　　　　　　　　　　　　　　　　t s

Case 411

*There is no information other than that this artist,
whose work is in the Prinzhorn Collection, was female.*

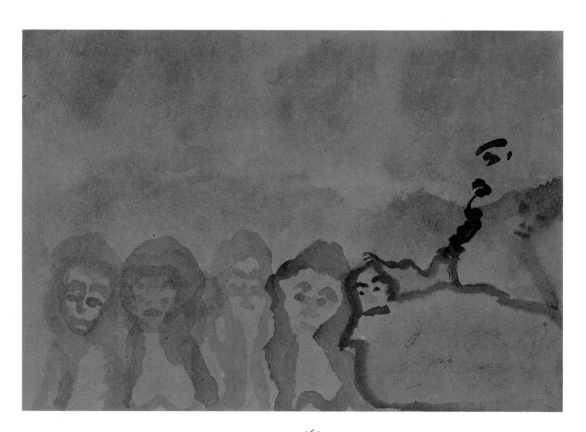

: 6 :
Case 411
Auf Erden im Himmel
(On earth in heaven), c. 1921

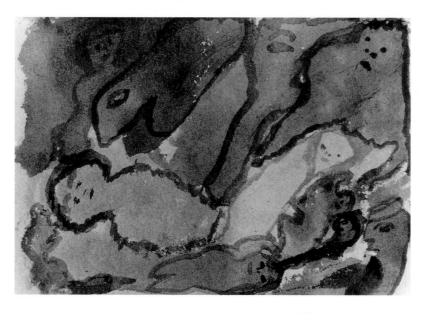

: 7 :
Case 411
Bilder im Tal (Paintings in the valley)

Gaston Chaissac

Avallon, France, 1910–64, La Roche-sur-Yon, France

**Principal
References**

*Gaston Chaissac: Aquarelles,
collages, dessins, gouaches,
huiles, et totems.* Exh. cat.
Paris: Galerie Louis Carré,
1988.

Nathan-Neher, Barbara.
Chaissac. New York: Rizzoli,
1987.

Gaston Chaissac, a boy of delicate health and
sensibilities, the fourth and youngest child of
cobblers, completed his compulsory education at
thirteen and took up various jobs in his hometown
of Avallon, southeast of Paris, before moving in
1926 with his mother to his sister's home nearby in
Vallapourçon. Chaissac, having little contact with
his father—who had gone to war in 1914 and
permanently abandoned the family in 1918—was
strongly attached to his mother, whose untimely
death in 1931 caused him grievous depression.

After an unsuccessful attempt in 1935 to earn a
living in Paris, Chaissac returned to the capital two
years later, residing with his older brother and
cultivating a friendship with his brother's neighbor,
the artist Otto Freundlich, who encouraged
Chaissac to paint. The relationship was continued
by mail when Chaissac was hospitalized in
Nanterre, where he was diagnosed as tubercular,
and later when he was sent to a sanatorium in
Normandy. There doctors supplied him with
painting materials, and he developed his personal
style of colored paintings webbed with black lines.

Released in 1942, after four years of
hospitalization, Chaissac married Camille Guibert,
whom he had met at an exhibition of patients' art.
The following year the couple settled in Boulogne-
les-Essarts, where Camille taught school and
Chaissac cared for the house, garden, and a baby
daughter while producing a wealth of extraordinary
artwork. He exhibited at the 1944 Salon des
Indépendants, where Jean Dubuffet saw the work
and was astonished by Chaissac's untrained
creativity, adventurous ideas, and keenness of mind.

In 1948 Mme Chaissac was transferred to a
school in Sainte-Florence-de-l'Oie, and there, in
near isolation, Chaissac perfected his brilliant
collages, painted on stone and iron, created murals,
wrote letters filled with drawings and writing in
patterns, and from long planks made life-size
human figures he called totems. Weakened by high
blood pressure and asthma, he was unable to enjoy
the critical success of exhibitions in Paris, Milan,
and the United States in the 1960s; he died of a
stroke in 1964.

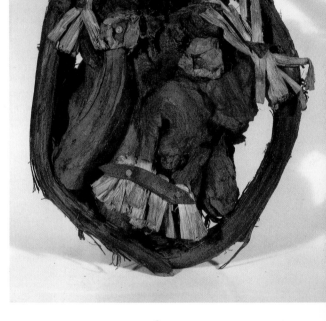

: 8 :
Gaston Chaissac
Tête archaique (Archaic head), 1947–50

32 FREEMAN Biogr
aphie
s of
Outsi
der
Artis
ts

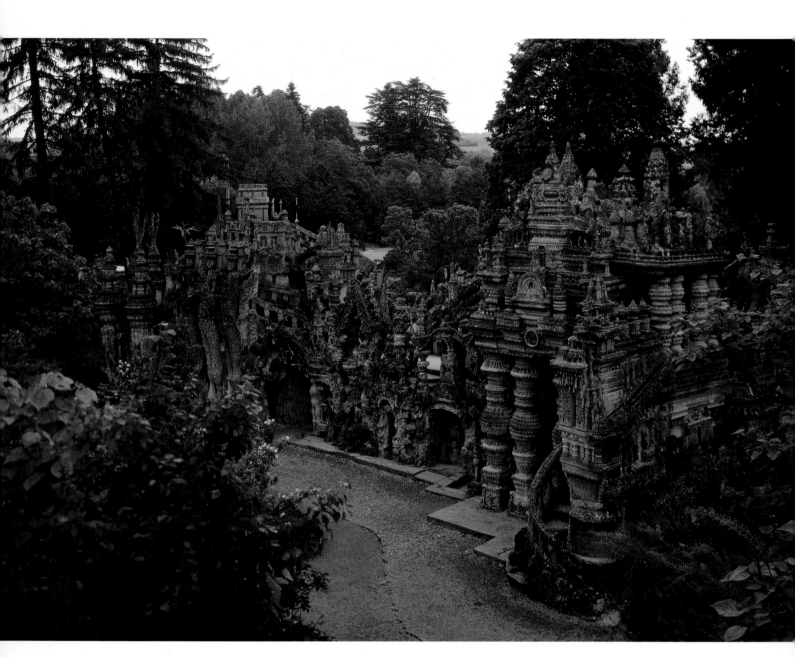

: 9 :
Ferdinand Cheval
Palais idéal (Ideal palace),
Hauterives, France, 1879–1912

Ferdinand Cheval

Charmes, France, 1836–1924, Hauterives, France

**Principal
References**

Cardinal, Roger. *Outsider
Art*. New York: Praeger,
1972, 146–53.

Jean, André. *Le Palais idéal
du facteur Cheval à Hauterives*.
Balence, France: Imprimerie
Nouvelle, 1937.

Jouve, Jean-Pierre, et al. *Le
Palais idéal du facteur Cheval*.
Paris: Editions du Moniteur,
1981.

Farmer, baker, postman, and in the words of André Breton, "undisputed master of mediumistic sculpture and architecture," Ferdinand Cheval dreamt of building his *Palais idéal* (Ideal palace) for twelve years prior to actually undertaking the project, which absorbed thirty-three years of his life. Inspired in 1879 by the chance discovery of an extraordinary piece of sandstone, Cheval, completely unschooled in building, resolved to become a mason and architect in order to utilize what he later referred to as nature's sculpture. On his postal rounds in the southeastern village of Hauterives, he collected stones of odd and fanciful shapes, transporting them home first in his pockets and later by wheelbarrow to be used in his construction.

Working mostly at night with rudimentary tools and a candle on his hat, Cheval built a skeleton of wire, over which he modeled a mixture of wet cement and lime. Into this surface he pressed his collection of rocks, pebbles, fossils, and shells, ornamenting every point of the eighty-five-foot-long, forty-foot-wide labyrinth of caves, galleries, stairways, corridors, grottoes, and towers that form the *Palais idéal*. Cheval noted in his diary that he was able to indulge his passion because, though his neighbors thought him mad or a fool, they did not think his condition contagious or dangerous and were willing to leave him alone with his work.

The palace, completed in 1912, enshrines figures of antiquity, tombs, a Hindu temple, biblical scenes, models of a mosque, the White House, a medieval castle, and a Swiss chalet, the inspirations for which might have come from books, monuments observed in Algiers during military service, or buildings seen at the Paris Exposition Universelle of 1878. One hundred thirty-five inscriptions add to the complexity of the incredible structure, which still stands today.

Refused permission to be buried in a vault under the east façade of the palace, Cheval began in 1914 an eight-year project to erect a tomb for himself in the local cemetery. At age eighty-eight, two years after its completion, Cheval was laid to rest in his Tomb of Silence and Endless Rest.

34 FREEMAN Biogr
 aphie
 s of
 Outsi
 der
 Artis
 ts

Joseph Crépin
Hénin-Liétard, France, 1875–1948, France

**Principal
References**

Breton, André. *Surrealism
and Painting*. New York:
Harper & Row, 1972,
298–307.

Dubuffet, Jean. "Joseph
Crépin." *L'Art brut*, fascicle
5. Paris: Compagnie de l'Art
Brut, 1965, 44–63.

In a 1954 essay André Breton designated the paintings of Joseph Crépin as collectively the "most beautiful florets of mediumistic art . . . possessing a quality of sacredness conspicuously absent from the rest of the modern art world." The profusion of luminescent beads of paint that Crépin applied at the feverish rate of fifteen hundred per hour to the otherwise rigidly symmetrical, flatly rendered paintings were a source of pride to Crépin and imbued the works with a talismanlike quality.

It was not until he was sixty-five that Crépin, the owner of a plumbing and well-drilling business in Pas-de-Calais, discovered that he possessed powers as a diviner and healer. Initially by the laying on of hands and later by pinning a heart-shaped paper bearing a musical symbol to his patients' chests, Crépin became well known as a successful healer, a proclivity that attracted up to forty clients a day.

In 1938, while copying music, Crépin, as if in a trance, began to make small drawings. The following year, after filling several exercise books with drawings of temples, vases, statues, and stars, he was challenged by a mysterious voice to produce three hundred paintings, the completion of which would guarantee the end of the war and restore world peace. Crépin set to this task professing to derive psychic and artistic strength from a ritualistic contemplation of the sun. Just as the entire suite of paintings was to ensure world harmony, Crépin avowed that each individual painting was invested with miraculous powers to secure personal safety.

Crépin claimed to have finished the last of the paintings on May 7, 1945, the day Germany surrendered. Soon after, a voice declared to him that the composition of an additional forty-five paintings would safeguard future world peace. Crépin began the second series of paintings in October 1947 and is said to have completed the forty-third a few days before his death in 1948.

=

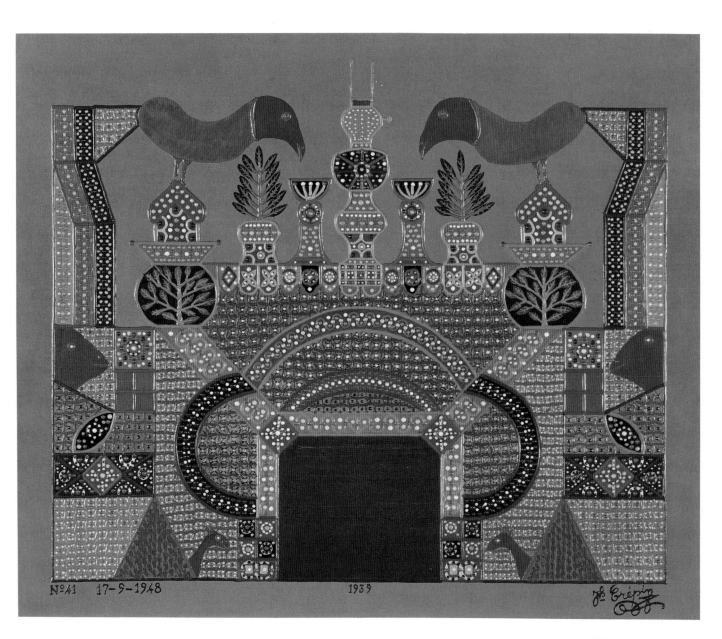

: 10 :
Joseph Crépin
Painting No. 41, 1948

Henry J. Darger

Chicago, Illinois, 1892–1973, Chicago, Illinois

Principal References

Cohrs, Timothy. "Henry Darger, Artist (Outsider, Naive, Folk, Autistic or Genuine Fine)." *Arts Magazine* 61, no. 5 (January 1987): 14–17.

Morrison, C. L. *Realms of the Unreal: The Work of Henry Darger.* Exh. cat. Chicago: Hyde Park Art Center, 1977.

Outsiders: An Exhibition of Art Brut. Exh. cat. Basel: Kunsthaus St. Alban, 1988.

Placed in a Catholic home for boys at the age of eight, when his crippled father could no longer care for him, Henry Darger developed behavioral problems and was sent to an institution for the feebleminded. After running away at sixteen, he found employment as a custodian in a hospital. An industrious employee, he supported himself with custodial work until a leg injury forced him to retire at seventy-one. During most of his adult life Darger, a reclusive man whose most ardent and unfulfilled desire was to adopt a child, attended Mass daily and walked miles collecting bottles, string, old newspapers, magazines, and other bric-a-brac.

At eighty-one, too frail to climb the stairs to a second-story room, his home of forty years, Darger asked his landlord, photographer Nathan Lerner, to help him move to a Catholic home for the aged. After Darger's departure Lerner, who had known his tenant twenty years, went to the old man's cluttered apartment and discovered a phenomenal literary and artistic trove, the work of a lifetime.

Amid the thousands of pages of written material was a two thousand-page diary, an eleven-year weather log, and most remarkably, a fifteen-volume, fifteen thousand-page saga entitled "The Story of the Vivian Girls in what is known as The Realms of the Unreal, of the Glandeco-Angelinnean War storm, caused by the Child Slave Rebellion." The epic, begun in 1909 or 1910, chronicles horrific battles between the child-enslaving people of Glandelinia and the Catholic nation of Abbieannia. Darger punctuates scenes of astonishing carnage with supernatural storms and earthquakes. Eventually winning the war, the Abbieannians, led by seven virtuous princesses—the Vivian sisters—were aided in their gruesome struggles by Captain Henry Darger, head of an organization devoted to the protection of children.

Utilizing a variety of materials, including figures cut or traced from storybooks, newspapers, and magazines, Darger enriched his cosmic tale with eighty-seven exquisitely collaged water-colors—some as large as four by twelve feet—and sixty-seven smaller pencil drawings. The illustrations portray the Vivian sisters, warring male adults, female children (with penises added by Darger), and winged creatures called Blen-giglomenean Serpents, or Blengins, in blissful fairyland settings or more frequently in scenes of incredible mayhem.

Six months after abandoning his private domain, Darger died. The manuscripts and paintings that he left behind represent his untutored artistic genius and reflect his poignant personal struggles.

=

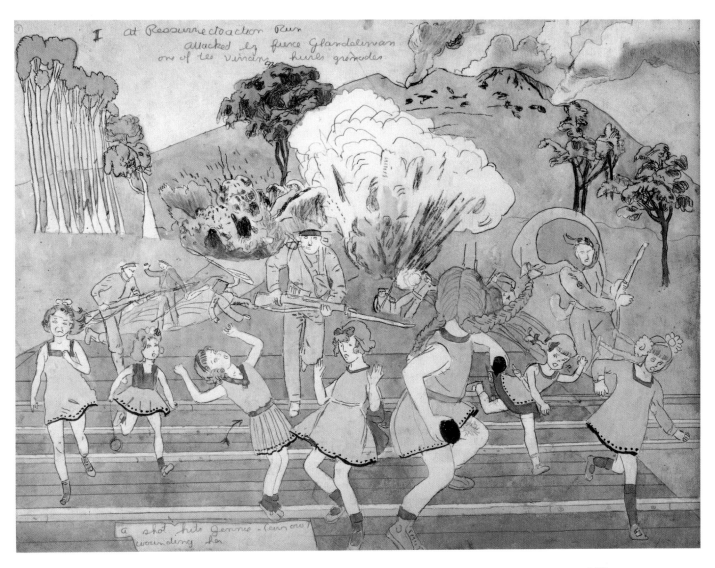

Henry Darger
At Ressurrecteaction Run

Howard Finster

Valley Head, Alabama, born 1916

Principal References

Patterson, Tom. *Howard Finster: Stranger from Another World*. New York: Abbeville, 1989.

Turner, John. *Howard Finster: Man of Visions*. New York: Knopf, 1989.

The Reverend Howard Finster, self-proclaimed "Last Red Light of God," "Stranger from Another World," "Messenger from God," and "Man of Visions," grew up on a remote forty-acre farm in De Kalb County, Alabama, with his mother, father, and thirteen brothers and sisters. Finster experienced his first vision at age three. At sixteen Finster vowed to preach the word of God, which he did for the following forty-five years at nine different churches in Alabama and Georgia. Married in 1935, Finster had five children and found it necessary to supplement his preacher's wages with additional employment. Aside from several jobs in local textile mills, Finster worked as a sign painter, carpenter, bicycle repairman, grocery-store owner, and woodworker.

In the late 1940s Finster began work on his first garden, in the yard of his Trion, Georgia, home. This environment, which he referred to as a "museum park," consisted of several miniature buildings, an eight-foot-tall cross, and an "exhibit house," which served as home for sixty pet pigeons as well as for his constantly expanding display of items "representing all the inventions of mankind."

In 1961, after working more than a decade on the "museum park," Finster moved to a new and larger location in Pennville, Georgia, and began the project known today as *Paradise Garden*. Originally conceived as a "plant farm museum," Finster intended to grow every plant and flower possible under the Georgia sun. He designed garden plots and laid intricate walkways embedded with broken bits of mirror, marbles, tools, and various found objects. By the mid 1970s the garden's paths, streams, bridges, and sculptural monuments covered two and a half acres.

In the mid 1970s Finster experienced a momentous vision. As he repaired a child's bicycle a facelike apparition appeared to him in a smudge of paint on one of his fingers, and a voice commanded him to "paint sacred art." Not knowing what to paint, Finster took a dollar bill from his pocket and copied the portrait of George Washington. Within months the garden was covered with portraits of American patriots, biblical characters, and ornate scriptural quotations. From that time to the present Finster has worked with intense energy, producing portraits of his personal heroes and paintings of religious and patriotic images. Representing his many visions, Finster's art resounds with evangelical messages and inspirational verse.

Perhaps America's most widely known visionary artist, Finster was commissioned to produce paintings for the Library of Congress in 1977, and he was the recipient of a National Endowment for the Arts fellowship in 1982. Finster appeared with Johnny Carson on "The Tonight Show" in 1983 and was invited to participate in *Paradise Lost! Paradise Regained: American Visions of the New Decade*, the exhibition for the American Pavilion at the 1984 Venice Biennial. In 1985 Finster designed an award-winning album cover for the musical group Talking Heads. Having produced more than eight thousand works, Finster continues to create paintings and sculpture shown in major museums and prestigious galleries.

=

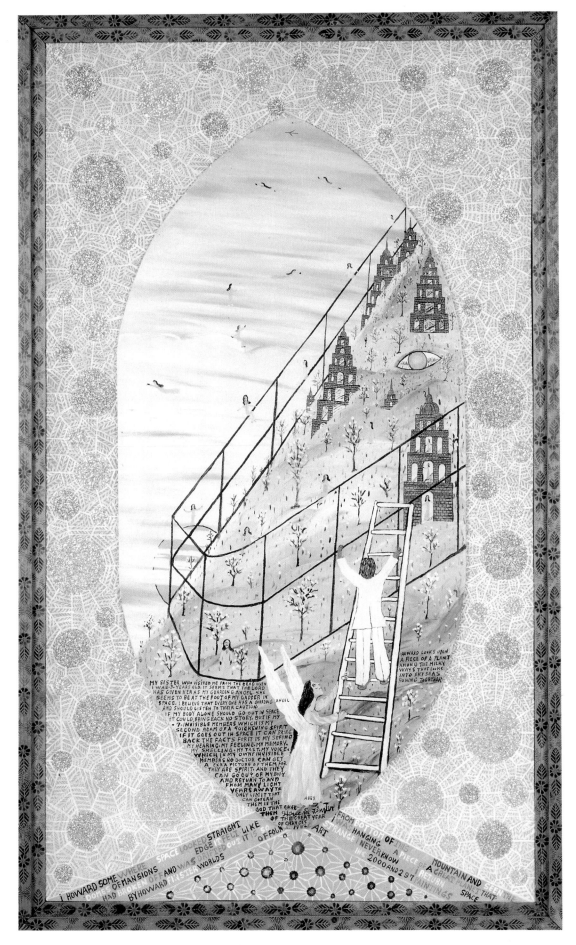

: 12 :

Howard Finster

*Howard Looks upon a Piece
of a Planet*, 1982

40 FREEMAN Biogr
 aphie
 s of
 Outsi
 der
 Artis
 ts

Madge Gill
London, England, 1882–1961, London, England

**Principal
References**

Cardinal, Roger. "The Art of
Entrancement: European
Mediumistic Art in the
Outsider Domain."
Raw Vision, no. 2 (Winter
1989–90): 30–31.

Thévoz, Michel. *Art Brut.*
New York: Rizzoli, 1976,
148–51.

Relinquished by her mother to an orphanage when she was nine years old, Madge Gill (born Maude Ethel Eades) was eventually sent to Canada to work as a farm servant. Returning to London at nineteen, Gill took a nursing job and lived with an aunt, who introduced her to spiritualism. In 1907 she married Thomas Gill; they had three sons, the second of whom died at age eight in an influenza epidemic. Soon after, Gill suffered the birth of a stillborn daughter, followed by a serious illness, from which she lost an eye.

Surviving heartache and misfortune, the thirty-seven-year-old Gill, claiming guidance by a spirit she referred to as Myrninerest, was inspired to an intense outpouring of artistic achievements. Often working feverishly through the night in near darkness, she produced an effusion of writing, embroidery, knitting, drawings, and painting. In her hundreds of drawings executed on paper (from postcard to mural size) and on rolls of calico fabric (some reportedly as long as thirty-six meters!), Gill's recurrent image is a large-eyed, oval-faced female, dressed in flowing robes, which dissolve into an intricate, mazelike background. The fluid outlines of these figures superimposed with color in combination with meticulous and tightly drawn geometric and asymmetric patterns produce a dynamic visual effect.

After the death of her husband in 1933, Gill increased her spiritualist activities, holding séances in her home and drawing complex astrological charts for friends. She also exhibited her large ink drawings on calico at annual East End exhibitions for amateur artists. Unwinding and painting on the fabric bit by bit, she never saw the larger pieces in their entirety until they were hung on the gallery wall. As detailed as her smallest works and often signed Myrninerest, the drawings on calico received acclaim in the press. Declaring the works belonged to her spirit guide, Gill refused all offers of purchase and generally shunned publicity.

A painting dated June 30, 1958, was probably her last piece. When she died at age seventy-nine in 1961, Gill left hundreds of drawings in the attic, closets, and under the beds of her Plashet Grove Street home. Lawrence, her son and most resolute admirer, bequeathed a large part of his mother's work to the London borough of Newham, in which she had lived.

■

: 13 :
Madge Gill
Woman and Staircase, 1951

42
FREEMAN
Biogr
aphie
s of
Outsi
der
Artis
ts

Paul Goesch

Schwerin, Germany, 1885–1940, Hartheim, Austria

**Principal
References**

*The Prinzhorn Collection:
Selected Work from the Prinz-
horn Collection of the Art of the
Mentally Ill.* Exh. cat.
Champaign, Illinois:
Krannert Art Museum,
University of Illinois, 1984.

Roters, Eberhard, et al.
*Paul Goesch 1885–1940:
Aquarelle und Zeichnun-
gen.* Exh. cat. Berlin:
Berlinische Galerie, 1977.

Chief state architect of Kulm (Chelmno) and an
accomplished painter, Paul Goesch, son of a Berlin
judge, is one of the few trained artists included in
the Prinzhorn Collection. An introvert and loner,
Goesch was interested in utopian architecture and
devoted time to planning imaginary cities. In 1919–
20 he was a founding member of a group of young
architects, known as Die Gläserne Kette (The glass
chain), with a mutual interest in visionary archi-
tecture. After a long history of mental problems, he
was hospitalized in 1921 at a Göttingen clinic where
his brother-in-law was a doctor.

The originality and diversity of Goesch's work
during his institutionalization is remarkable. He
produced hauntingly beautiful paintings: portraits,
nonobjective works, dreamlike visions, and works
with mythological and religious themes. He had
been associated with the Novembergruppe, and his
work continued to be included in its exhibitions
until 1929.

In 1933 or 1934 Goesch was moved to an
institution south of Berlin, where his brother-in-law
continued to care for him until 1940, when the
Nazis transported the artist to Hartheim, near Linz,
Austria, where he was exterminated along with
other mental patients. Many of his architectural
drawings and paintings were saved, however, and
carefully preserved by his relatives; nearly six
hundred were exhibited in Berlin in 1977.

＝

: 14 :
Paul Goesch
Kopf mit Farbteilung
(Head with colored pattern)

: 15 :
Paul Goesch
Traum eines Kindes (Child's dream)

Johann Hauser

Pressburg, Czechoslovakia, born 1926

Principal References

Cardinal, Roger. "The Enigma of Johann Hauser." *Artscribe*, no. 17 (April 1979): 27–29.

Navratil, Leo. *Johann Hauser: Kunst aus Manie und Depression*. Munich: Rogner and Bernhard, 1978.

Thévoz, Michel. "Johann Hauser." *L'Art brut*, fascicle 12. Lausanne: Collection de l'Art Brut, 1983, 10–25.

The illegitimate son of an aging widow, Johann Hauser lived with his mother in a displaced persons' camp and attended a school for retarded children. Unable to read or write, he was institutionalized at Mauer-Ohling in Austria when he was seventeen years old. Suffering from a manic-depressive disorder, he was transferred two years later to the mental institution known as Gugging, in Austria, where he has remained for more than forty years.

Beginning to draw at the encouragement of Dr. Leo Navratil in 1959 and pursuing his art to the present day—collaborating at times with Viennese artist Arnulf Rainer, who has befriended him—Hauser exhibits two distinct styles. In manic periods he creates colorful and flamboyant images of a wide variety of subjects; among his favorites are airplanes, rockets, castles, animals, and voluptuous femme fatales (often fashioned after pictures of film stars). During periods of depression Hauser creates images that are geometric and minimal. The blue stars from the latter period have become the symbol of the Künstlerhaus (Artists' house) at Gugging, where Hauser and other artistically gifted patients reside.

While Hauser is completely dependent on hospital life and has very limited contact with the world outside the institution, his work has been widely exhibited and has received considerable acclaim.

=

: 16 :
Johann Hauser
Frau mit Eule und Mond
(Woman with owl and moon), 1974

Carl Fredrik Hill
Lund, Sweden, 1849–1911, Lund, Sweden

Principal References

Bader, Alfred, and Leo Navratil. *Zwischen Wahn und Wirklichkeit: Kunst, Psychose, Kreativität.* Lucerne: C. J. Bucher, 1976, 137–44.

Carl Fredrik Hill. Exh. cat. Malmö: Malmö Konsthall, 1976.

Schneede, Marina, and Uwe M. Schneede, eds. *Vor der Zeit: Carl Fredrik Hill [,] Ernst Josephson: Zwei Künstler des späten 19. Jahrhunderts.* Hamburg: Frölich and Kaufmann, 1984.

Carl Fredrik Hill was consumed at an early age by driving ambition, pledging to his family and himself that he would achieve fame as an artist. Forced to study aesthetics at the University of Lund by his father, an eccentric mathematics professor who disparaged his son's artistic inclination, Hill left Lund to attend Stockholm's Konstakademien (Academy of Fine Arts) in 1871. In 1873 he traveled to Paris. Inspired by Camille Corot and the Barbizon painters, he developed a personal style of landscape painting. Measuring success with public recognition, Hill, who had not sold anything by his twenty-ninth birthday, suffered unbearable anxiety culminating in lifelong mental illness. While his illness was long considered a great loss to art, today his reputation rests on thousands of drawings produced during the years of his illness.

In the autumn of 1877, as his persecution disorder became apparent, Hill worked feverishly, often painting exclusively with Paris blue and cadmium yellow. As his behavior changed, so did the style and motifs of his work. Turning away from landscape and reality, he painted themes from ancient tales and religion, symbols of death ever present. Believing they were protecting his artistic reputation, Hill's friends destroyed the scores of expressionistic paintings produced at the onset of his illness and took him to Dr. Blanche's private hospital in Paris, where he remained for a year and a half before being transferred to St. Hans Asylum near Roskilde, Sweden.

Released to the care of his sister Hedda in 1883, who looked after him for the remainder of his life, Hill worked continuously, sometimes producing five or six drawings in a single day. His immense output is characterized by varied styles and vast thematic diversity. Often representing the tormented hallucinations that overwhelmed him until his death in 1911, Hill drew distorted and fearful gods and men, his ghostlike, avenging father, and the vegetables and fruits he believed to be poisoned and endowed with evil powers. In 1926 Sweden's Nationalmuseum acquired three hundred of Hill's drawings, and in 1931 the Malmö Konsthall acquired more than twenty-five hundred in watercolor, pencil, ink, and colored chalk.

: 17 :
Carl Fredrik Hill
Untitled

: 19 :
Carl Fredrik Hill
Untitled

: 18 :
Carl Fredrik Hill
August Strindberg

: 20 :
Carl Fredrik Hill
Untitled

Johann Knüpfer (Johann Knopf)

Wünschmichelbach, Germany, 1866–1910, Wiesloch, Germany

Johann Knüpfer, the youngest of four brothers, worked as a baker, cement maker, and locksmith. Until he was nearly thirty years old, he lived quietly in the security of his mother's home, but after her death in 1895 his once placid existence was fraught with adversity. He soon found himself in a wretched marriage. Ceasing to work regularly and abandoning his home and wife, he suffered from delusions of persecution, existed as a vagrant, and in 1902 alone was arrested seven times for begging. No longer able to endure what he termed terrible tortures, Knüpfer attempted suicide that year and was committed to a psychiatric hospital in Wiesloch, near Heidelberg.

Knüpfer began drawing soon after his admission to the hospital. Often enhanced with captions of words, numbers, and symbols, Knüpfer's decorative and highly patterned works display a strictly symmetrical arrangement. Believing himself divinely called for martyrdom, he documented his personal religious delusions in many drawings. In others he summoned up childhood memories, drawing detailed accounts of stylized farms, fanciful animals, and relatives recalled from his untroubled youth.

=

Principal References

Cardinal, Roger. *Outsider Art.* New York: Praeger, 1972, 81–82.

Prinzhorn, Hans. *Artistry of the Mentally Ill: A Contribution to the Psychology and Psychopathology of Configuration.* Trans. Eric von Brockdorff. New York: Springer, 1972, 172–79.

: 21 :
**Johann Knüpfer
(Johann Knopf)**
Untitled

Augustin Lesage
Saint-Pierre-les-Auchel, France, 1876–1954, France

In 1911, after twenty years in the coal mines of northern France, Augustin Lesage heard a voice foretelling his destiny as a painter. This revelation led to his involvement with spiritualism, and he soon showed significant gifts as a medium. In 1914 Lesage, who was also practicing spiritual healing, was acquitted of charges brought against him by the local doctors' union, after thirty of his satisfied patients testified on his behalf.

At the urging of his first spirit guide, Marie (the name of his long-dead sister), Lesage produced his first automatic drawings in 1912. (In 1918 he would identify his guides as Leonardo da Vinci and after 1925 as a spirit he called Marius de Tyana.) At the insistence of his spirit guide Lesage purchased paints and brushes in 1913 and undertook an enormous painting. Fastening a one hundred-square-foot canvas to a wall in his house, Lesage began painting in the upper right corner. Working evenings and Sundays for more than a year, he completed the painting in the symmetrical and architectonic manner of his subsequent works. After the first painting of 1913, Lesage developed the technique of drawing a median down the center of a canvas, on each side of which he placed miniature figures and designs, creating highly symmetrical paintings. After 1927 Lesage frequently incorporated Egyptian hieroglyphs, temples, and hieratic figures into his works.

After serving in World War I, Lesage returned to the mines and to his painting. By 1923 he had attracted attention in influential spiritualist circles and was able to retire from the mines, devoting all his time to spiritualist activities and painting. As he began to sell his work, Lesage calculated prices based on the hourly wage he would have earned in the mines for the time it took to create a painting.

In 1927, after exhibiting his work in Paris, Lesage was invited to demonstrate his abilities at the Institut Métapsychique, where his distinction as a medium and painter was validated. At the time of his death Lesage had completed an estimated eight hundred canvases.

Principal References

Notter, Annick, Didier Deroeux, et al. *Augustin Lesage 1876–1954*. Exh. cat. Paris: Philippe Sers, 1988.

Dubuffet, Jean, and Eugène Osty. "Le Mineur Lesage." *L'Art brut*, fascicle 3. Paris: Compagnie de l'Art Brut, 1965, 5–45.

: 22 :
Augustin Lesage
Untitled, 1912

48 FREEMAN Biogr
 aphie
 s of
 Outsi
 der
 Artis
 ts

Heinrich Hermann Mebes

Liebenwalde, Germany, 1842–? Eberswald, Germany

The devoutly religious son of a teacher, Mebes claimed to have committed a number of "evil acts" as a young man. Considering himself more artist than craftsman, he nevertheless established his own clock and watch business in 1868, which he ran until schizophrenia overtook him. He began painting and writing eleven years after he was confined to the psychiatric institution in Eberswald, near Berlin, Germany, where he lived the last thirty years of his life.

At his death Mebes left numerous notebooks filled with finely executed watercolors accompanied by voluminous poetic observations on the paintings. Dr. Hans Prinzhorn found Mebes's notebooks significant because of the striking parallels between the "stylized and oracularly dark language" and the "symbolically overladen pictures." Prinzhorn also noted the similarity between Mebes's mystical and formally constructed paintings and those of the German romantic painter Philipp Otto Runge.

=

**Principal
References**

*The Prinzhorn Collection:
Selected Work from the
Prinzhorn Collection of the Art
of the Mentally Ill.*
Exh. cat. Champaign,
Illinois: Krannert Art
Museum, University of
Illinois, 1984.

Prinzhorn, Hans. *Artistry of
the Mentally Ill: A
Contribution to the Psychology
and Psychopathology of
Configuration.* Trans. Eric
von Brockdorff. New York:
Springer, 1972, 90–94.

: 23 :
Heinrich Hermann Mebes
Ein Vienedig im Dunkeln
(Venice in the dark)

: 24 :
Heinrich Hermann Mebes
Untitled (Peace of life)

: 25 :
Heinrich Hermann Mebes
Untitled (Easter peace)

: 26 :
Heinrich Hermann Mebes
"Samuel hilf!" ("Samuel help!")

: 28 :
Heinrich Hermann Mebes
Untitled (Zeitgeist)

: 27 :
Heinrich Hermann Mebes
Untitled (Sin of the mad)

Heinrich Anton Müller
Boltigen, Switzerland, 1865–1930, Münsingen, Switzerland

In 1903, after working for many years in the vineyards of Vaud, north of Geneva, Heinrich Anton Müller invented an ingenious vine-trimming machine. Robbed of the profits from his creation, he became disconsolate. His brooding intensified despite medical treatment, and he eventually suffered from hallucinations, which led to his confinement at a Münsingen psychiatric hospital from 1906. By 1912 Müller was again developing machines, most of which investigated the principles of perpetual motion. Müller also assembled a large telescope in the garden of the hospital, reproducing his observations of the heavens in the form of assemblage, utilizing stones and other materials.

By 1912 Müller had begun to draw, initially using blue and black carpenter's pencils and white chalk to execute his images of contorted animals and people. In 1925, adopting multicolored pencils, Müller incorporated a quivering outline in his work, adding to the already disquieting tone of his beautiful, if grotesque, compositions.

Principal References

Cardinal, Roger. *Outsider Art*. New York: Praeger, 1972, 69–71.

Dubuffet, Jean. "Heinrich Anton M." *L'Art brut*, fascicle 1. Paris: Compagnie de l'Art Brut, 1964, 131–44.

: 29 :
Heinrich Anton Müller
Rops a mante, biscaume

J. B. Murry (John B. Murry or Murray)

Sandersville, Georgia, 1908–88, Sandersville, Georgia

Principal References

McWillie, Judith. *Even the Deep Things of God: A Quality of Mind in Afro-Atlantic Traditional Art*. Exh. cat. Pittsburgh: Pittsburgh Center for the Arts, 1990, 13.

Mhire, Herman, Andy Nasisse, and Maude Southwell Wahlman. *Baking in the Sun: Visionary Images from the South*. Exh. cat. Lafayette: University Art Museum, University of Southwestern Louisiana, 1987, 56–59.

Having no formal education, J. B. Murry labored from childhood to the age of sixty-five as a tenant farmer in rural Glascock County, Georgia. Murry married Cleo Kitchens in 1929 and with her raised a family of eleven children. At the time of his death Murry had sixteen grandchildren, thirteen great-grandchildren, and three great-great-grandchildren.

In 1977 Murry, suffering from a hip problem, came under the medical care of Dr. William Rawlings, Jr., who took an interest in his patient's personal as well as physical well-being. Soon after becoming acquainted with Dr. Rawlings, whom Murry described as his "spiritual doctor," Murry had a vision in which he was charged with spreading the word of God through the creation of "spirit script." After the vision, Murry produced and brought reams of "script" to Rawlings's office. A deeply religious man, Murry avowed the arcane script that he produced while in a trance represented direct communication with God. A session of prayer always preceded Murry's deciphering the spirit script, which he accomplished by viewing the script through a glass of well water.

Initially Murry produced the script on market receipts, bank calendars, or whatever material he had at hand. Eventually adding abstract linear figures representing human beings to the script, Murry produced stunning calligraphic drawings always concerned with good and evil, heaven and hell. Becoming increasingly interested in Murry's creations, Rawlings provided him with a small sum of money to purchase drawing supplies in 1979. From that time on Murry drew continuously with obsessional zeal. The drawings were shown to artist Andy Nasisse, who considered them marvelous and made available to Murry a variety of drawing materials, including colored pencils, watercolors, pastels, and marking pens.

In the ten years before his death from cancer Murry produced hundreds of abstract drawings, all imbued with a gentle and ethereal beauty.

=

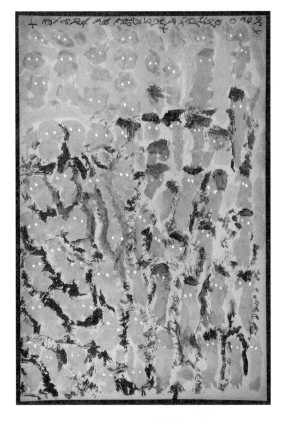

: 30 :
**J. B. Murry
(John B. Murry or Murray)**
Untitled

53

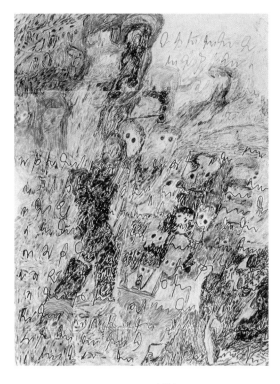

: 31 :
**J. B. Murry
(John B. Murry or Murray)**
Untitled

: 32 :
J. B. Murry
(John B. Murry or Murray)
Untitled

August Neter (August Natterer)

Schorneute, Germany, 1868–1933, Rottenmünster, Germany

According to Dr. Hans Prinzhorn, August Neter was a talented, ambitious man who liked adventure. The youngest of nine children, Neter traveled in Europe and the United States, owned a successful electrical engineering business, and married before acute delusions, severe depression, and anxiety resulted in a suicide attempt and hospitalization in 1907.

While hospitalized Neter recounted a hallucination he experienced at the onset of his illness, a hallucination that permanently altered his perception of reality: the Last Judgment, comprising vast numbers of faces, anthropomorphic landscapes, and symbol-laden figures, including Christ and the Antichrist, as well as scenes of war and "all the beauties of the whole world," appeared in the midday sky. This effusion of images, bursting forth at the rate of "ten thousand per half hour," was interpreted by Neter as his call to carry out the task of redemption uncompleted by Christ.

Neter came to consider himself redeemer of the world, basing his claim on a contrived and complex genealogy in which he maintained his grandmother to be the illegitimate child of Napoleon I. In 1911, with the skill of a technical draftsman, Neter began to create meticulous drawings intended to record his consuming hallucination; Prinzhorn illustrated seven of these drawings in *Bildnerei der Geisteskranken* (Artistry of the mentally ill).

=

Principal References

Cardinal, Roger. *Outsider Art.* New York: Praeger, 1972, 94–97.

Prinzhorn, Hans. *Artistry of the Mentally Ill: A Contribution to the Psychology and Psychopathology of Configuration.* Trans. Eric von Brockdorff. New York: Springer, 1972, 159–71.

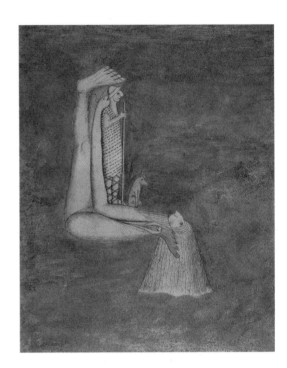

: 33 :
August Neter (August Natterer)
Wunder-Hirthe
(Miraculous shepherd), before 1919

56 FREEMAN Biogr
 aphie
 s of
 Outsi
 der
 Artis
 ts

Viktor Orth (Clemens von Oertzen)

1853–1919, Hubertusburg, Germany

Born Clemens von Oertzen to a noble family, Orth was an ambitious but mistrustful child. In 1880, while serving as a naval cadet, he shot himself, was then pensioned from the navy, and confined for a short time to a psychiatric hospital. Recognizing the impossibility of caring for him, his family found it necessary to recommit him to a psychiatric hospital in Hubertusburg in 1883, where he remained for thirty-six years until his death at age sixty-six.

In 1900 Orth, a confused and unapproachable patient, ardently took up painting, extracting juices from leaves to be used as paint or drawing with bricks on the garden wall if conventional supplies were unavailable. He drew inventive landscapes, decorative figures, and richly colored marine scenes from memory, repeatedly depicting a dignified three-master, apparently a replica of his own training ship. Orth also filled notebooks with airy apparitions so different in style from his other work that Dr. Hans Prinzhorn thought these to be the products of hallucinatory experiences.

=

**Principal
Reference**
Prinzhorn, Hans. *Artistry
of the Mentally Ill: A
Contribution to the Psychology
and Psychopathology of
Configuration*. Trans. Eric
von Brockdorff. New York:
Springer, 1972, 180–87.

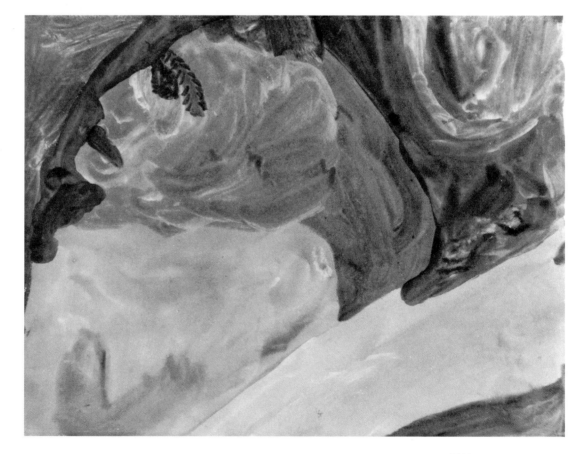

: 34 :
**Viktor Orth
(Clemens von Oertzen)**
Untitled

: 35 :
Viktor Orth
(Clemens von Oertzen)
Untitled

: 36 :
Viktor Orth
(Clemens von Oertzen)
Untitled, 1901

: 37 :
Viktor Orth
(Clemens von Oertzen)
Untitled

Franz Pohl (Franz Karl Bühler)

Offenburg, Germany, 1864–1940, Grafeneck, Germany

The son of an uneducated yet cultivated man, Franz Pohl, talented and energetic, at times overbearing, taught industrial arts, worked as a locksmith, and traveled to Chicago for the World's Columbian Exposition in 1893. Dismissed from his teaching post around 1897 for what was described as highly eccentric behavior, Pohl became increasingly confused and anxious. Overcome by panic in the winter of 1898, he jumped into a icy canal and frantically swam across it, leading to his first psychiatric hospitalization.

Drawings from the first years of Pohl's hospitalization, in which he mixed pencil, crayon, and ink, frequently portrayed fellow patients and hospital scenes in a realistic and skilled manner. The sobriety of these early drawings gave way to dynamic and wildly emotive works, combining realistic and dreamlike qualities. In the later works there is heightened tension and a convincing sense of force. A group of self-portraits from around 1918, painted with loose strokes and rich color, are characteristic of Pohl's artistic virtuosity.

When Dr. Hans Prinzhorn visited him in the early 1920s, Pohl had been institutionalized twenty-two years. Initially reluctant to permit Prinzhorn to view his drawings, Pohl responded to the doctor's praise by affirming that the work was indeed good. Prinzhorn judged the works masterpieces and likened Pohl's self-portraits to those of van Gogh's final years; Pohl had painted himself, according to Prinzhorn, looking out at the viewer with the "burning tension of a life inconsolable and destroyed." Pohl was exterminated by the Nazis in 1940 at Grafeneck, near Münsingen, Germany.

=

Principal References

Keller, Ruth. "Franz Karl Bühler: Kunstschmiede-arbeiten, Künstlerische Entwicklung, Bilder aus der Prinzhorn-Sammlung." Master's thesis, Freie Universität, Berlin, 1983.

Prinzhorn, Hans. *Artistry of the Mentally Ill: A Contribution to the Psychology and Psychopathology of Configuration.* Trans. Eric von Brockdorff. New York: Springer, 1972, 215–28.

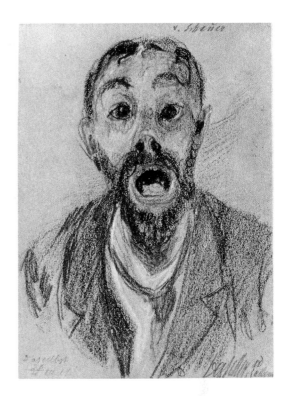

: 38 :
Franz Pohl (Franz Karl Bühler)
Untitled (Self-portrait), 1919

Martín Ramírez

Jalisco, Mexico, 1885–1960, Auburn, California

Principal References

Bowman, Russell, et al. *The Heart of Creation: The Art of Martín Ramírez*. Exh. cat. Philadelphia: Goldie Paley Gallery, Moore College of Art, 1985.

Martín Ramírez: Pintor Mexicano (1885–1960). Exh. cat. Mexico City: Centro Cultural/Arte Contemporáneo, 1989.

Anticipating a better life than the one he had as a laundry worker in Mexico, Martín Ramírez settled in California sometime between 1900 and 1910. Unfortunately the diminutive man encountered only despair. When the railroad work he undertook proved too strenuous, his life deteriorated, and he became an indigent in Los Angeles. Having lost the power of speech, Ramírez was picked up by authorities in 1930, placed in a local mental institution, and transferred seven months later to DeWitt State Mental Hospital in Auburn, where he spent the remaining thirty years of his life.

After twenty years of hospitalization, Ramírez commenced making remarkable drawings and collages on sheets of paper formed of scavenged scraps glued together with mashed potatoes. Having hidden his drawings from the hospital staff, whose policy it was to confiscate and burn such works in order to keep the wards clean, Ramírez in 1954 presented a bundle of them to Dr. Tarmo Pasto, a psychology professor at Sacramento State College, who was conducting research at the hospital. Recognizing the mastery of artistic craft, Pasto asked the staff's permission to keep the drawings. Pasto regularly visited Ramírez thereafter, bringing art supplies and saving the drawings, some of which he used in his classes. In 1968, while teaching at the college, Chicago artist Jim Nutt discovered Ramírez's work in the storage bins of the audiovisual department and with the assistance of Pasto organized the first exhibition of Ramírez's work.

Drawn in graphite, colored pencil, or crayon—some collaged with meticulously torn magazine illustrations—Ramírez's works depict a variety of subjects including cowboys, bandits, madonnas, animals, trains, and tunnels. The figures, often represented on stages, are set in deep, illusionistic space. Aware of the impact of perspective in his drawings, Ramírez often instructed viewers to stand in a particular spot when looking at them.

Ramírez died at seventy-five, and despite the restrictive and adverse circumstances of his life, he left a collection of three hundred powerful drawings, ranging in height from two inches to nine feet.

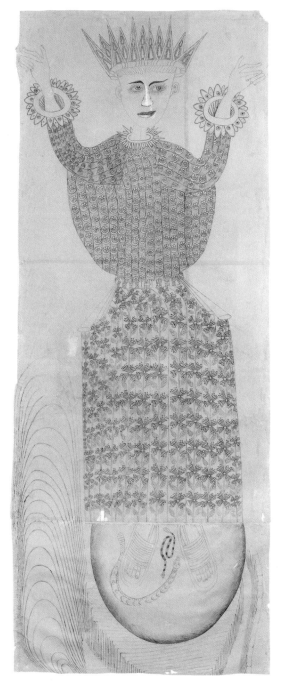

: 39 :
Martín Ramírez
Untitled, c. 1953

: 40 :
Martín Ramírez
Untitled

: 41 :
Martín Ramírez
Untitled (Black antelope), c. 1950

: 42 :
Martín Ramírez
Untitled, 1954

62 FREEMAN Biogr
 aphie
 s of
 Outsi
 der
 Artis
 t s

Simon Rodia

Avellino, Italy, c. 1879–1965, Martinez, California

**Principal
References**

Cardinal, Roger. *Outsider Art.*
New York: Praeger, 1972,
170–72.

Rosen, Seymour. *Simon
Rodia's Towers in Watts.* Exh.
cat. Los Angeles: Los
Angeles County Museum
of Art, 1962.

Trillin, Calvin, "A Reporter
at Large: I Know I Want to
Do Something." *New Yorker*
(May 29, 1965): 72–120.

Using approximately seven thousand bags of cement, seventy-five thousand seashells, and truckloads of broken crockery, tiles, and bottles, Simon Rodia, a small, wiry Italian immigrant, worked thirty-three years building three soaring towers, the *Ship of Marco Polo*, and a complex of arches, fountains, and pavilions in the yard of his Los Angeles home. Similar to the huge, steeple-shaped, processional towers used annually to celebrate a local religious festival in the village of Nola, not far from Rodia's childhood home, the Watts Towers may record Rodia's nostalgia for the gaiety of these annual celebrations.

Born Sabato Rodia near Naples, Rodia was sent to the United States by his parents to avoid conscription. Arriving when he was about fourteen, he lived with a brother, a coal miner, in Pennsylvania. At the time of his brother's death, Rodia was an itinerant laborer until marrying in Seattle, Washington, and settling in Martinez, California, where he lived with his wife and three children until his divorce in 1911.

Rodia resettled in Long Beach and was employed by a construction company; in 1921 he purchased the triangular lot at 1765 East 107th Street in the south-central section of Los Angeles known as Watts and began work on the monument that he called *Nuestro Pueblo* (Our town). Built of reinforced concrete (cement over steel rods), Rodia's skeletal structures, towering almost one hundred feet, withstood a destructive earthquake in 1933. Climbing the towers with only a window washer's belt, a pail of cement, a trowel, and a burlap pouch filled with shells, dishes, bowls, figurines, bottles, carnival glass, mirror, and tile,

Rodia worked every evening, weekend, and holiday until 1954. At about age seventy-five (the year of his birth is uncertain), having grown weary of derisive taunts, he sold the property—house, towers, and all—to a neighbor for a nominal sum and returned by bus to Martinez. Living in an inexpensive room above a dentist's office until his death in 1965, Rodia never returned to his towers, which were represented by six photographs in the catalogue of *The Art of Assemblage* (Museum of Modern Art, 1961) and eventually listed in the National Register of Historic Places.

∎

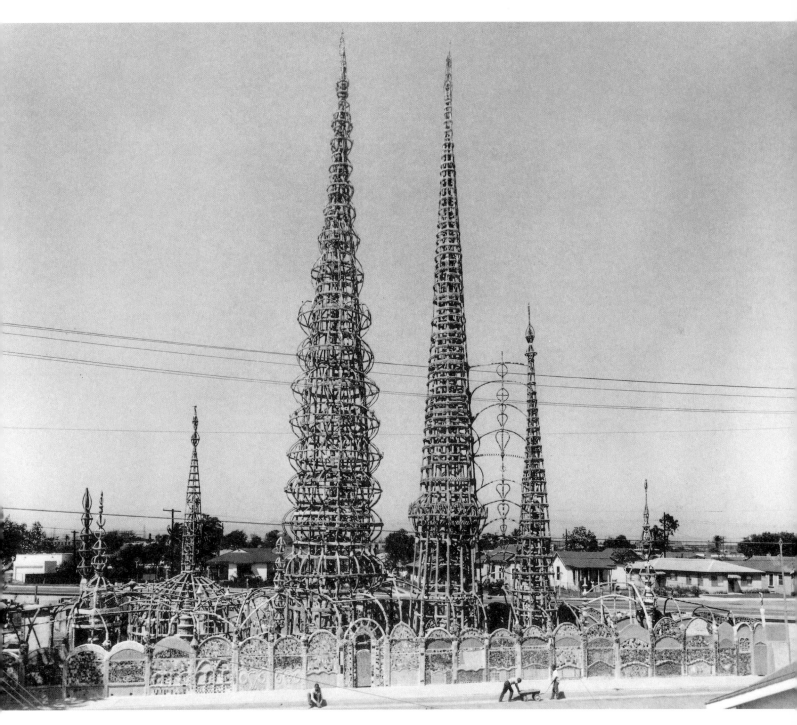

: 43 :
Simon Rodia
Watts Towers, Los Angeles, 1921–1954

64 FEEMAN B i o g r
 a p h i e
 s o f
 O u t s i
 d e r
 A r t i s
 t s

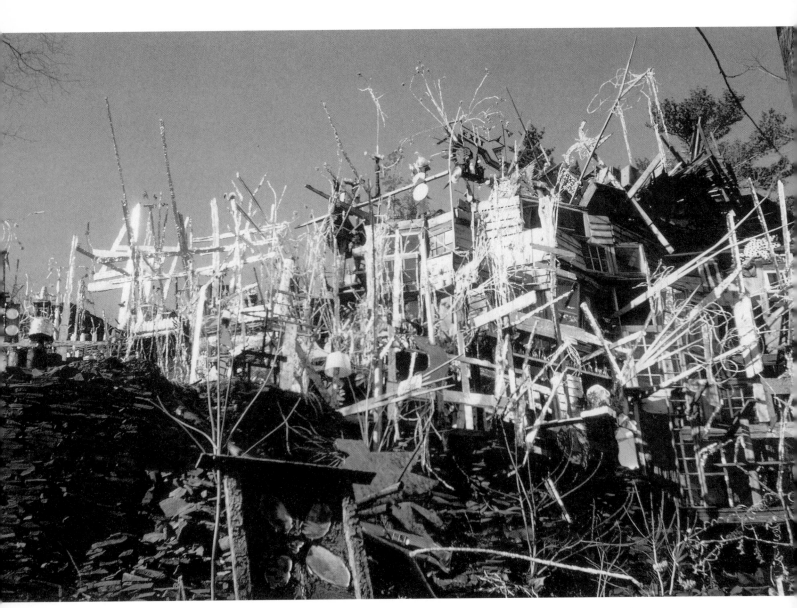

: 44 :
Clarence Schmidt
Woodstock Environment, or *House of Mirrors*, Woodstock, New York, 1948–1971 (destroyed)

Clarence Schmidt

New York City, 1897–1978, Albany, New York

**Principal
References**

Cardinal, Roger. *Outsider
Art*. New York: Praeger,
1972, 65–68.

Friedman, Martin, et al.
Naives and Visionaries. Exh.
cat. Minneapolis: Walker Art
Center, 1974, 43–52.

Lipke, William C., and
Gregg Blasdel. *Clarence
Schmidt*. Exh. cat.
Burlington: Robert Hull
Fleming Museum,
University of Vermont,
1975.

Clarence Schmidt's long, white hair, outlandish dress, and extraordinary living arrangements reinforced his image in the 1960s as a precursor of the counterculture. Born in Queens, Schmidt attended but did not complete high school and worked as a plasterer and mason. In 1930, having acquired five acres of property in the Catskill Mountains near Woodstock from a cousin, he built a one-room cabin he called *Journey's End*, where he spent his summers. Constructed of railway ties, the cabin was on the outside distinctively tarred and covered with cracked glass. During the next thirty years, after selling *Journey's End*, Schmidt constructed two additional eccentric houses, extensive spans of drywall terracing, and countless shrines and grottoes.

In 1940 Schmidt established his permanent residence in Woodstock and began work on his immense (seven-story, thirty-five-room) *House of Mirrors*. The house, built into a hillside and around a huge tree, had rooms that were joined by a labyrinth of halls and filled with a stupefying assortment of junk. Above the house Schmidt created a roof garden of densely packed found objects; outside the house he terraced the hills with memorial shrines, the most startling of which was draped with rubber masks and casts of hands and feet. Schmidt's wife, Grace, who lived with the couple's son in a nearby dwelling, detested the *House of Mirrors*, as did many of her relatives, whose property adjoined Schmidt's. Disputes with relatives were frequent and sometimes violent. In the winter of 1968 Schmidt narrowly escaped when the house and much of its surroundings burned to the ground.

Residing temporarily in a nearby motel, Schmidt turned his creative energies to writing until the early spring, when he returned to his property. Living in a station wagon, he started the construction of another house, *Mark II*. Near it he created the *Silver Forest*, acres of saplings brushed with aluminum paint, upon which he impaled the heads and bodies of dolls.

After *Mark II* was destroyed by fire in 1971, Schmidt left his mountain property and was reduced to sleeping in doorways, gas stations, or wherever he could find shelter. Suffering from diabetes and other ailments, he was placed in a convalescent hospital in Kingston, New York, in 1972. Nevertheless in 1976 he was able to attend the Woodstock Art Association opening of a traveling exhibition documenting his constructions. Later that year he was moved to the Green County Nursing Home in Albany, where he died in 1978.

=

66 FREEMAN Biogr
 aphie
 s of
 Outsi
 der
 Artis
 ts

Friedrich Schröder-Sonnenstern

Tilsitt, Lithuania, 1892–1982, Berlin, Germany

**Principal
References**

Friedrich Schröder-Sonnenstern.
Exh. cat. Düsseldorf:
Städtische Kunsthalle, 1967.

Schmied, Wieland, ed.
Friedrich Schröder-Sonnenstern.
Exh. cat. Hannover:
Kestner-Gesellschaft, 1973.

Schröder-Sonnenstern,
Friedrich, and Carl Laszlo.
Schröder-Sonnenstern. Basel:
Editions Menz, 1962.

Williams, Sheldon.
"Schröder-Sonnenstern."
Raw Vision, no. 2 (Winter
1989–90): 16–21.

Intelligent but unhappy and mischievous, Friedrich Schröder-Sonnenstern, one of thirteen children, was placed in a home for delinquents at fourteen and repeatedly confined to correctional institutions throughout his adolescence. Laboring on a farm, where he was accused of theft in 1910, Schröder-Sonnenstern threatened arresting police with a knife and was subsequently declared insane and placed in a mental institution for five months. He reportedly spent most of that time in a straitjacket. Upon his release the embittered Schröder-Sonnenstern published poems decrying social injustice and national corruption.

His conscription terminated for unorthodox behavior, Schröder-Sonnenstern worked for the postal service during World War I until he was apprehended for smuggling in 1917 and reinstitutionalized. Discharged at war's end, he undertook a number of menial jobs prior to plying his trade as astrologer, healer, and clairvoyant. Carrying a calling card identifying him as "Esteemed Professor Dr. Eliot Gnass von Sonnenstern, Psychologist of the University Sciences," Schröder-Sonnenstern, beard and hair long and flowing, used part of his considerable revenues to purchase and distribute sandwiches to countless victims of postwar inflation, meriting the title Sandwich King. Arrested in 1930 for practicing false medicine, Schröder-Sonnenstern was again confined to a mental institution, where he met an artist who inspired the production of his first drawings.

After World War II, living with his mistress, "Aunt Martha," and eking out a living by selling firewood, Schröder-Sonnenstern developed water on the knee. Temporarily unable to walk, he began painting in earnest at age fifty-seven. Images reflecting social disorder, sex, and Schröder-Sonnenstern's private mythology—equating the moon with the underworld and the sun with enlightenment—were drawn in a hard-edged style overlaid with thinly applied colored pencil. His fantastic creatures, posed in acrobatic and distorted postures, evoke magical and monstrous visions. The most popular images were reproduced by

copying a prototype. By the time he had completed about one hundred drawings, Schröder-Sonnenstern had attracted the attention of influential patrons. His work received an enthusiastic reception when exhibited in the Exposition inteRnatiOnale du Surréalisme (EROS) in 1959 at the Galerie Daniel Cordier in Paris. At one point he was earning so much money from the sale of his work that it was said he "ran into the street and threw scores of banknotes into the air."

The death of Aunt Martha in 1964 and Schröder-Sonnenstern's resultant reliance on alcohol cut short the artist's prosperous lifestyle. While the remainder of his life was spent in ill health and humble conditions, the prices of his early works escalated, and his artistic importance was confirmed in 1973 by a retrospective at the Kestner-Gesellschaft in Hannover.

=

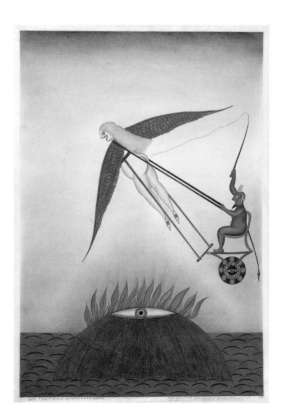

: 45 :
Friedrich Schröder-Sonnenstern
Des Teufels Himmelsfahrt
(Ascension of the devil), 1959

Hélène Smith (Elise-Catherine Müller)

Martigny, Switzerland, 1861–1929, Geneva, Switzerland

Principal References

Flournoy, Olivier. *Théodore et Léopold.* Neuchâtel: Editions de la Baconnière, 1986.

Flournoy, Théodore. *Des Indes à la planète Mars.* Paris: F. Alcan; and Geneva: C. Eggiman, 1900. Reprinted, Paris: Editions du Seuil, 1983.

Hélène Smith, the only surviving daughter of a Hungarian father and Swiss mother, grew up with two brothers in modest circumstances. Preferring the solitude of books and drawing materials to the company of other children, she rarely left home without her mother. After completing school, she was employed as an apprentice in a commercial business. In 1892, having had frequent visions since age twenty, Smith became interested in spiritualism. By 1893, engaged in weekly séances, she appeared to have remarkable supernatural powers.

Wishing to authenticate these powers, Smith invited Théodore Flournoy, a noted professor of psychology at the University of Geneva, to attend a séance in 1894. For the ensuing four years Flournoy recorded Smith's spiritual activities, documenting her visions in his book *Des Indes à la planète Mars* (From the Indies to the planet Mars). Receiving a good deal of attention, the book, published in 1900, was translated into several languages.

Smith claimed that during séances she experienced fantastic and varied adventures. In trances she became Marie Antoinette, a fifteenth-century Indian princess named Sinandini, and a cosmic traveler to Mars who described Martian people and their language. In 1895 "Leopold," alias Giuseppe Balsamo, alias the Count Alessandro di Cagliostro—an illustrious impostor who seduced Marie Antoinette—began speaking through Smith. Mysterious, capricious, and seemingly wise, Leopold interpreted Smith's Martian language and recounted long-forgotten Smith family secrets. In 1897 Smith began producing automatic writing in French, Martian, and Ultra-Martian. The Martian writing looks like a variant of French, while Ultra-Martian slightly resembles Sanskrit.

Smith produced beautiful books and watercolors in which she recreated the landscapes, animals, and humanlike inhabitants of her Martian visions. An exhibition of her delicate watercolors was organized at the time of her death by the Musée d'Art et d'Histoire in Geneva. The watercolors were well known to André Breton, who used six of them to illustrate his article "Le Message automatique" in the surrealist periodical *Minotaure* in 1934.

: 46 :
Hélène Smith
Lampe martienne (Martian lamp)

68 FREEMAN Biogr
 aphie
 s of
 Outsi
 der
 Artis
 ts

Louis Soutter
Moeges, Switzerland, 1871–1942, Ballaigues, Switzerland

**Principal
References**

Berger, René, and Ernest
Manganel. *Louis Soutter:
Témoignages de René
Auberjonois et de Le Corbusier.*
Exh. cat. Lausanne: Musée
Cantonal des Beaux-Arts,
1961.

Le Corbusier. "Louis Sutter
[sic], l'inconnu de la
soixantaine." *Minotaure* 3,
no. 9 (1936): 62–65.

Thévoz, Michel. *Louis
Soutter.* Lausanne: Editions
Rencontre, 1970.

Born in 1871, Louis Soutter studied engineering in Lausanne, architecture in Geneva, the violin in Brussels, and ultimately painting in Lausanne, Geneva, and Paris. Married to an American musician in 1897 and securely embarked the following year upon a successful career as director of fine arts at Colorado College, Soutter suffered a dramatic turnabout, transforming his cultivated existence to that of an alienated vagrant cut off from social and artistic mainstreams.

In 1902 the first manifestations of the somber eccentricity and emotional problems that would bedevil Soutter for the remainder of his life appeared. Plagued by increasingly poor mental and physical health, resulting in the breakup of his marriage and loss of his job, he returned to Switzerland in 1904. In 1906 he entered a private psychiatric clinic. Released after a year of treatment, he settled in Geneva to resume life as a musician, playing with the Geneva opera orchestra and the Lausanne symphony orchestra. Increasingly unable to cope—it is said that during one concert he set off on a melody of his own devising—Soutter withdrew from orchestral music. In 1915 he became a ward of the court and in 1922 was institutionalized for the second time. Released in 1923, Soutter, then fifty-two years old, was confined to a geriatric home, L'Asile du Jura, in Ballaigues, where he spent the remaining twenty years of his life.

At Ballaigues, in near total confinement, Soutter began to fill small copybooks with finely textured, densely hatched pen and pencil drawings of religious themes, fearful women, exotic landscapes and architecture, and designs he called ornaments. His fragile yet threatening compositions exhibited a vigorous freedom of pen and hand, bearing no resemblance to the conventional style of his youth. In 1930, encouraged by the friendship and enthusiasm of his cousin, the architect Le Corbusier (who arranged Soutter's first solo exhibition in 1936 and published an article on him in *Minotaure* the same year), Soutter undertook large India ink drawings. In a number of these larger works, commonly referred to as Soutter's mannerist works, he drew themes from the Italian Renaissance masters.

Suffering from a partial loss of sight in 1937, Soutter threw away pen and pencil, creating works by applying ink to paper with his fingers. In the finger paintings he abandoned all subject matter except the abstracted human figure, which he rendered boldly with a sense of fluid motion.

Soutter died after a short illness in 1942. Of his production from those twenty years at Ballaigues, an incalculable number of works were destroyed, but approximately sixteen hundred drawings survive.

=

: 47 :
Louis Soutter
Fuite d'Egypte (Flight from Egypt)

August Walla
Klosterneuburg, Austria, born 1936

Principal References

Breymann, Thomas. "August Walla." *L'Art brut*, fascicle 12. Lausanne: Collection de l'Art Brut, 1976, 36–53.

Navratil, Leo. *August Walla: Sein Leben & seine Kunst.* Nordingen: Greno, 1988.

Obliged by the untimely death of her husband to provide the family livelihood, forty-year-old Aloisa Walla left her only child, August, in the care of his elderly grandmother for much of his early childhood. Playing alone for hours with paper figures of people and animals, Walla showed evidence of creativity and confusion from the time he entered school. At sixteen, threatening suicide, he was committed for the first time to a psychiatric clinic, where he remained for four years. Discharged to the care of his mother, he lived with her by the Danube, northwest of Vienna, in a small house, the doors and walls of which he colorfully painted with words and emblems, including crosses, hammers and sickles, and swastikas. After treating him at Gugging in 1970, Dr. Leo Navratil, already appreciative of the unique quality of his patient's calligraphy and drawing, visited Walla's home and was impressed by the painted house and the garden overflowing with art objects created from an accumulation of cast-off materials.

In 1983 both Walla and his mother were confined at the Gugging mental institution. Devoted to one another, they initially shared a room. Now Walla visits his mother daily in the clinic's geriatric residence and lives in Gugging's Artists' House in a room he has painted from floor to ceiling with mythical beings, symbols, and letters of known and unknown scripts. Working continually, Walla creates paintings on canvas as well as paintings on plastic bottles, tin cans, wooden planks, trees, and even public roadways. He documents his creative activity in a diary and with photographs he takes of his finished pieces. Walla's vivid drawings and writings, reflecting both the commonplace occurrences of life and his private universe of religious and mystic fantasies, have been exhibited widely in galleries and public museums since 1970.

=

: 48 :
August Walla
Luluhonig/Naraka Batu

Heinrich Welz (Hyacinth von Wieser)

Vienna, Austria, 1883–?

**Principal
References**

Pierce, James Smith. "Paul
Klee and Baron Welz." *Arts
Magazine* 52, no. 1
(September 1977): 128-31.

Prinzhorn, Hans. *Artistry
of the Mentally Ill: A
Contribution to the Psychology
and Psychopathology of
Configuration.* Trans. Eric
von Brockdorff. New York:
Springer, 1972, 90-95.

Talented as a child and idealistic in his youth, Heinrich Welz, a well-educated lawyer and titled baron, was twenty-nine years old when he was suddenly seized by the hallucinations that resulted in his hospitalization in 1912. During his initial stay in the Neu Friedenheim-München Psychiatric Hospital, Welz, who had drawn and written poetry before his illness, produced a number of pencil sketches and watercolors, the most interesting of which were transcriptions of his hallucinations.

Obsessed with the mystery of thought transmission, Welz claimed the ability to feel his own inhibited thoughts free themselves from specific points in his brain and project outward. In many of his drawings he attempted to convey the process of thought through the use of abstract forms and graphic configurations. Professing to have mastered telepathic communication, he eventually gave up speech, but on the occasion of one of Dr. Hans Prinzhorn's visits, he broke his customary silence and informed Prinzhorn that he would soon abandon drawing. In the future, he revealed, he would merely cover his drawing paper with particles of graphite, which he would then force into forms by no means other than psychic will.

=

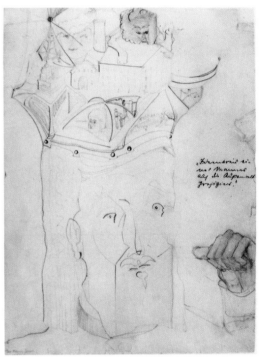

: 49 :
**Heinrich Welz
(Hyacinth von Wieser)**
*Ideenkreis eines Mannes auf die
Aussenwelt projijiert* (Circle of
ideas of a man projected onto
the outer world)

72 FREEMAN Biogr
 aphie
 s of
 Outsi
 der
 Artis
 ts

P. M. Wentworth
Active California, 1950–61

Very little is known about P. M. Wentworth beyond the facts that he lived in San Francisco in the 1950s and Santa Monica in the 1960s and at some point was employed as a night watchman. Even his legal name remains unconfirmed. For a time it was accepted that P. M. referred to his occupation as a night watchman, but when drawings were found bearing the signature Perley Wentworth, the theory was discounted.

Wentworth's drawings were first discovered by Dr. Tarmo Pasto, who made use of them in a course on art and psychology he taught in the 1950s at Sacramento State College, and rediscovered in 1968 by Jim Nutt, when he taught in the college's art department. It was asserted by Pasto, who corresponded with Wentworth until 1961, that the artist would stare at a blank sheet of paper affixed to a drawing board in the pantry of his home until an image would appear to him. Tracing the apparition (and exhibiting great skill by applying, rubbing, and blending pigments into his paper), he produced intricate, gossamer drawings of fantastic architecture, imaginary landscapes, and distant celestial worlds of extraordinary detail and beauty.

=

**Principal
Reference**

Larsen-Martin, Susan, and
Lauri Robert Martin.
*Pioneers in Paradise: Folk and
Outsider Artists of the West
Coast*. Exh. cat. Long Beach:
Long Beach Museum of Art,
1984.

: 50 :
P. M. Wentworth
Untitled, 1950

Scottie Wilson (Louis Freeman)

London, England, 1888–1972, London, England

Principal References

Marzolf, Helen. *Scottie Wilson: The Canadian Drawings/Les Dessins Canadiens*. Exh. cat. Regina, Saskatchewan: Dunlop Art Gallery, 1989.

Melly, George. *It's All Writ Out for You: The Life and Work of Scottie Wilson*. London: Thames and Hudson, 1986.

Schreiner, Gerard A. *Scottie Wilson*. Exh. cat. Basel: Galerie Schreiner, 1979.

Thévoz, Michel, et al. "Scottie Wilson." *L'Art brut*, fascicle 4. Paris: Compagnie de l'Art Brut, 1965, 5–32.

Depicted variably as a naive, a primitive, a working-class genius, and a visionary, Scottie Wilson spent the first forty years of his life hawking anything he could to make a living and the second forty as a solitary eccentric artist of eventual international renown. One of three sons of Lithuanian immigrants, Wilson, born Louis Freeman in London's East End, grew up in Glasgow, where his family moved before his second birthday. Wilson left school at age eight, helping to support his impoverished family by peddling everything from newspapers to patent medicines on the streets of the city. In 1906 he joined the Scottish Rifles, was posted in India and South Africa, and at the outbreak of World War I served on the Western Front.

After the war he immigrated to Canada, settling in Toronto, where he owned a secondhand shop. Sometime between the late twenties and early thirties, while sitting in the back room of his shop, he picked up one of the many fountain pens he collected for their gold nibs and started doodling. For the next thirty-seven years, until his death in 1972, Wilson, employing a distinctive hatching technique, created colorful symmetrical designs, blending the shapes of birds, fish, trees, fanciful architecture, and haunting human faces. Of his repertoire of motifs, the stylized forms of nature suggest goodness and truth, while demonic faces, termed "evils" and "greedies," personify adversity.

The Canadian art dealer Douglas Duncan was the first to buy and promote Wilson's work. While the artist disliked parting with his drawings, the money enabled him to abandon the junk business and establish a new career. Returning to London in 1945, Wilson avoided selling his work by exhibiting drawings in exchange for small viewing charges, sometimes attracting the public's attention with a gramophone or loudspeaker. Although suspicious of exploitation, Wilson was persuaded to exhibit his work in London galleries and was included in the

Surrealist Diversity exhibition at the Arcade Gallery in 1945. Wilson eventually gained a number of serious supporters and collectors including surrealists Roland Penrose and E. L. T. Mesens. During his last years, seldom straying from his Kilburn apartment, he continued to create amazingly elaborate and precisely defined drawings. Claiming he didn't have the price of a kipper in his pocket, Scottie Wilson died in 1972 leaving a suitcase of money under his bed and large sums in various banks.

=

: 51 :
Scottie Wilson (Louis Freeman)
Untitled, c. 1945

Adolf Wölfli

Bowil, Switzerland, 1864–1930, Bern, Switzerland

**Principal
References**

Morgenthaler, Walter. *Ein Geisteskranker als Künstler.* Bern and Leipzig: Bircher, 1921. Expanded edition, Berlin and Vienna: Medusa Wien, 1985.

Spoerri, Elka, and Jürgen Glaesemer, eds. *Adolph Wölfli.* Exh. cat. Bern: Kunstmuseum, 1976.

Spoerri, Elka, et al. *The Other Side of the Moon: The World of Adolf Wölfli.* Exh. cat. Philadelphia: Goldie Paley Gallery, Moore College of Art, 1988.

Adolf Wölfli's childhood was one of degradation and indigence. The youngest of the seven children born to a stonecutter and a laundress, Wölfli, orphaned before his tenth birthday, was made a ward of the community and lived in a succession of wretched foster homes. Forbidden to court the girl he loved by her scornful father, Wölfli temporarily abandoned life as an itinerant farm laborer in 1883 to join the infantry. In 1890 he was sentenced to two years in prison for the attempted molestation of two young girls, and in 1895, after a third incident of alleged molestation of a three-and-a-half-year-old girl, he was committed to the Waldau Psychiatric Clinic in Bern, where he remained until his death in 1930. Suffering from terrifying hallucinations, Wölfli was often placed in isolation during the first decade of his hospitalization. From 1910, working systematically on his writing and drawing, Wölfli desired the solitude and protection of a private cell, which he decorated with his own works.

After four years in the Waldau clinic, Wölfli began to draw. The earliest preserved works, dating from 1904, are restless, symmetrical pencil drawings on newsprint. Combining images, words, and musical notations, the early works forecast the principal motifs and pictorial devices of his later work. In 1908, the year Dr. Walter Morgenthaler arrived at Waldau, Wölfli embarked upon the epic autobiographical project that would consume the remaining twenty-two years of his life. The text of the fanciful autobiography, interspersed with poetry, musical composition, and three thousand illustrations, comprises more than twenty-five thousand pages. Hand bound by Wölfli and stacked in his cell, the forty-five volumes eventually

reached a height of more than six feet. Intermingling reality and fiction, Wölfli's autobiography begins as an adventurous geographical world expedition, of which Doufi (Wölfli's childhood name) is the hero, and expands to a grandiose tale of cosmic war, catastrophe, and conquest with Doufi transformed into St. Adolf II. The fascinating illustrations of the narrative are labyrinthine creations and mandalalike compositions of densely combined text and idiosyncratic motifs.

A few days before his death, Wölfli lamented his inability to complete the final section of the autobiography, a grandiose finale of nearly three thousand songs, which he titled "Funeral March." In 1972 Wölfli's work was exhibited at Documenta 5 and since then has been shown throughout Europe and the United States. In 1975, forty-five years after his death, Wölfli's staggering artistic production—including the autobiography and its illustrations, as well as some eight hundred loose-leaf drawings—was transferred from the Waldau Psychiatric Clinic to the Kunstmuseum in Bern.

=

: 52 :
Adolf Wölfli
Campbell's Tomato Soup, 1929

76 FREEMAN Biogr
 aphie
 s of
 Outsi
 der
 Artis
 ts

Joseph E. Yoakum
Window Rock, Arizona Territory, 1886 (or 1888)–1972, Chicago, Illinois

**Principal
References**

Halstead, Whitney. "Joseph
Yoakum." Unpublished
manuscript. Archives of the
Art Institute of Chicago.

*Joseph E. Yoakum: A Survey
of Drawings.* Exh. cat. Davis:
University of California,
1988.

Morris, Randall, and John
Ollman. *Animistic
Landscapes: Joseph Yoakum
Drawings.* Exh. cat.
Philadelphia: Janet Fleisher
Gallery, 1989.

Born on the Navaho Indian reservation in the
Arizona Territory, Joseph Yoakum, one of twelve
children, was raised on a Missouri farm. Attaining
less than six months' formal education, he joined
the Adams Forpaugh Circus at fifteen. After stints
with Buffalo Bill's Wild West Show and the
Ringling Brothers' Circus, Yoakum traveled around
the world as a stowaway, returning to the United
States and marrying in 1910 before setting off
in 1911 for Central and South America. Posted
in Clermont-Ferrand, France, Yoakum served in
World War 1 and was married a second time
in 1929.

Yoakum moved to Chicago in 1962 and in
his mid seventies, inspired by a dream, made his
first drawing. For the next eight years he worked
intently, producing each day one or more drawings
of the world he had explored during his younger
years. The landscapes of Yoakum's memory
blended with images from his imagination, in a
process he termed "spiritual unfoldment," yielding
delicately drawn, richly patterned, idiosyncratic
scenes of grove-covered hills, steeplelike moun-
tains, meandering roads, and rippled seas. Yoakum,
a large man—six feet, two inches; 250 pounds—
with huge hands, drew diminutive forms and
delicate landscapes. His early works were done
in ink or graphite and watercolor; later he used
colored pencils, burnished with cotton swabs to
create smooth, subtle color.

Yoakum lived and worked in a two-room
storefront building on Chicago's South Side. Hung
by clothespins to a string in the store's window,
Yoakum's drawings could be viewed by passersby.
A Presbyterian minister who ran the café at the

University of Chicago saw the drawings and
organized a show in the café. An employee brought
the work to the attention of gallery owner Ed
Sherbeyn, who gave Yoakum an exhibition in the
spring of 1968, where drawings sold from twelve
to fifty dollars. Admired by Chicago artists and
dubbed the Rousseau of the imagists, Yoakum died
at the age of eighty-six (or eighty-four, depending
on the correct birth year). He was honored with a
posthumous solo exhibition at the Whitney
Museum of American Art in New York.

=

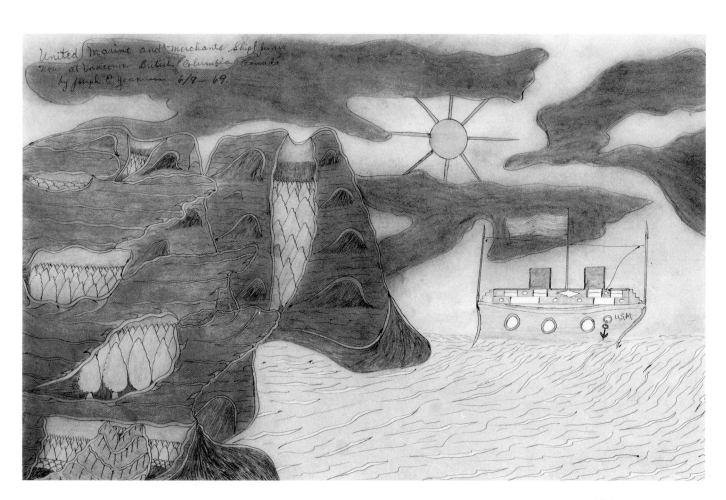

: 53 :
Joseph Yoakum
United Marine and Merchants Ship, 1969

Expressionism's Ancients

Expre
ssion
ism's
Ancie
nts

Reinhold Heller

In a frequently cited but still extraordinary observation published in the Swiss periodical *Die Alpen* on the occasion of the first Der blaue Reiter (The blue rider) exhibition, which opened at Munich's Galerie Thannhauser on December 18, 1911, Paul Klee (1879–1940) concisely identified unexpected sources of inspiration for the dramatic, seemingly incomprehensible, and apparently unprecedented paintings the artists' group displayed:

I will try to comfort anyone who was unable to link works at the exhibition to some favorite from some museum, not even to an El Greco.[1] Because it must be asserted that in addition [to such models] there are original beginnings for art such as we would more likely encounter in an ethnographic museum or at home in our children's nursery (do not laugh, dear reader). Because children too are able to make such art, and this is in no way detrimental to the newest artistic efforts, but rather the situation is a source of positive wisdom. The more untutored these children are, the more instructive is the art they give us, since even here corruption quickly enters: when children begin to absorb developed artworks or even imitate them. Parallel phenomena are the drawings of the mentally ill, and therefore the word "insane" must also be rejected as an appropriately derogatory characterization [of the new art]. These various things really should be taken far more seriously than are the collections of all our art museums if we truly intend to reform today's art. That is how far back we have to reach in order to avoid facile archaizing.[2]

Klee's contentious itemization of art's *Uranfänge* (its "original beginnings") functions as a response to conservative critics who denigrated the new art as infantile and insane, but it also echoes the Enlightenment and Romantic search for art's beginnings, for the primordial first of all artworks, through which the very nature and essence of art might be revealed in order to be applied in a process of exploration, analysis, and emulation. Significantly, in proposing this search, Klee maintains a traditional, even academic, attitude that artists must seek prototypes for their own work in the past and through emulation seek to gain a new perfection.

The thought process is identical to that which caused Johann Joachim Winckelmann (1717–68), in his seminal pamphlet of 1755, *Thoughts on the Imitation of Greek Works in Painting and Sculpture*, to adjure contemporary artists to emulate the example of ancient Greece: "There is but one way for the moderns to become great, and perhaps unequalled; I mean by imitating the ancients. . . . It is not only *Nature* which the votaries of the Greeks find in their works, but still more, something superior to nature; ideal beauties, brain-born images, as *Proclus* says."[3]

An existing artistic ideal is identified, "brain-born images" that proffer a means of approaching and even surpassing Nature in a manner that the modern age otherwise is incapable of attaining; the artists then should produce new images according to guiding exemplary principles they derive from their study. The pattern, if not the substance, of Klee's injunction is similar as it too invokes a process of learning, of seeing prototypes in the art of exemplary artists, and of abstracting the principles of image making from their precedents. Klee's exemplary "Greeks," however, reside paradoxically in the present, not in a temporally distant age. Whether children, African or Oceanic natives, or the insane, Klee's artistic prototypes share his time. If they are nonetheless distant to him, it is because they are divorced from his Western European geographic locale, its emphasis on change and development, or from his adult, urban, social milieu. A seemingly disparate grouping, they are united in their lack of involvement in the purposeful, "productive" activities of twentieth-century industrial civilization and in the apparently consistent, unchanging principles revealed by their works.

Winckelmann's Enlightenment ideal was the long-admired "classical" Greece he recognized in the *Apollo Belvedere* and in the *Belvedere Torso*. In the course of the eighteenth and nineteenth centuries, however, previously unknown or undervalued realms of artistic production became the goals of other artistic explorers whose appreciation now focused on the "primitives" of pre-classical Greece and pre-Renaissance medieval Europe in their search for archetypal formal vocabularies. By the beginning of the twentieth century few areas of past Western art, ranging from Assyria and Egypt to the baroque and rococo, had not been copied, mimicked, or resurrected in the historicist search for inspiring artistic vocabularies. This was the "archaizing"—the reference to a terminated, thus no longer current or viable, period of the past—to which Klee objected and which he insisted must be avoided. He therefore proposed a fundamentally different, ahistorical arena to survey and appropriate: the "uncivilized" world of tribal artifacts found in ethnographic collections, the "uncivilized" world of children, and the "uncivilized" world of the mentally disturbed. All "uncivilized," his exemplars lack history; conceptually, they precede it. They exist outside the temporal organizations, evolutionary progressions, and divisions of Western European historical consciousness with its transmuting fashions or tastes. To Klee, they appear to maintain a constancy of both vocabulary and concerns that transcends temporality.

Immutable laws, forgotten in the processes of humanity's historical civilization and the individual's temporal maturation from childhood to adulthood, in the growing separation from the unconscious forces of life, and in the increasingly dominant sense of an individual identification distinct from the communally human, were deemed by Klee to be at work, and their retrieval—so he posited in conclusion—would be necessary before art could be reformed. The conclusion that a process of forgetting, rejecting, and retrieving was necessary before renewal could begin similarly was argued by Franz Marc (1880–1916) in a letter to August Macke at about the same time Klee's comments were published:

I find it self-evident that we should look for the rebirth of our own artistic consciousness in this cold dawn of artistic intelligence rather than in cultures with thousands of years of history like the Japanese or the Italian. . . . We must be brave and turn our backs on almost everything that until now good Central Europeans like ourselves have thought precious and indispensable. . . . Our ideas and ideals must be clad in hair shirts, we must feed them on locusts and wild honey, not on history, if we are ever to escape the exhaustion of our European bad taste.[4]

Wearing hair shirts, eating locusts and wild honey, Marc's artists were the wild prophets of a coming new age, during which a New Testament for art would be established. Each artist would be a John the Baptist, rejecting the enticements of contemporaries and, as an outsider in a desert not yet cultivated, preaching harsh new messages of radical artistic contrition, repentance, reformation, and salvation. For the known, admired historical past Marc, like Klee, substituted an unknown, unexplored past which was not that of rationally ordered chronological history; it was instead an alogical "history" of human consciousness and "artistic intelligence" incipient in the "innocent" minds of the as yet uncivilized or no longer civilized. The pragmatic, positivist concept of artistic progress that posited an evolutionary development from past to present, a constant process of improvements in the framework of an illusionistic art, was thus rejected for a counter-image that values the apparent absence of a past.

Like Klee, Marc sought a human constant in the untainted art of the "primitive"—understood as either ethnographically primitive or primitive in the sense of not fully developed, as in children or the "halted development" of the mentally ill—in order to justify the experimentation and innovation of modernist art. Like Winckelmann, he suggested that the reform of contemporary art could be effected only by a turn to art outside its established concerns. In Winckelmann's eighteenth-century context, when German art focused primarily on the late manifestations of a rococo style and its ideology, the otherness of ancient Greece and its

art could appear as similarly severe as did the otherness of Klee's and Marc's "primitives" some 150 years later. A deliberate, forced halt to the evolutionary historical processes was demanded. A new beginning should be made on the basis of an alien, nonmimetic aesthetic discovered in art's forgotten, unexplored, and elemental beginnings. It was in the location of those beginnings that Winckelmann and the expressionist artists part company, the one seeking in the utopia of ancient Greece, while the others search among the uncorrupted minds of "primitives."

There are among Marc's paintings and drawings few that overtly demonstrate formal derivation from the ahistorical, "primitive" sources his letter to Macke praised. It has, however, become a commonplace of art-historical studies in German expressionism to discover and trace the influx especially of the narrowly defined primitivism of African and Oceanic forms into expressionist imagery.[5] Rather than add yet another to these chronologies and considerations, it now seems more constructive to consider the conceptual cohesion of expressionism's expanded "primitivism" and particularly to look at expressionism's admiration of such "primitives" as children, patients in mental hospitals, and academically untutored artists.[6]

When Klee in 1912 suggested that constructive approaches to art could be derived from children's nurseries, he had already begun to admire drawings by his four-year-old son, Felix. Later he is recorded as claiming they surpassed his own work in quality.[7] In addition Klee in 1911 incorporated eighteen drawings he himself made between ages three and ten into his "big exact inventory of all my productions since childhood." Rather than seeing these works as irrelevant or as the immature scribbling of a child and unrelated to the oeuvre of the trained and developed artist, Klee identified them as the very font or origin of his mature artistic efforts.[8]

Klee's drawings were saved by his sister, Mathilde, who acted in this much as a parent might, sentimentally preserving a memento of the innocence and charm of childhood. Such a personal motivation, rooted in one's own past or in family sentimentality, for the admiration and aesthetic appreciation of children's art may well be the dominant pattern for its early discovery by German artists. This is clearly the case in the best-known and most extensive expressionist collection of children's art, that of Gabriele Münter (1877–1962).[9] It began with her two nieces, Annemarie "Mückchen" Münter and Elfriede "Friedel" Schroeter, giving "Tante Ella" and "Onkel Was" (Wassily Kandinsky, 1866–1944) drawings as presents during Münter's and Kandinsky's visits to their families. By no later than 1908 Münter was collecting drawings not only by children in her family but also by others she knew or met— children of artists, village children from Murnau, children of acquaintances. She also had Kandinsky and others collect them for her. The collection was thus systematically expanded until 1914.

It was from Münter's collection that Kandinsky selected the drawings that he reproduced in *Der blaue Reiter* almanac, 1912, where they appeared interspersed among reproductions of works by contemporary artists and other examples of "primitive" art.[10] Two still-life drawings by a child are juxtaposed on the interleaf between pages four and five with Pablo Picasso's cubist painting *La Femme à la mandoline au piano* (Woman with mandolin at the piano), 1911, the values of the images being thereby declared equal in terms of their intrinsic artistic worth and comparable formal vocabularies. Similarly a quartet of drawings by Lydia Wieber of women seated in a chair are among the first to confront the reader of Kandinsky's essay "On the Question of Form." They become prototypes of artistic value and worth; like the Bavarian votive painting that precedes them and the Douanier Rousseau's painting *Portrait de Mme M* (Portrait of Mme M), 1896, that follows, they are instinctive manifestations of form serving as "the

outer expression of the inner content."[11] Using the metaphor of an "inner sound" to point to intrinsic formal values or "life" in the drawings, Kandinsky argues that children can achieve intuitively and unconsciously what professional artists should set out to relearn, something they could do only after forgetting the standard and established practices of art making:

If we draw the conclusions necessary for us here from the independent effect of the inner sound, then we see that this inner sound increases in intensity when the external, practical-functional meaning [i.e., the primacy of illusion, measured in terms of a world external to the image itself] that represses it has been removed. Herein lies one explanation for the remarkable effect a child's drawing can have on an impartial, untraditional viewer. The practical-functional is alien to a child, since it sees everything with fresh eyes and still has the undiminished ability to take in the thing as such. . . . Now, in addition to being able to delete the external, the talented child also retains the power to clothe the internal, which remains, in that particular form through which it becomes most forcefully noticeable and therefore is effective (or, as one customarily says, it "speaks"!). . . . There is an unconscious, enormous power active in a child that manifests itself here and that raises the child's work to the same level as an adult's (and often much higher!).[12]

What was implicit in Gabriele Münter's collecting activity Kandinsky here announces forthrightly and impassionedly, granting a theoretical voice to her instinctive practice: not only is children's art aesthetically worth consideration, it can even be shown to possess a value exceeding that of the works of many trained artists. Indeed he maintained that professional training, with few exceptions, would prove detrimental to a child's artistic abilities. "The academy," he thus proclaimed, "is the most certain way to kill off the power of children, which I have described." Children's art, produced outside the professional's "objective artistic knowledge," surpasses "a 'correct' drawing, that is dead."[13]

Münter, Klee, and Kandinsky did not discover children's art for Germany, however. Since the 1890s children's drawing abilities had been a significant concern of pedagogical reformers that objected to the supremacy of word over image in the German school system and on its emphasis on copying during drawing instruction.[14] Instead a recognition of a child's unique manner of comprehending the world, as seen in drawings done from memory, was demanded. A number of publications presented studies of children's art from the perspective of psychological or pedagogical principles and set out to redefine the school curriculum accordingly. These studies culminated in 1905 in two lengthy, extraordinarily well-illustrated books: Siegfried Levinstein's *Kinderzeichnungen bis zum 14. Lebensjahr* (Children's drawings up to age 14) and Georg Kerschensteiner's *Die Entwicklung der zeichnerischen Begabung* (The development of the talent for drawing).[15] The University of Breslau established a psychology seminar devoted to the study of children's drawings. Exhibitions of children's art also took place, beginning with *Das Kind als Künstler* (The child as artist) at Hamburg's Kunsthalle in 1898, where Alfred Lichtwark was director;[16] in 1908 Alexander Koch, one of the founders of Darmstadt's innovative Jugendstil artists' colony at the Mathildenhöhe, began publication of the illustrated periodical *Kind und Kunst* (The child and art), devoted totally to children's art and art for children.

While primarily directed toward professional educators, these books, periodicals, and exhibitions also were considered of interest and relevant—in the audience envisioned by Kerschensteiner—"to psychologists, art historians, ethnographers, and not least to artists themselves."[17] The aim, however, was not to provide contemporary artists with prototypes of how their own art should look but to indicate linkages between the psychological *Uranfänge* of art in the process of individual human development and the historical *Uranfänge* of art in the evolutionary process of human civilization. Artistic "progress" thus was also judged according

to the degree that a drawing corresponded to the fixed norms of illusionistic representation, with particular praise reserved for renderings of three-dimensionality both in objects or bodies and in space. Criteria were applied that Kandinsky would characterize as efforts to "force the practical-functional onto the child,"[18] for example, Kerschensteiner's critique of a "depiction [by the thirteen-year-old A. F.] of a boy who fell asleep on the meadow at the Jugendturnspielplatz. The form of the right arm has not been mastered; but quite remarkable I find the representation of the legs, specifically the right one with its visible relaxation of muscular tension during sleep."[19] What was more appropriate to a modernist perception of art, however, was the seemingly paradoxical—given the concern with illusionism—emphasis placed in all these studies on drawing from memory rather than copying from prior artworks or even directly from nature. Indeed it was precisely the dependence on emulation and copying that was criticized most sharply in the established practices of the schools' drawing lessons. The goal, deemed of fundamental significance for the harmonious education of a good and productive citizen, was "to develop the imaginary power of vision and thereby to gain a means of expression that is indispensable for concrete conceptions."[20] Drawing, understood in this way, then is a demonstration of "phantasy and ingenious imagination" that necessarily "leads to the conclusion that significant ability in drawing is always a sign of intelligence."[21]

What educators and educational psychologists understood as a means of fostering and measuring intellectual growth in the German student population, expressionist artists and theorists used as a justification for their "spiritual" art and its subjectively rendered imagery. Children's art, untainted by the "practical" demand of mimesis but rather oriented toward a conceptual understanding and presentation of reality, therefore also was extracted from its "primitive" position in theories of the evolution of artistic abilities and promoted to the status of artistic prototype, worthy of emulation and admiration by mature, fully developed artists.

Children were substituted for Winckelmann's ancients when Kandinsky praised "the artist who remains like a child in many ways for his entire life [in order to] more readily approach the inner sound of things."[22]

The revaluation of children's art and the reasoning process employed therein by expressionist artists was closely allied to their similar revaluation of the art of psychologically disturbed individuals.[23] As Klee's 1912 review pointed out, the adjective "insane" was no longer to be considered abusive in terms of art but rather indicative of intrinsic value. Such overt praise of the aesthetic worth of such imagery, however, was rare even among the innovative artists and critics in Germany at the time. Thus four drawings of heads that show signs of being authored by psychologically disturbed individuals are reproduced by Kandinsky in *Der blaue Reiter* almanac with his essay, "On the Question of Form," but they are identified by him euphemistically as "Drawings by Dilettantes."[24] While insanity was indeed praised with surprising frequency by expressionist writers as a means of retrogressive escape from the deadening routine and repression of modern bourgeois society,[25] admiration of paintings, drawings, or sculptures by the insane remained largely limited to works by such prototypically "mad" artists as Vincent van Gogh or the Swedish painter Ernst Josephson, eighteen of whose "schizophrenic" drawings were included in the 19th Berlin Secession Exhibition in 1909.[26] Significantly these were considered to be trained artists who had established a professional identity prior to their experience of psychotic episodes; the alienation of madness was therefore mitigated by means of professional identification and collegiality, permitting them to remain social insiders even in their outsider status. Despite flirtations with insanity, expressionist artists prior to World War I appear to have found the persistent theories, dating back to Aristotle and granted a popular scientific pose shortly before 1900 by Cesare Lombroso and his numerous followers,[27] and the historical examples, such as van Gogh or Friedrich Nietzsche, that linked artistic genius and

madness sufficiently prophylactic to prevent ready emulation. Even Klee would thus conclude in his diary: "His [van Gogh's] pathos is alien to me, but it is clear that he was a genius. Pathos heightened to the pathological. . . . A most horrible tragedy is played out here, sincere tragedy, tragedy of nature, exemplary tragedy. Permit me to be frightened!"[28]

Expressionism's hesitant initial flirtations with an aesthetic appreciation of the art produced by inmates of mental hospitals, like its more ready embrace of children's art, coincided with an increasing scientific interest in this art. Again, drawing from memory or the imagination was fostered for diagnostic purposes, with the hope of forming a concept of the human psyche's "primitive" processes, an approach especially evident in the writings of the Coblenz psychologist Friedrich Justinus Mohr. In his practice illness was identifiable according to signs it left in the drawings of patients; similar formal devices thus necessarily pointed to similar pathological conditions. "What things look like in the visual observation of a mentally disturbed individual is something of which we have previously been able to have absolutely no clear perception. It is in this that drawings and similar related products can be of greatest service to us, since after all they provide a certain direct look into the psyche."[29] Insofar as these insights might be applied to contemporary art, however, it was with a kindred effort to discover symptoms of the abnormal and pathological. Diagnostically viewed, the sign could have only one meaning and lacked intrinsic aesthetic value or significance:

Of course it is also possible to find that which is most overtly present in the drawings and painted products of psychologically ill persons in the art products of less severely ill individuals in various stages of gradation. If we only look at our moderns from this point of view, then the ultimate crossing over to the severely pathological side and the parallelism with the most apparent symptoms in drawing will be recognizable to the psychologically educated here as well. Even the individual, small idiosyncracies of lightly pathological artists often enough express themselves in art products there.[30]

Art that included subjective deviation from "normal" vision and established artistic illusionism was thereby excluded from the productive components of social life and relegated to an arena of negatively "primitive" irrationality, reified in order to be observed and perhaps studied but also to be decried or pitied from a position of civilized superiority. In effect, an attitude virtually the antithesis of Kandinsky's praise of art that is not "practical-functional" was propagated with the publication of, and initial professional fascination in, the art of the psychologically different.

Kandinsky's art and theory, however, were employed by the psychotherapist Paul Schilder in 1918 but ironically in an effort that continued to devalue Kandinsky's and expressionism's significance and worth by means of an equation with the art of the patient "G. H."[31] To overcome such judgments, it was necessary to totally reverse them, to take the argument of diagnostic equation and stand it on its head. This was accomplished in 1914 by Wieland Herzfelde, then an eighteen-year-old poet from Wiesbaden and newly arrived in Berlin. In Franz Pfemfert's socially engaged expressionist periodical, *Die Aktion* (Action), he published an impassioned defense, tinged with heavy irony, of "people [we call] mentally ill who do not understand us or whom we do not understand" and drew the following conclusions:

The mentally ill are artistically gifted. Their works show a more or less unexplained, but honest, sense for the beautiful and the appropriate. But since their sensibility differs from ours, the forms, colors, and relationships of their works appear to us as strange, bizarre, and grotesque: crazy. Nevertheless the fact remains that the possessed can work creatively and with devotion. . . . They only integrate into themselves that which is in harmony with their psychological changes, nothing else. They keep their own language: it is the statement of their psyche. . . . What has impressed itself on their psyche remains forever in their memory. For everything that impresses them, they have a better memory than do we, but they have no memory for unimportant things. A similar gift has caused artists to be considered as dreamers who avoid reality and live without structure.[32]

Kandinsky's concepts underlie this argument with its reliance on the intrinsic superiority of a "spiritual" reality defined by memory and materialized in an image. It is the "inner sound" of an art image that Herzfelde is able to recognize in the art of the mentally ill. He thereby extends the value of art to the products of psychotics, but their pathology significantly is not projected back onto the similar forms appearing in works by professional artists. Kandinsky's "inner sound," not symptoms leading to a diagnosis, is supreme.

The change in attitude toward drawings and other visually creative works by individuals in mental hospitals or under psychiatric treatment received its major impetus, however, from the well-known work of the Heidelberg psychiatrist Hans Prinzhorn (1886–1933). Art history was among his initial fields of university study, and like many of his German colleagues in psychiatry, Prinzhorn maintained an interest in art, although before his move to Heidelberg it appears to have been limited to friendships with Emil Nolde and other artists.[33] His involvement with the artistic production of mental patients, however, did not become a major focus of his work until he joined the staff of the Heidelberg Psychiatric Clinic in 1918. In less than eighteen months he collected over 5,000 objects by 450 patients from clinics in Germany, Austria, Switzerland, Italy, and Holland. In 1919 he published a lengthy and insightful review of the literature on artistic production by mental patients and sought to argue against its purely diagnostic interpretation while accenting its value as visual creation.[34] This then formed the basis for his invaluable book *Bildnerei der Geisteskranken* (Artistry of the mentally ill), 1922.[35] As distinguished from prior studies, Prinzhorn's emphasized the formal or constructive values of the art produced by mental patients, while relegating to a significantly subordinate position any efforts to identify diagnostic tools by means of the works. Patient biographies and case histories were virtually suppressed so as not to distract from the intrinsic

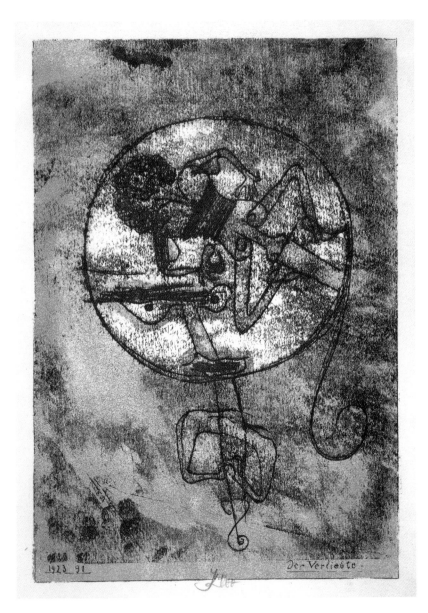

: 54 :
Paul Klee
Der Verliebte (The one in love), 1923

worth of the images. "Untrained, mentally ill persons, especially schizophrenics," Prinzhorn concluded, "frequently compose pictures which have many of the qualities of serious art. . . . We must avoid the fallacy of concluding, however, on the basis of superficial similarities, that there is a psychic equality."[36]

Despite earlier recognition of its value and worth, the art of mental patients does not begin to have a major impact on German artists until this point.[37] Klee's 1912 admonition to take the drawings of mental patients seriously surely was accompanied by his looking at their art, but so far no record of such an early encounter is known and no indisputable influence can be seen in his work of the time.[38] In July 1920, however, Oskar Schlemmer recorded that Klee was familiar with, and enthusiastic about, Prinzhorn's Heidelberg collection and that there were "quite surprising similarities" to Klee's work to be seen.[39] After publication of Prinzhorn's book, according to Lothar Schreyer's somewhat suspect recollections, Klee himself compared illustrations in it favorably with his own works, even identifying several individually as "a fine Klee."[40]

In assessing the impact of the Prinzhorn Collection on Klee, students of his work have concentrated most productively on artistic analogies. Stylistic conjunctions and borrowings are identified but so too are echoes of motifs and thought processes. For example, Klee's lithograph *Der Verliebte* (The one in love) of 1923, with its depiction of a seminaked woman seen within a man's head (FIGURE 54), finds a ready parallel in sculptures by Karl Brendel (Prinzhorn's pseudonym for Karl Genzel, 1871–1925), particularly in the rendering of the figure as hermaphroditic, according to James Smith Pierce's detailed study.[41] While the upper portion of Klee's figure, with revealed breasts and corseted waist, overtly represents a woman, the configuration of her lower torso and spread legs also reads as a face, apparently male and with a penislike extension emanating from the nose-mouth area. Since other works of 1922–23 employ the device as well

(FIGURES 55–57), the phallically extended face may derive from the head-and-feet figures devised by Brendel (FIGURE 58), which also are composed of large heads attached, torsoless, to splayed legs between which a penile appendage dangles. While such analogies are tempting, they also mislead. Indeed Klee and Brendel share the vocabulary of the sexually charged *Kopffüssler* (Head-and-feet figurine), but the device (FIGURE 59) in its hieroglyphic simplicity is one also common to children's drawings and pre-Columbian sculpture.[42] More than a single, identifiable source—verifiable or not—the phenomenon of a shared vocabulary among artistic outsiders is what intrigued Klee to the point of emulation. Traits akin to the art of the mentally ill do appear in Klee's works with increasing frequency and clarity around 1920 (FIGURE 60), and Prinzhorn's collection and book may well have contributed to this phenomenon (see FIGURE 49); however, the appearance of such traits

also coincided with Klee's renewed concern for the very foundations and primary principles of artistic creation when he joined the teaching faculty at the Bauhaus. The paradigmatic traits of artistic creation and their seemingly universal, extrahistorical, and originary forms found renewed application in works such as *Der Verliebte*, and outsiders such as Brendel were both a source and a means of affirming the validity of Klee's own explorations of a panhuman vocabulary.

Befriended by Klee, Alfred Kubin (1877–1959), another of Der blaue Reiter artists, displayed a similar interest in the art of mental patients and sought to validate it by identifying universal artistic principles in it. In 1922 he joined a neurologist in a pilgrimage to Heidelberg shortly before the publication of Prinzhorn's book and found the experience sufficiently significant to report on it in Paul Westheim's *Das Kunstblatt*, devoted to furthering a moderate modernism:

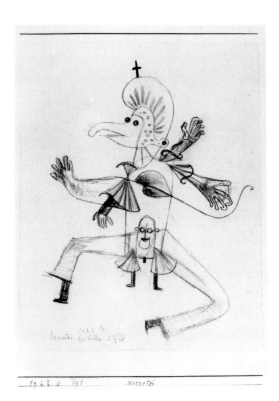

: 55 :
Paul Klee
Narretei (Buffoonery), 1922

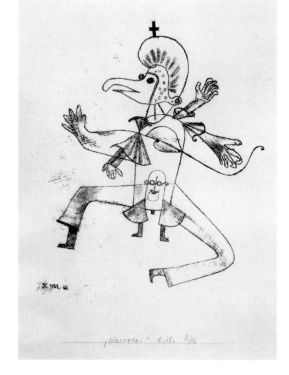

: 56 :
Paul Klee
Narretei (Buffoonery), 1922

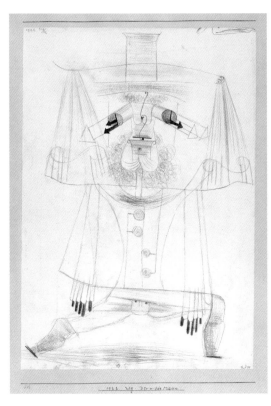

: 57 :
Paul Klee
Der wilde Mann (The wild man), 1922

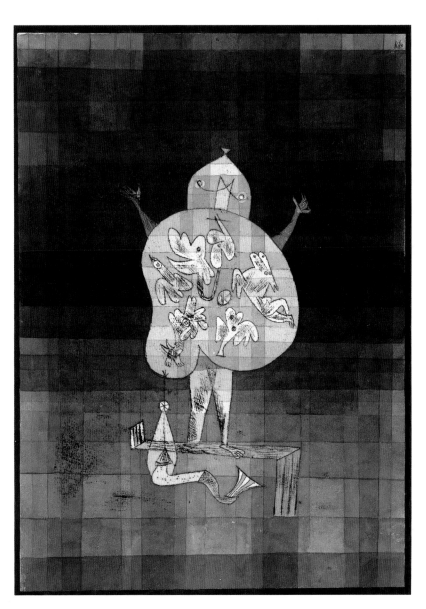

: 59 :
Paul Klee
Bauchredner und Rufer im Moor
(Ventriloquist: caller in the moor),
1923

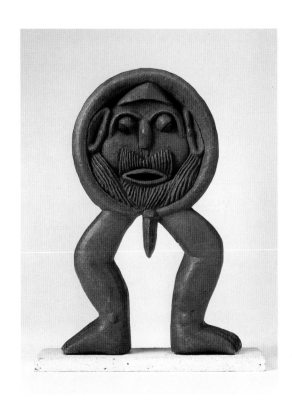

: 58 :
Karl Brendel (Karl Genzel)
Frau mit dem Storch/Jesus
(Woman with stork/Jesus)

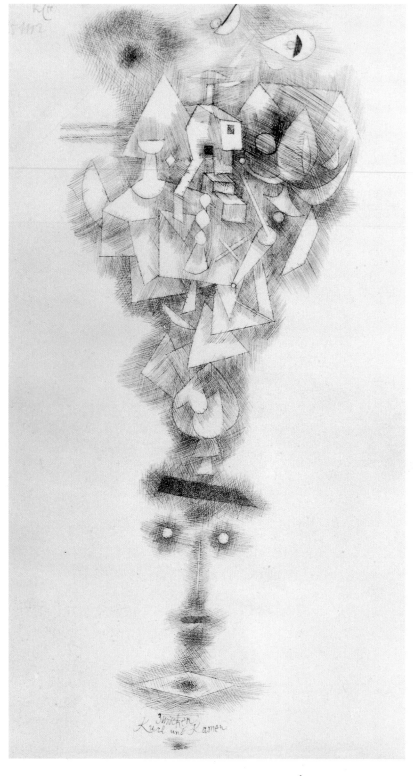

: 60 :
Paul Klee
Abenteuer zwischen Kurl und Kamen
(Adventure between Kurl and
Kamen), 1925

**The works themselves . . . affected me as well as my art-
loving friend extremely intensely by means of their hidden
adherence to artistic laws. We stood before miracles of the
spirit of art that emerge dawnlike from depths far beyond
thought and consideration. Work and admiration must
benefit from them. Herein resides the value that points to
universality. And that too is why I absorbed these
impressions into myself with an emotion of greatest joy . . .
and now these things refuse to leave me alone any longer.[43]**

Like Klee and Prinzhorn, Kubin approached
the drawings and sculptures of the Heidelberg
collection with an eye for untainted artistic
expression that contained within it primeval laws
of art for potential application in his own work.
He did not consider the works to be manifestations
of pathological disturbance but spontaneous
expressions of a liberated ego producing autono-
mously from a universal creative drive. The ability
to break the confines of rational existence and
to communicate the content of the unconscious
without inhibition—Kubin found the works of the
one patient with artistic training to be the weakest
in the collection—resulted in works that "measure
up to the best achievements of great artists."[44]

Kubin clearly recognized parallels between the
visions of the patients and his own bizarre, dark
renditions of ominous dreams and foreboding
fantasies (FIGURES 61–63). Perhaps as a measure of
self-protection, the observation that these artists are
"condemned into the incomprehensible circle of
their own imaginings, closed off toward the outside,
incapable of any communication with their fellow
human beings" is repeated several times in his
article. And my search for any direct traces, either
in style or in the presentation of motifs, left in his
work by the artists of the Prinzhorn Collection has
proven futile. The drawings and sculptures he
saw—those works that he said "refuse to leave
me alone any longer"—confirmed an already
formed aesthetic and artistic practice; they did not
inspire transformations in it. As models of intro-
spective creative production, as "brain-born
images," they professed an unmediated, contem-
porary contact with art's primeval origins. The
creations of institutionalized artists were viewed

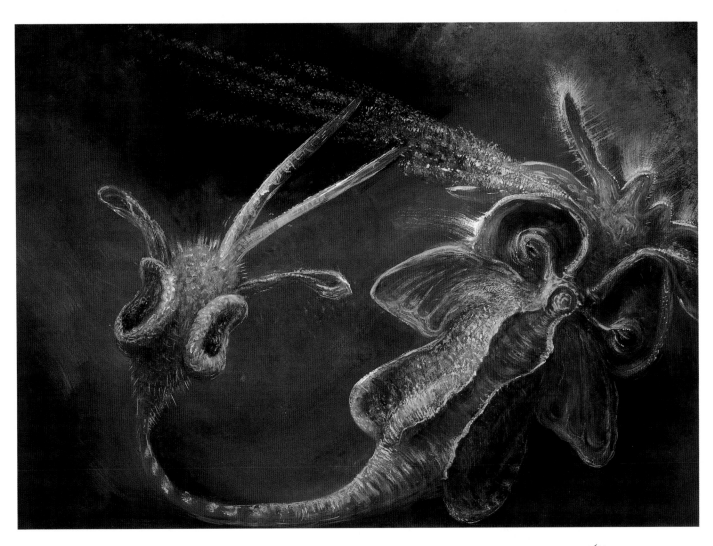

: 61 :
Alfred Kubin
Leuchtfisch (Fish of light)

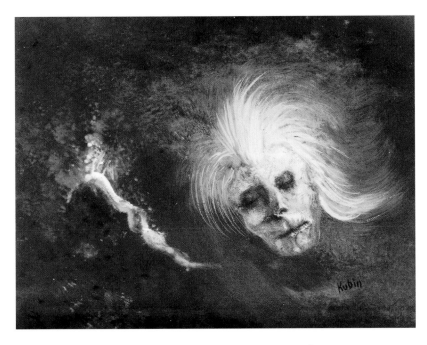

: 62 :
Alfred Kubin
Vision

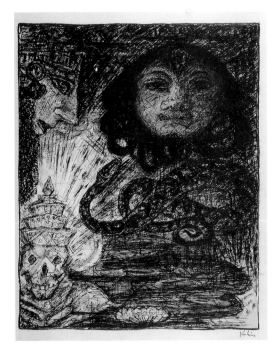

: 63 :
Alfred Kubin
Die Symbole von Leben und Sterben
(The symbols of life and death),
1923

as evidence for a new archaeology of artistic production that could be substituted for the limitations of transmitted histories of artistic practice. Kubin recognized in the works at Heidelberg the justification for a new art, thereby paradoxically proposing as prototypes for a modernist, universal means of communication what he believed to be the "isolated non-communication" of "so-called schizophrenics."

Kubin's aesthetic, like Prinzhorn's, is one formulated within the concerns of expressionism, but the moment of expressionism had passed by 1922, and its death repeatedly had been proclaimed. Prinzhorn's influence and significance is with other generations of artists in Germany and elsewhere, notably with surrealists such as Max Ernst and with other consciously fantastic imagery that Kubin's own work often prefigures. If, however, Prinzhorn and expressionism might be credited with standing the diagnostic approach to the art considered to be schizophrenic on its head, their expressionist aesthetic with its valuation of social outsiders and their art was, in turn, also flipped violently into its opposite during the course of the 1920s and 1930s as reactionary politics formed an alliance with conservative aesthetics. For Germany, Adolf Hitler became the major formulator of a renewed rejection of the social outsider. In the guide to the exhibition *Entartete Kunst* (Degenerate art), which capped the efforts to impose a National Socialist view of art in 1937, Herzfelde's essay is cited and Prinzhorn's collection is exploited to decry, reject, and ridicule the efforts of German innovative artists, notably the expressionists. At the simultaneous *Grosse Deutsche Kunstausstellung* (Great German art exhibition), meantime, the classicist aesthetics of Winckelmann received a perverted resurrection. The logic of his arguments, however, which had formed the foundation of expressionism's exploration of artistic archetypes among a revised identification of "the ancients" with the perceived innocence of society's outsiders, was rejected. For a society based in regimentation and a uniformity of violent repression, "brain-born images" could not but function subversively.

=

Notes

All translations are by the author unless otherwise indicated.

1
In December 1911 Hugo von Tschudi exhibited the Nemes Collection, which included works by El Greco, at the Alte Pinakothek in Munich. Newly discovered at the time, El Greco was in Germany frequently identified as a precursor of modernist art.

2
Paul Klee, exhibition review, *Die Alpen* 6, no. 5 (January 1912): 302, as reprinted in Paul Klee, *Schriften: Rezensionen und Aufsätze*, ed. Christian Geelhaar (Cologne: DuMont, 1976), 99–100. The text, revised when Klee copied it, probably around 1921, also appears as entry 905 in Klee's *Tagebücher* (diary), initiating entries for 1912, and is there identified as "from a Munich letter on art that I sent to Switzerland"; see Paul Klee, *Tagebücher 1898–1918*, ed. Felix Klee (Cologne: DuMont-Schauberg, 1957), 276–77. It is this version of the text that has most frequently been cited, e.g., by John M. MacGregor, *The Discovery of the Art of the Insane* (Princeton: Princeton University Press, 1989), 231.

3
Johann Joachim Winckelmann, *Reflections on the Painting and Sculpture of the Greeks*, trans. Henry Fuseli (London, 1765), 1.

4

Franz Marc, letter to August Macke, January 14, 1912, in *Briefwechsel August Macke, Franz Marc* (Cologne: DuMont, 1964), 39–40.

5

The significance of exotic sources for expressionist art is evidenced by Ernst Ludwig Kirchner's efforts, as early as 1913, to claim to have visited and been influenced by the ethnographic collections in Dresden well before similar visits were made by Maurice de Vlaminck and Pablo Picasso in Paris (see Kirchner's 1913 *Chronik [der] KG Brücke*, reprinted in Horst Jähner, *Künstlegruppe Brücke: Geschichte, Leben und Werk ihrer Maler* [Stuttgart: Kohlhammer, 1984], 422–26). The first consistent scholarly study on the subject of expressionism and primitivism is Robert Goldwater's classic work, *Primitivism in Modern Painting* (New York: Harper & Brothers, 1938); all subsequent citations are to the rev. ed., *Primitivism in Modern Art* (New York: Vintage/Random House, 1967). More extensive and involved with the parallelism between expressionist works and non-European art are L. D. Ettlinger, "German Expressionism and Primitive Art," *Burlington Magazine* 110, no. 781 (April 1968): 191–201; Britta Martensen-Larsen, "Primitive Kunst als Inspirationsquelle der Brücke," *Hafnia*, no. 7 (1980): 90–103; Manfred Schneckenburger, "Bemerkungen zur 'Brücke' und zur 'primitiven' Kunst," in *Weltkulturen und moderne Kunst*, exh. cat. (Munich: Haus der Kunst, 1972), 456–74; and Donald Gordon's lengthy essay "German Expressionism"

in William S. Rubin, ed., *"Primitivism" in Twentieth-Century Art: Affinity of the Tribal and the Modern*, 2 vols., exh. cat. (New York: Museum of Modern Art, 1984), 369–403. The most insightful studies on the significance of non-European primitive art for the expressionists are Jill Lloyd's essays "Emil Nolde's Still Lifes, 1911–1912: Modernism, Myth and Gesture," *Res*, no. 9 (Spring 1985): 36–52; and "Primitivism and Modernity," in *German Art in the Twentieth Century: Painting and Sculpture 1905–1985*, exh. cat. (London: Royal Academy of Arts, 1985), 105–11; and her book *German Expressionism: Primitivism and Modernity* (New Haven: Yale University Press, 1991), which is clearly the standard study on the topic now. See also Christopher Middleton's thoughtful account, "The Rise of Primitivism and Its Relevance to the Poetry of Expressionism and Dada," in his *Bolshevism in Art* (Manchester, England: Carcanet, 1978), 23–37.

6

That expressionist artists tended to meld these diverse groups into a single concept was noted at least implicitly when Goldwater included a discussion of "The Child Cult" in *Primitivism in Modern Art*, 192–215. Similarly MacGregor includes a discussion of the expressionist admiration for children's art in his *The Discovery of the Art of the Insane*, 231–32. A useful subdivision of "primitivism" into ten somewhat overlapping facets is also provided by Middleton, *Bolshevism in Art*, 24–25.

7

The conversation apparently dates from 1922; see Lothar Schreyer's account in *Erinnerungen an Sturm und Bauhaus* (Munich: Langen and Müller, 1956), as reprinted and translated in *Paul Klee: His Life and Work in Documents*, ed. Felix Klee (New York: Braziller, 1962), 180–85. Schreyer's veracity and accuracy have been questioned, however, most convincingly by Marcel Franciscono, *Walter Gropius and the Creation of the Bauhaus in Weimar* (Champaign: University of Illinois Press, 1971), 163 n. 34. I believe it to be likely that Schreyer's version, while in the form of a direct record of a conversation, paraphrases and synthesizes thoughts communicated by Klee during a period of time. While not technically accurate, they reflect a perceived attitude and position.

For an excellent, highly detailed, and precise discussion of Klee's attitudes toward children's art, their change in time, and their significance, see O. K. Werckmeister, "The Issue of Childhood in the Art of Paul Klee," *Arts Magazine* 52, no. 1 (September 1977): 138–51; an expanded and revised version of the essay is contained in Werckmeister, *Versuche über Paul Klee* (Frankfurt am Main: Syndikat, 1981), 124–78. Virtually all studies on Klee's work consider the parallels and possible influences of children's art on his own, but see especially Hans-Friedrich Geist, "Paul Klee und die Welt des Kindes," *Werk* 37, no. 6 (June 1950): 186–91; Goldwater, *Primitivism in Modern Art*, 192–215; and James Smith Pierce, *Paul Klee and Primitive Art* (New York: Garland, 1976).

8

Jürgen Glaesemer, *Paul Klee Handzeichnungen*, vol. 1, *Kindheit bis 1920* (Bern: Kunstmuseum, 1973). Klee began to emulate the appearance of children's drawings as early as 1905 (Werckmeister, "The Issue of Childhood in the Art of Paul Klee," 140–41). This may well be the earliest such effort among artists related to expressionism, but his valuing of the art he did as a child is not unique to Klee among the expressionists. Ernst Ludwig Kirchner, for example, copied his childhood drawings into woodcut reproductions, thereby translating them into the context of his mature work. In a related fashion Gabriele Münter saved her own childhood drawings; several were then reproduced in the first significant study of her work, written by her companion Johannes Eichner, *Kandinsky und Gabriele Münter* (Munich: Bruckmann, 1957), illustrations 1–2.

9

The collection, frequently misidentified as that of Wassily Kandinsky, is now housed in the Gabriele Münter und Johannes Eichner Stiftung, Munich.

10

In his documentary new edition of *Der blaue Reiter* almanac, ed. Wassily Kandinsky and Franz Marc (Munich: Piper, 1965; rev. ed., 1984; English translation, New York: Viking, 1974), Klaus Lankheit indicated he did not know the source of these drawings (p. 268; this and all

subsequent citations to the almanac are to Lankheit's edition and to his English translation). The Münter collection of children's drawings did not become publicly available for study until after publication of Lankheit's edition of the almanac.

11
Wassily Kandinsky, "On the Question of Form," in *Der blaue Reiter* almanac, 149. Recently it has been suggested that some of the children's drawings in the almanac are actually by psychologically ill individuals; for example, see Stefanie Poley, "Das Vorbild des Verrückten: Kunst in Deutschland zwischen 1910 und 1945," in Otto Benkert and Peter Gorsen, eds., *Von Chaos und Ordnung der Seele: Ein interdisziplinärer Dialog über Psychiatrie und moderne Kunst,* as cited by Roman Buxbaum, "Einführung," in Buxbaum and Pablo Stähli, eds., *Von einer Wellt [sic] zur Andern: Kunst von Aussenseitern im Dialog* (Cologne: DuMont, 1990), 23. Also compare the conclusions of Werckmeister, "The Issue of Childhood in the Art of Paul Klee," 141: "They [the drawings] are evidently not by small children, and they don't seem to go very far in their deviation from adult realism." There is no corroborating evidence to support these conclusions; comparison with other children's drawings would, however, seem to indicate that the drawings by Lydia Wieber are more correctly identified as those of a girl in young adolescence.

12
Kandinsky, "On the Question of Form," 174–76. I have adjusted the translation to bring it into closer compliance with the original German text.

13
Ibid., 176.

14
For an extensive history of drawing practices and pedagogical theories in Germany at the turn of the century and the significance of the *Reformbewegung,* see Clive Ashwin, *Drawing and Education in German-Speaking Europe 1800–1900* (Ann Arbor, Michigan: UMI Research Press, 1981).

15
Siegfried Levinstein, *Kinderzeichnungen bis zum 14. Lebensjahr* (Leipzig: Voigländer, 1905), and Georg Kerschensteiner, *Die Entwicklung der zeichnerischen Begabung* (Munich: Gerber, 1905).

16
See the exhibition catalogue by Carl Götze, *Das Kind als Künstler* (Hamburg: Lehrervereinigung für die Pflege der künstlerischen Bildung in Hamburg, 1898).

17
Kerschensteiner, *Die Entwicklung der zeichnerischen Begabung,* xi. Kerschensteiner, the superintendent of schools in Munich, was joined in 1901 in his initial survey of children's drawing practices at the Munich schools by the sculptor Adolf von Hildebrand and the architect Theodor Fischer, ibid., 6.

18
Kandinsky, "On the Question of Form," 175.

19
Kerschensteiner, *Die Entwicklung der zeichnerischen Begabung,* 100.

20
"Die Gesichtsvorstellung auszubilden und ein für konkrete Vorstellungen unersetzliches Ausdrucksmittel zu gewinnen." Kerschensteiner, *Die Entwicklung der zeichnerischen Begabung,* 444.

21
C. Kik, "Die übernormale Zeichenbegabung bei Kindern," *Zeitschrift für angewandte Psychologie und psychologische Sammelforschung* 2, no. 1 (1909): 148.

22
Kandinsky, "On the Question of Form," 178.

23
For a survey of expressionism's reception of the art of the insane, see MacGregor, *The Discovery of the Art of the Insane,* 222–44. I have also found extremely useful and insightful the study by Sander L. Gilman, "The Mad as Artists," in his *Difference and Pathology: Stereotypes of Sexuality, Race, and Madness* (Ithaca, New York: Cornell University Press, 1985), 217–38.

24
Kandinsky, "On the Question of Form," 173. There is no documentary evidence that identifies these drawings as by a mental patient, but see the argument of Stefanie Poley, cited by Buxbaum, "Einführung," 23.

25
A handy collection of such texts is provided by Thomas Anz, ed., *Phantasien über den Wahnsinn: Expressionistische Texte* (Munich: Hanser, 1980), while a brief survey appears in Wolfgang Rothe, "Der Geisteskranke im Expressionismus," *Confinia psychiatrica* 15, no. 2 (1972): 195–211.

26
Emil Nolde purchased three of these drawings at the time. For further discussion of Nolde's apparent early interest in the art of the insane, see MacGregor, *The Discovery of the Art of the Insane,* 230–31, 348 n. 44. MacGregor, 164, indicates there was an exhibition of artwork by mental patients in Berlin in 1913; I know of no record that expressionist artists visited this exhibition.

The major critical responses to Josephson in Germany then—Hermann Struck, "Ernst Josephson," *Zeitschrift für bildende Kunst,* n.s., 20, no. 10 (1909): 243–47; and Karl Wahlin, "Ernst Josephson," *Kunst und Künstler* 7, no. 7 (1909): 479–90—were largely biographical narratives rather than critical treatments of the drawings. The first significant critical appreciation of Josephson's drawings did not appear until 1920: G. F. Hartlaub, "Der Zeichner Josephson," *Genius* 2, no. 1 (1920): 21–33.

27
Lombroso's study *Genio e follia* (Milan: Chiusi, 1864) appeared in a first German translation as *Genie und Irrsinn in ihren Beziehungen zum Gesetz, zur Kritik und zur Geschichte* in 1887 in the popular, inexpensive *Universalbibliothek* series published by Phillip Reclam, Leipzig.

28
Paul Klee, *Tagebücher 1898–1918,* 235, entry no. 816, March 1908.

29
Fritz Mohr, "Mitteilung:
Zeichnungen von
Geisteskranken," *Zeitschrift
für angewandte Psychologie
und psychologische Sammel-
forschung* 2, no. 2 (1909):
299. See also the more
extensive article in which
Mohr first introduced his
theories, "Über Zeichnungen
von Geisteskranken und
ihre diagnostische
Verwertbarkeit," *Journal für
Psychologie und Neurologie* 8,
no. 1 (1906): 99–140.
30
Mohr, "Mitteilung," 300.
31
Paul Schilder, *Wahn und
Erkenntnis: Eine
psychopathologische Studie*
(Berlin: Springer, 1918),
passim.
32
Wieland Herzfelde, "Die
Ethik der Geisteskranken,"
Die Aktion 4, no. 14 (April 4,
1914), as reprinted by Anz,
ed., *Phantasien über den
Wahnsinn*, 58. My translation
largely follows that of
Gilman, *Difference and
Pathology*, 229.
33
MacGregor, *The Discovery of
the Art of the Insane*, 228.
34
Hans Prinzhorn, "Das
bildnerische Schaffen der
Geisteskranken," *Zeitschrift
für die gesamte Neurologie und
Psychiatrie* 52, no. 2 (1919):
307–26.
35
Hans Prinzhorn, *Bildnerei
der Geisteskranken* (Berlin:
Springer, 1922; reprint,
Berlin: Springer, 1968), and
in English as *Artistry of the
Mentally Ill: A Contribution
to the Psychology and
Psychopathology of
Configuration*, trans. Eric von
Brockdorff (New York:
Springer, 1972).

36
Prinzhorn, *Artistry of the
Mentally Ill*, 273.
37
Max Ernst maintained, in
autobiographical notations
(Max Ernst, *Ecritures* [Paris:
Gallimard, 1971], 18–20),
that as early as 1910 he was
deeply impressed by a
collection of art by patients
of the "Provincial-Heil- und
Pflegeanstalt" in Bonn,
especially by sculptures
kneaded from bread. Ernst's
recollections about his
studies in Bonn are highly
embroidered, however, and
it has not been possible to
verify the existence of such a
collection (compare Eduard
Trier, "Was Max Ernst
studiert hat," in *Max Ernst
in Köln: Die rheinische
Kunstszene bis 1922*, ed. Wulf
Herzogenrath [Cologne:
Rheinland, 1980], 63–66).
The reference to bread
sculpture may have its source
not in Ernst's Bonn but in
Prinzhorn's Heidelberg,
where such works by Karl
Brendel were preserved.
38
Goldwater, *Primitivism in
Modern Art*, 195, sees an
influence of the art of mental
patients in works as early
as Klee's etching series
Inventions (1903–5).
MacGregor, *The Discovery of
the Art of the Insane*, 233, 349
n. 53, suggests Klee knew
Adolf Wölfli's work by 1912.
Franciscono, *Walter Gropius*,
231–32, asks rhetorically if
Klee read Marcel Réja's
(i.e., Paul Meunier's) short,
pioneering book *L'Art chez les
fous* (Paris: Societé du
Mercure de France, 1907)
and postulates the likelihood.
None of these authors
succeed in pinpointing Klee's
initial awareness of art by the
mentally ill, however.
As an addendum to the
influence that the

pseudonymous Réja and
his collection may have
had on artists related to
expressionism, it should
be noted that in about 1898
Edvard Munch produced
a woodcut portrait of the
Parisian psychiatrist,
playwright, and art critic
(Oslo, Munch Museum),
which is illustrated in Eli
Greve, *Edvard Munch: Liv og
verk i lys av tresnittene* (Oslo:
Cappellen, 1963), 97. It is
possible, although again
without documentation, that
Munch's portrait was
projected (but ultimately not
used) to accompany Réja's
introduction to the French
translation of August
Strindberg's *Inferno* (Paris:
Société du Mercure de
France, 1898).
39
Oskar Schlemmer, *Briefe und
Tagebücher*, ed. Tut Schlemmer
(Munich: Prestel, 1958), 91.
40
See note 7.
41
James Smith Pierce, "Paul
Klee and Karl Brendel," *Art
International* 22, no. 4 (April–
May 1978): 8–10, 18–20, 41.
Also compare Pierce's "Paul
Klee and Baron Welz," *Arts
Magazine* 52, no. 1
(September 1977), 128–31,
which tracks intriguing
similarities of thought
processes as revealed in
statements by the two artists
as well as in their drawings.

42
For the reference to
children's drawings, see
Eberhard Haas, "Spuren
einer Grundsprache," in
*Die Prinzhorn-Sammlung:
Bilder, Skulpturen, Texte aus
Psychiatrischen Anstalten
(ca. 1890–1920)*, exh. cat.
(Königstein/Taunus:
Athenäum, 1980), 96. The
pre-Columbian reference is
provided by Franciscono,
Walter Gropius, 230, 362 n. 53.
43
Alfred Kubin, "Die Kunst
der Irren," *Das Kunstblatt* 6,
no. 5 (May 1922): 185, 187.
The essay is reprinted in
Alfred Kubin, *Werkstatt-
Berichte* (Salzburg: Residenz,
1977), 13–17.
44
Ibid.

Surrealism and the Paradigm of the Creative Subject

ROGER CARDINAL

Paris surrealism made a decisive impact upon the modern aesthetic sensibility through its commitment to a single unitary vision encompassing many disparate art forms. Living in cramped apartments, the surrealists loved to display their eclectic private collections in nonhierarchical, even willfully incongruous, ways. Their delight in the creative interplay of very different things led to collective exhibitions in which their own paintings were set without comment alongside masks by unknown tribal carvers, natural or industrial found objects, naive and child art, and drawings by mediums and psychotics. This practice of *provocative juxtaposition* reflected a zest for disturbing analogies and prefigured our present recognition of the parallelism of seemingly divergent artistic visions in the twentieth century.

The apparent waywardness of surrealist sympathies must be seen in the context of an avant-garde movement's typical rebellion against aesthetic convention. One of the ways in which surrealism worked out its program of dissent and renewal was by consulting art made outside the French cultural mainstream. I want to show how notions of fertile spontaneity and unconstrained creativity, indispensable to the surrealist project, were nourished by special enthusiasms for those marginal, nonconformist arts that this exhibition addresses, namely psychotic art, mediumistic art, and comparable work produced by naives, outsiders, or compulsive visionaries.[1]

My contention is that such enthusiasms were fueled by the surrealists' need to construct and have validated a model of what I shall call the *creative subject*, that is, the individual self seen as the initiator and monitor of its own artistic impulses. Ranging from the naive-awkward through the mediumistic-fluent to the schizophrenic-obsessional, the inventory of eccentric artworks esteemed by surrealism was regulated by the overriding postulate that true aesthetic quality and expressive authenticity derive from those fertile, subliminal levels of the psyche that are unmarked by establishment standards and indeed lie beyond

the scope of rational surveillance. It was this "psychic elsewhere" that surrealism identified as the locale of genuine invention, and it was an ideology of the intrinsic positive value of radically altered mental states that informed the enthusiasms and affinities I am concerned to evoke. With such notions in mind, I shall begin by situating the first stirrings of the paradigm of the creative subject in the early thinking of the poet André Breton (1896–1966), acknowledged spokesman and pilot of surrealism from its inception.

One crucial fact explains why it was that Breton, in seeking a heading by which to steer during the obscure days that preceded surrealism's formalization, should have turned to issues of psychology rather than of art. It is simply the case that Breton's early training lay in the field of medicine; in other circumstances he might well have become a professional psychiatrist.[2] A medical student in Paris at the outbreak of World War I, he found himself in July 1916 in the neuropsychiatric center at Saint-Dizier, set up near the frontline to treat battle-shocked troops. Sigmund Freud's major writings were not yet available in French, yet what psychoanalytic knowledge Breton had gleaned gave him the confidence to record and interpret the dreams and thought associations of his patients. "I could," he subsequently wrote, "spend a whole lifetime eliciting the confidences of the mad. They are people of the most scrupulous honesty, and their innocence is matched only by my own."[3] Already we may take such shared "innocence" as a coded reference to that moment of creative forgetting that is the prerequisite of true surrealist expression, a shift out of commonplace consciousness and into what I have called the psychic elsewhere.

One patient made an indelible impression on Breton with his *idée fixe* about the war being a mere spectacle faked up with firework bombs and waxwork corpses; he had been hospitalized after an episode in which he had clambered out of his trench to blithely direct the shells whistling overhead. Thrilled by the tenacity with which the man defended his delusions, Breton reconstructed them

in a text whose very title, *Sujet* (Subject), gives prominence to the theme of defiant subjectivism.[4] This may be counted as surrealism's first attempt to reproduce the psychic reality of the insane. Writing to Guillaume Apollinaire from Saint-Dizier in August 1916, Breton admitted to being spellbound by the autistic self-sufficiency of the insane and darkly added, "I instinctively feel my destiny is to put the artist to the same sort of test."[5] Thus the compelling solipsism of madness became a key reference for the model of the artistic self, or creative subject, that Breton was by now constructing.

Breton was in regular contact with Apollinaire for two and a half years up to the latter's death in November 1918. Hence—though Breton's reminiscences are silent on this point—it is reasonable to suppose that the topic of psychotic creativity came up in their conversations. We know that Apollinaire was, through his friendship with psychiatrist Dr. Jean Vinchon, in touch with Paris medical circles. We also know that besides his well-known passion for tribal art—not to mention *les arts populaires* and naive art, as witness his championship of Henri Rousseau—he took an informed interest in psychotic art and almost certainly knew the celebrated collection of Dr. Auguste Marie. We may sensibly surmise that Apollinaire at least drew such work to Breton's notice, sowing the seed for what would in due course become a keen responsiveness.[6]

For the time being, however, Breton's priorities remained verbal, even if not precisely literary. Though he received his diploma as an auxiliary doctor in July 1919, he had effectively given up all therapeutic aspirations. Enthused by the hallucinatory writings of Arthur Rimbaud and the Comte de Lautréamont, by the haunting precedent of the lunatic imagination seen in the light of psychoanalysis, and finally by his own experience of impromptu sentences floating magically to the surface of consciousness while he was in a semidormant state, Breton now embarked upon an

96 CARDINAL Surre
 alism
 and
 the
 Parad
 igm
 of
 the

epoch-making experiment in noncontrolled writing with fellow poet Philippe Soupault in May–June 1919. The resulting texts, printed as *Les Champs magnétiques* (The magnetic fields), are held to be the first specimens of surrealist automatic writing.

It is odd that when Breton came to draw up a formal program for the movement in his 1924 *Manifeste du surréalisme* (Manifesto of surrealism) he should have written so insistently of *écriture automatique* (automatic writing) without properly acknowledging that the expression denotes one of the practices of spiritualist mediumism. Scholars are still divided as to why in 1924 Breton should have preferred the backing of Freudian theory, still little known in France, and ignored such obvious works as Dr. Pierre Janet's *L'Automatisme psychologique* (Psychic automatism), 1903, or Dr. Théodore Flournoy's *Des Indes à la planète Mars* (From the Indies to the planet Mars), 1900, a classic case study of the medium Hélène Smith (Elise Müller; see FIGURES 220–21).[7] It is possible Breton's instinct for provocation made him highlight a foreign intellectual debt rather than local ones, and it is clear he hated Janet, whom he elsewhere attacks. Perhaps also he was fearful that overt mention of spiritualism might taint surrealism's atheistic image. Whatever the explanation, I insist that he *was* perfectly aware of the mediumistic precedent, as his subsequent "Le Message automatique" (The automatic message), 1934, amply confirms. Moreover it should be noted that once Breton began to count mediumistic automatism as a precedent he had no difficulty in refuting all suspicion of "mysticism," stating categorically that the subliminal message, ostensibly the responsibility of an otherworldly agency, must in fact be seen in exactly the same light as the expressions of the madman, namely as originating in the mind of the individual concerned. That is to say, whether faced with the products of the hypnotic trance, or those of psychotic delirium, or again those of the analysand engaging in free association, or finally those of the surrealist automatist, Breton saw only their common source in the unconscious and their amazing proof of the fluency of what Freud called the "primary process."

In late 1922 the artistic group taking shape around Breton in Paris was galvanized by the experience of the Period of Sleeps. Taking their cue from René Crevel, who had reported being mesmerized by a clairvoyant, the budding surrealists undertook a concerted prospection of the psychic elsewhere, which they now realized lay so close. The poet Robert Desnos emerged as a star performer, issuing oral, written, and graphic messages while in a hypnotic trance; many of these evoked the imminent demise of his surrealist associates. Day after day the group gathered to scribble automatically in notebooks, swept ecstatically away on what Louis Aragon was to call "a wave of dreams," whence they would float back to consciousness clutching marvelous new meanings.

The formula of "pure psychic automatism" was officially unveiled in the *Manifeste* of 1924 as the cornerstone of the surrealist theory of creativity. Breton's recipe for automatic writing insists that the practitioner empty his mind of all literary ambition, indeed of all conscious thought, and simply allow the pen to cross the page according to the dictation of the unconscious. I believe that such a permissive recipe is as likely to spawn pictorial forms as it is written words. Had Breton chosen to invoke her, there was the obvious example of Smith, whose mediumistic inspiration alternated between writing and graphic production; and indeed Breton mentions in passing that Desnos had shown in the Period of Sleeps that the unconscious might favor either mode. It is thus not surprising that a few weeks after the manifesto pictorial surrealism in turn received its charter. In the very first issue of *La Révolution surréaliste*, under the heading "Les Yeux enchantés" (The enchanted gaze), Max Morise argued the case for extending automatism to the visual sphere.

Morise's text is illustrated with an automatic drawing by André Masson, among the first specimens of its kind. Immediately beneath we read, "Let us admire the lunatics and the mediums who manage to impart fixity to their most fleeting

visions, in the same way the man dedicated to Surrealism tends to do, albeit on a somewhat different footing."[8] The comment neatly condenses a theoretical position that is characteristic of surrealism. We learn three things: first, that Morise is a partisan of psychotic and mediumistic art and wants his reader also to take them seriously; second, that psychotic delirium and the mediumistic trance are equivalent visionary media (in the same article Morise further asserts that "we may consider . . . the plastic works of those commonly known as *madmen* and *mediums* as perfectly comparable"); third, that the procedures of a surrealist automatist such as Masson are to be seen as *akin to, though not identical with,* those of the psychotic and the medium.

The last point is a crucial rider to a theory of authentic creativity that sets such store on a risky journey into an unmapped psychic interior. If it is undeniable that the twin practices of automatic writing and automatic drawing are the foundation for a specifically surrealist definition of artistic expression and that either practice presupposes a deliberate refusal of reason, it remains the case that surrealism does not expect the creative subject to renounce *all* control. True, Breton and others would often flirt with the *idea* of total abandonment, picturing the perfect surrealist as one ready to throw himself *corps et biens* ("lock, stock, and barrel"—the title of one of Desnos's collections) into a sort of glorious psychic shipwreck. When Breton claims that "it is not the fear of madness that will force us to furl the flag of the imagination,"[9] we should be wary of the dose of romantic rhetoric he is asking us to swallow. In actuality, as in its cooler moments of theorizing, surrealism would recommend commonsense caution, as if it envisaged automatism as more a figurative than a literal descent into the depths of the unconscious, a creative strategy whereby Dionysian excess is, so to speak, monitored by a certain Apollonian discretion.

This reservation explains the abrupt ending of the Period of Sleeps, in March 1923, when Breton called off the experiments, judging that a crucial point had been made but that the side effects of hypnosis gave warning of physical as well as psychic danger. As automatist supreme, Desnos was humiliated by Breton's curt intervention, but it has to be said that he was largely to blame, having been found, while in a trance, chasing after Paul Eluard with a knife, as though to actualize a morbid prediction. I suggest we can locate here the precise point on a continuum between mediumistic and psychotic states at which surrealism was typically to draw a line. The trance state or "possession" that surrealism deemed indispensable to the flowering of creativity had to be at least as extreme as mediumistic possession—but ought, on reflection, to fall short of that integral surrender to the irrational we call insanity. In other words, the surrealist unconscious would be invited to express itself through the pencil or the pen but not with the knife!

The measure of Breton's considered position may be taken by reference to the explicit reserve of *Nadja*, 1928, where he betrays anxiety about the mental deterioration of the young woman he has met, despite citing her poetic utterances and reproducing ten of her improvised drawings. Something rather less than total psychic collapse began to emerge as the recommended compromise. Breton spelled this out in 1930, after another experiment, this time conducted with Eluard. The jointly signed "Les Possessions" is the record of a controlled excursion into the psychoses. Five texts document the states of mental debility, acute mania, paresis, paranoid delirium, and schizophrenia and seek to prove that it is possible to emulate psychotic "possession" with impunity, to enter and leave the aberrant condition at will and "without there being any lasting disturbance," as Breton put it.[10] Clearly the insane model of involuntary creativity was modified to produce something one could adopt deliberately and safely: the surrealist creator was expected not to flounder about as an object of delirium but to retain the poise of the stable subject.

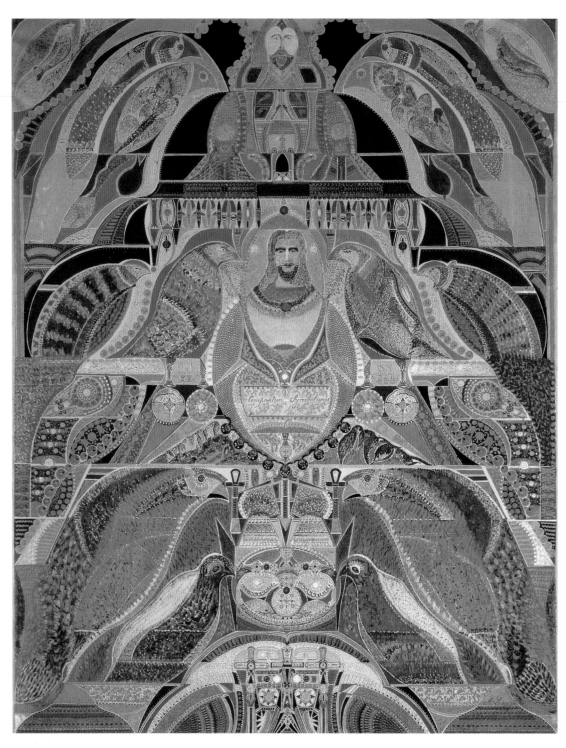

: 64 :
Augustin Lesage
Composition symbolique
(Symbolic composition), 1928

It is well known that the early surrealist agenda was biased toward writing because the group was dominated by the poets Breton, Soupault, Aragon, Desnos, Eluard, and Benjamin Péret. There are no illustrations at all in the transitional *Littérature*, 1919–24, but by December 1924 the situation had changed drastically, as is evident from the first issue of *La Révolution surréaliste*, containing Morise's pioneering essay and visual images on practically every page. Visual artists were now rallying to the surrealist flag, and within four years Breton had composed *Le Surréalisme et la peinture* (Surrealism and painting), an essay that cemented the credibility of surrealism in the pictorial sphere. True, Breton remained a little cautious even here, relying more on Picasso as an exemplar than more obviously loyal surrealists and signally failing to mention psychotic art; yet he did make admiring mention of Hélène Smith in reference to the subjectivist vision of Yves Tanguy and successfully launched the new concept of the "interior model," which, as I see it, subsumed all his prior thoughts about subliminal creativity and its intrapsychic orientation.

Breton's 1934 essay "Le Message automatique" is final proof of his belief in the fundamental kinship of writing and drawing. While much of the text speaks of verbal messages received aurally by the nonfocused mind, some two dozen illustrations from spiritualist sources ensure a simultaneous emphasis on the graphic (FIGURE 64). Printed on the glossy art spreads of *Minotaure*, with Man Ray's photo of a crystal ball to signal their provenance, the illustrations include a famous engraving by Victorien Sardou of *La Maison de Mozart dans Jupiter* (Mozart's house on Jupiter), a pen drawing by Léon Petitjean entitled *Portrait d'esprits revêtus de leur costume fluidique* (Portrait of spirits clad in their fluidic costume), and pictures and calligraphy by Hélène Smith, by now the imperative reference (FIGURE 65).[11] There are also some telling touches: reprints of a favorite trance drawing by the eighty-one-year-old Madame Fondrillon and of a schizophrenic sketch by Nadja, explicitly captioned "automatic drawing," and a photo of the postman Ferdinand Cheval's *Palais idéal* (Ideal palace), which Breton had visited around 1931 (see FIGURE 180).

: 65 :
Hélène Smith
Plantes extra-terrestres
(Extraterrestrial plants)

Such inclusions seem motivated by a comprehensive, flexible conception of the automatist subject, insofar as they invoke the complementarity—visually appreciable in terms of the stylistic kinship of these illustrations—of the medium (Fondrillon), the mentally deranged person (Nadja), and the independent visionary (Cheval).[12]

Commercial showings of psychotic art took place in Paris in 1928 and 1929, and at one of these Breton acquired a striking boxed assemblage made by an unnamed schizophrenic (FIGURE 66). Its compulsive neatness, along with the bizarre uselessness of its contents—half a pair of scissors, a safety pin, a coil of string, buckles, pen nibs—make of it a sort of exemplary demonstration piece, something akin to an enigmatic poem or a crowded, yet harmonious, collage. It is likely that Breton took a cue from its format for the object-poems he now began to produce, in which erratic verbal and visual elements interact within an encompassing frame (FIGURE 67). Having, with a similar object, been reproduced somewhat irrelevantly (but who is to say what is or is not relevant about surrealist juxtapositions?) beside an article on suicide by the psychoanalyst J. Frois-Wittmann in the December 1929 issue of *La Révolution surréaliste*, the box was featured in the Galerie Ratton show of surrealist objects in May 1936 and then became Breton's last-minute addition to the International Surrealist Exhibition in London a month later, where it was honored by being flanked by two of Giorgio de Chirico's paintings. Regularly exhibited ever since,[13] the schizophrenic box has become a ritual reminder that surrealism welcomes validation by insane analogues.

In 1945, while in Haiti, Breton came across the paintings of Hector Hyppolite; their imagery, steeped in the voodoo cult, thrilled him as another instance of creativity shaped by trances, visions, and delirium. Nowadays we might plausibly categorize Hyppolite as a naive or even a popular artist; at the time, Jean Dubuffet, to whom Breton showed the work, was prepared to see Hyppolite as a candidate for his *art brut* collection and invited Breton to draw up a text on him for an almanac of

: 66 :
Anonymous
Untitled, mixed media assemblage,
16 ¾ x 6 ⅛ in. (42.5 x 15.5 cm),
private collection

: 67 :
André Breton
Jack l'Eventreur (Jack the Ripper), 1942

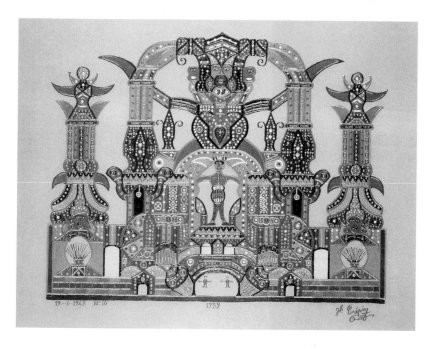

: 68 :
Joseph Crépin
Composition No. 10, 1948

art brut, which, however, never materialized. For the same publication Breton prepared a study of the medium Joseph Crépin (FIGURE 68) as well as the key article, "L'Art des fous, la clé des champs" (The art of the mad, the key to liberty), 1948, wherein he consolidated his view of psychotic art as the supreme creative paradigm. Breton busily invoked clinical authorities like Marcel Réja, Hans Prinzhorn, Jacques Lacan, and Gaston Ferdière, referred to psychotic masters like August Natterer, Josef Schneller (Natterer and Schneller were pseudonymously referred to as "Neter" and "Sell" in Prinzhorn's book *Bildnerei der Geisteskranken* [Artistry of the mentally ill], 1922), and Adolf Wölfli, and extolled the unconstrained art of the mentally ill as "a reservoir of moral health."[14] The phrase remains a little gnomic, but we are left in no doubt at all that Breton wished the art of the mad to take pride of place in the surrealist canon.

The last two decades of Breton's life saw an acceleration of responses toward the art of compulsive visionaries. Drawings by Wölfli and Aloïse Corbaz (FIGURE 69) were by now circulating in Paris, and Breton was keen to collect them, along with works by his own discoveries Baya and Pascal Maisonneuve and by Scottie Wilson (FIGURE 70), to whom he was alerted by the London-based surrealist E. L. T. Mesens. Breton's criticism at this time regularly dealt with such naive masters as Aloys Zötl, Séraphine Louis, Morris Hirshfield, and Tivadar Csontvary, and lesser figures like Miguel Vivancos and André Demonchy; he admitted to breathless impatience about queuing to see the great Henri Rousseau retrospective of 1961. A color plate of Aloïse's *Queen Victoria in Her Imperial Robe*, a work he owned, adorns the 1965 edition of *Le Surréalisme et la peinture*. And finally, in the closing paragraph of the very last text published in his lifetime, his preface to the group exhibition *L'Ecart absolu* (Absolute deviation) of December 1965, Breton took leave with the most unstinting praise of the schizophrenic Wölfli, crediting him with the production of "one of the three or four paramount

CARDINAL

Surre
alism
and
the
Parad
igm
of
the

: 69 :
Aloïse (Aloïse Corbaz)
Chalet gloire à dieu
(Chalet glory to God)

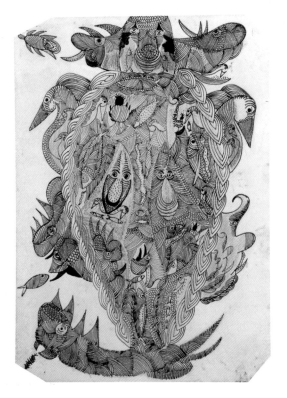

: 70 :
Scottie Wilson (Louis Freeman)
Dream, c. 1930

bodies of work of the twentieth century" (FIGURE 71).[15] It is as though, with this ultimate allusion, he wanted to emphasize the continuity of his ideas, faithful still to those "confidences of the mad" that, half a century before, had sparked his earliest speculations on the conditions of creativity.

Of the major surrealist writers Breton was far and away the best-informed enthusiast of the art of compulsive visionaries. Apart from Desnos and Antonin Artaud, only Eluard left substantial clues to other than a token solidarity with the insane, and the reticence even he shows is instructive. As well as tribal and popular art Eluard owned psychotic works[16] and admired Prinzhorn's book *Bildnerei der Geisteskranken*. Yet his principal public interventions betray a curious ambivalence. One article, "Le Génie sans miroir" (Genius unmirrored), came out in the nonsurrealist review *Les Feuilles libres* early in 1924, just a few weeks before Eluard's abrupt and unexplained departure on a round-the-globe trip. Whether or not Eluard was himself in a disturbed state, his text reads as an earnest if extravagant defense of psychotic art. But what is odd is that of thirteen anonymous drawings he reproduces from a Polish asylum, no less than ten were later attributed to Desnos. (The other three may have been by psychotics, but they remain untraced.) Furthermore it emerged that the psychotic poems Eluard quoted had also been provided by Desnos, the names cited being mischievous anagrams of members of the *Feuilles libres* circle. Was the whole thing a hoax? Or ought one to see this as a serious early attempt to simulate madness? Commenting in his book *L'Art et la folie* (Art and madness) on one of the Desnos drawings, *Roméo et Juliette*, Dr. Jean Vinchon benignly observed that nobody would be fooled for a moment by a purported psychotic drawing in which a spider dangles so coyly from a gibbet! When we finally realize that an anagram for "zero" lies behind Eluard's po-faced gratitude to "Dr. Rozé," the director of the Polish asylum, we may be tempted to dismiss the whole exercise as altogether too flippant.

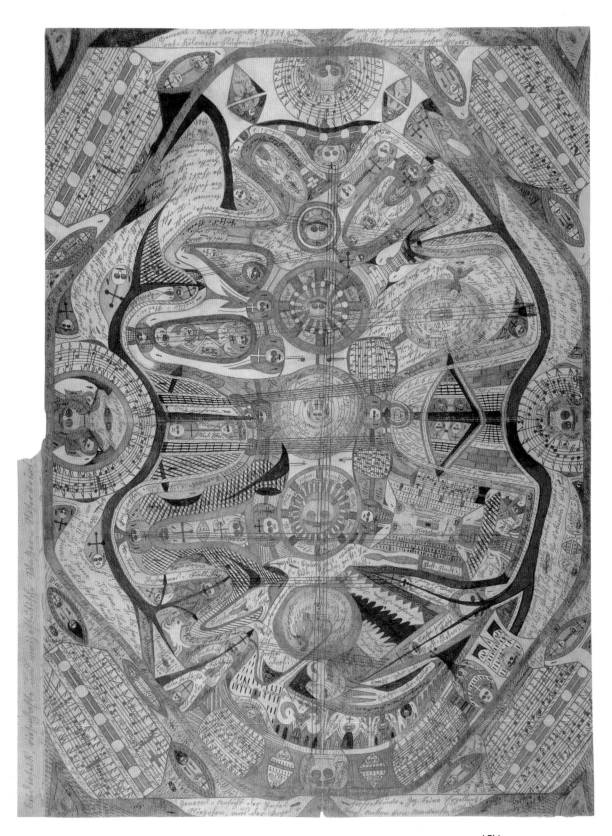

: 71 :
Adolf Wölfli
General-Ansicht der Insel Niezohrn
(General view of the island
Neveranger), 1911

I have argued elsewhere that Eluard's and Breton's performances in "Les Possessions," a chapter of *L'Immaculée Conception*, 1930, are poetically impressive rather than mimetically plausible.[17] That Eluard followed Breton in hesitating to identify at all points with the insane example is further evidenced in a 1938 piece in *Minotaure* where extracts from the poetic text "Juste milieu" (Happy medium), having no appreciable relevance, accompany twelve anonymous images captioned "FOUS ET NAIFS" (The mad and the naive). There would seem to be an obscure game here, for with the caption comes a quotation from Breton's preface to "Les Possessions" attacking the "arrogant categories" of psychiatry. Is this another warning of subversive pastiche? As it happens, two drawings (items 5 and 6) can be identified as the work of the psychotic Albert (de) Ravallet, probably borrowed from the Marie Collection.[18] Another four at least bear what I would call the schizophrenic stamp; one illustration is of a naive shell-assemblage. Yet even if the reader enjoys the puzzle, the lack of a solution within the pages of the magazine leaves a bad taste, as if surrealism were ready to sponsor such art but not to give it full credit.

How did artists in the surrealist camp respond to the work of compulsive visionaries? The outstanding case must surely be that of Max Ernst (1891–1976), whose importance here rivals that of Breton himself. Appropriately it is possible to make the very same point about Ernst as about Breton: his orientation as a student at Bonn University was similarly toward psychology and psychiatry, and though he never practiced as a therapist, there is evidence that at one time he had such a career in mind. Ernst's initiation into psychotic art occurred around 1910, when a study visit took him to an asylum near Bonn. There he saw drawings and sculptures, including figures molded from bread (a widespread phenomenon in asylums of the period). His third-person account of the discovery emphasizes the impact of such works and the incentive they offered: "He sought to understand these flashes of genius and to inquire into the vague and perilous territory on the borders of insanity. Only much later was he to discover certain techniques that helped him to advance into this no-man's-land."[19] Ernst is thought to have seriously planned a book about psychotic art, although this project lapsed without trace.

In November 1919 Max Ernst collaborated with Johannes Baargeld in mounting a show of dada art in Cologne under the banner of the Gruppe D, a provocative alternative to a more staid show of contemporary art held in the same building. Provocation was of course the whole point of a dada exhibition; the unusual feature of this one was that next to dada works were exhibited a selection of African carvings, amateur paintings, children's drawings, found objects, and works by psychotics. Sadly we lack information as to what these were and how Ernst obtained them, though we can say that this was very probably the first time psychotic art was publicly exhibited in an avant-garde context. (It is a well-known irony that this was to happen again in entirely different circumstances under National Socialism, at the 1937 *Entartete Kunst* [Degenerate art] show.) I mentioned earlier the principle of provocative juxtaposition: Ernst's gesture could equally be said to signal his determination to absorb garbled influences, following the logic of the collage, that quintessential genre common to dada and surrealism. Hence while a contemporary reviewer could be sardonic in dubbing Ernst "Hans Naivus,"[20] we might now suppose that Ernst's intention was precisely to "act stupid" or even "mad" in an attempt to shake off conventional logic so as to enter the psychic no-man's-land of irrational analogy.

The legend of Ernst leaving for Paris in the fall of 1922 and slipping a mint copy of Prinzhorn's *Bildnerei der Geisteskranken* into his suitcase as a gift for Eluard signals a moment of incalculable resonance. Though the Paris surrealists were aware of psychotic art and had access to French surveys by Rogues de Fursac and Marcel Réja, their orientation at this time, the Period of Sleeps, still privileged the mediumistic model. That Prinzhorn

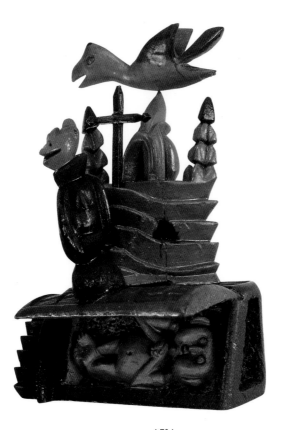

105

: 72 :
Karl Brendel (Karl Genzel)
Kirche (Church)

: 73 :
Franz Pohl (Franz Karl Bühler)
Untitled (Self-portrait), 1918

had selected the most striking illustrations from across the wide Germanic territories and that scarcely any of the Paris group read German meant that the volume was above all appreciated, as Eluard put it a few years later, as "the most beautiful book of images there is" (FIGURES 72–73).[21] *Bildnerei der Geisteskranken* became not so much an underground bible[22] as an alluring sample-book, a secret guide to the psychic elsewhere and an incitement to undertake its exploration.

What Prinzhorn did—unwittingly, for he had no personal contact with the Paris group—was to impel surrealism to look more closely at the connection between states of mental disarray and a peculiar brand of aesthetic intensity. Not that this meant the psychotic reference necessarily displaced the mediumistic one. It should be noted that several of Prinzhorn's early specimens of psychotic work are of fluid doodlings; and toward the end of the book he reproduces a spontaneous drawing by an unnamed hysteric from Zurich that is strongly reminiscent of the fluid mediumistic style. Prinzhorn makes this very point, likening the image to work by a medium called Wilhelmine Assmann. (He unfortunately says no more about this artist.) Prinzhorn's comparison, had it indeed been read by the surrealists, could have corroborated their

growing sense of the complementarity of certain psychotic states and the mediumistic trance. (It is amusing to note that it was while Desnos was himself in a trance during the Period of Sleeps that he answered the query "What will [Max Ernst] do?" with the sibylline utterance, "He will play with the madmen."[23])

In his mature work Ernst exploited all sorts of experimental techniques—collage, frottage, decalcomania, and so forth—which have in common that they derive from or lead to the dislocation of ordinary perception. Ernst himself spoke in 1969 of trance states, clairvoyance, and paranoia or schizophrenia, whether real or simulated, as being "normal, albeit acute, states that allow us to see and live as though time were abolished."[24] To say that Ernst's creativity was indebted to visionary precedents seems almost a truism. At the same time it is curiously difficult to positively identify instances of such influence; however, a few explicit borrowings are well attested. The 1931 collage *Oedipe (A l'intérieur de la vue 26)* (Oedipus [The inner vision 26]) definitely alludes to the innocently erotic drawing *Wunder-Hirthe* (Miraculous shepherd), by Natterer (FIGURES 74–75); a 1961 bronze head with the emblematic title *Der Schwachsinnige* (The imbecile) pays homage

August Neter (August Natterer)
Wunder-Hirthe
(Miraculous shepherd), before 1919

Max Ernst
Oedipe (A l'intérieur de la vue 26)
(Oedipus [The inner vision 26]),
1931, collage, height: 6 5/16 in.
(16 cm), location unknown

Max Ernst
Moonmad, cast 1956
after 1944 wood original

Max Ernst
Le Facteur Cheval
(The Postman Cheval), 1929-30

: 78 :
Max Ernst
Le Monde des naïfs
(The world of the naive), 1965

to *Der Teufel* (The devil), a carving by Karl Genzel ("Karl Brendel" in Prinzhorn's book). There is also something reminiscent of Ernst's collage-novels in the cartoon narratives of Gustav Sievers or in the eerie military scenes of Oskar Voll (illustrated by Prinzhorn in a montage suggestive of a cartoon strip).[25] I might equally suggest that the squiggled calligraphy found in Ernst's eccentric book *Maximilian*, 1964, is akin to the Martian writing of Hélène Smith. Even so, the fact remains that such examples are isolated enough to force us to settle for the less satisfying (though perfectly plausible) conclusion that Ernst's work *generally reflects* the outsider's vision while only rarely slipping into the mode of explicit quotation (FIGURES 76–78). This seems to me a fundamental point.

I have suggested that pure automatism—in the sense of an artistic strategy that abjures conscious intervention—became the sine qua non of the surrealist conception of creativity. Closer scrutiny of surrealist practice, however, reveals that it was never much more than an ideological construct, being but rarely enacted in literal terms. The early ink drawings and later sand paintings of Masson, which celebrate the spontaneity of the trace, may seem unimpeachable examples. Yet even here we stumble on an anomaly, insofar as Masson himself quickly tired of automatism, deciding that it conduced to laxity rather than intensity of form. At no time does he seem to have acknowledged any debt to the example of psychotics or mediums, as though he merely drifted through a passing allegiance to Breton's formula without concern for its antecedents. One can likewise scan the output of major surrealist artists like Joan Miró, Hans Arp, Yves Tanguy, Arshile Gorky, Roberto Matta, Jacques Hérold, or Richard Oelze and find plenty of works that recognizably derive from automatism. Yet at the same time as one applies Breton's really rather elastic criterion of the "interior model," it is hard to identify any firm visionary antecedents. One has to turn to another generation of committed automatists in the 1950s, with Robert Lagarde and Adrien Dax, to find any explicit indebtedness. In a semipolemical piece he wrote in 1955, differentiating surrealist psychic automatism from contemporary *tachisme* (action painting), Dax expressly invoked a tradition of visionary rhythm and organicism harking back to the classic mediumistic exemplars, Victorien Sardou and Augustin Lesage (see FIGURE 22).[26]

In the wartime essay "Genèse et perspectives artistiques du surréalisme" (Artistic origins and dimensions of surrealism), 1941, Breton drew up a wistful balance sheet, calling automatism "the essential discovery of surrealism" while conceding—in the light of what in 1933 he had complained of as automatism's "ceaseless bad fortune"[27]—that it had become necessary to envisage compromise and allow "certain premeditated intentions" into play. Seeking to retrieve the

108 CARDINAL Surre
alism
and
the
Parad
igm
of
the

: 79 :
August Neter (August Natterer)
Hexenkopf (Witch's head)

: 80 :
Salvador Dalí
La Charrette fantôme
(The phantom cart), 1933

dignity of his thesis, Breton clutched at the notion that automatism remained synonymous with surrealist authenticity even when its influence flowed *sous roche* (under the bedrock).[28] In that same paragraph Breton addressed a distinction sketched by Morise as far back as 1924. Surrealist art, Breton admitted, may manifest itself in two broad forms. First, it does so in terms of expressive traces that are the unmediated outflow of subjectivity, conceding nothing to the reality principle. Such is pure psychic automatism. (Morise had praised the madman and the medium for having externalized "the most imperceptible undulations of the flux of thought.") The second, alternative mode is the conscious, mimetic (*trompe l'oeil*) transcription of visual complexes that have *previously* arisen in the artist's mind. Here the analogy can no longer be that of mediumistic "surrender," nor of such types of madness as equate to the entranced, ecstatic model, but, if anything, with the more calculating intellectualism characteristic of such psychoses as paranoia.

It is with this secondary model of the creative process that Breton wrestled throughout his career as spokesman for surrealist art. I believe it was his ambition to subsume this model within an overarching theory of automatism; although he was always hard pressed to draw the two approaches into balance, resorting to the somewhat suspect argument that "possession" and "lucidity" are really two sides of the same coin. The historical fact is that once surrealism had been launched under the flag of psychic automatism a sequence of artists like Salvador Dalí, René Magritte, Hans Bellmer, and others rather inconveniently began to assert themselves as creators in a different vein. When *they* made art, it was not really by dint of unconscious impulse: rather, they exerted immense, even fastidious, control over their handiwork. Where, then, might lie the visionary element? It lies in the impact of the total image, seen as the equivalent of a dream or a psychotic's hallucination. If a mental patient like Natterer can hallucinate a visual complex and then painstakingly transliterate it on paper (FIGURE 79), then a surrealist like Dalí

: 81 :
Salvador Dalí
Senicitas, 1927–28

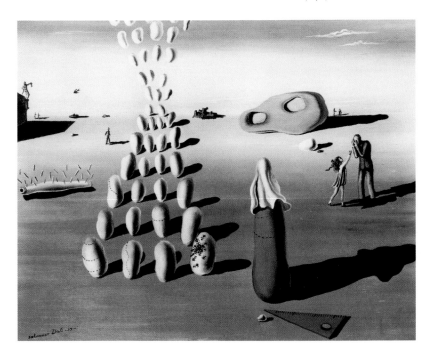

: 82 :
Salvador Dalí
Le Simulacre du jour
(Semblance of the day), 1930

can claim that startling irrational images invade his mind, which he then proceeds to transcribe in paint with the lucid craftsmanship born of academic training (FIGURE 80). (I might mention in passing that Natterer had a background in technical drawing.)

Dalí is of course notorious for his quip "The sole difference between myself and a madman is the fact that I am not mad!" Recalling that it was he who provided engravings for "Les Possessions" in 1930, I suggest that the remark chimes in perfectly with the claim Breton and Eluard made about their pastiches, that one *can* mimic madness and not suffer aftereffects. Dalí's self-styled "conquest of the irrational" and his pictures, with their unsettling juxtapositions and air of morbid derangement, come across as the expression of a remorseless lucidity, which, moreover, is eager to analyze its own procedures (FIGURES 81–82). Dalí's grandiloquent paranoiac-critical essays revel in appropriated scraps of psychiatric jargon and are thus no more than pastiche of another kind. They are, I hasten to add, no less entertaining for all that and by no means a discredit to surrealism; my point is simply that Dalí's flirtation with insanity never passes from the figurative to the literal. Significantly, while his prose reflects a familiarity with clinical textbooks, nowhere does he cite any psychotic *artworks*, nor, I think, do his pictures much resemble actual psychotic art of the period.[29] (To my mind, Dalí's most persuasively "insane" work is *Feux d'artifice* [Fireworks], 1930–31, an interpreted readymade in the form of an enamel ad for fireworks, eccentrically overpainted. It bears comparison with the schizophrenic box that belonged to Breton.)

Bellmer's vision was surrealist insofar as it was nurtured by mental processes alien to the average mind. His art seems to gravitate toward perversity and dissociation, though it is, in fact, highly structured and represents Bellmer's willful endeavor to recode the erotic domain in terms of interior models, to illuminate anatomy by way of outlandish realignments (FIGURE 83). Bellmer (1902–75) held

Prinzhorn's book in the highest regard and must
have prized the incisive graphics of Natterer (see
FIGURE 75) as well as the sadistic figure drawings
of Schneller. Bellmer later came across the work
of Friedrich Schröder-Sonnenstern, a mentally
disturbed down-and-out in postwar Berlin, and
arranged for his flamboyant, derisive drawings
to be shown in the 1959 Exposition inteRnatiOnale
du Surréalisme (EROS) in Paris (FIGURE 84 and see
FIGURE 135).

Bellmer's own imagery, in its refusal to admit
any limits to representability, carries the immediate
impact of that which is unequivocally erotic, if not
obscene (FIGURES 85–86). I feel, however, that such
extremism of subject matter ought not to be
ascribed to an interest specifically in the art of the
mad but rather to lucid obsessions that happen
also to crop up in the annals of psychopathology.
Bellmer hardly needed to gaze at insane drawings in
order to find his themes. This said, I would point to
the meticulousness of the lines he drew with pen or
lithographic stylus, to the incisiveness of his prose
commentaries, and to the ritual deliberateness of his
photos of the dismembered doll as evidence of the
most intense psychic investment, one that lends his
work an air of tragic estrangement that, I have to
say, *is* redolent of the psychotic mode (compare
FIGURES 87 and 88). If Bellmer's art is at all "mad,"
then that madness is a function of the resolute self-
centeredness of his vision. Yet there also comes
a point where psychopathology simply exhausts
itself as a reference, and the sheer immediacy of
aesthetic form, impeccably achieved, becomes the
sufficient event.

I think my distinction sharpens with the alter-
native case of Unica Zürn, Bellmer's companion
for some seventeen years, during which time she
underwent repeated treatment for depression
before finally throwing herself off the terrace of
their sixth-floor apartment. In 1954 Zürn published
Hexentexte (Witchy texts), an album of drawings
and anagrammatic poems that disclose an outstand-
ing surrealist propensity to float evenly between
the visual and the verbal as though both impulses
spring from a single matrix.[30] Though she wrote
a memoir in the third person that poignantly

: 83 :
Hans Bellmer
La Poupée (The doll),
1936, cast 1965

: 84 :
Friedrich Schröder-Sonnenstern
Der Mondmoralische Ziervogel
(The moon-moral ornamental bird),
1956

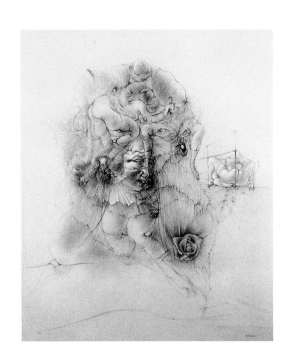

: 86 :
Hans Bellmer
Tête rose (Rose head), 1965

: 85 :
Hans Bellmer
La Toupie (The top), 1956

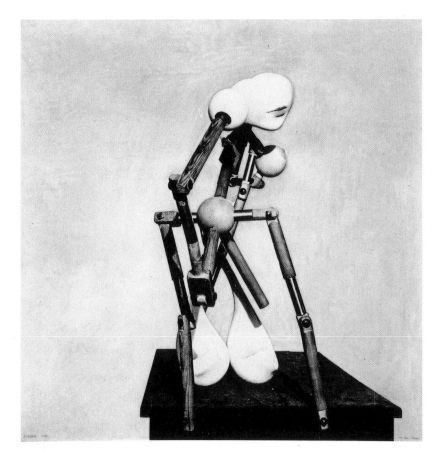

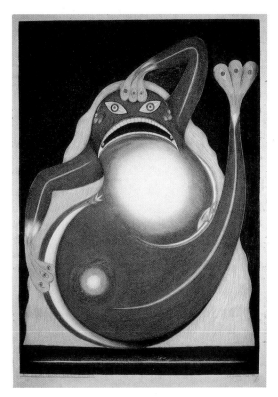

: 87 :
Hans Bellmer
La Mitrailleuse en état de grace
(Machine gun in a state of grace),
1937

: 88 :
Friedrich Schröder-Sonnenstern
*Der einsame entsetzte moralische
Mondfrosch* (The lonely horrified
moral moonfrog), 1952

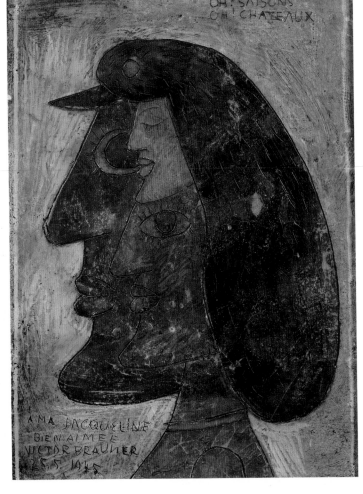

: 89 :
Victor Brauner
Oh! saisons, oh! châteaux
(Oh! seasons, oh! castles), 1945

: 90 :
Victor Brauner
Tout terriblement
(Completely terribly), 1948

reveals her psychic disarray, it is more in the eerie ingenuity of her letter-puzzle verses that one discerns a quality of mental compulsiveness, reminiscent of the word games of schizophrenics like August Klett ("Klotz" in Prinzhorn's book). It is most certainly in the delirious style of her drawings—exhibited, like Schröder-Sonnenstern's, at the 1959 Exposition inteRnatiOnale du Surréalisme—that one senses not just a surrealist's engagement with the flux of unprocessed configuration but a psychotic's abandonment of conscious handholds. Many of Zürn's pen improvisations bear a distinct family resemblance to drawings by the mad: to the accretive physiognomies of Nadja or Klett, for example, or the quirky caricatures of Heinrich Anton Müller or Gaston Duf. What is more, her jottings, curls, and squiggles often weave a textural skein reminiscent of the style of such mediums as Léon Petitjean, Madame Fondrillon, Jeanne Tripier, or Laure Pigeon.[31] Against what might be called the "lucid delirium" of a Dalí or a Bellmer, one might here oppose a "murky delirium," more autistic than communicative, that releases those telltale eddies of the giddy and the uncanny that speak of a very deep plunge into the subliminal depths.

The art of Victor Brauner (1903–66) represents a further instance of creativity nourished on varieties of abnormal psychic investment (FIGURE 89), including trances. It is known that Brauner had direct experience of spiritualist séances as a child in Romania, and the legend whereby his early paintings foreshadow the accident when he lost an eye is often cited as confirming the favorite surrealist equation of creativity and clairvoyance. Breton credits Brauner with having made an authentic surrealist pact with the forces of the imagination, establishing himself for lengthy periods in the "dangerous territories" of hallucination and primary process. However, since Brauner is also known to have been familiar with several pictorial traditions, including fantastic, archaic, and tribal art, and the iconography of magic and alchemy, it would be limiting to tie his work to mediumistic or psychotic references alone (FIGURES 90–91).[32]

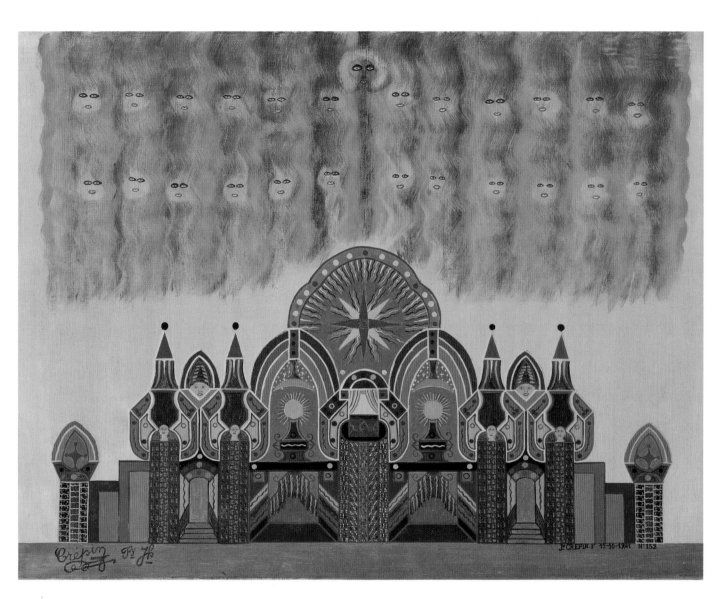

: 91 :
Joseph Crépin
Temple, 1941

114 CARDINAL Surre
 alism
 and
 the
 Parad
 igm
 of
 the

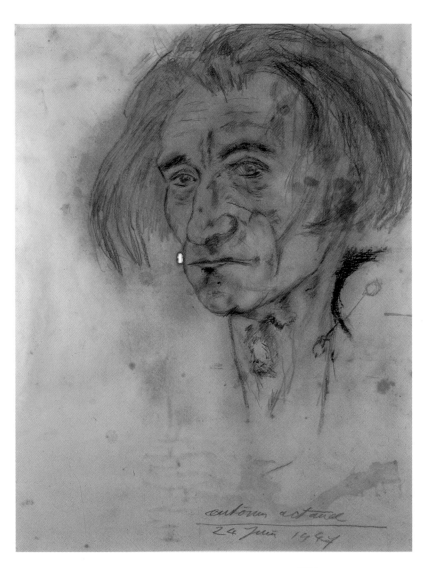

: 92 :
Antonin Artaud
Auto-portrait (Self-portrait), 1947

The foremost example of a surrealist who did far more than flirt with psychic imbalance is of course that of Artaud. The tragic extreme to which he gravitated in the war years, the climax of a case history of physical and mental disorders, was compounded by a series of clinical interventions, including electroshock therapy, which carried him to that point of total shipwreck whence the majority of surrealists understandably recoiled. Artaud's thoroughgoing descent into the murk of psychosis was without parallel in surrealism and, it may be thought, makes Breton's claim that *Les Champs magnétiques* was "a dangerous book" or Ernst's reference to the "vague and perilous territory" into which he might set foot or Dalí's slogan "the conquest of the irrational" sound emptily pretentious. The ravaged self-portraits that Artaud scrawled in the Rodez hospital as an accompaniment to his no less ravaged prose offer such a searing taste of the unsimulated "real thing" as to expose the limits of my discussion of the surrealist paradigm (FIGURE 92). Arguably, the sheer *viscerality* of Artaud's last expressive acts removes them from a surrealist context altogether. (The appropriate frame of reference might rather be expressionism, as perhaps Artaud's avowed affinity with Vincent van Gogh indicates.)

It would be idle to list every artist within surrealism or in its wider orbit whose work bears traces of mental disorientation or embodies qualities of the autistic, the entranced, the dreamlike, the fabulous, and so forth.[33] I have shown that the essence of the surrealist project had from the outset to do with inducing an unusual pitch of psychic self-absorption that conduces to unprogrammed creativity. Even today, to call a work "surrealist" ought strictly to imply that this long-consecrated ambition remains alive; although it is plain to see that a surrogate surrealism has been engineered by certain latter-day practitioners who, rather than confront the genuine "psychic elsewhere," simply marshal gimmicks and cues calculated to startle the viewer, thus aping without commitment, and most certainly without risk, certain alleged features of disturbed expression.

:

What I have sought to argue is that facile parallels between surrealism and the art of compulsive visionaries must be viewed with skepticism. To point to unequivocal influences in art is always a problematic gesture, and I am bound to voice a general recommendation to address relationships of contact and response in the more cautious terms of "affinity," "reflection," "resonance," or "echo." I believe it is simply wrongheaded to audit the surrealist accounts in search of quantifiable debts. What *really* matters here is how artists experience the incentive to create, or, more precisely, what state their minds are in as they cope with the impulse of primal expressivity. If such an impulse originates from outside, it is always, however illogically, experienced as a subjective fact. This is why I have stressed not formal plunderings but a congruity of mental postures; so that the paradigm of the creative subject in surrealism may be understood as having been postulated, corroborated, and refined across time by way of repeated consultations of the exemplar of the compulsive visionary, in a dialectic of reciprocal versions.

A more mundane difficulty is that key data are often simply lacking. Max Ernst, for instance, gives an exasperatingly elliptical account of his early contact with mental patients and their art. Did he, as has been postulated, visit the Prinzhorn Collection in Heidelberg circa 1920 or the 1921 exhibition of psychotic art held in Frankfurt? If he did, why did he not say so in his autobiographical notes? How was it that in the one-man shows held at the Galerie Surréaliste in 1926–27 the policy of provocative juxtaposition admitted tribal artifacts from Oceania or the northwest Pacific coast but nothing of psychotic or mediumistic provenance? Why was there no mention in *La Révolution surréaliste* of the celebrated demonstration of mediumistic painting that Lesage gave (FIGURE 93) in Paris in April–May 1927?[34] And why is there such a general lack of critical writing in surrealism regarding psychotic or mediumistic work?[35] Despite Breton's zeal in documenting his own career, in his books and in the radio interviews he gave in 1952, there are inexplicable gaps in the record. He never once refers to the schizophrenic box he owned for half his life, never enlarges on his visits to the *Palais idéal*, the Sainte-Anne hospital, or the Institut Métapsychique, never reminisces about his discovery of, say, the seashell faces of Maisonneuve.

It has been suggested that the reason the surrealists were so circumspect about the art of the mad is that they were at once captivated and jealous: for if it is true they saw it as surpassing their own art in intensity and inventiveness, they may have wanted to keep the "real thing" out of the public eye, while exploiting its lessons.[36] When Dalí insisted on distinguishing himself from the madman, might this not have implied segregation and a two-tier system of evaluation? Some might say that the surrealists' solidarity with the marginals of art was never strong enough to override a hankering for recognition within the very criteria of mainstream culture that at an earlier juncture surrealism had dismissed. On this view the psychotic reference would count as no more than a convenient red rag with which to bait the bourgeois, just another scandalous provocation. In 1928 Breton and Aragon announced the fiftieth anniversary of the invention of hysteria, thrilling to the paradox of the creativity of mental collapse and hailing this psychological aberration as a "great poetic discovery." I have no doubt that their model of defiant subjectivism has its validity within the specific context of art. And yet looking back at *La Révolution surréaliste*, we might now feel that this buoyant text sits ill beside photos of a young woman lifted from the archives of the Salpêtrière hospital, a woman whose ecstatic poses cannot really hide the sad fact that she is hallucinating, sitting on a bed in a locked ward, a lifelong prisoner

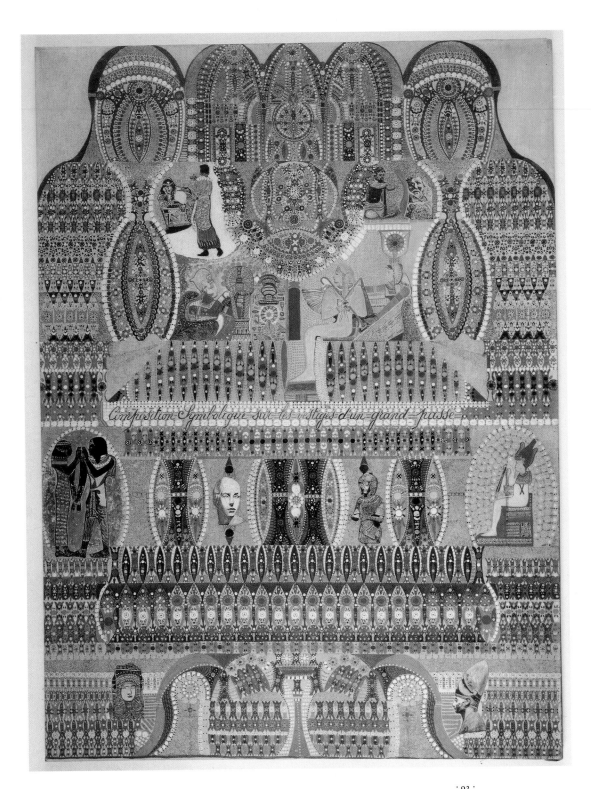

: 93 :
Augustin Lesage
Composition symbolique sur les vestiges d'un grand passé (Symbolic composition on the vestiges of a great past), c. 1937

of her delusions and of her guardians. We might similarly balk at a collage from *Une Semaine de bonté* (Seven days of kindness), 1934, where Ernst has snipped from a clinical textbook the image of a woman whose arched body enacts a symptomatic posture in *la grande hystérie*.[37] Such appropriations satisfied the surrealists' taste for convulsive beauty in their synthesis of the erotic and the bizarre; yet we might, on sober reflection, feel they give unwarranted priority to the aesthetic over the sympathetic. The way that surrealism steps into the psychic elsewhere yet tends to step back at any sign of entrapment could indeed be interpreted as a case of an adventure being acted out in purely figurative terms, within a charmed and protected circle.

I think it likely that despite their public profile as connoisseurs of scandal and excess the surrealists were in private as prone to embarrassment when confronting the actual facts of madness as is the average person. Faced with psychotic pictures, the surrealists could not be expected always coolly to separate the image in its own right from the mental and social circumstances of its fabrication. Arguably, surrealist aesthetics must in any event acknowledge the mental context. But what of the social one? With Breton, for example, one senses that his complicity with "the confidences of the mad" was often held in check. There is no evidence that when Nadja was interned in 1927 the surrealists made any more than a token effort to help her. Yet here was an obvious cue to launch a campaign on behalf of an artistically gifted mad person. For all their bold anticipations of latter-day antipsychiatry, typified by the 1925 open letter addressed under Artaud's editorship to the directors of lunatic asylums, informing them that "the mad are *par excellence* the individual victims of the dictatorship of society,"[38] and for all the irony of its being Artaud, rejected by the group in 1927 for lacking a social conscience, who reenters surrealist history two decades later as the archvictim of the psychiatric system, it remains the case that surrealism's practical record falls rather short of its avowed social and political ideals.

But one must beware of facile moralizing. And one must also ask whether these reservations, being ethical and social, are absolutely pertinent to the issue of why and how modern artists have pursued their interest in works so often emanating from unhappy mental states. Here indeed are issues confronting all visitors to this exhibition. I see no easy answers to the questions of whether the achievement of dazzling visual forms necessarily offsets suffering and how long aesthetic appreciation can legitimately retard the reflex of human sympathy.

=

Notes

All translations are by the author.

1
The surrealists' conception of the creative subject was also shaped in the light of other marginal arts, including child art, *art populaire*, and, above all, tribal art. Regarding this last, see Evan H. Maurer, "Dada and Surrealism," in William S. Rubin, ed., *"Primitivism" in Twentieth-Century Art: Affinity of the Tribal and the Modern*, 2 vols., exh. cat. (New York: Museum of Modern Art, 1984), 535–93. For a general appraisal of surrealism's versatile aesthetics, see my "Surrealist Beauty," *Forum for Modern Language Studies* 9, no. 4 (October 1974): 348–56; and Elizabeth Cowling, "An Other Culture," in Dawn Ades, *Dada and Surrealism Reviewed*, exh. cat. (London: Arts Council of Great Britain, 1978), 450–68.

2
Breton wryly cited the distinguished neurologist Dr. Joseph Babinski, under whom he served at the Centre Neurologique de la Pitié in Paris in 1917, as having predicted for him a glowing future in medicine. See André Breton, *Oeuvres complètes* (Paris: Gallimard, 1988), vol. 1, 673.

3
Ibid., 313.

4
Ibid., 24–25.

5
Quoted in Marguerite Bonnet, *André Breton: Naissance de l'aventure surréaliste* (Paris: Corti, 1975), 110. It is worth noting that the technical concept of autism, coined by Eugen Bleuler, was perfectly familiar to Breton; see his *Point du jour* (Paris: Gallimard, 1970), 91–92.

6
See Katia Samaltanos, *Apollinaire: Catalyst for Primitivism, Picabia, and Duchamp* (Ann Arbor, Michigan: UMI Research Press, 1984), 84–89, 207–8.

7
Regarding Breton's supposed debt to Janet, see Anna Balakian, *André Breton: Magus of Surrealism* (New York: Oxford University Press, 1971). For a discussion of his debt to the parapsychologist F. W. H. Myers, as well as to Freud, see Jean Starobinski, "Freud, Breton, Myers," *L'Arc*, no. 34 (1968): 87–96. An overview is offered in Bernard-Paul Robert, *Le Surréalisme désocculté* (Ottawa: Editions de l'Université d'Ottawa, 1975). See also Pierre Janet, *L'Automatisme psychologique* (Paris: Alcan, 1889); and Théodore Flournoy, *Des Indes à la planète Mars* (Geneva, 1900; reprint, Paris: Editions du Seuil, 1983).

8
La Révolution surréaliste, no. 1 (November 1, 1924): 27.

9
Breton, *Oeuvres complètes*, vol. 1, 313.

10
Ibid., 848.

11
It is notable that Smith was the only real-life (as opposed to fictional) heroine to be honored with a role in the card pack the surrealists devised in Marseille in 1940.

12
It should be mentioned that Breton had an idiosyncratic view of Cheval as "the uncontested master of mediumistic architecture and sculpture," *Point du jour*, 176.

13
The box was shown at the following exhibitions: *Fantastic Art, Dada and Surrealism*, 1936, New York; *Dada and Surrealism Reviewed*, 1978, London; *L'Aventure surréaliste autour d'André Breton*, 1986, Paris; and *André Breton*, 1991, Paris.

14
André Breton, *Le Surréalisme et la peinture* (Paris: Gallimard, 1965), 316. The draft contents page of the almanac shows the intention to print Breton's text beside an extract from the (at the time) untranslated monograph on Wölfli by Walter Morgenthaler.

15
André Breton, *Perspective cavalière* (Paris: Gallimard, 1970), 242. José Pierre pointedly asks, If Wölfli is one of three or four, who are the others? Picasso? Kandinsky? De Chirico? See his *André Breton et la peinture* (Lausanne: L'Age d'Homme, 1987), 253.

16
That Eluard was careless about listing anonymous outsider drawings may explain why the inventory of his private collection drawn up by Jean-Charles Gateau should cite only three wood carvings by the mental patient Auguste Forestier and a single Scottie Wilson drawing. See Jean-Charles Gateau, *Eluard, Picasso et la peinture* (Geneva: Droz, 1983), 339–45.

17
See my article "André Breton: Wahnsinn und Poesie," in *Psychoanalytische und psychopathologische Literaturinterpretation*, ed. B. Urban and W. Kudszus (Darmstadt: Wissenschaft-liche Buchgesellschaft, 1981), 300–320.

18
See Michel Thévoz, *Art brut: Psychose et mediumnité* (Paris: La Différence, 1990), 112.

19
Max Ernst, *Ecritures* (Paris: Gallimard, 1970), 20.

20
See Werner Spies, *Max Ernst, Collagen: Inventar und Widerspruch*, exh. cat. (Cologne: DuMont, 1988), 244.

21
Paul Eluard, *Lettres à Joë Bousquet* (Paris: Les Editeurs Français Réunis, 1973), 29. Prior to the very late publication of Prinzhorn's book in French in 1984, the sole extract available to the surrealists was an extract about August Natterer that Meret Oppenheim translated for their magazine *Médium*, n.s., no. 4 (January 1955): 27–30.

22
See John M. MacGregor, *The Discovery of the Art of the Insane* (Princeton: Princeton University Press, 1989), 281.

23
Breton, *Oeuvres complètes*, vol. 1, 278.

24
Ernst, *Ecritures*, 426.

25
See Werner Spies, "Getting Rid of Oedipus," in *Focus on Art* (New York: Rizzoli, 1982), 96–103; Stefanie Poley, "' . . . und nicht mehr lassen mich diese Dinge los.' Prinzhorns Buch *Bildnerei der Geisteskranken* und seine Wirkung in der modernen Kunst," in *Die Prinzhorn-Sammlung: Bilder, Skulpturen, Texte aus Psychiatrischen Anstalten (ca. 1890–1920)*, exh. cat. (Königstein/Taunus: Athenäum, 1980), 55–69; and Stephen Prokopoff, "The Prinzhorn Collection and Modern Art," in *The Prinzhorn Collection: Selected Work from the Prinzhorn Collection of the Art of the Mentally Ill*, exh. cat. (Champaign, Illinois: Krannert Art Museum, University of Illinois, 1984), 15–20. Collages in the Prinzhorn Collection by psychotics Schneller and Max Junge, of course, predate those of Ernst.

26
Adrien Dax, "Perspective automatique," in *Almanach surréaliste du demi-siècle*, special issue of *La Nef*, nos. 63/64 (March 1950): 82–89. Of Lesage, Christian Delacampagne has argued that he was in fact a poor model for surrealism, being altogether too conscientious an artisan to qualify as a true trance-painter. He also suggests he was too cultured to qualify for Dubuffet's art brut collection! See Christian Delacampagne, *Outsiders, fous, naïfs et voyants dans la peinture moderne* (Paris: Mengès, 1989), 57, 68. The one direct echo of Lesage's mosaic style in surrealism seems to be the painting of Yves Laloy.

27
Breton, *Point du jour*, 171.

28
Breton, *Le Surréalisme et la peinture*, 70.

29
MacGregor, *The Discovery of the Art of the Insane*, 288.

30
Schizophrenic creativity frequently mobilizes both these impulses. See my "Image and Word in Schizophrenic Creation," in *Literature and the Plastic Arts 1880–1930*, ed. I. Higgins (Edinburgh: Scottish Academic Press, 1973), 103–20.

31
See my article "The Art of Entrancement: European Mediumistic Art in the Outsider Domain," *Raw Vision*, no. 2 (Winter 1989–90): 22–31. I might add the further analogy with the ink drawings of the early 1950s done by the CoBrA artist Carl-Henning Pedersen.

32
Stefanie Poley points out a possible Brauner source in a 1909 drawing by the medium Madame A. entitled "Girl Surprised at the Sight of the Marvels of the World Beyond" and showing a face in profile with a swirling outgrowth curving away from the head. (See *Die Prinzhorn-Sammlung*, 69 n. 8.) A similar serpentine outgrowth occurs on female heads in several of Brauner's paintings, such as the 1937 *Homage to Penrose*. Of Brauner's early picture *L'Etrange Cas de Monsieur K.* (The strange case of Monsieur K.), it might be said that the regimented repetition of the selfsame plump figure has the compulsiveness, as well as the drollery, of drawings by the schizophrenic Gustav Sievers.

33
Of many possible names, let me simply mention that of Leonora Carrington, who relates her mental breakdown in "Down Below," *VVV*, no. 4 (February 1944): 70–86. However, unlike that of Unica Zürn, Carrington's art, albeit highly fantastical and whimsical, bears few psychopathological traits, to the point that it emerges more as a demonstration of how a delusional episode can leave intact the normal style of an established artist.

34
A succinct answer to this query might be that the surrealists were, at this historical juncture, distracted by burning political issues.

35
The surrealist José Pierre roundly compensates for this reticence in his richly illustrated "Raphaël Lonné et le retour des médiums," *L'Oeil*, no. 216 (December 1972): 30–43. Pierre has also written on naive art and art brut.

36
See MacGregor, *The Discovery of the Art of the Insane*, 290.

37
I owe this point to Sarane Alexandrian (*Le Surréalisme et le rêve* [Paris: Gallimard, 1974], 62), who refers to a separate collage using the same clipping. To compare the two, see Spies, *Max Ernst, Collagen*, figs. 332, 452.

38
Printed in Antonin Artaud, *Oeuvres complètes* (Paris: Gallimard, 1956–86), vol. 1, 266–67, the open letter was unsigned and may well be the collaborative effort of Théodore Fraenkel and Robert Desnos (see Pierre, *André Breton et la peinture*, 114).

From the Asylum to the Museum:

Marginal Art in Paris and New York, 1938–68

SARAH WILSON

From
the
Asylu
m to
the
Museu
m:
Margi
nal
Art
in
Paris
and
New
York,

There is no madness except as the final instant of the work of art—the work endlessly drives madness to its limits; *where there is a work of art, there is no madness*; and yet madness is contemporary with the work of art, since it inaugurates the time of its truth.
Michel Foucault [1]

The evolution of European modernism in tandem with a growing interest in and knowledge of "primitive" arts and their societies, children's art, and psychotic, or more broadly "outsider," art was a situation paralleled by developments in psychiatry, anthropology, philosophy, and the course of political history. In the post-1945 period of European art the living tissue of these relationships remains to be dissected, despite recent monographs, studies of stylistic movements, and broad historical surveys. Moreover Europe in the 1940s witnessed the coming together of artists who had a violent message for society, forced as they were to confront the trauma of 1939–45 and its aftermath, especially severe in cities that had suffered Nazi occupation, such as Paris, Amsterdam, and Copenhagen. A sense of rupture with the past was inevitable. Was it merely a coincidence that at the same time these artists were creating a distinctive postwar language for European art, psychotic art became both visible and inspirational as a vehicle of inchoate, passionate expression?

This essay[2] charts the shift of outsider art in France from the asylum to the museum, from the institutional to the private and thence to the public realm. In 1967 the major exhibition at the Musée des Arts Décoratifs of Jean Dubuffet's collection of *art brut* coincided with the growth of "anti-psychiatry" and the impact beyond France of Michel Foucault's study of madness, *Folie et déraison: Histoire de la folie à l'âge classique* (see NOTE 1). Foucault shifted attention from the patient to a diagnosis of the anxieties of society and the resulting ideologies enshrined in its institutions, of which Sainte-Anne Hospital, in Paris, a center for the study of psychotic art since before World War II, and my point of departure, is but one eloquent example.

The Sainte-Anne Hospital
and Its Exhibitions,
Physicians, and "Parasites"

The Sainte-Anne Hospital, a bastion of psychiatric study and experiment, became a focus for the exhibition and the understanding of outsider art in postwar Paris. This art was still known and exhibited as *l'art des fous* (the art of the insane) when artists began to explore the boundaries and implications that such an epithet suggested. Dr. Gaston Ferdière (1907–90) was a key figure and mediator between the worlds of high art and psychiatry since the late 1930s.[3] An intern at the Sainte-Anne Asylum[4] in Paris in 1934, he provided a link in the postwar period with the pioneers of twentieth-century psychiatry in France. He knew Jean Vinchon, author of *L'Art et la folie* (Art and madness), 1924, Jacques Lacan, who preceded him on an internship at Sainte-Anne, and Princess Marie Bonaparte, the translator of Sigmund Freud.[5] Moreover Ferdière was one of the first practicing French psychiatrists to understand the text of Hans Prinzhorn's seminal *Bildnerei der Geisteskranken* (Artistry of the mentally ill), 1922, thanks to his colleague Ernst Jolowicz, an émigré Viennese psychoanalyst who had his own collection of psychotic art.[6] Dr. Henri Ey, one of the great figures at Sainte-Anne, most probably possessed his own copy and read German perfectly.[7]

The doctors at Sainte-Anne encouraged artistic expression among the inmates, including the making of murals: a complicated allegorical narrative in honor of Voltaire, with figures in eighteenth-century dress, graced Professor Dumas's lecture theater, for example. Ferdière, in his memoirs, recalled that upon his arrival the walls of the *salle de garde*, the internees' common room and dining space, were covered with execrable erotic paintings and charcoal drawings by former patients. It was, however, a young artist, Frédéric Delanglade, and not a patient, whom he asked to paint a mural to cover up these expressions, some time around 1935. The result, rich in Freudian symbolism, was admired by André Breton as one of the high moments of surrealist painting.[8]

The surrealists were no strangers to Sainte-Anne. There were several curious practices at the hospital that constituted what Ferdière called the "great asylum tradition." One was the custom of keeping "parasites" in the salle de garde, where social life was unrestricted. Parasites included the odd doctor but generally designated painters and poets. These could be permanent hangers-on who depended upon the free or relatively cheap meals, sporadic visitors such as Alberto Giacometti (between about 1933 and 1935), or more esteemed guests: Breton and Marcel Duchamp came together to lunch with Ferdière in 1936 or 1937. When Ferdière became prominent enough to give lectures, the surrealists flocked to his courses in clinical psychiatry. Ferdière in turn frequented the surrealist meetings at the Cyrano, Place Blanche, or Deux Magots cafés. His collection of tiny dolls and fetish objects made by patients were scattered in the darkness at the feet of the famous mannequins in the principal room of the International Exhibition of Surrealism at the Galerie des Beaux-Arts in 1938, where recorded manic laughter was used as an accompaniment to Hélène Vanel's gyrations, *L'Acte manqué* (The unconsummated act), danced upon brushwood in the "hysterical bedroom" at the opening.

By 1938 Ferdière was becoming increasingly interested in the parallels between his discipline and the problems and methods of inquiry in ethnology and ethnography. He frequented the meetings at the Sorbonne of Georges Bataille's Collège de Sociologie, along with Michel Leiris, Roger Caillois, and the psychoanalyst Dr. René Allendy. With Dr. Jacques Vié, Ferdière elaborated the idea of a "museum-laboratory" for psychotic art and the study of "the civilization of the asylum"; the resulting corpus of material would be accessible to "psychiatrists and psychopathologists, ethnologists and prehistorians, structuralists, sociologists, folklore specialists, artists or critics."[9] Any enterprise of this nature was, of course, halted by the war. Ferdière would ultimately move from his job at Chezal-Benoit, in the prefecture of the Seine, south of Paris, to take charge of the psychiatric hospital at Rodez, in the south of France, by July 1941.[10]

122 WILSON From
the
Asylu
m to
the
Museu
m

Curiously never had the links between psychiatric institutions and "sane" artists been so close. The exodus from Paris—the tragic and panic-stricken flight from the north to southern France, unoccupied by the Germans—saw the emptying not only of homes and businesses but of hospitals; the mentally sick on the roads were especially vulnerable. There were literally thousands of deaths during the exodus, and subsequently, due to malnutrition.[11] The many fatalities meant empty hospital beds, while the movement of family and friends, of refugees, of resistance members, and in particular of intellectuals depended upon "safe houses." Thus the hospitals became part of the resistance network, thanks to sympathetic doctors and psychiatrists throughout the southerly unoccupied zone.

Rodez: Ferdière, Pujolle, Artaud

It was while at Rodez that Dr. Ferdière organized the first exhibition of psychotic art to be held in a museum. The accolade for this historic occasion goes to the Musée Denys Puech, which showed about fifty pieces—Ferdière's complete personal collection—some time in 1945.[12]

The numerous studies of Ferdière's most famous patient, Antonin Artaud (1896–1949), who began a tumultuous phase of writing and drawing under supervision at Rodez (FIGURE 94), fail to mention that the psychotic artist Guillaume Pujolle was also working there at this time. He was transferred from the Baraqueville Hospital near Toulouse specifically for the benefit of Ferdière's assistant Jean Dequeker, who was writing a thesis on Pujolle.[13] Thus Rodez could be considered to have been an annex of Sainte-Anne during the war from both scholarly and psychiatric points of view.

: 94 :
Dr. Gaston Ferdière with Antonin Artaud prior to Artaud's departure from Rodez Psychiatric Hospital, 1946

War, of course, engenders extreme situations and expressions. "The whole era was mad, whatever madness means," said Ferdière.[14]

Artaud was interned at Sainte-Anne in April 1938 and transferred to Ville-Evrard in February 1939, where he remained in an increasingly appalling state until January 1943, at which time the possibility of his death through malnutrition moved Ferdière to respond to Robert Desnos's entreaty and receive Artaud at Rodez. Acute schizophrenia was the diagnosis. Artaud was accorded extraordinary privileges: his own room, a personal library, a nutritious diet, and many visitors. Ferdière attempted to stimulate his writing, asking for assistance with the translation of passages from Lewis Carroll's *Through the Looking-Glass*, for example.[15] At this time Artaud began writing *Au Pays des Tarahumaras* (In the land of the Tarahumaras), which described his experiences in Mexico before the war.[16] The extraordinary spectacle of ritual human sacrifices that he had witnessed and the Tarahumara chants, which Artaud transcribed with a combination of phonetic imitation and glossolalia, marked his subsequent work with painful intensity. Concurrently at Rodez, Artaud endured sessions of electroshock therapy, which Ferdière administered in good faith as a very recent and effective treatment for desperate cases. Certainly Artaud suffered both physically and psychologically from the pain itself and traumatic aftereffects, which included terrifying periods of amnesia: "I died at Rodez," he would claim.[17]

In his writing extreme violence was perpetrated upon language itself just as violence had been inflicted on his own screaming body.

o penis ta penis

atura

o petura a petur peni

ta ksartam

ta kharon[18]

Artaud's "spells," imprecations scrawled with magic signs, written upon fragments of paper burned with cigarette ends, had been posted to Parisian friends and enemies as early as September 1937 (at the time of his notorious Irish escapade; see the brief biography of Artaud on PAGE 24 of this volume). Several had been sent from the Ville-Evrard Hospital in 1938. Marginalia now appeared from June 1945 onward in his famous exercise books, the *Cahiers de Rodez*. Geometric forms evolved into sadistic conglomerations of bones and body parts, nails, gibbets, and coffins that were to some extent manifestations of the physical and mental dislocation of the electroshock experiences. There were more positive forms of encouragement however. Delanglade, the "parasite" from Sainte-Anne, reappeared and set up a studio in the Rodez Hospital.[19] Delanglade invited him into his atelier, and Artaud began a portrait in charcoal. Excoriating self-portraits, made without a mirror, followed.[20] Dequeker, Ferdière's intern, declared, "I saw him create his double, as though in a crucible, at the price of nameless torture and cruelty. He worked with rage, broke crayon after crayon, enduring the throes of his own exorcism. . . . I have seen him blindly put out the eyes of his own image."[21]

There were no stylistic affinities in his work, of course, with either Pujolle, a talented psychotic artist, or the equipped "professional" Delanglade. Upon his return to Paris in 1946 Artaud soon became the focus for what one could call a "parallel visions" debate; that is, his undoubted stature as a major French writer was contrasted with his severe psychiatric symptoms (complicated by opium addiction) and his "untutored" graphic skills, demonstrated originally within an institutionalized context.

124 WILSON From
 the
 Asylu
 m to
 the
 Museu
 m

Sainte-Anne:
The 1946
Exhibition

A new Sainte-Anne mural (FIGURE 95), replacing the one destroyed by the Nazis, was designed by several surrealists including Delanglade, Oscar Dominguez, Jacques Hérold, Marcel Jean, Maurice Henry, Luis Fernandez, Lobo, and Manuel, with contributions by Dora Maar and Ferdière and "executed by Yvette Thomas," so the poster proclaimed (FIGURE 96). The mural was officially revealed to a select public in December 1945.

Psychotic art became a phenomenon widely known and discussed in Paris when a major exhibition organized by the Sainte-Anne Hospital opened in April 1946, creating a furor in both the artistic and popular press. The list of thirty-six works sent from Rodez to Sainte-Anne demonstrates Ferdière's links with other collectors and institutions at this time, in particular Dr. Lucien Bonnafé at the nearby hospital in Saint-Alban-sur-Limagnole, Lozère. Bonnafé and his colleagues had a gifted artist-patient in their charge, Auguste Forestier. His toylike, carved wooden soldiers and sea monsters would have been seen by the poet Paul Eluard and the painter Joan Miró on their recorded wartime visits.[22]

The literary and artistic circle around Eluard would certainly have been attracted to the 1946 Sainte-Anne exhibition. The show was a deliberate riposte to the suppression of "degenerate art" by the Nazis, whose campaign against modernism in Germany had continued as a policy under Marshal Philippe Pétain and with the collusion of Parisian officialdom. During the occupation the non-French

: 95 :
Surrealist mural at the Sainte-Anne
Psychiatric Hospital, Paris, 1945

element of the School of Paris was successfully forced into exile, deported, or even killed. Not untypical, alas, were the sentiments expressed by the notorious right-wing critic Camille Mauclair in *La Crise de l'art moderne* (The crisis in modern art), 1944. This violently anti-Semitic publication imitated the rubrics of the 1937 *Entartete Kunst* (Degenerate art) exhibition in Munich. Mauclair captioned works by Pablo Picasso and Marc Chagall "UN TALENT FOU!" (Crazy talent!) and juxtaposed a Georges Braque painting with a work labeled "Un Fou de l'asile Villejuif" (Madman from the Villejuif Asylum; FIGURE 97). It was none other than the first of two illustrations copied from Prinzhorn's book *Bildnerei der Geisteskranken* by a Sainte-Anne patient at Dr. Ey's request to hang in the hospital library. Ironically these served as the sole images in the 1946 exhibition catalogue; their origin in Prinzhorn's work was never mentioned.

Comprising more than two hundred works, the Sainte-Anne exhibition was quite varied in content. In his preface Waldemar George asked, "Genius and folly! Who will establish a parallel between these works of the insane and the sublime divagations of great artists? . . . It is thus wrong to affirm, as M. Camille Mauclair has done, that the masters of modern painting are the inspiration for psychiatric hospital inmates. Psychosis is no antidote to mediocrity, banality, and academicism!"[23] Waldemar George distinguished between works that imitated current modern styles, works he called "the last vestiges of a balanced existence," and the obsessive, nightmarish visions of other patients. With its tricolors, police officials, and champagne cocktails, the opening of the show was a resounding success—a talking point for both the intelligentsia and the public at large.[24]

: 96 :
Poster announcing the inauguration of the new surrealist mural at the Sainte-Anne Psychiatric Hospital, Paris, 1945

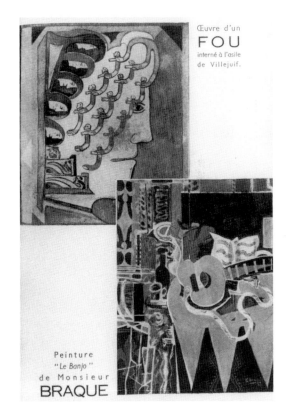

: 97 :
Illustration from Camille Mauclair's book *La Crise de l'art moderne* (The crisis in modern art), 1944, which juxtaposes a work by Georges Braque and one by a psychotic

125

The International
Exhibition of
Psychopathological Art, 1950

Of international importance, completely eclipsing in scale Dubuffet's 1949 gallery show *L'Art brut préféré aux arts culturels* (Art brut preferred to cultural arts), was the International Exhibition of Psychopathological Art in 1950. Planned as early as November 1948, it was held at Sainte-Anne from September 21 to October 14, 1950, in conjunction with the first International Congress of Psychiatry.[25]

Filling six large rooms of a transformed storage space, this was more than ten times bigger than the first exhibition of 1946. More than two thousand works from forty-five collections and seventeen countries were exhibited in geographical sections and attracted approximately ten thousand visitors in less than a month. Vinchon's *L'Art et la folie*, 1924, was reedited for the occasion; among exhibits from his collection were mandalas produced under "psychotherapy"—a practice with which he was now actively engaged.[26] Surprisingly Ferdière's collection was not included in the French section (he disapproved of the laxity of the show),[27] nor was Dubuffet asked to lend from his extensive private collection.[28]

The 1946 catalogue had already distinguished between the productions of inmates trained as artists, amateur Sunday painters, and psychotic productions. There was a similar contrast in the 1950 show. The critic Waldemar George, who also declared the existence of fakes on exhibit, nevertheless stated,

Many sections contain works of quality that reveal not only a vision of hallucinatory power whose intensity cannot be denied but also a remarkable mastery of line and color. The parallels between the works of patients and the art of twentieth-century painters—expressionists, surrealists, and certain pure abstract painters—is established beyond doubt.[29]

The popularity of the 1950 exhibition presented its own problems. Waldemar George condemned the vulgarization of the notion of the "pathological" by the media:

Radio, cinema, and illustrated journals are creating a climate of scandal around these exhibitions that their organizers seem to have no wish to disavow. . . . The visitors who today jostle each other in the rooms of Parisian asylums, turned into exhibition halls, are the same who once went to see a famous criminal executed or who queued to see monsters at the fair.[30]

Despite the perennial problem of vulgar curiosity—even voyeurism—the Sainte-Anne Hospital, its traditions, its research and practice, and above all its exhibitions with their large, popular audiences created a climate of receptivity to outsider art in postwar Paris and, in consequence, to new directions in the art of a Dubuffet or a Karel Appel. Indeed when Robert Volmat's extensive study of the 1950 Paris exhibition was published in 1956, a chapter was devoted to the position of modern art with regard to "insane" productions.

Dr. Ferdière continued to be involved with artists to the end of his life. He engaged, for example, in a famous polemic with the lettrist poet and artist Isidore Isou, which brought up again the ethics of electroshock in the Artaud case, and was asked to intervene in the tragic case of the brilliant but mentally unstable artist Bernard Réquichot.[31]

Postwar Paris:
Existentialism and the
Debate on
Art and Madness

The 1946 Sainte-Anne exhibition immediately gave rise to the question of whether psychotic art—works produced as a result of physical and mental pain and isolation—ought to be allowed to become spectacle. Such a question had relevance beyond the confines of the asylum, in the works of artists of the stature of Vincent van Gogh or Artaud, both of whom created in situations of extreme suffering.

Jean-Paul Sartre's *L'Etre et le néant* (Being and nothingness) was published in 1943. Existentialism, with its focus on the absurdity of individual existence versus the imperatives of moral choice, soon became far more than the total of Sartre's writings, which included novels, popular plays, and topical journalism besides philosophy. The vogue extended to a whole new youth movement. Sartre himself was widely informed about art and attacked surrealism viciously in 1947; the artists whose work most closely mirrored Sartre's own "existentialist aesthetic" were Alberto Giacometti and Wols.[32] Giacometti's emaciated figures (exhibited with a preface by Sartre at Pierre Matisse's Gallery in New York, 1948) are easily read as paradigms of man in extremis—and more topically as "the martyrs of Buchenwald," in Sartre's words.

Wols, the German émigré artist, abandoned figuration for an organic "inner" abstraction. He had no experience of painting in oils before 1947: almost like those of an untrained artist, his paint tricklings and surface scratches seemed wild and haphazard. They appeared to relate directly to the wounded and bleeding body, the vision behind tortured eyelids. In this world private experience is emblematic of the state of humanity—microcosm equates with macrocosm. A top-heavy, mushrooming form analogous to atomic explosion became a leitmotif. His marginal lifestyle ended abruptly in 1951: Wols's tragic, semisuicidal death at the age of thirty-eight cut short a highly influential career. Considered by Sartre to be the "existentialist" painter "par excellence,"[33] Wols was classed by artist and critic Michel Tapié as a precursor, along with Dubuffet and Jean Fautrier, of an aesthetic baptized in Tapié's book *Un Art autre* (An other [different] art), 1952. Dubuffet, Fautrier, Wols,

and the painter-poet Henri Michaux (whose "alphabets" and splotches of ink can be related to the craze for Rorschach tests in Paris at the time[34]) were precursors, in their "otherness," for a new generation of painters, artists such as the flamboyantly gestural Georges Mathieu or Camille Bryen, originator of *peintures-cris* (scream paintings), who would scream as he attacked the canvas.

The existential aspect of mark making or using the expressive capacities of the body as an artistic medium itself was demonstrated by the revelation of Artaud's work to the Parisian artistic and literary elite. The "genius versus madness" debate was rekindled by the great van Gogh retrospective at the Orangeries de Tuileries from January until March 1947. The issues surfaced again with the major William Blake exhibition in June.[35] A typically "psychiatric" article on van Gogh by a Dr. Joachim Beer in the weekly *Arts*, describing the artist as a "degenerate of the Magnan [sic] type," provoked Artaud's magnificent response "Van Gogh le suicidé de la societé" (Van Gogh the man suicided by society).[36] Of the *Self-portrait with a Soft Hat* Artaud wrote, "I don't know a single psychiatrist who could scrutinize the face of a man with such tremendous force and dissect . . . its irrefutable psychology." Subsequently, in the preface to the exhibition of his own remarkable crayon portraits (see FIGURES 2 and 92) at the Galerie Pierre in June, Artaud wrote:

The human face is an empty force, a field of death. . . . Only van Gogh knew how to draw from a human head a portrait that would be the explosive smoke from the beating of a bursting heart. . . . I have definitely broken with art, style, or talent in the drawings displayed here . . . cursed be he who considers them works of art, works of the aesthetic simulation of reality. None is properly speaking a work. They are all sketches or should I say staggering blows given in all the directions of chance, possibility, hazard, or destiny.

The paradox of Artaud's portraits is that to some extent a purely private expression had turned into the creation of works involving sitters, display, market value, and above all a public that was implicitly asked to participate in the existential condition of the artist. Artaud's radio broadcast, planned for February 1948 but prohibited (however, subsequently pirated), entitled "Pour en finir avec le jugement de Dieu" (An end to God's judgment, once and for all), and his subsequent appearance at the Vieux-Colombier theater in September presented to the public almost intolerable sights and sounds of human anguish.[37]

Both the "breaking" of language and the breaking up of the image into "taches" or free-floating signs became fashionable styles in the 1950s and after, just as existential angst became all too rapidly a postwar cliché. The experimental arena would be penetrated with the neodada activities of Isou and the lettrist movement—notably the recorded cries and gaspings of François Dufrêne.[38] For a short period, however, the reversion to "origins," the material and emotional constituents of expression, offered not only "parallel visions" with productions by "untrained" outsiders, works concurrently visible in Paris, but also a means of expressing shared concerns and practices.

Dubuffet, Breton, and Art Brut

Dubuffet had acquired a copy of Prinzhorn's book shortly after its publication, thanks to his Swiss friend Paul Budry.[39] Thus one may suppose that besides his familiarity with the dada and surrealist movements, Picasso's use of "poor" materials in the 1930s, and so forth, he may already have visited Dr. Auguste Marie's "Mad Museum" and perhaps was familiar with the psychotic art studies by Marcel Réja and Vinchon. During his military service in 1923 he worked for a meteorological office at the top of the Eiffel Tower and encountered the art of one "Clementine R.," who sent in fantastic drawings of clouds in response to a survey. His interest in collecting such art, along with children's drawings and outsider embroideries, had started before the war.[40]

Dubuffet's third and final attempt to be an artist coincided with the defeat of France. His work now responded to new sources: the discovery of the Lascaux cave paintings in September 1940, the burgeoning of graffiti on the walls of Paris (photographed by Brassaï from the late 1930s), a topical Romanesque influence, and wartime exhibitions of children's art— often to honor Marshal Pétain—which were viciously parodied in several Dubuffet paintings of 1943–44 such as *View of Paris, Life of Pleasure*.[41]

Dubuffet began to theorize; in lecture notes of January 1945, while working on the *Matière et mémoire* (Matter and memory) lithograph series, he pilloried the whole post-Renaissance achievement, including Henri Matisse, Georges Rouault, Picasso, van Gogh, and Henri Rousseau. Their medium was the message; all that smacked of the "French Tradition"—*belle peinture*, its conditions of production and exhibition, and its audience—was condemned. Instead Dubuffet's almost "anthropological" gaze turned in upon itself. His subject would become a reflection upon matter and memory. The reference to Bergson and his notion of *la durée* (duration), central to Dubuffet's *Matière et mémoire* series, soon mingled with Gaston Bachelard's more recent reflections upon *la pâte*, the "paste" of primal matter. This was infused in turn with topical Sartrean and Nietzschean notions involving the

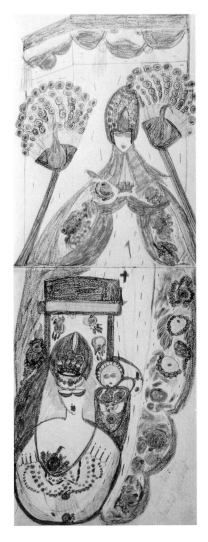

: 98 :
Aloïse (Aloïse Corbaz)
Facing pages from the sketchbook
Peinture et musique (Painting and
music), 1941

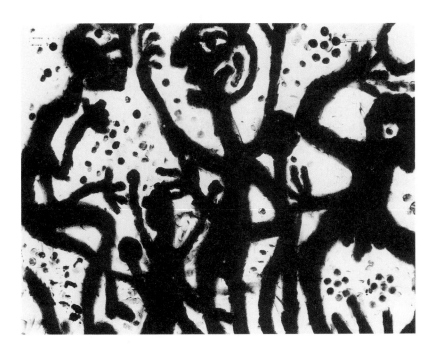

: 99 :
Louis Soutter
Six personnages gesticulant
(Six personages gesticulating),
c. 1937–42

gaze and the will to power. Perhaps Dubuffet's most shocking *haute pâte* of 1946 was the obviously sexed, nude male figure actually called *Volonté de puissance* (Will to power).[42] Despite these highly intellectual ingredients (one could also mention the impact of Maurice Merleau-Ponty's *Phénoménologie de la perception* [Phenomenology of perception], 1945) Dubuffet's rough *matière*—oil paint mixed with anthracite dust, studded with pebbles, straw, or bits of broken mirror—in itself was considered shockingly brutal.

During this breakthrough period Dubuffet continued his investigations into psychotic art. He visited Rodez at the end of the war both to see Artaud and to procure many addresses from Ferdière: the psychiatric hospitals at Saint-Alban, Mont-de-Vergues near Avignon, one near Aix, and La Charité-sur-Loire. He was also given the address of Dr. Charles Ladame in Geneva.[43] Dubuffet traveled with the Gallimard editor Jean Paulhan to Switzerland later in 1945 and discovered Adolf Wölfli (see FIGURE 235), the Prisoner of Basel, and Aloïse (FIGURE 98), among others. As early as November 1945 Dubuffet was writing to Professor Jakob Wyrsch at the Waldau Psychiatric Hospital in Bern with news of Gallimard's plan to publish a series on works that he had already baptized "art brut."[44] This nomenclature not only had the connotations of "art in the raw" (later corresponding to Claude Lévi-Strauss's "raw" versus "cooked" dichotomy) but, especially in the light of Dubuffet's wine-merchant background, art with the superior fizz of the best champagne. The first art brut fascicle was to be mainly concerned with Louis Soutter, Le Corbusier's Swiss relative who was, according to Dubuffet, not at all mad, but "exalted" (FIGURE 99).

It was in the wake of the 1946 Sainte-Anne exhibition and the excitement it generated that Dubuffet then submitted a plan for sixteen art brut publications to Gallimard in October 1946. The first of these, printed in October 1947, was devoted to *Les Barbus Muller* (Muller's bearded men) and other pieces of provincial statuary.[45] A second cahier was

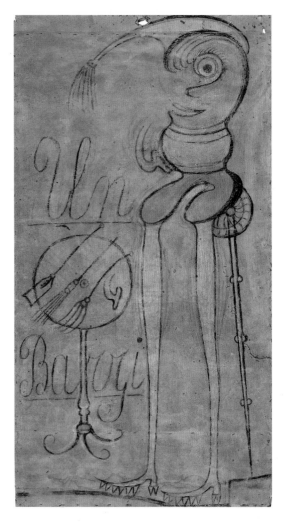

: 100 :

Heinrich Anton Müller

Un Barry

: 101 :

Gaston Chaissac

Bouffon (Clown), 1958

: 102 :

Jean Dubuffet

Le Dandy (The dandy), 1973

announced on the heroic precursor Adolf Wölfli, the first psychotic to be named and written about as an artist (by Dr. Walter Morgenthaler, as early as 1921).

Concurrently Dubuffet developed theories of "peoples' creativity" and an art open to all, to the *homme du commun*, or common man. His use of earth-based materials, of debris, becomes a metaphor for a gaze beneath the skin of this common man to the organic and mineral substances that may be said to condition the psychopathology of everyday life.

The philosophical breadth and topicality of Dubuffet's work, together with the intransigent matter itself—"shit" painting, "cacaism" following dadaism, as a critic put it in 1947—definitively distinguishes it from art brut productions. There are many parallels however: the harshness of the graffito, the sexual obsessions, and the conceptualized, perspectiveless space.

Heinrich Anton Müller's profiles (FIGURE 100 and see FIGURE 137) have rightly been claimed as a source for Dubuffet's *personnages* (personages), as in, for example, *L'Homme à la rose* (Man with a rose), 1949. Georges Limbour quoted the artist as saying in 1948, "All I want is to do things as well as Heinrich Anton [Müller] or Jeanne [Tripier] the medium."[46] It was surely with Dubuffet's knowledge, even approval, that his work was assimilated with art brut by his closest friends as well as by ignorant critics, for Limbour's 1953 monograph published by the Pierre Matisse Gallery is called *L'Art brut de Jean Dubuffet: Tableau bon levain, à vous de cuire la pâte* (The art brut of Jean Dubuffet: good dough pictures for you to bake).[47]

The first postwar Exposition Internationale du Surréalisme, held at the Galerie Maeght in July 1947, was yet another forum that claimed psychotic art as its own. Here, juxtaposed with surrealist paintings and sculptures from all over the world, including America, were objects from Ferdière's collection, together with works by Breton's recent discovery, the voodoo painter from Haiti, Hector Hyppolite.[48]

In November 1947 the surrealist leader Breton was one of those invited to participate in Dubuffet's *Foyer de l'art brut*, in the basement exhibition space of the Galerie René Drouin, along with Tapié, Charles Ratton, the distinguished collector of ethnic art, Henri-Pierre Roché, a writer and friend of Duchamp and Wols, and Paulhan, who represented the Editions Gallimard.

Dubuffet's relationship with Breton was warm at this time. In May 1948 Dubuffet was writing to Breton, welcoming him to the art brut confraternity, thanking him for information on Pascal-Désir Maisonneuve's seashell masks, introducing him to the works of Gaston Chaissac, and suggesting an excursion to the flea market of Saint-Ouen together. At Dubuffet's request Breton agreed to write on Hyppolite and Joseph Crépin (whose works he collected) and the important text "L'Art des fous, la clef des champs" (The art of the mad, the key to liberty) for an art brut almanac that was never realized. Breton here compared art brut with the thought of primitive peoples and children and underlined its authenticity of inspiration.[49]

A link not with children's art but with naive art and what was known as "proletarian literature"— the "spontaneous" writings of humble people whose daily life was led in factory, mine, or post office—was made with an important exhibition at the Galerie Portes-de-France in March 1948 called *Art brut, naïvisme et littérature populaire* (Art brut, naive art and popular literature).[50] Then came Dubuffet's landmark show at the Galerie René Drouin in 1949, *L'Art brut préféré aux arts culturels*. Whereas hospital exhibitions tried to preserve the anonymity of the patient—offering instead of a name a simple disease description, for example, "work of a schizophrenic suffering from hallucination"—here the luxurious, well-illustrated catalogue of two hundred items named the artists where possible, though in some instances halfway measures were taken: Forestier appeared as Auguste For, Heinrich Anton Müller as Heinrich Anton. Replacing descriptions of symptoms or disease was Dubuffet's brilliant text, which described the works found in the Swiss psychiatric

: 103 :
Gaston Chaissac
Le Samouraï (The samurai), 1947

: 104 :
Gaston Chaissac
Composition abstraite
(Abstract composition), 1954

: 105 :
Gaston Chaissac
Moins qu'on croit
(Less than one thinks), 1961

hospitals as "productions . . . by persons unscathed by artistic culture, where mimicry plays little or no part. . . . The artistic function is identical in all cases, and there is no more an art of the insane than there is an art of dyspeptics and people with sore knees."[51]

Dubuffet's categorization of what constituted art brut was a highly personal mixture of dead psychotics and living artists, such as the then recently discovered Chaissac. Chaissac refused to be incorporated into "urban life," let alone metropolitan Paris and the circuits of the art world. The untutored and eccentric aspects of his work were combined, nonetheless, with obvious influences—prehistoric art, Picasso, Otto Freundlich, who had encouraged Chaissac's initial efforts—so that Chaissac's work became a "test case" for what was and was not to be considered art brut. Chaissac showed a stencil, a pen drawing, and a sculpted-coal "Venus," the *Dame de moire*, at Dubuffet's exhibition. Chaissac's eccentric writings also interested Dubuffet, who laboriously typed out Chaissac's letters for publication by Gallimard as *Hippobosque au bocage* (Hippobosque of the marches) in 1951. After rows—and not unjustified claims by Chaissac of Dubuffet's plagiarism (compare FIGURES 101 and 102)—Dubuffet would ultimately conclude that Chaissac, the rustic shoemaker, had become "an educated man, in touch with cultivated circles . . . more or less a professional artist," excluding him from the art brut collection proper.[52] The savorous wildness of Chaissac's cloisonnéd Peeping Toms, his fantastic colors and strange supports—old cans, hoes, and wicker baskets—his quaintness, and the unusual aspects of his spidery drawings, where writing—letters, chants, and schoolboy rhymes—mingles with contour and infilling, surely refute any conventional "professional" status (FIGURES 103–6). Chaissac would comment bitterly: "Dubuffet talked about art brut. The phrase made a fortune, and I was fleeced."[53] As for Breton, he was from the start worried about the arbitrary nature of Dubuffet's categories: "The organic fusion he proposed to effect between the art of certain autodidacts and that of the mentally ill has revealed itself

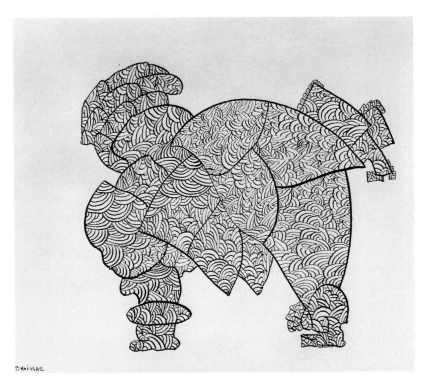

: 106 :
Gaston Chaissac
Animal, 1938

: 107 :
Friedrich Schröder-Sonnenstern
*Mondelinchen, fortschrittliche
Rekordleisterin zu Land, Luft und Meer*
(Little moon, progressive record
holder on land, by air and sea), 1957

to be inconsistent and illusory." Worse was
Dubuffet's attempt to monopolize a product, widely
discussed by the surrealists, that now had a new,
very attractive label; this was compounded by his
outrageous suggestion that the art brut collection
should leave France in 1951, as indeed it did.[54]

The denouement of Breton's novel *Nadja*, 1928,
said all: as the beautiful girl from the streets is
abandoned and left to the mercies of the asylum,
Breton himself is left with an unresolved moral
dilemma. Breton's own medical and personal
involvement with folly differed vastly from
Dubuffet's sense of fête and celebration and
his myth of the common man. In his public
presentation of art brut Dubuffet suppressed any
evocation of the pain and tragedy of schizophrenia
or of lifelong institutionalization.[55] Breton thus
broke off relations with Dubuffet but did not,
however, abandon his interest in *l'art des fous* as a
manifestation of the marvelous.

Daniel Cordier's Paris gallery was the venue
for the 1959–60 Exposition inteRnatiOnale du
Surréalisme (EROS), at which the works of the
Berlin visionary Friedrich Schröder-Sonnenstern
were presented by Hans Bellmer (FIGURE 107).[56]
Disturbing drawings by Unica Zürn, Bellmer's
longtime companion, were also shown, along with
Aloïse's *Queen Victoria* and works by the English
painter Leonora Carrington, who had been
temporarily interned in a Spanish asylum after her
breakdown in 1940. The famous, "mad," Fulmen
Cotton illustration of two naked, cherubic figures
holding a key in a lock prefaced the "Succinct
Lexicon of Eroticism" in the catalogue. The links
between love, madness, and repression continued to
be subsumed under the surrealist mantle, while the
works of "mad" and "sane" artists were presented
together in the exhibition's fantastic environments.
Meret Oppenheim's "cannibal feast" at the opening,
a living woman prone and bedecked with food,
epitomized the surrealist attitude toward Eros:
masculine creativity (that is, the surrealist artists)
objectified woman as Muse, inspiring and
delectable, onto whom irrationality, hysteria, and
madness—qualities relating to the artists' own
anxieties—were feminized, then projected.[57]

133

134 WILSON From
 the
 Asylu
 m to
 the
 Museu
 m

CoBrA and a
New Primitivism

CoBrA, an essentially anti-Parisian manifestation involving artists primarily from Copenhagen, Brussels, and Amsterdam, came into being in November 1948 at the café of the Notre-Dame Hotel in Paris. A proto-CoBrA manifesto was drawn up by the Belgian "revolutionary surrealist" Christian Dotrement. It was signed by his country-men Joseph Noiret and Corneille, representing the group Reflex, by Constant and Appel, both future representatives of the Dutch Experimental Group (founded in July 1948), and by Asger Jorn from Denmark, a one-man group representing Danish experimental artists. The agenda was international, experimental, political, and Communist but staunchly opposed to the increasingly dubious socialist realist trends promoted from Moscow at the time.[58]

The CoBrA painters recognized the formal characteristics shared by early modernism and primitive art; indeed precursors such as van Gogh, Paul Klee, and Miró were essential for the development of an Appel (FIGURE 108) or a Jorn. Dubuffet's apparent disinterest in classifying art brut from any ethnographic point of view contrasts with Jorn's greater range of interest, which included Scandinavian ethnography, folklore, and the permanence of symbols.[59] While Dubuffet's common man was essentially metropolitan—albeit a secret graffiti artist—the CoBrA artists sought inspiration at the more basic level. Animal imagery served to symbolize their concerns, and the first "languages" were suggested by depicting howling, barking jaws and mouths (Appel's *Crying Crab*, 1954) together with rough, primitive marks and traces on the canvas (FIGURE 109). For CoBrA painters, not only was man beastly but the School of Paris painters were far too polite and tradition-bound to express this beastliness—even Dubuffet, who was almost granted the status of an honorary CoBrA member.[60] Perhaps children's art and the art of the insane offered a new source of purity, untainted by irrevocably discredited, "civilized" values. An international children's drawing exhibition shown at the Musée du Luxembourg in Paris in 1947 and, as *Kunst en kind*, at the Stedelijk in

Amsterdam in 1948 was surely crucial.[61] A poignant demonstration of the links between this new "primitivism" and a postwar historical context was Appel's *Questioning Children* series. These rough, wood assemblages combine the sche-matic figures and primary colors of children's art with his memories of the faces of starving chil-dren in Germany seeming to ask "Why?" (FIGURE 110).

Appel's farewell poem to Amsterdam, "Gekke Prat" (Mad talk), 1947, was full of animalistic cries. In the original Dutch "Gek, gek, gek" sounds like barking or quacking, an effect lost in the translation to "mad, mad, mad":

Mad is mad

madmen are mad

to be mad is everything

to be everything is mad

not to be mad is everything

to be everything is not mad

to be nothing is to be mad

to be mad is nothing

everything is mad

mad is everything

because everything is mad

yet everything is mad

and not to be mad is to be mad

nothing is mad after all

non-madmen are mad

madmen are not mad

mad is mad

mad mad mad [62]

This epithet was applied to Appel himself retrospectively by N. Vroom, the director of the Dutch Academy of Fine Arts, and to the CoBrA artists as a whole at their sensational exhibition at the Stedelijk in 1949: William Sandberg, the museum's director, was accused of "trying to foist upon the public the total destruction of our age-old Western culture, contempt for art of past centuries, a fondness for a few deformed snapshots taken by mental defectives and the revolutionary rumblings of a few kids."[63]

: 108 :
Karel Appel
Arbre (Tree), 1949

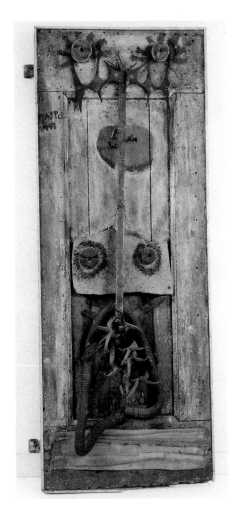

: 110 :
Karel Appel
Drift op zolder (Passion in the attic), 1947

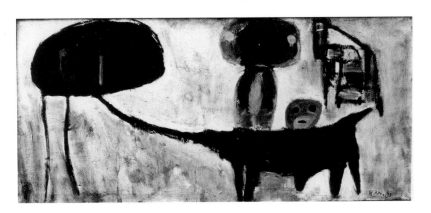

: 109 :
Karel Appel
Enfant avec âne (Child with donkey), 1949

: 111 :
Karel Appel
Title page from *Psychopathological Art*,
1947–50

: 112 :
Karel Appel
Pages 36 and 37 from
Psychopathological Art, 1947–50

Discovering Paris in 1950, Appel visited the great exhibition at Sainte-Anne. It made a profound impression upon him; he felt, he said, "the tension of mad people. . . . It was strange enough, depressive, not a stimulant like Picasso, Klee, or van Gogh." Yet he made a second visit to study the works from a technical point of view and produced what was literally a palimpsest of "parallel visions." He crayoned a personage first upon the cover of the catalogue, *Psychopathological Art*; then, over-whelmed with a desire to make it "rich with images," he continued, painting figures over the text and interleaving the pages with ink drawings and gouaches of cats, birds, children, monsters, houses—the whole repertory of his art responded to the geographies of folly categorized in this "International" of insanity (FIGURES 111–12).[64] Appel's "psychopathological art" series was—as for a Wölfli or an Aloïse—a strictly private document. Kept under lock and key, it has never before been seen by an "art public." A putatively sane, "high art" writes over—*vandalizes*—the productions decorously listed as marginal, psychotic. Vandalism suggests both northern barbarity and the destruction of the Rome of high culture—a culture ripe for renewal. Vandalism was an essential concept for the CoBrA artists' defini-tion of themselves, their new primitivism, and their northern European, anti-Parisian aspiration to internationalism.[65] Is it a coincidence that they combined words and phrases in their paintings and that writing in and writing over images are the most characteristic signs of their graphic techniques?

Dubuffet, Alfonso Ossorio, Jackson Pollock, and Art Brut on Long Island

In 1949 the extraordinary Alfonso Ossorio (1916–90) was introduced to Dubuffet in Paris. They set up a correspondence and exchanged photographs and paintings, Ossorio sending Dubuffet remarkable gestural works in gouache and wax resist on paper. He visited Dubuffet on his second trip to Paris in December 1950 and saw the art brut collection in the Gallimard pavilion. Born to a wealthy family in Manila, Ossorio was schooled in England and worked in Eric Gill's artistic community in Sussex in the mid 1930s prior to choosing America as his homeland and American nationality. Trained as both an artist and art historian, he was a man of extensive culture and wide experience. His was a profoundly religious, Catholic art. An initially conventional iconography gave way to greater mysteries: the flayed corpse of Saint Bartholomew, for example; and, above all, the paradoxes of Incarnation, the Word made Flesh. His work could be macabre however: he himself described *Klan Picnic*, 1949, as "the Ku Klux Klan having a picnic on the body of a Negro. . . . It *was* a horrid picture" (FIGURE 113).[66]

While working on the decoration of the Church of the Victorias in the Philippines, creating strong and surprising depictions of the Trinity, Ossorio started a series of works on paper. Almost four hundred were made, the last being painted in May 1951 in a nudist island colony at Hyères in France in the company of Dubuffet and his wife. Dubuffet was confecting a text for a luxurious collection of plates: *Peintures initiatiques d'Alfonso Ossorio* (Initiatic paintings of Alfonso Ossorio). Ossorio's art appealed to Dubuffet's taste for complicated recipes and processes. Dubuffet wrote of the works' "hybrid sorcery," their "viscera, bristling with hair . . . vile sexes," and noted the tortuous and tormented contours of Ossorio's irregularly shaped paper, torn or cut with a penknife.[67] Dubuffet noted the celebratory all-inclusiveness of the painting and yet the ultimately tragic and alarming potential of its "mental divagations." Religious themes, as expressed in *Sacred Heart* or *Mother Church*, were mingled with those of procreation, such as in *First Suckling*, *Contraception*, and *Astonished Mother* (FIGURE 114).[68]

: 113 :
Alfonso Ossorio
Klan Picnic, 1949

: 114 :
Alfonso Ossorio
Astonished Mother, 1950

: 115 :
Alfonso Ossorio
Rose Mother, 1951

138 WILSON From
 the
 Asylu
 m to
 the
 Museu
 m

Rose Mother (FIGURE 115), in particular, with its extended body can be compared with Dubuffet's own *Corps de dames* (Ladies' bodies) series, created from April 1950 to February 1951. Many works of this series came into Ossorio's possession.[69] Ossorio exhibited in Paris in 1951 at the Studio Fachetti, which, for its 1952 solo exhibition of Jackson Pollock, reprinted Ossorio's preface to the catalogue of Pollock's 1951 exhibition at Betty Parsons's New York gallery. Both artists figured in Tapié's *Un Art autre* publication of 1952, in which Pollock's works were described as "sulfured vehemence."

The idea of appointing Ossorio as temporary godfather to the art brut collection occurred to Dubuffet during this period of contact. Space was restricted in Paris. Not only had relationships with the committee worsened in 1950–51, so had the general political situation in Europe with the threat posed to international stability by the Korean War. However, in his retort to Breton's letter of resignation, in September 1951, Dubuffet claimed:

The temporary transfer of the collections to the United States was not done in order to protect them in the event of war, but primarily so that they could be made available to a U.S. public, which is very anxious to see them, to judge from the many American visitors who came to the "Foyer de l'Art Brut" in 1950 and 1951 and the many offers of exhibitions, as well as of assistance, made to me by American organizations and well-known individuals. Our collections have been shown time and again in Paris since 1947 and it seemed opportune to show them elsewhere. Secondly, it is important to undertake on the American continent the kind of research that until now I have done exclusively in Europe. I hope to find interesting work there and want to organize a network of people who would do prospecting.[70]

"I must say I was both flattered and appalled at the idea of it coming over to America," said Ossorio. Problems would not cease with the technicalities and costs of packing, shipping, and customs: while housed in his fabulous mansion, the fragile works had to be "fumigated, sprayed, housecleaned" once a year.[71]

Ossorio's Long Island estate, known as The Creeks, was a considerable distance from Manhattan. In the living quarters pieces of art brut were interspersed with paintings by Dubuffet, Fautrier, Wols, Pollock, Lee Krasner, Willem de Kooning, and Clyfford Still as well as Ossorio's own work, though most of the art brut collection was housed upstairs in a suite of six rooms (FIGURE 116).[72] It was certainly seen by the well-established local artistic community and the newcomers, members of the abstract expressionist circle, who escaped to Long Island from the heat of New York. Visitors from Europe arrived such as Appel, whose first trip to the United States was in 1957. He came once with Martha Jackson and again with Tapié.

: 116 :
The Collection de l'Art Brut
as installed at The Creeks, Alfonso
Ossorio's estate in Wainscott, Long
Island, New York, in 1952

Disappointingly, however, while it would have been fascinating to pinpoint an influence of the collection upon the abstract expressionist painters with whom Ossorio had tumultuous relationships at this period—Pollock and Still in particular— Ossorio had this to say: "Jackson wasn't interested. . . . He didn't feel it was that serious. I don't remember Jackson showing any great enthusiasm for art brut. Still couldn't have cared less . . . Practically none cared. Perhaps Barnett Newman . . . who had a wider range of intellectual interests."[73]

Ossorio saw abstract expressionism as an art of religious inspiration: the abstract sublime evolving from the dictum "Thou shalt have no false Gods." He recalled a sober and informed Pollock, knowledgeable about the American tradition, fascinated by Indian sand painting, an artist of splendor and metaphysical dimensions. He prefaced Pollock's Parsons Gallery exhibition with the words: "Void and solid, human action and inertia, are metamorphosed and refined into the energy that sustains them and is their common denominator."[74]

This Pollock stands in great contrast to both the putatively "schizophrenic" artist-patient of 1937–39 and to contemporary views of the artist by Long Island friends such as Fuller Potter: "I thought the guy was crazy, and when he took me to the barn I thought the work was crazy but out of it came poetry."[75] Pollock's personal reticence cannot, of course, be construed as proof that he was not moved and impressed by a display so vast, so unusual as the art brut collection in Ossorio's Long Island home.

Ossorio was apparently reluctant to allow New York City shows of the art brut collection, rejecting a proposal by the Stable Gallery in mid 1954, for example.[76] While psychotherapy had become more common in New York hospitals in the late 1940s and certain intellectual circles were alerted to the existence of schizophrenic art through various publications, this did not mean that they flocked to Long Island or were even aware of Dubuffet's collection.[77]

Daniel Cordier and Art Brut in New York

New York's notorious mixture of "high" and "low" cultures, its "melting pot" of émigrés, and its emphasis on the present not the past should have made it an ideal temporary showcase for Dubuffet's art brut. The mixing of established artists with outsiders became part of the policy of the Cordier-Warren Gallery; Cordier had close links with Dubuffet back in Paris. From 1960 to 1965 the Cordier-Warren Gallery (Cordier-Ekstrom after October 1962) took over from the now "establishment" Pierre Matisse Gallery the promotion in New York of the newest aspects of European art. Cordier-Warren showed a certain stable of artists who were simultaneously having an impact in Paris and Frankfurt. Their New York and Frankfurt galleries opened with Dubuffet exhibitions, followed closely by the works of Henri Michaux. In 1961 the Russian artist Eugène Gabritschevsky, a brilliant geneticist born in 1893 in Moscow, declared schizophrenic and interned at the Haar Psychiatric Hospital in Munich from 1929, exhibited in both the American and German galleries— again the link was through Dubuffet.[78]

The New York exhibition of Gabritschevsky's work came after an important retrospective of ten years of Richard Lindner's work (FIGURE 117).[79] By now an established New York artist, Lindner, as a young man in Germany, had been deeply impressed by Prinzhorn's *Bildnerei der Geisteskranken*. From the mid 1960s his large women in profile with huge eyes casting sidelong glances recall the outsider drawings of Aloïse (see FIGURE 1) and revitalize a heritage of early George Grosz, Oskar Schlemmer, and fairground painting in a pop art context. Lindner must surely have been one of the most enthusiastic of the initiated public who came to the exhibition of a very substantial part of the art brut collection in February 1962 at the Cordier-Warren Gallery, prior to its shipment back to Paris. Ossorio

140 WILSON From
 the
 Asylu
 m to
 the
 Museu
 m

recalled that the show was "a going-away present" for Dubuffet. But alas, pop art and minimalism were the new talking points for the intelligentsia: a polite notice in the *New York Times* remained the sole epitaph for the art brut collection's American adventure.[80]

Cordier's expansion from Paris to Germany and the United States, his immensely rich but essentially short-lived adventure as a dealer, was typical of the changing face of the art world in the 1960s. His choice of artists reflected the influence of so-called informal abstract painting and *art autre* in postwar Germany (Karl Buchheister, Karl Otto Gotz, and Bernard Schulze [the last very inspired by Wols] exhibited in Frankfurt in 1959); a continuation of surrealist tendencies with exhibitions of Matta; the penetration of the Italians, with the outrageous works of the "nuclearist" "bad painter" Enrico Baj. And to these must be added the outsider component: besides Gabritschevsky, Chaissac exhibited in New York in May 1964; the Yugoslav

Dado—his work so ostensibly similar to outsider productions, marked by his memories of childhood and wartime horror—exhibited there in 1962 and 1965.[81]

As for Ossorio himself, he exhibited in 1962 with Stadler and Cordier in Frankfurt and showed his constructions at the new Cordier-Ekstrom Gallery in New York in October 1963. An attempt to confront Ossorio squarely on the position of his work with regard to the notions of "mainstream" and outsider produced the charming and courteous reply: "I'd be awfully tempted to think that *I* was the main tradition."[82] His large, wall-mounted pieces from the later 1960s, bristling with antlers and an astonishing range of found objects, have indeed perpetuated a school: works once regarded as astonishingly eccentric in their choice of unusual materials and disturbing images must now be reckoned as precursors of the "postmodern" creations of a Julian Schnabel or a Daniel Spoerri (FIGURE 118).[83]

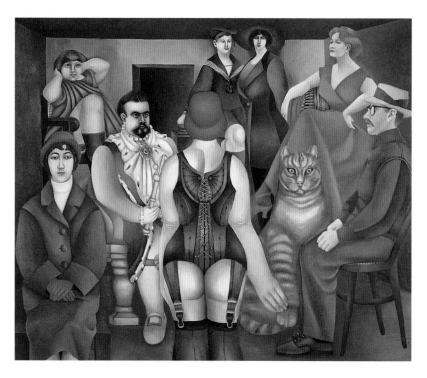

: 117 :
Richard Lindner
The Meeting, 1953

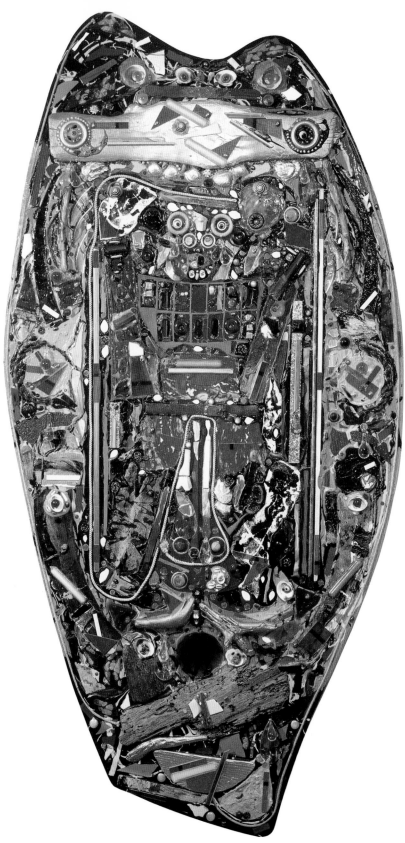

: 118 :
Alfonso Ossorio
Thee and Thy Shadow, 1961, reworked 1966

Art Brut
and Antipsychiatry:
The 1960s

Dubuffet's own retrospective of more than four hundred works was held at the Musée des Arts Décoratifs in the winter of 1960–61. No longer outside the mainstream French tradition (as he was in the early 1940s), in less than twenty years Dubuffet had created the oeuvre of a master and won an international reputation.[84] Having negotiated the return of the art brut collection and his archives from Ossorio—a protracted process— he installed them in a large converted house in the rue de Sèvres. A new Compagnie de l'Art Brut, with a dynamic managerial committee that included Cordier and the former CoBrA painter Jorn, was created in late 1962. Dubuffet assured Ossorio: "In no way is it my intention to allow the public access to this site where the art brut collections will be installed, to allow visits, nor to organize exhibitions or anything of that kind, but on the contrary to keep it closed and strictly private."[85]

Returning from his New York retrospective in March 1962, Dubuffet announced the acquisition of several new pieces thanks to psychiatrists in France and Switzerland and encouraged Ossorio to pursue contacts with New York psychiatrists.[86] Eight beautifully produced and illustrated fascicles of *L'Art brut* had appeared by 1966: Dubuffet's homage to the creators he admired was made magnificently manifest. Yet the "cloistering" of art brut as a protective measure against both "asphyxiating culture" and the problem of spectacle was a nonsolution. Dubuffet changed his mind.

The grand exhibition of the art brut collection at the Musée des Arts Décoratifs in 1967 was a tremendous success. Dubuffet's preface, "Place à l'incivisme" (Make way for incivism), which again derided any notion of a "pathological" art, reiterated an almost twenty-year-old position. Was it still a major incitement to revolt?[87] Paradoxically the exhibition of art brut in 1967 turned the classification of marginals into Parisian spectacle yet again, as in 1946 and 1950, with one additional

142 WILSON From
 the
 Asylu
 m to
 the
 Museu
 m

irony: the shift from asylum (Sainte-Anne) to museum (Musée des Arts Décoratifs). This was a symbolic act of absorption and ratification—an obliteration of a once essential difference. Surely the deliberate "museumizing" of both Dubuffet's collection and his own art was the first step in what one could call civic recuperation. With typically Machiavellian generosity Dubuffet, eschewing the Musée National d'Art Moderne, gave a substantial donation of his own work to the Musée des Arts Décoratifs, effectively guaranteeing a permanent solo show in Paris.

Dubuffet's manifesto of 1968, *Asphyxiante Culture* (Asphyxiating culture), which called yet again in its conclusion for artists to explode the mediating system of received notions and forms, was overtaken by events on the streets and by the implications of the subsequent "failure" of the May revolution and return to order.[88] With the *Hourloupe* series begun and the second half of Dubuffet's career still ahead of him, he had become a historical figure.

Meanwhile in the United States the junk aesthetic continued to develop. Its ancestry in Dubuffet's work (with input from Kurt Schwitters) has been widely acknowledged by such artists as Claes Oldenburg.[89] As the moments of pop art and minimalism passed, junk emerged as a greater challenge to establishment (or mainstream) art, parallel to developments in music, in poetry, and to America's discovery of Artaud and "antipsychiatry."[90] Now the "rejected" in terms of both people and materials was celebrated as the very contrary of the "clean," comic imagery of Roy Lichtenstein or of the flags and targets of Jasper Johns. The "marginal" emerged as a challenge to notions of American social unity and political hegemony undermined at the time of the Vietnam war and the student uprisings of 1968. A line of development may be traced between Peter Selz's *New Images of Man* exhibition at the Museum of Modern Art, 1957, which juxtaposed European

"existential angst"—Dubuffet, Appel, and Francis Bacon—with American expressionists such as de Kooning, and Robert Doty's exhibition *Human Concern/Personal Torment: The Grotesque in American Art*, held at the Whitney Museum of American Art, 1969, and then at the University Art Museum, Berkeley, California, 1970. The first illustration to confront Doty's text was Ossorio's disturbing encaustic and watercolor *Birth*, 1949. A tradition going back to Ivan Albright, passing via the fibrous surrealism of Pavel Tchelitchew and the later works of Grosz (both émigrés to America and not included in the *Human Concern/Personal Torment* show), could be seen to lead ultimately to a contemporary definition of funk as "organic, usually biomorphic, nostalgic, anthropomorphic, sexual, glandular, visceral, erotic, ribald, scatological"[91] and to such statements as Leonard Baskin's "The cracked world around me impinges at every open sluice."[92] In the context of the fetishlike nailed boxes of Lucas Samaras, the wrapped rag dolls of May Westen, and the mutilated doll-victim of Bruce Conner's *Child*, 1959, Doty concluded that "so long as men of conscience are moved to create art, they will testify to the cracks in the myths of their time and to man's inherent vulnerability.... The grotesque is a form of art, with certain characteristics. First the rejection of reason, its benefits, protection and institutions."[93] In both Paris and New York, then, the myths cracked, the boundaries were questioned, frontiers breached.

Conclusion

The whole art brut adventure together with the major 1946 and 1950 "psychotic art" exhibitions in Paris had served as an inspiration, a "glossolalia" speaking above the established tongues. Simultaneously both categories of art were a literal "gloss," an aid to interpretation, of a certain *art autre* of the period. "Lunatic art" had become a constituent part of André Malraux's "museum without walls" by the early 1950s, thus becoming another "text" of twentieth-century art.[94] Yet of all such texts it most insistently calls up the banished specter of psychobiography, both in our reading of art brut and outsider art and in its appeal to many artists who were themselves (with the notable exception of Dubuffet) tragic figures, among them Wols, Artaud, Réquichot—one could add Pollock. Who could dispute that their destiny was to some extent prefigured in their violent painting?

The events of the 1960s shifted the discussion, setting up a dialectic between the "objectivity" of structuralist analysis, with its "death of the author," and the continuing cult of the author-hero, be he Lévi-Strauss, Roland Barthes, Foucault, or indeed Dubuffet, author of *Asphyxiante Culture*. The passage from Dubuffet's matière painting to the 1960s movement that in France paralleled pop art, baptized *nouveau réalisme* by the critic Pierre Restany, marked the transition from a scabrous, dadaistic critique of society to a new "anthropological" vision of the metropolis. Now Jean Tinguely, Arman, and Spoerri displayed their analyses of society's structurings through its debris, its marginalia, its classifications: one could read in their work a direct response to Foucault's analysis of the nature of society's institutions by his investigation of society's boundaries and exclusions.

This period coincided with the growth of the notion of "antipsychiatry" in France: Artaud became a touchstone for the 1960s generation; in *La Politique de l'expérience* (The politics of experience), 1969, the English "antipsychiatrist" R. D. Laing started attracting a French audience;[95] there would be revisionist rumblings soon from within the psychiatric institutions themselves. The mad were no longer to be treated as mad. And the

sane could certainly no longer be conceived as sane in the intersubjective worlds and syntactical conundrums of Laing's *Knots*, a series of convoluted poems describing "normal" human relationships.

In the 1990s art brut/outsider art can no longer be considered outside culture.[96] As appropriation and display succeed recuperation, outsider art becomes both an essential element of the story of modernism—as in this exhibition—and merely another visual repertory in the synchronic "postmodernist" worldview. The occulted Château de Beaulieu now housing the art brut collection—and the "non-collection" of Chaissac and company—in Lausanne, with its black walls and "mug shots" and case histories of "mad" artists displayed beside the works, has become a disturbing museological curiosity.

Museums proliferate, "culture" disperses, "parallel visions" fracture in an atomized, increasingly electronic, increasingly "unreal" society: only the suffering, creative individual can be the true locus of an insider/outsider encounter. The artist Réquichot declared, "I am the actor of my own apocalypse, it is my own while I experience it, but it is also the meeting place; perhaps through it one can grasp the sense of understanding."[97]

=

Notes

All translations are by the author unless otherwise indicated.

1

Michel Foucault, *Folie et déraison: Histoire de la folie à l'âge classique* (Paris: Librarie Plon, 1961), published in English as *Madness and Civilization: A History of Insanity in the Age of Reason*, trans. Richard Howard (New York: Pantheon, 1965), 288–89.

2

This essay is dedicated to the memories of Gaston Ferdière and Alfonso Ossorio, both of whom died in 1990. Their last interviews regarding outsider art were with the author.

3

Trained in legal medicine and psychiatry in Lyons, Ferdière arrived in Paris in 1931 and subsequently followed courses at Sainte-Anne. After his first professional stint at the Villejuif Asylum in the suburbs, where he noted the still-primitive methods of classification and treatment, he returned to Sainte-Anne for an internship in 1934. See Gaston Ferdière's memoirs, *Les Mauvaises Fréquentations* (Paris: Editions Jean-Claude Simoën, 1978). Interviews with Ferdière were conducted by the author on May 21, 1985, October 28, 1985, June 23, 1990, and September 6, 1990.

4

Sainte-Anne was called an asylum until 1937, at which time a law was passed renaming all *asiles* (asylums) *hôpitaux psychiatriques* (psychiatric hospitals).

5

Ferdière distinctly recalled both Lacan and Salvador Dalí in the early 1930s claiming credit for the other's theory of paranoia. The proximity of surrealist theories and medical investigations is also demonstrated by Ferdière's *L'Erotomanie, l'illusion délirante d'être aimé*, his dissertation, written in 1937.

6

Hans Prinzhorn, *Bildnerei der Geisteskranken* (Berlin: Springer, 1922; reprint, Berlin: Springer, 1968), and in English as *Artistry of the Mentally Ill: A Contribution to the Psychology and Psychopathology of Configuration*, trans. Eric von Brockdorff (New York: Springer, 1972). In circa 1933–34 Jolowicz arranged weekly sessions with Ferdière and a Dr. Maréchal, during which Prinzhorn's book was discussed after meticulous line-by-line translations. Drs. Jolowicz and Gunther Stern lectured on January 16, 1934, in conjunction with the exhibition *Peintures d'un fou, l'art schizophrénique (documents sur la folie créateur)* (Paintings of a madman, schizophrenic art [documents of creative madness]), Galerie de la Pléiade, January 11–13, 1934. Jolowicz's catalogue preface tells the story of Oscar Herzberg, born in 1844, who began to draw at age sixty-five in the psychiatric clinic at Leipzig and continued until his death in 1917. Mark Gisbourne provided the author with this exhibition catalogue.

7

Ferdière confirmed that André Breton possessed a copy of Prinzhorn's book as did the poet Robert Desnos, who had many German friends. After Paul Eluard's death in 1952 Cécile Eluard, the poet's daughter, bequeathed his historic copy of the book (which he received as a gift from Max Ernst), bearing Eluard's characteristic "crossed-swords" signature and date, 1923, to Ferdière. She also gave to Ferdière all the letters Eluard had received from *aliénés* during his spell as a journalist, circa 1923–25, perhaps in response to his *Les Feuilles libres* article, which contained drawings and poems allegedly done by psychotics but later attributed for the most part to Desnos, a point Roger Cardinal makes in his essay.

8

Alas, Delanglade's spider with swastika arms became a pretext for the destruction of the mural once the Germans invaded Paris.

9

Ferdière, *Les Mauvaises Fréquentations*, 137. See also Ferdière and Jacques Vié, "Appel en faveur d'un musée d'art psychopathologique," *Annales de la société médico-psychologique*, no. 1 (1939): 130–31; and "Introduction à la recherche d'un style dans le dessin des schizophrènes (la forme opposée au contenu et les limites de l'analyse. Intérêt de l'étude. Considérations méthodologiques. Le musée-laboratoire de l'avenir)," *Annales médico-psychopathologiques*, no. 6 (1947): 35.

10

At the time Ferdière assumed the directorship of Rodez there were between three hundred and four hundred patients at the hospital; in the months before his arrival sixty patients had died from disease and malnutrition.

11

According to Roger Gentis in the preface to Marc Burton, *Vous qui entrez* (Paris: Maspero, 1976), 7, during the exodus thirty thousand former inmates died, due in part to the malnutrition they suffered in the "glorious French asylums."

12

At the request of a bookseller, Ferdière had organized a successful, smaller exhibition in the main square of Montpellier at the end of the war, just preceding the Musée Denys Puech show.

13

Jean Dequeker, "Monographie d'un psychopathe dessinateur: Etude de son style," university doctorate, Toulouse, 1948.

14

Ferdière, *Les Mauvaises Fréquentations*, 182.

15

Artaud's translation of chapter six of *Through the Looking-Glass*, "L'Arve et l'aume," was published in *L'Arbalète*, no. 12 (Spring 1947). His violation of "Jabberwocky" was an act of outrage at the repression he perceived in Lewis Carroll: "All mimsy were the borogroves" becomes "Jusqu'là où la rourghe est à rouarghe à rangmbde et rangmbe à rouarghambe." See Jean-Jacques Lecercle, *Philosophy through the Looking-Glass: Language, Nonsense, Desire* (London: Hutchinson, 1985), 31–46, which omits any reference to the obviously collaborative aspects of the translation from English.

16
Ferdière arranged for the publication of *Au Pays des Tarahumaras* (Paris: L'Age d'Or, 1945) and for publication of Artaud's translation of Robert Southall's poem "The Burning Babe" in *Les Cahiers du Sud.* The English translations were done with the assistance of the Abbé Julien, who was both the almoner for the hospital and an English teacher in the *école libre* in Rodez. They worked together almost every day. Ferdière himself was helped with work on English source material through his very close contact with the surrealist artist and cinema expert Jacques Brunius, who worked in England for the British Broadcasting Corporation during the war. Ferdière, in conversation, August 6, 1990.

17
See Gaston Ferdière, "J'ai soigné Antonin Artaud," *Le Tour de feu*, special issue devoted to Artaud, nos. 63/64 (1959; reissued as no. 112 (December 1971). Ferdière's claim here that electroshock therapy was painless was viciously attacked by the lettrist poet (and self-promoter) Isidore Isou in "Antonin Artaud et le Dr. Ferdière," *Pariscope* (October 29–November 4, 1969). This was elaborated in Isidore Isou, *Antonin Artaud torturé par les psychiatres*, which also included Maurice Lemaître, "Qui est le Docteur Ferdière?" (Paris: Editions Lettristes, 1970). Excessive in its presentation and conclusions regarding the "torture" of Artaud, it nonetheless quotes extensively and conclusively from the thesis of 1944 written by Ferdière's intern Jacques Latrémolière, "Accidents et incidents observés au cours de 1,200 electrochocs."

18
Antonin Artaud, *Cahiers de Rodez* (September–November 1945), *Oeuvres complètes* (Paris: Gallimard, 1956–86), vol. 18, 157.

19
See Frédéric Delanglade, "L'Art à l'asile," *Quadrige*, no. 7 (1946), issue devoted to "La folie."

20
Artaud's first known drawing—a self-portrait—dates from 1915. He drew while under the care of Dr. Dardel in a sanatorium in Neuchâtel for two years during World War I and on his return to Paris in 1930 under Dr. Edouard Toulouse. See Paule Thévenin and Jacques Derrida, *Antonin Artaud: Dessins et portraits* (Paris: Gallimard, 1986), which includes Artaud's own lists of the drawings he made in the *Cahiers de Rodez.*

21
Jean Dequeker, "Naissance de l'image," *Le Tour de feu*, no. 112 (December 1971); and, in the same publication, see also Frédéric Delanglade, "Artaud chez Gaston Ferdière."

22
See Paul Eluard, *Souvenirs de la maison des fous* (Paris: Editions Pro Francia, 1945), which includes the poem "Le Cimetière de Saint-Alban," 1943. For a discussion of Forestier, see Jean Dubuffet, "La Fabrique d'Auguste," *L'Art brut*, fascicle 8 (Paris: Compagnie de l'Art Brut, 1966).

23
Exposition des oeuvres éxécutés par des malades mentaux, exh. cat. (Paris: Saint-Anne Psychiatric Hospital, 1946). There were 141 numbered exhibits generally describing the sex and psychiatric affliction of the artists; another 17 works from Dr. Colin and 20 from Dr. Beaussart arrived from Villejuif at the last moment. Ferdière's 36 works (including a chair and a *King* by Forestier, who was referred to as a "deséquilibré schizophrénique") were numbered separately.

24
For Waldemar George's recollections of the exhibition, see his "La Plus Grande Mystification du siècle: L'Art des malades mentaux," *Le Peintre*, no. 13 (October 15, 1950): 6.

25
All information concerning the 1950 Sainte-Anne exhibition comes from Robert Volmat, *L'Art psychopathologique* (Paris: Presses Universitaires de France, 1956).

26
See Adrian Hill, *L'Art contre la maladie: Une histoire d'art-thérapie* (Paris: Vigot, 1946), which probably introduced the English term to France. See also Jean Vinchon, "La Valeur du mandala en psychothérapie," *Aesculape* 31, nos. 8/9 (1950): 166–97; and the Vinchon bibliography in Volmat, *L'Art psychopathologique*, 300. Vinchon included a chapter entitled "La Schizophrénie selon Ferdière" in the reedition of his book (Paris: Editions Stock, 1950).

27
Ferdière likewise wished to distance himself from preparations for the large exhibition at La Villette, Paris, organized by Dr. C. Wiart and Robert Volmat and held in conjunction with the thirteenth Congrès International de Psychopathologie de l'Expression, June 12–15, 1991.

28
In his letter to Volmat dated December 28, 1952, printed in Volmat, *L'Art psychopathologique*, 90, Dubuffet sourly damned the exhibition, declaring it had assembled a vast number of mediocre works in which imitation, mannerism, and platitude were rife. Five items belonging to Dr. Charles Ladame of Geneva were exhibited in the Swiss section. Almost the entire Ladame collection, while promised in Ladame's lifetime to Ferdière, was bought by Dubuffet for the Compagnie de l'Art Brut.

29
Waldemar George, "La Plus Grande Mystification du siècle," 6. He claims to have prefaced the 1926 exhibition of Dr. Auguste Marie's collection at the Galerie Vavin and gives an account of Marie's ignorance of the fine arts and his rigidity of interpretation.

30
Ibid.

31
See Roland Barthes, "Réquichot et son corps," in Barthes, Marcel Billot, and Alfred Pacquement, *Bernard Réquichot* (Brussels: Editions La Connaissance, 1973).

32
See George Bauer, *Sartre and the Artist* (Chicago: University of Chicago Press, 1969).

33
Sartre's writings on Wols are partially translated in Peter Inch, ed., *Circus Wols* (Todmorden, Yorkshire, England: Arc, 1978). See also *Wols*, exh. cat. (Zurich: Kunsthaus Zurich, 1989), with full bibliography.

34
Hermann Rorschach's "psychodiagnostic" test, invented in 1921, was promoted in Paris by Eugène Minkowski, a pioneer in the study of schizophrenia, and his wife Françoise Minkowska. The Rorschach test was published without plates (to protect its medical validity) by the Presses Universitaires de France in 1947. Ferdière around this time did Rorschach tests on approximately forty to fifty well-known personalities of Saint Germain-des-Près. In his "Le Dessinateur schizophrène," *L'Evolution psychiatrique*, no. 2 (1951): 215–30, Ferdière cited Minkowska's 1943 studies on Rorschach tests and "psychopathology" and her "De van Gogh et Seurat au dessins d'enfants. A la recherche du monde des formes (RORSCHACH)" in the illustrated catalogue for an exhibition at the Musée Pédagogique, April 20–May 13, 1949. The overspill from Rorschach into the visual arts was evident, the method of "reading" central to the whole impact and interpretation of surrealist decalcomania and *informel* painting, and not limited merely to the works of Henri Michaux; for example, see Emile Malespine's "La Peinture intégrale," which is illustrated with decalco-manias and contains quotes from Leonardo da Vinci and Rorschach, *Cahiers d'art*, no. 22 (1947): 288–92.

35
William Blake, exh. cat. (Paris: Galerie René Drouin, 1947). *Cahiers d'art*, no. 22 (1947), carries extensive articles on Blake (pp. 119–34) and van Gogh (pp. 159–266), while Jean Arp's article "L'Oeuf de Kiesler et la Salle des Superstitions," regarding Frederick Kiesler's work at the Exposition Internationale du Surréalisme of 1947, reflects the folly and anguish of the age as a whole.

36
Antonin Artaud, "Van Gogh le suicidé de la societé" (Paris: K. Editeur, 1947). See also Isou, *Antonin Artaud torturé par les psychiatres*, 114, who quotes Paule Thévenin's article "1896–1948" as his source. Dr. Beer's full article, "Van Gogh: Sa folie," *Arts* (January 31, 1947), is reproduced in Artaud, *Oeuvres complètes,* vol. 13, 302–3.

37
Pirate copies of "Pour en finir . . ." and a recording were soon in clandestine circulation. See text and notes in Artaud, *Oeuvres complètes*, vol. 13, 69–104, 322–48; for an admirable account of Artaud's last years, see Jean-Louis Brau, *Antonin Artaud* (Paris: Editions de la Table Ronde, 1971); see also Stephen Barber, *Artaud: Blows and Bombs* (London: Black Spring, forthcoming).

38
Dufrêne provided a "sound track" of gasps and cries for the Exposition inteRnatiOnale du Surréalisme (EROS) in 1959.

39
According to John M. MacGregor, *The Discovery of the Art of the Insane* (Princeton: Princeton University Press, 1989), 358 n. 3.

40
Ferdière supposed that, bearing in mind the age of the widow of Dr. Auguste Marie (he died in 1934) and Dubuffet's interest and intelligence, he would have visited her before the war—long before she left him her collection. Ferdière, in conversation, August 17, 1990.

41
The impact of children's art on Dubuffet cannot be extricated from the art brut influence on his work. An essay by Jonathan Fineberg on Dubuffet and children's art will appear in the catalogue to the exhibition *The Innocent Eye* (Dallas: Dallas Museum of Art, forthcoming).

42
Gaston Bachelard's essay "L'Eau et les rêves: Essai sur l'imagination de la matière," based on his much frequented lectures at the Collège de France during the occupation, was published in 1942, before both Jean Fautrier's *Otage* (Hostage) series, which abandoned conventional oils for "pastes," and Dubuffet's possibly imitative *hautes pâtes* (raised pastes). Bachelard divided the imagination into the formal and the material and reflected upon *la pâte* as the primal material to be smeared and kneaded in a *rêverie* (dreamy identification) or alternatively penetrated with "male joy" and a "will to power."

After Dubuffet's New York show of 1946 Clement Greenberg related the work to existentialism. Dubuffet was certainly fully informed of both the existence and the essence of the movement, although it is not certain that he read the entire text of Sartre's vast and complex *L'Etre et le néant* (Being and nothingness), 1943. Dubuffet claimed he was "warmly existentialist" in a letter to Jean Paulhan of summer 1946.

43
Ferdière, *Les Mauvaises Fréquentations*, 21. He continued to provide Dubuffet with addresses and reveal his most recent discoveries (such as the postman Facteur Lonné) in the 1950s. Nine-tenths of Dubuffet's collection was acquired through similar contacts with the medical profession, Ferdière claimed.

44
See Jean Paulhan, "Guide d'un petit voyage en Suisse au mois de juillet 1945," *Cahiers de la Pléiade* (April 1946): 201. Letter to Wyrsch communicated by Henry-Claude Cousseau, 1980.

45
See Jean Dubuffet, *Prospectus et tous écrits suivants* (Paris: Gallimard, 1967), vol. 1, 498 n. 29. The publisher did not distribute *Les Barbus Muller et autres pièces de la statuaire provinciale*.

46
See John M. MacGregor, *The Discovery of the Art of the Insane*, 299.

47
A typical (that is, disparaging) press response to Dubuffet's work appeared in *Libération* (April 1, 1954): "Humorists, cynics, sadists or cretins see [in Dubuffet's art] the manifestations of what they dare to call 'art brut.' " This was in reaction to the artist's retrospective organized by René Drouin under the aegis of André Malraux at the Cercle Volney.

48
The problematic status of an "untrained" artist like Hyppolite from the French colonies would presumably have been demonstrated in the larger context of the UNESCO exhibition of naive art from Haiti, held in Paris in March 1947.

49
See Dubuffet's letters to Breton of May and June 1948 in Dubuffet, *Prospectus et tous écrits suivants*, vol. 2, 265–67. Breton's text was first published as "L'Art des fous, la clef des champs," along with Dubuffet's text on Miguel Hernandez, in *Cahiers de la Pléiade* (Autumn 1948/ Winter 1949), then with a modified title in *La Clé des champs* (Paris: Editions du Sagittaire, 1953; reprint, Paris: Société Nouvelle des Editions Pauvert, 1979).

50
See Michel Ragon, *Histoire de la littérature prolétarienne de langue française* (Paris: Editions Albin Michel, 1976; reprint, 1986).

51
Jean Dubuffet, *L'Art brut préféré aux arts culturels*, exh. cat. (Paris: Galerie René Drouin, 1949), unpaginated; trans. Allen S. Weiss and Paul Foss in *Art Brut: Madness and Marginalia*, a special issue of *Art & Text*, no. 27 (December 1987– February 1988): 31–33.

52
Quoted in Dominique Alain Michaud, *Gaston Chaissac: Puzzle pour un homme seul* (Paris: Gallimard, 1974), 62. The approximately fifty works by Chaissac—totems, paintings, and drawings— at the Collection de l'Art Brut, Lausanne, were never shown as part of the art brut collection and were only listed upon the publication of *Neuve Invention: Collection*

d'oeuvres apparentées à l'art brut (Lausanne: Collection de l'Art Brut, 1988), without the slightest indication of their controversial status. I discuss this and translate Dubuffet's preface to Chaissac's 1947 show at Galerie de l'Arc-en-Ciel in *Gaston Chaissac*, exh. cat. (London: Fischer Fine Art, 1986). See also Barbara Nathan-Neher, *Chaissac* (Stuttgart: Klett, 1987; and New York: Rizzoli, 1987), 24–26.

53
Michaud, *Gaston Chaissac*, 72.

54
"Never has an enterprise been run in a more dictatorial manner," Breton claimed in his letter of September 20, 1951 (Dubuffet, *Prospectus et tous écrits suivants*, vol. 1, 493). He revealed that Dubuffet refused to allow critics access to documentation, prevented the art brut almanac from appearing, and was generally obstructive.

55
Only once, in a preface to an exhibition of Paul End, Alcide, Liber, Gasduf, and Sylvcoq at the Librarie Marcel Evrard, Lille, January 1951, did Dubuffet explain the reason for the artist's pseudonyms: "They are people for whom, indeed, everything is lost. No enterprise can offer them any hope. They have to confront the human condition reduced to a minimum, at its most extreme point" ("Honneur aux valeurs sauvages," *Prospectus et tous écrits suivants*, vol. 1, 206).

56
Exposition inteRnatiOnale du Surréalisme, Galerie Daniel Cordier, December 15, 1959–February 29, 1960 (with illustrated catalogue). See also *Donations Daniel Cordier: Le regard d'un amateur*, exh. cat. (Paris: Musée National d'Art Moderne, Centre Georges Pompidou, 1989), 506–9. Significantly Schröder-Sonnenstern and Unica Zürn are represented in *Neuve Invention*.

57
Oppenheim's complicity (or satire?) contrasted with an aggressive, self-affirmative, new attitude among certain female surrealists, the desires and pains expressed, for example, in the writings of Nora Mitrani or Joyce Mansour.

58
The *détournement* of orthodoxy was demonstrated by the conflation of dialectical and Bachelardian brands of "materialism" in CoBrA: "We believe that the origins of art are instinctive, hence materialist," declared Asger Jorn in "Les Formes conçues comme langage," *Cobra*, no. 2 (March 21, 1949): unpaginated.

59
See the CoBrA reviews and publications, especially Asger Jorn, *Guldhorn og Lykkehjul* (Copenhagen: A/S Selandia, 1957); and Jorn and Noël Arnaud, *La Langue verte et la cuite* (Paris: Pauvert, 1968), in itself a skit upon the notion of "brut" and Lévi-Strauss's "raw" and "cooked" distinction.

60
Dubuffet was an important reference for the CoBrA artists: *Cobra*, no. 6 (April 1950), contains an engraving by Dubuffet and his declaration "Life is a fête,

much more interesting than the pseudo fêtes people invent to forget it!" *Cobra*, no. 8, intended for spring 1951, edited by Michel Ragon in Paris, would have incorporated Dubuffet's work, but it never appeared.

61
Jorn, at Le Corbusier's request, had enlarged two children's drawings to mural scale for the 1937 Paris world's fair and was inspired by Klee and Miró before returning to Denmark at the outbreak of war.

62
See Michel Ragon's superb monograph, *Karel Appel: The Early Years, 1937–1957* (Paris: Editions Galilée, 1988), 374, for Dutch and English versions of Appel's poem. Appel must have seen the very large 1945 van Gogh exhibition at the Stedelijk. Other exhibitions he may have seen and been influenced by were *Seven Belgian Painters*, including Ensor, 1945; Klee, 1948; van Gogh in Netherlandish collections, 1948; and *Kunst en kind*, 1948 (an international exhibition of almost 150 works plus an extensive publications section). *Expressionism from van Gogh to Picasso* in 1949 included an extensive representation of the major German expressionists. These exhibitions are not detailed in Ragon, though he does mention the influence of Johan Huizinga's *Homo Ludens*, published in Holland in 1939. (Concurrently Dubuffet was reading Georges Henri Luquet, whose *Le Dessin enfantin* was published in 1927. *Homo Ludens* did not appear in French until 1951.)

63
Ragon, *Karel Appel*, 49, 282.

64
In ibid., 12, Ragon notes that "this series . . . includes three sizes of paintings and drawings: 26 x 20 cm . . . 24 x 32 cm . . . 30 x 42 cm. See reproductions nos. 6–9, 223–27, 228–34, 237–40, 327–30, 333–36 (includes cover), 361–65, 412–17, 423–25, 427, 430–31." Astonishingly Ragon does not discuss these works.

65
Ironically the move of painters such as Appel and Jorn to Paris and CoBrA's inclusion of School of Paris painters in its exhibitions outside France led to its rapid demise in 1951.

66
Ossorio in Jeffrey Potter, *To a Violent Grave: An Oral Biography of Jackson Pollock* (New York: G. P. Putnam's Sons, 1985), 111.

67
Jean Dubuffet, *Peintures initiatiques d'Alfonso Ossorio* (Paris: La Pierre Volante, 1951).

68
See Ossorio's detailed analysis of his religious and body imagery in the marvelous, rich interview with Judith Wolfe in *Ossorio, 1940–1980* (East Hampton: Guild Hall, 1980), 16, 20.

69
See the copy of a letter by Dubuffet of July 22, 1951, listing the works by Dubuffet in Ossorio's collection (typescript of May 14, 1960), including several of the most important *Corps de dames* oils, and see the list (in the form of Dubuffet's secretary's request for photographs, October 17, 1960) of gouaches and drawings, totaling twenty-seven items, including six pen-and-ink drawings for the *Corps de dames* series and six signed trial proofs for unpublished lithographs (litho crayon). A *Corps de dames* book, with a text by André Martel, was never realized. Letter and lists are from the Alfonso Ossorio Papers (1950–1962), Archives of American Art, Smithsonian Institution (henceforth "A. O. Papers"), kindly communicated to me by Barbara Freeman.

70
Letter to Breton, September 23, 1951, in Dubuffet, *Prospectus et tous écrits suivants*, vol. 1, 497 (translation from A. O. Papers).

71
Ossorio, in conversation, February 20, 1990.

72
See B. H. Friedman's comprehensive monograph *Alfonso Ossorio* (New York: Abrams, 1973), 59–60, with installation photograph.

73
Ossorio, in conversation, February 20, 1990.

74
Ossorio, preface, *Jackson Pollock*, exh. cat. (New York: Betty Parsons Gallery, 1951); reprinted as "Mon ami Pollock" for Pollock's first solo show in Paris, at the Studio Paul Fachetti, March 7–31, 1952; revised in *15 Americans*, exh. cat. (New York: Museum of Modern Art, 1952); and quoted in *The New American Painting: As Shown in Eight European Countries 1958–1959* (New York: Museum of Modern Art, 1959). (This homecoming show, held May–September 1959, was the exhibition that definitively changed the center of art from Paris to New York. Between April 1958 and March 1959 it visited Basel, Milan, Madrid, Berlin, Amsterdam, Brussels, Paris, and London.)

75
Fuller Potter in Jeffrey Potter, *To a Violent Grave*, 106. In this *Parallel Visions* context it is surely imperative to refer to C. L. Wysuph's *Jackson Pollock: Psychoanalytic Drawings* (New York: Horizon, 1970). Drawings were made by Pollock at his suggestion during his Jungian analysis by Dr. Joseph Henderson in 1939 (this information comes from Henderson's unpublished essay "Jackson Pollock: A Psychological Commentary"). Wysuph suggests that Pollock may have encountered art therapy as a practice when he first had eight months of psychiatric treatment for acute alcoholism in 1937 (p. 12 and n. 11). To Dr. Henderson, his patient was "an unknown artist suffering from a serious mental disturbance" (p. 12), which he diagnosed as "schizophrenia," indicated by periods of "violent agitation," by states of "paralysis and withdrawal," and by a "pathological form of inversion [sic]" (p. 14).

76
See letter from Dubuffet in A. O. Papers, date illegible (circa July 1954; translation and emphasis as in my copies):
I agree that it is preferable not to follow through on Madame Eleanor Ward's request for an Art Brut show at the Stable Gallery in New York. I think that it's best to avoid an exposition in New York. Everything is fine just as it is, the collections are in your house and accessible to any visitor really interested in seeing them and who requests an appointment. I find this arrangement very satisfactory. A subsequent letter from Dubuffet declared:
So far as putting or not putting on that exhibition of the Art Brut collections in her gallery I leave it entirely up to you. You are a much better judge of what is or is not opportune.

77
Margaret Naumburg, a pioneer of psychotherapy and art therapy in America, authored *Schizophrenic Art: Its Meaning in Psychotherapy* (New York: Grune & Stratton, 1950), following Karen Machover, *Personality Projection in the Drawing of the Human Figure* (Springfield, Illinois: Thomas, 1949). See also José Ortega y Gasset, *The Dehumanization of Art* (Princeton: Princeton University Press, 1948); Ernst Kris, resident in New York, used the example of the psychotic artist Franz Xaver Messerschmidt in "A Psychotic Sculptor of the Eighteenth Century," in his *Psychoanalytic Explorations in Art* (New York: International Universities Press, 1952); and F. Reitman, *Psychotic Art* (New York: International Universities Press, 1950).

78
Dubuffet discovered Gabritschevsky at Haar on a brief visit in 1960. See *Donations Daniel Cordier*, 210–58, where the astonishing stylistic variety of Gabritschevsky's small-format works in crayon, watercolor, and gouache was revealed.

79
The intervening shows—the *nouveau réaliste* Arman, a selection of Ossorio's works from 1941 to 1961, and Wols's watercolors—were eloquent of Cordier's taste.

80
Ossorio, in telephone conversation, October 10, 1990.

81
Donations Daniel Cordier, 102–43.
82
Ossorio, in conversation, February 20, 1990. See *Donations Daniel Cordier*, 386–93, 525–26.
83
Ossorio, in conversation, February 20, 1990. For a book that exemplifies the Ossorio "tradition," see *Collision: Alfonso Ossorio, Jesse Lot, David Best, Larry Fuente, Antoni Miralda, James Metcalf, Ana Pellicer, Luis Jimenez*, exh. cat. (Houston: Lawndale Alternative, University of Houston, Ineri Foundation, 1985). Ossorio showed me exemplary kindness and was most generous with time, books, and catalogues.
84
Jean Dubuffet 1942–1960, Musée des Arts Décoratifs, December 16, 1960– February 25, 1961, was patronized by André Malraux, minister of culture, and inaugurated by Gaeton Picon, director general of arts and letters.
85
Letter of December 27, 1961, which included a plea for the return of archival material (A. O. Papers).
86
Letter of March 4, 1962: "Have you pursued the contacts you made with the New York psychiatrists who might find interesting works? Mr. Eckstrom had also got some intermediaries to talk to psychiatrists, and I don't know what has happened. It would be very useful if you could find interesting documents in New York to enrich our collections" (A. O. Papers).

87
Dubuffet's sixteen-page brochure *La Compagnie de l'Art Brut*, 1963, which gave the history of his enterprise, stated there were approximately two thousand works by more than two hundred artists by the time the installation of Dubuffet's collection at his foundation in the rue de Sèvres, Paris, was completed. This history was partially reprinted for the major exhibition *Bildnerei der Geisteskranken/Art Brut/ Insania pingens*, held at the Kunsthalle, Bern, August 24– September 15, 1963. *L'Art brut* at the Musée des Arts Décoratifs, April 7–June 5, 1967, contained a "Histoire de la Compagnie de l'Art Brut," 123–25; *L'Art brut* fascicles nos. 1–8 were advertised for sale. "Place à l'incivisme" appears in English translation in *Art and Text*, no. 27 (December 1987–February 1988): 34–36.
88
Jean Dubuffet, *Asphyxiante Culture* (Paris: Editions du Minuit, 1968; reprint, 1986).
89
Compare Oldenburg's *The Street* show (held first at the Judson Gallery, New York, in a collaboration with Jim Dine and second at the Reuben Gallery, New York, in a solo exhibition) and his mimicking of Dubuffet's texts in "Views of the Store," preface, *The Store*, exh. cat. (New York: Martha Jackson Gallery, 1961). I am indebted to Angela Whitbread of University College, London, for her extended essay "Anticultural Positions: Dubuffet in America," circa 1984, which first brought the connection between Oldenburg's work and Dubuffet's to my notice.

90
See Jack Hirschman, ed., *Antonin Artaud Anthology* (San Francisco: City Lights, 1965).
91
Definition of *funk* from Harold Paris, "Sweet Land of Funk," *Art in America* 55, no. 2 (March–April 1967): 96.
92
Leonard Baskin, quoted in Robert Doty, *Human Concern/Personal Torment: The Grotesque in American Art* (New York: Whitney Museum of American Art, 1969), unpaginated.
93
Ibid.
94
André Malraux's *The Voices of Silence* was published in English in 1953 (New York: Doubleday); see therein works by Pujolle and an unidentified artist illustrated on 531 and 533.
95
This was followed by Laing's *L'Equilibre mentale, la folie et la famille* (Paris: Maspero, 1971); and Robert Boyers and Robert Orill, eds., *Robert Laing et l'antipsychiatrie* (Paris: Editions Payot, 1973). Isou's book *Antonin Artaud torturé par les psychiatres*, 1970, was another case in point. Françoise Eliet's "Le Psychiatre 'révolutionnaire' et son fou: Un nouveau maître, un nouvel esclave," *Art Press International*, n.s., no. 3 (December 1976), gives an aperçu of the "anti-psychiatric struggle" and organized opposition.

96
The very term "outsider art," coined by Roger Cardinal, and certainly the best of all possible solutions to the problem of translation and definition, is, I would argue, already far too fraught with its own recent mythology. The idiosyncracies of Dubuffet's exclusions, alas, prevented his far more potent expression from gaining international currency.
97
Bernard Réquichot, "Faustus," in *Les Ecrits de Bernard Réquichot* (Brussels: Témoins et Témoignages, Editions la Connaissance, 1973), 33.

Looking to the Outside

Art in Chicago, 1945–75

RUSSELL BOWMAN

Perhaps due in part to their own sense of being "outsiders" in relation to the New York mainstream, Chicago artists since 1945 have demonstrated a continuing interest in outsider art. Their awareness and appreciation of the work of untrained artists, eccentrics, isolates, compulsive visionaries, and psychotics must be understood as part of a larger tradition in Chicago of exploring nonmainstream sources. Rather than look to the rational and classic strain in the history of art, Chicagoans, at least since the 1930s, have been drawn to the subjective, emotive vein in artistic expression. This essentially expressionist tradition can be said to have commenced with native Chicagoan Ivan Albright (1897–1983), who worked in and around the city until 1963, and to have continued through three successive generations: the so-called Monster Roster of the late 1940s and early 1950s; a middle generation maturing in the late 1950s and early 1960s and including H. C. Westermann, Irving Petlin, and Robert Barnes; and, finally, those associated with the Hairy Who and other exhibiting groups, collectively and widely known as the Chicago imagists, in the late 1960s and early 1970s.[1] The work of the Monster Roster leaned toward a figurative, painterly expressionism not atypical of the art of the 1950s; the second generation explored imagistic and literary juxtapositions reminiscent of surrealism; and the third generation combined pop subjects with sharply distorted form and fiercely adolescent humor. These three generations were united by a commitment to figurative imagery and densely worked manipulations of form and by a desire for direct, unmediated self-expression—manifestations many Chicago artists perceived and admired in outsider and psychotic art.

: 119 :
Leon Golub
In-Self III ("Anchovie Man" II), 1953

Leon Golub

Despite the role and impact of Albright's particular **151** blend of regional subject matter and obsessive, almost surrealistically detailed realism, a tradition of direct influence from untrained artists can be said to have begun with Leon Golub. A student at the School of the Art Institute of Chicago from 1946 to 1950, Golub (born 1922) became known in the 1950s as part of a group of younger figurative expressionists, defined by Patrick Malone and Peter Selz in a 1955 *Art News* article, including George Cohen, Cosmo Compoli, Joseph Gato, and Ray Fink. Selz and Malone asserted that these artists "do not compose a unified group, nor have they a unified style. They share, however, a deep concern with the human image, which re-emerges in their work after an age of abstraction to direct the sensations of the spectator toward more specific responses." The two authors concluded,

All these artists belong to a generation which follows that of the Abstract-Expressionists. While not denying the accomplishments of Abstract-Expressionism, they are not concerned primarily with self-disclosure through abstract means. . . . They also believe that a work of art may communicate more than ineffable sensations, that painting and sculpture can, in fact, present visual symbols which may clarify and intensify our emotions about life and its meaning.[2]

Franz Schulze, a painter of the same generation, expanded the list to include Ted Halkin, June Leaf, and Seymour Rosofsky among others and, in a 1959 review of an exhibition of H. C. Westermann's work, christened the group the "Monster Roster."[3]

From 1946 to 1954 Golub produced several groups of works based on primitive, archaic themes and hieratic forms (not unrelated to the pictographic work of Mark Rothko of 1940–46 or Adolph Gottlieb through the 1940s). These works—chiefly frontal figures rendered as seers, kings, dervishes, shamans, and priests—reflect Golub's interest in tribal art, an interest he shared with Cohen, Compoli, and a number of his colleagues from the School of the Art Institute. Schulze has noted their familiarity with the tribal collections of the Field Museum of Natural History

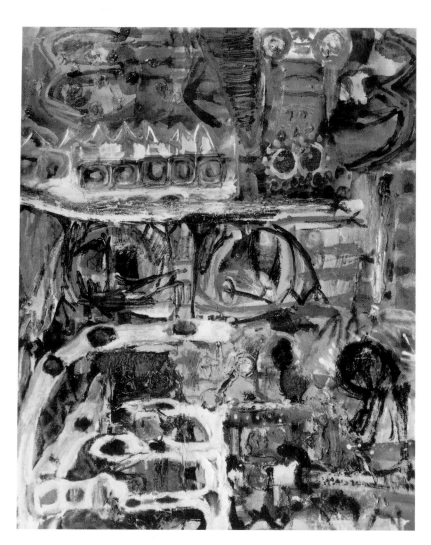

: 120 :
Leon Golub
In-Self IV, 1954

and the ancient art of the Oriental Institute at the University of Chicago and their reverence for a tradition, essentially northern European, extending from Hieronymus Bosch, Matthias Grünewald, and Francisco de Goya to Edvard Munch, James Ensor, Chaim Soutine, Emil Nolde, Paul Klee, and Max Ernst. He also has mentioned their regard for the almost contemporaneous expressionist figuration of Francis Bacon, Jean Dubuffet, and Alberto Giacometti.[4]

What Golub and his contemporaries were seeking, not unlike the slightly older abstract expressionist generation in New York, who mined many of the same sources, was a true *authenticity* of expression. They were aware, as were the abstract expressionists, of the surrealist interest in so-called "primitive" art of all kinds and of contemporary currents in literature and philosophy, which during the postwar period had a distinctly existential cast. In addition to Sigmund Freud they read Franz Kafka, Louis-Ferdinand Céline, and Hermann Hesse. All these influences directed them toward an intensely introspective and expressive art.

Golub has stated that he was trying to achieve a schizophrenic sense in his *Inself* paintings of the early 1950s (FIGURES 119–20), particularly after having looked at schizophrenic art in a book of that time, perhaps a publication of the Prinzhorn Collection. His wife, Nancy Spero, brought from Paris copies of *Art d'aujourd'hui* (November 1950) with examples of art of the insane.[5] Also, Peter Selz gave him a copy of the book *Mirobulus, Macadam & Cie: Hautes Pâtes de Jean Dubuffet* around 1950. Golub and Spero were quite struck by the Dubuffets reproduced in the book and believe they also saw a Dubuffet acquired by the Art Institute of Chicago at about this time.[6] Both Golub and Spero recall attending Dubuffet's "Anti-Cultural Positions" lecture at the Arts Club of Chicago, although, as they remember, it had little immediate impact personally. It is more likely that the influence of Dubuffet's lecture grew in the discussions of it among Chicago artists.[7] In any case, all these influences combined to make the *Inself* paintings

some of the most fragmented of Golub's early output. Perhaps paradoxically it is at this juncture that his art, both in its fierce self-analysis and its broken, almost abstract form, comes closest to some of the tenets of abstract expressionism.

While the abstract expressionists took the same lines of influence toward a form of painting that was purely abstract and intuitive, the Chicagoans could not let go of the figure. Golub argued in a 1955 article, "Critique of Abstract Expressionism," that in seeking an art that was precognitive and prelogical, abstract expressionism tended to become actually anonymous and impersonal; the personal and communicative ground was lost. For Golub, an "intrinsic and personal" art could not be achieved through a rejection of representation, which was "equivalent to the cultural dehumanization of man."[8] According to one of the most perceptive critics of the artist's work, Lawrence Alloway, Golub's solution to the dilemma of how to create a highly personal and expressive art while remaining connected to humanist culture was his reference to the sculptural forms of classical Greece and Rome. A still-early work such as *Thwarted* (FIGURE 121), 1953, while it retains the fetishistic quality and the fragmentation of the early work, also has a sense of underlying order and cohesion. Golub has said he had the *Belvedere Torso* in the Vatican Museum in mind while painting it.[9] Though the finished work is quite different from the source, it still conveys a sense of a timeworn fragment. Peter Selz called the neckless, armless figure "an image of tragic frustration,"[10] but it must be noted that it expresses, as does Giacometti's work, a strong sense of survival. This sense of survival somehow seems the key to Golub's art as it has developed to the present day. All of Golub's work combines a sense of elemental existence with an awareness of humankind's actions, its history.

While his later historicist references and political commentaries seem antithetical in some ways to the primarily expressionist tradition among Chicago artists, Golub established a clear model of the artist seeking self-expression through a figurative style that did not leave the human behind—that communicated through imagery—and of the artist as someone acting outside the accepted art-world norms of theory or style. Based on his understanding of the northern European expressionist tradition, tribal art, and the art of the insane, as well as of the classical and Renaissance humanist traditions, Golub helped to establish in Chicago a tradition of looking to outsider art as a source of inspiration.

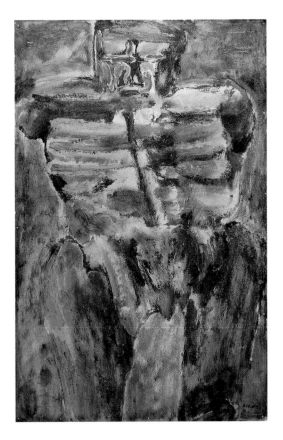

: 121 :
Leon Golub
Thwarted, 1953, oil and lacquer on canvas, 47 x 31 in. (119.4 x 78.7 cm), collection of Nancy Spero

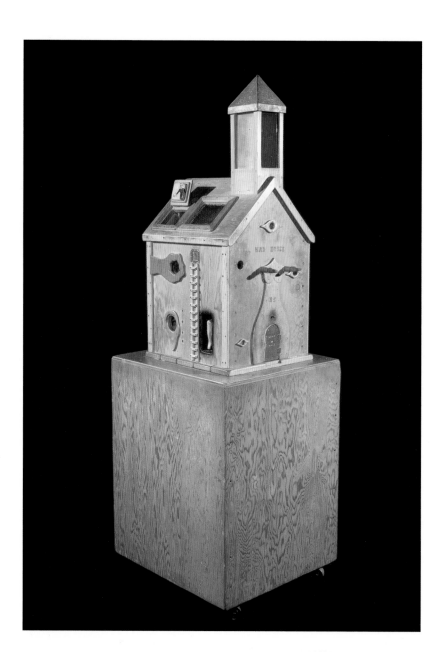

: 122 :
H. C. Westermann
Mad House, 1957

H. C. Westermann

H. C. Westermann (1922–81) provided a vital link between the first generation of Chicagoans interested in primitive and outsider art and the so-called third generation, which emerged in the mid-to-late 1960s. Westermann's example extends beyond the influences he reflected, or even the work he produced, to the determinedly nonmainstream approach he took to both his art and his life. For the younger Chicagoans, Westermann's steadfast refusal to adapt his vision to accepted artistic canons, whether those of Chicago, New York, or anywhere else, was paradigmatic. He represented for them an artist willing to create art only on his own terms, and in this sense his example was truly seminal.

The facts of Westermann's life reflect his determination to go his own way. Although he had qualified for an appointment to the U.S. Naval Academy, Westermann left home and military prep school in January 1942 and spent approximately six months working in logging camps and sawmills in Northern California, Oregon, and Washington before enlisting in the Marine Corps. While serving on the aircraft carrier *Enterprise* during World War II, he participated in combat as a gunner and witnessed kamikaze attacks, experiences that became the subject of a number of later works. Following his four-year tour with the Marines, he traveled with the U.S.O. in an acrobatic act. Westermann began his studies at the School of the Art Institute of Chicago in 1947, obtaining jobs as a handyman to augment his GI Bill payments.[11]

Throughout his life he seems to have been more comfortable in the milieus of the circus performer, the carpenter, and the craftsman than in the art world. He always took a distinctly nonintellectual, clearly personal approach to his art (FIGURES 122–23), and his letters record not only the directness of his artistic decisions but his unique responses to people and the events of the day.[12]

Walter Hopps has remarked that "Westermann was an outsider,"[13] obviously not to the degree of psychosis and antisocial behavior but rather to the extent of following his own artistic plan or his own life plan regardless of conventions. In the context of this exhibition Westermann stands as a case apart. Unlike the later generation of Chicago artists, he did not seriously collect or look to the art of compulsive visionaries. Rather, he positioned himself as an outsider (which, in fact, he was not), validating "outsiderness" for the next generation and thus serving as an inspiration to them.

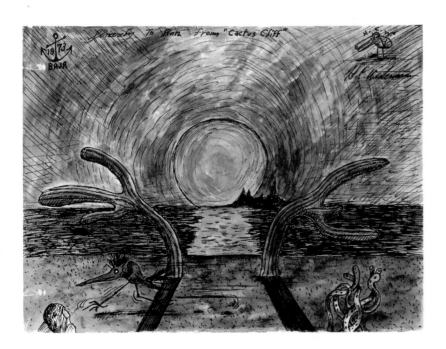

: 123 :
H. C. Westermann
Untitled (Baja/Sincerely to Ann from "Cactus Cliff"), 1973

Ray Yoshida

Although he has frequently been associated with the generation of artists that matured in the late 1960s—that is, the imagist generation—Ray Yoshida is actually closer to Westermann's generation and was, in fact, a teacher to many of the later imagists. Born in Hawaii in 1930, he began attending the School of the Art Institute of Chicago in 1950 with such classmates as Westermann, Claes Oldenburg, John Chamberlain, Robert Barnes, Jack Beal, and Richard Estes. Although Yoshida saw Golub's work at a gallery exhibition during that period, most important for his appreciation of tribal, folk, and outsider art was the teaching of Katherine Blackshear. A number of artists have acknowledged that Blackshear's practice of taking drawing classes to the Field Museum of Natural History was formative for them. Blackshear, who was a disciple of Helen Gardner and assisted her in an edition of the text *Art through the Ages* (which integrated Western and non-Western art in its broad historical scope), brought examples of African, Native American, Oriental, as well as folk and naive artists into her slide lectures. Yoshida particularly remembers seeing work by New York untrained painter Morris Hirshfield and Wisconsin carver Albert Zahn. Yoshida did not go to, nor did he know of, Dubuffet's lecture in 1951. By the time he began teaching painting at the School of the Art Institute in the late 1960s and had artists of the imagist generation such as Roger Brown, Christina Ramberg, and Phil Hanson in his classes, he not only knew of Dubuffet's interest in untrained artists but also was following in Blackshear's footsteps by bringing outsider and *art brut* materials and publications to share with his students.[14]

Interestingly both Yoshida's art and his appreciation of the work of outsiders were fueled by his friendship and frequent contact with students whom he had first inspired—Brown, Hanson, Ramberg, and others. It was with these friends that Yoshida would search Chicago's Maxwell Street flea markets, looking for what they called "trash treasures," that is, commercial catalogues, advertisements, toys, packaging, and anonymous

handmade objects of all kinds (shell baskets, cigarette packages woven into purses or wrapped around coat hangers, dolls, lawn ornaments, button collections, and much more).[15] This led them to a consideration of folk art, the often anonymous productions of individuals working within established traditions, and more importantly to the acceptance of works by eccentrics, isolates, and untrained artists with a compulsion to express their own visions.

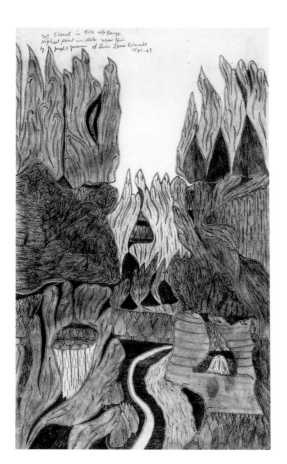

: 124 :
Joseph Yoakum
Mt. Elberst in Elk Mtn. Range, 1967

The Discovery of Joseph Yoakum

Although Joseph E. Yoakum (1886 or 1888–1972) seems first to have been noticed by Karl Wirsum, Jim Nutt, and Gladys Nilsson, Yoshida visited the Sherbeyn Gallery in 1968 and was, like them, immediately taken with Yoakum's work (FIGURE 124). In turn Yoshida brought his younger friends Brown, Ramberg, and Hanson, and thus began the Chicago imagists' deep involvement with the art of Yoakum. An untrained artist living on Chicago's South Side, Yoakum claimed to have been born on the Navaho reservation, to have traveled with the Ringling Brothers circus, and to have taken up drawing late in his life after having a dream he called "a spiritual unfoldment."[16] His intricate, colored drawings with densely patterned geological formations and interlocking ranks of trees are extraordinary fugues on the potential of organic form (FIGURE 125).

Indeed Yoshida found it intriguing that "one man who had no idea of Michelangelo and Cézanne could invent form with an intensity equivalent to the art I knew. Yoakum reinforced the idea that we can learn as much from untrained outsiders as from the mainstream." When asked if the faces and profiles that often occur in Yoakum's geological forms were correlatives of the faces and profiles that appear in his own work (FIGURE 126), Yoshida replied, "Yes, there must be a connection."

While Nutt, Nilsson, Brown, and a number of Chicago artists drew inspiration from Yoakum, none seems to have done so more clearly, and inventively, than Yoshida. His buildup of layered, striated forms, his twisting contours, his sensuous but restrained color, and most of all his short, even-stroked touch are reminiscent of Yoakum. Yet all these elements are utterly transformed into Yoshida's distinctive imagery and handling (FIGURE 127).[17]

Above all, however, it is the sense of animism pervading Yoakum's work that Yoshida seeks to achieve in his own. His interest in animism arose from the stories he heard as a child in his native Hawaii, stories that frequently included spirits of places, particularly of mountains. Interestingly Yoshida's first purchase of Yoakum's work, from the

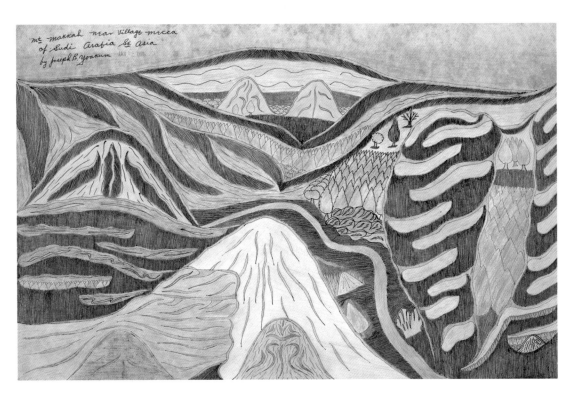

: 125 :
Joseph Yoakum
*Mt. Makkah near Village Mecca of
Sudi Arabia*, 1968

: 126 :
Ray Yoshida
Froggy, 1989

: 127 :
Ray Yoshida
Partial Evidences II, 1973

: 128 :

Joseph Yoakum

Mt. Mauna Kea in Volcanoic Range in Central Hawaii County of Hawaii Islands, 1968

: 129 :

Ray Yoshida

Analogies #3, 1973, collage on paper, 29 ¾ x 22 ¼ in. (75.6 x 56.5 cm), Museum of Contemporary Art, Chicago

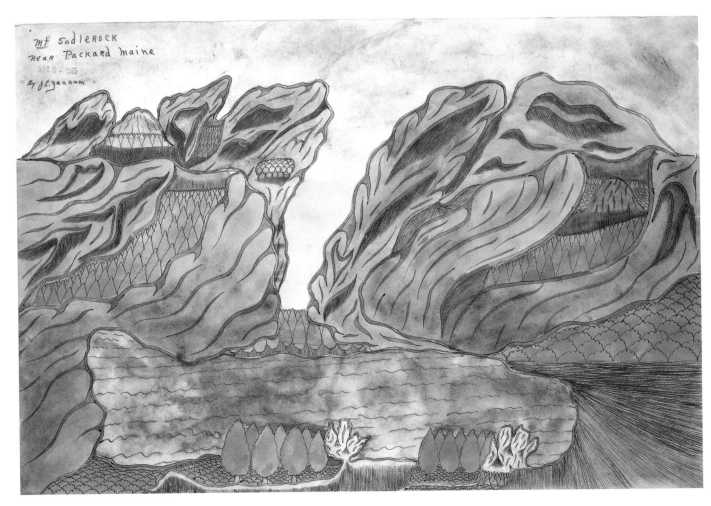

: 130 :

Joseph Yoakum

Mt. Sadlerock near Packard Maine, 1965

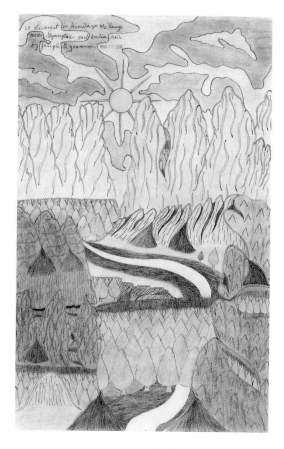

: 131 :
Joseph Yoakum
E. P. Leverest in Himilaya Mtn. Range,
1968

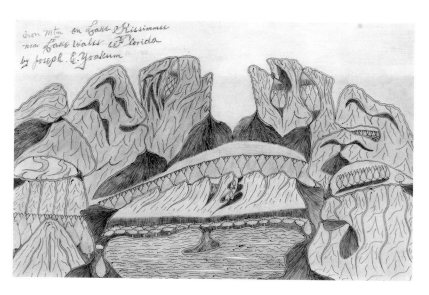

: 132 :
Joseph Yoakum
Iron Mtn. on Lake Kissimmee, 1968

Sherbeyn Gallery, was *Mt. Mauna Kea in Volcanoic Range in Central Hawaii County of Hawaii Islands* (FIGURE 128), 1968.[18] One can see in it a correspondence—in its forms, its hidden faces, and its suffusive animism—to works such as Yoshida's *Analogies #3* (FIGURE 129), 1973.

By late 1968 Yoshida had visited Yoakum's storefront workroom and saw literally hundreds of drawings (FIGURES 130–32). He also noted the copies of *National Geographic* that undoubtedly inspired some of Yoakum's imagery and many of his titles. Yoshida once asked to purchase an unfinished work, and the artist refused, saying it was not complete.[19] That refusal, along with the "copyright" and date Yoakum often applied to his works, indicates his clear consciousness that in spite of, or because of, his avowed inspiration from God he thought of himself as an artist. Too often it is assumed that eccentric or isolate artists have only vision and not a self-awareness as artists. Yoakum unquestionably believed he was working as an artist, despite his lack of artistic training and his remoteness from the art world.

In addition to a number of Yoakums, Yoshida's extensive collection includes African and Oceanic art, Mexican ex-votos, willow furniture, tramp art, ashtray stands, and other anonymous objects of all kinds. He also lives with works by known artists such as Martín Ramírez, Jesse Howard, and Chicagoans Pauline Simon, Aldo Piacenza, Lee Godie, and William Dawson.

Reflecting the opinion of many of the Chicago artists, Yoshida has stated that he does not distinguish between tribal, folk, vernacular, and outsider art. For Yoshida, as for many of his colleagues, it is the intense personal vision embodied in a powerful, invented visual form that provides the principal attraction to the art of outsiders. Interestingly Yoshida's notion of what constitutes an "outsider" is not limited to the untrained visionary; he sees Vincent van Gogh, Auguste Rodin, Edvard Munch, and the Japanese artist Sharaku as outsiders as well.[20]

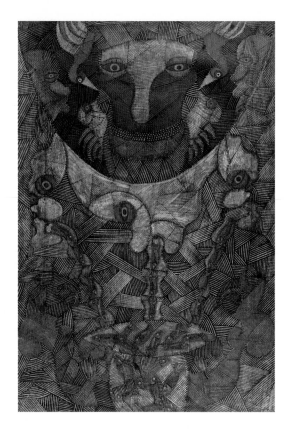

: 133 :
Scottie Wilson (Louis Freeman)
Untitled, c. 1950

Gladys Nilsson,
Jim Nutt,
and the Hairy Who

If any artists epitomize the association of Chicago with a bumptious, raucously adolescent brand of figurative expressionism, they are probably Gladys Nilsson (born 1940) and Jim Nutt (born 1938), closely followed by their compatriot Karl Wirsum (born 1939). These three took part, along with Art Green, Suellen Rocca, and James Falconer, in an exhibition group called—no one seems to know quite why—the Hairy Who.[21] This moniker was so catchy, so rock-and-roll right for a 1960s artists' group in the capital of indifferent middle America that it has frequently been used erroneously to describe the entire imagist group or stylistic phenomena.

The Hairy Who based their imagery on the comics, cheap advertising, and kitsch but always thoroughly transformed these sources through inventive line, high-keyed color, slick surfaces, and a mischievous delight in wordplay of all kinds— puns, misspellings, malaprops, and more. These elements, with clear individual variants not only for the original Hairy Who members but also for the slightly younger exhibition groups they spawned at Chicago's storefront Hyde Park Art Center, such as the False Image (Roger Brown, Christina Ramberg, Phil Hanson, and Eleanor Dube) and the Non-Plussed Some (Don Baum and Ed Paschke, among others), constituted a style that was readily identifiable and, moreover, exportable, a new phenomenon in Chicago during the late 1960s and early 1970s. The artists won prizes at the Art Institute's *Chicago and Vicinity* shows, were included in Whitney Biennials, and in 1973 were chosen to represent the United States in the São Paulo Biennial. Franz Schulze's 1972 *Chicago Imagist Art* exhibition, which traveled to New York, and Jim Nutt's inclusion in the 1972 Venice Biennial cemented the reputation of this broad group.

Frequently dismissed as a *retardataire* combination of surrealism and pop, the work of the Hairy Who and the other Chicago imagists was much more.[22] While it shared with surrealism a frequent transmogrification of figurative elements, a formal inventiveness often based on the organic extension of form, and a playful penchant for both visual and verbal puns, it sought no specific analogues to the subconscious or the dream. The Chicago imagists had no ideological program; they, in fact, refused to theorize or to develop a program (a stance common to the two preceding generations of Chicago artists). They sought to reach beyond conventions of style (or even of good taste) and beyond ideologies to a personal expression based in part on their understanding of outsider propensities. They differed from the pop artists in that their interest in the comics and advertising had to do with the visual communicativeness of the form and not with the subversion of art through copying a debased prototype. While the imagists directed a good deal of irony at the mainstream (their flaunting of abstraction, formal refinement, and historical or aesthetic progress) and self-consciously lampooned their own essential seriousness (the outrageous imagery, the occasional scatology, the puns, and the zany exhibition theatrics), they sought to break through the irony toward a true self-expression.

Jim Nutt's outsider attitude may have been shaped to some degree by his knowledge of the earlier Chicagoans, particularly Westermann, as is now well documented. Nutt worked as a gallery assistant at the Allan Frumkin Gallery, 1964–65, and had the opportunity to see such early Westermann paintings as *Battle of Little Big Horn*, 1959,

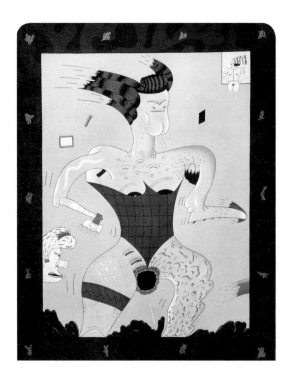

: 134 :
Jim Nutt
Smooth Sailing, 1970

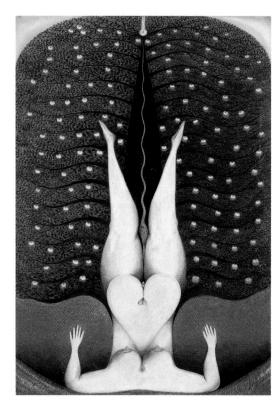

: 135 :
Friedrich Schröder-Sonnenstern
*Die Praxis, oder die
Lebenszauberkünstlerin* (The practice,
or the artist of the magic of life),
1952

which was replete with comics-inspired grotesques and misspellings, and the illustrated letters the artist sent to Frumkin, which extended the same stylization to autobiographical anecdotes.[23] Although Westermann had left Chicago for Connecticut in 1961, Nutt and Nilsson remember his presence as very much felt among their artistic acquaintances, both through the works included in his almost annual shows at Frumkin Gallery and as an example of someone eschewing art-world conventions in favor of an acutely idiosyncratic style.

This interest in unconventional expression had grown in the minds of Nutt and Nilsson, as it had with earlier generations of Chicagoans, through the teachings of the School of the Art Institute. Both Nutt and Nilsson, who were married in 1961, remember classes with art historian Whitney Halstead, who continued and extended Blackshear's instruction in the art of many cultures, folk art, and outsider art. Nilsson remembers a dada and surrealism class in the summer of 1961 during which Halstead showed slides of works by Henri Rousseau, Scottie Wilson (FIGURE 133), Ferdinand Cheval (see FIGURES 9 and 180), and Simon Rodia (see FIGURES 43 and 178) and of the local Surf Cleaners, a dry-cleaning establishment fancifully

painted inside and out by its owner. Nutt also served as Halstead's projectionist and was literally bombarded with hundreds of images of African, Oceanic, Native American, and folk artworks. Both remember undergraduate drawing assignments done at the Field Museum. Also, they came into direct contact with American untrained artists' works when in 1963 Nutt, Nilsson, and Wirsum were included in a show at the Old Town Art Center, a gallery that also exhibited untrained artists Justin McCarthy and Pauline Simon.[24]

Nilsson and Nutt became acquainted with art brut and the art of the insane during their undergraduate years, probably first in Halstead's classes. In approximately 1962, at the Art Institute's Burnham Library, Nutt came upon a book of Friedrich Schröder-Sonnenstern's work and was particularly taken with the aggressiveness of the imagery and its sexual obsessiveness. The disjunction of large and small figures attracted him as well as the transformation of form, particularly in the limbs and extremities, which became almost arabesques. Comparing the Hairy Who period work *Smooth Sailing* (FIGURE 134), 1970, with Schröder-Sonnenstern's *Die Praxis, oder die Lebenszauberkünstlerin* (The practice, or the artist of the magic of life; FIGURE 135), 1952, reveals a

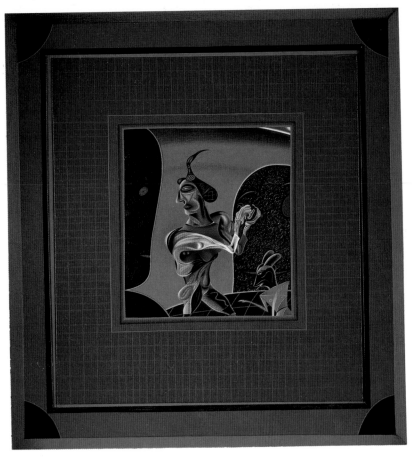

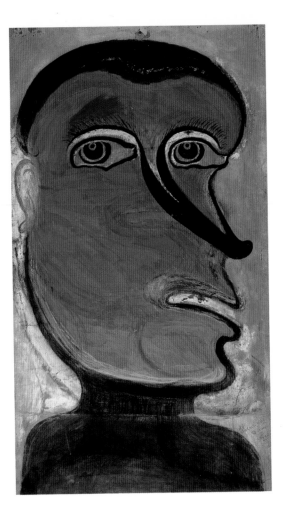

: 136 :
Jim Nutt
Excuse Me (a Touch Surprised), 1974

: 137 :
Heinrich Anton Müller
Tête d'homme (Head of a man)

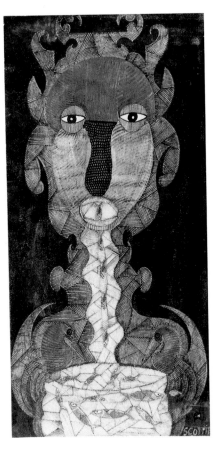

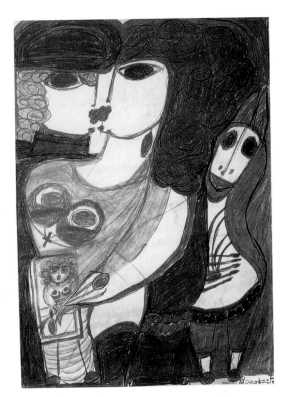

: 139 :
Aloïse (Aloïse Corbaz)
Bonaparte, c. late 1950s

: 138 :
Scottie Wilson (Louis Freeman)
Fish Eater, c. 1950

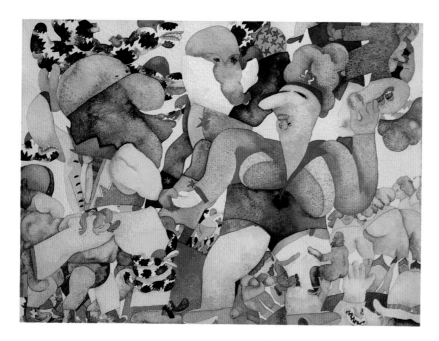

: 140 :
Gladys Nilsson
Stompin' at the Snake Pit, 1968

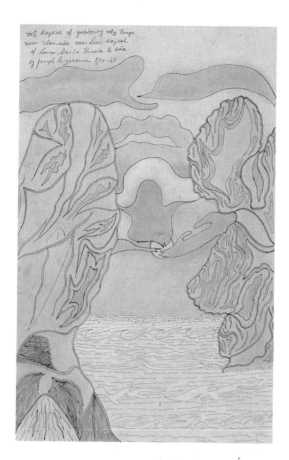

: 141 :
Joseph Yoakum
Mt. Baykal of Yablonvy Mtn. Range,
1969

clear relationship in terms of centrality of the
figurative image, an emphasis on the figures'
sexuality, and a fantastic, playful transformation of
form. Nutt discovered the first *L'Art brut* fascicle
when it appeared in 1964 and followed the eight
volumes published over the next two years; he was
particularly drawn to the reproductions of Adolf
Wölfli's works, responding to their density, their
rhythm of line, and the way the forms abutted (see
FIGURE 71). He also admired Heinrich Anton
Müller's deformations of form and his doubled,
hooked lines. In Nutt's *Excuse Me (a Touch Surprised)*
(FIGURE 136), 1974, there is a distortion of features
somewhat similar to Müller's (FIGURE 137) and a
related snaking, sometimes jagged, line. Nutt and
Nilsson have also been excited by the work of
Augustin Lesage, Scottie Wilson (FIGURE 138), Paul
End, Guillaume, Gaston le Zoologue, Joseph
Crépin, and Aloïse.[25] The dense, fluidly outlined,
and voluptuous forms of Aloïse's *Bonaparte* (FIGURE
139) seem to correspond to Nilsson's watercolors
of the period, particularly *Stompin' at the Snake Pit*
(FIGURE 140), 1968.

In the spring of 1968 Nutt saw a work by
Joseph Yoakum in Wirsum's collection, and soon
thereafter he and Nilsson bought one of Yoakum's
works themselves. Both Nutt and Nilsson recall a
train trip with Karl and Lori Wirsum to a Hairy
Who show at the School of the San Francisco Art
Institute in 1968 during which they all had the
feeling of passing through landscapes reminiscent
of Yoakum. As to Yoakum's specific influence on
their work, Nutt cited the double-lined patterns
that occur frequently in Yoakum's art and began to
appear in his own in late 1968 and 1969 (FIGURE 141).
As for Nilsson, she has stated, "I know there was an
influence, but it's difficult to define. Certainly his
line, patterning, and play of large forms against
small ones interested me [FIGURE 142]. Also the fact
that his work was on paper, which is my principal
medium. He showed me that it was getting the idea
down on paper, not how you got it down [in terms
of others' expectations], that mattered." Nilsson

BOWMAN L o o k i
n g t o
t h e
O u t s i
d e

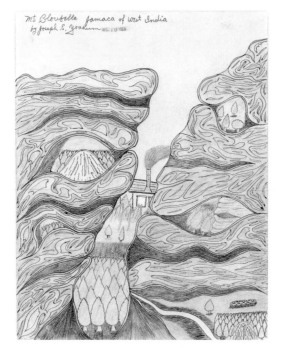

: 142 :
Joseph Yoakum
Mt. Cloubelle Jamaca of West India,
1969

: 143 :
Jim Nutt
I'd Rather Stay (on the Other Hand),
1975

also commented on what may be the central importance of outsider artists for trained artists: "They [outsiders] just did what they had to do. So I felt I could take things from my own life, like shopping for shoes, as my subject if I chose. This freedom to reflect my own life seems particularly true of the work lately."[26]

Shortly after their introduction to Yoakum made them realize that "this art was all around us," Nutt and Nilsson discovered the work of institutionalized California visionary Martín Ramírez. In July 1968 the couple moved to Sacramento where Nutt was to assume a teaching position at Sacramento State University. In August, on his first day at Sacramento State, Nutt was taken on a tour of the facilities. His last stop was the audiovisual room, and there, in bins at the back of the room, along with reproductions of various artworks, were drawings by Ramírez, P. M. Wentworth, and John Podhorsky. These works had been collected by Dr. Tarmo Pasto through his contact with the artists as patients at the DeWitt State Mental Hospital, and he was using them as illustrations for his art-therapy classes. Along with Phil Linhares, who was curating a show of California folk art for the School of the San Francisco Art Institute, Nutt and Nilsson visited Dr. Pasto to see the larger-scale Ramírez pieces. According to Nutt, "It was a feeling of being close to what we knew intuitively was great stuff—a body of work done without anybody. It related to the way we felt about having to do art for oneself first." As to the influence Ramírez has had on his work, Nutt mentioned the geometric patterning he employed at about this time and particularly the use of architectural segments or proscenium settings that began to emerge in his work in the early 1970s.[27] A work such as *I'd Rather Stay (on the Other Hand)* (FIGURE 143), 1975, seems to take up not only elements of a proscenium setting and striated patterning familiar from Ramírez's work, such as an untitled drawing from circa 1950

(FIGURE 144), but to combine them with an extension of the sexually charged interactions and fluid transformations of form found in Schröder-Sonnenstern (see FIGURE 135).

Nutt and Nilsson went on to amass one of the most extensive collections of folk and outsider art among the Chicago imagists. In addition to large bodies of work by Yoakum and Ramírez, the Nutt/Nilsson collection includes outsiders Wölfli, Wentworth, Drossos P. Skyllas, and Californians B. J. Newton and Frank Day among examples of American folk art and African and Oceanic pieces. As with Yoshida, Nutt and Nilsson see no reason to categorize their experience of outsider art, or even psychotic art, as different from their interest in popular, folk, or tribal materials. They respond to all of these in terms of their powerful forms and their potential for direct, primal communication.

: 144 :
Martín Ramírez
Untitled, c. 1950

Roger Brown

No Chicago artist has been more voluble in expressing a nonmainstream position than Roger Brown (born 1941).[28] He began his undergraduate training in the mid 1960s and recalls being then quite captivated by the paintings of Henri Rousseau, Giorgio de Chirico, and René Magritte, still strong referents in his work, as well as those of Albert Pinkham Ryder, Marsden Hartley, Georgia O'Keeffe, Thomas Hart Benton, Edward Hopper, and Grant Wood. For Brown, these artists represent something outside the rationalist, High Renaissance tradition. In his words,

Giotto and Fra Angelico were like outsider artists with a fiercely held personal vision. The Renaissance made rational man the artist. Art became rational and scientific as it got away from simple, pure visions. By the end of the late nineteenth century we began to be liberated from the rational. Artists like Ensor and Munch began to look within themselves. . . . Artists like Rousseau, de Chirico, and Magritte had a clear vision, also Hopper and Wood. I intuitively knew this was the way I saw.[29]

Undoubtedly Brown's embrace of outsider art was due in large part to his educational experience at the School of the Art Institute of Chicago, which he attended from 1965 to 1970, receiving both bachelor and master of fine arts degrees. In 1966–67 Brown took his first painting courses with Yoshida, and as a graduate student, 1968–70, Brown formed important friendships with Christina Ramberg and Phil Hanson. With Yoshida they scoured Chicago's neighborhoods and flea markets looking for the vernacular objects that they all found so fascinating and stimulating. They sought objects clearly tinged with a nostalgia for the 1930s and 1940s (their childhood years) and anonymous objects that were carefully, even obsessively, made. Unlike the pop generation, these Chicagoans were not seeking irony in their adoption of popular culture; they were, instead, searching for a world of feeling.

BOWMAN L o o k i
n g t o
t h e
O u t s i
d e

: 145 :
Joseph Yoakum
Lebanon Mts. near Phoenicia Asia,
1964

: 146 :
Roger Brown
Contrail Crucifix, 1975

Brown too had the benefit of Halstead's art history courses with their liberal interweaving of medieval, Oriental, tribal, and folk art. Halstead also introduced Brown to the work of Dubuffet, to art brut, and to the art of psychotics. Brown too saw slides of Cheval's work, Raymond Isidore's *Maison Picassiette*, and Rodia's *Watts Towers*. All of this more than prepared him for his introduction to Yoakum, which happened when, as he recalls, either Nutt or Yoshida took him to the Sherbeyn Gallery. He was soon seeing Yoakum in the company of Ramberg, Hanson, and Yoshida. What particularly impressed Brown upon his initial exposure to Yoakum's work was his schematic view of landscape, with numerous layered forms building up to a high horizon line (FIGURE 145). He has said, "I was most influenced by his landscapes and began to do my own. Seeing his gave me a feeling of the possibility of moving on [from the somewhat claustrophobic street scenes, highly reminiscent of de Chirico, of 1968–69]. His compositions and patterns were a specific influence, and his Oriental space which goes up the page with a high horizon seemed natural to me. Even the bands of color in the sky reinforced my own."[30] A comparison of an early Brown landscape such as *Contrail Crucifix* (FIGURE 146), 1975, with a typical Yoakum such as *Mt. Phu-Las-Leng in Plateau near Xieng Laos* (FIGURE 147), 1968, reveals just how much Brown did learn from Yoakum's example at a formative time in his career. While Brown's debt to Yoakum's compositional devices and patterning is quite clear, more important, it seems, is Brown's adoption of a kind of stylized vocabulary of forms that is infinitely repeatable from composition to composition, a tendency also seen in Yoakum and in many folk or outsider artists.

: 147 :
Joseph Yoakum
Mt. Phu-Las-Leng in Plateau near
Xieng Laos, 1968

: 148 :
P. M. Wentworth
Imagination: Serp

Following his experience of Yoakum, Brown was actively to seek out other examples of outsider art. In 1970 Brown made his first trip to Europe, where he saw in more depth the Sienese and other Italian "primitives" he so much admired. More importantly he visited, along with Ramberg and Hanson, the Collection de l'Art Brut in Lausanne. In 1971 Brown read Gregg Blasdel's 1968 article on folk art environments and traveled through the Midwest, visiting the environments of S. P. Dinsmoor, Dave Woods, Ed Root, and Jesse Howard. Also in 1971 he visited an artist brought to his attention by Halstead, Kentucky carver Edgar Tolson, from whom he purchased some pieces; and Brown also in that year organized an exhibition of Chicago untrained artist Aldo Piacenza's work. The birdhouse constructions of Piacenza, modeled on cathedrals he remembered from his native Italy, certainly influenced Brown's decision in 1974 to begin making painted constructions similar to the stylized buildings represented in his own paintings. In 1972 Brown traveled to South Dakota by way of northern Wisconsin, where he photographed the environment of Fred Smith. Another Wisconsin trip took him to the Dickeyville Grotto and the environment created by Herman Rausch. Many of his photographs of these environments were shared with Herbert Hemphill and appeared in his and Julia Weissman's groundbreaking book *Twentieth-Century American Folk Art and Artists* in 1974. In 1973 Brown visited Tolson again and bought additional works for his collection. He has explained that he began to feel more positively about his own Southern roots as he came to appreciate how Tolson's Appalachian culture was reflected in his work. Also, around 1973–74, Brown became cognizant of Ramírez, Wentworth (FIGURE 148), and Newton through Phyllis Kind, who was exhibiting these artists brought to her attention by Jim Nutt. In 1974 Brown returned to Europe, again with Ramberg and Hanson and also with Barbara Rossi, where they viewed the Collection de l'Art Brut, the Prinzhorn Collection in Heidelberg, and the collection of the Adolf Wölfli Foundation in Bern.[31]

Barbara Rossi

Barbara Rossi (born 1940) remains one of the less widely known of the Chicago imagists despite the fact that she participated in the last of the imagist group exhibitions at the Hyde Park Art Center (*Marriage Chicago Style*, 1970, and *Chicago Antiqua*, 1971) and most of the various museum exhibitions examining the Chicago imagist phenomenon. She shares with many of her imagist colleagues an intense interest in outsider and visionary art. Rossi's regard for this art coincides, as it does with her colleagues, with a respect for European northern and Italian "primitive" painting and Oriental, tribal, folk, and popular art. In recent years Rossi has been engrossed by Persian and Indian miniature painting and Indian folk art. In addition to appreciating the formal and decorative interplay of much of this art, Rossi is particularly drawn to its religious or spiritual intent; her own art has recently been compellingly interpreted as something of a spiritual journey.[32]

Rossi's early mature style emerged almost full-blown in 1967–68.[33] Her early works, mostly drawings in graphite and colored pencil, are almost entirely Arcimboldesque heads made up of fluidly outlined, organic forms. *Sovereign* (FIGURE 149), 1968, for example, resembles parts of the body, organic in the most visceral sense. Rossi has stated that this early work "had no precedent in my making of art or in my visual experience of the time. These works did not come from a teacher's suggestion either, but seemed to come out of nowhere or of their own accord. Yet I did recognize it as more vital and more thoroughly personal than anything I had done before." She calls these works "stream-of-consciousness drawings"[34] because she employed what might be thought of as an automatic drawing technique in an attempt to move beyond the control of the conscious mind and let the form flow spontaneously. Working out from the center of the paper, Rossi could "free-associate" the developing forms into generalized shapes of face, head, and shoulders.[35] This technique is important in that it predisposed her to look at the work of those artists—for example, outsiders and psychotics—for whom creation is much less (or perhaps not at all) a matter of conscious control.

Rossi was introduced to the art of outsiders and mental patients in the summer of 1968, when she took a School of the Art Institute class in "Fantastic and Eccentric Art," taught by a visiting artist, collagist Ray Johnson. During that class she came across the book *Psychoanalytic Explorations in Art*, by Dr. Ernst Kris. Of her response to the artists illustrated (among them August Neter [see FIGURE 79] and August Klotz), Rossi said,

I was happy to find work that looked as odd as mine and perhaps odder. The work by Prinzhorn artists radically modified familiar cultural symbols by a curious internalization. This work employed, as did mine, multiple figures—more or less abstracted—to create a composite image of a single figure. It employed an elaborate system of substitution of one reality for a part of the whole of another reality. The system of substitution distracted them from easy perception of the whole. The "total" image was somewhat disguised and hidden.

Rossi has said of the emotive power of these images,

Unlike Arcimboldo's work, which I was also coming to know at the same time (through the same class), the substitutions were not always from the same genus and species of form, and the juxtapositions were far more startling. Behind these double (and sometimes more) entendres, I perceived a quiet scream. . . . The scream seemed to proceed from these artists' awareness of their distance from their imagined viewers in "the outside world." In their visual language of stranger substitutions and juxtapositions as well as more abstracted form being used as substitutions, I sensed a greater psychological necessity for sending the disguised hidden message to the world beyond their immediate environs. Next to this work Arcimboldo's seemed more an art game of form than personal communication. Though I did not identify with the isolating condition of mental illness which the Prinzhorn artists shared, my encounter with their work reinforced my own . . . language of the time."[36]

By late 1968 Rossi was taking classes with Yoshida and Halstead. She particularly recalls Halstead's dada and surrealism class, which included many examples of European outsider artists. Although she did not see the Hairy Who shows at the Hyde Park Art Center, Rossi did see their work in the 1968 *Chicago and Vicinity*

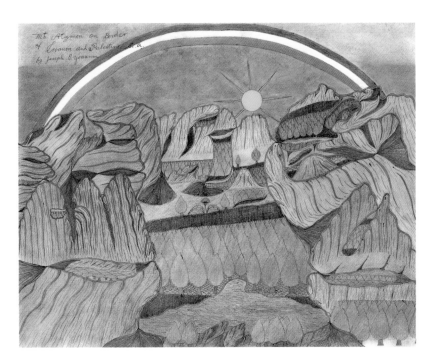

: 149 :
Barbara Rossi
Sovereign, 1968, colored pencil and
graphite on paper, 13 x 10 in. (33 x
25.4 cm), collection of the artist

: 150 :
Joseph Yoakum
*Mt. Atzmon on Border of Lebanon and
Palestine*

: 151 :
Barbara Rossi
Brr'd and Baa'd, 1972

exhibition. Rossi met Brown, Ramberg, and
Hanson in 1969 when Don Baum included her
work with theirs in the *Don Baum Says: "Chicago
Needs Famous Artists"* exhibition at the Museum of
Contemporary Art.

Interestingly Rossi first heard of Joseph
Yoakum not from Brown, Ramberg, and Hanson
but from Halstead, who helped her acquire works
for her own small collection in the early 1970s.[37]
Yoakum reinforced Rossi's use of automatic
drawing. In her view Yoakum's work seemed to
flow from an unbridled imagination yet resulted
in a significant and powerful form (FIGURE 150).
Obviously, too, Yoakum's forms were primarily
organic, strongly correlative with Rossi's own.
Working as she does from center to edge, Rossi
feels that her forms "unfold" in much the same way
as Yoakum's. Also, she believes her content, like
Yoakum's, reflects something of a spiritual
unfoldment as well (FIGURE 151).[38]

Rossi's other involvement with folk and
outsider art included visits to Cheval's *Palais idéal*
in 1971, Wisconsin's Holy Ghost Park in 1971,
Fred Smith's Concrete Park in 1975, various
environments in Illinois and Missouri in 1975–76,
and the Museum of International Folk Art in Santa
Fe in 1982. Most important for her study of outsider
and psychotic art was a trip to Europe with Brown,
Ramberg, and Hanson in 1974, during which they
visited the *Maison Picassiette*, the Collection de l'Art
Brut, the Prinzhorn Collection, and the Wölfli
Foundation. Rossi suggested these collections to

: 152 :
P. M. Wentworth
Moon, 1952

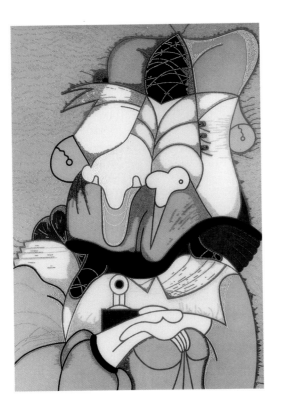

: 153 :
Barbara Rossi
Sea-N-Cipher, 1974, acrylic on
Plexiglas, oil on wood frame, 39 ¼ x
29 x 2 in. (99.7 x 73.7 x 5.1 cm),
private collection

the group and wrote all the introductory letters to
arrange the visits. She went on to document, with
notes and slides, folk art museums in Basel,
Munich, and Vienna. She also began visiting the
prison art shows at the Stateville Correctional
Center, Joliet, Illinois, in 1982, first in the company
of Yoshida and then on her own. Perhaps most
important for her recent work have been her travels
to India in 1982–83, 1985–86, and 1989, which
included viewing of traditional, folk, and tribal art,
much of it in the form of architectural ornamenta-
tion and mural painting. One site that she relates
to outsider art is the Rock Garden by Nek Chand in
Chandigarh.[39] Her collection, which is quite small
by comparison with Yoshida's, Nutt/Nilsson's, and
Brown's, includes Indian folk art and work by
Yoakum, "Peter Charlie" Bochero, Skyllas, Went-
worth (FIGURE 152), Piacenza, and little-known,
untrained artist Adam Berg of Wisconsin.

As for the specific influence of outsider art on
her own work, Rossi cites several examples: her
Sea-N-Cipher (FIGURE 153), 1974, has a mitered,
bishop figure that forms the forehead and nose of
the larger head and is based on Neter's *Antipapst*
(Antipope; FIGURE 154), circa 1917, which is
reproduced in Kris's book; she also sees August
Klotz's *Wurmlöcher* (Worm holes; FIGURE 155), 1919,
from the Prinzhorn Collection, as the inspiration for
the upper-left form in her drawing *Graces' Rigor*
(FIGURE 156), 1976; and a work by American out-
sider Bochero in her own collection provided the
compositional model for her drawing *A Lake in a
Dream*, 1976.[40] Certainly the dense interlace evident
in her drawing *Sailing Stage* (FIGURE 157), 1975,
relates as much to the interwoven forms of
Wölfli (see FIGURE 232) as to her simultaneous
appreciation of Celtic manuscript illuminations. As
with most of the Chicago artists, Rossi synthesizes
her interest in outsider and psychotic art with
myriad other sources to achieve a form that is both
visually compelling and communicative of some
deeper resonance. That resonance, especially in her
more recent works, might be described, despite the
frequent playfulness and humor, as mystical and
spiritual, as her "disguised hidden message to
the world."

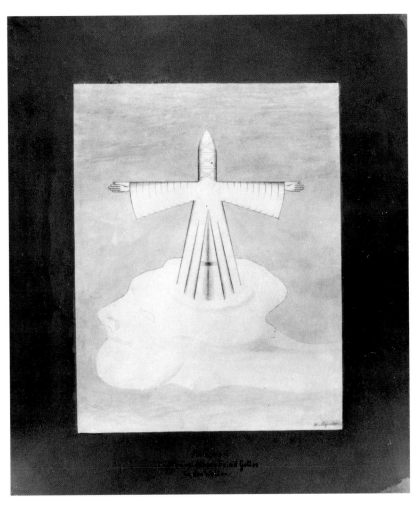

: 154 :
August Neter (August Natterer)
Antipapst (Antipope), c. 1917

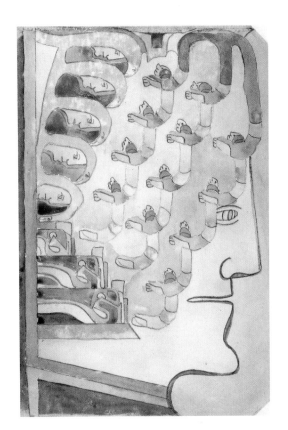

: 155 :
August Klotz (August Klett)
*Wurmlöcher (Badegesichter),
Wurmzüge (Klavierstockzähne),
Wurmbänder (Speichelbadeleben der
Erzleiergallerie)* (Worm holes [bath-
faces], wormtrains [pianostickteeth],
wormbands [spittlebathlife of the
archlendergallery]), 1919, pencil and
watercolor on paper, 13 ⅛ x 9 ⅞ in.
(33.4 x 25 cm), Prinzhorn Collec-
tion, University Psychiatric Clinic,
Heidelberg

: 156 :
Barbara Rossi
Graces' Rigor, 1976, graphite and
colored pencil on paper, 23 x 29 in.
(58.4 x 73.7 cm), private collection

: 157 :
Barbara Rossi
Sailing Stage, 1975

Conclusion

In the consideration of all these artists several key
points arise, which seem to define what might be
called an "outsider tradition" in Chicago. First, the
artists of Golub's generation, despite the similarity
of their interests in expressionism, surrealism,
and primitivism to those of the first abstract
expressionist generation of the 1940s, developed an
antithetical style that clung to the figure as a vessel
for emotive communication. Golub's investigation
of schizophrenic art and art brut and his effort to
emulate schizophrenic means in his *Inself* series
were attempts to reach and express a raw psychic
state. Later generations of Chicago artists adhered
to this need for powerfully felt content and the
figure as the means of expression. Second,
apparently feeling their distance from world art
centers, Golub and Westermann deliberately chose
to create art "outside" mainstream theoretical
and stylistic positions. Third, and a point that
cannot be overemphasized, was the importance of
the School of the Art Institute of Chicago, or at
least a group of teachers there, in presenting a
range of artistic precedent that included Italian
"primitives," the northern European expressive
tradition, Oriental, tribal, folk, popular, and
outsider art. It is worth noting that Chicago
collections have reflected a similar range of
interests, frequently mixing expressionist or
surrealist work with tribal art. Fourth, and probably
as a result of this broad-based educational tradition,
the Chicagoans tended to group the work of
outsider or psychotic artists with other kinds of art
that embodied, for them, distinctive formal and
expressive power.

With the possible exception of early Golub,
the Chicago artists have not shown an interest in
the psychic state that produced the art they have
admired. What unifies the Chicagoans' attitude and
draws them so strongly to the work of outsider
artists is both the outsiders' position beyond society
and their obsessive need to communicate through
their art. The "quiet scream," in Rossi's words,
resulting from this need is what compels these
Chicago artists not only to absorb aspects of
outsider art but to seek a similar level of emotive
expression in their own work.

■

1 **Notes**
The most definitive source
on the Chicago generations
emerging between 1945 and
the early 1970s is Franz
Schulze, *Fantastic Images:
Chicago Art since 1945*
(Chicago: Follett, 1972).
Although Schulze includes all
three generations under the
rubric of *Chicago imagist*, the
term has come to be widely
used to refer only to the
last generation, which is
the way I have employed it
throughout this essay.
2
Patrick T. Malone and Peter
Selz, "Is There a New
Chicago School?" *Art News*
54, no. 6 (October 1955):
36–39, 58–59.
3
Franz Schulze, "Chicago,"
Art News 57, no. 10 (February
1959): 49, 56.
4
Schulze, *Fantastic Images*,
11–13.
5
Golub and Spero in
conversation with Carol
Eliel, December 9, 1989.
Golub recounted the
conversation to the author
on January 9, 1991. In
Lynn Gumpert and Ned
Rifkin, "On Power and
Vulnerability: The Art of
Leon Golub," *Golub*, exh. cat.
(New York: New Museum of
Contemporary Art, 1984), 13
n. 8, the year that Spero
presented the *Art
d'aujourd'hui* issue to Golub
was incorrectly given as 1949.
6
The first Dubuffet work to
enter the Art Institute of
Chicago's collection was
*Supervielle, grand portrait
bannière*, 1947, acquired in
1950.

7

Dubuffet's lecture was delivered in English at the Arts Club of Chicago on December 20, 1951, in conjunction with an exhibition of the artist's work at the same institution. For a transcription of the text, see *Arts Magazine* 53, no. 8 (April 1979): 156–57. For a more complete account of the impact of Dubuffet's lecture and art on the artists of Chicago, see Dennis Adrian, "The Artistic Presence of Jean Dubuffet in Chicago and the Midwest," in *Jean Dubuffet: Forty Years of His Art*, exh. cat. (Chicago: David and Alfred Smart Gallery, 1984).

8

Leon Golub, "A Critique of Abstract Expressionism," *College Art Journal* 14, no. 2 (Winter 1955): 142–49.

9

Lawrence Alloway, "Leon Golub: The Development of His Art," in *Leon Golub*, exh. cat. (Chicago: Museum of Contemporary Art, 1974), unpaginated.

10

Selz, quoted in Joan Ley Thompson, "Golub," in Lee Nordness, ed., *Art: U.S.A.: NOW* (Lucerne: C. J. Bucher, 1962), 361.

11

Barbara Haskell, *H. C. Westermann*, exh. cat. (New York: Whitney Museum of American Art, 1978), 11.

12

Bill Barrette, ed., *Letters from H. C. Westermann* (New York: Timken, 1988).

13

Hopps, in conversation, December 27, 1990.

14

Yoshida, in conversation, November 6, 1990.

15

For an examination of the collecting enthusiasms of all the later Chicago imagists, see *Made in Chicago: Some Resources*, exh. bro. (Chicago: Museum of Contemporary Art, 1975).

16

See the Yoakum biographical note in *Outsiders*, exh. cat. (London: Arts Council of Great Britain, 1979), 162.

17

For a thorough evaluation of Yoshida's development and his relationship to other Chicago artists, see Dennis Adrian, *Ray Yoshida: A Review*, exh. cat. (Chicago: N.A.M.E. Gallery, 1984).

18

Yoshida, in conversation, November 6, 1990.

19

Ibid.

20

Particularly because of the influence Yoshida's collection has had on his students, a large selection from it was exhibited at the School of the Art Institute in 1985. See *Ray Yoshida's Adoptive Home for Misplaced Muses*, exh. bro. (Chicago: School of the Art Institute of Chicago, 1985).

21

For a discussion of the origins of the Hairy Who, see Franz Schulze's early article on the group, "Chicago Popcycle," *Art in America* 54, no. 6 (November–December 1966): 102–4. For a discussion of origins of the name, see Schulze, *Fantastic Images*, 160.

22

For a discussion of the distinct style of the Chicago imagist generation, see Russell Bowman, "Chicago Imagism: The Movement and the Style," in *Who Chicago?* exh. cat. (Sunderland, England: Sunderland Arts Centre, 1980), 21–28.

23

Haskell, *H. C. Westermann*, 46.

24

Nutt and Nilsson, in conversation, November 7, 1990.

25

Ibid.

26

Ibid.

27

Ibid.

28

See Russell Bowman, "An Interview with Roger Brown," *Art in America* 66, no. 1 (January–February, 1978): 106–11. See also Roger Brown, "Rantings and Recollections," in *Who Chicago?*, 29–33.

29

Brown, in conversation, November 7, 1990.

30

Ibid.

31

Ibid. For a complete chronology and examples from Brown's collection, see also Sidney Lawrence, *Roger Brown*, exh. cat. (New York: Braziller, in association with the Hirshhorn Museum and Sculpture Garden, Smithsonian Institution, Washington, D.C., 1987).

32

See Carol Becker, "Drawing from the Subtle Body," in *Barbara Rossi: Selected Works 1967–1990*, exh. cat. (Chicago: Renaissance Society at the University of Chicago, 1991), 17–27.

33

For a full discussion of the chronological and stylistic development of Rossi's work, see Dennis Adrian, "Barbara Rossi," in ibid., 3–16.

34

Rossi, draft letter (unsent) to Suzanne Ghez, director, Renaissance Society at the University of Chicago, January 29, 1991. Given to the author May 7, 1991.

35

Rossi, in conversation, May 7, 1991.

36

Rossi, draft letter to Suzanne Ghez, January 29, 1991.

37

Ibid.

38

Rossi, in conversation, May 7, 1991.

39

Ibid.

40

Ibid.

Playing Tennis with the King:

Visionary Art in Central Europe in the 1960s

MARK GISBOURNE

I visited the Künstlerhaus (Artists' house) at Gugging near Vienna on February 28, 1990, the day before the psychotic artists and poets there were awarded the state art prize named for Oskar Kokoschka. Ironically Kokoschka's own works had been denounced by being compared to those of the mentally ill in the infamous *Entartete Kunst* (Degenerate art) exhibition organized by the National Socialists in 1937 and traveling to Vienna in 1939.[1] The presentation of the award was another milestone in the public recognition of outsider art that began when Jean Dubuffet's own collection of *art brut* was exhibited at the Musée des Arts Décoratifs, Paris, in 1967.[2]

Behind this recognition we find, among conventionally trained artists, distinctive strategies with regard to outsider art throughout the century. Invariably the basic driving force and initial material innovation has been that of the outsiders themselves, whereas the identifiable artists of culture have responded by acts of innovative appropriation. These range from emulation and simulation to outright embodiment. It is equally true, however, that the outsider artists are not outside cultural influence as Dubuffet frequently claimed.[3] Overstatement and oversimplification have dogged these materials from the days they were first recognized, a matter further complicated by the frequent inability of outsider artists to speak for themselves.

The power of outsider works was reinforced for me in a strange way during my visit when one of the patients, the poet Edmund Mach, confided that he used to work on an ocean liner and there frequently played tennis with the king of England. It transpired that Mach, contrary to my disbelief, had worked on board ships; however, playing tennis with the king was simply a figment of his imagination. Such suppression of boundaries between the imaginary and the real—the creation of a universe of spontaneous expression and material adaptation, whose meaning, while apparently hermetic, is yet somehow concrete on its own terms—has been a constant in the attraction of outsider works.

Vienna

In Central Europe in the 1960s outsiders were again to create a pole of attraction as they had for Max Ernst, Ernst Ludwig Kirchner, Paul Klee, and other early twentieth-century artists.[4] Arnulf Rainer (born 1929) and Georg Baselitz (born 1938), who in the 1960s drew upon the inspiration of psychotic artists, had been interested earlier in surrealism. In 1951, at age twenty-two, Rainer traveled to Paris to meet André Breton, though he was somewhat disappointed by the meeting.[5] Of greater import to him was an exhibition, *Véhémences confrontées*, of works by Willem de Kooning, Georges Mathieu, Jackson Pollock, and Jean-Paul Riopelle.[6] Their works preoccupied him throughout the 1950s, replacing his interest in surrealism with the metaphysical subjectivism represented by his paintings of the period. He returned to Vienna and by 1953 had destroyed all the surrealist works remaining in his possession.[7] Even so there remained a desire to leave the world of reality for one shaped by the imagination.

Take painting as an example of something that forsakes this kind of world, to unveil its culture and painting through itself, without getting mixed up with the world, unveil it as a substitute for absent and lost metaphysical bonds (where there is neither act nor mission nor evidence nor art), to reveal it as a mere link between the aesthetic and the metaphysical.[8]

Georg Kern (later Baselitz) was similarly drawn to surrealism, avidly reading the sources that had inspired the surrealists themselves, including Lautréamont's *Chants de Maldoror* (Songs of Maldoror) and the writings of Antonin Artaud, Charles Baudelaire, and Samuel Beckett.

That Berlin and Vienna had no real history of surrealist involvement is significant, since we have to consider why, when Central European artists responded to outsider or art brut materials, they were drawn almost invariably to the productions of schizophrenics and other persons confined in mental hospitals and not to the wider parameters of outsider art as defined in France. Rainer, Baselitz, and to a lesser extent A. R. Penck (born 1939) developed distinct artistic strategies based on ideas taken from outsider artists and their experiences. The psychiatric traditions of Central Europe— Sigmund Freud and the Freudian psychoanalysts in Vienna, Carl Jung and Walter Morgenthaler in Switzerland, and Hans Prinzhorn (rediscovered in Germany in the 1960s)—were natural poles of gravitation distinct from the French tradition of philosophical and psychological automatism codified by Pierre Janet and adapted by Breton. Moreover these psychiatric theorists were part of the Central European intellectual tradition, which these artists comprehended innately from the points of view of language and context. Therefore strategies born of both image and text often underpin the Central European artists' use of outsider art in the 1960s; this is in marked contrast to the earlier surrealists who generally favored the images "raw."

Abstract art did not sweep all before it in Central Europe; postwar dislocation led to a rather bland adoption of *tachisme*, or *art informel*, generally interpreted as a French gestural equivalent of American abstract expressionism.[9] Neither did pop art, with its overly optimistic view of popular culture, find fertile soil. Vienna was just a few kilometers from the Iron Curtain, which had a somewhat sobering effect on artists who lived there. "Austria," Rainer observed, "was on the front line or at the edge of the Western world, and so it is in this context that my work seems very different and individual. Today, I think this is not so: I am inclined to believe [my work] is part of the tradition of Middle Europe, or something like that."[10] Similarly West Berlin was an island in a sea of East German socialist realism, its alienation reinforced by the erection of the Berlin Wall in 1961.

Rainer began collecting outsider materials in the early 1960s. The first works in his collection were by mental patients. Married to a Czech, he traveled to Prague, Budapest, and Warsaw and gained access to psychiatric collections there. He acquired an archive of Czech psychiatric materials, though he is reticent to identify the source. It is evident that the condition of insanity held more

than a pictorial fascination for him: "What interested me more and more were not only the images alone but every form of document, texts, photographs, histories of illness."[11]

Rainer has frequently spoken of his interest in the physical, graphic qualities of the works and not the image alone. This is a feature that markedly separates his concerns from earlier surrealist and art brut considerations and connects him with the expressionist tradition of Central Europe. (These graphic qualities are the same that first attracted Baselitz.) In the 1950s, when Rainer started painting his famous *Übermalungen* (overpaintings), he began his compulsive repetition of themes inspired by mystical Buddhist and Christian writings, including those of Jakob Böhme (1575–1624), which developed into series of works. Repetition is also characteristic of the works of psychotic artists, who are frequently drawn to religious themes of persecution, punishment, sex, and death. The cross appears continually in the 1950s as a motif in Rainer's work (as it does in works by Baselitz throughout the 1960s).

Dismissing religious obsessions as part of the Austrian baroque pictorial tradition would not negate the appeal of madness for Rainer. "An artist," he has asserted, "must be a little psychotic to be a good artist, or so the theory runs."[12] Madness and hence psychotic artists, he has claimed, offered him a way back to the elemental state of man. He has frequently acknowledged that his drawings in the 1960s were influenced by psychotic art but more importantly that they essentially sought a confrontation with the primitive: "As I am of another generation, later than that in which African and Oceanic art had already been much used, for me these materials were a confrontation with a type of primitive art."[13] In this manner the psychotic artist became for Rainer a means of identification and a cultural strategy with which to attack the existing situation in Vienna, a city he felt had been largely bypassed by modern art since the 1920s.

The desire to outrage was endemic to most of the art produced in Vienna in the 1960s, not least because there was a strong feeling among many younger artists that fascism had not been purged as it had in Germany. Many Austrians were claiming to have been victims of the Nazis, when in reality a significant proportion of the population had welcomed the *Anschluss* in 1938.

The years 1960–65 were the period of *Aktionismus* (actionism), an action painting and performance movement that employed the ritual disemboweling of animals, overt and violent eroticism, and strategies of direct cultural subversion.[14] Veit Loers has described the roots of the works produced by the movement as "surrealism, the CoBrA group, Dubuffet, expressionism, art brut and graffiti."[15] The movement itself turned exclusively, and logically, to performance in 1966–71.[16] An interest in religious themes, violated genitalia, and death pervaded the movement, as they do the works of the Gugging artists Johann Hauser and August Walla (FIGURE 158). There are also striking thematic comparisons between the deformed and sexually ambivalent genitals and self-mutilation depicted by Günther Brus and Baselitz; both artists have experienced government repression and/or confiscation of their works. Baselitz's *Die grosse Nacht im Eimer* (The great night down the drain; sometimes translated as The great piss-up), 1962–63, which shows a distorted figure masturbating, was seized by the police when it was exhibited in West Berlin in 1963;[17] several Aktionismus artists were incarcerated later in the decade.[18]

Clearly Aktionismus was not unrelated to the *arte povera*, *nouveau réalisme*, pop art, fluxus, happenings, and no-art movements of the 1960s. What it shared with outsider art were deconstructional characteristics that broke down the language and convention of signs that constituted modern art. Madness and the irrational are forms of cultural transgression; one need only witness the discomfiture experienced by people in the presence of the mentally ill. Above all the exaggerated and often radical manifestations of Aktionismus

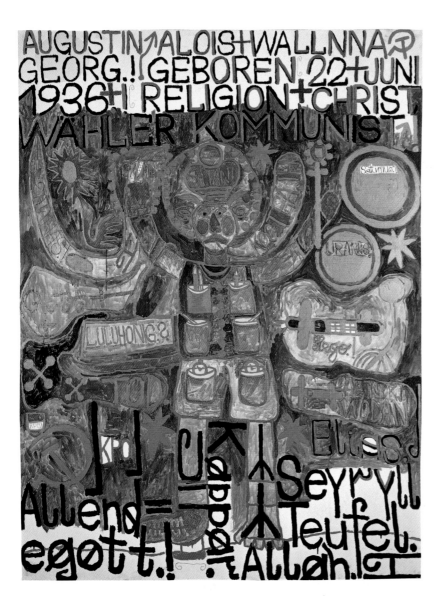

: 158 :
August Walla
Religion-Christus (Religion-Christ),
1983

reflected the marginalization felt in Vienna and its project, or desire, to contribute once again to the larger international art scene. The fact that it was more shocking than the related performance movements in other countries represented the overassertion the artists felt necessary to gain some form of international acknowledgment.[19]

Given Austria's geographical marginality, it is not surprising that there were only two principal avant-garde venues in Vienna, and these were politically and ideologically polarized. The Aktionismus manifestations were mostly connected to the Galerie Junge Generation (Young generation gallery), an organ of the socialist party. (The party distanced itself from the most radical of the Aktionismus performances.) The other exhibition space was that of the Galerie nächst St. Stephan, owned by the Catholic church but partly financed by the conservative party, whose director was the enterprising Monsignor Otto Mauer. This was the home of art informel in Austria; it had exhibited Rainer's works and after 1969 works by psychotic artists from Gugging.[20]

While Rainer, a Catholic, was not directly associated with Aktionismus, he could hardly have remained untouched by the value they placed on action and experience. Indeed on certain occasions he even championed some of the works produced by the group. Accordingly his turning toward the work of outsiders would appear to have been less for its formal characteristics than for the potentialities of the psychotic state itself. Though Rainer's and Hauser's works of the 1960s share graphic qualities of effacement, it was the condition of "being mad" that Rainer linked with primitive impulses, transgressive powers, and the possibility of retrieving "old forms and primitive expression by bringing them into contemporary times." These became the impetus for his art.[21]

In 1965 Rainer began experimenting with hallucinogenic drugs, initially LSD, in order to simulate specific mental states. Shortly afterwards, in 1966, he traveled to Dr. Alfred Bader's Center for the Study of Psychopathological Expression in Lausanne.[22] There, under the influence of

: 159 :
Egon Schiele
*Photographisches Selbstporträt mit
geschlossenen Augen* (Photographic
self-portrait with eyes closed), 1914,
gelatin-silver print, 3 ⅛ x 2 ³/₁₆ in.
(8 x 5.5 cm), Graphische Sammlung
Albertina, Vienna

psilocybin, he continued his effort to simulate
different psychoses in order to produce psychotic
works of art. The drug left him too disoriented to
work but increased his admiration for psychotic
artists.

In 1967 Rainer wrote his essay "Schön und
Wahn" (Nice and mad),[23] in which he articulated
his interest in the mimetic powers of catatonics as
manifested in their facial expressions. His photo-
booth experiments, 1967–68, simulating such facial
expressions, were an extension of a long-established
Austrian interest in facial distortions and grimaces;
one has only to think of Richard Gerstl's famous
Selbstporträt, Lachend (Self-portrait, laughing), 1907,
and Egon Schiele's *Photographisches Selbstporträt mit
geschlossenen Augen* (Photographic self-portrait with
eyes closed; FIGURE 159), 1914. He continued his
investigations into both the physical and
psychological experiences of madness in his
Körpersprache (Body language) series.[24] (A similar
curiosity about the bodily distortions of the
mentally ill is to be found in Max Ernst's famous
painting *Rendezvous des amis* [Rendezvous of
friends], 1923.[25])

In the mid 1970s Rainer returned to the subject
of facial distortions in his series of overdrawings
of the Austrian baroque sculptor Franz Xaver
Messerschmidt (FIGURE 160), whose famous
distorted heads mingled several forms of insane
facial expressions into a single work. An obsession
with distorted heads and/or compendium elements
of the human face is typical of many psychotic
artists, including the late Rudolf Horacek at the
Künstlerhaus, Gugging, whose work is close in
style to the portrait heads of schizophrenics
reproduced by Dr. Pastural in 1911.[26] That the
source for Rainer's distortions derived from
psychotics is evident in his writings: "Like Louis
Soutter, I am often assailed by a multitude of faces.
And so, rather than remain defenceless in the
wilderness of patho-physiognomy, I have made the
experiment of tackling the onslaught head-on,
through forms that pre-exist in the culture [FIGURE
161]."[27]

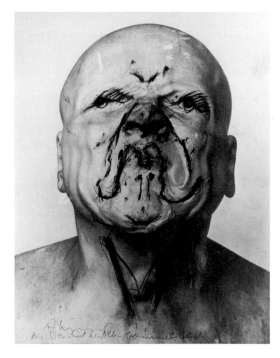

: 160 :
Arnulf Rainer
Die Weisheit des Alters (Himmelsblick)
(The wisdom of age [view of
heaven]), oil chalk on photograph,
24 x 18 ½ in. (61 x 47 cm), collection
of the artist, Vienna

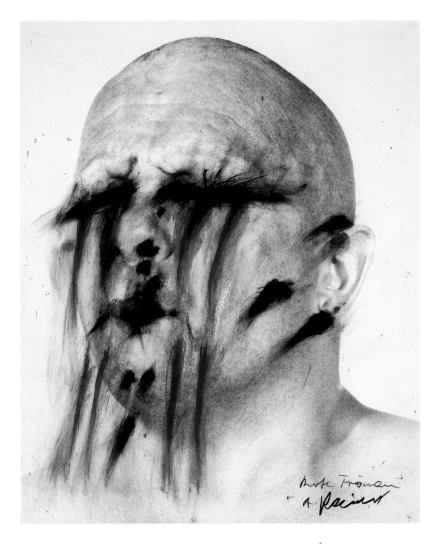

: 161 :

Arnulf Rainer

Rote Tränen (Red tears), 1970

: 162 :

Johann Hauser

Hubschrauber und Feuer
(Helicopter and fire), 1982

About the condition that led increasingly to **179** identification with the psychotic state, he wrote: **I devote myself to the contemplation of a concise, minimal form of overpainting. But this cannot hold my interest indefinitely: sometimes the swarming of the faces around and within my head is just too insistent. Cause: perhaps a dearth of close personal contacts, perhaps some individual stress? Are these the paranoiac's familiar hallucinations of mocking faces, the menacing leers, the piercing unnerving stares, the faces that come too close to one's own?**[28]

From the late 1960s onward Rainer's agenda was set by his pursuit of the simulation of psychotic states. Soutter's finger paintings (see FIGURE 47) became the impetus for his own series of hand paintings from 1971 onward.[29] For Rainer, true art existed at the margins; it was "painting to forsake painting," as his essay of the early 1950s proclaimed. The artworks of psychotics appeared a real art and possessed for him a synthesis between that created and that lived. In this context it was not surprising that Rainer was the first Austrian artist to champion the work of Hauser (FIGURE 162) and the other patient-artists at Gugging.[30]

It is evident that although Vienna had been the city of Freud, there was from the beginning a marked dichotomy between the great man's view of the mind as a dynamic entity and the day-to-day practices of Austrian clinical psychiatry. When Leo Navratil (born 1921), who was later to found the Künstlerhaus, first came to the hospital in the late 1940s, the situation was little different from that of the large, anonymous psychiatric institutions of other countries in Europe. Confinement and the euphemistic "normalization" of the inmates were the major concerns. The use of electroshock therapy as a means of restraint and remediation was just as evident there as in France, where the system had been used earlier on Artaud at Rodez.

What started as an interest on the part of Navratil in psychiatric testing developed into a practiced system followed by the slow realization on the part of the doctor that among his many patients there were some with exceptional talent. He had first become interested in the drawings of the mentally ill as early as 1950, when studying at

Maudsley Hospital in London. There he came across Karen Machover's book on personality projection.[31] Navratil returned to Vienna and throughout the 1950s tested his patients drawing the human figure. Extending Machover's simple system, he got his patients to draw at different stages of their illnesses; that is to say, when in severe psychotic episodes and when their illnesses were arrested and they were more normal. Navratil observed that "what was interesting for me was the discovery that during the patients' severe psychotic state the drawings were much more creative and original and often more artistic than in their other states, where everything appeared far more conventional and ordinary."[32]

While at first these drawing experiments were conducted simultaneously with traditional therapies, such as electroshock and neuroleptics, Navratil concluded, "It was interesting to see and observe the effect of these therapies. I could see the effects and at the same time noted during severe stages of psychosis drugs were inhibiting their creativity."[33]

In the early 1960s, his observations reinforced by the writings on Aloïse Corbaz by his friend Bader,[34] Navratil minimized, or in some cases eliminated, drug intervention. Given the severity of his patients' illnesses, the goal was less rehabilitation as citizens in society than "habilitation" as artists.

The accomplishments of Hauser, Walla, and other Gugging artists and poets prompted Navratil throughout the 1960s and 1970s to seek a creative environment in which they could live together as a community and pursue their art. All Navratil's subsequent endeavors—the establishment of the Künstlerhaus in 1981, numerous public exhibitions,[35] sale of the artists' work, separate bank accounts for each artist—were part of this process of habilitation, in essence, facilitating artistic expression. In this respect Navratil's position differed from Dubuffet's: Navratil has always perceived the patient-artist as a gifted psychotic and not, as in Dubuffet's antipsychiatric perspective, as a producer of art detached from illness.

Although from the beginning it was principally Hauser's art that attracted Rainer, it was the liberation of all the Gugging artists and poets from the forum of psychiatric congresses that both Rainer and Navratil strove to achieve. In the intervening twenty years Rainer has sought to stage a joint exhibition with Hauser, but the latter has always refused.

It was in 1966 that Hauser was placed directly under Navratil's supervision. Hauser's work, like Rainer's, often begins with existing materials, often photographs in magazines found at the Künstlerhaus. (He rarely responds to reproductions of modern art, but on occasions when he does, it is invariably a work that is figurative and academic.) Whereas Rainer effaces the source (FIGURE 163),[36] Hauser takes the image as the starting point of his *de*formation; though it must be said that he is hardly aware that he is deforming the source as such. Indeed he believes himself most often to be making improvements to the image. While Rainer's source images are effaced and obscured, relating to his idea of the primitive mark, Hauser's works elaborate and emphasize particular features depending on the specific *state* of his psychosis at the moment.[37] When he is medicated, his drawings are reminiscent of a child's copying an assigned motif. When he is in an arrested depressive state, his drawings are frequently reduced to a block of black on a white paper ground or to such a simple form as a red heart (FIGURE 164). The deformation becomes heightened, however, when he is in an intense psychotic state, and he lays particular emphasis on things like teeth, breasts, and female sexual organs (FIGURE 165). From a medical/psychological standpoint these characteristics of his drawings are seen to be determined by the clinical traits of physiognomization, formalization, and symbolization, a reductive formula that reflects the scientific desire to describe, define, and categorize phenomena in the world in which we live.[38] From an aesthetic viewpoint, however, Michel Thévoz, the director of the Collection de l'Art Brut, has written that "Hauser likes to place his universe in a state of tension, that is to say, between the

: 163 :
Arnulf Rainer
Frau im Mehl (Woman in flour), 1969

: 164 :
Johann Hauser
Herz (Heart), 1967, pencil, wax, and
crayon, 8 ¼ x 11 ⅝ in. (21 x 29.5 cm),
Städtische Galerie im Lenbachhaus,
Munich

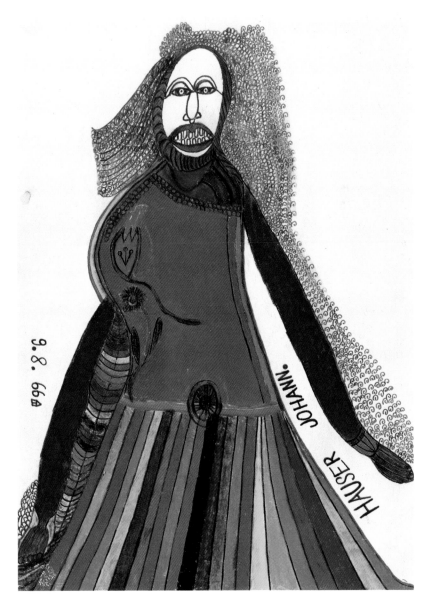

: 165 :
Johann Hauser
Frau, 9.8.66 (Woman, 9.8.66), 1966

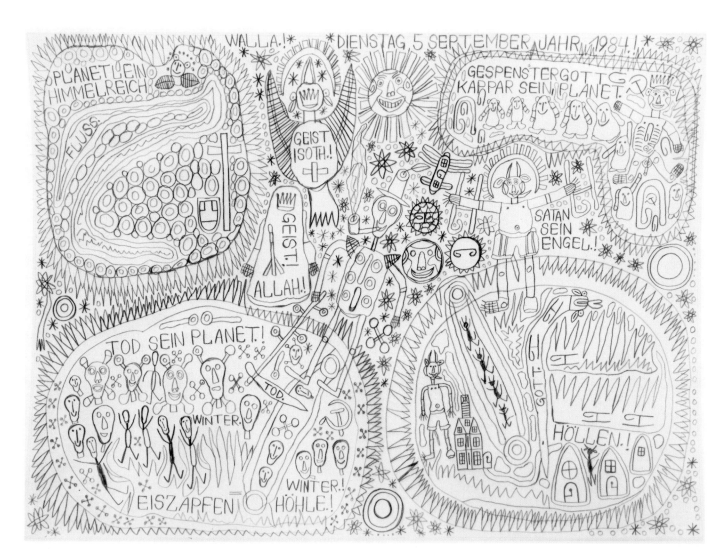

: 166 :
August Walla
Planeten (Planets), 1984

poles that we might determine as the real and the imaginary, the visible and the mental, the image and the sign, description and generalization, formulation and omission, centrifugal energy and closed form."[39]

The distinctions inherent in these positions represent the essential dichotomy that has separated medical from artistic discourse throughout this century. That Hauser cannot explain his deformations is of little consequence on the one hand to an artist like Rainer, who is concerned with the quality of the state that ends in the thing produced; while on the other hand, a doctor's concern is with explanations of the biochemical or psychical predispositions that produced it. What is at risk of being lost in such arguments is Hauser's need to describe the world in this way; it is such compulsive need, whether psychopathological or not, that has always given integrity to the outsider in the mind of modern masters. From the banal source materials he chooses or has been given, Hauser remakes the world as he wants it, altering and distorting images to assuage his compulsive yearnings. In a state of acute mania the need is all the more intense, and therefore he relinquishes contact with the real and replaces it with the imaginary real. That this may be reduced to a system of definable marks does not diminish the impact for the viewer.

August Walla's interest in creating imaginary landscapes and symbolic environments began in the late 1960s, when on a small allotment garden near the Danube he assembled wood, metal scraps, and broken pots. These discards were arranged as if to take on an animistic or totemic function, then painted with words whose meanings were known only to him. Pebbles were placed in configurations signifying certain essential notions such as hell. Walla believes that his projection of a symbolic view of the world gives potential life to these materials: "If one day destroyed objects without life were possessed of a soul then those things which are neither animals nor man would ascend to heaven."[40] Political symbols (swastikas, for instance, and the hammer and sickle), manifestations of his obsessions, abound in

Walla's paintings along with such idiosyncratic abominations as the ÖVP (Österreich Volks Partei), the Austrian conservative party (FIGURE 166). The color red has from childhood symbolized certain devilish associations for the artist. He perceives himself as some malefic demon, in contrast to his mother, whom he views as benign and life sustaining. There is a strong, emblematic frontality to his figures. Unlike Hauser he rarely shows female genitalia, favoring erect penises thrusting out of trouser flies or hanging in a flaccid state from beneath the hems of skirts. These works are often intended as a form of demonic self-portraiture. His angels, by contrast, are usually without gender. Gods, churches, and religious symbols and personifications of himself and his mother as hare and leveret are profuse.[41]

Unlike other psychotic artists Walla has exhibited great interest in photography; he painted his camera green because he did not like its original black. In 1970 he photographed himself naked in the manner of his pictures, holding a painted sign to his chest.

Walla works at enormous speed, unable to put his crayon or brush down until he has filled every inch of paper or, more recently, canvas with images and words. This suggests a persistent *horror vacui*. Perhaps for us the most significant element of Walla's art is his fascination with language, which he sees both in material terms as well as in his world of private predicates (see FIGURE 48). He is fascinated by foreign dictionaries, never ceasing to add to his collection. Although he does not understand such languages as Slovenian, Indonesian, Korean, or Bulgarian, they function as a point of departure into his private world. Over the years he has developed a decisive calligraphy, another feature he shares with his predecessor Adolf Wölfli.

A deep concern with impenetrable and imaginary languages is something that has preoccupied outsider artists throughout the century. In this respect outsiders have also shown a concern parallel to those many modern artists who have, through word and image, sought to question the arbitrary nature of language and its predicates.

Berlin

The situation of Baselitz in the 1960s was somewhat analogous to that of Rainer, although the work of the German master is more easily assimilable within the context of traditional art-historical sources as opposed to that of madness itself.

Baselitz became interested in schizophrenic artists immediately after his arrival in West Berlin from the east in 1958. Given the peculiar situation of the city at that time, this hardly seems surprising. Surrounded by the German Democratic Republic and facing the other half of a divided city, there was a palpable psychological tension in the years before the erection of the Berlin Wall. Whereas in the mid 1950s Baselitz had been interested in the mystical writings of Böhme, an interest not unrelated to that of Rainer in Vienna, by late in the decade he had gravitated toward surrealism, particularly issues of anamorphism (deformation). Finding it impossible to respond to the dogma of socialist realism, he was expelled in 1956 from the Kunsthochschule (Weissensee), the school of applied and visual arts in East Berlin, for "socio-political immaturity." Similarly, after enrolling in 1957 at the Akademie der Künste (Academy of fine arts) in West Berlin, he was unable to accommodate himself to the bland abstraction taught by his professor Hans Trier. In the dozen years that followed, that is, until 1969, when he began to invert his motifs, he drew upon a group of sources that were quite directly taken from schizophrenic artists.

Reading Karl Jaspers's *Strindberg und Van Gogh* (Strindberg and van Gogh) introduced him to the late nineteenth-century Swedish schizophrenic artists Ernst Josephson and Carl Fredrik Hill (FIGURE 167),[42] whose works embody many of the characteristics associated with Baselitz's *Neuer Typ* (New type) series, begun in 1965. (Baselitz in recent years has amassed a collection of Hill's work.) Baselitz's *Der Hirte* (The shepherd; FIGURE 168), 1965, is reminiscent of Josephson's *Das Erwachen* (The awakening), 1895, which depicts a similar clumsy figure with large hands and feet, his genitals exposed. While the *Neuer Typ*, usually depicted surrounded by devastated symbols of

Baselitz's own childhood in Saxony, represented for Baselitz the artist in revolt, an epithet frequently applied to him in the early 1960s, it also asserted the key role of deviance and madness in achieving the stature of an artist in revolt.

At the time he discovered Jaspers, he also came into contact with Prinzhorn's writings. Baselitz's *G-Kopf* (G-head), 1960, was loosely adapted from the work of a psychotic whom Prinzhorn identified simply as Case 13;[43] contrary to an earlier suggestion,[44] the motif was not derived from Jean Fautrier's *Otage* (Hostage) series, 1944–45. Similarly his *Oberon*, 1963–64, in which four heads with serpentine necks, painted in fleshy pink tones on a red ground, may be taken as a detail from a Prinzhorn Collection work executed by the schizophrenic Paul Goesch (FIGURES 169–70).[45] Given Baselitz's preoccupation with anamorphism, the emphasis he placed at that time on physiognomical distortion appears to have been resonant with psychotic art. The numerous crosses in his works of these years also mirror their appearance among the Prinzhorn artists. The totemic qualities of Baselitz's later sculptures seem further to owe as much to the works of Prinzhorn's Karl Brendel (1871–1921) as they do to such German expressionist precedents as Kirchner.[46]

Whether we regard these sources as firm or speculative, there is evidence that Baselitz identified with additional artists. His *Hommage à Vrubel—Michail Vrubel—1911—Alte Heimat—Scheide der Existenz* (Homage to Vrubel—Mikhail Vrubel—1911—The old native country—Border of existence), 1963, is a somber painting in which a flayed human appears alongside a dark void. A single brutal eye engages the viewer accusingly. Mikhail Vrubel (1854–1911), a Russian symbolist, suffered severe manic-depressive illness and spent the last years of his life in confinement. We may assume that the corpse in Baselitz's painting is Vrubel himself.[47] The same might be said of his *Hommage à Charles Meryon* (Homage to Charles Meryon), 1962–63; Meryon similarly experienced mental disturbance. The themes of madness, dream, death, sadomasochism, and violation pervade

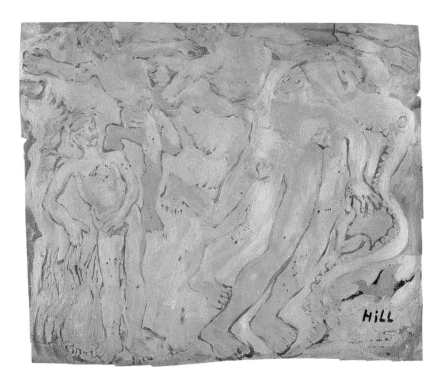

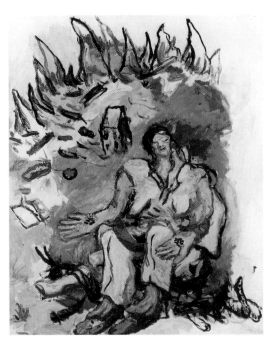

: 167 :
Carl Fredrik Hill
Untitled

: 168 :
Georg Baselitz
Der Hirte (The shepherd), 1965,
oil on canvas, 63 ¾ x 51 ³/₁₆ in.
(162 x 130 cm), private collection

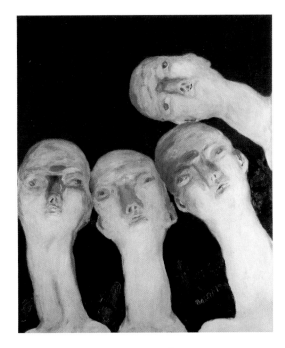

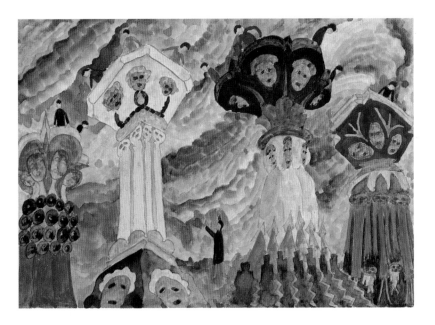

: 170 :
Paul Goesch
Traumphantasie (Dream fantasy)

: 169 :
Georg Baselitz
*Oberon—Erster Orthodoxer Salon
64 E Neizvestny* (Oberon—First
Orthodox Salon 64 E Neizvestny),
1963–64, oil on canvas, 98 ⁷/₁₆ x 78 ¾
in. (250 x 200 cm), private collection

: 171 :
Georg Baselitz
Untitled, from the *Peitschenfrau*
(Whipwoman) series, 1964

nearly all Baselitz's works of the first half of the
1960s, whether it is his *Peitschenfrau* (Whipwoman)
series (FIGURE 171), 1964, in which masochism
is most evident (he was reading Leopold von
Sacher-Masoch at the time), or the anguished
isolation of onanism, in which alienated
gratification is always experienced alone. While it
should be remembered that all these pictures were
preceded by Baselitz's discovery of Prinzhorn,
perhaps even more significant for him were the
writings of Antonin Artaud.

Baselitz was most intensely absorbed in the
writings of Artaud during the years 1960–63, that
is, roughly from the time of his painting *Paranoia*,
1960, and the extraordinary drawing he made in
1962 of Artaud masturbating (FIGURE 172), a
drawing that foreshadowed *Die grosse Nacht im
Eimer*. For the German artist, the French poet
represented the ultimate brutalized creative being.
Artaud's role as the mad prophet of the postwar
period is comparable in many ways to the gloss
given in the first half of the century to van Gogh's
life. Indeed what is perhaps Artaud's most
significant text, "Van Gogh le suicidé de la société"
(Van Gogh the man suicided by society), is a
diatribe against a festering world:

**You can say all you want about the mental health of van
Gogh who, during his lifetime, cooked only with his hands,
and other than that did no more than cut off his left ear, in
a world in which every day they eat vagina cooked in green
sauce or the genitals of a newborn child whipped into a
rage plucked as it came out of its maternal sex. And this is
not an image but a fact abundantly and daily repeated and
cultivated throughout the world. And thus, demented as
this assertion may seem, present day life goes on in its old
atmosphere of prurience, of anarchy, of disorder, of
delirium, of dementia, of chronic lunacy, of bourgeois
inertia, of psychic anomaly (for it isn't man but the world
that has become abnormal), of deliberate dishonesty and
downright hypocrisy, of a mean contempt for anything that
shows breeding.[48]**

: 172 :
Georg Baselitz
Antonin Artaud, 1962, ink on paper,
10 1/16 x 8 5/16 in. (25.6 x 21.1 cm), gift
of the Karl August Burckhardt-
Koechlin Fund to the
Kupferstichkabinett Basel

: 173 :
Karl Brendel (Karl Genzel)
Mann und Frau mit Hobel und Massstab
(Man and woman with plane and
ruler)

The writings of Artaud provided Baselitz both
a persona and a way to shock the world, feeding the
artist's sense of severe isolation in the face of banal
bourgeois art produced in Berlin at the time. In
1961 Baselitz issued the first of two *Pandemonium*
manifestos, in which he mimicked Artaud's
assertions and rhetorical style.

Under the blanket a being stirs, and behind the curtain
someone laughs. In my eyes can be seen the altar of
Nature, the sacrifice of flesh, bits of food in the drain,
evaporation from the bedclothes, bleeding from stumps
and aerial roots, oriental light on pearly teeth of lovely
women, gristle, negative shapes, spots of shadow, drops of
wax, parades of epileptics, orchestrations of the flatulent,
warty, mushy, and jellyfish beings, bodily members,
braided erectile tissue, mouldy dough, gristly growths in a
desert landscape.[49]

While containing many of the visual notions that 187
would preoccupy Baselitz in the years up to 1965,
the form of this statement is also greatly indebted
for its rhythm and tone to Artaud. Figures depicted
on the broadside, shown with erect penises, are
inscribed "A. Artaud." In the second manifesto,
1962, Baselitz again mentions Artaud, calling him
the "bursting sign."[50]

It is apparent that what constituted an outsider
for Baselitz was what the world termed a deviant or
disordered person; anyone thought of as deviant,
whether trained as an artist or not, was grist for his
mill (in contrast to Rainer, who was generally
interested in untrained psychotics). Josephson, Hill,
Vrubel, and Meryon were all trained artists, and
Artaud was an acknowledged writer who became
mentally ill. When Baselitz looked to the untrained,
psychotic artists of the Prinzhorn Collection, he did
so purely for their motifs; that is to say he did not
choose to simulate or identify with madness itself,
in contradistinction to Rainer. It should be noted
that before 1966 Baselitz's familiarity with the
Prinzhorn Collection consisted of, it seems,
reproductions in the psychiatrist's famous text and
not any actual experience of the works themselves.

The lucky survival of the Prinzhorn Collection
represented the confluence of antithetical
intentions.[51] When Prinzhorn died of typhus in
1933, the contribution made by insane artists to
an understanding of the nature of creativity came
to an abrupt end in Germany, but in the twelve
subsequent years of National Socialism the works
themselves survived as exemplars of "degeneracy"
and as cudgels to decimate those works by
modernist artists with which they were compared.[52]
In this way several works by insane artists,
including two sculptures by Karl Brendel from the
Prinzhorn Collection, were included in the guide
for the Nazis traveling exhibition *Entartete Kunst*
and possibly in the exhibition itself (FIGURE 173).[53]
It may be that the Nazis' biologically determined
use of Brendel's work colored Ernst's subsequent
choice of the schizophrenic sculptor as his
inspiration in 1961.[54]

For twenty years after the war the collection moldered in a damp attic at the Heidelberg clinic, largely forgotten. It was not until the intervention of Maria Rave-Schwank, a medical assistant at the clinic in the mid 1960s, that the situation improved and the extraordinary scope of the collection came to light. From 1966 to 1972, when Rave-Schwank left, the almost six thousand works were put into some order and thereafter finally catalogued.[55] A small exhibition of works from the collection was held at the Galerie Rothe, in Heidelberg, in 1967.[56] Once again the impact of the works on contemporary art became apparent, a fact that almost certainly led to republication of Prinzhorn's famous text the following year.[57]

The impact on Baselitz's own art in the second half of the 1960s, that is, after he actually saw the works in 1966 at the Heidelberg clinic, is far more difficult to assess, not least because his art was undergoing rapid formal changes in his Fracture paintings, 1966–69.[58] The six months he spent at the Villa Romana in Florence (1965) had redirected his art toward painterly concerns related to mannerism and the conventions of naturalistic distortion typical of the works of the sixteenth-century Italian masters. In this way the distorted forms that in his earlier works had been derived from those of psychotic artists mingled with broader aesthetic considerations. The tendency for Baselitz to stress "ornamental infill" and "surfaces covered by repeating ornament" has usually been connected with mannerism and the rejection of mimetic determinism. More recent writers have tried to trace Baselitz's ornamental tendencies back to older German aesthetic issues expressed by Wilhelm Worringer, who in his *Abstraktion und Einfühlung* (Abstraction and empathy), 1908, claimed that the impulse to imitate nature was nothing more than an "absurdity" imposed upon artists by the history of art.[59]

While Rafael Jablonka rightly described the artist's tendency toward "a pronounced linear structure . . . emancipated from the classical function of imitation, and which has as its purpose the articulation of the picture surface,"[60] he nevertheless ignored the immediate precedent, in that Baselitz's ideas were gathered directly from the writings of Prinzhorn—ideas so apparent that in the artist's statement "Warum das Bild 'Die grosse Freunde' ein gutes Bild ist" (Why the picture "The great friends" is a good picture), 1966, he repeated not merely the main characteristics written of earlier by Prinzhorn but also used the same type of descriptive language.[61] This explicit demonstration of the significance of Prinzhorn's text for Baselitz throughout the first half of the 1960s and the fact that the artist finally saw the collection in 1966 indicates that we have no need to look further for aesthetic and philosophical foundations for Baselitz's ideas on the role of ornamentation. His rejection of classical mimesis is rooted in the psychological tradition of Prinzhorn's theory of the "ornamental urge," or "environment enrichment," and as such is evident in abundance among the works of the schizophrenic artists cited by the psychiatrist, who described it as a primary primitive impulse in man.[62] Psychotic artists generally do not demonstrate any stylistic development (though their technical facility may improve); the ornamental urge is manifest in fixed patterns of repetition. This explains in large part why these productions have for so long remained in the province of medicine and not art. Filling the surface is implicit in the phenomena of horror vacui, an established observation in regard to psychotic art.

What distinguishes Baselitz's ornamental urge is its deep concern with the tradition of painting. It is as if he took the ornamental schizophrenic distortions and placed them at the service of a new system of formalist picture making. The fracturing of the image into disconnected surface elements is also found in the work of Asger Jorn, the CoBrA artist, who arrived at a similarly "dismembered" arrangement of his images in 1951–52 (see Sarah Wilson's essay in this volume).

: 174 :
Georg Baselitz
Weisshaariger Mann
(White-haired man), 1983

CoBrA and Dubuffet assimilated various surrealist concerns in postwar France, and the fact that Baselitz was attracted to these same concerns reflects a parallel interest in the creative role of madness. The productions of outsiders gave him a means to attack the prevailing hegemony of abstraction without reviving a banal illusionist figuration; the former tended toward purely aesthetic considerations, while the latter brought with it all the incumbent theoretical problems of the autonomy of picture making at the time. The inverted images that after 1969 became his signature may also be seen as indebted to outsider art (FIGURE 174). Such inversion is common enough among psychotic artists who work around the picture in a circular manner, turning it as they go, leading to figures that appear vertically, horizontally, and inevitably upside down. An artist like the Italian psychotic Carlo springs immediately to mind (see FIGURES 5 and 236–38).[63] A familiarity with border patterning and ornamentation led Baselitz to similar upside-down elements, a characteristic that can be seen interpretively in the transitional period of his work in 1968–69. A painting like *Waldarbeiter* (Woodman), 1968, shows the fragmented figure pinned horizontally to a vertical tree; in another work of the same title, upside down on the tree; a year later the entire motif has been inverted. If Baselitz's works appear not to show the psychotic sources in a literal way, it is because by the late 1960s he had so fully assimilated the theoretical aspects of Prinzhorn's work that he no longer felt compelled to emulate psychotic imagery.

What had begun as adaptations from psychotic art became a much more complex strategy in the processes of Baselitz's art. Unlike Rainer, he never sought to simulate the experiential terrors of madness but rather to see madness as a way to exorcise the past. Madness was for him an antiauthoritarian stance in a country whose recent cultural history was one of fascist repression, a repression still in force in the East German state he had abandoned. As Donald Kuspit has stated:

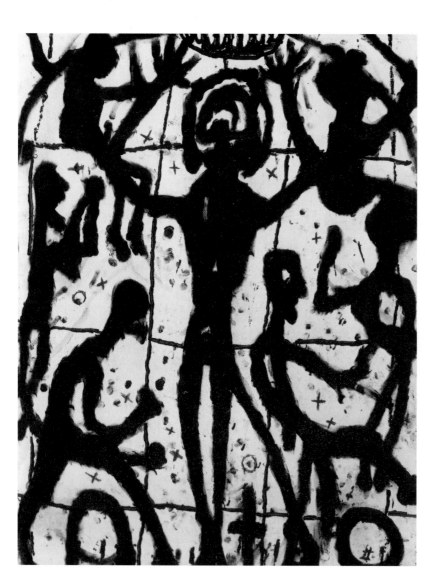

: 175 :
Louis Soutter
L'Ascension (Ascension)

Baselitz's early antiheroes deliberately flaunt their degeneracy or madness. They are Hitler's victims become devilish, haunting Germany with its own mad aggression. . . . The pandemonium of his pictures—he makes the pandemonium latent in the image as manifest as possible, to the point of disintegrating the image—is a post-war response to Nazi repression and authoritarianism, appropriating it for the higher purpose of artistic revelation of the madness that underlies art and existence in general.[64]

These historical concerns were endemic in Germany and Austria throughout the 1960s. In retrospect they make it possible for us to discern circumscribed national schools of painting in the face of the international styles that swept all before them elsewhere. History saturated the works of Joseph Beuys, Jörg Immendorff, Markus Lüpertz, and many others, which illustrated an intense and significant rift within Central European culture. Not all chose to look at the art of psychotics, but those who did found a correlation between the Nazi proscription of the Jew and the situation of the madman. The state of madness and mad art unearthed an existential experience, one so subjective at its extreme that it seemed totally incommunicable and alienated. Such experience, intensely intimate and personal, by compulsive necessity affirmed an inverse pole of attraction, a condition far removed from the biological determinism and proscriptive formulas inherent in Nazi theories of art. Yet even with its antidogmatic character it revealed a new psychological didacticism, one in which unconscious cathartic motives emerged in an attempt to expiate the repressed traumas of the past.

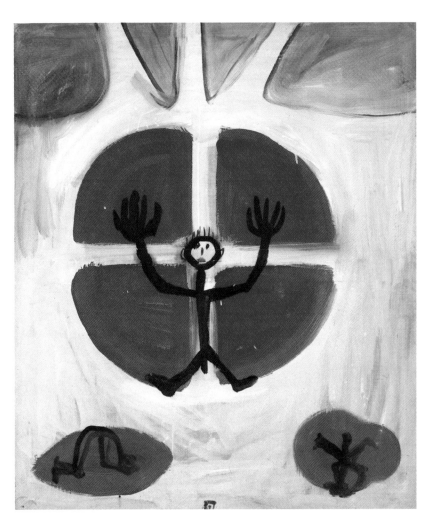

: 176 :
A. R. Penck
Kreuʒ (Cross), 1968

:
One day in 1961, before the border between East and West Berlin was sealed, A. R. Penck[65] visited his friend Baselitz in the West, returning that evening to East Berlin, little sensing perhaps the political and social "ice age" that was to come. Penck and Baselitz were from that day separated for nineteen years.

The relationship of Penck to outsider art is difficult to establish. While Penck has often declared himself an outsider, he is not an outsider as we define it. It is true that he was largely untrained, but from early in his life he was aware of art and the subversive role it plays in society. Forbidden admission in 1955 to the academies of East Berlin and Dresden, he made his living as a boilerman, postman, and night watchman. His first recognition as an artist came in 1961, when a few of his works were shown at the Akademie der Künste der DDR (Academy of fine arts, GDR) in East Berlin.

Pictures such as those shown at that time, later to be called his World Pictures, preoccupied him for the next six years. With their elongated, sticklike figures, they show close affinities with the finger paintings of the psychotic Louis Soutter, an influence Penck disavows.[66] His denial begs scrutiny, however, since Penck began to develop what have been called his Neo-Stone Age World Pictures[67] at the very time the first major retrospective of Soutter's work toured Germany.[68] As Penck had made frequent visits to the West before the wall was built, it seems likely that he saw reproductions of the work in German art journals. Further circumstantial evidence can be gleaned from his relationship with Baselitz inasmuch as his friend was pursuing outsider sources.

A comparison of Soutter's *L'Ascension* (Ascension) with Penck's *Kreuʒ* (Cross) of 1968 is totally persuasive (FIGURES 175–76). Both possess a flat background and figures with large hands and feet, and both use gesticulation as signals to the viewer. In other drawings by Penck we find lines bordered by dots, very like those used by Soutter.[69] Penck has adapted them to a didactic purpose, as if to rationalize Soutter's impenetrable meaning and

192 GISBOURNE P l a y i
n g
T e n n i
s
w i t h
t h e
K i n g

create a communicable system of signs. The Soutter figures appear to be constrained by the dimensions of the picture surface, a feature common to psychotic art, while those of Penck are rationally ordered both in space and composition.

Despite such analogies, Penck's World Pictures do not appear to reflect an interest in madness per se. His art is much indebted to that of Klee; some commentators have gone so far as to claim that his works complete the investigations of the earlier German master,[70] though Klee's sources included the art of children as well as psychotics. Penck made use of pictograms to free the articulation of human experience from the rationalized slavery of written language. This led in turn to the more developed *Standart* (Standard) system, which he has used since 1967.

At a time when Penck was particularly attracted to cybernetics, information systems, and even nuclear physics in the 1960s, his pictorial conventions drew upon primitive cave paintings and bear comparison with those more instinctual forms of creation. He clung throughout the 1960s to the notion that he was an amateur scientist-painter who was creating new ideological metaphors to confront the East German authorities, who in turn considered him little more than a subversive deviant.

The isolation he experienced in the 1960s in East Germany, where his art was thoroughly rejected, has made it extremely difficult to establish precise influences apart from those the artist has chosen subsequently to acknowledge. Championed by Michael Werner, a Cologne art dealer, Penck had his first solo exhibition in the West in 1969.[71] An interest in finding a rational form of communication expressive of the psychological reality of images is indicative of his attraction to systems, and in this respect his signs have been compared with Jackson Pollock's famous psychoanalytic drawings, which also attempted a form of signlike objectivity.[72] What separated Penck from Rainer and Baselitz was clearly a desire to establish an objective system, and he appears to have had little interest in the expressive subjectivism that surrounds much outsider art.

It should be said here that *outsider* is something of a historical misnomer in that many "insider" artists, precisely because of their appreciation of the authenticity of the hermetic, or imaginary real, have been attracted to outsiders, denying that these artists have sought to communicate. The outsiders do not of necessity see what they produce as inexplicable. It was the intensity and nature of their untutored visions along with their obsessive personalities that left them open to the deterministic categorizations of medicine and psychology. This has been the case even in those circumstances where they are not confined but reside at large in the community.

Penck and his systems have themselves been criticized by Robert Hughes for being similarly uncommunicative, to which Penck has responded, "Well, yes, in a way he is correct. I think I would often underline that. If it were different, then my interest would quickly disappear. Mystery, coding, is essential. Once you have crossed the threshold of naivety that coding process starts automatically."[73]

The statement vindicates to some extent Penck's relationship to outsider art: it locates his work within the broad theoretical tradition linking the work of primitives, the mentally ill, and obsessives in general, the difference being that though Penck has always valued precognitive thinking, he sees it as a form of sign language that unearths authentic images of the unconscious. His pursuit of a methodical system for unearthing the unconscious recalls Salvador Dalí's paranoiac-critical system, inasmuch as Penck believes that unconscious imagery can be made visible, and, beyond that, clearly has an affinity with the surrealist automatist tradition. Like Dalí and many outsider artists, he is fascinated by sexuality and aggression. In *Ein mögliches System* (A possible system; FIGURE 177), 1965, we find three groups of neoprimitive stick figures. The first, with penises erect and armed with axes, dismember figures of the

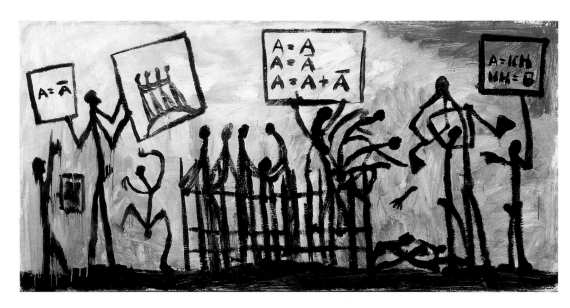

: 177 :
A. R. Penck
Ein mögliches System (A possible system), 1965, oil on canvas, 37 ½ x 78 ¾ in. (90 x 200 cm), Galerie Michael Werner, Cologne and New York

second, a group of figures fenced in the center of the painting, who in turn brandish placards bearing witness to torture. The third group, introduced on the left by a dancing figure, his torso forming a hammer and sickle, points to the placards decrying torture. From left to right these symbolic groups represent a pictogram narrative of instruction, victimization, and transgression.

While this ideological work surely represents a critique of Penck's specific situation in East Germany, it nonetheless bears comparison with the distorted moral universes of such outsiders as Wölfli and Walla. Walla's figures also brandish placards, or are surrounded by words, locating them within the artist's moral world, but his placards are to some extent impenetrable and certainly less rational than the systematic method of Penck's "demonstration tablets."[74]

:

In the last thirty years we have come to see that existence is not simply a series of chronological facts but a far-more-complex interaction between the human imagination and these occurrences. The fabrication of myths and fictions parallels events to such an extent that a straightforward diachronic view of history is no longer possible. These experiences might be called the commonplace hermeneutics of daily life. In Central Europe in the 1960s these sentiments were at their most prescient not least because of the historical and emotional catastrophes many artists had survived. Penck saw Dresden burn when he was six, Baselitz experienced a similarly traumatic destruction of his childhood home by the Red Army, and Rainer was compelled to attend a Nazi school. In turning to outsiders, each found an alternative world, less tyrannical than so-called reality: a world where the imagination reigned. Whether these alternative worlds were psychopathological mattered little since what resulted appeared more original than the banal systems of art production that surrounded them. They like Edmund Mach saw that there was some merit in playing tennis with the king.

=

Notes

All translations are by the author unless otherwise indicated.

1
There is a copious literature on the subject of National Socialist art policies and degeneracy theories. The most recent publication in English is Stephanie Barron et al., *"Degenerate Art": The Fate of the Avant-Garde in Nazi Germany*, exh. cat. (Los Angeles: Los Angeles County Museum of Art, 1991). See also Hellmut Lehmann-Haupt, *Art under a Dictatorship* (New York: Oxford University Press, 1954); and George Mosse, ed., *Nazi Culture: Intellectual, Cultural, and Social Life in the Third Reich* (London: W. H. Allen, 1966). The Mosse volume contains documents from the period. In German the best overview remains Franz Roh, *"Entartete" Kunst: Kunstbarberei im Dritten Reich* (Hannover: Fackleträger, 1962).

2
L'Art brut, exh. cat. (Paris: Musée des Arts Décoratifs, 1967).

3
Jean Dubuffet, *L'Art brut préféré aux arts culturels*, exh. cat. (Paris: Galerie René Drouin, 1949); reprinted in Jean Dubuffet, *Prospectus et tous écrits suivants* (Paris: Gallimard, 1967), vol. 1, 198–202.

4
See John M. MacGregor, *The Discovery of the Art of the Insane* (Princeton: Princeton University Press, 1989), 222–44; and essays in this volume by Reinhold Heller and Roger Cardinal.

5
Rainer, in conversation, February 28, 1990.

6
Organized by Michel Tapié, the exhibition took place at the Galerie Nina Dausset, March 8–31, 1951.

7
Today our access to his early surrealist works is limited largely to published reproductions.

8
Arnulf Rainer, "Malerei, um die Malerei zu verlassen," text accompanying an exhibition of his work, *TRR—Automatik, optische Auflösung, Blindmalerei, Zentralgestaltung*, at the Art-Club-Galerie, Vienna, May 1952. Quoted in *Arnulf Rainer*, exh. cat. (New York: Solomon R. Guggenheim Museum, 1989), 34.

9
With the revival of German painting in the 1980s has come a body of literature speculating on why figuration in Germany, particularly in Berlin, was not swamped by postwar abstraction. See, for example, Siegfried Gohr, "The Difficulties of German Painting with Its Own Tradition," in Jack Cowart, ed., *Expressions: New Art from Germany*, exh. cat. (Saint Louis: Saint Louis Art Museum, 1983). The discussion continued throughout the 1980s in such books as *Refigured Painting: The German Image 1960–88*, exh. cat. (New York: Solomon R. Guggenheim Museum, 1989); and *Berlinart 1961–87*, exh. cat. (New York: Museum of Modern Art, 1987).

10
Rainer, in conversation, February 28, 1990.

11
Rainer, quoted in Georg F. Schwarzbauer, "Das Sammlerporträt," *Kunstforum International*, no. 26 (February 1978): 224–25.

12
Rainer, in conversation, February 28, 1990. Rainer himself possesses a compulsive desire to be alone in his studio and is almost never photographed at work.

13
Ibid.

14
The principal adherents of the movement in its early years were Günther Brus, Otto Mühl, Hermann Nitsch, and Alfons Schilling. See Dieter Schwarz and Veit Loers, eds., *Von der Aktionsmalerei zum Aktionismus: Wien 1960–65/ From Action to Actionism: Vienna 1960–65*, exh. cat., vol. 1 (Klagenfurt, Austria: Ritter, 1988). The exhibition traveled from Kassel to Winterthur to Vienna. The shocking nature of much of the movement's content was underscored by the peremptory cancellation of the show by the Scottish National Gallery of Modern Art, Edinburgh, a few weeks before its scheduled opening, December 17, 1988.

15
Veit Loers, "Als die Bilder laufen lernten/When Pictures Learnt to Walk," in ibid., 11.

16
Hubert Klocker, ed., *Wiener Aktionismus 1960–71: Der zertrümmerte Spiegel/Viennese Actionism 1960–71: The Shattered Mirror*, exh. cat., vol. 2 (Klagenfurt, Austria: Ritter, 1989).

17
Litigation continued for more than two years. Eventually the painting was returned to the artist. See Martin Buttig, "West Berlin's Baselitz Case," *Censorship* 2, no. 1 (Winter 1966): 35–41.

18
Following the performance *Kunst und Revolution* (Art and revolution), held at Vienna University at the request of SÖS (the Austrian association of socialist students) on June 7, 1968, the movement's leader, Otto Mühl, Günther Brus, and Oswald Wiener were arrested and subsequently sentenced to six months' imprisonment. Ostensibly it was Brus's actions that led to the prosecution. As part of his *Körperanalyseaktion nr. 33* (Body analysis action no. 33), he disrobed, slashed his chest and thigh with a razor blade, and urinated into a glass. He drank his urine and smeared his body with feces then masturbated while singing the national anthem. The last of these acts was seemingly the most offensive, since the group was charged with defaming state symbols.

19
International recognition came when Günther Brus, Kurt Kren, Otto Mühl, Hermann Nitsch, and Peter Wiebel were invited to participate in the "Destruction in Art Symposium," held in London in September 1966. See *Wiener Aktionismus/Viennese Actionism*, vol. 2, 119–20.

20
The first exhibition of Gugging works at the Galerie nächst St. Stephan, *Pareidolien: Druckgraphik aus dem Niederösterreichischen Landeskrankenhaus für Psychiatrie und Neurologie Klosterneuberg*, took place September 29–October 25, 1970; the second, by the same title, 1972.

21
Rainer, in conversation, February 28, 1990.

22
Founded in 1963, the center was located at Cery Hospital, part of the Centre d'Etude de l'Expression Plastique de la Clinique Psychiatrique Universitaire de Lausanne. Bader's objective was to

permit psychiatric patients to express themselves in a non-ergotherapeutic (undirected) situation. Patient-artists at the center exercised considerable control over the processes by which their films and other works were made. Bader was also studying outsiders such as Anselme Boix-Vives, Friedrich Schröder-Sonnenstern, and such insider artists as Fritz Hundertwasser. The experiment involving Rainer, Jean Monod of Lausanne, and Hans Richter of Berlin was filmed in 1967 and entitled *3 Künstler + Psilocybin* (3 artists + psilocybin). See Christian Müller and Alfred Bader, "The Cinema and the Mental Patient: A New Form of Group Therapy," in *Current Psychiatric Therapies*, vol. 8 (1968): 168–72; and "The Center for the Study of Psychopathological Expression at the Lausanne University Psychiatric Clinic," in *Japanese Bulletin of Art Therapy*, vol. 4 (1972): 95–101.

23
"Schön und Wahn" is reprinted in *Kunstforum International*, no. 26 (February 1978): 219–21, accompanied by photographs of *Katatonkunst* (cata-tonic art).

24
Arnulf Rainer, "Psychosen und Körpersprache," in *Körpersprache/Body Language*, exh. cat. (Graz: Steirischer Herbst, 1973). His photo-graphic sources include Wilhelm Weygandt, *Atlas und Grundriss der Psychiatrie* and *Erkennung der Geistesstörungen* (both Munich: Lehmann, 1920); and Eugen Bleuler, *Lehrbuch der Psychiatrie* (reprint, Berlin: Springer, 1966).

25
The well-known painting by Ernst, which depicts the members of the surrealist movement in 1923, the year before the first surrealist manifesto, drew upon images from psychiatric textbooks by Emile Kraepelin. See Elizabeth Mary Legge, "Conscious Sources of the Unconscious: Ernst's Use of Psychoanalytic Themes and Imagery, 1921–24," Ph.D. diss., Courtauld Institute of Art, University of London, 1985.

26
M. Pasturel, "Dessins anatomiques et conceptions médicales d'un dément précoce," *Encéphale* 6, no. 4 (1911): 358–60.

27
Arnulf Rainer, "My Overdrawings of Franz Xaver Messerschmidt," trans. David Britt, in *Franz Xaver Messerschmidt Character Heads 1770–83/Arnulf Rainer Overdrawings Franz Xaver Messerschmidt*, exh. cat. (London: Institute of Contemporary Art, 1987), 35.

28
Ibid.

29
Rainer, in conversation, February 28, 1990. "At the same time there was the influence of Soutter, who as you know always painted with his fingers, whilst I painted with my hands. It's important this, it is not the same, but another system in that I painted this way."

30
Arnulf Rainer, "Schön und Wahn," *Protokolle: Jahrschrift für Literatur und Musik* (Vienna: Jugend und Volk, 1967); reprinted in *Der Himmel Elleno: Zustandsgebundene Kunst, Zeichnungen und Malereien aus dem Niederösterreichischen Landeskrankenhaus*, exh. cat.

(Graz: Kulturhaus, 1975). See also Arnulf Rainer, "Was aber ist Johann Hauser?" *Protokolle*, n. s., no. 2 (1979); reproduced in Otto Breicha and R. Urbach, eds., *Österreich zum Beispiel, Literatur, bildende Kunst, Film und Musik seit 1968*, exh. cat. (Vienna: Residenz, 1982), 281–83.

31
Karen Machover, *Personality Projection in the Drawing of the Human Figure* (Springfield, Illinois: Thomas, 1949).

32
Navratil, in conversation, March 2, 1990.

33
Ibid.

34
Alfred Bader, *Wunderwelt des Wahns: Insania Pingens* (Cologne: DuMont, 1961); an English edition, *Insania Pingens*, was published in London by Thames and Hudson in 1963. Subsequently Bader and Navratil collaborated on a more significant publication on artistic "habilitation": *Zwischen Wahn und Wirklichkeit: Kunst-Psychose-Kreativität* (Lucerne: C. J. Bucher, 1976). The book, including a survey of psychotic artists beginning in the late nineteenth century, constitutes a history of outsider materials from a medical standpoint.

35
The most significant of Gugging exhibitions (and attendant catalogues) remains Leo Navratil, ed., *Die Künstler aus Gugging*, exh. cat. (Vienna: Museum Moderner Kunst, 1983).

36
From 1959 to 1962 Rainer overpainted works by other artists, notably Sam Francis, Georges Mathieu, Victor Vasarely, and Vedova. By 1967 he had begun painting himself in performance and the following year began overpainting photo-booth images of himself. He subsequently painted over photographs of Old Master paintings, masks, women, and most recently, in his Shakespeare series, reproductions of late eighteenth-century engravings.

37
The theory of mental "state-boundaries" was expounded by Roland Fischer in the 1960s. Arousal and hyperarousal, according to Fischer, are measurable on a circular scale; there are relations between perceptual-hallucinatory and perceptual-meditational mental states. On this scale "insomuch as experience arises from the binding and coupling of a particular state or level of arousal with a particular symbolic interpretation of that arousal, experience is *state-bound*." See Roland Fischer, "A Cartography of the Ecstatic and Meditative States," *Science* 174, no. 4012 (November 26, 1971): 897–904.

38
Such categorization is evident even in Navratil's open-minded research. See his "The Plastic Creation of Psychiatric Patients," in A. Seva, ed., *The European Handbook of Psychiatry and Mental Health* (Barcelona: Prensas Universitarias y Anthropos Editorial del Hombre S.A., 1991), 2205–20.

39
Michel Thévoz, "Johann Hauser," *L'Art brut*, fascicle 12 (Lausanne: Collection de l'Art Brut, 1983), 21–22.

40
Walla, quoted in Thomas Breymann, "August Walla," in ibid., 43.

41
The drawing in question, entitled *Hasin und Hasinkind* (Mother hare and leveret), now in the Collection de l'Art Brut, is reproduced as FIGURE 27, in ibid., 38.

42
Baselitz, in a letter to the author, June 1, 1990.

43
Hans Prinzhorn, *Bildnerei der Geisteskranken* (Berlin: Springer, 1922; reprint, Berlin: Springer, 1968), and in English as *Artistry of the Mentally Ill: A Contribution to the Psychology and Psychopathology of Configuration*, trans. Eric von Brockdorff (New York: Springer, 1972). The Case 13 illustration appears on p. 79 of the English edition.

44
See Richard Calvocoressi, "Georg Baselitz," in *Georg Baselitz: Paintings 1960–83*, exh. cat. (London: Whitechapel Art Gallery, 1983), 11. The Prinzhorn source is confirmed in Andreas Franzke, *Georg Baselitz* (Munich: Prestel, 1989), 19.

45
This comparison is more problematical than the previous one since works by Paul Goesch were not reproduced in *Bildnerei der Geisteskranken* and Baselitz claims not to have seen the Prinzhorn Collection itself until 1966. Nevertheless the similarities between *Oberon* and a color reproduction of the Goesch work (1980, see below) are so striking and at the same time consonant

with Baselitz's Prinzhorn interests that the comparison seems inescapable. Goesch's works along with many more of the almost six thousand Prinzhorn works were reproduced in *Die Prinzhorn-Sammlung: Bilder, Skulpturen, Texte aus Psychiatrischen Anstalten (ca. 1890–1920)*, exh. cat. (Königstein/Taunus: Athenäum, 1980). The latter publication begs the question (beyond our current brief) of a second period of influence of Prinzhorn artists on Baselitz. The issue seems particularly pertinent to the development of his sculpture in the 1980s.

46
Karl Brendel's influence on the sculpture of Max Ernst has already been noted. See MacGregor, *The Discovery of the Art of the Insane*, 279–81. The same remains to be investigated in the case of Baselitz.

47
Mikhail Vrubel has come to be seen as a prophetic figure unrecognized in his lifetime. Camilla Gray has referred to him as "the Russian Cézanne"; see *The Russian Experiment in Art 1863–1922*, rev. ed. (London: Thames and Hudson, 1986), 35. Baselitz's choice of Vrubel may seem peculiar. It may not have been merely Vrubel's illness, however, that attracted Baselitz but his status as a prophetic figure as well.

48
Quoted in Jack Hirschman, ed., *Antonin Artaud Anthology*, 2d ed. (San Francisco: City Lights, 1970), 135.

49
Georg Baselitz, "Georg Baselitz Manifestoes," in *Georg Baselitz*, 21–25.

50
Ibid., 24–25.

51
For a brief history of the collection, see *The Prinzhorn Collection: Selected Work from the Prinzhorn Collection of the Art of the Mentally Ill*, exh. cat. (Champaign, Illinois: Krannert Art Museum, University of Illinois, 1984).

52
Dr. Carl Schneider, director of the Heidelberg clinic and chief assessor of the Nazi euthanasia program, spoke of the art of the insane in these terms: "We have, however, precisely because of his (the insane's) deficiency the right to prevent his deficiencies from having an effect on his own life or on the lives of his neighbors. Therefore, the insane is brought to appropriate treatment and, therefore, the removal of the degenerate artists who are similar to him from the life of the people is justified for biological reasons also." Quoted in ibid., 3.

53
The Nazis produced a guide to the *Entartete Kunst* exhibition, and though the publication date was 1937, it was not ready in time for the first venue, Munich. Four works by "insane" artists are illustrated in the guide: a painting and a drawing by two unnamed artists and two works by Karl Brendel, *Mädchenkopf* (Head of a girl) and *Katze* (Cat); only *Mädchenkopf* is identified as a work by a patient at the psychiatric clinic in Heidelberg, though neither Brendel nor Prinzhorn is mentioned by name. *Mädchenkopf* shared a plinth with Eugen Hoffmann's *Mädchen mit blauem Haar* (Girl with blue hair) when the exhibition was mounted in Frankfurt in 1939. It is possible that it or other works by insane artists were exhibited as early as 1938 in

Berlin, the second venue, and as late as 1941, when the exhibition was finally dispersed, but documentation of venues other than Munich is scanty, and the content of the exhibition did change from venue to venue. Works by insane artists were not included in the Munich installation. A facsimile of the guide with English translation appears in Barron et al., *"Degenerate Art,"* 357–90.

54
The close relationship between Brendel's sculpture *Der Teufel* (The devil) and Ernst's bronze *Der Schwach-sinnige* (The imbecile) is noted in MacGregor, *The Discovery of the Art of the Insane*, 281.

55
The task was undertaken by the German Society for the Psychopathology of Expression. Conservation was funded after 1973 by the Volkswagen Foundation.

56
Maria Rave-Schwank et al., *Bildnerei der Geisteskranken aus der Prinzhorn Sammlung*, exh. cat. (Heidelberg: Galerie Rothe, 1967). Rave-Schwank was also responsible for opening a small exhibition space in the attic of the clinic in 1972.

57
See note 43.

58
One of the best formalist analyses of these works remains Rafael Jablonka, *Ruins: Strategies of Destruction in the Fracture Paintings of Georg Baselitz*, exh. cat. (London: Anthony D'Offay, 1982).

59
Norman Rosenthal cites Worringer in *Recent Paintings by Georg Baselitz*, exh. cat. (London: Anthony D'Offay, 1990), 12.

60

Jablonka, *Ruins*, 20.

61

Georg Baselitz, "Warum das Bild 'Die grosse Freunde' ein gutes Bild ist," *Georg Baselitz*, exh. cat. (Braunschweig: Kunstverein, 1981); reprinted in *Georg Baselitz: Paintings 1960–83*, 33.

This document is crucial to an understanding of Baselitz's work inasmuch as it lists a set of formal criteria, which warrant inclusion here.

1 Regressions such as: gingerbread shapes, playful tendencies, pictographs.

2 Pictorial distortions such as: luxuriant growth, confectionery, overblown emotion, comic grotesquerie, auricular style.

3 Consolidations such as: mixed salad, porridge effects, ornamental infill, script elements, combinations of heterogeneous materials.

4 Neomorphisms such as: maiming, atrophy, caricature, duplication of heads, monstrous new formations, combinations of man and beast or man and landscape, etc.

5 Stereotypes such as: reproduction of formal details, surfaces covered by repeating ornament, ideas done to death.

6 Ossifications such as: framing the picture, absence of shadows, "steely" hardness of effect.

7 Signs of disintegration such as: disregard of space, loss of composition, linear, planar, fragmentary nonsense; softening and disintegrating of physiognomy.

Baselitz even extended this list beyond merely formal concerns into his idea of what constituted a criterion of content:

1 Non-representational content such as: formless scribbles and curlicues, organic forms, geometric linear representation, carpet effect.

2 Representational elements such as: "apparatus," "inventions," things like maps; minutely executed linear landscapes, moonscapes; religious, cosmic, magical.

While there may be an element of tongue-in-cheek nonsense about the artist's criteria, it is inescapable that he has listed almost every major characteristic found in psychotic art in general. Since it was written in 1966, the very year that he saw the Prinzhorn Collection, it seems to be overwhelming evidence that he took the characteristics from Prinzhorn's book.

62

Prinzhorn, *Artistry of the Mentally Ill*, 21.

63

For a discussion of Carlo's work, see Vittorino Andreoli, Cherubino Trabucci, and Arturo Pasa, "Carlo," *L'Art brut*, fascicle 6 (Paris: Compagnie de l'Art Brut, 1966).

64

Donald B. Kuspit, "Pandemonium: The Root of Georg Baselitz's Imagery," *Arts* 60, no. 10 (June 1986): 24.

65

Penck is the last of several pseudonyms of Ralf Winkler, who modeled his alias on Albrecht R. Penck, author of *The Alps in the Ice Age* (1909). The "ice age" was a suitable metaphor in Winkler's view for the status of art in the German Democratic Republic.

66

For the attribution to Soutter, see, for example, Paolo Bianchi, "Bild und Seele: Über Art Brut und Outsider-Kunst im Zentrum Europas," *Kunstforum International*, no. 101 (June 1989): 82.

67

Thomas Allen Heinrich coined the term. See "A. R. Penck: Documenta 6/Part III: Painting," *Arts Canada*, nos. 220/221 (April–May 1978): 60–62.

68

Rétrospective Louis Soutter, organized by the Musée Cantonal des Beaux-Arts, Lausanne, containing 272 drawings, paintings, and illustrated books, toured Switzerland March–August 1961 and Germany September 1961–February 1962. It was widely reviewed in Swiss and German art periodicals. See Michel Thévoz, *Louis Soutter ou l'écriture du désir* (Lausanne: Editions L'Age d'homme, 1974), 242–43, for a bibliographical survey of reviews.

69

This observation was made by Dieter Koepplin in "Experience in Reality: The Art of A. R. Penck," *Studio International* 187, no. 964 (March 1974): 112–16. Lines bordered by dots are evident in the work of Picasso of the 1920s as well. Ibid., 116.

70

Ibid. Also Donald B. Kuspit, "A. R. Penck," *Art in America* 70, no. 2 (February 1982): 139.

71

See A. R. Penck, *Standarts* (Cologne: Editions Galerie Michael Werner; Munich: Jahn und Klüser, 1970); and Penck, *Was ist Standart?* (Cologne: Gebrüder König, 1970).

72

For a discussion of Pollock's drawings, see C. L. Wysuph, *Jackson Pollock: Psychoanalytic Drawings* (New York: Horizon, 1970); and Judith Wolfe, "Jungian Aspects of Jackson Pollock's Imagery," *Artforum* 11, no. 3 (November 1972): 65–73.

73

Andrea Schlieker, "A. R. Penck," *Artscribe*, no. 43 (October 1983): 31–33.

74

Penck's term for these didactic paintings was deliberately modeled on the didacticism of Brecht; see Dorothea Dietrich, "A Talk with A. R. Penck," *The Print Collector's Newsletter* 14, no. 3 (July–August 1983): 91–95.

Contemporary
Artists
and
Outsider
Art

CAROL S. ELIEL AND BARBARA FREEMAN

Just as contemporary art seems more diffuse and perplexing to the public than the art of earlier decades of the twentieth century, less easily categorized or rationalized, so too the contemporary section of *Parallel Visions* is stylistically and attitudinally less neat and orderly than the earlier sections of the exhibition. Whereas the surrealists or the Chicago imagists shared a certain ethos, the contemporary artists included in *Parallel Visions*—with few exceptions—work independently of each other, yet have interests in common that they themselves are not necessarily aware of. On a number of occasions, in fact, a contemporary artist expressed surprise upon learning that another contemporary artist was also to be included in *Parallel Visions*. Ironically it is often—consciously or no—because of the competitive pressures of the contemporary "scene" that a number of these artists have looked to compulsive visionaries as role models, as people working outside the art world, unaffected by its goals and pressures, creating solely to externalize their internal visions and to satisfy their own internal needs.

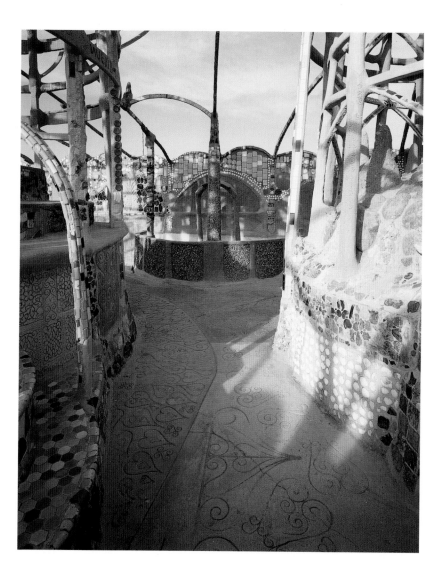

: 178 :
Simon Rodia
Detail of interior walkway, *Watts
Towers*, Los Angeles, 1921–1954

The significance of visionary environments—such
as Simon Rodia's *Watts Towers* (FIGURE 178; see also
FIGURE 43), Ferdinand Cheval's *Palais idéal* (Ideal
palace; see FIGURE 9), or Clarence Schmidt's Wood-
stock, New York, environment (FIGURE 179)—
for contemporary artists has not gone unnoticed
in the literature of art history. In 1982 Selden
Rodman wrote,

**Long before the avant-garde discovered that junk labeled
"art" could be sold for profit, . . . long before
Chamberlain put smashed cars on pedestals, or Warhol
made Campbell's soup cans and Brillo boxes into
assemblies mocking their intended uses, Simon Rodia had
buried his Hudson touring car in the backyard and begun
to erect his towering monument out of welded pipe and
Coca-Cola bottles.[1]**

The indefatigable spirit and untutored genius
evident in Rodia's *Watts Towers*, in Cheval's *Palais
idéal*, and in Schmidt's environment, where he
actually lived—all created in artistic obscurity—
communicated the works' architecturally irrational
beauty to all who came to view them as well as to
many who saw them only in reproduction.
Exposure to these visionary environments, such
magnificent tributes to human resourcefulness,
perseverance, and boundless imagination, has been
inspiring and liberating for many contemporary
artists and has led them to explore other manifes-
tations of outsider art.

Michel Thévoz has characterized Cheval's
Palais idéal (in Hauterives, France) as a mixed
assortment of reminiscences not governed by the
principles usually associated with architecture. It is
a creative digression, a hallucinatory migration
through time and place. Thévoz considers it to
belong to the realm that Paul Klee called the
"between world," the borderline dividing the real
from the imaginary.[2] It is within this mysterious and
intriguing domain that the visionary environments
fall, and it is for this reason that so many
mainstream artists have found them compelling.

200 ELIEL / FREEMAN Conte
 mpora
 ry
 Artis
 ts
 and
 Outsi
 der
 Art

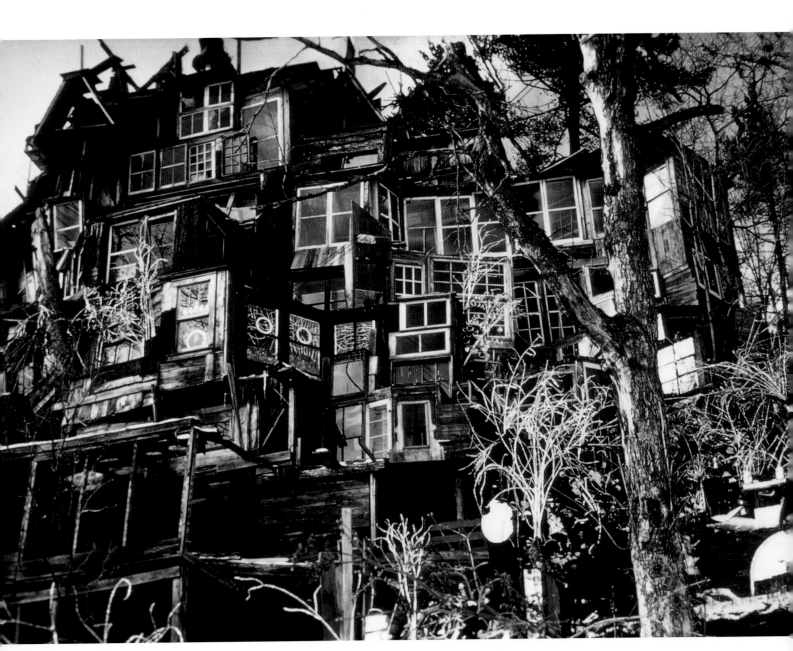

: 179 :
Clarence Schmidt
Woodstock Environment, or *House
of Mirrors*, Woodstock, New York,
1948–1971 (destroyed)

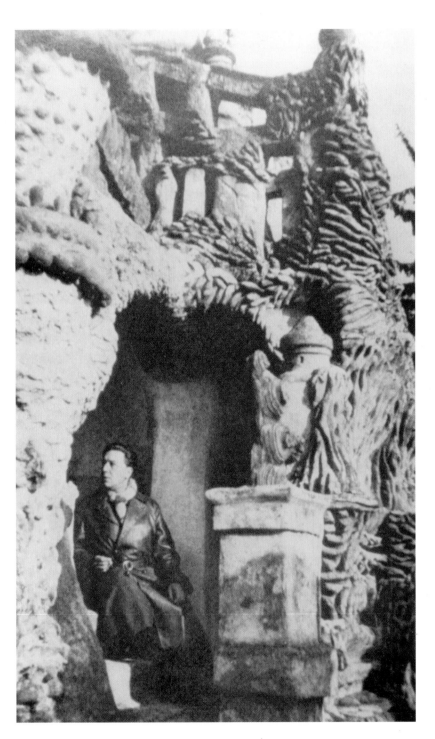

Exploration of visionary environments is not unique to contemporary artists. Andre Bréton visited Cheval's *Palais idéal* in 1931 (FIGURE 180) and distinguished its creator as the "uncontested master of mediumistic architecture and sculpture."[3] The *Palais idéal* became a mecca for the surrealists, and Alfred H. Barr, Jr., recognizing its artistic importance, reproduced photographs of it in the Museum of Modern Art's 1936 exhibition catalogue *Fantastic Art, Dada and Surrealism*.[4] Similarly William Seitz twenty-five years later affirmed the significance of the *Watts Towers* (in Los Angeles) when he wrote of Rodia's "wondrously colored towers of concrete and scrap" and reproduced six photographs of the towers in the catalogue accompanying his landmark exhibition *The Art of Assemblage*.[5] In 1962 the Los Angeles County Museum of Art mounted a photography exhibition devoted exclusively to Rodia's towers.[6]

In the introduction to the 1990 exhibition catalogue *Forty Years of California Assemblage*, Henry Hopkins wrote,

Simon Rodia's wonderful towers in Watts were also important to us [the California assemblage artists of the 1950s and 1960s], since they functioned as a mysterious symbol of the power of the individual creative will. . . . Our association with the towers also led us to the photographer Seymour Rosen, who had become so absorbed by the towers that he had begun a lifework of documenting hundreds of environments . . . throughout the United States. . . . Seymour's photographs, as well as the environments they captured, became important source material for the emerging assemblage artists.[7]

: 180 :
André Breton at Ferdinand Cheval's
Palais idéal (Ideal palace),
Hauterives, France, 1931

: 181 :
Jess (Jess Collins)
Love's Captives, 1954

Jess

Included in the *Forty Years of California Assemblage* exhibition, Jess (Jess Collins, born 1923), whose work has been characterized by Michael Auping as "hermetically symbolic and obsessively crafted,"[8] inherited an interest in the *Watts Towers* from his father long before forming associations with other California artists.

My father, . . . one day taking the family for a drive, took us from our home in Long Beach to Watts to see "the towers." Their significance was emphasized and linked by my father (a civil engineer) to the "Tower of Jewels" of the Panama-Pacific Exhibition. He saw it when a young man. The Rodilla [sic] work was, of course, still underway. As a student engrossed in becoming a chemist (but still repressing a desire to be an artist), I filed this salient experience away for later sustenance.[9]

In the 1940s, traveling to and from the California Institute of Technology in Pasadena, where he was working toward a bachelor's degree in chemistry, Jess passed the towers each day, and his fascination with the visionary monument grew. Some years later, in 1953, he made a pilgrimage to Watts and had a chance meeting with Rodia himself. In Jess's studio, among the personal treasures with which he surrounds himself and from which he draws inspiration, is a photograph of the towers' exquisite mosaic detail.[10]

Jess creates mysterious and fanciful collages out of images cut from comic strips, engravings, magazine and newspaper illustrations, jigsaw puzzles, and photographs. The resulting works—hallucinatory, metaphoric, and surreal—reflect his enduring interest in folklore, the occult, and mythology (FIGURE 181).

George Herms

George Herms (born 1935), a close friend of Jess, creates "delapidated shelves of lost and forgotten objects [that] are cousins to Jess's own perverse objects."[11] After seeing reproductions of the *Watts Towers* in Seitz's *The Art of Assemblage* in 1961, Herms developed a respect for Rodia's achievement that quickly "blossomed into a full-blown love affair."[12] A champion of the towers, Herms makes an effort to accompany out-of-town and foreign friends and visitors to the Watts environment whenever he can.

In addition to the towers, Herms attributes his heightened sensitivity to visionary art to several exhibitions that came to Southern California in the early 1960s, chief among them the Dubuffet exhibition organized by Peter Selz for the Museum of Modern Art in New York and shown at the Los Angeles County Museum of Art in the summer of 1962.[13] It is Herms's conviction that the compulsive ordering that distinguishes the commanding work of Adolf Wölfli and other visionaries represents the very potent need of all humans to make sense of, and bring order to, the chaos of our modern existence.

In 1976 Herms created *The Bomb Scare Box* (FIGURE 182), which recalls the formal characteristics of an anonymous work he had first seen in the mid 1950s reproduced in the exhibition catalogue *Fantastic Art, Dada and Surrealism* and there referred to as "Objects assembled and mounted by a psychopathic patient" (see FIGURE 66). For Herms, both works symbolize a movement from chaos to order. In 1979 Herms constructed *The Alcove of Beginnings*, a triptych meant to expose his own artistic roots. On the work's central panel Herms placed, along with other objects of personal relevance, a reproduction of the anonymous work (FIGURE 183), thus acknowledging it as a touchstone for his artistic creativity.

: 183 :
George Herms
Detail of *The Alcove of Beginnings*, 1979, mixed media, 107 x 94 in. (271.8 x 238.8 cm), Los Angeles County Museum of Art, gift of L.A. Louver Gallery and the Gerard Junior Foundation

: 182 :
George Herms
The Bomb Scare Box, 1976

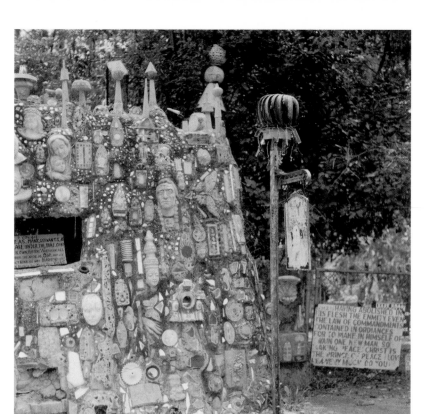

: 184 :

Howard Finster

Paradise Garden, Pennville, Georgia, begun in 1961, mixed media in landscape

: 185 :

James Hampton

Throne of the Third Heaven of the Nations Millennium General Assembly, 1964, mixed media, National Museum of American Art, Smithsonian Institution, Washington, D.C.

Gregg Blasdel and the Increasing Appreciation of Environments

It was not until 1968, when Gregg Blasdel's article "Grass-Roots Artists" appeared in *Art in America*, that anything of consequence was written about Schmidt's Woodstock environment or other environmental wonders in the United States.[14] This seminal piece, featuring photodocumentation of fifteen American environments and biographical sketches of the artists who created them, was the first survey of its kind. Blasdel had begun to document such work in 1959, during his undergraduate years at the University of Kansas. As a graduate student at Cornell University, he continued to travel the country, interviewing environmental artists and photographing their creations. Blasdel became acquainted with B. H. Friedman at Cornell, through whom he was introduced to Alfonso Ossorio. Keenly interested in the art of the untrained, Ossorio, who had housed Dubuffet's art brut collection at his Long Island estate from 1952 to 1962, facilitated an arrangement whereby Blasdel sent his photographs to Ossorio, who then forwarded them to Dubuffet in France. Dubuffet, who had long wanted to expand his search for art brut to the United States, was aided by Blasdel's efforts.[15]

Blasdel expected his account of the maverick artists and the outlandish environments to garner considerable notice and was disappointed when the article prompted less than a half-dozen inquiries.[16] While working at the Whitney Museum of American Art in New York from 1968 to 1973, Blasdel endeavored to interest the museum in organizing an exhibition of American environments but was unable to generate the necessary support.

After accepting a teaching post at the University of Vermont in 1974, Blasdel, in collaboration with colleague William C. Lipke, organized the exhibition and catalogue *Schmidt* for the Robert Hull Fleming Museum at the university. Prior to traveling to seven institutions in 1975–76, the *Schmidt* exhibition's photomurals and sculptural

pieces were shown as part of the 1974 group exhibition *Naives and Visionaries* at the Walker Art Center, Minneapolis. The essay written by Lipke and Blasdel for *Schmidt* was reprinted in the *Naives and Visionaries* catalogue.[17]

Since the exhibitions *Simon Rodia's Towers in Watts*, *Schmidt*, and *Naives and Visionaries*, there has been a steadily growing regard for American environments. Ruth Kohler in Wisconsin and Seymour Rosen and his organization SPACES, based in Los Angeles, have made great efforts to recognize and preserve visionary environments. Once known only to local residents, many environments are now nationally recognized. Rodia's towers have been designated a national historic landmark. Two monographs have been written on the Reverend Howard Finster, best known for his rural Georgia environment called *Paradise Garden* (FIGURE 184).[18] James Hampton's *Throne of the Third Heaven of the Nations Millennium General Assembly* (FIGURE 185) has been acquired by and is on permanent display at the Smithsonian Institution's National Museum of American Art. The increased exposure of visionary environments in particular and of outsider art in general has necessarily led to a heightened awareness of this special body of work on the part of mainstream artists and collectors.

Niki de Saint Phalle

More than any other contemporary artist, Niki de Saint Phalle (born 1930) credits visionary environments with inspiring her own artistic production. She "fabricates a make-believe world, inhabited by frolicking earth mothers, open-mouthed monsters, and fantastic birds with gilded crests. Her art is at once a vivid exercise of unrestrained, quirky imagination and an eloquent reminder of the universality—and durability—of ancient myths, legends, and fairy tales."[19] In 1955, when Saint Phalle was twenty-five and had been painting for three years, a friend urged her to visit Antonio Gaudí's *Parque Güell* in Barcelona. She did and it altered her art and her life. "That day I knew that I too would one day make a fantastic garden, a place for people to come and dream, a place of joy."[20] After seeing the work of Gaudí in Spain, Saint Phalle, captivated by fantastic architecture, visited the Postman Cheval's *Palais idéal* and Rodia's *Watts Towers* repeatedly.

For me these works were profoundly inspiring, but at the time they were not considered serious by my fellow artists, who thought of them as "Folk Art." I identified with them as outsiders, I too felt like an outsider among my fellow artists. I have never been to art school, and I am self-taught. . . . My art school became all the museums I visited, and all the fantastic architecture that I came to know. I feel these people are my teachers and my masters and I feel much closer to them than to my contemporaries. My major works have all been fantastic architecture.[21]

In 1961 Saint Phalle began to construct her "Nanas," vividly painted sculptures of voluptuous female figures. With the passage of time the Nanas grew larger and more fanciful. In 1966, in collaboration with Jean Tinguely and Per Olof Ultvedt, Saint Phalle created *Hon* (Swedish for "she"), an enormous, inhabitable sculpture (twenty feet in height, eighty-two feet in length, and thirty feet in width). The great sprawling giantess, gaily painted and lying on her back, was installed in the main hall of the Moderna Museet in Stockholm.

206 ELIEL / FREEMAN

Conte
mpora
ry
Artis
ts
and
Outsi
der
Art

: 186 :
Niki de Saint Phalle
Giardino dei Tarocchi
(Garden of the tarot), Garavicchio,
Italy, begun in 1979

: 187 :
Heinrich Anton Müller
Machine (destroyed)

Visitors who entered *Hon* through a doorway between her legs discovered a twelve-seat cinema, an art gallery, a milk bar, vending machines, music, and an aquarium.

In 1971 Saint Phalle constructed three fantasy houses in the south of France. In 1972 she built *Golem*, a playhouse and slide for Arab and Jewish children in Jerusalem, and in 1973 she created *Dragon*, a fully equipped house for children, in Knokke-le-Zoute, Belgium. Twenty-four years after her first visit to Barcelona, Saint Phalle began to build her *Giardino dei Tarocchi* (Garden of the tarot; FIGURE 186) in Garavicchio, southern Tuscany. The garden is a magnificent complex of twenty-two freestanding structures representing the ancient tarot cards. The tarot garden will be the largest sculpture garden created by anyone since Gaudí. Sainte Phalle has said, "In a sense, my whole life has been a preparation for this project.... I did trial runs, so to speak, when I created the *Golem* ... and the *Dragon*.... Once the garden is completed, my work will be over and I'll move out. I'll go somewhere else, farther away, and start a new project."[22]

Jean Tinguely

Jean Tinguely (1925–91), known for his whimsical kinetic sculpture and self-destructing contraptions, collaborated frequently with Saint Phalle and was likewise fascinated and inspired by the inventiveness of outsider art, especially Rodia's towers, the work of Wölfli, and the drawing and machines of Heinrich Anton Müller (FIGURE 187).

While living and working in New York in 1960–61 and experiencing a period of intense creativity, Tinguely saw reproductions of Müller's work and, in the words of K. G. Pontus Hultén, the photos "made a deep impression on him as did Müller's case history."[23] Müller's work confirmed Tinguely's belief that art could be made in any location and of any material. In 1962 Tinguely created the huge construction *Hommage à Anton Müller* (Homage to Anton Müller), shown at the Stedelijk Museum in Amsterdam in the exhibition *Dylaby*. In the same year, while visiting California to exhibit his work at the Everett Ellin Gallery, Tinguely toured the *Watts Towers*, which, like Müller's work, made a lasting impression on him.

In 1969 Jean Tinguely began constructing *La Tête/Cyclope* (The head/cyclops; FIGURE 188), a monumental sculpture situated in an isolated area of Milly-la-Forêt, near Fontainebleau. For Tinguely, the fifty-foot-high work represented a center for thought, reflection, and creativity. To symbolize the thinking process, the artist created an intricate network of flashing lights and moving parts in the work's interior. Saint Phalle, one of the project's many collaborators, covered the exterior of the head with a mirror mosaic.

In 1976 Tinguely, in collaboration with Bernhard Luginbühl, paid homage to Wölfli by burning Luginbühl's wooden sculpture *Zorn*, named after the term Wölfli used to denote a particular mystical number whose precise definition was understandable only to him. For this memorial celebration Tinguely attached explosives to the wooden sculpture, which then spewed sparks, flame, and smoke meant to represent Wölfli's own volatile creativity.

208 ELIEL / FREEMAN C o n t e
 m p o r a
 r y
 A r t i s
 t s
 a n d
 O u t s i
 d e r
 A r t

: 188 :
Jean Tinguely
La Tête/Cyclope (The head/cyclops),
Milly-la-Forêt, France, begun in
1969

: 189 :
Italo Scanga
Composite Deer, 1981

: 190 :
Italo Scanga
Transmitting, 1983

Italo Scanga

Peter Boswell, in his essay "Beat and Beyond: The Rise of Assemblage Sculpture in California," characterized Rodia as an Italian immigrant who created his towers in gratitude to the United States for the new life he found here. They were intended as a gift of love to any who would receive them.[24] As an Italian immigrant in the United States, Italo Scanga (born 1932) recognized and identified with Rodia's desire to create a splendid gift for his adopted country.[25] While Scanga has not attempted to create his own fantasy environments, he has been subtly but surely affected by those of others. Scanga first visited the *Watts Towers* in 1975 and then traveled to Martinez, California, in the hope (never realized) of meeting with Rodia's family members. Scanga admired Rodia's abilities as a craftsman and as an (untrained) engineer, qualities he had also admired in his own father. The towers recalled for Scanga shrines he had seen in his native Italy. Scanga, noticing that Rodia had left impressions of his tools in the surface of the concrete structure, remembered that certain tombstones he had seen in Italy were similarly imprinted with images of tools. On his next trip to Italy, Scanga visited an old cemetery; indeed, his recollection about the tools was correct.

Scanga's appreciation for outsider art is not restricted to environments. Scanga purchased the work of Joseph Yoakum after seeing a 1969 Yoakum exhibition at the Pennsylvania State University Art Museum. Scanga continues to read and see all that he can on the subject of self-taught artists. In his own work, such as *Composite Deer* (FIGURE 189), 1981, and *Transmitting* (FIGURE 190), 1983, Scanga achieves an honesty and integrity of craft along with the imaginative quality that he respects in the work of the outsider artists. Scanga "constructs his visions and hallucinations with patience, with the competence of an ancient worker who, detail after detail, constructed cathedrals."[26]

209

: 191 :
Allan Kaprow
Apple Shrine, 1960, mixed media
environment (destroyed)

Allan Kaprow

In the mid 1960s Allan Kaprow (born 1927) began making large assemblages incorporating a variety of found objects. Expressing a desire to eliminate the boundaries between art and life, he was soon creating environments and happenings. In 1967 he expressed his belief that the most advanced art of the previous half-dozen years was inappropriate for museum display. Advanced art was art of the world: art of enormous scale, environmental in scope, art incorporating mixed media, spectator participation, technology, and themes drawn from the artist's daily milieu. Museums, in Kaprow's view, "isolate such work from life, they subtly sanctify it, and thus kill it."[27]

Setting forth his account of artistic evolution up to the mid 1960s and the innovation of environments and happenings, Kaprow proclaimed, "This is what happened: the pieces of paper curled up off the canvas, were removed from the surface to exist on their own, became more solid as they grew into other materials and reaching out further into the room, finally filled it entirely. Suddenly, there were jungles, crowded streets, littered alleys, dream spaces of science fiction, rooms of madness, and junk-filled attics of the mind."[28]

Kaprow was introduced to Schmidt in 1959 at Schmidt's five-acre Woodstock, New York, environment, replete with its "dream spaces" and "rooms of madness." Their first meeting took place in an old Chevrolet station wagon, with Schmidt holding a twenty-gauge shotgun on his lap. The shotgun, Schmidt asserted, was necessary to protect his "gift to mankind" from a vandalizing cousin who mistakenly maintained that Schmidt's sprawling *House of Mirrors* had trespassed his property lines.[29]

A description of Kaprow's environment *Apple Shrine* (FIGURE 191), shown in 1960 at the Judson Gallery in New York, is evocative of Schmidt's grottoes, shrines, and thirty-five interconnected junk-filled rooms:

[*Apple Shrine*] well might . . . be a grotto shrine, or a city zoo or a three-way mirror, . . . there is no limit to the imagination's imaginings. . . . His labyrinth is cluttered with remnants of our daily offal. . . . The mountain trail, or subway hole or birth canal . . . leads to an actual retreat, illumined with silence almost holy, or farce hysterical. . . . It's beauty made from trash from our pre-fabricated world. It's a social comment.[30]

In his momentous book of 1966, *Assemblage, Environments and Happenings*, Kaprow devoted many pages of text and accompanying photographs to Schmidt's environment, acknowledging similarities between his own work and Schmidt's.[31] Kaprow clearly found in Schmidt's building projects of twenty-three years confirmation that new artistic forms must break down the barriers between art and life and release the artist from conventional notions of a detached, closed arrangement of time and space. According to Roger Cardinal, Schmidt's environment, "resistant to the very concept of final completion," was "an eloquent articulation of what Kaprow terms the metaphysics of constant metamorphosis."[32]

Jim Dine

Jim Dine (born 1935), influenced in the early years of his career by Kaprow, was an active organizer of happenings in the late 1950s and early 1960s.[33] Kaprow was the codirector of the Judson Gallery, where Dine showed *The House* (along with Claes Oldenburg's *The Street*) in 1960. Dine did not become acquainted with Schmidt's environment through Kaprow, however. He first encountered the work when he was shown slides of the environment by Gregg Blasdel, a student of his at Cornell, in 1967. Blasdel's slides fortified Dine's own early held conviction in the value of outsider art.

Dine acquired an interest in the art of children as an elementary school teacher on Long Island, 1958–59. Intrigued by the work of untrained artists, Dine at this time read Sidney Janis's masterpiece, *They Taught Themselves*, and in it found the work of Horace Pippin, Morris Hirshfield, and John Kane particularly compelling.[34] Janis later represented Dine from 1962 to 1964.

: 192 :
Jim Dine
Shoes Walking on My Brain, 1960

: 193 :
Jim Dine
Artaud at the Rodez Sanatorium, 1966

Dine continues to cultivate his interest in outsider art. He is familiar with the major collections of outsider art, and while he has never produced imagery directly based upon it, he views outsider art as an inspirational source of subject matter. Some of Dine's earliest work encompasses both the savagery and seriousness found in the productions of many compulsive visionaries and has been characterized as "rude and brutal as a Dubuffet." *Shoes Walking on My Brain* (FIGURE 192), 1960, "expresses a trampled, grievous condition."[35]

In 1965 City Lights published the *Antonin Artaud Anthology*, which incorporated reproductions of Artaud's drawings from Rodez into the text.[36] Artaud's haunting essays and poems, his extraordinary theories on the theater, and the intensity and force of the anguished drawings from Rodez were stunning to Dine, a cause for reflection and a source of insight. Dine found Artaud's writings on audience participation especially significant for contemporary performance art. He discovered even greater inspiration in Artaud's moving graphic works. In 1966, soon after reading the anthology, Dine painted *Artaud at the Rodez Sanitorium* (FIGURE 193) in homage to Artaud's creative spirit.

In the winter of 1987 Dine attended the exhibition *Jean Dubuffet & Art Brut* at the Palazzo Venier dei Leoni in Venice.[37] While Dine had long appreciated the work of Dubuffet and had visited the Collection de l'Art Brut in Lausanne on several occasions, he was particularly captivated by this exhibition, which comprised Dubuffet's work from the collections of Pierre Matisse and the Solomon R. Guggenheim Foundation and that of eight untrained artists from the Collection de l'Art Brut. Dine was especially enthralled by the exquisite paintings of Carlo. For Dine, who considers his own work to be autobiographical and explicative of his own sensibilities, Carlo's art resonated for him with an intensely personal emotion.

Claes Oldenburg

Dine recalls that he and Claes Oldenburg (born 1929), as early as 1959, often discussed their common interests in the art of children, the art of the untrained, and the art of the mentally disturbed. They enjoyed visiting Oldenburg's friend, the printmaker Richard Tyler, who served as superintendent of Oldenburg's apartment building and who had a collection of anonymous art, which they took pleasure in seeing.

Though Oldenburg was first exposed to the art of compulsive visionaries while living in Chicago (before moving to New York in 1956), it was only with his work of 1960, in particular *The Street*, that the impact of outsider art became clearly recognizable. He has pondered the relation of creative invention to compulsion and has tried to discover within himself a connection to the driven state of a compulsive individual, a state that he could then express through his own art.[38]

In 1959 he read the recently published English edition of Antonin Artaud's *Le Théâtre et son double* (The theater and its double) and talked about mounting a "psychasthenic spectacle" with Tyler.[39] Around this time Oldenburg was working in the stacks at the Cooper Union library, where he sought information on outsider art. He remembers reading about Dubuffet and feeling sympathy for his anticultural position; he also remembers looking at the writings of Ernst Kris and a study of Franz Xaver Messerschmidt's sculptures.[40] Oldenburg in 1961 wrote a letter to Alfonso Ossorio asking to see Dubuffet's art brut collection, then housed at The Creeks, Ossorio's estate on Long Island (FIGURE 194): "Dear Mr. Ossorio, I sure want to see your nut collection." (For reasons he cannot remember, Oldenburg never sent this missive to Ossorio.[41]) In 1969, asked about the relationship between his work and Dubuffet's, Oldenburg wrote, "Jean Dubuffet influenced me to ask why art is made and what the art process consists of, instead of trying to conform to and extend a tradition. . . . My homages to Jean Dubuffet occur in the period of my most primitive site, the streets of the slums, because the key to his formulation came from a study of primitive mentality."[42]

: 195 :
Claes Oldenburg's *The Street* being
installed at Reuben Gallery, New
York, 1960, under the artist's
supervision

: 194 :
Claes Oldenburg's 1961 letter to
Alfonso Ossorio (not sent)

: 196 :
Claes Oldenburg
Drawing for the announcement of
The Street at Reuben Gallery, New
York, 1960

: 197 :
Claes Oldenburg
Ray Gun Poster, 1961

214 ELIEL / FREEMAN Conte
mpora
ry
Artis
ts
and
Outsi
der
Art

In 1960 Oldenburg began to create the environment *The Street* (FIGURES 195–96), which was made out of found materials (including corrugated cardboard, string, and burlap) from the streets of the Lower East Side in New York.[43] Oldenburg relates the elements of *The Street* to what he calls the "wall work" of compulsive street people in New York City.[44] In 1960 Oldenburg wrote of his work, "After all, I don't come out of Matisse or the sunny concept of art. I come out of Goya, Rouault, parts of Dubuffet, Bacon, the humanistic and existentialist imagists, the Chicago bunch, and that sets me apart from the whole Hoffman-influenced school (who would maintain I am set off from art, this being New York!). I find it natural to move toward poets, troubled lives, darkness, mystery."[45]

Oldenburg's Ray Gun motif (FIGURE 197) likewise reflects his fascination with imagery deriving from instinctual, emotional sources, which the artist associates with the art of outsiders. Barbara Rose, in her monograph on the artist, characterizes Oldenburg as a neo-Freudian looking "for ways in which alternatives to civilized thinking might be found in non-civilized thought. . . . The world views of . . . the schizophrenic are seen not merely as antidotes to the deadness of civilization, but as conceivably more 'rational' and sane than civilized thought."[46] She goes on to say that Oldenburg's interest is in the "conceptual structure" of the art of schizophrenics and other "primitives" or groups of "non-civilized" people (as she calls them) rather than in the formal stylistic aspects of such work.[47] The artist has stated that the "compulsive, instinctual areas of creation" are what intrigue him about outsider art, while symmetry is the only *stylistic* element he has in common with outsiders.[48] Thus Oldenburg very much fits the model of the relationship between insider and outsider that has been constructed elsewhere in this catalogue.[49]

Red Grooms

Red Grooms (born 1937) shares with Dine and Oldenburg a highly developed admiration for outsider art that predates his arrival on the New York art scene. As curator Judith E. Stein has noted, "In the late 1950s and early 1960s, before the critical formulation of Pop art imposed sharper boundaries between them, Red Grooms, Dine, and Oldenburg shared a similar iconography [and] . . . explored the fresh territory of Happenings."[50]

Grooms grew up in Nashville, working the summers of 1953 and 1954 at Myron King's Lyzon Gallery and Frame Shop, where he saw the works of the "great self-taught artist William Edmondson."[51] King introduced Grooms to Sterling Strausser, a dealer of what was referred to at that time as "primitive art." Through Strausser, Grooms met and traded paintings with Justin McCarthy, a self-taught visionary whom he found profoundly interesting.

In 1955 Grooms enrolled in the School of the Art Institute of Chicago, where he spent much of his time in the Institute's galleries and library studying the work of Jean Dubuffet. While in Chicago, Grooms became friendly with the group then known as the Hairy Who and shared their enthusiasm for the work of Joseph Yoakum and other outsider artists. By 1960 Grooms was aware of Cheval's *Palais idéal*, which, because he considered it "so clearly splendid and grandiose in terms of ambition," had a significant influence on his creative output. Visionary environments have continued to appeal to Grooms, who visited the *Palais* twice during the 1980s. As recently as August 1991 Grooms discovered and photographed a "phantasmagoric environment" in Hawaii. Visionary art and environments have stimulated Grooms's creation of large-scale works, cultivated his proclivity for turning art into fantasy, and enhanced his spontaneity of technique. *Police Woman* (FIGURE 198), 1959, was produced during a period when Grooms first became interested in creating art in the spirit of the untrained. *Lumberjack* (FIGURE 199), 1977–84, fuses the rough spirit of the untrained with the refined technique of metal casting.

: 198 :
Red Grooms
Police Woman, 1959

: 199 :
Red Grooms
Lumberjack, 1977–1984

Walter Navratil

Of all the insider artists in the exhibition, Walter **215**
Navratil (born 1950) may have the most intimate
relationship with outsiders; they actually could
be considered his earliest mentors. The son of
psychiatrist Leo Navratil, who started the Künstler-
haus (Artists' house) at the mental institution
known as Gugging outside Vienna, Walter Navratil
grew up on the grounds of the hospital surrounded,
from his birth to age seventeen, by the patients and
their bold artistic creations (see FIGURES 16 and
158).[52] (Although the Künstlerhaus was only
officially opened in 1981, Leo Navratil already
decades earlier had begun studying and encourag-
ing his psychotic patients' interest in drawing.)
As a boy Walter Navratil was not aware of the
exceptional nature of his surroundings. He spent
a lot of time with the patients, some of whom
became—and remain to this day—close friends.
Although he studied briefly at the Akademie der
Bildenden Künste (Academy of Fine Arts) in
Vienna, Navratil perceives the mainstream art
world of academies and galleries to be confining,
preferring—indeed needing—to work in isolation.
The solitary figures and expressive melancholy of
paintings such as *Pastorale* (Pastoral; FIGURE 200),
1987, and *Gürteltier auf der Flucht* (Armadillo driving
away; FIGURE 201), 1991, reflect Navratil's sense of
loneliness and his remove from the art world, while
Nocturne (FIGURE 202), 1986, suggests the torment
experienced by outsiders as well as by insiders who
feel themselves to be outsiders.

: 201 :
Walter Navratil
Gürteltier auf der Flucht
(Armadillo driving away), 1991

: 200 :
Walter Navratil
Pastorale (Pastoral), 1987

: 202 :
Walter Navratil
Nocturne, 1986

: 203 :
Jonathan Borofsky
Counting from 1 to Infinity,
begun in 1969

: 204 :
Howard Finster
A House Divided, 1977

Jonathan Borofsky

For Jonathan Borofsky (born 1942), outsider art has served as an affirmation rather than a shaping influence.[53] Borofsky explains that he perceives most of twentieth-century art as falling into one of two schools: what he calls "the Mondrian school of constructivism," which led to minimalism later in the century; and the "surrealist school of imagery," which led to pop art. The former is highly rationalized and cerebral, the latter more emotive and humanistic. Borofsky aspires to combining both aspects in his work, in the way that Adolf Wölfli, an outsider he has admired since the early 1970s, did.[54] Borofsky sees Wölfli's intricate drawings (which completely cover the page), accompanied by words and at times musical notation as well (see FIGURE 239), as confirmation of his own tendencies as evident in *Counting from 1 to Infinity* (FIGURE 203). This work, which began in 1969 as "the clearest, cleanest, most direct exercise that I could do that still had a mind-to-hand-to-pencil-to-paper event occurring," subsequently became richer and fuller: "In 1971, after counting for a couple of years (and doing nothing else), I had the occasional need to scribble on the same sheet of paper as the counting. It was like taking a break. The counting had become a break from my thought process, and the scribbling now became a break from the counting."[55] Here again we see the combination of the physical and the cerebral that is so fascinating to Borofsky and that he sees exemplified in Wölfli's drawings.

Borofsky has also known the work of Howard Finster for many years and finds it to be, like Wölfli's, an affirmation of his own art with "its directness, its religious fervor, its touch of humor, and its craziness" (FIGURE 204). He feels that Finster "pushes the boundaries of good taste and good mental stability," as he himself does. Borofsky maintains that good artists need to "scratch through the surface and get to the texture beneath the slickness . . . to scrape through the slick surface and get to the grittiness that's a little off-center, a little crazy." For Borofsky, compulsive visionaries achieve this level of penetration; Borofsky himself constantly strives to do so as well and then to "come back to tell about it" in his work.

: 205 :
Jeanne Tripier
Large Rectangular Embroidery,
1935–39, cotton, wool, and string,
9 ⅞ x 35 ⁷⁄₁₆ in. (25 x 90 cm),
Collection de l'Art Brut, Lausanne

: 206 :
Annette Messager
Detail of *Mes Ouvrages* (My works),
1987, acrylic on gelatin-silver prints
under glass and colored crayon on
wall, dimensions vary, Galerie
Crousel-Robelin BAMA, Paris

Annette Messager

After being transfixed by the exhibition of
selections from Dubuffet's Collection de l'Art Brut
at the Musée des Arts Décoratifs in Paris in 1967,
Annette Messager (born 1943), who was then
young and impoverished, went out and—in a
fashion appropriately outside the norms of
conventional, accepted behavior—stole a set of
L'Art brut fascicles so that she could read them and
live with them.[56] The daughter of a painter who
was also interested in art brut, Messager feels an
affinity with outsider artists and continues to be
influenced by their work.

The *horror vacui* evident in Adolf Wölfli's
fantastic creations (see FIGURE 232) and the
compulsive richness of the embroidered works in
Dubuffet's art brut collection, by such artists as
Jeanne Tripier (FIGURE 205) and Juliette Elisa
Bataille, inspired and affirmed Messager's own
artistic tendencies. Messager has likewise
acknowledged the influence of Augustin Lesage—
whose work (see FIGURE 64) she knew from her
youth in the north of France, near where Lesage
lived and where his works are now housed—and
of Scottie Wilson (see FIGURE 70). According to
Messager, her series *Mes Ouvrages* (My works;
FIGURE 206), 1987, with its arabesques of words
punctuated by small photographs, reflects these
very influences. Similarly a work such as *Pièce
montée, no. 2* (FIGURE 207), 1986, reflects her
recognition of outsiders' seeming understanding
of the animistic forces within the landscape and
their fascination with human physiognomy (see
FIGURE 79).

: 207 :
Annette Messager
Pièce montée, no. 2, 1986

Christian Boltanski

It was through Messager that Christian Boltanski (born 1944) was first introduced to the art of compulsive visionaries.[57] Unlike her, however, Boltanski is attracted to outsider art not visually or stylistically but rather conceptually. He sees an affinity between the emotional intensity of outsider art and that of his own work, both far removed from what he perceives to be the cerebral coolness and highly intellectualized quality of much contemporary art. The greatness of outsider art, in Boltanski's view, lies in its ability simultaneously to be timeless and individual and in its ability to elicit strong emotional reactions from the viewer. He strives to achieve these ends in his own work (FIGURE 208) and, in fact, feels that contemporary artists should "strive to be mad" like their outsider counterparts so as to be truly creative.

: 208 :
Christian Boltanski
Reliquaire (Reliquary), 1989

: 209 :
Donald Baechler
Untitled, 1985

Donald Baechler

While his work (FIGURE 209) superficially resembles most closely the art of children, Donald Baechler (born 1956) has, in fact, looked carefully at a wide variety of art outside the mainstream, including not only children's art but also images by prisoners, alcoholics, and psychiatric patients.[58] He has visited the Prinzhorn Collection in Heidelberg and is fascinated by the irregular cycles of rationality and irrationality experienced by the mentally disturbed (particularly schizophrenics), as evidenced in their art. Baechler's efforts to suggest the imbalance and pain of such an existence are evident in works such as *Holiday in Cambodia II* (FIGURE 210), 1985, with its heavily worked, painted, and collaged surfaces. The severely limited palette and harsh pentimenti further serve to accentuate the painful aspects of the act of creation for both the mainstream and the outsider artist.

: 210 :
Donald Baechler
Holiday in Cambodia II, 1985

ELIEL / FREEMAN

Conte
mpora
ry
Artis
ts
and
Outsi
der
Art

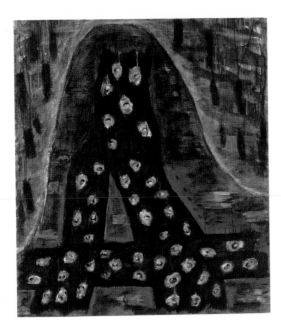

: 211 :
Gregory Amenoff
Santuario XVII, 1989

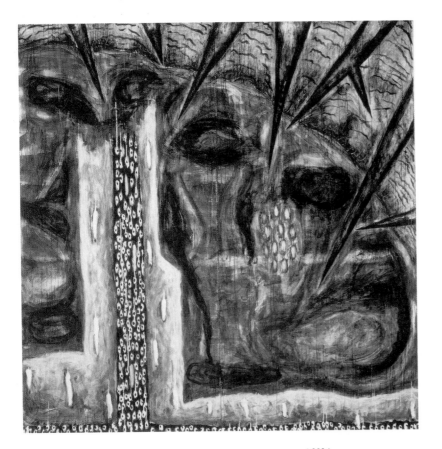

: 212 :
Gregory Amenoff
Center panel of *Altarpiece for
St. Peter's Church*, 1990

Gregory Amenoff

Though the work of Gregory Amenoff (born 1948) does not look like that produced by the outsiders he so admires, it nonetheless reflects the extent to which he has been inspired by them. He has written of the "feral sensibility" of compulsive visionaries, **which slices all the "fat" out . . . leaving only what is necessary to make a "picture work." . . . It is not the *look* of art made in isolation that is appealing and therefore worthy of appropriation. It is the fact that such art is *not* encumbered by those layers of meaning that have to do with "art culture" and "art language." Instead the isolate artist provides a clear window directly to the content—there are no barriers to understanding the artist's intent. *Ramirez* is an example of that direct communication—when standing in front of a Ramirez— the heart of the drawing is exposed. The mythic doesn't unfold—it stares right back at you—there are no forks in the road—the intention of the artist is clear and unencumbered. Such art is an *inspiration* for its clarity. It is *truly* minimal—leaving only that which is necessary to communicate.[59]**

Amenoff seeks the same level of intensity and directness in his own paintings. The shimmering abstraction of *Santuario XVII* (FIGURE 211), 1989, suggests a direct confrontation with forces larger than man, a theme echoed in the central panel of Amenoff's monumental altarpiece for St. Peter's Church in Cologne (FIGURE 212). Here the oversized thorns and bottom portion of a crucifix hover over an abstract form suggestive of a landscape; a light of purifying clarity seems to illuminate the entire image.

: 213 :
J. B. Murry
(John B. Murry or Murray)
Untitled

Andy Nasisse

Andy Nasisse (born 1946) exemplifies the American mainstream artist who is fascinated by and has surrounded himself with work by self-taught visionaries, mainly those working in the Afro-Atlantic vernacular. Over the past twenty years Nasisse has both documented and collected the work of numerous outsiders, including J. B. Murry (FIGURE 213) and Howard Finster (FIGURE 214). Like Amenoff, Nasisse is inspired by the directness and freshness of the art of outsiders:

I guess [I am fascinated by] the sense of inspired innocence it [outsider art] reveals. Often the visionary doesn't even identify what they make as being "art." Many are illiterate and few have ever been to a museum or gallery. The work they make is not conditioned by society's definitions and limitations and is consequently startlingly fresh and truly inspired. Their work is made out of vital needs, obsessions, and compulsions and their motivations are honest, pure, and intense.[60]

Nasisse seeks to achieve the same ends in his ceramic sculptures (FIGURE 215), to achieve "a feeling like the work came through the artist more than from [him]. . . . I think that is what makes good art, when it transcends the artist's intentions."[61] Nasisse uses this benchmark for the work of both insiders and outsiders.

223

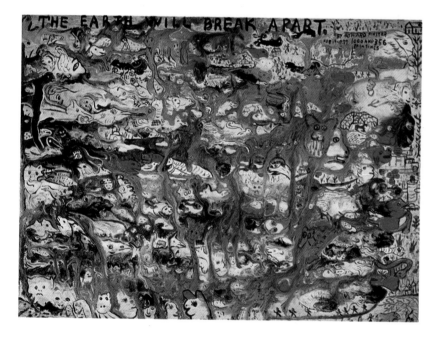

: 214 :
Howard Finster
The Earth Will Break Apart, 1979

ELIEL / FREEMAN

Conte
mpora
ry
Artis
ts
and
Outsi
der
Art

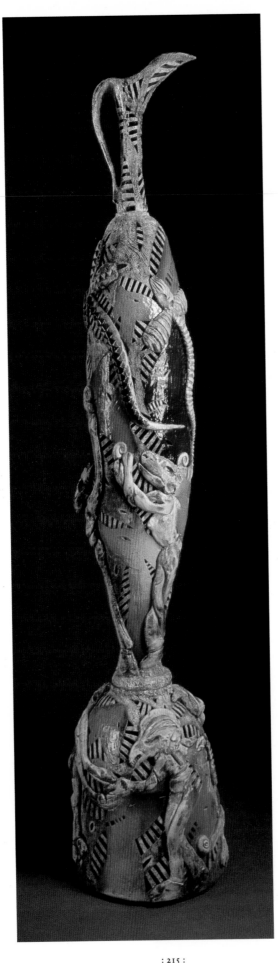

: 215 :
Andy Nasisse
Untitled, 1989

The Mainstream Expands

Given the pressure within the contemporary art world constantly to present something new and different, coupled with a revisionist attitude that things previously rejected from the canon should now be enthusiastically received, it is hardly surprising to discover that by the last decade of the twentieth century we see outsider art increasingly drawn into the mainstream art world. While it was a relatively simple task for us, in organizing this exhibition, to distinguish between Adolf Wölfli as an outsider and Paul Klee as an insider in the early decades of the century, with Gaston Chaissac (circa 1938) the distinctions between insider and outsider begin to blur.[62] In considering contemporary artists for *Parallel Visions*, we were faced with the work of artists such as Pascal Verbena (FIGURE 216), Willem van Genk (FIGURE 217), Michel Nedjar (FIGURE 218), and Gregory van Maanen (FIGURE 219), who all seem to have erased the distinctions between outsider and insider artists. Unschooled and seemingly isolated from the artistic mainstream, these artists nonetheless have been shown since the beginnings of their careers in galleries in major art centers and included in important collections. Perhaps most significantly they have always been aware, unlike the compulsive visionaries in *Parallel Visions*, that they are creating art for an audience.[63] Important showcases for contemporary art, including the Phyllis Kind Gallery, Hirschl & Adler Modern, and the Galerie Karsten Greve, now show the work of outsiders alongside work by main-stream artists without distinguishing between them. ABC's "World News Tonight" has done a segment on Finster, who has also appeared on NBC's "Tonight Show," with Johnny Carson; Ramírez and Wölfli have been accorded retrospective exhibitions, which traveled across the United States and Mexico. The works of these artists can hardly be considered to exist outside the mainstream of twentieth-century cultural life.

All of which begs the questions: Is the fading of distinctions between insiders and outsiders necessarily problematic? Is it important in the long run to be able to distinguish between these two groups?

: 216 :
Pascal Verbena
Holocaust, 1988, wood and mixed
media, 75 x 150 in. (190.5 x 381 cm),
Sam and Betsey Farber

: 217 :
Willem van Genk
Kyoto, 1970, mixed media,
35 7/16 x 66 ½ in. (90 x 169 cm),
Collection de l'Art Brut, Lausanne

226

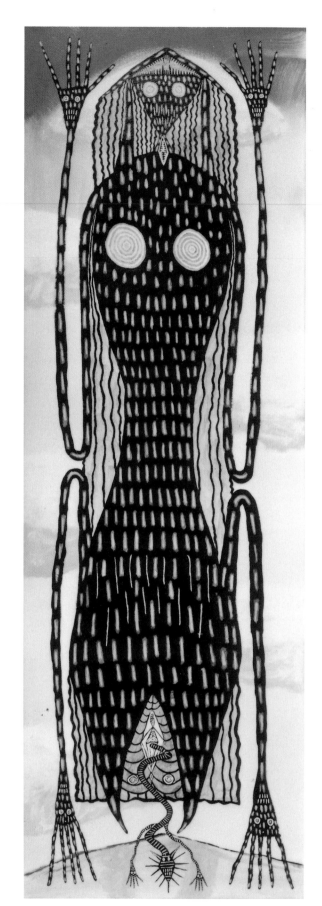

: 218 :
Michel Nedjar
Untitled, cloth and mixed media,
height: 32 in. (81.3 cm), Sam and
Betsey Farber

: 219 :
Gregory van Maanen
Red Spirit Mother, 1987, acrylic
on canvas, 66 ¾ x 22 ½ in.
(169.5 x 57.2 cm), Cavin-Morris,
Inc., New York

Despite the importance—even necessity—of these categories for this exhibition, which casts a retrospective eye across the twentieth century from the vantage of the 1990s, they do not necessarily have significance for the future. We have already seen that the distinctions between the categories of insider and outsider are disappearing, just as differences between American, German, French, Italian, and even Japanese art have narrowed since the early years of this century. The so-called global village has expanded to include outsiders; as outsiders are absorbed into mainstream culture—or, more precisely, as mainstream culture expands to include them—the term *outsider* is likely to become obsolete.[64] This exhibition is itself a prime example of the cultural mainstream—in this case the art museum—expanding to show work not heretofore (or at best only very rarely) included.[65] The world of contemporary art—the diversity of which we acknowledged at the beginning of this essay—is expanding to embrace outsider art as well.

=

Notes

1
Selden Rodman, *Artists in Tune with Their World: Masters of Popular Art in the Americas and Their Relation to the Folk Tradition* (New York: Simon and Schuster, 1982), 81.

2
Michel Thévoz, *Art Brut* (New York: Rizzoli, 1976), 25–27.

3
André Breton, "Le Message automatique," *Minotaure*, nos. 3/4 (December 1933): 55–65.

4
Alfred H. Barr, Jr., ed., with essays by Georges Hugnet, trans. Margaret Scolari, *Fantastic Art, Dada and Surrealism*, exh. cat., 2d ed., revised and enlarged (New York: Museum of Modern Art, 1937), 236.

5
William C. Seitz, *The Art of Assemblage*, exh. cat. (New York: Museum of Modern Art, 1961), 72–73, 77–80.

6
Seymour Rosen, *Simon Rodia's Towers in Watts*, exh. cat. (Los Angeles: Los Angeles County Museum of Art, 1962).

7
Henry Hopkins, "Recollecting the Beginnings," in *Forty Years of California Assemblage*, exh. cat. (Los Angeles: Wight Art Gallery, University of California, Los Angeles, 1990), 15.

8
Michael Auping, "Songs of Innocence," *Art in America* 75, no. 1 (January 1987): 118.

9
Jess, in a letter to Barbara Freeman, September 1991.

10
Jess, in conversation with Maurice Tuchman, Carol Eliel, Barbara Freeman, and Rosalinde Leader, October 24, 1991.

11
Auping, "Songs of Innocence," 126.

12
Herms, in a telephone conversation with Barbara Freeman, October 9, 1991.

13
Peter Selz, *The Work of Jean Dubuffet*, exh. cat. (New York: Museum of Modern Art, 1962). Herms also cited the following as influential: *Marcel Duchamp: A Retrospective*, exh. cat (Pasadena: Pasadena Art Museum, 1963); *Retrospective Kurt Schwitters*, exh. cat. (Los Angeles: Wight Art Gallery, University of California, Los Angeles, 1965); and *Man Ray*, exh. cat. (Los Angeles: Los Angeles County Museum of Art, 1966).

14
Gregg N. Blasdel, "Grass-Roots Artists," *Art in America* 56, no. 5 (September/October 1968): 24–41. While Blasdel's essay was the first to survey environments in America, there were earlier publications that included some information on environments: Wendy Buehr, "Home Is What You Make It," *Horizon* 6, no. 4 (Autumn 1964): 114–19; Allan Kaprow, *Assemblages, Environments and Happenings* (New York: Abrams, 1966); Jules Langsner, "Watts Towers," *Craft Horizons*, no. 19 (November 1959): 34; and Selden Rodman, "The Artist Nobody Knows," in *New World Writing* (New York: New American Library of World Literature, 1952), 151–57.

15
Michel Thévoz, *Art Brut* (New York: Rizzoli, 1976), 28–31. Thévoz illustrates Schmidt's environment and Rodia's towers. The photograph of Schmidt's environment reproduced on p. 28 of *Art Brut* was taken by Blasdel. Thévoz documents other examples of "grass-roots artists" in the

United States, all of whom were researched by Blasdel, including Jesse Howard, David Rousseau, Dave Woods, and S. P. Dinsmoor. In the foreword to *The Artworks of William Dawson*, exh. cat. (Chicago: Chicago Public Library Cultural Center, 1990), Roger Brown states that after learning of Blasdel's article in *Art in America* from Whitney Halstead he followed the route traveled by Blasdel, photographing the environments. The slides that Brown made of the environments were shown in Chicago on many occasions and duplicates were given to Dubuffet in the early 1970s.

16
Blasdel, in a telephone conversation with Barbara Freeman, July 16, 1991.

17
Gregg Blasdel and Bill Lipke, "Toward Journey's End," in *Naives and Visionaries*, exh. cat. (Minneapolis: Walker Art Center, 1974), 43–52.

18
Tom Patterson, *Howard Finster: Stranger from Another World* (New York: Abbeville, 1989); and John Turner, *Howard Finster: Man of Visions* (New York: Knopf, 1989).

19
David Bourdon, "Niki de Saint Phalle: Targets, Nanas, and Tarot," in *Fantastic Vision: Works by Niki de Saint Phalle*, exh. cat. (Roslyn, New York: Nassau County Museum of Fine Art, 1987), 11.

20
Saint Phalle, in a letter to Barbara Freeman, July 19, 1991.

21
Ibid.

22
Quoted in Prince Michael of Greece, "House of Cards: Niki de Saint Phalle's Tuscan Fantasy," *Architectural Digest* 44, no. 9 (September 1987): 125, 131.

23
K. G. Pontus Hultén, *Jean Tinguely: "Méta"* (Boston: New York Graphic Society, 1975), 171.

24
Peter Boswell, "Beat and Beyond: The Rise of Assemblage Sculpture in California," in *Forty Years of California Assemblage*, 66.

25
Unless otherwise indicated, information about Scanga and statements by him derive from the artist's conversation with Barbara Freeman and Carol Eliel, April 6, 1990, and his telephone conversation with Barbara Freeman, July 16, 1991.

26
Michele Bonuomo, *Italo Scanga*, trans. Pasquale Verdicchio (Salerno: Amalfi Arte, 1989), 18.

27
Quoted in *Allan Kaprow*, exh. cat. (Pasadena: Pasadena Art Museum, 1967), unpaginated. Kaprow has not altered his opinion regarding the role of the museum. In a telephone conversation with Barbara Freeman on May 16, 1991, Kaprow advised that the proper method to acknowledge his link to Schmidt and to convey his own artistic sensibility would be for him to "reconstitute" an environmental work from the early 1960s in a "trashy adjunct" outside the bounds of a formal museum space.

28
Kaprow, *Assemblage, Environments and Happenings*, 165.

29
Kaprow, telephone conversation with Freeman. The phrase "gift to mankind" is Schmidt's.

30
Valerie Petersen, "Reviews and Previews," *Art News* 59, no. 9 (January 1961): 12.

31
Kaprow, *Assemblage, Environments and Happenings*, passim.

32
Roger Cardinal, "All the Room in the World," *Studio International* 186, no. 959 (October 1973): 127.

33
Dine, in an artist's statement in John Gordon, *Jim Dine*, exh. cat. (New York: Whitney Museum of American Art, 1970), unpaginated, wrote that after he came to New York in 1959, meeting and knowing Allan Kaprow, Bob Whitman, and Claes Oldenburg were the real influences in his life.

34
Sidney Janis, *They Taught Themselves* (New York: Dial Press, 1942). Unless otherwise indicated, information about Dine and statements by him derive from the artist's conversation with Barbara Freeman, July 18, 1991.

35
David Shapiro, *Jim Dine: Painting What One Is* (New York: Abrams, 1981), 20.

36
Jack Hirschman, ed., *Antonin Artaud Anthology* (San Francisco: City Lights, 1965).

37
Thomas M. Messer, Fred Licht, and Michel Thévoz, *Jean Dubuffet & Art Brut*, exh. cat. (Venice: Peggy Guggenheim Collection, 1986).

38
Oldenburg, in conversation with Maurice Tuchman, August 20, 1989.

39
Barbara Rose, *Claes Oldenburg* (New York: Museum of Modern Art, 1969), 27. Psychasthenia is defined by *Webster's Ninth New Collegiate Dictionary* as "a neurotic state characterized especially by phobias, obsessions, or compulsions that one knows are irrational."

40
Oldenburg, in conversation with Carol Eliel and Maurice Tuchman, August 9, 1991.

41
Oldenburg, in conversation with Carol Eliel, October 8, 1991.

42
Oldenburg in *Dubuffet and the Anticulture*, exh. cat. (New York: Feigen, 1969), as quoted in Coosje Van Bruggen, *Claes Oldenburg: Nur ein anderer Raum* (Frankfurt am Main: Museum für Moderne Kunst, 1991), 18–19.

43
Rose, *Claes Oldenburg*, 37.

44
Oldenburg, conversation with Tuchman.

45
Quoted in *Claes Oldenburg*, exh. cat. (Amsterdam: Stedelijk Museum, 1970), 17.

46
Rose, *Claes Oldenburg*, 171–74.

47
Rose, *Claes Oldenburg*, 174.

48
Oldenburg, conversation with Eliel and Tuchman.

49
See Carol S. Eliel, "Moral Influence and Expressive Intent: A Model of the Relationship between Insider and Outsider," in this volume.

50
Judith E. Stein, "Red Grooms: The Early Years (1937–1960)," in Judith E. Stein et al., *Red Grooms: A Retrospective 1956–1984*, exh. cat. (Philadelphia: Pennsylvania Academy of Fine Arts, 1985), 34.

51
Unless otherwise indicated, information about Grooms and statements by him derive from the artist's telephone conversation with Barbara Freeman, September 6, 1991. William Edmondson, an untrained painter and sculptor, was the first African-American artist to have a solo exhibition at the Museum of Modern Art, New York (1937).

52
Unless otherwise indicated, information about Walter Navratil and statements by him derive from the artist's brief undated letter and autobiography sent to Maurice Tuchman and from conversations with Carol Eliel, September 11–12, 1991.

53
Unless otherwise indicated, information about Borofsky and statements by him derive from the artist's conversation with Carol Eliel, July 24, 1991.

54
Borofsky first saw Wölfli's work reproduced in books. Later, during Borofsky's drawings show at the Kunsthalle Basel in 1981, he visited the Wölfli Foundation at the Kunstmuseum Bern.

55
Quoted in Mark Rosenthal and Richard Marshall, *Jonathan Borofsky*, exh. cat. (Philadelphia: Philadelphia Museum of Art, in association with the Whitney Museum of American Art, 1984), 33.

56
Unless otherwise indicated, information about Messager and statements by her derive from the artist's conversation with Carol Eliel in Paris, November 6, 1989.

57
Unless otherwise indicated, information about Boltanski and statements by him derive from the artist's conversation with Carol Eliel in Paris, November 4, 1989.

58
Barry Blinderman, "From the Bay of Naples to Coney Island (and Back Again)," in *Donald Baechler: Paintings 1981–1987*, exh. cat. (Normal, Illinois: University Galleries, Illinois State University, 1988), unpaginated; Ben Brantley, "Bohemian Grooves," *Vanity Fair* (January 1990): 103; other information about the artist derives from conversations with Carol Eliel, Barbara Freeman, and Maurice Tuchman, March 23 and 26, 1991, in Los Angeles. In Richard Kalina, "Donald Baechler," *Arts* 63, no. 10 (Summer 1989): 74, Baechler asserts that he is "less interested in the art of children than in that of schizophrenics."

59
Amenoff, in a letter to Maurice Tuchman, Barbara Freeman, Rosalinde Leader, and Carol Eliel, July 21, 1989.

60
From an unpublished interview of Nasisse by Samantha Krukowski of PRO-ART, St. Louis. Transcript provided by the artist.

61
Nasisse, in a letter to Maurice Tuchman, March 27, 1991.

62
Chaissac's ambiguous position was evident already to Dubuffet, who first included him in the Art Brut collection but subsequently transferred him to the so-called Neuve Invention collection. This collection is "simultaneously distinct from art brut and from cultural art. . . . One finds there . . . works nearer art brut without obeying all its characteristics, owing, for example, to the artists' . . . having been introduced into the commercial art world, like Gaston Chaissac. . . . In short, the auxiliary collection [Neuve Invention] began by constituting a place to relegate doubtful cases and a means to avoid the overly brutal alternatives of art brut and cultural art." Michel Thévoz in *Neuve Invention: Collection d'oeuvres apparentées à l'art brut* (Lausanne: Collection de l'Art Brut, 1988), 7.

63
It is worth mentioning in this context that van Genk has stipulated that his dealer may only sell his work to museum collections.

64
It has been variously suggested, and discussed in some detail at the first scholars' planning conference for this exhibition (held in Los Angeles, October 13–15, 1989), that the only true contemporary outsider artists are to be found among the homeless (particularly those released from mental institutions or drug rehabilitation programs) who walk the streets of America's cities, along with their counterparts elsewhere.

65
For a broader discussion of this theme, see Donald Preziosi, "Art History, Museology, and the Staging of Modernity," in this volume.

229

Constructing Creativity and Madness

Freud and the Shaping of the Psychopathology of Art

Sander L. Gilman

"Madness" cannot be understood apart from human history.[1] Its form or its reception is shaped by its context. This does not mean that it is invented or merely a fantasy. Rather, it means that madness may well shift its form or its significance from age to age, from culture to culture, depending on the meaning attributed to it in specific times and places. Likewise "creativity" is a universal category of Western thought, but what it means is historically and culturally determined.[2] Each age invents, to fulfill its own needs, what the truly creative is, and each individual constructs a working definition that satisfies his or her own needs to place him or herself in relationship to the creative.

But are madness and creativity necessarily linked? Aristotle believed that they were. In the *Problemata* he asked, "Why are men of genius melancholics?"[3] Melancholia, the dominance of one of the humors, the mythic black bile, was seen as the cause of most mental illnesses from the ancient Greeks through the Renaissance. Aristotle saw figures such as Heracles as possessing a melancholic constitution but also saw "most of the poets" as being "clearly melancholics." Creative minds, at least according to the ancients, are diseased, housed in a body dominated by black bile, the source of madness. The special role, closely associated with that of the priest, attributed to the artist and poet by the Greeks demanded a specific type of insight, an insight that was unique. Aristotle, whose "materialism" moved him to find the boundary between the "normal," observing member of society (defined by himself) and the "poet," sought the difference between these two categories in a strictly somatic definition of creativity as the product of the imbalance between the natural forces (the humors). Creativity was, for the Greeks, not the inspiration or punishment of the gods but a product of the body and a sign of its pathology. The creative individual was thus considered different from the observer.

This view of the relationship between madness and creativity has been sporadically accepted in Western culture since the Greeks. Creative individuals have been distinguised from the normal not only by their actions but also by their motivation. (Indeed today we as a culture wonder at the anomalies: How could "geniuses" such as Franz Kafka, Wallace Stevens, or Charles Ives spend their "noncreative" lives working every day in insurance companies!) The uniqueness of the creative individual has been popularly perceived to be the result of some greater, overwhelming force. This view, which places the observer at some remove from the wellspring of creativity, was commonly accepted throughout the nineteenth century and attained the status of a truism. Whether in the works of the romantic psychiatrists of the early nineteenth century, who sought a metaphysical answer to the problem of madness, or in the work of the biologically oriented psychiatrists, who today see mind (and, therefore, creativity) as a simple product of the brain, the creative individual has been labeled as drawing on resources (or errors) not present in the normal individual. And that normal individual is tacitly assumed to be the physician, scientist, or philosopher who is describing creativity. With the reform of the asylums in the early nineteenth century and the parallel literary glorification of the mad as those solely possessing true insight (in the writings of romantics such as E. T. A. Hoffmann or Mary Shelley), attention was thrown for the first time on the artistic production of the insane. For if the creative are mad, must not the corollary also be true, that the mad are creative?

The creativity ascribed to the insane was understood as deformed, as frightening, or indeed as not creative at all. With the transvaluation of madness in the late eighteenth century into a state of "true" insight or a correct response to a universe itself out of control, the artistic products of the insane and the prisoner were seen for the first time as keys to the inner world of the outsider. This is not to say that even after the age of the romantics these products were always understood as being creative—but they had meaning ascribed to them, whether as pathognomonic sign or as sign of insight. But the European romantics, such as Novalis and William Wordsworth, evoked an ancient tradition that linked the exemplary state of the outsider—madness—with the concept of creativity.

It was within the institutions in which the outsiders were held—in the asylum and the prison—that they were first seen to be productive. One of the founders of American asylum psychiatry, Pliny Earle, published in 1845 an essay on the creativity of the insane in which he presented the theories medicine had developed during the first half of the nineteenth century to deal with the aesthetic products of the mad.[4] He condemned the isolation of the insane as an inhuman practice and offered as proof of their innate humanity the fact that they too produce works that can be seen as "elevated." He saw in these works the truths of a prelapsarian state of humanity:

It has been asserted, by one who was laboring under mental derangement, that the only difference between the sane and the insane is that the former conceal their thoughts, while the latter give them utterance. This distinction is far less erroneous than might be supposed, and is not destitute of analogy to the remark of Talleyrand, that "language was invented for the purpose of concealing thought." The contrast between lunatics and persons retaining the use of reason is not so broad and striking as would appear to such as are but little acquainted with the former. It seems to me that one of the most prominent points of difference, having the general character in view,

232 GILMAN Const
 ructi
 n g
 Creat
 ivity
 and
 Madne
 s s

is that with the insane, "the shadow had receded upon the dial-plate of time," and they are, truly, "but children of a larger growth." In their attachments and antipathies, their sources of pleasure and of pain, their feelings, motives, all their secret springs of action, they appear to have returned again into childhood. But childhood and early life are emphatically the poetical age of man, when hope is unclouded and care is but a name, when affection is disinterested, the heart unsullied, and imagination untrammeled by the serious duties of a working world.[5]

Earle considered mad poets to be like child poets in their inability to repress the inner truths they have seen. This poet as child also saw more intensely than did the sane: "It is well known that insanity not infrequently develops, or gives greater activity to powers and faculties of the mind, which, prior to its invasion, had remained either dormant or but slightly manifested. No other power is more frequently thus rendered prominent than that of poetical composition."[6] The mad poet saw more deeply and was able to articulate this perception. Earle's examples, however, contradicted this position. The poetry he cited from his patients he labeled as either confused or banal. Earle provided an aesthetic differentiation between his notion of what constituted true creativity and the unbridled products of the mentally ill.

For Earle and other mid nineteenth-century thinkers, the mental state of madness was neither sufficient nor even necessary to explain creativity. Concepts of madness and true creativity were not linked within Earle's system, nor indeed within the intellectual systems of other nineteenth-century psychiatrists. The creativity of the mentally ill was always considered to be damaged, different, incomplete. That was the great escape valve for

scientists of the nineteenth century, for inherent in their attempt to place themselves beyond the world of the outsider was a desire to see their own work as normal but also as creative. After all, what author in the nineteenth century, whether of a volume of poetry or of a study of madness did not imagine that what he or she was doing constituted original-ity and, therefore, creativity? What is of interest is how this view shifted over time and how the association between creativity and psychopath-ology was altered as these two concepts took on quite different meanings and as the context for both of these concepts changed. We must, therefore, explore together what madness and creativity mean in given, limited contexts to understand the complexity an author may read into their relationship.

Today, in the late twentieth century, madness and creativity remain closely linked as states that differentiate the voice of the observing scientist from the voice of the observed. The present argument, like that of classical Greek or late nineteenth-century medicine, associates these two aspects of the mind through a definition that in some manner regards the mind as a reflex of the body. The most radical example of this epiphenomenalism views the mind simply as a product of the brain, much as bile is a product of the liver. Creativity is thus a state resulting from some inherent error in the body of the "genius." Exemplary of this most radical position is the work of Nancy Andreasen and I. D. Glick of the University of Iowa's College of Medicine.[7] In a review-essay published in 1988, they argued that there is a clear relationship between creativity and affective illness, particularly bipolar illness (manic-depressive psychosis). They did not argue a causal relationship between the act of creation and the presence of illness, indeed noting that creative individuals are more productive when their affective symptoms are under control. They assume that the

creativity of the artist is a parallel manifestation of the same underlying genetic error that they postulate "causes" bipolar illness. Thus the creativity of the artist is a reflex of his or her underlying biology and is closely linked to the simultaneous potential for illness.

This view has been qualified by Kay Redfield Jamison of the Johns Hopkins School of Medicine.[8] Citing literature from both popular writing on creativity (such as the work of Arthur Koestler) as well as Andreasen's earlier essays on the relationship between bipolar disorder and creativity, she has suggested that the cognitive, perceptual, mood, and behavioral implications of creativity are analogous to madness. Jamison's inquiry focused on a sample of "eminent British writers and artists" in order to study the differences of the experience of madness and creativity in self-designated subgroups—poets, novelists, playwrights, and artists— as well as to study the overall structure of their creative experience. Jamison regards the seasonal patterns of moods and productivity as potentially similar to, but not identical with, the hypomanic state of bipolar illness.[9]

A third position has been taken by Arnold Ludwig of the A. B. Chandler Medical Center of the University of Kentucky.[10] Unlike most medical writers on this question, who are quite detailed in their definition of psychopathology but unable or unwilling to define creativity, Ludwig has tried to define creativity. Acknowledging the psychoanalytic discourse about creativity (but not using it), he views it tautologically as the structural relationship between the creative individual, the creative process, and creative product. While he stresses the cultural context of any creative work, he too assumes that all cultures produce works that are creative. And though he does not consider madness to be a prerequisite for creativity, Ludwig argues that a touch of madness can enhance the creative.

What does the creative mean in these contemporary contexts? Can we simply assume, as all of these authors do, that this category is a "reality" that transcends any historical context? What is the idea of madness with which it is linked? It is evident that there is an extensive critical literature on the question of the meaning attributed to madness. Indeed even the most radical thinkers who deal with questions of psychopathology today assume there is some component in the presentation of madness—whether it is in the type or formation of symptoms or in the social identity of people with "mental illness"—that is culturally or socially determined. Thinkers such as Thomas Szasz, R. D. Laing, and Michel Foucault—in very different ways—have argued in the recent past that madness may well be a product or a label rather than a reality. Contemporary cultural critics such as Roy Porter, Susan Sontag, and I, who assume the existence of psychopathologies, argue—again in very different ways—that our understanding of these phenomena is so shaped by social or psychological forces, such as the stigmatization of those labeled as mentally ill, that no one can speak about mental illness (or mental health) without evoking the social context of these very real states. If this is the case, then the link to the creative may also be historically determined. Both madness and creativity can mean different things at different times to different audiences; but they always reflect the presuppositions of those powerful groups that manipulate language and create categories of difference.

234 GILMAN Const
ructi
ng
Creat
ivity
and
Madne
ss

:

The link between the constructed meanings of madness and creativity is exemplified by the work of Sigmund Freud, which constitutes the predominant twentieth-century theoretical inquiry relating creativity with psychopathology in the arena of culture. Indeed his work has informed the biologically oriented discussions of madness and creativity and continues to have the most direct impact on modern ideas of the interpretation of outsider art.

Freud's own views were a response to the dominant theories of the late nineteenth century, those of the Italian forensic psychiatrist Cesare Lombroso. Lombroso, in his first major study of the subject, *Genio e follia* (Genius and madness), 1864, drew analogies between the products of genius and those of the insane, which he had seen in his work at the Turin psychiatric clinic.[11] Lombroso's book and his subsequent fame as the medical champion of the concept of "degeneracy" as the central explanation of deviancy (from sociopathic and psychopathic to creative acts) moved the relationship between genius and madness into the center of concerns of modern clinical and asylum psychiatry. It was only following Lombroso that the two questions are clearly separated: one line leads to the examination of the "great" in order to find the psychopathological origin of their greatness; the other to examine the aesthetic products of the mentally ill to establish the creativity of the mad. Lombroso's *Genio e follia* grew out of his examination of 107 mentally ill patients (of whom about half spontaneously painted). In the art of his patients Lombroso saw proof of his basic tenet, that sociopathic and psychopathic acts reflect a throwback to a more primitive stage of human development; the paintings were, for Lombroso, an atavistic form of representation paralleling the art of the "primitive." As in the art of the primitive, Lombroso saw a fixation on the obscene as well as a stress on the absurd. He also believed that this art did not fulfill a function either in the asylum or in the greater world. The art was, he thought, merely a reflection of madness, a sign of the patient's disease, and had therefore only superficial meaning.

Lombroso denied that the work had any deeper significance. What he was interested in was the seemingly spontaneous act of painting, which he saw as similar to the seemingly spontaneous act of painting among "savages."

Freud's view was quite different. In his writings from the close of the nineteenth century through the onset of World War I he saw creativity, as he did dreams or slips of the tongue or neurotic symptoms, not as a set of formal processes or disease mechanisms in a subset of the population but as clues to the normal functioning of the unconscious. Whereas Lombroso believed the mad and their aesthetic productions to be throwbacks to an earlier, more primitive state of development, Freud saw all creativity as a sign of the universal, underlying forces that make all human beings human. He, too, considered creativity to be pathological in that it was the result of deviation from normal psychological development; this pathology, however, was the potential of all human beings, not merely of a subset. He studied the creative to understand the centrality of unconscious processes, especially the role of unconscious motivation in human action.

Freud, in his case studies of Leonardo (1910) and Michelangelo (1914) as well as in his critical readings of the creative works of Wilhelm Jensen (1907) and the strange autobiography of the "psychotic" Dr. Daniel Schreber (1911), looked at creative work as a sign of the displacement of psychic (and for Freud that means sexual) energy into a different, seemingly unrelated undertaking.[12] The creative impulse, he believed, is a form of displacement or repression analogous to the symptoms of the neurotic. For Freud, it was within the sphere of the sexual that these products (whether symptoms or works of art) always arose. The creative individual is by Freud's definition one who *must* sublimate his sexual drive into the realm of fantasy. And the reason for this sublimation, as in the cases of the individuals he studied, is the

socially unacceptable direction of the expression of their sexuality (from the homosexuality of Leonardo to the incestuous leanings of Jensen). The active, social repression of these drives, in a few individuals, leads to the total sublimation of sexual curiosity into the creative process and the true work of art.[13] Works of art "conceal their personal origin and, by obeying the laws of beauty, bribe other people with a bonus of pleasure."[14] The overarching "laws of beauty," the technique of the aesthetic, are the means by which the creative works. The creativity of the artist is the placing of a repressed aspect of the artist's psyche into the realm of the aesthetic. The creative object thus represents the fixed fantasies of the individual. In *Studies in Hysteria,* coauthored with Freud in 1895, Joseph Breuer commented on the ultimate creative figure for nineteenth-century German culture: "Goethe did not feel he had dealt with an experience till he had discharged it in a creative artistic activity."[15]

It was the act of seeing—the observer's act of seeing and responding to the creative product of the artist—that defined creativity for Freud. The uninformed viewer's response is aesthetic; the psychoanalyst, however, is able to see beneath the initial evocation of the aesthetic (which disguises the motivation of the author) and provide an interpretation of the work of art and of the artist's psyche. Analogous to the psychoanalyst explaining to the patient the topology of the dynamic unconscious is the critic explaining to the viewer what is observed. It is here that we learn to distrust the initial act of seeing and to link the act of seeing not with a visceral response but with the act of knowing. Freud's focus seems to be solely on the motivation that underlies creativity. It is the discovery that the creative individual is "subject to the laws which govern both normal and pathological activity with equal cogency" that Freud illustrates.[16] But his hidden agenda was to undermine our sense that we can see the world directly.

This is clearest in Freud's popular essay "Creative Writers and Day-Dreaming," which was presented as a lecture to a lay (i.e., nonmedical) audience in Vienna during 1907.[17] In this essay Freud acknowledged the special status of the creative artist: "We laymen have always been intensely curious to know—like the Cardinal who puts a similar question to Ariosto—from what sources that strange being, the creative writer, draws his material, and how he manages to make such an impression on us with it and to arouse in us emotions which, perhaps, we had not thought ourselves capable."[18] Freud placed himself as a layman in opposition to the creative individual who makes a world that seems complete and who uses that world to manipulate our (lay or noncreative) emotions. He was, however, a very special lay observer, one who had the insight to understand the underlying meaning of the creative. Freud's initial analogy was to the play of the child. Such play is rooted in fantasies of having control over the immediate world of toys as opposed to the real world, which is beyond the manipulation of the child.[19] The child creates a realm where uncontrollable realities are transmuted into manipulable fantasies. For Freud, humor was the ultimate example of how the healthy adult can escape back into this world of playfulness: "By equating his ostensibly serious occupations of today with his childhood games, he can throw off the heavy burden imposed on him by life and win the high yield of pleasure afforded by *humor*" (Freud's emphasis).[20]

Fantasy is like dreaming. It uses everyday impressions, relates them to earlier (infantile) experience, and "creates a situation relating to the future." This creative individual is thus like a playful child who has the compulsion to tell (represent) his or her fantasies: "There is a class of human beings upon whom, not a god, indeed, but a stern goddess—Necessity—has allotted the task of telling what they suffer and what things give them happiness. These are the victims of nervous illness,

who are obliged to tell their fantasies."[21] In paraphrasing Goethe's *Torquato Tasso* in this passage ("and when a man falls silent in his torment / A god granted me to tell how I suffer"), Freud integrated the artist (Tasso) and the healer of the mad (Freud). The artificial line Freud drew between the creative individual as neurotic on the one side and himself (and his listeners) on the other is a false dichotomy. The informed, psychoanalytically instructed observer sees below the surface. Freud joined the world of art, as artifact and inspiration, in his creative role as the psychoanalyst but only in the most hidden and covert way.

In Freud's essay of 1907 the creative individual was also not gender neutral. Young women, in his view, had more erotic fantasies than did young men, who had in turn more fantasies of ambition. Both must learn to conceal and repress these drives as they are unacceptable in polite society: "The well-brought-up young woman is allowed a minimum of erotic desire, and the young man has to learn to suppress the excess of self-regard which he brings with him from the spoilt days of his childhood, so that he may find his place in society which is full of other individuals making equally strong demands."[22] Human sexuality, the wellspring of creativity, is initially and more strongly present in the fantasy world of the female.

Thus Freud in this text provided a set of working hypotheses about creativity: first, that creativity has to do with the representation of internal stories in a highly affective and effective manner; second, that creativity is parallel to the states of childhood and neurosis in that it is an attempt to gain control over the world by creating a world over which one can have control; third, that there is a difference, but also a similarity, between the fantasy life (and therefore the creativity) of men and of women. All of this is framed by a most ambiguous narrative voice that claims the creative artist is different from the author of the text we are reading (the difference is evident in the banality of the hypothetical novel that Freud summarized in his essay).

Freud, however, was not interested in the problem of creativity for its own sake. He saw his explanation of the nature of creativity as one of the central proofs for the validity of his science, psychoanalysis. In the programmatic text of 1913, "The Claims of Psycho-Analysis to Scientific Interest," Freud outlined the theory of repression as the key not only to an understanding of the production of the "beautiful" but also as one of the substantial pieces of evidence for the scientific[23] validity of his views:

Most of the problems of artistic creation and appreciation await further study, which will throw the light of analytic knowledge on them and assign them their place in the complex structure presented by the compensation for human wishes. Art is a conventionally accepted reality in which, thanks to artistic illusion, symbols and substitutes are able to provoke real emotions. Thus art constitutes a region half-way between a reality which frustrates wishes and the wish-fulfilling world of the imagination—a region in which, as it were, primitive man's strivings for omnipotence are still in force.[24]

Freud's reading of the work of art was clearly both within the paradigm of late nineteenth-century visual and literary art and, more importantly, still bound by Lombroso's association of the creative and the primitive. But it was not the primitive localized in the inhabitants of the asylum or of the prison, the throwback, but the primitive within each and every human being. Freud seemingly needed to associate the creative with the universal and with a universal science, psychoanalysis.

The flaw in Freud's argument is clear: if sexual repression is the key to creativity, why are not all individuals who are sexually repressed creative? After World War I Freud himself became quite aware of this difficulty, as he later noted in his study of "Dostoevsky and Parricide" (1928): "Before the problem of the creative artist analysis must, alas, lay down its arms."[25] Or, as he stated in his "Autobiographical Study" (1925): "[Psychoanalysis] can do nothing towards elucidating the nature of the artistic gift, nor can it explain the means by which the artist works—artistic technique."[26] But were Freud's early categories of creativity constructed so as to make all human beings potentially creative? Why did Freud need to universalize the question of the creative? Why did he need to place creativity within those sexual drives and psychic phenomena that are, according to Freud, present in all human beings? Why was it that the feminine seemed to have the closest relationship to the wellspring of creativity? What did sexuality, creativity, and madness have to do with one another at the turn of the century? Why must he still maintain that creativity is like neurosis in its inherent characteristic of repression?

The meaning of Freud's representation of the creative, not as Lombroso's throwback or deviant but as a reflection of universal processes, can be understood in the context of Freud's role as a scientist and a Jew in fin-de-siècle Vienna.[27] For Freud, the discovery of his role as a scientist and as one racially labeled as a Jew took place at the same moment: "When in 1873, I first joined the University, I experienced some appreciable disappointments. Above all, I found that I was expected to feel myself inferior and an alien because I was a Jew. I refused absolutely to do the first of these things. I have never been able to see why I should feel ashamed of my descent or, as people were beginning to say, of my 'race.'"[28] Being Jewish meant being inherently different from the Aryans

who dominated his world and who defined what was normal and acceptable in the world of science. It is no accident that Freud, when he began to study medicine, also began to learn about the meaning assigned to him as a member of the Jewish "race." Freud's reevaluation of the relationship between madness and creativity reveals the core contradiction of the late nineteenth-century Jewish physician-scientist, which is how one can be the subject of scientific study at the same time that one has the role of the scientific observer. For the Jewish physician in late nineteenth-century Germany and Austria, the ability to enter into the sphere of science meant acknowledging the truth of the scientific project and its rhetoric, and central to the agenda of fin-de-siècle science was the paradigm of race.[29]

Leopold von Sacher-Masoch made this the centerpiece of his tale of Austrian Jewry included in his literary ethnography of European Jewry.[30] In his story we observe the confrontation between the scientific Jewish physician and his primitive, miracle-working counterpart. Only science can win and religion must bow gracefully to its preeminence. Sacher-Masoch's tale of science and the Jews reflects the siren song of the Jewish Enlightenment, which perhaps even more than the general Enlightenment saw science as the path of escape from the darkness of the ghetto into the bright light of modern culture. It was a modern culture defined very much by the Enlightenment's understanding of science and technology as the tools for the improvement of the common man. Science, especially applied science such as medicine, provided an opportunity to enter into the mainstream of the so-called free professions.[31] It implied a type of social mobility increasingly available to Jews, especially in Austria, over the course of the nineteenth century.[32] For the late nineteenth-century Jewish scientist, especially those in the biological sciences, the path of social and cultural acceptance was complex. It entailed, more

than in any other arena, the acceptance of the contradiction in being both subject and object, because among the basic premises of nineteenth-century biological science was the primacy of racial difference. For the physician-scientist, the case became even more complex. The assumption was that there is a hierarchy of race, with each race higher (or lower) on a "great chain of being"; in addition, it was believed that the pattern of illness varied from group to group and marked the risk each group had in confronting life, especially modern civilized life. The Jewish physician was both the observer of this form of disease and also, because he (and he was almost always male until the very late nineteenth century) entered into the competition of civilized society (i.e., the public sphere of medicine), precisely the potential victim of exactly these illnesses. The demands of "scientific objectivity" could not, therefore, be met by Jewish physicians, and they were forced to undertake complex psychological strategies to provide themselves with an objective observing voice.

Let us begin by framing the special meaning that madness would have had for Freud, the Eastern European Jew from Moravia transplanted to Vienna as a small child. The idea of the hysteric was a central one for the imaginative world of Freud, as it was close to his self-definition as an Eastern Jew. At the close of the nineteenth century the idea of being able to recognize the hysteric physiognomically was closely bound to the idea of likewise recognizing the Jew—and very specifically the male Jew.[33] For if the visual representation of the hysteric within the world of images of the nineteenth century was the image of the female, its subtext was that feminized males, such as Jews, were also hysterics, and they too could be seen. The face of the Jew was as much a sign of the pathological as was the face of the hysteric. But even more so, the face of the Jew became the face of the hysteric. Maurice Fishberg, in *The Jews: A Study of Race and Environment*, 1911,

stated the case boldly: "The Jews, as is well known to every physician, are notorious sufferers of the functional disorders of the nervous system. Their nervous organization is constantly under strain, and the least injury will disturb its smooth workings."[34] This, however, was not true of all Jews, as Fishberg further asserted, quoting from Raymond's 1889 study of mental illness in Russia: "The Jewish population of [Warsaw] alone is almost exclusively the inexhaustible source for the supply of specimens of hysterical humanity, particularly the hysteria in the male, for all the clinics of Europe." It is the male Jew from the East, from the provinces, who is most at risk for hysteria. This remained a truism of medical science from 1880 to 1940. Professor H. Strauss of Berlin, in one of the most cited studies of the pathology of the Jews, provided a bar chart representing the risk of Jews for hysteria.[35] It indicated that male Jews suffered twice as often from hysteria as did male non-Jews. While it is clear that women were the predominant suffers from the disease, it is evident from the visual representation of the cases of hysteria that there was a clear feminization of the male Jew in the context of the occurrence of hysteria.

Freud's teacher, the liberal, Jewish neurologist Moriz Benedikt, also linked the "American" quality of life with the appearance of hysteria—a disease understood by him to be "a uniquely feminine nervous disease"—in men.[36] The struggle for life in the city caused the madness of the male Jew: "Mental anxiety and worry are the most frequent causes of mental breakdown. They are all excitable and live excitable lives, being constantly under the high pressure of business in town."[37] The reason for this inability to cope with the stresses of modern life lies in "hereditary influences," i.e., in their being Jews.[38] Here we find the link to sexuality made explicit. For not only was hysteria understood by scientists such as Jean-Martin Charcot, with whom Freud studied in Paris, to be directly related to sexuality, but it is the "perverse" sexuality of Jews with their "inbreeding" that caused their disability.

Nineteenth-century science did not make a clear distinction between inbreeding and endogamous marriage. The constant attack on the Jews in the scientific literature of the day was aimed at their selective marriage practices and the overt sign of their sexuality, the circumcision of their male young. Indeed these were seen as absolutely linked. One of the most widely cited sexologists of the late nineteenth century, Paolo Mantegazza, wrote:

It is altogether likely that the most important reason which has led men of various ages and of varying civilizations to adopt the custom of cutting off the prepuce has been that it was felt to be necessary to imprint upon the human body a clear and indelible sign which would serve to distinguish one people from another and, by putting a seal of consecration upon nationality, would tend to impede the mixture of races. A woman, before accepting the embraces of a man, must first make sure, with her eyes and with her hands, as to whether he was of the circumcised or the uncircumcised; nor would she be able to find any excuse for mingling her own blood-stream with that of the foreigner. It had, however, not occurred to the legislator that this same indelible characteristic would inspire in the woman a curiosity to see and to handle men of a different sort.[39]

It was again the act of seeing that lay at the center of perceiving the difference of the Jew. Seeing is culturally loaded: the positivistic science of the day demanded that the cause of disease be seen—if only under the microscope. Here the scientist saw the Jew as different, as damaged, and narrated this act of seeing the Jew to his audience.

In Henry Meige's dissertation of 1893, on the wandering Jew in the clinical setting of the Salpêtrière, the image of the Jew and the gaze of the Jew became one.[40] Meige undertook to place the appearance of Eastern European (male) Jews in the Salpêtrière as a sign of the inherent instability of the Eastern European Jew. In his dissertation he sketched the background to the legend of the wandering Jew and provided (like his supervisor and Freud's mentor, Charcot) a set of visual "images of Ahasverus."[41] He then provided a series of case studies of Eastern (male) Jews, two of which he illustrated. The first plate is of "Moser C. called Moses," a Polish Jew in his mid forties from Warsaw, who had already wandered through the clinics in Vienna and elsewhere;[42] the second plate is of "Gottlieb M.," a forty-two-year-old Jew from Vilnius, who likewise had been treated at many of the psychiatric clinics in Western Europe.[43] Given the extraordinary movement of millions of Eastern Jews through Western Europe toward England and America beginning in the early 1880s, the appearance of these few cases of what came to be called "Munchausen syndrome" should not be a surprise. Without any goal, these Jews "wandered" only in the sense they were driven West; that some should seek the solace of the clinic where they would at least be treated as individuals, even if sick individuals, should not make us wonder. What is striking is that Meige provided images and analyses that stress the pathognomonic physiognomy of the Jew—especially his eyes.[44] These images of the Jew inform us of his inherent hysterical pathology. The Jew is the hysteric; the Jew is the feminized Other; the Jew is seen as different, as diseased. This was the image of the hysteric with which the Jewish scientist was confronted.

No wonder that Jewish scientists such as Freud sought to find the hysteric outside of their own self-images, for that image was immutable within the biology of race. And that image appeared every time he looked in a mirror. As the German anthropologist Richard Andree stated: "No other race but the Jews can be traced with such certainty

240 GILMAN

Const
ructi
n g
Creat
ivity
and
Madne
ss

backward for thousands of years, and no other race displays such a constancy of form, none resisted to such an extent the effects of time, as the Jews. Even when he adopts the language, dress, habits, and customs of people among whom he lives, he still remains everywhere the same. All he adopts is but a cloak, under which the eternal Hebrew survives; he is the same in his facial features, in the structure of his body, his temperament, his character."[45] And this constancy of character, with its "deviant" sexual nature, leads to the disease that marks the Jew—madness.[46] The etiology of the Jew's hysteria, like the hysteria of the woman, was to be sought in "sexual excess," specifically in the "incestuous" inbreeding of this endogamous group: "Being very neurotic, consanguineous marriages among Jews cannot but be detrimental to the progeny."[47]

If madness is Jewish or if at least Jews are especially at risk for certain types of insanity, what must this make of the idea of the creative, given Lombroso's close association between the mad and the creative? As we have seen in the work of Lombroso, himself a Jew, the category of the creative was contaminated by the pathological. The question of the relationship between the idea of madness and the meaning of creativity was much discussed at the turn of the century. That Jews were active within the sphere of culture and science could not be contradicted, but was their activity to be understood as creative? Thus the seemingly central role of Jews in culture could be countered by arguing that this type of art was superficial or perhaps even corrupting. Indeed it could be argued that the creativity of the Jew was really a sign of his diseased, mad state. Madness was a mental state the Jew shared with woman. Freud's younger Viennese contemporary, the self-hating Jew Otto Weininger, presented the outline of this argument clearly in his widely read and widely cited study *Sex and Character*, 1903.[48] This book, read by Freud in an early draft, was fundamental in shaping at least

some of his attitudes toward the nature of the body.[49] Indeed it was seen as a serious work of science by radical thinkers of the time, such as the American archfeminist Charlotte Perkins Gilman![50]

For Weininger, Jews and women have no "true humor," for true humor must be transcendent; Jews "are witty only at [their] own expense and on sexual things."[51] Jews, Weininger asserted, are inherently more preoccupied by the sexual but less potent than Aryans.[52] Jews, like women, are "devoid of humor and addicted to mockery."[53] Continuing Weininger's argument, Jews are historically extremely adaptable, as can be shown by their talent for the superficial areas of creativity such as journalism (that is, their adaptability demonstrates their lack of a center, and lacking a center they are unable to be "real" writers). But in their essence they are truly unchangeable. They lack deep-rooted and original ideas.[54] The Jews are the quintessential unbelievers, not even believing in themselves.[55] And it is in one arena that this immutability of mind and spirit, this moral madness, most clearly manifests itself and that is within science, most specifically within the world of medicine. For the Jews there is no transcendentalism, everything is as flat and commonplace as possible. Their effort to understand everything robs the world of its mystery.[56] Evolutionary theory, for example, is mere materialism. The development of nineteenth-century medicine from its focus on bacteriology in the 1880s to its focus on biochemistry at the turn of the century meant a real shift of interest from the "organic" to the "inert" on the part of the medical scientist. For Weininger, Jews are natural chemists, which explains why medicine had become biochemistry. Weininger interprets this as a "Jewification" of medicine. The Jews focus on the dead, the inert.

This litany of hate places the Jew in an antithetical relationship to true creativity and as bearing a great risk for madness. Weininger's position is hardly unique. It reflected the general view of anti-Semitic racial science about the special nature of the Jew. Thus creativity was linked to Jews, their madness, and the ultimate source of their madness, their sexuality. Now we must imagine Freud confronted with this view. Of all the means he could have used to explore the nature of the psyche, why was it that creativity captured his interest? This is indeed as idiosyncratic as his choice of dreams or jokes or slips of the tongue to discuss the normal structure of the psyche. And each of these sources for the information about the psyche can be linked to debates within the racial science of the late nineteenth century.[57]

We can assume that the question of creativity had a significance for Freud, especially during the period from 1903 to 1910, the period when Weininger's views were most widely circulated and discussed in the culture of Vienna. Freud needed to move the question of the Jew's madness and the Jew's creativity onto another level of debate. For Freud, the special definition of these concepts and their relationship became part of his proof for the universality of the human psyche. Freud's stress on the sexual etiology of all neurosis led to his view that creativity is analogous to neurosis in its repression of conflicted sexual identity. The creative, the psychopathological, and the sexual come together in the portrait of the psyche of the Jew that existed precisely when Freud's interest turned to the question of the creative.

Freud's response was to separate the question of Jewish madness and Jewish creativity from the universal laws that he believed caused psychopathology. These laws are parallel to the laws that determine the creative. Freud began, in the first decade of the twentieth century, to refashion Lombroso's separate categories of the normal and the abnormal. He was forced to do so because, unlike the Italian Jew Lombroso, he first sensed (according to his own active memory) his difference from everyone else when he began to study medicine and was confronted with the image of his own "racial" difference. (Lombroso, one might add, was forced to confront this sense of his own difference only at the very end of his creative life, in the 1890s. He accepted the difference of the Jew, attributing it to the long period of oppression of the Jews.) For Freud, science and race were linked experiences.[58] Weininger saw as the salient example of this association the nature of Jewish medicine—a purely mechanistic, materialistic medicine, more chemistry than the art of healing. Jews are not creative, especially in this realm of science, but rather destructive.

Freud first struggled to show how everyone who is creative or dreams or is mad responded to the same, universal rules of psychic organization. Freud, through the science of psychoanalysis (which evolved over the closing decade of the nineteenth century, while rooted in a materialistic paradigm[59]), self-consciously attempted to move medicine toward an understanding of the dynamic processes of the psyche, the immaterial aspect of the human being. He abandoned "chemistry" for "metapsychology." This he was constrained to do because of his certainty that sexuality—associated with the obsessive hypersexuality of the Jews, the very source of their perverse madness—lay at the center of human experience. Freud positioned himself (more and more successfully as his thought developed after World War I) in opposition to the positivistic clinical gaze of Charcot and the materialistic brain mythology of Benedikt. His was not the medicine sketched by Weininger and had,

242 GILMAN Const
 ructi
 n g
 Creat
 ivity
 and
 Madne
 s s

therefore, at least the potential to claim a position as creative. But Freud did not do this unambiguously (as we have seen in his 1907 essay on creativity). In openly labeling himself as creative in this context he would have been labeling himself as a Jew. He would be setting himself off from the universal role of the layman (to use his word) as observer. But he was not the layman, he was the physician-scientist. And his science must be universal, not particularistic, in its claims for creativity. The physician-scientist laid claim to the positivistic gaze, unencumbered by national or racial perspective, especially in the arena of sexology, where the accusation was that Jews, by their very nature, were predisposed to seeing the sexual everywhere.

Freud thus had the creative operate as a reflex of that force present in all human beings—sexuality.[60] This force, which had been used to label the Jew as different, now became the source of all human endeavors including the truly creative. But this is present more in the feminine fantasy than in the masculine, which certainly mirrors Weininger's dismissal of the sexual contamination of Jewish (not feminine) creativity. Freud reversed all of the poles of the anti-Semitic discourse on creativity that framed Weininger's view. The link between madness and creativity was maintained, but these tendencies were now a product of universal rather than racial psychology. What is striking is that during the period from 1900 to 1919 Freud never evoked any Jewish writer or painter—neither his contemporary and neighbor, the playwright Arthur Schnitzler, nor the best-known German artist of his day, the impressionist Max Liebermann, nor the classic examples of Jewish creativity, Spinoza and Heine—in his discussions of creativity and the nature of the creative.[61] Creativity is universal; Freud's examples were not. He self-consciously eliminated the Jewish component in European culture.

Freud was still limited by the context of his struggle with the anti-Semitic implications of madness and creativity in his age. It was in 1938, against the backdrop of triumphs by Nazis, that Freud finally confronted this question in a German emigré magazine. His answer to the rise of anti-Semitism was a paraphrase of a lost or invented essay reputedly by a non-Jew, in which the contributions of the Jews to the Diaspora were evaluated: "Nor can we call them [the Jews] in any sense inferior. Since we have allowed them to cooperate in our cultural tasks, they have acquired merit by valuable contributions in all the spheres of science, art, and technology, and they have richly repaid our tolerance."[62] Science, such as psychoanalysis, and then art represented the Jews' creative contributions to German culture. The ambiguity of creativity at the fin-de-siècle vanished in the harsh light of the Nazi recognition of the view of Jews in German culture represented by Weininger. Against this Freud reacted.

In the 1950s, after the Shoah, Silvano Arieti, certainly the most widely influential psychoanalyst after Freud to deal with the question of creativity, reversed the argument about the meaning of Jewish creativity.[63] Arieti was fascinated by the relationship between madness in its mid twentieth-century manifestation—schizophrenia—and the creative.[64] Arieti's interest lay in examining the relationship between Freud's sense of creativity as stemming from the primary processes of psychic development (as reflected in the mechanisms of the dream) and higher forms of psychic organization. For Arieti, clues to the meaning of creativity could be found in the psychopathological structures of the schizophrenic, who organized the world along quite different structures from that of normal consciousness:

> The seriously ill schizophrenic, although living in a state of utter confusion, tries to recapture some understanding and to give organization to his fragmented universe. This organization is, to a large extent, reached by connecting things that have similar parts in common. Many patients force themselves to see similarities everywhere. In their relentless search for such similarities they see strange coincidences; that is, similar elements occurring in two or more instances at the same time or at brief intervals. By considering these similarities as identities they attempt to find some clarity in the confusion of the world, a solution for the big jigsaw puzzle.[65]

As one can see by this statement, Arieti continued, but expanded upon, Freud's model of the creative.

There is also an extraordinary subtext in Arieti's corollary to Freud's argument. For Arieti, an Italian Jew whose study *The Parnas* is one of the most moving accounts of the psychological destruction of Italian Jewry, the Jew was the prototypical creative individual.[66] Arieti created a category labeled the "creativogenic culture," which encourages the innovation of creativity. Qualities such as the availability of cultural means, openness to cultural stimuli, stress on becoming (not just on being), tolerance for diverging views, freedom following repression all provide the matrix for creativity. And it is of little surprise that for Arieti the exemplary creative individuals were the Jews. The exemplary Jews whom Arieti chose as his examples of the truly creative were scientists, especially medical scientists. He tabulated the relationship of Jewish Nobel prizes to German, French, Italian, and Argentinian Nobel prizes and determined that "Jews exceed in all categories with the exception of the Peace prize, where they are surpassed by the French and the Argentinians. If we examine the five fields in which prizes are assigned, we notice that the greatest contributions are in the fields of medicine and physics."[67] Of course, no working definition of the Jew can be offered by Arieti. He instead constructed an ontological category quite similar to that of Weininger, simply

reversing the poles of his argument. For Arieti, the creative became the Jewish state of mind, and the Jew creativity incarnate. But again it is a specific form of the creative, it is science and specifically the science of medicine, Arieti's own self-definition.

To contrast Freud and Arieti on the concept of creativity is to confront a world in which the question of Jewish particularism is repressed or qualified when creativity is addressed and one in which it is celebrated. Both views are answers to the charge that Jews, through perverse sexuality, are different, mad, and inherently uncreative, even though they claimed to be truly creative. Today we have sufficient distance from the wellsprings of this turn-of-the-century debate about the creative and its sequelae to see how Freud and his followers such as Arieti found themselves confronted with a need to provide a rationale for their own creativity in their construction of the world. What is the truly creative in this context becomes the writing of the scientist in his striving to define the creative. In framing the debates about the nature of creativity in the medical sciences of the twentieth century, we can see how the very object and meaning of the creative has shifted over time.

■

Notes

All translations are by the author unless otherwise indicated.

1

I am using the terms "madness" and "creativity" in this context to categorize two traditions of labeling individuals and their products as different and unique. I am not taking any position on the validity of these labels. What "madness" is may well relate to questions of commodification or the fascination with ideas of original genius. The initial discussion of these questions draws on "The Mad as Artists," in my *Difference and Pathology: Stereotypes of Sexuality, Race, and Madness* (Ithaca, New York: Cornell University Press, 1985), 217–38.

2

See E. Hare, "Creativity and Mental Illness," *British Medical Journal*, vol. 295 (December 1987): 1587–89; and J. H. Mason, "The Character of Creativity: Two Traditions," *Journal of the History of European Ideas* 9 (1988): 697–715.

3

See the discussion in Bennett Simon, *Mind and Madness in Ancient Greece* (Ithaca, New York: Cornell University Press, 1978), 228–37.

4

Pliny Earle, "The Poetry of Insanity," *American Journal of Insanity* 1, no. 3 (January 1845): 193–224. Other nineteenth-century works on the poetry of the insane are R. G. Brunet, *Les Fous littéraires* (Brussels: Gay et Douce, 1880); and its continuation, A. I. Tcherpakoff, *Les Fous littéraires* (Moscow: Gautier, 1883).

5

Earle, "Poetry of Insanity," 195–96.

6

Ibid., 197.

7

N. C. Andreasen and I. D. Glick, "Bipolar Affective Disorder and Creativity: Implications and Clinical Management," *Comprehensive Psychiatry* 29, no. 3 (May/June 1988): 207–17.

8

Kay Redfield Jamison, "Mood Disorders and Patterns of Creativity in British Writers and Artists," *Psychiatry* 52, no. 2 (May 1989): 125–34.

9

There is a psychoanalytic parallel to these discussions: André Haynal, *Depression and Creativity* (New York: International Universities Press, 1985). On the present state of the psychology of creativity, see Robert J. Sternberg, *The Nature of Creativity: Contemporary Psychological Perspectives* (New York: Cambridge University Press, 1988); and Albert Rothenberg, *Creativity and Madness: New Findings and Old Stereotypes* (Baltimore: Johns Hopkins University Press, 1990).

10

Arnold M. Ludwig, "Reflections on Creativity and Madness," *American Journal of Psychotherapy* 43, no. 1 (January 1989): 4–14.

11

Cesare Lombroso, *Genio e follia* (Milan: Chiusi, 1864).

12

See John E. Gedo, *Portraits of the Artist: Psychoanalysis of Creativity and Its Vicissitudes* (New York: Guilford, 1983).

13

Sigmund Freud, *Standard Edition of the Complete Psychological Works of Sigmund Freud,* ed. and trans. J. Strachey, A. Freud, A. Strachey, and A. Tyson, 24 vols. (London: Hogarth, 1955–74), vol. 9, 167–76. On Freud's cultural background, see Henri Ellenberger, *The Discovery of the Unconscious: The History and Evolution of Dynamic Psychiatry* (New York: Basic, 1970).

14

Freud, *Standard Edition,* vol. 23, 187. In this context, see Charles M. T. Hanly, "Psychoanalytic Aesthetics: A Defense and an Elaboration," *Psychoanalytic Quarterly* 55, no. 1 (1986): 1–22; and Donald M. Kaplan, "The Psychoanalysis of Art: Some Ends, Some Means," *Journal of the American Psychoanalytic Association* 36, no. 2 (1988): 259–93.

15

Freud, *Standard Edition,* vol. 2, 207.

16

Ibid., vol. 11, 63.

17

Ibid., vol. 9, 143–53.

18

Ibid., 143.

19

For a more extensive interpretation, see Sarah Kofman, *The Childhood of Art: An Interpretation of Freud's Aesthetics,* trans. Winifred Woodhull (New York: Columbia University Press, 1988).

20

Freud, *Standard Edition,* vol. 9, 145.

21

Ibid., 146. See also the discussion by Janine Chasseguet-Smirgel, *Creativity and Perversion* (New York: Norton, 1984), on the relationship between object-relations theory and creativity.

22

Freud, *Standard Edition,* vol. 9, 147.

23

Until now the studies of Freud's understanding of science have ignored the idea of race. See Nigel Mackay, *Motivation and Explanation: An Essay on Freud's Philosophy of Science* (New York: International Universities Press, 1989).

24

Freud, *Standard Edition,* vol. 23, 187–88.

25

Ibid., vol. 21, 177.

26

Ibid., vol. 20, 70.

27

I am using the term "Jew" here in a very limited sense as someone who was labeled a Jew within the discourse of the science of race in the nineteenth century. For reasons that shall become evident in the course of this argument, a Jew was also by this definition male. The scientific literature of the time saw the inscription of Jewishness on the body of the Jew in the sign of circumcision. On the general context of this definition, see Raphael and Jennifer Patai, *The Myth of the Jewish Race* (Detroit: Wayne State University Press, 1989).

28

Freud, *Standard Edition,* vol. 20, 304.

29

William F. Bynum, "The Great Chain of Being after Forty Years: An Appraisal," *History of Science* 13, no. 1 (1975): 1–28.

30

Leopold von Sacher-Masoch, "Zwei Ärtze," in his *Jüdisches Leben in Wort und Bild* (Mannheim: Bensheimer, 1892), 287–98.

31
See Monika Richarz, *Der Eintritt der Juden in die akademische Berufe* (Tübingen: Mohr, 1974).

32
On the social history of the Jews in this context, see George E. Berkley, *Vienna and Its Jews: The Tragedy of Success, 1880s–1980s* (Lanham, Maryland: Madison, 1988); William O. McCagg, Jr., *A History of Habsburg Jews, 1670–1918* (Bloomington: Indiana University Press, 1989); Ivar Oxaal, Michael Pollak, and Gerhard Botz, eds., *Jews, Antisemitism and Culture in Vienna* (London and New York: Routledge & Kegan Paul, 1987); Peter Pulzer, *The Rise of Political Anti-Semitism in Germany and Austria*, rev. ed. (London: Halban, 1988); and Steven Beller, *Vienna and the Jews 1867–1938: A Cultural History* (Cambridge: Cambridge University Press, 1989).

33
For a discussion of the representation of the individual seen as mad, see my *Seeing the Insane* (New York: Wiley, 1982).

34
Maurice Fishberg, *The Jews: A Study of Race and Environment* (New York: Scott, 1911), 6, 324–25.

35
H. Strauss, "Erkrankungen durch Alkohol und Syphilis bei den Juden," *Zeitschrift für Demographie und Statistik der Juden*, n.s., 4 (1927): 33–39, chart on 35.

36
Moriz Benedikt, *Die Seelenkunde des Menschen als reine Erfahrungswissenschaft* (Leipzig: Reisland, 1895), 186–87, 223–26.

37
Cecil F. Beadles, "The Insane Jew," *Journal of Mental Science*, vol. 46 (1900): 736.

38
Frank G. Hyde, "Notes on the Hebrew Insane," *American Journal of Insanity* 58, no. 3 (January 1902): 470.

39
Paolo Mantegazza, *The Sexual Relations of Mankind*, trans. Samuel Putnam (New York: Eugenics, 1938), 98; the relevant passages in the German edition, *Anthropologisch-kulturhistorische Studien über die Geschlechtsverhältnisse des Menschen* (Jena: Costenoble, 1891), which Freud knew, are on 132–37. On Mantegazza, see Giovanni Landucci, *Darwinismo a Firenze: Tra scienza e ideologia (1860–1900)* (Florence: Olschki, 1977), 107–28.

40
Henry Meige, *Etude sur certains neuropathes voyageurs: Le juif-errant à la Salpêtrière* (Paris: Battaille, 1893). On Meige and this text, see Jan Goldstein, "The Wandering Jew and the Problem of Psychiatric Anti-Semitism in Fin-de-siècle France," *Journal of Contemporary History* 20, no. 4 (October 1985): 521–52.

41
Meige, *Etude sur certains neuropathes voyageurs*, 17.

42
Ibid., 25.

43
Ibid., 29.

44
Ibid.

45
Richard Andree, *Zur Volkskunde der Juden* (Leipzig: Velhagen & Klasing, 1881), 24–25, cited by Maurice Fishberg, "Materials for the Physical Anthropology of the Eastern European Jew," *Memoirs of the American Anthropological Association* 1, no. 1 (1905–1907): 6–7.

46
Beadles, "The Insane Jew," 732.

47
Fishberg, *The Jews*, 349.

48
All quotations are from the English translation, Otto Weininger, *Sex and Character* (London: Heinemann, 1906). For background, see my *Jewish Self-hatred: Anti-Semitism and the Hidden Language of the Jew* (Baltimore: Johns Hopkins University Press, 1986).

49
On the relationship between Freud and Weininger, see the exemplary essay by Peter Heller, "A Quarrel over Bisexuality," in Gerald Chapple and Hans H. Schulte, eds., *The Turn of the Century: German Literature and Art, 1890–1915* (Bonn: Bouvier, 1981), 87–116.

50
Charlotte Perkins Gilman, "Review of Dr. Weininger's *Sex and Character*," *The Critic*, no. 12 (1906): 414.

51
Weininger, *Sex and Character*, 318.

52
Ibid., 311.

53
Ibid., 319.

54
Ibid., 320.

55
Ibid., 321.

56
Ibid., 314.

57
See my *Difference and Pathology* (3d ed., 1990), 175–91.

58
In this context, see Maurice Olender, *Les Langues du Paradis: Aryens et Semites—un couple providentiel* (Paris: Gallimard, 1989).

59
Frank J. Sulloway, *Freud, Biologist of the Mind* (New York: Basic, 1979), 11–22.

60
See the general context as outlined in my *Sexuality: An Illustrated History* (New York: Wiley, 1989).

61
He does evoke Heine in other contexts during this period. See my "Freud Reads Heine Reads Freud," *Southern Humanities Review* 24, no. 3 (Summer 1990): 201–18.

62
Freud, *Standard Edition*, vol. 23, 292.

63
Beginning with his essay "New Views on the Psychology and Psychopathology of Wit and of the Comic," *Psychiatry* 13, no. 1 (1950): 43–62, to his major study *Creativity: The Magic Synthesis* (New York: Basic, 1976), Silvano Arieti's work focuses on creativity and the, for him, related question of the nature and meaning of schizophrenia.

64
See the discussion of the history and meaning of schizophrenia in my *Disease and Representation: Images of Illness from Madness to AIDS* (Ithaca, New York: Cornell University Press, 1988).

65
Silvano Arieti, *New Views of Creativity* (New York: Geigy, 1977), 7.

66
Silvano Arieti, *The Parnas* (New York: Basic, 1979).

67
Arieti, *Creativity*, 327–28. The slipperiness of this undertaking can be judged by examining Armin Hermann, ed., *Deutsche Nobelpreisträger* (Munich: Moos, 1978), where the "Jewish" prize winners are suddenly "German" prize winners. The ideology behind both of these categorizations is clear.

I See a World within the World : I Dream but Am Awake[1]

JOHN M. MACGREGOR

Within each of us, carefully veiled from the outside world and in part from ourselves, is a secret life that is lived only in fantasy. To the extent that this fantasy life differs from our external world, it can be said to represent a more or less fragmentary second life, an alternate existence.[2] While a rich imaginative life is readily accepted as a necessary part of childhood, maturity is occasionally defined in terms of the ability to dispense with fantasy fulfillment in favor of an active involvement with the outside world, in the attempt to attain at least some of our wishes and goals in reality.[3] However, in that reality invariably proves frustrating, we are all driven to fall back, at least occasionally, on fantasy. For most of us our fantasy existence tends to occupy a limited amount of time and to depart only minimally from conventional reality, correcting small segments of our life situation in terms of internal needs, imaginatively bringing a fragment of the outer world into line with our desires.

In some individuals, however, the life of fantasy seems to become, or remain, richer, more dominant, and less fragmentary. There can be a tendency for specific fantasies to go on being elaborated over months or even years. These ongoing fantasies grow cumulatively, becoming more complex and detailed with time. Fantasy then becomes the dominant mode, at the expense of adaption to the real world.[4] It is not clear why these people are so intensively preoccupied with fantasy, but it can probably be assumed that their lives in the real world provide little stimulation and insufficient satisfaction of their needs. They also seem to become caught in the process of invention and begin to enjoy the creation of seemingly

extraneous detail for its own sake. It should not be assumed that all continuing fantasies result in the creation of fully developed alternate worlds; however, when carried to an extreme, such an elaborate buildup of detail does occasionally lead to the kind of encyclopedic density that permits us to speak of a true alternate world.

My concern in this essay is to examine the relatively rare situation in which the private life of fantasy in the individual almost completely replaces involvement with reality and in which, far from being fragmentary, it assumes elaborate proportions representing not only a second life but an encyclopedic alternate world. As my source for the investigation of these alternate worlds I will make use of the extremely rare instances in which these elaborate fantasies find expression in material, usually graphic or written, form.

Shared Vision

So accustomed are we to the human tendency to fashion imaginary other worlds that we do not often stop to consider the strangeness of this sometimes playful, sometimes obsessive, involvement with substituting one world for another. As far back as one can go in history, humankind reveals a preoccupation with the imaginary conception of alternate worlds, most frequently in mythological and religious contexts. These other worlds, almost invariably modeled to some extent on "reality" but generally remote in space or time, range from highly idealized but plausible inventions to the overwhelmingly strange and fantastic. The historical and psychological factors underlying the emergence of these ideal, sometimes frightening, constructs are incredibly complex, reflecting deep-seated needs within the individual and in society.

Three universally experienced realities play a major role in motivating the creation of other worlds and in their shared acceptance by large numbers of "believers." The first, the inevitable experience of frustration inherent in all human life, has already been mentioned. Second, all alternate worlds reveal a significant contribution from the radically different, and largely forgotten, experiences of infancy. These early experiences of a passive, dreamlike state, both ideal and frustrating, even occasionally terrifying, and contrasting completely with the later demands of reality, invariably emerge when the mind embarks on the "free" elaboration of an imaginary other world. Historically these infantile experiences can be seen to motivate the mythological accounts of a previous Golden Age, contrasting with mankind's present tormented state, which serve as an imaginary prelude to most civilizations.[5]

Third, our awareness of death, our inability to accept its finality, and our agonizing fear of what may lie beyond have necessitated the elaboration of a wide range of alternate worlds on the "other side." Here too, early experience of the parents and of the passive and protected existence of infancy also enters into the ubiquitous conceptions of deities, paradise, and hell found in all religions.

248 MACGREGOR I S e e
 a
 W o r l d
 w i t h i
 n t h e
 W o r l d

Much of the content of religious literature and mythology is concerned with the detailed description of other worlds that follow upon death, and no one is totally free of fantasies concerning a possible afterlife.

The range of experiences, imaginative schemata, locations, and structures subsumed under the notions of heaven and hell, while initially taking shape in the minds of individuals (for example, inspired or gifted religious leaders), eventually are accepted as the common property of the group. Losing their idiosyncratic and individual characteristics, they become acceptable to large numbers of believers, forming a shared idea of the world to come. As we shall see, however, some individuals reveal an inability to accept or make use of these commonly held conceptions and insist on forging their own visions of the next world.

On a more worldly level there is also the occasional tendency, found in religion, philosophy, and politics, to conceive of ideal or utopian societies (often otherworldly in the extreme) that could be, and indeed have been, put into effect. These more realistic proposals, conceived of by charismatic leaders, at times find acceptance by groups of followers, moving from fantasy to embodiment in small alternate societies. It is by no means necessary that otherworldly social constructs be plausible or even particularly ideal for them to find mass acceptance within either politics or religion. Even wildly psychotic and dangerous delusions concerning the nature of reality or the next world run the risk of being accepted by groups of believers and put into effect.

My concern is, however, not with widely shared imaginative conceptions of other worlds, no matter how complex or elaborate, but with intensely private and subjective constructs, secret other worlds elaborated by individuals and shared, at least initially, by no one. Preoccupying an individual mind, invariably with compulsive and occasionally with delusional intensity, these alternate worlds, if they become known, are dismissed as evidence of eccentricity or even insanity. Called into being to satisfy the special needs of their creators and imaginatively "occupied" by them in complete isolation, they only rarely find external expression in written or graphic form. It is precisely these idiosyncratic and private expressions of an alternate reality that form the central core and essential characteristic of the phenomenon known as outsider art. It is also the compulsive preoccupation with or delusional belief in these private other worlds that seem to serve as crucial factors separating the individual from his or her milieu and underlying an isolated existence, outside any group, as an outsider.[6]

From Heaven
to the
Planet Mars

The discovery or creation of alternate worlds on the "other side" is the particular concern of spiritualists and of specially gifted spiritualist mediums. There has long been a tradition of automatic writings and drawings dictated or executed by the spirits.[7] Belief in the otherworldly origin of such graphic communications frees the individual to engage in the creation of inspired texts and images independent of any personal ability, training, or prior involvement with art. The examination of a series of famous cases involving the depiction of alternate worlds in the great beyond will allow us to differentiate descriptions and images stemming from spiritualism, as a group phenomenon, from the more private and subjective visions of the other side contained in the accounts of isolated individuals. The initially more conventional manifestations of Hélène Smith will be used to represent the former, with the pictorial productions of outsider artists Madge Gill and Perley M. Wentworth providing examples of intensely personal visionary experience.

Spontaneous psychological manifestations occasionally occur within religious groups, which then become, at least briefly, supportive of individual mystical experience. Visionary states, experiences of possession or trance, glossolalia, as well as clairvoyance and other specifically spiritualist phenomena allow for individual contact with other realities or worlds. In most cases these experiences, however personal they seem, remain tradition bound and unoriginal, departing only minimally from the norms of the group. Most spiritualist manifestations remain well within predictable limits, conforming to what is expected of otherworldly images and events.[8]

The role of medium has often provided an outlet for unconventional forms of insight and expression traditionally associated with women, whose sensitivity and intuition is thought to render them particularly suitable for such a function. As long as these spiritual manifestations can be "contained" within an otherwise normal life, the individual is free to experience the most unusual mental states without excessive risk of panic or loss of control. The mere fact that such unusual religious or psychic occurrences are widely believed to be possible and are occasionally accepted as valid by others provides justification and support for a wide range of individual and unique mental events, which might otherwise be experienced as overwhelmingly strange and frightening.

However, only very rarely does a "gifted" medium or psychic move out beyond what is anticipated, developing intensely personal conceptions of the nature of the other world and its inhabitants. To the extent that automatic psychological manifestations and states of somnambulism or trance are involved, suppressing the normal conscious personality, the phenomena go far beyond imaginatively manipulated fantasy or daydreams to include the spontaneous eruption of material from the unconscious. A way is opened for the emergence of secondary or multiple personalities, for the return of the repressed, and for the limitless expansion of fantasy in the construction of other worlds.

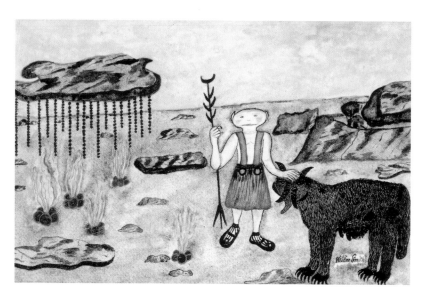

: 220 :

Hélène Smith

Paysage ultramartien
(Ultramartian landscape), 1900

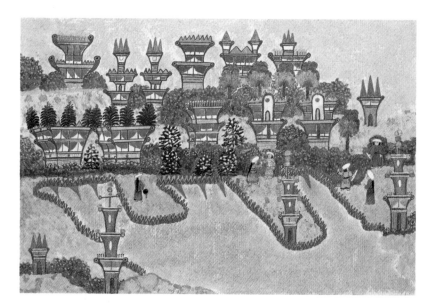

: 221 :

Hélène Smith

Paysage martien (Martian landscape),
1896

Hélène Smith

One of the most famous psychics of the late
nineteenth century was the medium Hélène Smith
(1861–1932) of Geneva, whose case was extensively
studied by the eminent psychologist Théodore
Flournoy.[9] A conventional bourgeois business-
woman, well educated and socially at ease, she was
in no sense a social outsider. In the mediumistic
trance state, however, she exhibited dramatic psy-
chological abnormalities: somnambulism, catalepsy,
partial amnesia, a variety of automatisms, as well
as radical personality change. Seeking explanations
for these dramatic alterations and utilizing the psy-
chological assumptions available to him, Flournoy
considered a hysterical personality to be the basis
of the visions, and hypnoid states (self-induced)
to be the mechanisms behind the automatisms.
He was very emphatic about the genuineness of
the phenomena, insisting that Smith exerted no
conscious control over the content of her visions.
"With the fixed and concrete content itself of her
automatisms she has nothing to do and no share in
the responsibility for it. So far as her great cycles
or her detached messages are concerned, they are
fabricated in her in spite of herself, and without
her having a word to say about their production,
anymore than one has in the formation of his
dreams."[10] The modern reader has an under-
standable tendency to assume that all spiritualist
phenomena are fraudulent. In fact, the majority of
psychics are experiencing very real and confusing
internal psychological manifestations in whose
reality they believe. Though I do not accept
the spiritualist belief in the supernatural and in
the intervention of spirits, I do contemplate the
possibility of states of consciousness and of unusual
mental experiences beyond those of the everyday.

Smith's initial visions, concerned with the world on the other side, were conventional and therefore of little interest to us. Mediumistic accounts of heaven have seldom been the source of truly encyclopedic alternate worlds; they tend, in fact, to be no more than a fleshing out of popular assumptions about life after death. Smith, however, soon proceeded to the simultaneous elaboration of several fully realized alternate worlds, with one of the more spectacular and visually interesting located on the planet Mars (FIGURE 220). Surprisingly this tendency to move from heaven to far more original descriptions of life on other planets is encountered repeatedly in spiritualist productions.

A crucially important factor in the case of Smith, and one extensively discussed by Flournoy, was the tendency for an alternate personality or personalities to take shape parallel with, or even preceding, the elaboration of another world. This tendency is encountered in all mediumistic phenomena and is regularly found as an accompaniment to the creation of alternate worlds in general. Smith's alternate self was male and was most fully and evidently given voice in the person of her spirit guide, Leopold, who was later revealed to be Giuseppe Balsamo (Count Cagliostro, 1743–95). Powerfully dominant, aggressively male, he was at the same time protective and admiring of her. Evident in this case, as in many others involving a female medium, particularly in the nineteenth century, is the attempt to compensate for the frustrations of life by creating a far more vivid and exciting existence, full of activity and significance, in which the medium is able to function as a man. "These diverse fragments make part of some vast subconscious creation, in which all the being of Mlle Smith, crushed and bruised by the conditions which the realities of life have imposed upon her, gave free wing to the deep aspirations of its nature and expanded into the fiction of an existence more brilliant than her own."[11]

In discussing another medium, the fifteen-year-old S.W., Carl Jung pointed to yet another essential characteristic, the tendency of the fictitious alternate self to be notably superior to the day-to-day personality, to exhibit extraordinary intellectual accomplishment, psychological insight, and maturity far surpassing that which the person possesses in the waking state. Jung called this phenomenon "heightened unconscious performance."[12] We will encounter this tendency in even more dramatic form in the alternate personalities and worlds constructed by psychotics. In the case of Smith this heightened performance was chiefly associated with her various male counterparts or alternate selves. In the majority of mediums one is struck by the extent to which creativity, totally obstructed in the individual's daily life, is able to flourish to an astonishing degree in their invention of alternate worlds. It was the remarkable complexity and thorough systematization of Smith's creation that motivated Flournoy to go on studying the phenomena over a period of some five years.

The elaboration of a systematized and complete alternate world is best illustrated by Smith's extremely original visions of Mars. In 1896 she began to be preoccupied by this planet and its inhabitants both during séances, when she traveled there, and in waking visions (hallucinations), in which she saw it in great detail. Not content with the verbal description of its features, she began to paint elaborate Martian scenes illustrating its landscape, architecture, inhabitants, and plant life (FIGURE 221). She also began the automatic writing of the Martian script, a language she soon learned to speak. In his account of the "Martian romance" Flournoy put forward the interesting idea that her internal fantasies concerning life on Mars were far more complete than we realize, representing a genuine alternate world, which her verbal and pictorial accounts only touched on but failed to convey adequately. Flournoy hypothesized that the

252

MACGREGOR

I S e e
a
W o r l d
w i t h i
n t h e
W o r l d

complete version of the alternate world remained psychic, internal, and unconscious, with only fragments visible in drawings or in Smith's verbal descriptions. Its source was to be found almost entirely in her imagination, with occasional pictorial elements derived from borrowed East Asian motifs.

Describing the creation of her visual representations of Mars, Smith said, "The pencil glided so quickly that I did not have time to notice what contours it was making. I can assert without any exaggeration that it was not my hand alone that made the drawing, but that truly an invisible force guided the pencil in spite of me. The various tints appeared to me upon the paper, and my brush was directed in spite of me towards the color I ought to use."[13]

Although Smith described her creative activity as inspired, and to a certain extent automatic, Flournoy pointed out that the results do not support such a contention. Flournoy, in his description of her image-making activity, distinguished carefully between her image-making procedure and that of other mediums involved with drawing. Clearly he was far less impressed by her graphic products than by her other mental constructs. "None of these pictures has been executed in complete somnambulism, and they have not, consequently, like the drawings of certain mediums, the interest of a graphic product, absolutely automatic, engendered outside of and unknown to the ordinary consciousness. They are nothing more than simple compositions of the normal consciousness of Mlle Smith. They represent a kind of intermediary activity, and correspond to the state of hemisomnambulism."[14] In most cases it is clear that she drew from a memory image of her visions after waking, with the result that the technique has more to do with naive painting than with true mediumistic art.[15] It has to be admitted that her graphic depictions of Mars are curiously disappointing and weak in comparison to the graphic visions of true outsiders.

In summarizing Smith's Martian material, Flournoy courageously admits that the ideas, language, and images are fundamentally childish and insignificant.[16] Far from paralleling the situation of Jung's case, where the spirit personality was on occasion superior to the waking personality of the medium, Smith's Martian inventions reflected not her normal mind but an earlier, more adolescent version of herself. Obviously processes of regression are extensively involved in the creation of alternate worlds.

: 222 :
Madge Gill
Figure in Geometrical Setting, 1954

Madge Gill:
A Spiritualist Outsider

For the majority of spiritualist mediums, spoken words provide the fundamental vehicle of experience and expression. This does not imply that they do not also have visions but that internal visual experiences usually are embodied and communicated in spoken or written words. Much more rarely the medium yields to automatic processes that guide the hand, producing unplanned images that can be clearly seen only after they have been produced. These "automatic drawings," in their formal density and uniqueness and in their complex and unexpected subject matter, can, especially if there is a long series of them, suggest an alternate world extending as it were out beyond the individual drawing. A considerable portion of outsider art consists of extremely unconventional pictorial and written products of self-identified psychics or mediums, for the most part women, functioning nominally within a spiritualist framework but usually in isolation rather than as part of an organized group.[17] The phenomenon of inspired drawing is most clearly seen in the lifework of Madge Gill (1884–1961).

In this case, as in many others involving spontaneous graphic activity, the initial impulse was an urgent need to draw, with the spiritualist "explanation" only arrived at later as a means of accounting for what had happened. "It was in 1919 when I first started my work. I then had an inspiration to take up my pen and do all kinds of work of an artistic type. I felt that I had an artistic faculty seeking expression. It took various forms. . . . Then came a flow of all kinds of inspirational writing, mostly Biblical. Then I felt impelled to execute drawings on a large scale on calico. I simply couldn't leave it and I did on average 20 pictures a week, all in color. All the time I was in quite a normal state of mind and there was no suggestion of a 'spirit' standing beside me. I simply felt inspired. . . . But I felt I was definitely guided by an unseen force, though I could not say what its actual nature was" (FIGURE 222).[18] Clearly the sensation of being "inspired" or "possessed" comes first, and then, providing the individual is

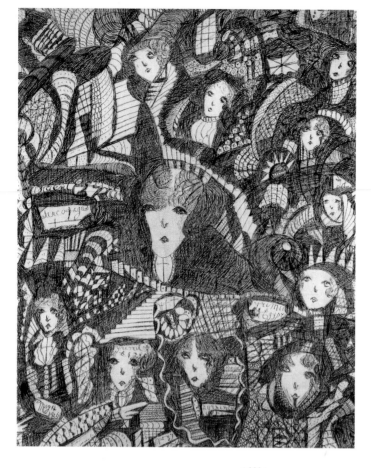

: 223 :
Madge Gill
Untitled (detail), 1926

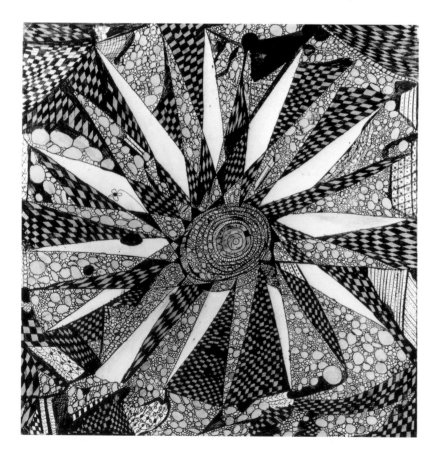

: 224 :
Madge Gill
Star

familiar with spiritualist phenomena and theory, the explanation in terms of spirits guiding the hand is elaborated, usually with a very genuine sense of conviction. Gill had been introduced many years earlier to spiritualist thought and activities by her aunt Kate, and this therefore provided a safe explanation for her sudden and compulsive need to make images.

It would seem that at least initially Gill was experiencing dramatically altered states of consciousness, which were also accounted for by explanations deriving from spiritualist practice. "It was on March 3rd. 1920 when the now medium was taken in a trance and controlled by a very progressed Spirit, whom we now know as MYRNINEREST her guide. All that day the medium was in a trance and as no one in the domestic circle knew what Spiritualism meant, it caused great awe at the time."[19]

In spiritualist artists the degree of true psychic automatism varies. In the case of Gill there seems to have been, much of the time, a total passivity of hand and eye, with graphic activity prompted by internal and largely unconscious forces. In other artists of this kind consciousness intervenes and more control is exerted, with the result that the content becomes more obvious and predictable, the form and space more conventional.[20] Of course in any true creative activity there is invariably an element of automatism, and artists commonly describe the acute sensation of being inspired or possessed. Few professional artists would be prepared, however, to dismiss their work as being entirely the creation of spirits. Obviously there is less of a split between the creative personality and the otherwise mundane life of the trained artist. In general, professionals, in contrast to outsiders, assume more responsibility for their work, accepting the contribution of the unconscious but utilizing their technical ability and consciousness to impose a degree of order and meaning on the initially raw experience.

For the rest of her life Gill continued to draw compulsively, producing vast numbers of black-and-white and colored drawings between 1919 and 1958. Many of these are drawings executed on huge expanses of cloth two and a half meters high (FIGURE 223), the largest of which is said to have been thirty-six meters in length! The overall stylistic consistency of the enormous body of work is immediately suggestive of an alternate world explored over time. Although Gill preferred to do her work in private, once the drawings were created she tended to conceive of them as messages from another realm to be shared. Eventually she exhibited her drawings in amateur art shows; yet she refused to sell them, insisting that they were the work, and therefore the property, of her spirit guide.[21]

Characteristic of all outsider artists is the extreme urgency of the image-making process, with the pressure to create resulting in a veritable flood of complex images. Also typical is an overall unity of form and content linking all of the pictures, a feeling of continuity or of an overriding personal style that evolves slowly if at all. This continuity is very marked in Gill's drawings, even those of enormous size, so that one quite legitimately senses a unified world behind the images. Each drawing represents a "snapshot," a segment of an otherwise continuous alternate world within. That internal world, perceived through drawing, is experienced by the artist as lying outside of the individual, on the "other side," or on another planet. Gill's drawings invariably involve unnatural, strange, and ambiguous forms unrelated to earthly experience (FIGURE 224). The curiously unstable, dense, immensely complex, and patterned space extends back, tilts upward, or collapses inward. At times form and space alternate in a confusing manner, with the resultant images suggestive of a vast and unfamiliar Piranesian architecture.

Gill's alternate world is a society of curiously undifferentiated women, fashionable but anonymous. Embedded in the mass of overlapping textures, patterns, and abstract forms are images of elaborately costumed women and girls. Their body contours fuse with the matrix of background forms such that only the face and occasionally the hands emerge with any clarity from the surrounding image.[22] What is unclear is the extent to which she participated in this spirit world, in what sense it was her true environment. An elaborately embroidered dress, reflecting the style of her drawings, may imply an attempt to adapt her body to her other world, allowing her to participate in it. Otherwise there is little suggestion in her drawings or writings of an alternate personality, other than that of the spirit guide Myrninerest, who fails to coalesce as a distinct and separate entity.

Spiritualist artists are fortunate in being able to disclaim any responsibility for the content and style of their drawings, since these are said to be the work of a disembodied other. Emphasis is entirely on the depiction of the other world, often in considerable and very specific detail. Gill was unusual among spiritualist outsiders in that she offered almost no explanation of what her images represented. She was apparently able to withstand the essentially passive experience of allowing images to emerge without feeling compelled to account for them or to describe what they were about. This means that while we can see her alternate world, we can understand very little of its nature or function. Nevertheless it is possible to feel something of its claustrophobic and anxiety-provoking reality and to understand why she may not have wished to explore its meaning.

Possessed by spirits, the medium is expected and encouraged to move out beyond the confines of her or his limited personality and experience into unfamiliar and occasionally frightening territory. In such a situation she or he may be reluctant to inquire too deeply as to what a drawing represents, preferring to emphasize its strangeness and mystery. The day-to-day personality of the artist

256 MACGREGOR I S e e
 a
 W o r l d
 w i t h i
 n t h e
 W o r l d

is, however, not threatened or "flooded" by the emergence of unconscious imagery. In this respect the process is very different from that which we encounter in psychosis.

That Gill's pictures depict an alternate world is made evident by the inclusion in some of the drawings of fragments of an unknown written script, similar to that invented by Smith. A completely unfamiliar language implies an unknown or lost civilization or world. Most of Gill's inspired writings were, however, dictated to her in English. They do not reflect the graphic world of her drawings very closely and represent bits of wisdom or insight from the "other side" and generally are religious in tone. An exception to this are segments of nonsensical verbal play, which may also represent efforts in the direction of an alternate language.

When an alternate world reaches the level of complexity and elaboration evident in Gill's work, it often is relocated from a nebulous heavenly location to a more precise setting on another planet, Mars being thus far the planet of choice.[23] This tendency to relocate is frequently observed when the alternate world becomes extremely personal and idiosyncratic, moving out beyond the conventional notions of a Christian paradise, with its traditional iconography, and assuming a pseudoscientific rather than a religious character. This shift is evident in the drawing entitled *Mars*, a drawing that differs markedly from Gill's more obviously spiritualist drawings. Given the unusual amount of Martian script on the form of the planet, which is in the shape of a flying saucer, one wonders about the direct influence on Gill of the Martian adventures and language of Smith.

Perley M. Wentworth

The visionary discovery of alternate worlds on other planets is most clearly to be seen in the disturbing graphic work of an all but anonymous outsider, Perley M. Wentworth.[24] While almost nothing is known about Wentworth or about the motivation inspiring his image-making activity, it seems unlikely that it emerged in a spiritualist context, though it does on occasion reflect a deep concern with an afterlife in another realm. This concern is particularly evident in a picture of the kingdom of heaven and its reverse side, which shows heavenly beings in curious white robes.[25] If anything, his involvement with life on other planets has a pseudoscientific cast that may best be understood in terms of the experiences of individuals who believe they are in contact, in various ways, with extraterrestrial beings and realms. Such experiences differ radically from the romances of science fiction in that they originate not in imagination but in delusional reality.[26]

Wentworth seems to have possessed not only visionary knowledge of the future and of interplanetary civilizations but also detailed psychic familiarity with the biblical past. His work can readily be divided into two categories, with depictions of specific places and things mentioned in the Bible (Sea of Galilee, Mount Ararat and Noah's ark, Nazareth, and Lazarus's Tomb, Bethany) constituting the first, or historical, group. These large architectural drawings are perhaps best understood as manifestations of naive art. The character of these drawings derives from the biblical engravings that served Wentworth as models for his archaeological reconstructions. The ancient structures are represented with innocent but imaginative archaeological exactitude, stone by stone, and with amazingly rich surface textures suggestive of earth and rock.

It is in the texture of his engraved models that he "sees" and makes evident heretofore undiscovered forms and beings. It is his far stranger, more lyrical, and yet frighteningly powerful, maplike depictions of the surfaces and civilizations of other planets that carry him most clearly over the edge into the alternate world of the outsider. Inspired by

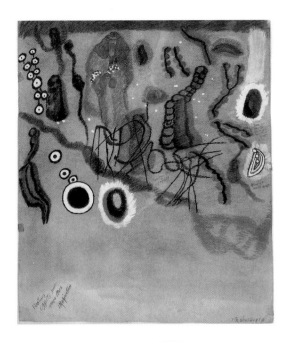

: 225 :
P. M. Wentworth
*Floating Objects Down—Threw Space
Imagination*, c. 1950s

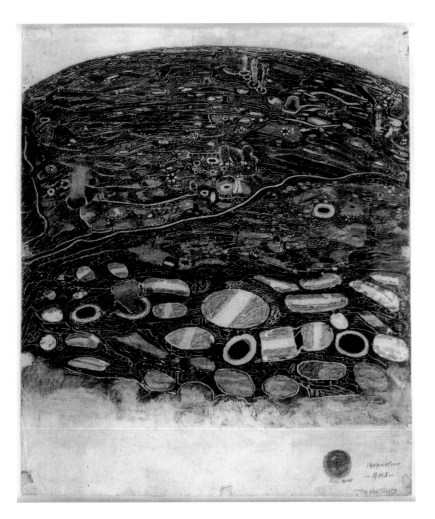

: 226 :
P. M. Wentworth
Imagination: Mars—Full Moon

photographs of the planets derived from telescopic study of our solar system, he created a series of large-scale depictions of life on specific planets, which include bizarre and richly imaginative architecture and terrain as seen from above, perhaps from a spaceship. As evidence of the scientific nature of his findings, he attached the photographs, cut from a magazine, to the bottom of his drawings of the respective planets.[27]

His highly personal and unconventional process of discovery seems to have involved close observation of the sky, of cloud formations, as well as of shapes seen in the sun, moon, and stars.[28] The graphic records documenting these observations are dated not only to the day but to the exact time of the observation. "Formation of clouds seen at sunset. Cross and Temple. 1/1/52. . . . Image of beautiful things seen from Heaven." This unusual mode of investigation probably dictated his extraordinarily subtle and complex technique. Some possibly unfinished works seem to suggest that he created textured surfaces on paper employing a frottage technique, to which he added media including pencil, chalk, and watercolor. These textures then became the basis for the discovery and depiction of very specific land forms, architectural details, and even strange, robed figures. As late as 1961 he was involved with depictions of outer space. "I am sketching some space pictures . . . stars, moon, rotations across the sky . . . Even if imaginative or real on paper after sight so long a time in pass years why blank papers show up pictures."[29]

Light seems to have played an unusual role in Wentworth's conception of creation and in his unique method of defining form, with objects outlined with light rather than with dark contours (FIGURE 225). He made extensive use of erasures of surfaces to create effects of glowing light. The various planetary civilizations and landmasses are overwhelmingly impressive and convincing and must have appeared to him as scientific revelations of the truth of other worlds surpassing the reality of the attached photographs. On at least two occasions Mars was depicted in great detail (FIGURE 226).

258 MACGREGOR I S e e
 a
 W o r l d
 w i t h i
 n t h e
 W o r l d

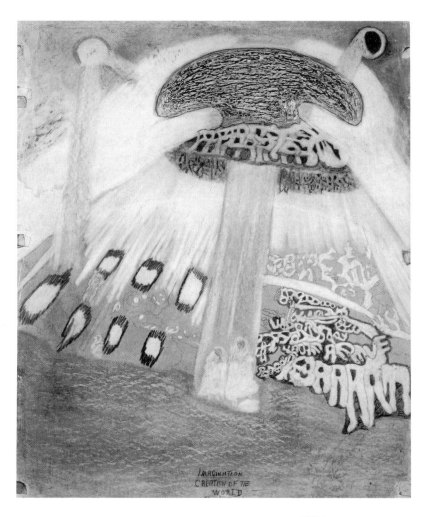

: 227 :
P. M. Wentworth
Imagination: Creation of the World,
c. 1940, mixed media on paper,
30 x 25 ½ in. (76.2 x 64.8 cm),
Collection of Matt Mullican,
New York

The extraterrestrial and scientific nature of his observations of the sky did not preclude religious implications. On occasion the face of God readily emerges from the rocky features of a planet's surface.

The picture entitled *Imagination: Creation of the World* seems to involve a curious juxtaposition of religious dogma and scientific hypothesis (FIGURE 227). A mushroom cloud takes shape between the hands of God, its form reminiscent of both the human brain and a flying saucer. To the right and left the sun and moon appear, with rays of natural light extending downward. A vertical shaft of far more brilliant light emerges straight down from the spaceship, and in its beam two figures dressed in white materialize before our eyes. Nearby, a chaotic group of amorphous white forms coalesces as letters and finally as words, including the name Abraham. Clearly Wentworth was involved in cosmological speculation, with God as an extraterrestrial prime mover behind the creation of the universe and humankind.

In the absence of much biographical data it is not possible to determine the nature of the mental states underlying these complex images. It is occasionally suggested that Wentworth labeled many of his drawings as "imaginary" in order to refute any suggestion that he might be insane. We do know he functioned adequately in society and took an active interest in promoting his work. Nevertheless the intensity of the images and their extreme originality and strangeness would seem to imply visionary states far removed from conventional experience.

Henry Darger:
In the
Realms of the Unreal

Thus far we have been examining situations in which an alternate world coexisted with a life lived in reality, that is, a life in which the individual continued to function more or less normally in terms of social contacts, family, and sense of self while devoting considerable time to the elaboration of an at least partial alternate world. One of Gill's sons did express the fear that his mother might slip over the edge into madness, yet, except for the extreme alcoholism she manifested at the end of her life, she continued to function adequately in her home and in her community. I want now to turn to a more complex situation, one in which the creation of an alternate world appears to have swallowed up a life, to have truly become its creator's new realm of existence. While in this case we are not yet encountering a complete collapse of reality, or full-blown psychosis, we are entering the realm of schizophrenia, in which life is sacrificed to a dream. This is the world of the isolate outsider.

Henry Darger (1892–1973) created his work in complete isolation.[30] There is no evidence that anyone ever saw the alternate world he spent his life inventing. It is paradoxical that while he occasionally described himself as an author and an artist, he seemingly never sought an audience or a publisher. This paradox lies at the very heart of true outsider art, which is so frequently created in total secrecy, often in the complete absence of any of the motives traditionally attributed to "artists" and to the making of "art."[31] In an effort to obtain insight into Darger's motives for the elaboration of his private world, we will explore his creation in considerable detail.

Darger's lifework began as a piece of imaginative fiction. He was nineteen years old when the writing of what was probably to have been a novel began (1911). The process continued until his death sixty-one years later. The title of the vast work, "In the Realms of the Unreal," seems to indicate that he was readily able to distinguish between reality and his fantasy world. He was at least initially, and superficially, in control. He was aware of being an author and of having at least imaginary readers.

Darger's real life was a tragic story of thwarted development, increasing isolation, and massive intellectual and emotional frustration. Born in Chicago (though some have wrongly asserted he was born in Brazil), Darger lost his mother and newborn sister before he reached the age of four. Raised by his crippled father, he was abandoned at the age of eight to a sequence of boys' homes and was finally incarcerated in an institution for feebleminded children.[32] The writing of "The Realms," which began only two years after his escape from "the asylum," seems to represent the elaboration of continuing fantasies whose origin can be located in adolescence. Darger remained an emotional adolescent for the rest of his life. He managed, however, to function in low-level hospital jobs until his retirement at the age of seventy-one. Profoundly involved with religion, his only social activity consisted of compulsive churchgoing. He lived in rented rooms, ate in a nearby restaurant, worked, and attended Mass. Yet, in terms of meaningful human contact, he was completely isolated. In his entire life he appears to have had only one friend, William Schloder, who eventually moved away from Chicago. This permanent situation of almost complete emotional, intellectual, and creative starvation offered him not the slightest possibility of growth or development.

Darger's alternate world was originally conceived of as located on an imaginary other planet. "The scenes of the story, as its title indicates, lies among the nations of an unknown, or imaginary, world, or countries, with our earth as their moon, on an imaginary planet, a thousand times as large as our own world." Having established this new creation, he then traveled from Chicago by train and boat to get to it, and the other planet was soon forgotten. This other world involves an elaborately systematized group of nations and distinct peoples engaged in an ongoing and terrible war being fought over the issue of child slavery. Darger functions as historian of the epic struggle he describes while at the same time playing an important, at times central, role in determining its outcome.

The project grew far beyond the bounds of reason, finally resulting in an unpublished, and unread, typewritten manuscript in fifteen volumes (15,145 pages), the creation and illustration of which occupied most of the rest of Darger's life (FIGURE 228). Engaged in meaningless and exhausting work by day, he returned to his room at night to live his real life in the realms of the imagination.

The history that Darger elaborated over many years was entitled "The Story of the Vivian Girls in what is known as The Realms of the Unreal, of the Glandeco-Angelinnean War storm, caused by the Child Slave Rebellion." Its theme is war, terrible and vast. "This description of the great war, and its following results, is perhaps the greatest ever written by an author, on the line of any fabulous war, that could ever be entitled, with such a name. The war lasted about four years and seven months, in this story, and the author of this book has taken over 11 years in writing out the graphic details, and has fought from day to day in order to win for the Christian side this long and bloody war." (Darger was in the early part of the book's creation when these lines were written.) The writing style is characterized by unusual grammar, the rhythmic repetition of words, and the use of neologisms. The punctuation is bizarre when there is any. This is outsider literature, the equivalent of outsider art. Darger was reinventing the language.

Terror was in the streets of Genitori, terror and rage, tears and frenzy, and miserable cries pealing through the air. Desperation of the Glandelinians rushing to the slaughter. Mothers with streaming eyes, and wild and frenzied at seeing their children die. The crammed prisons inside the city seemed about to burst, so full were they with women and children. Madness, murder, and horror were committed by the enraged Glandelinians. The far distant Glandelinian cannon was now roaring its loudest, with some 5000 children, with 80 poor priests, were forced along to the main prison by the angry Glandelinian multitudes, who were cursing and swearing as they moved. "Accursed priests, this is the most terrible death you and the children are condemned to die," they howled. The next moment the prisoners were surrounded by raging endless tumults and yells, deaf to the cries for mercy and piteous screams of the children which the Glandelinians only answered with sabre thrusts through the heart. The priests themselves were cut, hacked, and torn to pieces, and the children were frightfully massacred, about the prison yards, until their life-blood covered the streets. Everywhere there was a howling tumult. The poor children being intermingled in a howling sea of grey coats. . . . Many of these poor little ones sank, hewn asunder, one after another sank with dying cries, and soon there were formed a pile of corpses, and the streets began to run red. Fancy the yells of these wicked Glandelinians, their faces covered with sweat and blood, the fiercer shrieks of more women and children crying, "Mercy, oh please have mercy," but there was no mercy.

: 228 :
Henry Darger
Untitled (recto)

Darger's conception of war and of battles was influenced by his knowledge of American Civil War history. As a boy Darger had a remarkably intense interest in the war, reading as much of the available literature as he could obtain. The influence of that war and its literature is very evident in the war he creates in his alternate world. His war is similarly fought over the issue of slavery, in this case the keeping of child slaves. The number of combatants is vastly increased, and the obsessional concern with detail goes beyond anything expected of a historian of war. Individual accounts of battles and massacres go on for hundreds of pages. The war is waged on numerous fronts at the same time, in several countries, and at sea, with ships, submarines, and mines used to blockade the harbors. At times he writes as a war correspondent, in newspaper-headline style, filing his reports from the field of battle. The war slowly increases in intensity and violence, engulfing the civilian population. Cities are overrun by the Glandelinians, who show no mercy. Vast populations are displaced, as starving refugees flee to Christian lands. Entire peoples are ordered deported, and trains full of victims cross the landscape from place to place. Darger often mentions orphanages, as though they are to be found everywhere, filled with child victims of war, flood, fire, and storm.

Throughout the book it is children who function as heroes and especially as heroines. In Darger's world children are both innocent, helpless victims and a powerful force, resisting adult manipulation and violence. The heroines of the story are the seven "Vivian Sisters," whose adventures occasionally display an innocent storybook character, as does the graphic style of the later illustrations. The sisters range in age from five to seven (like all the children in the story, they do not age). Always depicted with blond hair, they are usually dressed alike (FIGURE 229). "Their beauty could never be described, but their nature and ways, and goodness and soul, was still more pretty and spotless. They were always willing to do what they are told, keeping away from bad company, and going to Mass and Holy Communion everyday, and living the lives of little saints." Darger hints that there is an element of mystery about these children; they seem both supernatural and indestructible. He frequently compares them to the Virgin Mary. They possess adult intelligence and savoir faire, are excellent horsewomen, perfect shots, and masters of disguise. Brilliant military strategists, they play a major part in the conduct of the war. Functioning as spies and messengers, they are repeatedly captured, tortured, and sentenced to death. They have,

: 229 :
Henry Darger
Untitled (recto)

however, a miraculous ability to escape from even the tightest situations. Their spirits remain high, their optimism limitless, and their religious faith untarnished.

Darger's personal experience of little girls was limited. In his drawings of them, tracings from published sources, girls are frequently shown naked and usually with male genitals, which he carefully added. We must at least contemplate the possibility that he did not know of the physical difference. While romance and even a chaste kiss occasionally happen between boys and girls in "The Realms," there is no hint of sexual activity, apart from the sadistic torture of children, which is a dominant feature of Darger's writings.

About noon, a frenzied mob of Glandelinians came swarming for the prison of Violet and her sisters. The standards they followed were the heads and even gashed bodies of six beautiful little children, with their intestines protruding from their bellies, and every one of these were on pikes dripping with blood. Fortunately, Violet and her sisters did not see this. These were carried into the courtyards of the great prison under that window of that tower in which the Vivian girls were confined, and these, yelling like demons, demanded Violet and her sisters to appear, and when they did, they thrust up on to their windows the heads and bodies of these lovely children, and managed to cast them inside amongst them. Then, bursting into the doors, they thrust the heads into their laps, ordering them to make a copy of them in pencil. Although it seemed to them that they would die of horror, they thought it best to obey, and as their arms were freed, and the paper and pencils had been given to them, they started in to draw the hideous bodies and heads, being good at drawing pictures in the most perfect form.

It seems possible that "In the Realms of the Unreal" first took shape in Darger's mind in adolescence, as a highly idiosyncratic variant of sexual fantasy. The invention of an alternate world may often come about in this way. In the absence of any natural outlet there is nothing to stop its endless and compulsive elaboration. At times one has the impression that Darger is recording a complex fantasy developed long before the writing began; it is as if he knows the whole story, has been part of it for ages. Yet his writing fairly regularly betrays a loss of control, as free association and elaborate visual fantasy take over. If the initial impulse was to write a children's adventure story, then it must be admitted that his creative activity was troubled early on by powerful currents of sadism, with the theme of child slavery, with all its attendant tortures, present from the start.

From the beginning he wrote himself into the book as a heroic fighter in the Christian cause and as the chief defender of children. But then a strange series of events began to trouble him, upsetting his good intentions. In July 1912 Darger apparently lost a photograph, this not in fiction but in reality. It was one of *thousands* of photographs, drawings, cartoons, advertisements, and coloring-book images depicting little girls that he had cut out and collected in his room. But this photograph, of a child he called "Annie Aronburg," seems to have been of crucial importance to him. Whatever meaning this photograph of a murdered child possessed for Darger does seem intimately tied to the real loss of his baby sister, the sister whose name he never knew. He began to pray for the picture's recovery, to petition heaven. His prayers were not answered. He erected an altar in a garage, he dedicated Masses, made sacrifices—no response. Months passed. Finally Darger grew very angry. He began to threaten God. In his journal we read: "October, 1912: Prediction and Threat: Despite the new situation in the war, petition must be granted before March 21, or change will come in favor of the enemy. H.J.D."

This was just one of many such threats and predictions. Soon the tide of battle began to change. "The loss of the Aronburg picture has caused the frightful disasters during the battles, the torment of the Vivian girls, and the frightful fury of the great war." The increased terror unleashed by the Glandelinians can be seen to be directly connected with Darger's profound anger at God. He finally left the Catholic church in disappointment (and in reality) and then enlisted in the Glandelinian Army (in fantasy). Clearly a remarkable mixing of fact and fiction had begun to occur. The character of the story changes; the violence becomes horrendous. Darger's alternate world is now awash in monstrous evil, with the principal victims the child slaves, mostly little girls (FIGURE 230).

It is evident that Darger had moved into his alternate world (at least at night) and that the conflict going on in his war-torn countries possessed far greater reality for him than his day-to-day life. His realm of action was now immensely increased, even God had to take notice. He wrote: "Am an enemy against the Christian cause, and desire with all my heart to see to it that their armies are crushed! I will see to the winning of the war for the Glandelinians. Results of too many unjust trials. Will not bear them under any conditions, even at the risk of losing my soul, or causing the loss of many others, and vengeance will be shown if further trials continues! God is too hard to me. I will not bear it any longer for no one! Let him send me to Hell, I'm my own man." The result for the child slaves was a blood bath:

The children, seized from their frantic mothers were killed in all the ways imaginable. Many were burned to death at the stake, and many others were cut to pieces and left lying where they had been thrown. And many children looked as if they had gone through the meat chopper. Even little girls, from the ages of nine, eight, and even younger, were tied down stark naked, and a spade full of red hot live coals would be laid on their bellies. Many of the children had been choked to death, with as it seemed iron hands, for the looks in their faces were horrid. Naked opened bodies were seen lying about in the streets by the thousand.

Indeed the screams and pleads of the victims could not be described, and thousands of mothers went insane over the scene, or even committed suicide. . . . About nearly 56,789 children were literally cut up like a butcher does a calf, after being strangled or slain, in all ways, indeed the sights of the bloody windrows, with their intestines exposed or gushed out, was a sight that no one could bear to witness without losing their reason. Hearts of children were hung by strings to the walls of houses, so many of the bleeding bodies had been cut up that they looked as if they had gone through a machine of knives. One street was covered with a sea of dead children's bodies and mangled fragments of every vital describable. In the curbing of the streets, and at some points along the sidewalks, blood lay like water after a thunderstorm.

Darger now devotes hundreds of pages to the description of the torments and deaths of individual children in endless, bloody detail. Children are strangled, hung, beheaded, cut to pieces, burned at the stake, crucified, and most frequently cut open and disemboweled. Child slaves are stripped, beaten, starved, and murdered. At times, and such accounts are frequent in the later volumes, one senses within Darger a potential for mass murder. It was, however, a potential defended against by his intense devotion, his absolute conviction of the existence and power of God. This conflict is at the heart of Darger's experience and of his writings, with the outcome invariably hanging in the balance. This is an alternate world powered by an over-whelming force . . . restrained.

There is, happily, a lighter side to "The Realms," what we might call the unreal side. This is most evident in Darger's invention, or discovery, of a species of extraordinary animals known as Blen-giglomenean Serpents, "creatures of flesh and blood, same as any other" (FIGURE 231). There are many kinds of these creatures, identified by specific names and characteristics: "Human Headed Roverines, called Rabona, which are the prettiest; Taporeans, which are the longest, some exceeding 8000 feet (very violent); Fairy winged, and Angel Winged Gazonians, both of which have butterfly wings; and the horribly ugly Dog and Cat headed Crimacean

Gazooks. All are called 'Blengins' for short." Some look curiously like little girls whose bodies end in enormously long and powerful tails. These animals, obviously of tremendous importance to Darger since they reappear constantly throughout the volumes, may, in their possession of powerful and destructive tails, be seen to challenge the notion that he was unaware of the anatomical difference between the sexes, suggesting that at least on an unconscious level the mechanism of denial was involved. The human-headed varieties are usually equipped with ram's horns. All are winged and can fly. Some are excellent swimmers. The essential psychological characteristics of Blengins are their love of children and their hatred of anyone who harms a child. Darger explains:

As far back as 1188, the creatures have shown a greater fondness towards children of all nations, as to exceed the love of any mother. As they have somehow knew of the existence of God, they feel sure that any man, no matter what nation he is in, who ill treats a little child, for whatever reason, is not only an enemy of children, but also an enemy of God. No man is safe in their presence who hurts a child.

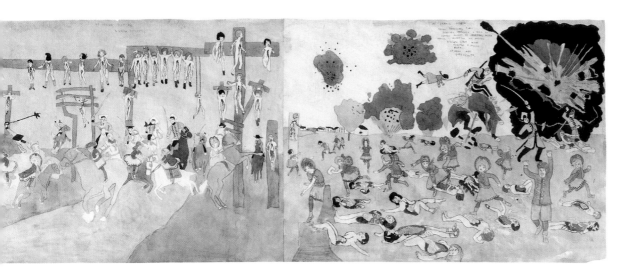

: 230 :
Henry Darger
Untitled (recto)

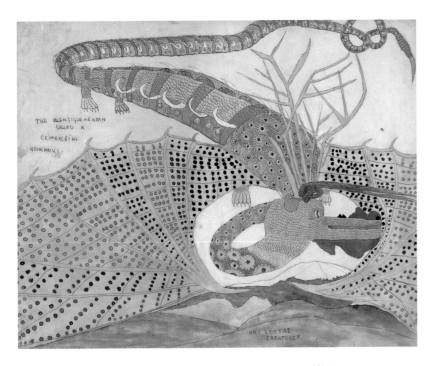

THE BLENGIGLOMENEAN
CALLED A
CRIMERCEÏAN
VENEMOUS

UNIVERSAL
CREATURES?

: 231 :
Henry Darger
*The Blengiglomenean Called
a Crimerceïan Venemous*

Throughout the book we participate in a puzzling mixture of fantasy and fact, of playful invention and delusional reality. To what extent was Darger in control?

Thousands of pages into the history of the Glandeco-Angelinnean War the descriptions of battle, massacre, and destruction grow still more violent. But now Nature begins to participate mysteriously in the carnage. The other world is ravaged by storms, earthquakes, unexplained explosions, universal floods, and forest fires, which burn unceasingly.

Poor Calvarinia, East and West, overwhelmed by hideous floods, torn by battles, made harrowing by massacres of thousands of children, rent and shattered and torn gaping open by so many terrific explosions, and hidden in all its horror for months and months by the smoke of forest-fires that prevent sunshine even more than a thousand miles away—a beautiful, magnificent, satisfactory outcome of the war so far, is it not?

For hundreds and hundreds of pages, Darger describes the vast floods that inundate the nations.

266 MACGREGOR I S e e
 a
 W o r l d
 w i t h i
 n t h e
 W o r l d

At about 12 o'clock noon, the resistless flood, increasing more rapidly, tore away the huge forest of trees not so far off, and this was the real beginning of the end [for Sperryville]. The enormous masses of trees were rapidly hurled down upon the doomed town or city, and the lines of every stream was rapidly obliterated, and was nothing but a raging sea. The great trees, hundreds of thousands of them, like big log jams, bore onward, levelling everything before them, crushing scores of frame houses like egg shells, and going on unchecked until the flood reached elsewhere. Had the jam of trees passed on and spread out on the flood, instead of remaining so thickly jammed together, Sperryville might not have met such a horror. The big masses of floating trees formed enormous and impenetrable floating barriers, and still carried all before them. As the flood increased in its rise, the people fled. For them, however, there was no longer any chance of getting away, and had they known indeed what was in store for them, the contemplation of their fate would have been enough to make them stark mad indeed. The towering wall of water roared down upon the city of Sperryville with the noise of a great tidal wave that follows an earthquake, and rushed with a force and speed that actually carried all before it. . . . pouring into the city like Niagara, and at once half of the houses of the big town were swept from their foundations and hurled with force and speed against neighboring houses and crushed, each the other, so suddenly that immediately this formed an immense jam of wreckage. The flood increased and increased, and hurled itself against the long jam of wrecked houses, in succession of big waves, and each wave carried with it thousands of houses, furniture, and legions of human beings. For half an hour the long jam of wreckage stood firm, but finally the pressure of the flood grew and grew, then came the main torrent, a towering wall of water more than 50 feet high, which swept the almost impenetrable and immovable barrier before it, as if it were only a reed, and the rest of the city was crushed down, and part of it was entirely washed away.

For several volumes a troop of Christian Girl Scouts, led by the girl hero Gertrude Aronburg and accompanied by Boy Scouts, adults, and horses, are swept along on a huge raft through the flooded world. From time to time formal discussions are held, during which the best minds, including that of volcanology expert Hendro Dargar, attempt to understand and explain the causes of these unnatural disasters. Where, for example, does all the water come from? The children also discuss the meaning of the war and of Nature's rampages and their effects, both good and bad, on humankind. As she surveyed the vast expanse of water filled with floating debris, Gertrude said, "How powerless indeed is our nation, as it seems, after Nature assails, through the suspected efforts of the enemy. How feeble our boasted strength, and intellect, against the stupendous natural forces produced by the unknown, strange works of the enemy, who created explosions which could rend mountains in twain; make the earth rock like the waves of the sea from the concussion, and cause floods which no one can comprehend. And Glandelinia calls this war! If it is, then what is civilized warfare?

While the low-lying ground is covered to a depth of twenty feet by flood waters and is slowly sinking beneath the great weight, the hills and forests are simultaneously on fire. Great islands of wreckage drift, ablaze on the dark seas. "There were fierce fires burning in the wreckage, which afforded the only light there was. When no fires were burning, everything was in total darkness, save where the red glow could be seen in the sky." Darger is at his most passionate, and visual, in his verbal descriptions of the forests afire. Despite the fact that these accounts of burning forests go on for hundreds and hundreds of pages, they are seldom repetitious or dull. One catches some of Darger's excitement, which approaches frenzy and is, at times, evidently sexual. The fire burns with supernatural intensity and duration: a world is on fire! This enormous fire grew rapidly and where it spread, mountains of smoke soared upward from it towards the sky in billows that seemed to try to reach the planets, in the sky far above the world. The conflagration assumed the form of an enormous wild fire ocean, and burned forward

with incredible speed . . . Bigger and bigger grew the fire sea, rushing forward like a wild cyclone, a roaring rushing sea of flame. It is now a veritable sea of fire clouds, leaping hundreds or thousands of feet, and driven forward by an unusually strong gale evidently originated by the heat of so much fire. It was a most dreadful fire hurricane, of enormous magnitude, beyond description horrible!

The pictorial aspect of Darger's oeuvre made its appearance somewhat later than his written work, and his mature drawings commenced after the "novel" was more or less complete.[33] He suffered like many adults from the conviction that he could not draw. Nevertheless at a certain point it would seem that the need to make drawings assumed irresistible intensity, driving him to find extraordinary methods for arriving at pictorial images of his inner world.

There is obviously a vitally important problem here connected with the choice of expressive means, writing, painting or drawing, and in the case of other outsiders, sculpture, architecture, and musical composition. We are nowhere near understanding why artists select one or another of the media to start with, or why their internal development then forces them to expand into other areas. Darger's pattern is unusual in that he began not with images but with the writing of prose. More typically these artists are inundated with visual images, which inspire a graphic response. To the extent that the initial phase often involves sensory experiences of hallucinatory intensity, the choice of expressive means may, in part, be determined by whether the hallucinations are auditory, visual, or both. In Darger's case we know that he carried on lengthy conversations with imaginary visitors to his room, using his powers as a mimic to play both sides of the conversation. To what extent he actually heard voices and responded to them we do not know. It is clear, however, that whatever was occurring involved verbal exchanges and a compulsive involvement with writing.[34] More difficult to explain is the subsequent move into the production of large and very powerful pictorial images.

Darger had been cutting out and collecting pictures from the beginning of his creative life. The picture of Annie Aronburg, which he lost, was by no means the only image that he possessed. He was cutting out and accumulating every image of a little girl that he could find. This included thousands of advertising drawings for children's clothes, newspaper and magazine photographs of female children, coloring-book images, illustrations from children's storybooks, and even tiny cartoon drawings featuring young girls. We also know that he had actively attempted to adopt a child and that his failure to find acceptance as an adoptive parent was one of the chief reasons for his anger with God. The vast collection of pictorial images can therefore be seen as a symbolic means of possessing the little girls he so desired. In reality his room was inundated with depictions of girls of all ages, amidst which he lived out his fantasy existence. The most beautiful little girls became his adoptive family in this way.

Darger's first attempt to transform these found images into a visual document of his war epic involved adding colorful details of costume, uniforms, or hats to black-and-white photographs or drawings. Handwritten inscriptions then reidentify the individuals in the modified pictures as characters in his story. A series of "portraits" of generals emerged in this way.

At some point early in the process Darger also began to construct complex battle scenes using collage techniques. From the start his method of doing collage involved assembling groups of suitable figures—such as soldiers, horses, weapons, and children—in an overlapping and additive fashion to construct a battle picture. The family of images was being used to create groupings of figures and scenes, with individual figures combined in elaborate compositions. Clearly the technique depended on his being able to find suitable military and equestrian images. The size of the collage was also limited by the rather small size of pictures then being reproduced in magazines and newspapers. Large collages featuring a multitude of figures

tended to be overly detailed, complex, and hard to read.[35] It was also difficult to incorporate images of children, specifically little girls, into the fairly elaborate battle groupings because of differences in relative size.

Then, in 1944, Darger made an enormous creative leap, inventing an entirely new method of doing collage in an effort to solve the problem of size. Selecting suitable, small images of children, soldiers, horses, buildings, and even plants, trees, and clouds, he took them to the photography counter of his local drugstore to have negatives made from them. Using these negatives, he then ordered eleven-by-fourteen-inch photographic prints made. This procedure, very expensive for him, yielded images that he could then trace, thereby arriving at large and relatively simple drawings of the various figures he required. In this way he slowly assembled a file of images, which he could draw from in constructing elaborate, horizontal, scroll-like compositions, with numerous figures traced in various attitudes and positions. This means that traced images are often repeated within a single composition and may also be used repeatedly in various compositions over time.[36] This tracing technique was particularly suitable in that it provided a means of transferring his accumulated collection of little girlfriends into his personal space, his pictorial dreamworld. In the form of collage-drawings favorite images could be repeated both within a given composition and in sequences of compositions.

At this time no children in newspapers or magazines were depicted fully unclothed (except occasionally from the rear). In the process of tracing the figures of children, Darger would simply not trace the underwear or other clothing. Then, in accordance with his unusual belief, he would add tiny male genitals to frontal female figures. (Female figures are provided with a male genital only in situations where their legs are sufficiently apart for this otherwise "hidden" organ to be seen. The same is true for his far-less-frequent depictions of little boys.) Numerous examples of this curious

procedure survive in the form of original image and modified tracing. He also felt at ease modifying his drawings of children by depicting the body slit open from neck to groin, with intestines spilling out in great loops. When the need to draw became pressing enough, he was able to invent, even modifying facial features when a more suitable expression of terror or anguish was needed.

A similar additive technique was used in arriving at the highly imaginative hybrid images of Blengins and was especially necessary in those with the head and upper body of little girls. Borrowed forms were also added in the case of Blengins with enormous curved horns. One senses that Darger actually might have been able to draw on his own but that the method he used, a sort of pictorial "adoption" technique, was in itself meaningful to him. Certainly it yielded magnificent, large compositions two feet high and up to twelve feet in length. Possessed of a highly original sense of space and an extraordinary sensitivity to color, he created marvelous settings—interiors and outdoor scenes—as backgrounds to his imagined events. His ability to suggest pictorially the time of day and the effects of weather plays a part in the intensity of mood evoked by most of his drawings. His lyrical color—soft, fluid, often unnatural, and invariably moving—provides one of the chief delights of his work. The pictures possess a freshness and innocence that permits the occasional scenes of violence, sadism, and murder to pass almost unnoticed, a curiously innocuous juxtaposition of Dick and Jane with the Marquis de Sade.

This collage-drawing technique, which Darger invented for himself, suggests just how intense his need for pictorial images must have been. Desirable images could be removed from "reality," reidentified, colored, and incorporated into his private world. What would be for a professional artist merely a formal technique of juxtaposing borrowed images became in Darger's hands a means of radical possession and manipulation.

The task of writing, typing, and then illustrating "In the Realms of the Unreal" went on for much of Darger's life, more than sixty years. It obviously required tremendous discipline and determination. This was especially so when you consider that it was done in the absence of any audience. Perhaps it was precisely because the process remained secret that it retained its power and its hold on his life. It *was* his life!

He wrote "The Realms" alone in his room, with God. Darger, like the Christian mystics, talks to Him, pleads and bargains with Him, struggles against Him, curses Him, even threatens to abandon Him; but he never doubts the existence of his God. In creating his vast alternate world, Darger entered into rivalry with God, inevitably assuming a degree of equality, at least in his role as creator-author of another world. The result was a cosmic struggle, waged in a room in Chicago.

In observing this alternate world, it seems crucial to recognize that its nature, its character, was never a matter of pure choice. While elements of wishful fantasy and idealized daydream are obviously present, a deeper and more troubling reality keeps asserting itself. The frightening world that Darger was creating was a world of chaos and darkness, a world threatened with destruction, filled with savage and gratuitous violence. Given the full extent of the horror and suffering he describes, including the mass murder and torture of millions of children, his creation can be seen as anticipating the terror of World War II and of the Holocaust.[37]

To the psychiatrist it is evident that this fantastic endeavor represents the mechanisms of projection run wild! Clearly Darger was not free. Everywhere one sees and feels internal conflict externalized as war, inner mental states projected onto a landscape, sexual and aggressive drives embodied in murder and massacre. Certainly Darger's alternate world, with its endless battles, its raging fires and floods, represents a visual externalization of the psyche, flooded with internal and unconscious content. And at the heart of darkness was rage!

It is, however, essential that in our acknowledgment of Darger's pathology we do not miss several crucial points: his extraordinarily creative accomplishment, his invention of a powerful means of expression, his discovery of a voice. We must not overlook, or undervalue, the truly staggering artistic importance of what Darger managed, despite all odds, to create. In exploring Darger's verbal and graphic world, I have been time and again overwhelmed by its endless inventiveness, its variety, its playfulness, and its sheer beauty. "In the Realms of the Unreal" is a work of amazing complexity and conviction, the single most important American example of outsider art in existence. In the fifteen volumes we are provided with an overview, a God's-eye view, of an entire world at war. In its unity, its totality of vision, and in the overwhelming depth of detail it is entirely convincing as history and as literature. Encyclopedic in scope, it is a vast literary epic, probably the longest novel ever written!

It is exceedingly difficult to conceive of a mental state that would enable one to imagine and to contain this incredible spectacle. Darger kept a variety of additional notebooks in which he maintained lists of generals, alive or dead, of battles won or lost, and of the exact numbers of casualties on each side after every battle. He also drew maps of the territories involved and designed the flags of the various nations and armies. While the vast scope and complexity of his ongoing war required him to keep track of endless details from volume to volume, there is, undeniably, a degree of compulsiveness about these lists. He also listed illustrations required for each chapter and checked them off as they were completed. It is no less difficult to envision the lifelong creative process by which this internal fantasy was given external form and structure. Externally, and to all who knew him, Darger was a barely functional old man; a feebleminded boy become a man without really

growing up along the way. We have now to contemplate the possibility that Darger was a suppressed genius, potentially an intellectual and creative giant. What happens to a man of genius when his environment, his family, his upbringing and education, his means of earning a living, and his sense of his own identity all contribute to opposing any possibility of growth or development? The result, surely, is sensory, emotional, and intellectual deprivation on a massive scale.

I would like to suggest that in such a hopefully rare situation genius, by its very nature, is not and cannot be destroyed. It is, however, driven into strange channels. Frustrating external reality may then be denied or abandoned, and in its place an entirely private world begins to be elaborated in enormous detail and with incredible, perhaps delusional, intensity! This is precisely the reality of the outsider artist. Unmistakably Darger opted out of the world while continuing to function minimally in it. At night he entered a new realm of activity, better suited to his richness of personality, his intellect, his need for action and heroic deeds, his love of visual imagery and language, and his overwhelming need to create. This imaginary new world did not deny his reality. It gave voice to his torment, to his personal experience of frustration and humiliation, of conflict and of pain. It embodied his agonized awareness of moral contradictions in himself and in the world and of the real existence of injustice and evil in the lives of children. While he always insisted on the unreality of the realm he had created, it was in this "other world" that Darger chose, of necessity, to live.

An Ordered Chaos: The World of Adolf Wölfli

In selecting this series of alternate worlds created by outsiders, I have deliberately presented a somewhat contrived sequence of increasingly elaborate, bizarre, and autistic world views, depicted in images of mounting strangeness and intensity. Such a sequence must inevitably culminate in the work of the so-called "schizophrenic masters," a small group of unusually creative psychotic inmates of psychiatric institutions.[38] It is only in the case of institutionalized psychotic individuals that one can justifiably speak of the art of the insane.[39] While all true creative activity carries the artist out beyond the perimeters of conventional mental experience, the radical nature of the function, form, and content of almost all outsider manifestations is generally reflective of extremely unconventional states of consciousness, permanent or transitory. Indeed in the absence of such extremes of experience and expression it is doubtful that we can legitimately speak of outsider art.[40]

Almost without exception the most powerful works of outsider art have tended to be, in fact, the creations of individuals diagnosed as psychotic. It is important to note that the very rare spontaneous appearance of extraordinary artistic ability in such individuals is not explained by the illnesses from which they suffer. We are no more able to explain artistic genius in the context of psychosis than out of it. We do know, however, that the extraordinary nature of the form and content of masterpieces created by such individuals is, at least in part, the result of their plunge into a vastly altered world of perceptual experience generally associated with the schizophrenias.[41]

A fully developed alternate world is not arrived at suddenly with the onset of schizophrenia. While the patient may well be plunged into a new world of experience with extreme suddenness, graphic and written response to this radical change in the form of a fully elaborated alternate world is arrived at slowly if at all, usually beginning to emerge only after about four or five years of essentially untreated psychosis.[42] This was the situation in

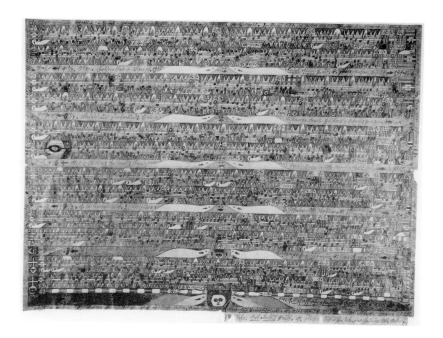

: 232 :
Adolf Wölfli
Foliantten = Marsch. Stooss Nr. 4 1/2–8 1/2
(Folio = march. blast no. 4 ½–8 ½),
1915

: 233 :
Adolf Wölfli
Juno, die Göttin der Neger (Juno, the
goddess of Negroes), 1904

the case of Adolf Wölfli (1864–1930), perhaps the greatest of all psychotic artists.[43] The alternate world created by Wölfli is one of the most elaborate, strange, and yet thoroughly consistent world pictures ever created by a single individual.[44] In terms of its artistic quality it is also one of the most highly organized and powerful, providing a clear and overwhelmingly impressive view of the workings of the mind in extremis (FIGURE 232 and see FIGURE 239).

Born in Switzerland, Wölfli was hospitalized in 1895, at the age of thirty-one, with a diagnosis of chronic schizophrenia with paranoid features. Displaying an extreme lack of judgment, he was sexually impulsive and occasionally physically violent, indeed dangerous. Withdrawn, though not mute, he hallucinated constantly, experiencing both auditory and visual hallucinations.

A near-illiterate peasant laborer with little or no experience of art, Wölfli began drawing spontaneously in 1899. All of the early work was destroyed, regretfully obscuring the origins of his art. By 1904 he had arrived at a fully developed and technically masterful personal style. The surviving early drawings are executed in black pencil and are characterized by a dense, largely abstract, geometric and ornamental form, into which small figures and scenes are occasionally introduced (FIGURE 233). Not a wild or "crazy" style, it is highly ordered, often symmetrical, and full of implied movement. Numerous shapes, overlapped by the ornamental framing device that surrounds all of his early works, suggest that the pictures represent a window on a world that can be understood as extending beyond the frame in all directions. Did Wölfli actually see reality in this way?

The answer would seem to be a qualified yes. We know that Wölfli was experiencing visual hallucinations; indeed he complained of visions that forced him to draw. The early work does, in fact, bear a striking relation to what is known of the onset phase of visual hallucinatory experience. This involves the "perception" of linear patterns in black and white—spirals, checkerboards, netlike designs, tunnels, concentric circles—in constantly changing

abstract geometric designs. These patterns appear with the eyes open or closed and are superimposed on whatever is present in the environment. Later, small human and animal figures occasionally appear within this geometric order, just as they do in Wölfli's early drawings.[45] Whatever he looked at in this initial phase would have been covered with moving geometric patterns, an overwhelmingly impressive visual experience, which in his case seems to have led eventually to the totally unexpected involvement with image making. Space had collapsed or rather had become mysteriously occupied. From the beginning all the negative shapes in the drawings were densely filled with "beings," strange birds, slugs, giant snakes, and monster faces. It would seem that Wölfli was actually experiencing a radically changed world and changed perception. In this sense his alternate world was not "imagined" but "imposed."

In its origin his work was not the result of an involvement with the making of "art" but represented a desperate attempt to come to grips with, to organize and order, his new world.[46] Inherent in the Black Drawings of 1904–6 was all of his later mythological realm; but at this point he was only beginning to explore and to attempt to understand that realm. In Wölfli's early work one can readily identify figural elements and scenes that reflect his life experience as a Swiss peasant;[47] however, from the beginning there were images that went far beyond his personal experience: unexplained, numinous, and terrifying visions of Godlike forms. Even the later involvement with the cosmos and outer space is hinted at in the powerful moving bands and in visions of the sun, moon, and stars of the Black Drawings. His new universe seems to have presented itself most impressively in visual form, with efforts to "explain" or rationalize the experience in words coming only later. Drawing this new universe may have been a first attempt at mastery of an otherwise totally passive experience.

In 1907 Wölfli's art changed. Color entered the picture. A year later he began to write his vast and totally fantastic autobiography, *From the Cradle to the Grave*, in nine volumes, 2,970 pages.[48] His experience was now embodied in a richly illustrated narrative, a travel book documenting his voyages around the world. In endless detail he described his entirely imaginary journeys to North and South America, Africa, Europe, and Asia, adventures that occurred, he explained, before he reached the age of eight.[49] Despite the fact that he depicts himself as an infant, he describes a vastly enhanced life of wealth and power, experienced against a background of beautiful cities, filled with palaces and cathedrals, and shared with elegant and sympathetic women and aristocratic friends. One senses that he still experienced things in the form of images and that the text was invented as a means of explanation. Material was pouring out of his unconscious mind, dreamlike experience far beyond anything he had known in his own very limited prior life and in marked contrast to the sensory deprivation of life in the asylum. This compensatory life of fantasy found expression in rich, colorful, formally inventive illustrations, intimately linked to the text. This later development of a figural style connected with a dreamlike narrative accords with the later form assumed by hallucinations, which also become colored, figurative, narrative, and more like the images experienced in dreams. While Wölfli's initial travels take place on Earth, his descriptions of cities such as New York, Madrid, or Peking are totally fantastic, and his illustrations are absolutely unconcerned with naturalistic representation. Almost from the start he invents new cities unknown to geography and dazzling in their complexity and size.

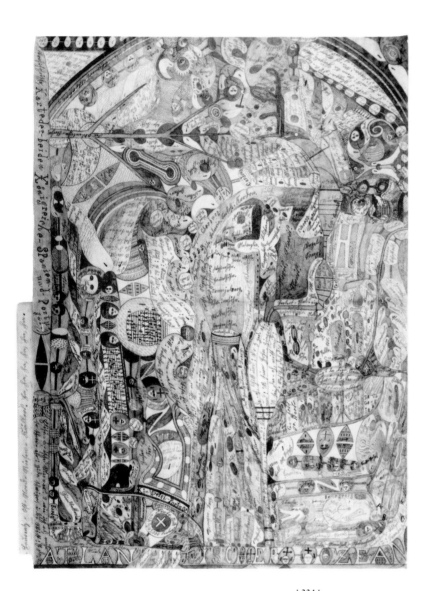

: 234 :
Adolf Wölfli
Provisorische Karte der beiden Königreiche Spanien und Portugal (Provisional map of the kingdoms of Spain and Portugal), 1910, pencil and colored pencil on paper, 39 ¼ x 28 ½ in. (99.7 x 72.3 cm), Adolf-Wölfli-Stiftung, Kunstmuseum Bern

And now All of us are back again on the South Wall Promenade in Hartzeron. Ha, ha, ha, ha, ha, ha,? Can you see over there: Fairly far East: On the plain of Alex. South of the Oron Lake: the enormous, unevenly line of Houses directly connected with the towns of Chindon, Alex and the Glaser Bridge: Like a silver ribbon glittering in the Sun. They are a number of towns and some of them enormous university, factory, garrison, business, hotel towns and large cities along a stretch of a length of 9 hours, width 1 to 3 hours, forming a number of 1st Class main roads with the most extraordinary, historical-sounding town names. Alright!! We march from Alex or Chindon, to the Glaser Bridge. And now, come on, Here we go. Donkeysear (large city) Hedgehogear (town), Niggerear (large city) Oxear (large city) Pigsear (large city) Ramsear (large city) Goatsear (large city) Biiderchohr (town) Angelear (town) Figgen (town, Fish town) Glaser Bridge (large city). All these sumptuous and industrious, amidst the prettiest villas, mansions and parks, as well as innumerable and most manyfold gaardens, promenades and graaveyards as well as numerous grand Squares with lofty, luxurious memorials, equestrian statues and monnuments, as well as perhaps 4 to 8 to 12-pipe wells with pretty figurines, wide lanes crossing each other with electr. tramms and elegannt pavements running right and left, enormous palaces of Justice, Supreme Court, Government, Prison, privaate and other grand Palaces and ditto Grand 1st, IInd and IIIrd Class Hottels, Theatres, Museums, Schools, Factories, Hospittals, Stations, Establishments and Institutes, Shipping Harbours, Great Bridges and pretty tree avenues amidst plantations of the South.[50]

It is not possible for us here to explore Wölfli's incredibly detailed and elaborate world, with its limitless host of characters and its endless variety of experiences. I would like, therefore, to focus on a single aspect of his quest for coherence amidst the chaos of his experience, the use of "maps" as a means of imposing order on a new world.

Having fallen through the floor, as it were, into a new world, one experiences disorientation, chaos. One is lost. Some of Wölfli's elaborate diagrams embody both this state of chaos and an attempt to rectify it by creating maps, another form of order. Consider, for example, *Provisoriche Karte der beiden Königreiche Spanien und Portugal* (Provisional map of the kingdoms of Spain and Portugal;

FIGURE 234). Chaos predominates in this image. It is unusual to encounter in a Wölfli drawing such extensive evidence of processes of disintegration and loss of control. If I didn't know this drawing was by Wölfli, I would nevertheless be able to identify it at once as an example of psychotic art. It is more or less like thousands of other pictures made by productive schizophrenics in the last century. The composition is confused, chaotically busy, crowded to bursting with disordered form, oriented in every direction, and covered in writing. This is typical schizophrenic art;[51] however, it is precisely this fact that makes it so untypical of Wölfli! Wölfli's artistic genius led him to impose order on chaos, to find form to express his internal experience. He invented powerful images to illustrate his unique reality. In this endlessly inventive play with image and idea, with form and composition, he emerges as a true schizophrenic master. On occasion his mental state may have become so fragmented that order was impossible, as here. But other maps show him reasserting control, imposing structure, pattern, and form on chaos. An example is seen in the map-picture *General-Ansicht der Insel Nieʒohrn* (General view of the island Neveranger), 1911, in which Wölfli achieves an almost perfect balance between the forces leading to complexity and those connected with order (see FIGURE 71). The result is a powerful, highly organized, and utterly original image. Occasionally his compositions appear to grow almost excessively ordered, crystallizing, like iron filings responding to a magnet, around the form of the mandala.[52] In 1912 Wölfli finished work on *From the Cradle to the Grave* and began a new project, the writing and illustration of the so-called *Geographical Volumes*, in seven volumes, 3,500 pages.[53] A profound change is evident in this continuation of his travel accounts, both in the narrative content and in the character of the illustrations. Having moved from the "old universe" into the "new universe," he attempts to describe his cosmic journeys with his family, companions, wives, and God out into space. He journeys now among the stars, encountering, and indeed creating, new worlds, planets, unknown realms. After riding on the backs of giant traveling snakes and cosmic birds and on lightning bolts, he is a transformed personality, a creator God, St. Adolf II. Once again we encounter the necessity of creating an alternate personality to inhabit the new world, to encompass the radical shift in the nature of reality.

In this new universe description becomes more difficult, almost impossible. He is forced to invent new words to report experiences far beyond the norm.

Werrantts, Zionists, Corrintts, fixed stars, Ignotts, Negrantts, Polligohns, planets, regentts, ancestors, Hyloths, Ysahrs and Zornantts, etcettera. Allright!! God, the Allmighty Father, accompanied by all of us Swiss huntsmen and Natuhrvorscher, as well as their children, friends male and female, on his 5 very smallest satelites, Kondoor, Agralong, Kormora, Horatora, and Albatros, away from our earthly existence direct through the endless ether, through a great part of the whole universe, putting us down directly on numerous heavenly bodies of different kinds, as for example on the Moon and the Sun. Alright!![54]

Language occasionally begins to break down completely, approximating "sound poetry," the literary form that would dominate his final years of written production. Wölfli drew less after 1912, and when he did draw he was often forced into complete abstraction by the difficulty of depicting events and forms that had no earthly parallels. A new type of image appeared in this connection, the so-called "music picture," a combination of musical notation, collage, and abstract form. The preoccupation with music making is also to be seen in the picture *Der Gross = Gott + Vatter = Huht mit skt Adolf = Kuss, Riesen = Founttaine* (The great = god + father = hat with St. Adolf = kiss, giant = fountain; FIGURE 235), 1917, a work of almost terrifying complexity. One senses here that Wölfli is all but overwhelmed by the density of the experience he attempts to objectify. The composition, potentially a mandala, had begun to warp and flow in unpredictable ways, as Wölfli sought to find means to subdue the irrational flood of images and forms in motion.

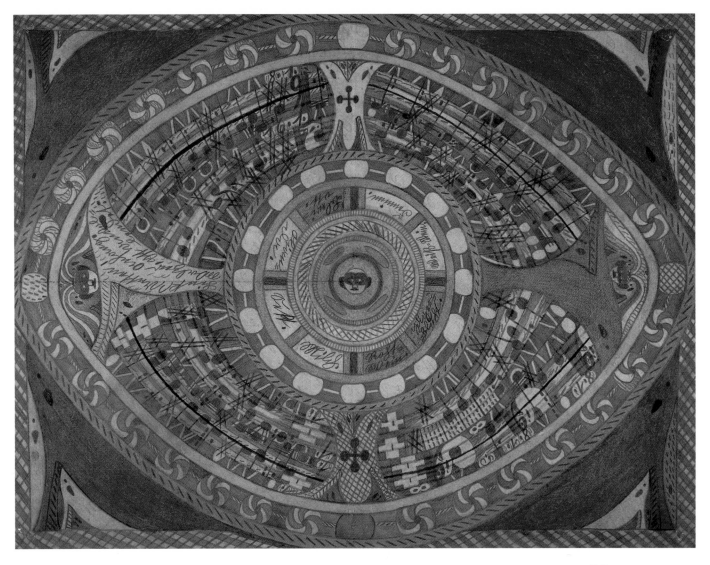

: 235 :
Adolf Wölfli
*Der Gross = Gott + Vatter = Huht mit
skt Adolf = Kuss, Riesen = Founttaine*
(The great = god + father = hat with
St. Adolf = kiss, giant = fountain),
1917

Wölfli's work was in no sense therapeutic. It led him, if anything, deeper and deeper into his illness, or into his creation, not back into our world. Occasionally his depictions became primitive, even frightening. In the later years his experience was increasingly unique, remote, obscure, even autistic. Clearly we cannot always follow him into the remoter reaches of his alternate world. At times it is evident that he was encountering, and seeking to describe, mental events and corresponding images existing entirely outside our limited experience.[55] However little we can understand of his reality, it is precisely this glimpse into another world that we seek in the art of Wölfli.

Much of the literature and visual art of this century, and indeed quite a lot of nineteenth-century art as well, has been concerned with the exploration of the inner world of the unconscious. Our artists, like courageous divers, have learned to make the descent into this dark world, to tolerate its obscurity and terror, so as to bring back valuable fragments of the unknown. As viewers, we have developed a very high degree of tolerance for the irrational and the obscure, and we have learned to look in unexpected places for these images from the dark side of the mind. Wölfli and the other psychotic masters descend permanently and without protection into the same obscure realms of the mind, but they do not return. On occasion, however, they send back tracings from the dark-ness, images of an alternate reality that is our own.

=

Notes

1
Adapted from Hugo von Hofmannsthal's libretto for *Die Frau ohne Schatten*, act 1, scene 2. This essay is dedicated to Kerry K. Ko, without whose encouragement it could not have been written.

2
The notion of secret fantasy as a second life unlived was developed by Moriz Benedikt (1835–1920) of Vienna and had a major influence on the development of psychoanalysis. To this concept Freud added the observation that much of our fantasy activity occurs and remains below the level of consciousness.

3
While the ability to fantasize is never eliminated, even the partial loss of the imaginative faculty seriously undermines creativity, a not unusual accompaniment of "maturity" in our society. An extreme inability to fantasize or to make use of fantasy is occasionally encountered in psychiatric practice, where it is usually accompanied by an inability to dream, a general flattening of all emotion, and a total obstruction of creativity in all aspects of life. This condition, known as alexithymia, often plays an important part in psychosomatic disorders. See Graeme J. Taylor, *Psychosomatic Medicine and Contemporary Psychoanalysis* (Madison, Connecticut: International Universities Press, 1987).

4
Freud emphasized the central role of fantasy in the life of the artist. "An artist is originally a man who turns away from reality because he cannot come to terms with the renunciation of instinctual satisfaction which it at first demands, and who allows his erotic and ambitious wishes full play in the life of phantasy. He finds the way back to reality, however, from this world of phantasy by making use of special gifts to mould his phantasies into truths of a new kind." Sigmund Freud, "Formulations on the Two Principles of Mental Functioning," in *Standard Edition of the Complete Psychological Works of Sigmund Freud,* ed. and trans. J. Strachey, A. Freud, A. Strachey, and A. Tyson, 24 vols. (London: Hogarth, 1955–74), vol. 12, 224.

5
See Richard Heinberg, *Memories and Visions of Paradise: Exploring the Universal Myth of a Lost Golden Age* (Los Angeles: Tarcher, 1989).

6
It should be stressed that the term *outsider art*, introduced by Roger Cardinal in 1972 as an English variation of the French term *art brut* as used by Jean Dubuffet, was intended to characterize the creations of individuals isolated, ostracized, or removed from their society. It was not intended to refer to works of art created outside accepted cultural fashions.

7
A brief history of the early phase of mediumistic drawing is contained in my unpublished study "The Flowers of Spiritland: Spiritualist Painting in Victorian England."

8
These shared psychic phenomena represent an aspect of spiritualism as an organized religion with a fairly coherent system of beliefs.

9
Théodore Flournoy, *From India to the Planet Mars: A Study of a Case of Somnambulism with Glossolalia* (New Hyde Park, New York: University Books, 1963).

10
Ibid., 71.

11
Ibid., 26.

12
From an early study by Carl Gustave Jung of the fifteen-year-old medium Miss S. W. (his cousin Helene Preiswerk), published as *On the Psychology and Pathology of So-called Occult Phenomena* (Leipzig, 1902), and reprinted in *The Collected Works of C. G. Jung* (Princeton: Princeton University Press, 1970), vol. 1, *Psychiatric Studies*, 3–88.

13
Flournoy, *From India to the Planet Mars*, 170.

14
Ibid., 169. Hemisomnambulism implies a "half" or only a partial state of trance.

15
In such cases the form may be conventional and of less interest, while the subject matter in its strangeness is still more closely connected with outsider art than with naive art.

16
The images have also become "dated" very rapidly, as is not the case with most outsider art, which often appears to possess a curiously timeless quality.

17
There are a number of important male outsider artists who identified themselves with the spiritualist cause or felt themselves to be acting under the influence of spiritual beings. Among the more important were the French medium and artist Augustin Lesage (1876–1954) and his contemporary, the mediumistic artist Joseph Crépin (1875–1948). The outsider artist Raphaël Lonné (1910–89) began his work in a spiritualist milieu and then dispensed with such explanations as he began to perceive his work as "art."

18
This quotation as well as much of the factual information on the career of Madge Gill is taken from the publications on the artist by Roger Cardinal: *Outsider Art* (London: Studio Vista, 1972), 135–45; and "Madge Gill," *L'Art brut*, fascicle 9 (Paris: Compagnie de l'Art Brut, 1973), 5–35.

19
Laurie Gill, "MYRNINEREST The Spheres," broadsheet issued March 1926 by Madge Gill's son.

20
This variation is particularly noticeable in the work of Lesage, whose later, more consciously "spiritualistic" creations are considerably less inspired than his earlier compositions. See Annick Notter et al., *Augustin Lesage: 1876–1954* (Paris: Sers, 1988).

21
Exactly the same situation can be observed in the case of a still little-known but enormously important Canadian psychic outsider, Alma Rumball. See Michael Greenwood, *The Automatic Drawings of Alma Rumball* (Toronto: York University, 1977).

22
The onset phase of true visual hallucinatory experience, discussed later in this essay in the case of Adolf Wölfli, may be relevant to an understanding of Gill's personal graphic style and her "psychic" experiences.

23
The "discovery" of canals on Mars in 1879 by the Italian astronomer Giovanni Schiaparelli added immensely to its mystery. This, along with its red color and the fact that it is relatively close to earth, made it the most popular of the planets in the late nineteenth century and for much of the twentieth. Conjecture about life on Mars encouraged speculation about the existence of yet other worlds in space, which in turn contributed to the flowering of science fiction as a genre around 1926.

24
Despite the presence of signatures on some of the drawings as well as dates, almost everything we say about P. M. Wentworth is speculative and derived entirely from the work, since the individual responsible for it has not been discovered. He apparently lived and worked in California in the 1940s, 1950s, and 1960s. This case is unusual in that the designation outsider has been arrived at entirely on the basis of the work.

25
See Herbert H. Hemphill and Julia Weissman, *Twentieth-Century American Folk Art and Artists* (New York: Dutton, 1974), 106–7.

26
In the twentieth century such individuals have become the major representatives of the delusional belief in, and elaborate description of, other worlds, for the most part replacing spiritualism as the chief source of personal, encyclopedic, alternate universes. Popular science (scientific mythology) has become an important new factor inspiring religious invention. For a discussion of the psychological factors involved in this relatively new phenomenon, see Carl G. Jung, "Flying Saucers: A Modern Myth of Things Seen in the Skies" (1958), *The Collected Works of C. G. Jung*, vol. 10, 311–433.

27
Incidentally Wentworth, who also used the name Ted, exhibited and sold his work widely in California, where he lived in Santa Barbara and later in Santa Monica. His artworks can also be found in Florida and even as far away as Australia, where they have been exhibited and sold.

28
Another case involving observation of images seen in the sky is that of Hans Prinzhorn's patient August Natterer ("Neter"), a psychotic whose initial experience of illness involved rapidly changing hallucinations seen in the sky. Hans Prinzhorn, *Bildnerei der Geisteskranken* (Berlin: Springer, 1922; reprint, Berlin: Springer, 1968), and in English as *Artistry of the Mentally Ill: A Contribution to the Psychology and Psychopathology of Configuration*, trans. Eric von Brockdorff (New York: Springer, 1972), 159–60.

29
This obscure reference to his creative process, in all but indecipherable English, comes from a letter sent by Wentworth to Dr. Tarmo Pasto, October 26, 1961. All Wentworth's works presently known originated in the collection of Pasto, where they were discovered by the Chicago painter Jim Nutt.

30
The author is currently working on an extended monograph on the life and work of Henry Darger.

31
That critics and dealers enter the picture at some point, usually after the artist's death, and begin to see the alternate world as "art," and indeed as a commodity, leads to considerable confusion, with the meaning of the work to its creator obscured or lost in the process. The typical response of critics encountering this unique form of expression is to attribute all the motives of a professional artist to the outsider. This misapprehension and distortion of the psychological processes underlying outsider creativity is particularly serious, indeed tragic, when it enters the life and activity of an outsider artist who is still alive, a fate that Darger fortunately avoided.

32
The home for feebleminded boys was almost certainly the Lincoln Developmental Center in Lincoln, Illinois. State privacy regulations have made it impossible to obtain records concerning Darger's confinement and history in that institution. There is not the slightest possibility that he was retarded.

33
An exact chronology of Darger's artistic development has yet to be established. His manuscripts were apparently written in longhand and later typed. He tells us that the writing began in 1911, and the typing in 1916, but he gives no dates for the completion of the book. The final volumes are unbound and undated, and it is even uncertain whether he ever actually completed work on "The Realms." It appears that separate volumes were typed at different times. There is no report of his typing anything once he had moved to the house at 851 Webster Avenue, where he lived from 1932 on. This may imply that the book as it exists now was finished or abandoned by that time. The dating of the illustrations is a more complex problem. There is reliable evidence (yet to be examined) for establishing a chronology. His final work, "The Story of My Life," written in his later years, was begun in 1968 and is, for the most part, a completely imaginary continuation of the adventures described in "The Realms."

34
It is unclear at present whether Darger represents a case of multiple personality, but the nature of the writings does support such a possibility.

35

Darger executed a very large collage that includes thousands of figures and separate details. He experimented by coating the surface with varnish, which has since darkened to the point that the subject matter is largely impossible to make out. The failure of this large-scale work may have forced him to abandon this technique and to seek new means of pictorial construction.

36

To the extent that the negatives are still in dated envelopes, as received from the drugstore, the initial appearance of any image can be almost exactly dated. This has not yet been done.

37

I do not wish to imply any psychic ability on Darger's part but rather an anticipatory sense similar to that which we observe in the German expressionists prior to the onset of World War I. Certain aspects of "The Realms" show the influence of accounts of that war, which was going on during the writing of the initial volumes. Darger was drafted to serve in the United States Army but was then found unfit and sent home. In this context his desire to create his own war becomes less surprising.

38

The term *schizophrenic masters* was introduced in 1922 by Prinzhorn in his book *Bildnerei der Geisteskranken* as a means of distinguishing extremely rare schizophrenic artists of great artistic importance from the vast mass of psychotic patients who may paint or draw but whose work does not rise above the level of amateur art. He included in this category untrained and spontaneous imagemakers as well as highly trained artists who had subsequently become psychotic.

39

Since use of the term *psychotic*, a specifically psychiatric designation, is productive of considerable confusion and distrust, it should be stated at once that the human mind is clearly capable of a very wide range of experiences beyond the norm, not all of which are necessarily pathological and some of which are extraordinarily valuable even if they are reflective of mental pathology. It is, in any case, unacceptable for untrained critics and scholars to indulge in amateur psychiatric diagnosis, referring to the work of unconventional naive artists or outsiders as psychotic art or to unusual mental states as pathological in the absence of a professional diagnosis. It is equally unwise for responsible psychiatrists to risk commenting on the psychiatric status of works of art in the absence of a patient.

40

While this essay has not attempted to explore the creation and nature of alternate worlds by recognized artists, it in no way denies the existence of such creations, nor is it intended to suggest that the elaboration of such worlds is dependent upon a social or psychological break between an individual and society.

41

This is not to suggest that other forms of severe mental illness or of neurological disorder are never productive of significant works of art, but such cases have not been as extensively studied and are not presented here. For additional discussion of creativity as it relates to the manic-depressive (or bipolar) disorders, see the publications of Nancy C. Andreasen or Kay Redfield Jamison. Valuable contributions concerning the effect of the impact of neurological disorders on artistic creation are to be found in the writings of Dr. Oliver Sacks; see, for example, *The Man Who Mistook His Wife for a Hat and Other Clinical Tales* (New York: Summit, 1985).

42

The discovery and increasing use of psychotropic and antipsychotic drugs as a major aspect of treatment, along with other therapies, has led to the almost complete disappearance of true psychotic art from modern psychiatric institutions. My acknowledgment of this situation, which is from an artistic point of view regrettable, should not be taken as a plea for a return to the psychiatric past or as hostile to advances in psychiatric treatment. The large numbers of untreated psychotics living on the streets of large cities now represent the only possible source of this rare form of human expression.

43

The author is nearing completion on a monograph on the life and work of Adolf Wölfli.

44

My discussion of the life and work of Wölfli is dependent upon the research and publications of Dr. Elka Spoerri of Bern, without whose contributions no Wölfli scholarship would be possible. Our knowledge of the case and of the psychiatric diagnosis derives from the publication of his physician, Dr. Walter Morgenthaler, *Ein Geisteskranker als Künstler* (Bern: Bircher, 1921; reprint Vienna: Medusa, 1985), and from the hospital records. Morgenthaler's concept of schizophrenia and his interest in the disorder derived from the work of his colleague and teacher Eugen Bleuler, who developed the concept of schizophrenia. Dr. James S. Grotstein has speculated that Wölfli suffered from chronic mania or possibly a schizoaffective disorder. For Grotstein's rethinking of the nature of schizophrenia, see "The Psychoanalytic Concept of Schizophrenia," *The International Journal of Psychoanalysis*, vol. 58, pt. 4 (1977): 403–25, 428–52.

45

For a more thorough description of the onset and development of visual hallucinations and particularly of the onset phase of hallucinatory experience, see Heinrich Klüver, *Mescal and the Mechanisms of Hallucinations* (Chicago: University of Chicago Press, 1966); and Ronald K. Siegel and Louis Jolyon West, *Hallucinations: Behavior, Experience, and Theory* (New York: John

Wiley and Sons, 1975).
I would like to thank Michael
Birmingham for sharing his
personal experience of the
essentially graphic and
abstract nature of the onset
phase of visual hallucinations
with me. The initial phase
of visual hallucinatory
experience may be important
in understanding the under-
lying motivation and the
style of a number of other
schizophrenic masters—
Martín Ramírez, for
example. The new and
spectacular case of Achilles
G. Rizzoli, recently
discovered by Bonnie
Grossman of Berkeley,
California, is of crucial
importance in that it provides
detailed information,
furnished by the artist
himself, concerning the
direct connection between
his hallucinatory experience,
his drawings, and his
creation of a remarkable
alternate world.

46
The motivation of outsider
artists, like that of prehistoric
and primitive man, is almost
never the result of a
preoccupation with the
making of "art." Their
involvement with the making
of objects or images stems
rather from a variety of
strange and compulsive
intentions, such as
communicating with spirits
or space creatures, the
mapping or portrayal of
other realms of being, the
creation of magical, religious,
or apotropaic objects, and
the carrying out of ritual.
(These unusual motivations
are important factors
distinguishing them from
naive artists, who are
generally motivated by an
involvement with pictures as
art.) The assumption that

what is being made is "art"
(and therefore a commodity
to be hung on the wall,
exhibited, collected, bought,
and sold) is imposed from
outside by the naive critic or
psychiatrist. The occasional
acceptance of this assump-
tion by the outsider who
has been "discovered"
often has damaging results.
Wölfli's early Black
Drawings seem to have had
more to do with musical
composition than with art.
The long, horizontal scores
are filled with empty musical
staffs, and he signs himself as
"composer."

47
All outsider art, without
exception, contains elements
derived from the environ-
ment, historical influences
reflecting the individual's
contact with external images
and works of art. This has
led in the cases of Wölfli and
Ramírez to naive attempts
to equate their work with
folk art.

48
The complete work has
recently been published
in the Swiss German
original text, with selected
illustrations. Adolf Wölfli,
Von der Wiege bis zum Graab,
ed. Dieter Schwarz and Elka
Spoerri (Frankfurt am Main:
Fischer, 1985).

49
An interesting, if somewhat
tamer, parallel is offered by
the wide-ranging imaginary
journeys depicted in the
drawings of Joseph Yoakum.

50
Quoted from Harald
Szeemann, "No Catastrophe
without Idyl, No Idyl
without Catastrophe," in
Elka Spoerri and Jürgen
Glaesemer, eds., *Adolf Wölfli*,
exh. cat. (Bern: Adolf
Wölfli Foundation, 1976), 57.

51
That is to say it conforms
to lists of characteristics
of schizophrenic art
compiled by psychiatrists.
Paradoxically these lists are
often developed using the art
of schizophrenic masters
such as Wölfli or Aloïse
Corbaz, whose work is not
in the least typical. See, for
example, Helmut Rennert,
"Eigengesetze des
bildnerischen Ausdrucks bei
Schizophrenen," in *Psychiatrie,
Neurologie und medizinische
Psychologie* (Leipzig: Fischer,
1963).

52
Jung's discussion of the role
of the mandala as a source
of order in psychosis is of
interest in this context. See
"Concerning Mandala
Symbolism," in *The Collected
Works of C. G. Jung*, vol. 9.1,
*The Archetypes and the
Collective Unconscious*, 355–90.

53
A printed edition of the
Geographical Volumes is
currently in preparation
under the direction of
Dr. Elka Spoerri.

54
Quoted from Szeemann,
"No Catastrophe," 60.

55
The undeniably obscure
nature of some of Wölfli's
images and occasionally of
other examples of psychotic
art has led to the mistaken
assumption, now prevalent
among some psychoanalysts,
that this is an art incapable of
communication, an autistic
form of expression of merely

clinical interest. See, for
example, Ernst Kris,
*Psychoanalytic Investigations in
Art* (New York: International
Universities Press, 1952).
The fact that the viewer is on
occasion unable to follow an
artist, psychotic or other-
wise, into the more remote
reaches of his or her
experience is not, however,
sufficient reason to dismiss
the artist's work as "not art."
What we are encountering in
such a situation is the failure
not of the artist but of the
critic. For a detailed history
of the reception of psychotic
art in history, see my *The
Discovery of the Art of the
Insane* (Princeton: Princeton
University Press, 1989).

Nostalgia for the Absolute:

Obsession and Art Brut

ALLEN S. WEISS

Can our critical and theoretical pandemonium ever truly come to grips with the vehemence of obsession? Perhaps two lexical considerations would be useful. *Obsession*: **the act of a devil or a spirit in besetting a person or impelling him to action from without.** *Obsession*: **a persistent and disturbing intrusion of or anxious and inescapable preoccupation with an idea or feeling especially if known to be unreasonable.**[1] The first definition is presumedly archaic, anachronistic, mythical. To be obsessed, in this older sense of the word, means to be haunted, possessed, beset; it implies a spiritual malady. The second definition is modern, psychologically motivated, rationalist; this use of the term implies (whether in the neurotic context of obsessive-compulsive behavior or in the psychotic sense of paranoid delusions and impulses) a certain psychical derangement. These uses of the term would seem to be radically disparate, the former relegated to aesthetics and mythology, the latter to psychiatry and psychology. I wish, however, to investigate several cases where the two meanings converge and where the thresholds between mythology, aesthetics, and psychopathology are unclear and perhaps even nonexistent. While in much modern art profound obsessions, phantasms, and deliria are sublimated into the artwork, *art brut* (Jean Dubuffet's term for "outsider" productions, literally "raw art") proffers the direct, desublimated representation of these psychic symbols. It is precisely due to the proximity of art brut representations to the psychic primary process that word and image are often intricately tied in these works, not unlike the manner in which word and image combine in the rebus of our dreams. This essay will center on these obsessional artworks and their implications for the broader concerns of modernism.

The twentieth century has proposed radically antiromantic answers to the question "What is art?" Perhaps the limits to these responses can be outlined by proposing two paradigms stemming from the antipodal influences of idealism and empiricism. One possibility is Marcel Duchamp's radical claim that whatever an artist deems to be art is art—an aesthetic tautology. This transcendent model, with the readymade and conceptual art as its practical limits, is based upon the intuitive coherence permitted by an axiomatic system of rules or laws wherein the notion of art is established on *a priori* principles. The contrary possibility is a radical, sociologically oriented art history, whereby whatever society accepts as art is art. This pragmatic or empirical model is based upon a doxical insistence on the dominance of statistical coherence, whereby the meanderings of history determine what constitutes art—a sociological tautology. But what of those creators who neither claim to be artists nor share the commonplace notions of what constitutes art? And what of those works not recognized as art by either the "general public" or by the art-historical establishment? Can there be an art without a proper name and art that, as Dubuffet claimed, "forgets its very name"? How would we have to modify our aesthetic theories and our histories of art to accommodate such works?

Carlo

Carlo (1916–74), diagnosed in 1947 as schizophrenic, suffered from an extreme solipsism or autism with a consequent breakdown of communication (dialogue was impossible), a radical dissociation of ideas and loss of logical faculties, loss of emotion, comportment resembling an automaton, and language disorders. He spoke only in truncated, fragmented sentences of chopped up words, neologisms, and mutterings and repeated certain symbolically significant words and phrases such as "the end of the world."[2]

We must ask how the manifestations of his illness, expressed in his behavior and his drawings, are transformed into aesthetic objects. What are the modernist preconditions of aesthetic recognition that permit the possibility of determining that these particular works constitute art rather than mere psychopathological symptoms? His aphasic language was dominated by the use of assonance, distortion, and neologisms, manifested as a sort of glossolalia, or "gift of tongues." For example, "*miri miritàcca leratanil leratanlīr marileràr*" or "*intradélico come l'intrifrético l'infrético l'inferno*." Here only the word *inferno* is recognizable in Italian, certainly an enunciation summing up his extreme experience of the human condition. Glossolalia—even in its prepoetic modes, characteristic of the speech of infants, schizophrenics, and mediums—is the enunciation of a pure signifier, the refusal of meaning, and the valorization of pure voice, beyond any immediate referential function. We should remember that many early modernist poetic experiments in language—Italian futurism's *Parole in libertà*, Russian futurism's *ẓaum*, Tristan Tzara's dadaist experiments, Kurt Schwitter's *Merẓ*, surrealism's automatism—recognized glossolalia and glossographia as poetic devices.[3] What had previously been considered strictly symptomatic of psychopathology thereafter became available as a form of poetic expression.

Roman Jakobson's psycholinguistic investigation of mental functioning describes the two basic types of aphasic language disturbances— similarity disorders and contiguity disorders— which ultimately serve as the foundation of his

282

aesthetic theory.[4] *Similarity disorders* affect the
lexical selection of linguistic units and their
possible substitutions and exchanges; each word is
dependent upon syntax, upon its context, for
meaning. A word out of context has no meaning,
no referential stability. Such speech is structured
according to metonymic connections and disallows
translation, tautology, metaphor, and metalanguage.
Ultimately there is a failure to shift from index or
icon to a corresponding symbol. Sentences are but
elliptical sequels to previous sentences, permitting
no possible interpretation. It is a discourse that
approaches a truly private language, a pure
ideolect. *Contiguity disorders* affect the syntactic rules
of sentence organization such that words bear their
own meaning and sentence structure tends to
disintegrate. The organizational principle consists
of metaphoric, formal, or rhythmic relations,
resulting in chaotic word order and the use of
monoremes (one-word sentences), leading to the
disintegration of words into pure phonemes. This
can ultimately result in *aphasia universalis*, the
complete loss of language.

 Carlo's language disorders clearly fall into the
second category. To a large extent his pictorial
expression (FIGURES 236–37) is consistent with this
same sort of structuring: stereotyping of figures as
elemental forms (images reduced to primal
ideograms), iteration, serialization, the move
toward derealization and ultimately abstraction, and
the use of verbal signs as plastic elements. There is
also his *horror vacui*—a typical manifestation of
schizophrenic expression that demands each
moment be filled with sound and each space filled
with images so as to escape the horror of the void,
of silence, of death, by negating the milieu that
might give rise to dreaded and repressed thoughts
and impulses. His works have no determinable
narrative content: the figural elements are
paratactically (i.e., without coordinating
connections between the terms) related such that
each picture seems to be part of a larger whole
that can be cut up absolutely anywhere to create

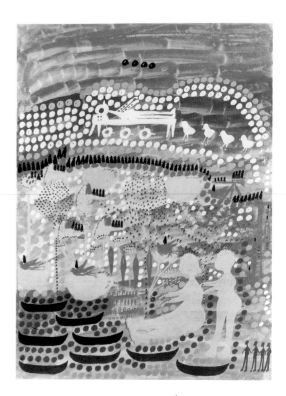

: 236 :
Carlo (Carlo Zinelli)
Untitled (recto)

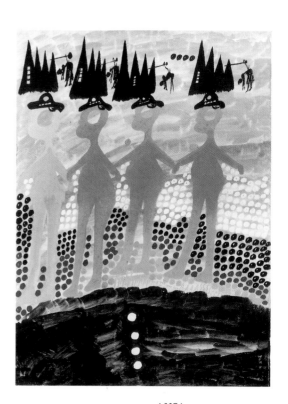

: 237 :
Carlo (Carlo Zinelli)
Untitled (verso)

: 238 :
Carlo (Carlo Zinelli)
Untitled (recto; see FIGURE 5)

individual works. Finally, in his last works, words are incorporated into the drawings. Yet they serve merely as graphic, pictorial elements, following the same obsessive laws as all other figures that enter into this iconography.

It is precisely the obsessive aspects of Carlo's work that create its structural articulation, that prevent it from being the pictorial equivalent of pure silence. Consider, for example, his obsession with the number four: most elements are repeated four times in a drawing and many of his speech acts reveal a quaternary structure or demand (FIGURE 238). He was also obsessed with priests, the archetypal figure of his drawings. Finally there is the elimination of faces and eyes or the use of empty circles as eyes. As psychopathological symptoms, these linguistic and pictorial features may be deemed expressions or symbols of both his schizophrenic malady (dissociation, illogic, fixation, etc.) and of the existential conditions of his incarceration (anonymity, overcrowding, affective deprivation, regimentation, and uniformity of hospital milieu, etc.). But once transformed by the new modernist aesthetic criteria, these lineaments take on new meaning and form a style, permitting Carlo's works to become "masterpieces" of art brut.

Such creations of art brut as Carlo's mark the sites of individuality and eccentricity in an institutional setting, indeed in a society that all too often serves to dampen creativity by acting as a leveling environment, where what is to be produced is always *the same*. The psychiatric patients who produce such art must overcome not only their mental and physical handicaps and the side effects of their medication and treatment but also the influence of their doctors and teachers. Yet we can never second-guess the sources of creativity; what may be a resistance to some is an inspiration to others. Nevertheless we must aid these patients to surmount all those social activities and institutions that inhibit true creativity and hide true difference.

284 WEISS N o s t a
 l g i a
 f o r
 t h e
 A b s o l
 u t e

Dubuffet, in his understanding of art brut and its relation to the psychopathology of expression, went so far as to question the very conception and politics of psychopathology: "There are certainly many ways to find oneself seized and dragged off to the asylum: for example, for not having thought enough or for having pushed the imagination to the point where it is deemed excessive. To make one and the other—the too much and the too little—into a single category makes no sense at all."[5] These claims are certainly too polemical and of decidedly romantic inspiration. It does not necessarily follow from Dubuffet's wish to valorize the uniqueness of each manifestation of "madness" that madness does not exist, even if no precise symptomatology or nosology of schizophrenia has been, or may be, established.[6] The difficulties inherent in this manner of rhetorically and poetically conjuring away mental illness dissimulate an often terrible suffering. Antonin Artaud most forcefully expressed what is at stake here: "There is for me a certain evidence in the domain of the pure flesh, which has nothing at all to do with the evidence of reason. The eternal conflict between reason and the heart is settled within my very flesh, but this is a flesh irrigated by nerves."[7] These considerations reach beyond the aesthetic; they bespeak an ethical imperative in regard to both the creative act and the social reality of mental illness; they indicate the intense anguish that underlies, and perhaps motivates, certain of these works. This is often forgotten by many who otherwise valorize such art, Dubuffet included. Pain, the memories of pain, or especially the overcoming of pain are transformed into meaningful signs of the relation of the artist's body to society—signs we must take up as our own.

Adolf Wölfli

Consider the most famous case of all, Adolf Wölfli (1864–1930), whose most descriptive signature, from 1908, reads, "Drawer, — Poet, — Scribe, — COMPOSER, — Allgebrahtor, — Patient, — cast-off accident, — casualty, — grim casualty, — Doufi."[8] At least on the quotidian level of Wölfli's life in the Waldau asylum, these epithets well describe his earthly existence. They also describe the varied aspects of his creative activity, where image, music, and word form a *Gesamtkunstwerk* (FIGURE 239). Yet the signature of "St. Adolf" is no less important, denoting the core of his spiritual life with its incessant cosmic voyages and ecstatic martyrdoms. For Wölfli, the quotidian and the spiritual are never dissociated: the paranoid systematization of experience entails a conceptual and emotional organization that excludes all accident and creates a fully integrated symbolic system in which all elements are inextricably interrelated. Everything is essential to the system, constant interchanges of elements occur, and there is no "dead air" or empty space.

His illness was characterized by weakened associations with the outside world, hallucinations, flights of morbid imagination, megalomania, religious deliria, extreme identifications, persecution complex, guilt, fixations, autism, memory disorders, affective disorders, linguistic disorders, depression, catatonic symptoms, dementia, and violence—nearly the entire gamut of psychopathological symptoms of schizophrenia. How much of this was due to his illness and how much to what would be a normal reaction to the severe conditions of his incarceration is impossible to ascertain. This paranoid system exhibited the extreme limits of obsessive, anguished, repetitive acts. The horror vacui was manifested not only in Wölfli's work (see FIGURE 232) but also in his life. His obsessive logorrhea, melomania, and iconophilia all served to reduce the anguish that gripped him. The hyperbolic use of numbers, music, words, and images—all in paratactic relations tending toward extension to infinity—

: 239 :
Adolf Wölfli
Irren-Anstalt Band-Hain
(Mental asylum Band-Hain), 1910

served as a means of both filling in the material emptiness of his isolated existence and reducing the anguish and terror of his all-too-full paranoid spiritual manifestations. His entire work is a sort of apotropaic incantation, simultaneously creating a cosmos *and* avoiding its catastrophic destruction— or, in psychological terms, achieving a certain amount of ego stability (see FIGURE 71). Each obsession gives rise to a symptom (i.e., a stylistic feature) manifested in his art: symmetry, seriality, repetition, hyperbole, neologism, and horror vacui. These formal characteristics of his work can each be deemed an expression of his mental and physical condition, all the while evincing the greatest degree of aesthetic inventiveness.

A synoptic description of Wölfli's work would be impossible, not only due to its huge quantity but also to its very nature: his oeuvre is infinitely extensible and hyperbolically hyperbolic. He recreated an imaginary cosmos that corresponded to his greatest desires and his greatest fears. Residing in the asylum of Waldau, Saint Wölfli recounted his cosmic voyages through time and space. He lived in the Empire of St. Adolf-Wald, where there existed, among an indefinite number of other places, the *Urwald* (virgin forest) and the *Uhrwald* (clock forest). The tragic irony, of course, was that the Empire of St. Adolf-Wald extended in reality no farther than the reaches of his tiny cell at Waldau. Yet everything about Wölfli's expression has a primal (*Ur-*) quality about it, since it stems so directly from the unconscious. This mode of nomination indicates one of the origins of his creative mechanisms: associations between words and objects having broken down, the referential function existed in the tautological realm of the pure imagination. His discourse is a sort of solipsistic stream-of-consciousness, guided by pure obsession, to which we possess only a small part of the referential code. In Wölfli's case the relations between words as well as between fixations and obsessions determine the flow of his writing.

286 WEISS

Nosta
lgia
for
the
Absol
ute

Sound, rhythm, and rhyme (rather than referential meaning) rule the texts; formal (and not representational) aspects rule the images. Wölfli's linguistic disorders alternated between both limits of aphasia: the total breakdown of syntax into fragmented words *and* the total rule of syntax, such that words no longer have any representational meaning beyond their linguistic context. Here form is privileged over content, and content finds its reference in the unconscious rather than in the external world. Both nonsense verse and senseless narrative abound. Thus we find dispersed throughout his writings glossolalic texts that may be considered either as tone poems or magic formulas:

Mitta z'witt!

Hung noi noi,

Bitta Stritt!!

Aren't these "disorders" indeed characteristics of certain types of modern poetry, as Jakobson so aptly points out? Consider also the organization of Wölfli's narratives and their relation to the drawings. The "descriptions" on the reverse of the drawings are as little indicative of their object as the narratives are descriptive of the real events of his life. Rather, they are perhaps affectively representative, as in the case of the text on the reverse of the drawing *Chimberasso-Forest*:

Explanation. The picture in front, (copperplate engraving,) is from north to south, 12,000,000, hours long, 8,000,000, hours wide, and 9,000,000, hours, calculation-rate or, 80,000,000,000,000, square-hour, surface-content-enclosing—Chimberasso-Forest, in North America.

He further explains:

Thus it happened at the Chimberasso-Forest, South-forest-Thunder-Wall, from which I fell fatally from the high alpine-ridge at the time. ? Yes!! And that one. Sacred Thund'r, Orang Uttang-, Monkey, on that narrow stone-strip up there: That one, obviously, is still right now acting like a pig.[9]

Here the sublime mixes with the banal, the catastrophic with the monumental, the imaginary with the nonsensical. Rather than being true "explanations," these texts are a continuation of his voyage, a literary extension of his pictorial quest.

Such works call into question the usual museological criteria of inclusion and exclusion as well as the problem of ideal artistic forms. They disrupt those beaux arts systems still bound to the notions of "great style," the "great artist," and the "great work." Counter to these aesthetic limitations, André Malraux, in *The Voices of Silence*, wrote of "the creative expression of an emotion far exceeding a mere will to art," where the expression of religious faith is never diminished before a roughly hewn idol.[10] Might this not suggest, *mutatis mutandis*, that a sociological or ethnographic museological paradigm might also be utilizable in relation to works of art brut, which are not primarily created in direct discourse with our artistic tradition and which are, in a sense, often created in accord with a relatively private inner "faith"? Many such works must be initially approached not as "art" but rather as the expressions, excrescences, or exorcisms of deliria and dreams, of fantasies and beliefs. We here approach the sacred in one of its contemporary contexts: a sacredness that may be manifested either as the psychological result of the return of the repressed or as the expression of a new quest for faith, transcendence, and the supernatural in a secularized Western world.

: 240 :

Jeanne Tripier
Croquis de fantaisie (Fantasy sketch),
1937, ink on paper, 10 ⅝ x 8 ¹/₁₆ in.
(27 x 20.5 cm), Collection de l'Art
Brut, Lausanne

Jeanne Tripier

Jeanne Tripier (1869–1944) was a spiritualist
medium incarcerated in the asylum of Maison-
Blanche, near Paris, in 1934, diagnosed as having
chronic hallucinatory psychosis, psychic excitation,
logorrhea, megalomania.[11] It was impossible to
distinguish her mediumistic activities from her
presumed psychopathological symptoms. The vast
network of psychic communications transmitted
through her included messages—both spoken and
transcribed—as well as painted images, dictated by
such historical, theological, and astral luminaries as
Zed Zed Zibodandez (the Universal Dictator), Saint
Teresa, Marie Antoinette, Lucifer I, Morpheus of
the Catacombs, Jesus of the Miracles, Jupiter I,
Esperanto, Pontius Pilate, the Doctors of the Dead,
et alia. From the moment she entered the asylum,
she considered herself dead and deemed herself an
evangelical, revolutionary missionary, preaching
the Apocalypse and the Last Judgment—after
which, not coincidentally, all those incarcerated in
psychiatric asylums were to be freed. This, in fact,
indicates the potentially subversive power of
spiritualism: by direct contact with the deceased
this occult procedure circumvents the role of
the priesthood as mediators with the dead, thus
obviating the powers of established religion. Her
spiritual messages were the staging for this final
catastrophe, this morbid obsession, as the following
section of a message dated September 11, 1936,
indicates:

**Inquiries and offerings to God for the Last Judgment.
Lucifer, avenger of the astral borealis troops descended
upon the earth. Where the terrestrial paradise divulges the
secrets of the terrestrial paradise; which are Cain and
Abel, their mortifications, what they endure and bear in
the flesh so as to try and restore all the barbaric peoples
and others.**[12]

Tripier's writings—occult communications from the
underworlds and afterworlds of the barbaric past
and the apocalyptic future—were often messages
from Joan of Arc, Tripier's "fluidic double." She
believed herself to be Joan of Arc's missionary and,
in fact, identified with that prophet, signing many

of her interplanetary communications "Sainte
Jeanne Tripier Jeanne d'Arc." These messages thus
describe a closed circuit of communication, a
solipsistic discourse. A letter of July 28, 1936,
clearly explains her self-image and the nature
of her communications:

**Joan of Arc, Medium of the first necessity, Chief
Justiciary of the barbaric people and the entire universe,
wants to remind you that certain remarkable ancient
Mediums escape from their primary missions, under the
pretext that they will be interned if they reveal themselves.
They prefer to act on their own; and we want you to note
that Saint Cecile too is interned at Maison-Blanche, under
the primitive private initials obdqgxyz-abdqrgstuwaïz
oubdqjasitgapdqaï rstuxwaïz honorific.**[13]

Beyond providing a rationale for her incarceration,
this text also bears interest for its linguistic
invention. Here the glossographia purportedly
designates the enciphered "initials" of Saint Cecile.
But at other times the glossographic texts are
totally undecipherable, revealing an unknown
"language":

**AXYZZKXY. toyou govistoricotoloya sisquisi pédro Géolio
bgdqxasivdqg üobodico siscotoya dico puelsicofloye
abdgqgxyzz, iabcqvxtzavryisqui bibicotogoldano.**[14]

These "holy writings" were often accompanied by
drawings (FIGURE 240). Tripier called herself a
"famed transformist sketcher" and referred to these
drawings—variously designated as astrological
medallions, modern escutcheons, or pretty,
miraculous paintings—as *clichés*, implying (in
French) their instantaneous, photographic nature.
She characterized them as "geographic *clichés*,
atmospheric *clichés*, agglomerative *clichés*." Yet the
drawings revealed anything but photographic
realism. Always abstract—consisting of highly
gestural spots, blotches, hatching, and curlicues—
they are accompanied by "captions" that
contextualize the drawings as aspects of her
mediumistic activity, for example: "Venus and
her divine astrological mission. Omens of an
astrological aerial civil war. Catastrophic puritan
considerations of the definitive Last Judgment." As
glossolalia is the reduction of language to the pure

gesture of voice, these drawings are the reduction
of figuration (a reduction implied by the captions)
to the pure gesture of the painterly act. The
spiritual "representational" power of the drawings
permits their simultaneous consideration as
psychopathological, spiritualist, and modernist
aesthetic phenomena. Indeed Tripier believed that
the Last Judgment she predicted would coincide
with the Paris Universal Exposition of 1937, where
her "modern modernized works of art"—drawings,
paintings, and embroideries—would be exhibited.
This desire does not simply display the megalo-
maniacal delusion of a schizophrenic; rather, it
reveals the historical aspirations of an artist, as
well as the specific historical connections between
an asylum inmate and the popular culture that finds
its way into even the isolation of the psychiatric
institution.

Sacred ritual objects (and pathological
symptoms) tend to be hermetically enclosed within
their own symbolic systems; they are less engaged
in external cultural exchange and thus more easily
appropriated since less concerned with cultural
communication, commerce, and critique. These
objects are, on the symbolic level, both recalcitrant
and fragile: we are thus needy of initiation into
their meaning. Within our museums these works
become orphans, deterritorialized, wrenched from
their own symbolic. The place they find within our
own symbolic systems is superficial, created by
formal similarities, "affinities," and by our own
phantasms—in any case, their magic disappears
in the daylight of our rationality. Our model of
detached aesthetic contemplation belies the original
complex situatedness of these bizarre ritual objects,
whose efficacy is dependant upon profound, and
most often exclusionary, initiatory systems. We
discover here precisely the theoretical point of
articulation between not so much different
"worlds" or worldviews but rather different
symbolic systems. It is precisely the initiatory
aspect—a *knowledge*, a *practice*, and a *passion*—of
such rites and objects that necessarily escapes us.

Antonin Artaud

Antonin Artaud (1896–1948) was continuously excluded from the mainstream of modernist art. While clearly not an outsider artist in the accepted sense of the term (since Artaud's work was intricately related to the developments of surrealism and the theatrical arts), Artaud was already rejected from the avant-garde art establishment by his break with surrealism and cast even further outside the cultural realm by virtue of his extended period of incarceration in psychiatric hospitals. Not surprisingly Artaud identified with van Gogh, "the man suicided by society." Ultimately Artaud's psychic state of schizophrenic dissociation is emblematic of how this unique example of outsiderness was constituted. Artaud's is obsession in its most complicated and sublime form: the representation of a paranoid theological system. While many obsessions are ephemeral and restricted in form, in paranoia it is the entire delirious system that possesses the individual. Thus it is particularly important to consider the pictorial representations of these obsessions in the context of their verbal counterparts, which frequently provide clues to the obsessions' often hermetic meaning.

In 1923 Artaud submitted some of his earliest poetry to Jacques Rivière, director of *La Nouvelle Revue Française*. Rivière rejected the poems but was sufficiently fascinated by them to enter into correspondence with Artaud, which resulted in the publication of this exchange as *Correspondance avec Jacques Rivière* (Correspondence with Jacques Rivière), 1924. Rivière insisted on the formal inadequacy of the poems; Artaud responded that their authenticity was guaranteed by the suffering and passion invested therein. Beyond all formal criteria, it was their *force*, or at least the force behind them, that established their aesthetic quality. This was, of course, intricately related to Artaud's psychic state: "This scatteredness of my poems, these defects of form, this constant sagging of my thought, must be attributed not to a lack of practice, a lack of command of the instrument that I employed, a lack of *intellectual development*, but to

a central collapse of the soul, a sort of erosion, both essential and fleeting, of thought."[15] He also explained that "thus when *I can grasp a form*, imperfect as it may be, I fix it, for fear of losing all thought."[16] Artaud wrote so as not to go mad. Later he was to write so as to defy and aesthetically transform madness. While his early works were placed under the judgment of one man (Rivière), the totality of his oeuvre assumes mythopoetic dimensions as this judgment is raised, through his madness, to the cosmic level of a paranoid conflict with God Himself.

Artaud's affiliation with the surrealist movement was impassioned, brief, and tragic. In the volume of *La Révolution surréaliste* that he edited, Artaud included a report, "L'Activité du Bureau de Recherches Surréalistes," wherein he asserted that "surrealism records a certain number of repulsions rather than beliefs" and further expounded that "here a certain Faith is instilled; but let me be heard by coprophiliacs, aphasics, and in general by all those discredited in words and speech, the Pariahs of thought. I speak only for them."[17] In doing so, he was no longer speaking for the surrealists but rather against them. His desublimational tendencies were radically opposed to Breton's highly sublimational poetics, with the result that he was soon excluded from the movement—an expulsion thematized in the collectively signed pamphlet *Au grand jour* (In broad daylight), 1927, where he was accused of "veritable bestiality" and of desiring to see revolution as a purely interior condition of the soul. Artaud responded in "A la grande nuit, ou le bluff surréaliste" (In the dark of night, or the surrealist bluff), explaining that the only possibility of changing the human spirit was by "a metamorphosis of the interior conditions of the soul."[18] He thus denied any possible efficacy of social revolution and berated the surrealists for being "revolutionaries who revolutionize nothing," mere creators of "grotesque simulacra."[19]

: 241 :
Page from one of Antonin Artaud's
Rodez notebooks, December 1945

After his break with the surrealists Artaud
devoted himself in great part to the theater,
writing a series of texts destined to become his
masterpiece, *Le Théâtre et son double* (The theater
and its double), which thematized and expanded
upon his earlier aesthetic—or rather antiaesthetic—
reflections. He described a "theater of cruelty"—
an antirealist, antinaturalist, antipsychological
theater—where the exigencies of the unrepressed,
desublimated body would bear equal importance
with that of the spoken word. This would be a
theater that "invites the mind to share a delirium
that exalts its energies,"[20] where language is
transformed into a sort of incantation, a curative
magic: "The theater is an exorcism, a summoning
of energy. It is a means of channeling the passions,
of making them serve something, but it must be
understood not as art or distraction, but rather as a
solemn act, and this paroxysm, this solemnity, this
danger must be restored to it."[21] Until that time
Western art was but a manifestation of form,
dissimulating the very forces of life; henceforth the
"theater of cruelty" would be life itself. This desire
to change the psyche would reach its ultimate limits
in Artaud's madness, where paroxysm and exorcism
were to define the center of his existence.

In 1937, during a trip to Ireland, Artaud went
mad. He was forcibly returned to France and spent
the following nine years in various psychiatric
institutions, notably at Rodez under the care of
Dr. Gaston Ferdière, who treated him by a combina-
tion of means, including insulin- and electroshock
therapies. Upon emerging from the nearly autistic
depth of his malady, as well as surmounting the
comalike effects of the shock therapy, he began to
write numerous letters to friends and in February
1945 began to keep a diary, the *Cahiers de Rodez*
(FIGURE 241).[22] If *Le Théâtre et son double* was the
manifesto of a theater of exorcism and curative
magic that Artaud wished it to be, then this magic
was never more needed than during his stay at
Rodez. In his paranoid delusions Artaud recognized

: 242 :
Antonin Artaud
La Machine de l'être (The machine of
being), 1946, pencil and colored
pencil, 25 ⅝ x 19 ¹¹/₁₆ in. (65 x 50 cm),
Collection Luis Cardoza y Aragón,
Mexico

God as the "monomaniac of the unconscious."[23] Sometimes God and sometimes Satan was "that vacuity between me and my thought."[24] Artaud was caught in a web of conflicting identities, shackled by a schizophrenic splitting and megalomania. Within an ultimate dispossession of self (common to the theological deliria of paranoid schizophrenia) he believed himself to be God *and* the Devil, man *and* woman, living *and* dead. Here the theological is subsumed within the pathological; the true prolegomenon to any possible theater of cruelty as well as perhaps its greatest manifestation is the exorcism of God from the unconscious. This exorcism, this catharsis, was experienced in the form of a rebirth. "To die is to be done with God."[25] In the book of poetry *Artaud le mômo* (Artaud the madman), 1947, he explained how the therapeutic, electroshock techniques utilized at Rodez constituted a sort of black magic used against him, resulting in his "artificial death." Much of his work in this period was created specifically as a defense mechanism against the treatment that he was receiving as well as against the demons and the God that tormented him. He wrote of his drawings:

The goal of all these drawn and colored figures was the exorcism of a curse, a corporeal vituperation against the obligations of spatial form, of perspective, of measure, of equilibrium, of dimension, and through this demanding vituperation a condemnation of the psychic world encrusted like a crab-louse on the physique that it incubates or succubates by alleging to have formed it.[26]

Yet Artaud was well aware not only of the distinctions that must be made between his creations and art but also between his works and the manifestations of psychopathological symptoms. In a letter to Dr. Ferdière dated February 10, 1944, he wrote: "You forget that I also staged theater, and that all of my stagings were based upon a particular utilization of *psalmody* and of *incantation*. Is this mental alienation?"[27] Perhaps not; but Artaud will also argue that it is equally not art:

To the devil with art. There is not only art, there is the void, the abyss of what is always farther off, deeper, more absolute, which one day will be a being, not through perfection or the absolute, but through this terrifying lack in being that is the driving characteristic of the persistence of

puru purshe rasha shubane
rasha shabune ara pursha
rara rapuna tanu gada
paha
ketra terpuna aru kuda

the infinite, which is not an idea but a being.[28]

Artaud began to draw in Switzerland in 1919, at the time of his first residence in a psychiatric hospital; he created numerous drawings at the asylum of Ville-Evrard in 1939, conceived as magic objects to protect him against the imminent assassination that he feared; yet his major production of drawings began at the Rodez asylum and continued in Paris after his release, culminating in his exhibition of portraits at the Galerie Pierre (Paris, 1947).

Artaud's drawings—insofar as they serve as magical tools, incantatory presences, documents of his inner condition, and expressions of his desires—"definitively broke with art, style and talent."[29] Consider his own descriptions of his techniques and concerns, here specifically regarding *La Machine de l'être* (The machine of being; FIGURE 242), 1946, also known as *Dessin à regarder de traviole* (Drawing to be seen askew):

This drawing is a serious attempt to give life and existence to what until today had never been accepted in art: the spoiling of the support, the pitiful clumsiness of forms that collapse around an idea after having toiled for so many eternities to be reunited with it. The page is dirtied and spoiled, the paper crumpled, the characters drawn as with a child's consciousness.[30]

WEISS

Nosta
lgia
for
the
Absol
ute

: 243 :
Antonin Artaud
La Maladresse sexuelle de Dieu
(The sexual awkwardness of God),
1946, pencil and colored chalk on
paper, 24 ¹³⁄₁₆ x 19 ⁵⁄₁₆ in. (63 x 49 cm),
private collection, Paris

: 244 :
Antonin Artaud
Exécration du père-mère
(Execration of the father-mother),
1946

Of the drawing *La Maladresse sexuelle de Dieu* (The sexual awkwardness of God; FIGURE 243), 1946, he wrote, "This drawing is voluntarily botched, thrown onto the page as if in contempt for forms and features, so as to spurn the grasped idea and succeed in causing its fall."[31] And referring to his portraits, he asserted that "these drawings must thus be accepted according to the barbarism and the disorder of their style of drawing, 'which is never preoccupied with art,' but with the sincerity and the spontaneity of the stroke."[32] His drawings, which he insisted *represented nothing*, consist of "a sort of counter-figure that would be a perpetual protest against the law of the created object."

Artaud's drawing *Exécration du père-mère* (Execration of the father-mother; FIGURE 244), created at Rodez in April 1946 and published in *Artaud le mômo*, which is autobiography in its most virulent form, poses the question,

But what then in the end, you, the madman?
Me?
This tongue between four gums,
this beef between two knees,
this scrap of hole
for madmen.[33]

These holes, this void, this abyss, this emptiness, this asshole, this cunt: such is precisely the image that he wants us to grasp, the sign that he places over his existence. Whence the monumentally iconoclastic aspect of his work:

And if you don't get the image,
— and that is what I hear you saying
in a circle,
that you don't get the image
which is at the bottom
of my cunt hole. —
it is because you don't know the bottom,
not of things,
but of my cunt.[34]

The text signifies the very "image" of nothingness, perhaps of death itself. In "Le Retour d'Artaud, le mômo" (The return of Artaud, the madman), another poem in this book, he wrote of himself as having been interred in the hole of the fireplace on the day he was killed:

: 245 :
Antonin Artaud
Le Totem (The totem), 1945

And afterward?
Afterward?
Afterward!
He is this unframed hole
that life wanted to frame.
Because he is not a hole
* but a nose*
always a little too good at sniffing
the wind of the apocalyptic
* head*
pumped on his clenched asshole,
and how good Artaud's ass is
for pimps in Miserere.[35]

Does not this poem conjure up the image of
L'Exécration du père-mère? A distorted body,
truncated at the waist; unidentifiable, partial body
parts floating in a spaceless field; the sex covered
or replaced by a death's-head, surrounded by
projectiles; machinelike instruments torturing the
flesh, the "beef," the "meat"; an ethereal woman-
like creature floating above it all—perhaps death
incarnate. We find here an archetypal expression
of the experience of the fragmented, dismembered
body—common to both dreams and schizophrenic
states, where death and aggression are often the
central themes.

Artaud was reacting to the quotidian condi-
tions of his existence. His drawings were not only
intended as a magical defense against the deaths
inflicted upon him by electroshock therapy but
were later presented as a critique of, a monument
against, such therapy. Certainly the forms mani-
fested in these drawings (FIGURE 245) are a
function of the physical and social conditions of
incarceration that Artaud suffered; the manifest
content of schizophrenia, like the manifest content
of dreams and neuroses, is dependent upon the
subject's everyday experiences. The rise of
electrical technology has simply added new
subject matter to these possibilities: electroshock
apparatuses as torture devices; radio and television
as cosmic paranoid transmitters; cinema as a divine
projector. Yet these new forms are quite often
experienced, by paranoiacs, within a theological

294 WEISS Nosta
lgia
for
the
Absol
ute

system of deliria, since the hyperbolic, absolute
nature of religious experience is the ideal foil for
megalomaniacal paranoid projections.

In *The Interpretation of Dreams* Freud describes
an unreachable, uninterpretable, originary nexus
of significations in the dreamwork—a vast over-
determination, an unfathomable polysymbolism—
leading to the ineluctable realm of pure
contingency. It would seem that the ungraspable
profundity of the symbolic is a function of sheer
circumstantiality, of local, historical situatedness.
This contingency is ultimately absorbed into and
expressed by stereotyped, reiterative cultural
symbols. This nexus is precisely the point where
the symbolic enters into history, where the
particularization and the communalization of the
individual are accomplished as contemporaneous
events. The body is the site of this contingency—
where the magma of the imaginary and the
exigencies of history manifest their connection in
dreams, symbols, and acts. Though there is always
a signifier at this unattainable point, this signifier,
this originary nexus, can be *anything* whatsoever;
yet it remains unknown, not because it is repressed
but because it is ineluctably real. Might this
condition of symbolic organization be the precon-
dition of faith—and of magic? It would seem,
in fact, that it is precisely here that structuralist
anthropology and psychoanalysis find their
limits—at that point where the organizational pivot
of the symbolic is no longer a *floating signifier*
(which depends upon the diacritical organization
of the cultural system for its function) but rather
a *lost signifier* that is fully localized. This site of loss
might well be the place of our own rediscovery.
Might not these models—of dream interpretation
and ethnographic study—provide a new paradigm,
a new mode of criticism and theory, through which
we can more accurately describe and interpret
works of art brut? Perhaps the only way for us to
truly reach the symbolic web at the core of these
works is not through our criticism but rather in
the dreams and nightmares that they produce.

=

Notes

*All translations are by the author
unless otherwise indicated.*

1
*Webster's Third New
International Dictionary*
(Springfield, Massachusetts:
Merriam-Webster, 1986),
1558.

2
Biographical and pictorial
information on Carlo was
gathered from the following
sources: Vittorino Andreoli,
Cherubino Trabucci, and
Arturo Pasa, "Carlo," *L'Art
brut*, fascicle 6 (Paris:
Compagnie de l'Art Brut,
1966); V. Andreoli, "Les
dernières années de Carlo,"
L'Art brut, fascicle 11
(Lausanne: Collection
de l'Art Brut, 1982); and
V. Andreoli, "Carlo: La
communication non verbale
d'un schizophrène," in
*Psychopathologie de
l'expression*, vol. 24 (Basel:
Laboratoires Sandoz, 1977).

3
On glossolalia in early
modernism, see Annette
Michelson, "De Stijl, Its
Other Face: Abstraction and
Cacaphony, or What Was the
Matter with Hegel?" *October*,
no. 22 (Fall 1982): 5–26. On
the relation between the
poetics and the psycho-
pathology of glossolalia,
see my essay "The
Other as Muse: On the
Ontology and Aesthetics of
Narcissism," in David B.
Allison, Prado de Oliverra,
Mark S. Roberts, and Allen S.
Weiss, eds., *Psychosis and
Sexual Identity: Toward
a Post-Analytic View of the
Schreber Case* (Albany: State
University of New York
Press, 1988), 70–87.

4
Roman Jakobson, "Two Aspects of Language and Two Types of Aphasic Disturbances," in *Selected Works* (The Hague: Mouton, 1971), vol. 2, 239–59.

5
Jean Dubuffet, "Make Way for Incivism" (1967), trans. Allen S. Weiss and Chantal Khan Malek, in Allen S. Weiss, ed., *Art Brut: Madness and Marginalia*, a special issue of *Art & Text*, no. 27 (December 1987–February 1988): 34–36.

6
Sander L. Gilman, "Constructing Schizophrenia as a Category of Mental Illness," in his *Disease and Representation: Images of Illness from Madness to AIDS* (Ithaca, New York: Cornell University Press, 1988), 202–30.

7
Antonin Artaud, "Manifeste en langage clair" (1925), *Oeuvres complètes* (Paris: Gallimard, 1956–86), vol. 1, pt. 2, 52–53.

8
On Wölfli, see especially Dr. Walter Morgenthaler, "Adolf Wölfli," trans. Henri-Pol Bouché, *L'Art brut*, fascicle 2 (Paris: Compagnie de l'Art Brut, 1964); Elka Spoerri and Jürgen Glaesemer, eds., *Adolf Wölfli* (Bern: Adolf Wölfli Foundation, 1976); Elsa Longhauser and Elka Spoerri, *The Other Side of the Moon: The World of Adolf Wölfli*, exh. cat. (Philadelphia: Moore College of Art, 1988); and *Wölfli: Dessinateur-Compositeur*, ed. Elka Spoerri, Michel Thévoz, and Geneviève Roulin (Lausanne: L'Age d'Homme, 1991).

9
Cited in Spoerri and Glaesemer, eds., *Adolf Wölfli*, 111.

10
André Malraux, *The Voices of Silence*, trans. Stuart Gilbert (London: Paladin, 1974), 65.

11
Information on Jeanne Tripier, including citations, is from Jean Dubuffet, "Messages et clichés de Jeanne Tripier la planétaire," *L'Art brut*, fascicle 8 (Paris: Compagnie de l'art brut, 1966); and Michel Thévoz, ed., *Ecrits bruts* (Paris: Presses Universitaires de France, 1979).

12
Cited in Thévoz, ed., *Ecrits bruts*, 208.

13
Ibid., 202.

14
Dubuffet, "Messages et clichés de Jeanne Tripier la planétaire," 23.

15
Artaud, *Correspondance avec Jacques Rivière, Oeuvres complètes*, vol. 1, pt. 1, 28.

16
Ibid., 24.

17
Artaud, "L'Activité du Bureau de Recherches Surréalistes," *Oeuvres complètes*, vol. 1, pt. 2, 46–47.

18
Artaud, "A la grande nuit, ou le bluff surréaliste," *Oeuvres complètes*, vol. 1, pt. 2, 60.

19
Ibid., 59–63.

20
Artaud, *Le Théâtre et son double, Oeuvres complètes*, vol. 4, 39.

21
Artaud, letter to Natalie Clifford Barney dated August 12, 1933, *Oeuvres complètes*, vol. 5, 153.

22
For a detailed study of Artaud's *Cahiers de Rodez*, especially in regard to the poetics of glossolalia, see "Psychopompomania," in my *The Aesthetics of Excess* (Albany: State University of New York Press, 1989), 113–134.

23
Artaud, *Cahiers de Rodez, Oeuvres complètes*, vol. 15, 315.

24
Artaud, *Cahiers de Rodez, Oeuvres complètes*, vol. 24, 87.

25
Artaud, *Cahiers de Rodez, Oeuvres complètes*, vol. 16, 30.

26
From Artaud's notebooks of February 1947, cited in *Antonin Artaud: Dessins*, exh. cat. (Paris: Musée National d'Art Moderne, Centre Georges Pompidou, 1987), 18. See also Paule Thévenin and Jacques Derrida, *Antonin Artaud: Dessins et portraits* (Paris: Gallimard, 1986).

27
Antonin Artaud, *Nouveaux Ecrits de Rodez* (Paris: Gallimard, 1977), 82.

28
Artaud, *Cahiers de Rodez, Oeuvres complètes*, vol. 20, 208–9.

29
Artaud, cited in *Antonin Artaud: Dessins*, 50.

30
Artaud, *Cahiers de Rodez, Oeuvres complètes*, vol. 19, 259.

31
Artaud, *Cahiers de Rodez, Oeuvres complètes*, vol. 20, 173.

32
Antonin Artaud: Dessins, 50.

33
Antonin Artaud, "Artaud le mômo," trans. Clayton Eshleman, in *Conductors of the Pit: Major Works by Rimbaud, Vallejo, Artaud, Césaire, and Holan* (New York: Paragon House, 1988), 149.

34
Ibid., 151.

35
Ibid., 153.

Art History,
Museology,
and the
Staging of Modernity

DONALD PREZIOSI

I

Typically art history has taken the problem of *causality* as its particular concern. Within its domain of analytic attention art history has invariably held the image or object to be *evidential* in nature: as effect, result, trace, medium, or sign. The characteristic task of the art historian has been the *restoration* of the circumstances surrounding the object's production, the articulation of which, it is assumed, renders the visible artifact *legible* to a wider audience.[1] The historian or critic typically takes up the role of exegete or cryptographer, perpetually seeking to discern *in* objects the traces of their origins. The art object is normally construed as in some way *reflective* of its origins.

In the century and a half of its professionalization as an academic discipline[2] art history has provided a variety of theoretical perspectives upon what might constitute adequate explanations for the origins of a work of art. Such origins commonly have been situated in two frameworks: internal conditions of creativity and external circumstances of production. For some art historians the first set of conditions is dominant and primary, and the second marginal, circumstantial, or of lesser interest. Others see the second set of circumstances as dominant or determinative of the resultant form of the artwork, with personal factors being of marginal interest.

Both paradigms are concerned with locating the particular "truth" about an artwork, and both have been in play from the beginnings of the discipline of art history. What underlies both perspectives on the truth of an artwork is a single, fundamental metaphor: that an art object is a medium of communication or expression akin in some way to a word or verbal text[3] and that, like a verbal utterance, the object is a vehicle *through which* the intentions, attitudes, values, or thoughts of a maker are conveyed to the mind of a beholder or observer. The form of the work is the vehicle of conveyance, and changes in form are held to signal changes in what is being communicated.

The general premise among art historians has been that artworks say, express, or reveal (even inadvertently) something determinate. Logically certain assumptions are necessary to disciplinary practice:

1 that such determinacy is grounded in authorial intention (even if the maker is unaware of such intentions);

2 that the properly equipped and experienced (professional) analyst could reconstruct such determinacy; and

3 that the expert could produce an interpretation of the artwork that other similarly equipped and experienced analysts might agree possesses some manner of objectivity.

These three assumptions depend upon the following:

1 that everything about an art object is significant in *some* way;

2 that not everything about the object could be significant in the *same* way; and

3 that not everything about an object could be significant in *every* way.

The first of these specifies that there are no semantically empty or meaningless parts of a work; the second that the contributions of the parts of a work to the overall signification are varied and disparate (for example, line, color, texture, or materials); the third specifies that the signification of a work must be determinate, not promiscuously expandable or fluid, because if everything about a work meant everything or anything, there would be no dependable way of distinguishing artworks as a class of objects from any other cultural products. This last assumption, at the same time, provides the interpretation of forms by maker or beholder with a certain boundedness or limitation, marginalizing the personal responses to an object by a viewer as precisely that—personal, beyond the purview of art history and criticism.

These assumptions are important in another respect, providing as they do a certain determinacy to the meaning of the objects of study, contributing to the specific *disciplinarity* of art history as a systematic, even "scientific," field of inquiry concerned with visual formations as examples of a "code" specific to a time, a place, an artistic movement, or to a particular artist. Form is thus assumed to have discoverable "laws," the illumination and articulation of which are the proper concern of the professional historian, critic, or curator.

Art history established itself as a discipline by defining its particular object of attention—the entire corpus of works of art—as a set of objects with determinate *meanings*. The exemplary disciplinary activity came to be the reading, interpretation, and explication of individual objects according to the *symptoms* or traces they could be said to reveal regarding their origins both in individual mentalities and in the "mentalities" of an age, place, or race. It is of no small interest that members of the medical profession played a substantial role in launching the professional career of art history—not only as with the case of the father of modern connoisseurship, Giovanni Morelli, in the nineteenth century but also two centuries earlier with Giulio Mancini (chief physician to Pope Urban VII), whose writings were aimed at training visitors to the annual art exhibits at the Pantheon in Rome to distinguish masterpieces from mediocre works and to distinguish the characteristics of artwork of different historical periods.[4]

298 PREZIOSI Art
History,
Museology,
and
the
Stagi

II

Since their origins in familiar form some two centuries ago, museums of art have worked in a manner similar (but not identical) to the discourse of art history as outlined above. The task of the museum generally has been assumed to be the judicious assemblage of objects and images deemed particularly evocative of time, place, personality, mentality, and the artisanry or genius of certain societies, groups, races, or individuals.[5]

Accordingly the museum of art functions as an archive or tableau of evidentiary materials: an aggregation of windows upon history, geography, biography, and ethnicity. The landscape of the museum gathers together in an articulated space the fragments of totalities past, distant, or absent. There is a certain resonance here with the ritualistic practices of geomancy, wherein the proper siting/ sighting of objects or formations works to guarantee the preservation of the spirit of a departed or absent person or group. In the museum what is guaranteed above all is the spirit of artisanry and human creativity and the existence of such a *thing* as Art beneath what are staged as its myriad manifestations or exemplars. In staging examples of what we expect to see as characteristically Flemish, Florentine, Polynesian, or Islamic art, we are prepared to see evidence of what is quintessentially human in all its variety.

At the same time that the museum is a repository of evidence for the seemingly inexhaustible variety of artistic expression, it also functions as an institution for the staging of historical and aesthetic evolution, as a narrative instrument for the simulation of historical change both of and through artwork. In this respect the museum of art has had distinctly dramaturgical functions in modern life, circulating individuals through spaces articulated by sequential arrangements of historical relics. Art objects are choreographed together with the (moving) bodies of beholders.

Two primary models for articulating museological space have coexisted since the late eighteenth century, and both remain fundamental to museum practice in the late twentieth century:

1 the decoration of a given space (room, gallery, or set of rooms) in such a way as to simulate the period ambience of a work or works by the inclusion of objects from the contexts in which they would have been originally viewed or used; and

2 the use of given spaces to delimit particular time periods, styles, or "schools" of art, or the art of specific artists.[6]

The first model has obvious parallels with the familiar panoramas of museums of natural history and ethnography, wherein plants, animals, or human effigies are set up within characteristic (simulated) "natural" settings or environments;[7] the second model is analogous to the art-historical survey textbooks, wherein sections of the text are devoted to episodes in the historical development of styles, genres, schools, or individuals.[8]

Both modes of museological practice have served a common function: the display of evidence for the "truth" of artwork. Yet in each case the truth is *located* differently. The first model purports that the significance of a work is a complex function of its multiple relationships to all the elements of the *environment* in which it originally was produced or displayed. In the second case the significance of the work is staged as part of a stylistic evolution of similar works over *time*.

It will be apparent that these two modes of staging works correspond in a general sense to social-historical modes of explanation in art history on the one hand and to models of formal analysis and stylistic evolution on the other. Nonetheless these parallels are only generic on this level, for in both modes of museological practice the significance of a work is staged as a function of its "context"—in the first case a synchronic context, and in the second case a diachronic or temporal one. In both cases the meaning of a work is a differential product of the work's relationship(s) to other things.

It may be said that each form of museological explanation privileges a different set of origins to the work of art: in the first case the object is purported to be in some way a product of its time and place, a reflection of that environment. The underlying assumption here is of a certain homogeneity in that environment such that the time and place—the specificities of history and moment—are to be construed as in some way unified (for example, stylistically, cognitively, or ideologically) and that one can find traces or symptoms of that specificity in many or all of the details of the material products of that milieu.

In the second case the specific art object is construed more explicitly as a moment in an evolution of a certain style or genre such that its meaning is localized incrementally, as a complex product of the works (of an artist or school) preceding it chronologically. The work then stands as a historical document of the evolutionary unfolding of that style, school, or genre or of the oeuvre of a particular artist.

Museological stagecraft thus works metaphorically and metonymically, which is to say by analogy and by juxtaposition.[9] The museum establishes what may be termed *predicative frameworks* for viewers—the framing of objects with respect to viewers such that the framing itself predisposes the viewer toward certain kinds of conclusions regarding the origins, truth, significance, or meaning of works. In this regard the institution of the museum functions in a manner not unlike that of the diagrammatic or visual logic of scientific demonstration, wherein the actual arrangement of evidence itself constructs the "truth" of what is intended—conclusions regarding origins, descent, influence, affiliation, evolution, progress, historical direction, the homogeneity or heterogeneity of the mentality of an age, place, people, class, race, or individual.

With respect to the histories of art staged by the museum, viewers are situated in a kind of *panoptic* position so as to survey or examine those histories through their circulation in and among a variety of articulated spaces containing various kinds of evidence of artistic creativity.[10] Regardless of the fragmentary nature of some museum collections, all museums function as exemplary (if at times partial) instances of an imaginary and ideal plenitude, wherein instances of the entire range and scope of the artistic creativity of all times and places might be staged, might "speak directly" to their beholders.[11]

The point is that ideally the object must be situated so as to declare its own particular truth clearly, however complex, enigmatic, or even elusive that truth might be. In the confrontation between beholder and object a contemplative state of mind is invariably deemed ideal: art (i.e., good art) demands of the viewer time and freedom from distraction for its unique truth to surface. Every effort is made to stage artworks as palpable objects of desire and explication.[12]

At the same time, museums of art stage a vision of the past as that from which we would like to be descended, as that which prefigures our presentness, our *modernity*.[13] In other words, the museological framing of the past is only in part sepulchral: the museological past is anticipatory, and its "history" of art is teleological—ordered, oriented, and arrowed, focused on the present. It is well known that the great national and civic museums of art of the late eighteenth and early nineteenth centuries in Europe were organized so as to stage the dramaturgies of modern nation-states, that is, to show the evolution of a people from its earliest aesthetic traces up to the present and to connect particular European states with the heritage of antiquity, the legacies of Greece and Rome.

In this regard the origins and development of the great civic museums of art were inextricably bound to the formation of national, imperial, and ethnic identities, and the "histories" staged therein were (and remain) closely tied to the definition and legitimation of such identities. Museums of art became public institutions for rendering such (imaginary) legacies visible and palpable, places

300 PREZIOSI Art
History,
Museology,
and
the
Stagi

where "history" could be surveyed and walked through from the beginnings of time to the present age. In that sense museums became places where the individual viewer or visitor could literally "perform" a collective history as, in effect, an *agent* of the particular modernity of which one's own country was a notable, or even the archetypical, exemplar.[14]

We are clearly dealing with an institution of astonishingly potent and subtle illusion, no mere contemplative retreat from the complexities and contradictions of modern life but, in fact, one of the most powerful factories for the production of modernity. Museums of art are thus anamorphic instruments in social life[15]—places where "the past" is transformed into that which gives meaning and direction to the present. Correlatively the present is staged as an anamorphic point from which the past may be *seen* as making sense. In the late twentieth century, as museums of art have come to incorporate a seemingly endless variety of human creativity in all facets of visual or material culture, this remains as a fundamental programmatic mission, and the museum remains as the very emblem of desires set into motion by the enterprise of the Enlightenment.[16]

Museums are thus social instruments for the fabrication and maintenance of *modernity*; historically coterminous with that modernity, they have served as one of our premier theoretical machineries for the production of the present. The underlying order of the topological system of the museum is correlative and complementary to the rhetorical order of the discourse of art history.

III

In a number of crucial ways *Parallel Visions* addresses questions that are at the heart of the critical, historical, and theoretical developments just outlined. As we shall see, *Parallel Visions* occupies a unique critical position with respect to questions of modernity, artistic creativity, interpretation, and of the social and epistemological roles of the museum as historically construed. In order to appreciate this, we shall have to consider the exhibition in its historical contexts and in particular in its relationships to an exhibition mounted half a century ago at the Museum of Modern Art in New York.

Under the directorship of Alfred H. Barr, Jr., MOMA mounted an exhibition in 1936 entitled *Fantastic Art, Dada and Surrealism* (hereafter *Fantastic Art*).[17] *Fantastic Art* followed an exhibition mounted at MOMA earlier in the same year entitled *Cubism and Abstract Art* and was intended, in Barr's own words, as the "second of a series of exhibitions planned to present *in an objective and historical manner* [my emphasis] the principal movements of modern art."[18] The *Fantastic Art* catalogue included an introduction to the exhibition by Barr, two essays by surrealist writer and artist Georges Hugnet on dada and surrealism,[19] and a brief chronology of these artistic movements by Barr and Elodie Courter, establishing "certain pioneers and antecedents."

The exhibition was divided into eight sections. Five of these provided a background genealogy for dada and surrealism, presenting a selection of fantastic art from the fifteenth century to the present. Three sections were devoted to artists independent of the dada and surrealist movements; comparative materials; and fantastic architecture. In his preface to the catalogue Barr stated that "the divisions of the exhibition are self-explanatory."[20]

The disingenuousness of the assertion is clear in the rather strenuous efforts to justify the distinctions in the *Fantastic Art* catalogue by evasive or blatantly contradictory explanations. A noteworthy example is the inclusion in the show, under the rubric of comparative material, of the art

of children and the insane. "Why," Barr asked, "should the art of children and the insane be exhibited together with works by mature and normal artists?" He answered his own rhetorical question as follows:

But, of course, nothing could be more appropriate as comparative material in an exhibition of fantastic art, for many children and psychopaths exist, at least part of the time, in a world of their own unattainable to the rest of us save in art or in dreams in which the imagination lives an unfettered life. Surrealist artists try to achieve a comparable freedom of the creative imagination, but they differ in one fundamental way from children and the insane: they are perfectly conscious of the difference between the world of fantasy and the world of reality, whereas children and the insane are often unable to make this distinction.[21]

What, in fact, is the nature of the comparison intended? The inclusion of the art of children and the insane simultaneously includes and excludes. Despite whatever formal similarities might be pointed to between such works and those of, in Barr's words, "mature, normal" surrealists with their "esthetic of the fantastic, hypnogogic and anti-rational," the surrealists were said to be perfectly conscious of the difference between fantasy and reality.

The distinction between surrealist art and that of children and the insane was clearly purported to lie with intentionality on the part of the artists. Whatever might be adduced regarding the intentions of children or the insane with respect to their art,[22] nowhere in the catalogue was such evidence discussed. The products of children and the insane, then, were framed in an ambiguous position as both art and nonart.

The problem was compounded by Barr's efforts to find what he terms pioneers and predecessors to contemporary surrealist art. Nearly a quarter of the seven hundred pieces on display fall into this category, and it is clear that intentionality, awareness, or "conscious[ness] of the difference between the world of fantasy and

the world of reality" can in no way be conclusively demonstrated: such demonstrations would be well beyond the capacity of a psychological archaeology, whose art-historical instruments are unrefined and ineffectual, to say the least.

In short, Barr's essay reveals a fundamental set of contradictions with respect to criteria for inclusion in the art of the fantastic. On the one hand, a corpus of pioneers and predecessors was assembled on the basis of certain formal similarities to contemporary fantastic or surrealist artworks. On the other hand, equally cogent formal similarities or resemblances between surrealist art and that of children and the insane were discounted, using a different set of standards—those of purpose and intentionality on the part of makers.

Interestingly *Fantastic Art* included in its comparative section folk and primitive art, commercial advertisements, "miscellaneous objects and pictures with a surrealist character" (i.e., found objects, curiosities of various periods, Rorschach patterns, a spoon found in the prison cell of a condemned man), and a photomontage political poster of Franklin D. Roosevelt—objects and images (whether artificial or natural) that bear a formal resemblance to the "character" of surrealist artworks.[23]

At the end of his concluding remarks in the introduction to the *Fantastic Art* catalogue, Barr noted,

When the movement [surrealism] is no longer a cause or a cockpit of controversy, it will doubtless be seen to have produced a mass of mediocre and capricious pictures and objects, a fair number of excellent and enduring works of art, and even a few masterpieces. But already many things in this exhibition can be enjoyed in themselves as works of art outside and beyond their value as documents of a movement or a period.[24]

302 PREZIOSI Art
 Histo
 ry,
 Museo
 logy,
 and
 the
 Stagi

Within the same sentence Barr clearly articulated the double, polarized agenda of the modernist museum and the discourse of modern art history when pointing out the art object's simultaneously historical and ahistorical nature. *Fantastic Art* worked explicitly to construct a history and a genealogy for surrealism, a legitimacy as a movement or period style, and to frame surrealist art within a traditional system of aesthetic value of a kind explicitly eschewed by artists of the movement itself. On this level the specific "intentions" of surrealist artists (so crucial elsewhere in Barr's text) were put aside or forgotten in MOMA's attempt to valorize surrealism as an exemplary mode of modernist art with an extensive "pedigree" in the long evolutionary development of Western art history.

At the same time, it is clear that artistic products of certain groups (namely children and the insane) cannot be admitted to the modernist canon, and the reader of the catalogue is left to conclude that these works must belong to the "mass of mediocre and capricious pictures and objects" that Barr prohibited from the mainstream of modern surrealist work.

In an important sense the exhibition and catalogue sections by Barr stand in direct contrast to the very explicit statement of the catalogue's primary essayist, Hugnet, who in his text on surrealism categorically declared that "in Surrealism the work and the man are inseparable. Politically and poetically Surrealism seeks man's liberation. What a work of art expresses formally is of no importance—only its hidden content counts. . . . *There is no surrealist art* [my emphasis], there are only proposed means—and these proposed means may be only temporary."[25]

If the means are temporary and contingent, how can one write (or stage) their "history" in the same framework used to fabricate a history of artistic expression, a "history of art"? Hugnet's statement clearly pulls the rug out from under the entire *Fantastic Art* project, rendering Barr's art-historical mission of canonizing "surrealist art" as an episode in the evolution of modern art rather ironic. *Fantastic Art* sought to accomplish two incompatible, and ultimately contradictory, things:

1 to recreate the atmosphere of provocative and incongruous juxtapositions of objects found in the surrealists' collective exhibitions, where their works were jumbled together with works by naives, primitives, children, the insane, and with found objects; and

2 to frame surrealist art *as* art with a lineage and a history of antecedents and corollaries, as if surrealism were an artistic movement in the same sense as realism, impressionism, or cubism.[26]

The contradictions and beguiling rhetoric of the 1936 *Fantastic Art* exhibition were neither unique or even remarkable: they constituted examples of the most commonplace dramaturgies of art history and its museology as these have evolved over the past two centuries and remain in place today.[27] As the first two sections of this essay have argued, the heart of the matter is that as a mode of disciplinary practice art history comprises contradictory, incompatible, and irreconcilable perspectives on the nature of art, of signification, and of interpretation. This is not the same as claiming that the discipline has a variety of competing theoretical or ideological perspectives in play at any one time in its evolution—a situation that is, in fact, as true for art history as for any other field of knowledge. The claim here is more fundamental: that art history at base is a discipline *built out of* a tension created by the opposition between historicism and aestheticism. As with optical illusions, these incompatible visions alternate perpetually and irreconcilably.[28]

IV

In the *Fantastic Art* exhibition certain works were bracketed outside the evolutionary mainstream of modern art history while at the same time being recuperated and contextualized in the service of defining and situating surrealism as an episode in the evolution of the modernist canon. Since World War II and most especially since the 1967 landmark exhibition of Jean Dubuffet's collection of *art brut* at the Musée des Arts Décoratifs in Paris[29] there has been a growing public awareness and recognition of the artwork of outsiders, which has led to an increased appreciation of the role such work has often played in influencing mainstream modern and contemporary artists. These developments are recorded in a variety of ways elsewhere in this volume; here our concern will be with the effect such developments have had on the institutions of the museum, art history, and criticism.

Certainly in the most fundamental sense the increased appreciation of "raw art" (art brut) may be said to signal important potential changes in our general notions of what constitutes artistic expression, creativity, and variety. Dubuffet's strategic use of the term art brut as a differential category (in opposition to *les arts culturels*) suggests a reconfiguration of what is to be considered as artistic or aesthetic. The term referred to any art unadulterated by received, normative notions of artwork produced within that network of institutions collectively referred to as the art world. The implication is that if raw art exists at all it is a sign that artistic creativity is not limited to those professionally involved in the production of "fine" or "art-market" art. The semantic shift is clear: "insider" art is no longer a polar opposite to the art of "outsiders" but is to be understood as *one kind* of art.

The shift, in fact, parallels certain changes that have taken place within art-historical education over the past twenty-five years, wherein the purview or domain of art history has come to include many forms of visual or material culture previously bracketed out of art-historical pedagogy— products of popular culture, the art of peoples not associated with the major world civilizations,

the art of "primitive" peoples, and so forth.[30] In short, the analytic domain of the contemporary discipline of art history has come more nearly to approximate the entire built or visual environment, that is, the entire human artifact world. This is reflected currently in American university education, where it is now frequently the case that the material culture of a given group may be attended to simultaneously by departments of art history, anthropology, history, archaeology, and sociology.

Parallel developments have taken place in museology as well in terms of increased attention to the display of objects other than painting and sculpture or the canonical high-status objects of Western and certain non-Western societies with which Europeans came to be directly concerned through conquest, trade, and territorial expansion.[31]

Yet the expansion of the fields of interest of art history and museology has not in itself signaled substantive changes in the way these institutions function, for they have continued to work by and large to assimilate new materials into the canonical frameworks of traditional art history, domesticating the unfamiliar as it were. This was certainly the case with the justly infamous *"Primitivism" in Twentieth-Century Art* exhibition at the Museum of Modern Art in New York in 1984.[32]

My point is that the recognition of art brut and the problematizing of distinctions between insider and outsider art raise more fundamental challenges to the nature of art-historical practice than has the expansion of disciplinary interest to the arts of non-European societies or of non-fine art practices within the West. These challenges concern fundamental conceptions of artistic practice itself as well as the implications of these changing conceptions to issues of signification and meaning and of the consequences for the enterprise of interpretation and analysis.

304 PREZIOSI Art
 Histo
 ry,
 Museo
 logy,
 and
 the
 Stagi

One major concern of *Parallel Visions* has been to investigate the roots of the modernist movement in the visual arts. On this level it delineates in fine detail the complex web of influences that the art of compulsive visionaries and other outsiders has had on mainstream developments.

At the same time, *Parallel Visions* makes a significant critical and theoretical statement regarding the artistry of these outsiders by situating it alongside what Dubuffet termed les arts culturels, or insider modern and contemporary art. The implications of this move are as follows.

First, the aesthetic dichotomy of "inside versus outside" and its explicit hierarchy of values are rendered moot. The exhibition frames works of all kinds in compatible or identical ways, thereby redefining "modernism" in the visual arts as a more neutral, chronological category. In other words, modernism is expanded beyond the interlinked series of avant-gardist practices canonized by art history and museology. All manner of artistic practices become, in effect, part of the "story" of modernism.

Second, the relationship of the work to the viewer is altered in a number of respects. As the linear, evolutionary stagecraft of avant-gardist modernism is rendered problematical, the nature of museological "reading" on the part of beholders becomes less that of following an inexorable, progressive "story line" and more one of critical understanding of multiple directions, affiliations, feedbacks, and interactions. In short, the "time" of art history is multiplied, compounded, enriched, and diversified. The history of art ceases to be a series of linked solutions to narrowly defined aesthetic or stylistic problems; traditional histories of art come to be contextualized as one kind of account among a variety of equally plausible and cogent perspectives on modernity. From a critical standpoint this has the effect of rendering multiple perspectives on our modernity accessible to the beholder, placing the observer in a far more active, critical position with respect to making sense of the art of modernity than was possible before.

Third, the problem of meaning or signification of artworks is given a new slant. If (as was argued above in section I) the discipline of art history is traditionally grounded in the notion that artworks express or reveal, however inadvertently, something determinate and that such determinacy is grounded in authorial intention, then the problematizing of such determinacy as a characteristic of *all* artistic practice alters the task of interpretation and explanation in significant ways.

The situation is as follows. The basic task of art history has been the reconstruction of the "principles of reason" in a work, the object's "truth."[33] If, however, "reasonableness" is now recognized as a quality of determinacy only in *certain kinds* of works, then the meaning of a work is not necessarily fixed, static, or articulatable. Instead it becomes a complex function of the specific interactions among object, beholder, and environment at a given time and place. The artwork becomes the *occasion* for the production of (potentially multiple) meanings on the part of makers and beholders. The beholder, then, is no longer merely a passive reader or consumer of the purported intentions of a work but is rather an active construer of meaning.

Conventionally the processes of signification in art history have been regarded as transitive such that the art object has been considered principally a medium or vehicle for the conveyance of meanings and intentions from maker to beholder. Interpretation has thus been seen in a normative framework, wherein the task of explication is an attempt to reconstruct the maker's intentions. The paradigm is fundamentally linguistic in origin.[34] *Parallel Visions* problematizes this paradigm: the intentions of the artist become only part of an extended range of significations produced by the juxtaposition of object and beholder.

This is not to say that the meaning of a work becomes simply or solely a matter of personal construction on the part of the beholder. Rather it indicates that the tasks of interpretation and explication are no longer simply focused upon the reconstruction of a maker's intentions. The artist's *authority* is no longer, or not necessarily, determinate of the significance of a work for a given beholder. Moreover such authority is more clearly highlighted as itself an artifact of the systems of art history and the museum, a product of certain relationships of power.[35]

Readings of the past—and, in particular, interpretations of past works of art—are invariably addressed *to the present* in significant ways. If museums, for example, are assemblages of artifacts drawn from the past of our own or other societies, then it is to be understood that such assemblages are intended to do work *in* and *on* the present. In the most general sense museums work to fabricate a "past" from which we may imagine ourselves as descended, thereby constituting that past as part of our presentness, as an important component of our identities—as individuals, ethnic groups, or nation-states. Therefore museums and art history are, in direct and poignant ways, institutions of power, of empowerment, and of disempowerment.

Parallel Visions clearly works to empower the artistry of individuals outside the canon of modernist art history. In this regard it continues the work of a number of other institutions and collections over the past several decades, as other essays in this volume have made abundantly clear.[36] Yet *Parallel Visions* goes significantly further by standing counter not only to *Fantastic Art* but also to the entire museological and art-historical tradition of which *Fantastic Art* was a prime instance. It opens up critical questions with regard to the idea of modernism in the arts and, I would claim, with regard to modernity in general. It takes up, in fact, a genuinely *post*modernist position, in the critical (as opposed to the merely chronological) sense of that term,[37] by unambiguously giving prominence to the multiplicity and otherness *within* modernity

itself. Accordingly *Parallel Visions* serves a distinctly historical function in that it makes it possible for us to appreciate the sleights-of-hand by which modernism in art has been conjured. At the same time, it sensitizes us to the criticality of other institutions and practices with respect to that modernity.[38]

Parallel Visions stages a vision of modernity that is, in fact, *stereoptical*. By submitting art brut and les arts culturels to the same optical, museological frame, it restores modernity's depth, heterogeneity, and multiplicity—complexities occluded in the aestheticization of history by conventional art history and museology.

In so doing it calls our attention to the fact that from their beginnings art history and the museum have constituted *trompe-l'oeils* of extraordinary power and tenacity, promoting a modernity that was, after all, only part of the story.

306 PREZIOSI

A r t
H i s t o
r y ,
M u s e o
l o g y ,
a n d
t h e
S t a g i

Notes

1
A detailed study of the epistemological frameworks of the discipline of art history may be found in my *Rethinking Art History: Meditations on a Coy Science* (New Haven: Yale University Press, 1989), 21–121; and Oskar Bätschmann, *Einführung in die kunstgeschichtliche Hermeneutik* (Darmstadt: Wissenschaftliche Buchgesellschaft, 1988), 1–30.

2
Bätschmann, *Einführung in die kunstgeschichtliche Hermeneutik*, 57–82.

3
Preziosi, *Rethinking Art History*, 44–53, 148–52.

4
Ibid., 91–95.

5
On the early development of museums of art, see Oliver Impey and Arthur MacGregor, eds., *The Origins of Museums* (Oxford: Oxford University Press, 1985); Joseph Alsop, *The Rare Art Traditions* (New York: Harper & Row, 1982), especially 615–65; and my "Modernity Again: The Museum as *Trompe-l'Oeil*," in Peter Brunette and David Wills, eds., *Deconstruction and the Visual Arts* (Princeton: Princeton University Press, 1992).

6
See Stephen Bann, *The Clothing of Clio: A Study of the Representation of History in Nineteenth Century Britain and France* (Cambridge: Cambridge University Press, 1984), 77–92.

7
See Paul Holdengräber, "A Visible History of Art: The Forms and Preoccupations of the Early Museums," *Studies in Eighteenth-Century Culture*, no. 17 (1987): 107–17; and Ann Reynolds, "Reproducing Nature: The Museum of Natural History as Nonsite," *October*, no. 45 (Summer 1988): 109–27.

8
See Carol Duncan and Alan Wallach, "The Universal Survey Museum," *Art History* 3, no. 4 (December 1980): 448–69; similar issues are discussed in Preziosi, *Rethinking Art History*, 68–79; see also Carol Duncan and Alan Wallach, "The Museum of Modern Art as Late Capitalist Ritual," *Marxist Perspectives* (Winter 1978): 28–51.

9
On metaphoric and metonymic relationships, see Roman Jakobson, "Closing Statement: Linguistics and Poetics," in Thomas A. Sebeok, ed., *Style in Language* (Cambridge, Massachusetts: MIT Press, 1960), 350–77; and Louis Marin, "Towards A Theory of Reading in the Visual Arts: Poussin's *The Arcadian Shepherds*," in Norman Bryson, ed., *Calligram: Essays in New Art History from France* (Cambridge: Cambridge University Press, 1988), 63–90.

10
For a discussion of panopticism with respect to the visual arts, see Preziosi, *Rethinking Art History*, 59–67, 70–71; on Jeremy Bentham's invention of the Panopticon, see Michel Foucault, "The Eye of Power," in Colin Gordon, ed., *Power/Knowledge: Selected Interviews and Other Writings 1972–1977 by Michel Foucault* (New York: Pantheon, 1980), 146–65.

11
On the claim that artworks must be allowed to "speak" for themselves, see David Finn, *How to Visit a Museum* (New York: Abrams, 1985), 10. That this perspective continues to be maintained in contemporary museology may be clearly seen in Pilar Viladas, "The Design of the Installation," in *"Degenerate Art": The Fate of the Avant-Garde in Nazi Germany*, exh. bro. (Los Angeles: Los Angeles County Museum of Art, 1991), 4.

12
Preziosi, *Rethinking Art History*, 21–53.

13
Douglas Crimp, "On the Museum's Ruins," *October*, no. 13 (Summer 1980): 41–57; Crimp, "The Postmodern Museum," *Parachute*, no. 46 (March–May 1987): 61–69.

14
On the relationships of museology to the fabrication of national and ethnic identities, see Robert Hewison, *The Heritage Industry* (London: Methuen, 1987); Kenneth Hudson, *A Social History of Museums* (London: Macmillan, 1987); Robert Lumley, ed., *The Museum Time Machine: Putting Cultures on Display* (London: Routledge, Chapman and Hall, 1988); Impey and MacGregor, *Origins of Museums*, especially 232–80; George W. Stocking, ed., *Objects and Others: Essays on Museums and Material Culture* (Madison: University of Wisconsin Press, 1985); and Tony Bennett, "The Exhibitionary Complex," *New Formations*, no. 4 (Spring 1988): 73–102.

15
On anamorphic representation, see Michel de Certeau, "The Gaze of Nicholas of Cusa," *Diacritics* 17, no. 3 (Fall 1987): 2–38; and Jean Baudrillard, "The Trompe-l'Oeil," in Norman Bryson, ed., *Calligram*, 53–62.

16
See Adalgisa Lugli, "Inquiry as Collection: The Athanasius Kircher Museum in Rome," *RES*, no. 12 (Autumn 1986): 109–24; and Timothy Reiss, *The Discourse of Modernism* (Ithaca, New York: Cornell University Press, 1982), 21–167.

17
Alfred H. Barr, Jr., ed., with essays by Georges Hugnet, trans. Margaret Scolari, *Fantastic Art, Dada and Surrealism*, exh. cat., 2d ed., revised and enlarged (New York: Museum of Modern Art, 1937).

18
Barr, "Preface," in ibid., 7. Barr in the introduction (p. 9) stated that "the first of the retrospective series, *Cubism and Abstract Art*, was, *as it happens* [my emphasis], diametrically opposed in both spirit and esthetic principles to the present exhibition."

19
Ibid., 15–34 ("Dada"), 35–52 ("In the Light of Surrealism").

20
Ibid., 7.

21
Ibid., 12–13.

22
See Ellen Handler Spitz, *Art and Psyche* (New Haven: Yale University Press, 1989), for a detailed and comprehensive recent study of this question. See also John M. MacGregor, *The Discovery of the Art of the Insane* (Princeton: Princeton University Press, 1989); Roger Cardinal, "Image and Word in Schizophrenic Creation," in Ian Higgins, ed., *Literature and the Plastic Arts 1880–1930* (Edinburgh: Scottish Academic Press, 1973), 103–20; Allen S. Weiss, ed., *Art Brut: Madness and Marginalia,* a special issue of *Art & Text*, no. 27 (December 1987–February 1988); and the other essays in this volume.

23
The objects and images in the exhibition were extremely diverse by any measure, including items that might equally have served as examples of cubist or abstract artwork. In short, the formal resemblance to works of a surrealist character was entirely arbitrary.

24
Barr, "Introduction," in *Fantastic Art, Dada and Surrealism*, 13.

25
Hugnet, "In the Light of Surrealism," in ibid., 52.

26
On the versatility of surrealist aesthetics, see Roger Cardinal, "Surrealist Beauty," *Forum for Modern Language Studies* 9, no. 4 (1974): 348–56; Dawn Ades, *Dada and Surrealism* (London: Thames and Hudson, 1974); and Elizabeth Cowling, "An Other Culture," in Dawn Ades, ed., *Dada and Surrealism Reviewed*, exh. cat. (London: Arts Council of Great Britain, 1978), 450–68.

27
Crimp, "On the Museum's Ruins," 41–50; and Preziosi, *Rethinking Art History*, 21–79.

28
Preziosi, *Rethinking Art History*, 156–59.

29
L'Art brut, exh. cat. (Paris: Musée des Arts Décoratifs, 1967). See Jean Dubuffet, "L'Art brut préféré aux arts culturels," in Dubuffet, *Prospectus et tous écrits suivants* (Paris: Gallimard, 1967), vol. 1, 198–202; trans. Paul Foss and Allen S. Weiss as "Art Brut in Preference to the Cultural Arts," in *Art & Text*, 30–33.

30
Many examples could be cited; however, most familiar to the author is the curriculum of the University of California, Los Angeles, department of art history, which presently lists, in addition to specializations in the principal periods of Western art history, concentrations in African, Chinese, Indian, Islamic, Japanese, Native North American, Oceanic, pre-Columbian, and Southeast Asian art history; all students (graduate and undergraduate) are required to take courses in both Western and non-Western areas of study.

31
The history of this development is delineated in Impey and MacGregor, eds., *Origins of Museums*, 232–80. See also George Marcus and Michael Fischer, *Anthropology as Cultural Critique* (Chicago: University of Chicago Press, 1986); and Ivan Karp and Steven D. Lavine, eds., *Exhibiting Cultures: The Poetics and Politics of Museum Display*, especially the introduction, "Museums and Multiculturalism," 1–9.

32
William S. Rubin, ed., *"Primitivism" in Twentieth-Century Art: Affinity of the Tribal and the Modern*, 2 vols., exh. cat. (New York: Museum of Modern Art, 1984). More recently another MOMA exhibition, addressed to distinctions between fine art and popular culture, became cause for controversy among art historians, sociologists, and anthropologists: see Kirk Varnedoe and Adam Gopnik, *High and Low: Modern Art and Popular Culture*, exh. cat. (New York: Museum of Modern Art, 1990), which excluded tribal art, children's art, the art of the insane, visionary amateurs, and the artisanry of rural peoples. *October*, no. 56 (Spring 1991), is devoted solely to the *High and Low* exhibition and the issues arising out of it. Issues pertaining to "primitivism" may be found in James Clifford, "Of Other Peoples: Beyond the Salvage Paradigm," in Hal Foster, ed., *Discussions in Contemporary Culture: Number One* (Seattle: Bay Press, 1987), 121–30.

33
Jacques Derrida, *The Truth in Painting*, trans. Geoff Bennington and Ian MacLeod (Chicago: University of Chicago Press, 1987), from *La Vérité en peinture* (Paris: Flammarion, 1978), especially pt. 1, "Parergon," 15–82. See also Jacques Derrida, "The Principles of Reason: The University in the Eyes of its Pupils," *Diacritics* 13, no. 3 (Fall 1983): 3–20.

34
Preziosi, *Rethinking Art History*, 44–53 and 149–54.

35
See Michel Foucault, "What Is an Author?" in Donald F. Bouchard, ed., *Language, Counter-Memory, Practice: Selected Essays and Interviews with Michel Foucault* (Ithaca, New York: Cornell University Press, 1977), 113–38. A clear introduction to the work of Roland Barthes with respect to the contemporary "death of the author" may be found in Bjørnar Olsen, "Roland Barthes: From Sign to Text," in Christopher Tilley, ed., *Reading Material Culture* (Oxford: Basil Blackwell, 1990), 163–205.

36
See especially the essays by Roger Cardinal, Mark Gisbourne, and Sarah Wilson.

37
François Lyotard, *The Postmodern Condition: A Report on Knowledge*, trans. Geoff Bennington and Brian Massumi (Minneapolis: University of Minnesota Press, 1984), especially the appendix, "Answering the Question: What is Postmodernism?" 71–82.

38
Preziosi, "Modernity Again," discusses in detail the critical stagecraft of Sir John Soane's Museum, Lincoln's Inn Fields, London, which during the 1830s took up an oppositional stance with respect to the "art historicist" project of the newly installed British Museum across town in Bloomsbury. The latter's stagecraft is discussed in John Mordaunt Crook, *The British Museum: A Case-Study in Architectural Politics* (London: Allen Lane, 1972). A critical study of Soane's Museum is Susan Feinberg Millenson, *Sir John Soane's Museum* (Ann Arbor, Michigan: UMI Research Press, 1987), especially 129–50.

Checklist of the Exhibition

Aloïse
(Aloïse Corbaz)
SWITZERLAND,
1886–1964
:

Peinture et musique
(Painting and music)
1941
Sketchbook
19⁵/₁₆ x 13 in.
(49 x 33 cm)
Private collection
FIGURE 98

Bonaparte
c. late 1950s
Oil chalk on paper
27⁹/₁₆ x 19¹¹/₁₆ in.
(70 x 50 cm)
Private collection
FIGURE 139

Chalet gloire à dieu
(Chalet glory to God)
Graphite and crayon on
paper
13³/₄ x 10¹/₄ in.
(34.9 x 26 cm)
Sam and Betsey Farber
FIGURE 69

Mickens
Mixed media on paper
39³/₈ x 57¹/₂ in.
(100 x 146 cm)
Collection de l'Art Brut,
Lausanne
FIGURE 1

Gregory Amenoff
UNITED STATES,
BORN 1948
:

Santuario XVII
1989
Distemper on linen
56 x 50 in.
(142.2 x 127 cm)
Courtesy Stephen Wirtz
Gallery, San Francisco,
California
FIGURE 211

Center panel of *Altarpiece
for St. Peter's Church*
1990
Rabbitskin glue and pure
pigment on board
100 x 100 in.
(254 x 254 cm)
Hirschl & Adler Modern and
the artist
FIGURE 212

Karel Appel
NETHERLANDS,
BORN 1921
:

Drift op zolder
(Passion in the attic)
1947
Mixed media
62⁵/₈ x 23¹/₄ in.
(159 x 59 cm)
Karel van Stuijvenberg
FIGURE 110
Los Angeles only

Psychopathological Art
1947–50
Portfolio of 137 drawings
Graphite and ink on paper
Dimensions vary
Collection of the artist
FIGURES 111–12

Arbre
(Tree)
1949
Oil on wood
36 x 24 in.
(91.4 x 61 cm)
Collection of the artist
FIGURE 108

Enfant avec âne
(Child with donkey)
1949
Oil on canvas
27¹/₂ x 61 in.
(70 x 155 cm)
Collection of the artist
FIGURE 109

Antonin Artaud
FRANCE,
1896–1948
:

Le Totem
(The totem)
1945
Pencil and colored chalk
on paper
24¹³/₁₆ x 18⁷/₈ in.
(63 x 48 cm)
Musée Cantini, Marseille
Figure 245

Exécration du père-mère
(Execration of the father-
mother)
1946
Pencil and colored chalk on
paper
25¹/₂ x 19¹/₂ in.
(64.7 x 49.4 cm)
Musée National d'Art
Moderne, Centre Georges
Pompidou, Paris
FIGURE 244
Los Angeles only

Auto-portrait
(Self-portrait)
1947
Pencil and colored chalk on
paper
21⁵/₈ x 17³/₄ in.
(55 x 45 cm)
Private collection, Brussels
FIGURE 92
Los Angeles, Madrid, and
Basel

Portrait de Jacques Crevel
(Portrait of Jacques Crevel)
1947
Crayon and stumping
on paper
22⁵/₈ x 18 in.
(57.4 x 45.6 cm)
Musée National d'Art
Moderne, Centre Georges
Pompidou, Paris
FIGURE 2
Los Angeles only

Donald Baechler
UNITED STATES,
BORN 1956
:

Holiday in Cambodia II
1985
Acrylic, cotton, lace, and
Rhoplex on canvas
111 x 66 in.
(281.9 x 167.6 cm)
Collection of the artist
FIGURE 210

Untitled
1985
Acrylic, muslin, and Rhoplex
on canvas
64 x 64 in.
(162.6 x 162.6 cm)
James and Alexandra Brown
FIGURE 209

Georg Baselitz
GERMANY,
BORN 1938
:

Untitled, from the
Peitschenfrau (Whipwoman)
series
1964
Pencil on paper
24¹/₂ x 19¹/₄ in.
(62.2 x 49 cm)
Collection of Matthew
Marks, New York
FIGURE 171

Weisshaariger Mann
(White-haired man)
1983
Oil on canvas
98³/₈ x 78⁵/₈ in.
(249.9 x 199.7 cm)
Toni and Martin Sosnoff
FIGURE 174
Los Angeles only

: 246 :
Roger Brown
Jonestown, 1980

: 247 :
Roger Brown
Houses on Hillside, 1987

Hans Bellmer
GERMANY,
ACTIVE FRANCE,
1902–75
:
La Poupée
(The doll)
1936, cast 1965
Painted aluminum
19⅛ x 10⅝ x 14⅞ in.
(48.6 x 27 x 37.8 cm)
The Museum of Modern Art,
New York, the Sidney and
Harriet Janis Collection,
1967
FIGURE 83
Los Angeles only

*La Mitrailleuse
en état de grace*
(Machine gun in a
state of grace)
1937
Gelatin-silver print with oil
and watercolor
25½ x 25½ in.
(64.8 x 64.8 cm)
San Francisco Museum of
Modern Art, gift of Foto
Forum
FIGURE 87

La Toupie
(The top)
1956
Oil on board
25⅝ x 25⅝ in.
(65.1 x 65.1 cm)
Didier Imbert Fine Art,
Neuchâtel
FIGURE 85

Tête rose
(Rose head)
1965
Chalk on paper
22¹³⁄₁₆ x 18⅞ in.
(58 x 48 cm)
Kirk Edward Long
Collection
FIGURE 86

Christian Boltanski
FRANCE,
BORN 1942
:
Reliquaire
(Reliquary)
1989
Photographs, wire, electric
lamps, metal boxes, and
cloth
131 x 54½ x 27¼ in.
(332.7 x 138.4 x 69.2 cm)
Los Angeles County
Museum of Art, Modern and
Contemporary Art Council
Fund
FIGURE 208

Jonathan Borofsky
UNITED STATES,
BORN 1944
:
Counting from 1 to Infinity
Begun in 1969
Stacked sheets of paper
32 x 8½ x 11 in.
(81.3 x 21.6 x 27.9 cm)
Collection of the artist and
courtesy of the Paula
Cooper Gallery, New York
FIGURE 203

Victor Brauner
ROMANIA,
ACTIVE FRANCE,
1903–66
:
Oh! saisons, oh! châteaux
(Oh! seasons, oh! castles)
1945
Wax on cardboard
13 x 9½ in.
(33 x 24 cm)
Musée d'Art Moderne, Saint
Etienne
FIGURE 89

Tout terriblement
(Completely terribly)
1948
Oil on canvas
36¼ x 28¾ in.
(92 x 73 cm)
Maurice Weinberg, Paris
FIGURE 90
Los Angeles, Madrid, and
Basel

Karl Brendel
(Karl Genzel)
GERMANY,
1871–1925
:

Untitled
(Figure with hat)
c. 1920
Wood
9⁷⁄₁₆ x 5⅛ x 5⅛ in.
(24 x 13 x 13 cm)
Westfälische Klinik für
Psychiatrie Lippstadt
FIGURE 3

Frau mit dem Storch / Jesus
(Woman with stork / Jesus)
Wood
7³⁄₁₆ x 4¹³⁄₁₆ x 1⅛ in.
(18.3 x 12.2 x 2.8 cm)
Prinzhorn Collection,
University Psychiatric
Clinic, Heidelberg
FIGURE 58

Kirche
(Church)
Wood and pigment
10⅞ x 7¼ x 5½ in.
(27.7 x 18.5 x 14 cm)
Prinzhorn Collection,
University Psychiatric
Clinic, Heidelberg
FIGURE 72

Mann und Frau mit Hobel
und Massstab
(Man and woman with
plane and ruler)
Wood
11¹³⁄₁₆ x 3 x 2½ in.
(30 x 7.5 x 6.5 cm)
Prinzhorn Collection,
University Psychiatric
Clinic, Heidelberg
FIGURE 173

Untitled
Wood
5½ x 3¹⁵⁄₁₆ x ⅜ in.
(14 x 10 x 1 cm)
Prinzhorn Collection,
University Psychiatric
Clinic, Heidelberg
FIGURE 4

André Breton
FRANCE,
1896–1966
:

Jack l'Eventreur
(Jack the Ripper)
1942
Mixed media
18 x 14 in.
(45.7 x 35.6 cm)
Timothy Baum, New York
FIGURE 67

Roger Brown
UNITED STATES,
BORN 1941
:

Contrail Crucifix
1975
Oil on canvas with
tramp art frame
61 x 48½ in.
(154.9 x 123.2 cm)
Richard S. Rosenzweig and
Judy Henning
FIGURE 146

Jonestown
1980
Oil on canvas
72 x 72 in.
(182.9 x 182.9 cm)
Private collection
FIGURE 246

Houses on Hillside
1987
Oil on canvas
48 x 72 in.
(121.9 x 182.9 cm)
Jeanne and Richard Levitt
FIGURE 247

Carlo
(Carlo Zinelli)
ITALY,
1916–74
:

Untitled [double-sided work]
Tempera on paper
36 x 20 in.
(91.4 x 50.8 cm)
Dudley E. Morris
FIGURES 5, 238

Untitled [double-sided work]
Tempera on paper
27½ x 20 in.
(69.9 x 50.8 cm)
Albert J. Petcavage
FIGURES 236–37

Case 411
GERMANY, ?
:

Auf Erden im Himmel
(On earth in heaven)
c. 1921
Watercolor on paper
4¹¹⁄₁₆ x 6⅞ in.
(11.9 x 17.5 cm)
Prinzhorn Collection,
University Psychiatric
Clinic, Heidelberg
FIGURE 6

Bilder im Tal
(Paintings in the valley)
Watercolor on paper
4¹¹⁄₁₆ x 6⅞ in.
(11.9 x 17.5 cm)
Prinzhorn Collection,
University Psychiatric
Clinic, Heidelberg
FIGURE 7

Gaston Chaissac
FRANCE,
1910–64
:

Animal
1938
India ink on paper
7⅞ x 9⁷⁄₁₆ in.
(20 x 24 cm)
Musée de l'Abbaye Sainte-
Croix, Les Sables d'Olonne
FIGURE 106

Le Samouraï
(The samurai)
1947
Tempera on paper on canvas
25⅝ x 19¹¹⁄₁₆ in.
(65 x 50 cm)
Galerie Messine, Paris
FIGURE 103

Tête archaique
(Archaic head)
1947–50
Tree root
9 x 7¹⁄₁₆ x 3⁹⁄₁₆ in.
(23 x 18 x 9 cm)
Collection of Madame
Jakovsky
FIGURE 8

Composition abstraite
(Abstract composition)
1954
Oil on stone
18⅝ x 24¼ in.
(47.4 x 61.5 cm)
Collection of Dr. Peter
Nathan, Zurich
FIGURE 104

Bouffon
(Clown)
1958
Oil on paper and wood
20⅛ x 8½ in.
(51 x 21.5 cm)
Kristin and Helmut Zambo,
courtesy Galerie Heike
Curtze, Düsseldorf and
Vienna
FIGURE 101

Moins qu'on croit
(Less than one thinks)
1961
Oil on wood
83⅞ x 12⁹⁄₁₆ x 3 in.
(213 x 32 x 7.5 cm)
Collection of Barbara
Nathan, Zurich
FIGURE 105

Ferdinand Cheval
FRANCE,
1836–1924
:

Palais idéal (Ideal palace)
Hauterives, France
1879–1912
Mixed media in landscape
FIGURE 9

Joseph Crépin
FRANCE,
1875–1948
:

Temple
1941
Oil on canvas
21¼ x 28 in.
(54 x 71 cm)
Musée National d'Art
Moderne, Centre Georges
Pompidou, Paris, gift of
Mme Brauner
FIGURE 91

Composition No. 10
1948
Oil on canvas
24¹³⁄₁₆ x 31⅞ in.
(63 x 81 cm)
Edouard Malingue
FIGURE 68

Painting No. 41
1948
Oil on canvas
22⁷⁄₁₆ x 27½ in.
(57 x 70 cm)
Galerie von Bartha
FIGURE 10

Salvador Dalí
SPAIN,
1904–89
:

Senicitas
1927–28
Oil on wood
25³⁄₁₆ x 18⅞ in.
(64 x 48 cm)
Museo Nacional Reina Sofía,
Madrid
FIGURE 81
Los Angeles, Madrid, and
Basel

Le Simulacre du jour
(Semblance of the day)
1930
Oil on linen
19½ x 25³⁄₁₆ in.
(49.5 x 64 cm)
Perls Galleries, New York
FIGURE 82

La Charrette fantôme
(The phantom cart)
1933
Oil on wood
6¼ x 8⅝ in.
(15.9 x 21.9 cm)
Yale University Art Gallery,
gift of Thomas F. Howard
FIGURE 80
Los Angeles only

: 248 :
Jean Dubuffet
L'Accouchement (Childbirth), 1944

: 249 :
Jean Dubuffet
Tête au fort menton (Head with a
strong chin), 1951

: 250 :
Jean Dubuffet
L'Effacement des souvenirs
(The effacement of memories), 1957

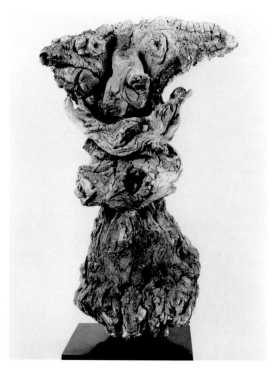

: 251 :
Jean Dubuffet
Le Vieux de la plage
(The old man of the sea), 1959

Henry Darger
UNITED STATES,
1892–1973
:

At Ressurrecteaction Run
Mixed media on paper
17³⁄₄ x 25⁵⁄₈ in.
(45.1 x 65.1 cm)
Collection of Robert M.
Greenberg
FIGURE 11

*The Blengiglomenean Called
a Crimerceïan Venemous*
Mixed media on paper
19 x 24 in.
(48.3 x 61 cm)
Sam and Betsey Farber
FIGURE 231

Untitled [double-sided work]
Mixed media on paper
19 x 49 in.
(48.3 x 124.5 cm)
Nathan Lerner
FIGURE 229

Untitled [double-sided work]
Mixed media on paper
22 x 89 in.
(55.9 x 226.1 cm)
Nathan Lerner
FIGURE 230

Untitled [double-sided work]
Mixed media on paper
24 x 107 in.
(61 x 271.8 cm)
Nathan Lerner
FIGURE 228

Jim Dine
UNITED STATES,
BORN 1935
:

Shoes Walking on My Brain
1960
Oil, cloth, and leather
40 x 36 x 6 in.
(101.6 x 91.4 x 15.2 cm)
Sonnabend Collection
FIGURE 192

*Artaud at the Rodez
Sanatorium*
1966
Watercolor and collage
4 panels, each 24³⁄₈ x 18 in.
(62 x 46 cm)
Galerie de France
FIGURE 193

Jean Dubuffet
FRANCE,
1901–85
:

L'Accouchement
(Childbirth)
1944
Oil on canvas
39⁵⁄₈ x 31³⁄₄ in.
(100 x 80.6 cm)
The Museum of Modern Art,
New York, gift of Pierre
Matisse in memory of
Patricia Kane Matisse, 1982
FIGURE 248
Los Angeles only

Tête au fort menton
(Head with a strong chin)
1951
Oil on canvas
46 x 35 in.
(116.8 x 88.9 cm)
Los Angeles County
Museum of Art, bequest of
David E. Bright
FIGURE 249

L'Effacement des souvenirs
(The effacement of
memories)
1957
Oil on canvas
35 x 46 in.
(88.9 x 116.8 cm)
Los Angeles County
Museum of Art, bequest of
David E. Bright
FIGURE 250

Le Vieux de la plage
(The old man of the sea)
1959
Driftwood
13³⁄₈ x 8 x 4¹⁄₄ in.
(34 x 20.3 x 10.8 cm)
Milly and Arne Glimcher
FIGURE 251
Los Angeles only

Le Dandy
(The dandy)
1973
Cast polyurethane and epoxy
paint
35⁷⁄₁₆ x 20¹⁄₄ x 7¹⁄₂ in.
(90 x 51.5 x 19 cm)
William Beadleston Fine Art,
New York
FIGURE 102
Los Angeles only

Norris Embry
UNITED STATES,
1921–81
:

Untitled (Wrote Gertie for
the Prinzhorn)
1979
Oil stick, watercolor, and ink
on paper
18 x 24 in.
(45.7 x 61 cm)
Norris Embry Estate
FIGURE 252

Max Ernst
GERMANY,
1891–1976
:

*Max Ernst, oeuvres de 1919 à
1936*
(Max Ernst, works from
1919 to 1936)
1937
Book
12⁵⁄₈ x 9³⁄₄ in.
(32.1 x 24.8 cm)
Los Angeles County
Museum of Art, Mr. and Mrs.
Allan C. Balch Art Research
Library
NOT ILLUSTRATED

Le Facteur Cheval
(The Postman Cheval)
1929–30
Paper and fabric collage with
pencil, ink, and gouache on
paper
25³⁄₈ x 19¹⁄₄ in.
(64.5 x 48.9 cm)
Peggy Guggenheim
Collection, Venice (Solomon
R. Guggenheim Foundation)
FIGURE 76
Los Angeles only

Moonmad
Cast 1956 after
1944 wood original
Bronze
38¹⁄₂ x 14 x 13¹⁄₂ in.
(97.8 x 35.6 x 34.3 cm)
Frederick Weisman
Company, Los Angeles,
California
FIGURE 77

Le Monde des naïfs
(The world of the naive)
1965
Oil on canvas
45⁷⁄₈ x 35¹⁄₄ in.
(116.5 x 89.5 cm)
Musée National d'Art
Moderne, Centre Georges
Pompidou, Paris
FIGURE 78

Howard Finster
UNITED STATES,
BORN 1916
:

A House Divided
1977
Enamel on wood
24 x 42¹⁄₂ in.
(61 x 108 cm)
Phyllis Kind, New York
FIGURE 204

The Earth Will Break Apart
1979
Enamel on sheet metal
15³⁄₄ x 21³⁄₈ in.
(40 x 54.3 cm)
Andy Nasisse
FIGURE 214

: 252 :
Norris Embry
Untitled (Wrote Gertie for the
Prinzhorn), 1979

*Howard Looks upon a
Piece of a Planet*
1982
Enamel and glitter on wood
51 x 31¹⁄₄ in.
(129.5 x 79.4 cm)
Barbara Orbison; courtesy
Outside-in Gallery, Los
Angeles
FIGURE 12

Madge Gill
ENGLAND,
1882–1961
:

Untitled
1926
Ink on fabric
99 x 30 in.
(251.5 x 76.2 cm)
Sam and Betsey Farber
FIGURE 223

Woman and Staircase
1951
Ink on board
24¹⁄₄ x 19³⁄₄ in.
(61.6 x 50.2 cm)
Passmore Edwards Museum
Service, London Borough of
Newham
FIGURE 13

Figure in Geometrical Setting
1954
Colored ink on board
24¹⁄₄ x 19³⁄₄ in.
(61.6 x 50.2 cm)
Passmore Edwards Museum
Service, London Borough of
Newham
FIGURE 222

: 253 :
Joseph Glasco
Big Head #1, 1951

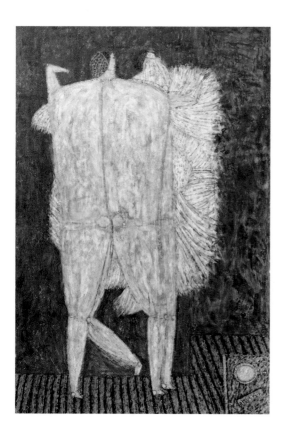

: 254 :
Joseph Glasco
Leda, 1956

Star
Colored ink on board
20 x 20 in.
(50.8 x 50.8 cm)
Passmore Edwards Museum
Service, London Borough of
Newham
FIGURE 224

Joseph Glasco
UNITED STATES,
BORN 1925
:
Big Head #1
1951
Oil on canvas
76 x 50 in.
(193 x 127 cm)
Fayez Sarofim Collection
FIGURE 253

Leda
1956
Oil on paper
59 x 39½ in.
(149.9 x 100.3 cm)
Private collection
FIGURE 254

Paul Goesch
GERMANY,
1885–1940
:
Kopf mit Farbteilung
(Head with colored pattern)
Watercolor and pencil on paper
8 x 6½ in.
(20.5 x 16.5 cm)
Berlinische Galerie, Berlin
FIGURE 14
Los Angeles and Madrid

Kopf mit Schachbretteilung
(Head with checkerboard
pattern)
Watercolor on paper
14³/₁₆ x 10³/₈ in.
(36 x 26.3 cm)
Berlinische Galerie, Berlin
NOT ILLUSTRATED
Basel and Tokyo

Phantasie III
(Fantasy III)
Watercolor on paper
8¹³/₁₆ x 11⅛ in.
(22.4 x 28.3 cm)
Berlinische Galerie, Berlin
NOT ILLUSTRATED
Basel and Tokyo

Traum eines Kindes
(Child's dream)
Ink on paper
9 x 8⅞ in.
(23 x 22.5 cm)
Berlinische Galerie, Berlin
FIGURE 15
Los Angeles and Madrid

Traumphantasie
(Dream fantasy)
Tempera and pencil on paper
6½ x 8⅛ in.
(16.5 x 20.6 cm)
Prinzhorn Collection,
University Psychiatric
Clinic, Heidelberg
FIGURE 170

Leon Golub
UNITED STATES,
BORN 1922
:
In-Self III
("Anchovie Man" II)
1953
Oil on canvas
35 x 24 in.
(88.9 x 61 cm)
Josh Baer Gallery, New York
FIGURE 119

In-Self IV
1954
Oil on canvas
42 x 33 in.
(106.7 x 83.8 cm)
Josh Baer Gallery, New York
FIGURE 120

Red Grooms
UNITED STATES,
BORN 1937
:
Police Woman
1959
Wood, metal, and paint
45 x 32 x 5½ in.
(114.3 x 81.3 x 14 cm)
The David and Becky
Anderson Collection, State
University of New York at
Buffalo
FIGURE 198

Lumberjack
1977–1984
Painted bronze
99 x 47 x 18 in.
(251.5 x 119.4 x 45.7 cm)
Courtesy Marlborough
Gallery, Inc., New York
FIGURE 199

Johann Hauser
CZECHOSLOVAKIA,
ACTIVE AUSTRIA,
BORN 1926
:
Frau, 9.8.66
(Woman, 9.8.66)
1966
Pencil, wax crayons, and
colored pencils on paper
17⁵/₁₆ x 12³/₁₆ in.
(44 x 31 cm)
Städtische Galerie im
Lenbachhaus, Munich
FIGURE 165

Frau mit Eule und Mond
(Woman with owl and
moon)
1974
Pencil and crayon on paper
15¾ x 11¹³/₁₆ in.
(40 x 30 cm)
Heinz Kammerer
FIGURE 16

Hubschrauber und Feuer
(Helicopter and fire)
1982
Pencil and colored pencil on
paper
11¹³/₁₆ x 15¾ in.
(30 x 40 cm)
Sam and Betsey Farber
FIGURE 162

George Herms
UNITED STATES,
BORN 1935
:
The Bomb Scare Box
1976
Mixed media
6¹⁵/₁₆ x 31 x 3⅛ in.
(17.6 x 78.7 x 7.9 cm)
Los Angeles County
Museum of Art, gift of
Barry Lowen
FIGURE 182

Carl Fredrik Hill
SWEDEN,
1849–1911
:

August Strindberg
Charcoal and pencil on
paper
16⅚₁₆ x 13⅜ in.
(41.5 x 34 cm)
Konstmuseet Malmö
FIGURE 18

Untitled
Charcoal and colored chalk
on paper
13⅜ x 8¼ in.
(34 x 21 cm)
Konstmuseet Malmö
FIGURE 17

Untitled
Bronze, gold, and silver
on paper
12 x 14⅜ in.
(30.5 x 36.5 cm)
Konstmuseet Malmö
FIGURE 167

Untitled
Black chalk on paper
6¹¹⁄₁₆ x 8⅜ in.
(17 x 21.3 cm)
Private collection
FIGURE 19

Untitled
Colored chalk on paper
7³⁄₁₆ x 8⅞ in.
(18.2 x 22.6 cm)
Private collection
FIGURE 20

Jess
(Jess Collins)
UNITED STATES,
BORN 1923
:

Love's Captives
1954
Collage on paper
14 x 18¼ in.
(35.6 x 46.4 cm)
The Estate of Robert
Duncan
FIGURE 181

Paul Klee
SWITZERLAND,
1879–1940
:

Narretei
(Buffoonery)
1922
Pencil on paper
9⅛ x 6⅝ in.
(23.2 x 16.8 cm)
E. W. Kornfeld, Bern
FIGURE 55

Narretei
(Buffoonery)
1922
Lithograph
7⅝ x 6⁵⁄₁₆ in.
(19.4 x 16 cm)
Paul-Klee-Stiftung,
Kunstmuseum Bern
FIGURE 56
Los Angeles and Madrid

Der wilde Mann
(The wild man)
1922
Colored pencil on paper,
mounted on cardboard
15¾ x 11 in.
(40 x 27.9 cm)
Mr. and Mrs. James R.
Foster, Chicago, Illinois
FIGURE 57
Los Angeles only

*Bauchredner und Rufer
im Moor*
(Ventriloquist: caller in
the moor)
1923
Watercolor and transferred
printing ink on paper,
bordered with ink
15¼ x 11 in.
(38.7 x 27.9 cm)
The Metropolitan Museum
of Art, New York, the
Berggruen Klee Collection,
1984
FIGURE 59
Los Angeles only

Seiltänzer
(Tightrope walker)
1923
Lithograph
17½ x 10½ in.
(44.5 x 26.7 cm)
Mills College Art Gallery
FIGURE 255

Der Verliebte
(The one in love)
1923
Color lithograph
10¾ x 7½ in.
(27.4 x 19 cm)
E. W. Kornfeld, Bern
FIGURE 54

*Abenteuer zwischen
Kurl und Kamen*
(Adventure between
Kurl and Kamen)
1925
Pen and ink on paper,
mounted on cardboard
12⅛ x 6¹¹⁄₁₆ in.
(30.8 x 17 cm)
Dian and Andrea Woodner
FIGURE 60

Johann Knüpfer
(Johann Knopf)
GERMANY,
1866–1910
:

Untitled
Pencil, ink, and Conté
crayon on paper
8¼ x 13 in.
(20.9 x 32.9 cm)
Prinzhorn Collection,
University Psychiatric
Clinic, Heidelberg
FIGURE 21

Alfred Kubin
GERMANY,
1877–1959
:

*Die Symbole von Leben
und Sterben*
(The symbols of life
and death)
1923
Ink with watercolor on
paper
15⅝ x 12⁵⁄₁₆ in.
(39.7 x 31.3 cm)
Städtische Galerie im
Lenbachhaus, Munich
FIGURE 63

Leuchtfisch
(Fish of light)
Tempera on paper
12³⁄₁₆ x 17⅜ in.
(30.9 x 44.2 cm)
Graphische Sammlung
ALBERTINA, Vienna, Austria
FIGURE 61
Los Angeles and Madrid

Vision
Tempera on paper
9¼ x 12⅜ in.
(23.8 x 31.5 cm)
Graphische Sammlung
ALBERTINA, Vienna, Austria
FIGURE 62
Los Angeles and Madrid

Augustin Lesage
FRANCE,
1876–1954
:

Untitled
1912
Colored pencil, graphite, and
pastel on paper
20½ x 13⅞ in.
(52 x 35.2 cm)
Institut Métapsychique
International, Paris, on loan
to the Musée de Béthune
FIGURE 22
Los Angeles and Madrid

Untitled
1912
Pastel and colored pencil on
paper
14³⁄₁₆ x 20½ in.
(36 x 52 cm)
Institut Métapsychique
International, Paris, on loan
to the Musée de Béthune
NOT ILLUSTRATED
Basel and Tokyo

Composition symbolique
(Symbolic composition)
1928
Oil on canvas
55½ x 42⅞ in.
(141 x 109 cm)
Musée de Béthune
FIGURE 64

*Composition symbolique sur les
vestiges d'un grand passé*
(Symbolic composition on
the vestiges of a great past)
c. 1937
Oil on canvas
48 x 36 in.
(121.9 x 91.4 cm)
Phyllis Kind Gallery
FIGURE 93

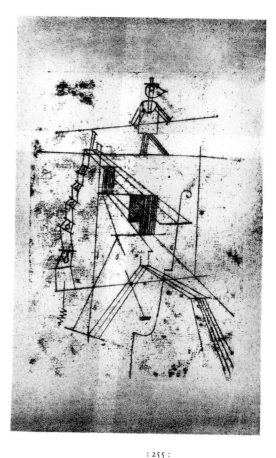

: 255 :
Paul Klee
Seiltänzer (Tightrope walker), 1923

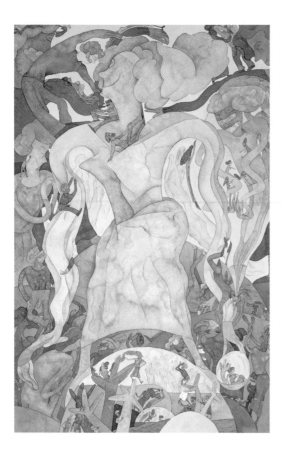

: 256 :
Gladys Nilsson
Gladalupay, 1977

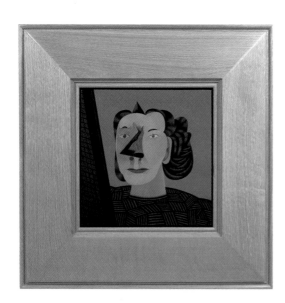

: 257 :
Jim Nutt
Fret, 1990

Richard Lindner
GERMANY,
ACTIVE
UNITED STATES,
1901–78
:
The Meeting
1953
Oil on canvas
60 x 72 in.
(152.4 x 182.9 cm)
The Museum of Modern Art,
New York, given
anonymously, 1962
FIGURE 117
Los Angeles, Madrid, and
Basel

**Heinrich Hermann
Mebes**
GERMANY,
1842–?
:
"Samuel hilf!"
("Samuel help!")
Gouache over pencil and ink
on paper
4⅞ x 6⅛ in.
(12.3 x 15.5 cm)
Prinzhorn Collection,
University Psychiatric
Clinic, Heidelberg
FIGURE 26

Ein Vienedig im Dunkeln
(Venice in the dark)
Gouache over pencil and ink
on paper
5½ x 6⅛ in.
(14 x 15.5 cm)
Prinzhorn Collection,
University Psychiatric
Clinic, Heidelberg
FIGURE 23

Untitled
(Easter peace)
Gouache over pencil and ink
on paper
5⅛ x 4⅞ in.
(13 x 12.4 cm)
Prinzhorn Collection,
University Psychiatric
Clinic, Heidelberg
FIGURE 25

Untitled
(Peace of life)
Gouache over pencil on
paper
5⅞ x 7 in.
(14.9 x 17.7 cm)
Prinzhorn Collection,
University Psychiatric
Clinic, Heidelberg
FIGURE 24

Untitled
(Sin of the mad)
Gouache over pencil on
paper
6½ x 4 in.
(16.5 x 10.3 cm)
Prinzhorn Collection,
University Psychiatric
Clinic, Heidelberg
FIGURE 27

Untitled
(Zeitgeist)
Gouache over pencil and ink
on paper
6½ x 4⁵⁄₁₆ in.
(16.5 x 11 cm)
Prinzhorn Collection,
University Psychiatric
Clinic, Heidelberg
FIGURE 28

Annette Messager
FRANCE,
BORN 1943
:
Pièce montée, no. 2
1986
Acrylic and oil on gelatin-
silver print mounted on
canvas
104⁵⁄₁₆ x 32¹¹⁄₁₆ in.
(265 x 83 cm)
Courtesy of Galerie
Crousel-Robelin BAMA,
Paris, and the artist
FIGURE 207

**Heinrich Anton
Müller**
SWITZERLAND,
1865–1930
:
Un Barry
Pencil and chalk
32¹¹⁄₁₆ x 21¹¹⁄₁₆ in.
(83 x 55 cm)
Kunstmuseum Bern
FIGURE 100
Los Angeles and Madrid

"Mon Cochon s'appelle Rafi"
("My pig is named Rafi")
Chalk and ink over pencil on
cardboard
32 x 52⅜ in.
(81.5 x 133 cm)
Kunstmuseum Bern
NOT ILLUSTRATED
Basel and Tokyo

*Personnage avec chèvre et
grenouille*
(Figure with goat and frog)
Black and white chalk over
pencil on cardboard
31½ x 21⅞ in.
(80 x 55.5 cm)
Kunstmuseum Bern
NOT ILLUSTRATED
Basel and Tokyo

Rops a mante, biscaume
Chalk, pen, and ink over
pencil on cardboard
30⁵⁄₁₆ x 39 in.
(77 x 99 cm)
Kunstmuseum Bern
FIGURE 29
Los Angeles and Madrid

Tête avec animal
(Head with animal)
Gouache, chalk, and pencil
on cardboard
31⅛ x 17¾ in.
(79.1 x 45 cm)
Kunstmuseum Bern
NOT ILLUSTRATED
Basel and Tokyo

Tête d'homme
(Head of a man)
Gouache, chalk, and pencil
31⁵⁄₁₆ x 17½ in.
(79.5 x 44.5 cm)
Kunstmuseum Bern
FIGURE 137
Los Angeles and Madrid

**J. B. Murry
(John B. Murry
or Murray)**
UNITED STATES,
1908–88
:

Untitled
Watercolor, pen, and marker
on paper
14 x 10¼ in.
(35.6 x 26 cm)
Andy Nasisse
FIGURE 213

Untitled
Mixed media with silver-
metallic ink on paper
23¾ x 17¾ in.
(60.4 x 45.1 cm)
Collection of Jonathan
Williams
FIGURE 32

Untitled
Mixed media on paper
11¾ x 8⅞ in.
(29.8 x 22.5 cm)
Collection of Dan and Janis
Connally
FIGURE 31

Untitled
Mixed media on paper
18 x 12 in.
(45.7 x 30.5 cm)
Dr. William Rawlings, Jr.,
Sandersville, Georgia
FIGURE 30

Andy Nasisse
UNITED STATES,
BORN 1946
:

Untitled
1989
Ceramic
Height: 119 in.
Diameter: 26 in.
(302.3 x 66 cm)
Andy Nasisse
FIGURE 215

Walter Navratil
AUSTRIA,
BORN 1950
:

Nocturne
1986
Oil on canvas
43⁵⁄₁₆ x 51³⁄₁₆ in.
(110 x 130 cm)
Heinz Kammerer
FIGURE 202

Pastorale
(Pastoral)
1987
Oil on canvas
70⅞ x 31½ in.
(180 x 80 cm)
Patricia Kahane
FIGURE 200

Gürteltier auf der Flucht
(Armadillo driving away)
1991
Oil on canvas
25⅝ x 31½ in.
(65 x 80 cm)
Private collection, Vienna
FIGURE 201

**August Neter
(August Natterer)**
GERMANY,
1868–1933
:

Antipapst
(Antipope)
c. 1917
Watercolor over pencil on
paper
10¼ x 8 in.
(26.1 x 20.4 cm)
Prinzhorn Collection,
University Psychiatric
Clinic, Heidelberg
FIGURE 154

Wunder-Hirthe
(Miraculous shepherd)
Before 1919
Watercolor over pencil on
cardboard
9⅝ x 7½ in.
(24.5 x 19.5 cm)
Prinzhorn Collection,
University Psychiatric
Clinic, Heidelberg
FIGURE 33

Wunder-Hirthe
(Miraculous shepherd)
Before 1919
Pencil on paper
9½ x 7¹¹⁄₁₆ in.
(24.4 x 19.5 cm)
Prinzhorn Collection,
University Psychiatric
Clinic, Heidelberg
FIGURE 75

Hexenkopf
(Witch's head)
Pencil, watercolor, and ink
on cardboard
12¹³⁄₁₆ x 16 in.
(32.5 x 40.5 cm)
Prinzhorn Collection,
University Psychiatric
Clinic, Heidelberg
FIGURE 79

Gladys Nilsson
UNITED STATES,
BORN 1940
:

Stompin' at the Snake Pit
1968
Watercolor on paper
22 x 30 in.
(55.9 x 76.2 cm)
Richard D. Christiansen
FIGURE 140

Gladalupay
1977
Watercolor on paper
40¼ x 25⅞ in.
(102.2 x 65.7 cm)
Claude Nutt
FIGURE 256

Jim Nutt
UNITED STATES,
BORN 1938
:

Smooth Sailing
1970
Acrylic on metal
46¾ x 36 in.
(118.8 x 91.4 cm)
Nancy N. Carroll
FIGURE 134

Excuse Me (a Touch Surprised)
1974
Acrylic on wood and canvas,
covered with papier-mâché
30⅜ x 23⅜ in.
(77.2 x 59.4 cm)
Milwaukee Art Museum, gift
of Herbert H. Kohl
Charities, Inc.
FIGURE 136

*I'd Rather Stay (on the Other
Hand)*
1975
Acrylic on canvas in wood
frame
49 x 43 in.
(124.5 x 109.2 cm)
Private collection
FIGURE 143

Fret
1990
Acrylic on canvas with wood
frame
26 x 26 in.
(66 x 66 cm)
Collection of Mark and Judy
Bednar, Chicago
FIGURE 257

Claes Oldenburg
SWEDEN,
ACTIVE
UNITED STATES,
BORN 1929
:

*Strange Eggs, v— "screams
climb ladders . . ."*
1957
*Strange Eggs, xi— "sandpaper
and thorns . . ."*
1957
*Strange Eggs, xiv— "this grey
star/is it Pittsburgh . . ."*
1957
*Strange Eggs, xxi— "now a
lionous moon . . ."*
1957
Paper clippings on board
14¼ x 11 in. each
(36.2 x 27.9 cm)
Collection of Claes
Oldenburg and Coosje
van Bruggen, New York
FIGURE 258

*Drawing for the announce-
ment of The Street at Reuben
Gallery, New York*
1960
Ink and torn newspaper on
paper
13¾ x 10 in.
(34.9 x 25.4 cm)
Collection of Claes
Oldenburg and Coosje
van Bruggen, New York
FIGURE 196

Ray Gun Poster
1961
Sprayed oil wash on torn
paper
24 x 18 in.
(61 x 45.7 cm)
Collection of Claes
Oldenburg and Coosje
van Bruggen, New York
FIGURE 197

**Viktor Orth
(Clemens
von Oertzen)**
GERMANY,
1853–1919
:

Untitled
1901
Watercolor on paper
13 x 16⁷⁄₁₆ in.
(32.9 x 41.8 cm)
Prinzhorn Collection,
University Psychiatric
Clinic, Heidelberg
FIGURE 36

Untitled
Pencil and watercolor on
paper
10⅛ x 8¾ in.
(25.7 x 22.3 cm)
Prinzhorn Collection,
University Psychiatric
Clinic, Heidelberg
FIGURE 37

Untitled
Watercolor on paper
8¹¹⁄₁₆ x 11⁹⁄₁₆ in.
(22 x 29.4 cm)
Prinzhorn Collection,
University Psychiatric
Clinic, Heidelberg
FIGURE 35

318

Check
list
of
the
Exhib
ition

Untitled
Watercolor on paper
8¹¹/₁₆ x 11⁹/₁₆ in.
(22 x 29.4 cm)
Prinzhorn Collection,
University Psychiatric
Clinic, Heidelberg
FIGURE 34

Alfonso Ossorio
PHILIPPINES,
ACTIVE
UNITED STATES,
1916–90
:

Klan Picnic
1949
Gouache on paper mounted
on board
40 x 60 in.
(101.6 x 152.4 cm)
Edward F. Dragon
FIGURE 113

Astonished Mother
1950
Wax, watercolor, gouache,
and ink on paper
30 x 22 in.
(76.2 x 55.9 cm)
Los Angeles County
Museum of Art, promised
gift of Eleanor and Max Baril
and purchased with funds
provided by George Cukor
FIGURE 114

Rose Mother
1951
Ink, wax, watercolor, and
gouache on paper
32⁵/₁₆ x 24 in.
(82 x 61 cm)
Collection de l'Art Brut,
Lausanne
FIGURE 115

Thee and Thy Shadow
1961, reworked 1966
Plastic and mixed media on
plywood
96 x 48 in.
(243.8 x 121.9 cm)
Edward F. Dragon
FIGURE 118

Feast and Famine
1966
Plastic and mixed media on
wood
Diameter: 56 in.
(142.2 cm)
Los Angeles County
Museum of Art, gift
of Frederick E. and
Siena H. Ossorio
FIGURE 259

A. R. Penck
GERMANY,
BORN 1939
:

Kreuz
(Cross)
1968
Dispersion on canvas
43⁵/₁₆ x 36¼ in.
(110 x 92 cm)
Hans and Christa
Mennemann, Münster
FIGURE 176

Untitled
1974
Acrylic on canvas
57¹/₁₆ x 57¹/₁₆ in.
(145 x 145 cm)
Private collection,
Switzerland
FIGURE 260
Los Angeles, Madrid, and
Basel

Roland Penrose
ENGLAND,
1900–1984
:

Magnetic Moths
1938
Collage
22 x 32 in.
(55.9 x 81.3 cm)
Tate Gallery
FIGURE 261
Los Angeles, Madrid, and
Basel

Franz Pohl
(Franz Karl
Bühler)
GERMANY,
1864–1940
:

Untitled
(Self-portrait)
1918
Chalk on paper
10⁷/₈ x 7⁷/₁₆ in.
(27.7 x 18.9 cm)
Prinzhorn Collection,
University Psychiatric
Clinic, Heidelberg
FIGURE 73

Untitled
(Self-portrait)
1919
Chalk on paper
6⁷/₈ x 5¹/₁₆ in.
(17.4 x 12.9 cm)
Prinzhorn Collection,
University Psychiatric
Clinic, Heidelberg
FIGURE 38

Arnulf Rainer
AUSTRIA,
BORN 1929
:

Frau im Mehl
(Woman in flour)
1969
Graphite on Ultraphan
16½ x 11¹³/₁₆ in.
(42 x 30 cm)
Galerie Ulysses, Vienna
FIGURE 163

Rote Tränen
(Red tears)
1970
India ink and oil crayon on
gelatin-silver print
23⁵/₈ x 19¹¹/₁₆ in.
(60 x 50 cm)
Mr. and Mrs. F. Simons,
Montreal
FIGURE 161

Zweihändige Doppelgeste
(Two-handed double
gesture)
1973
Oil on cardboard
28¾ x 40⅛ in.
(73 x 102 cm)
Galerie Ulysses, Vienna
FIGURE 262

Martín Ramírez
MEXICO,
ACTIVE
UNITED STATES,
1885–1960
:

Untitled
c. 1950
Pencil and mixed media on
paper
44½ x 41⅜ in.
(113 x 105.1 cm)
Jim Nutt and Gladys Nilsson
FIGURE 144

Untitled
(Black antelope)
c. 1950
Pencil and crayon on paper
47½ x 35⅜ in.
(120.7 x 89.9 cm)
Collection of Gregory
Amenoff and Victoria Faust
FIGURE 41

Untitled
c. 1953
Pencil and mixed media on
paper
91 x 36¾ in.
(231.1 x 93.3 cm)
Jim Nutt and Gladys Nilsson
FIGURE 39

Untitled
1954
Colored pencil on paper
55 x 51 in.
(139.7 x 129.5 cm)
Ellen and Les Kreisler
FIGURE 42

Untitled
Mixed media on paper
32½ x 61 in.
(82.6 x 154.9 cm)
Jim Nutt and Gladys Nilsson
FIGURE 40

: 259 :
Alfonso Ossorio
Feast and Famine, 1966

319

: 258 :
Claes Oldenburg
*Strange Eggs, v— "screams climb
ladders . . . ,"* 1957
*Strange Eggs, xi— "sandpaper and
thorns . . . ,"* 1957
*Strange Eggs, xiv— "this grey star/is it
Pittsburgh . . . ,"* 1957
*Strange Eggs, xxi— "now a lionous
moon . . . ,"* 1957

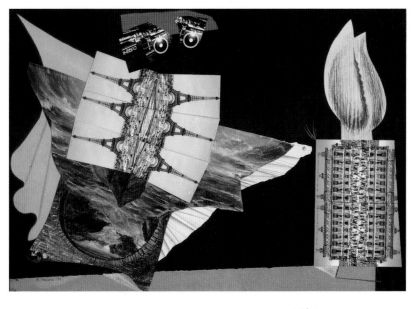

: 261 :
Roland Penrose
Magnetic Moths, 1938

: 260 :
A. R. Penck
Untitled, 1974

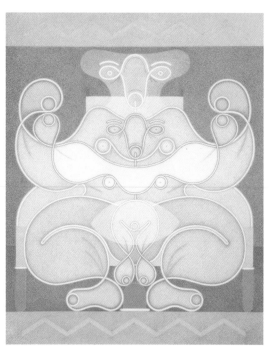

: 262 :
Arnulf Rainer
Zweihändige Doppelgeste
(Two-handed double gesture), 1973

: 263 :
Barbara Rossi
Mumtric, 1989

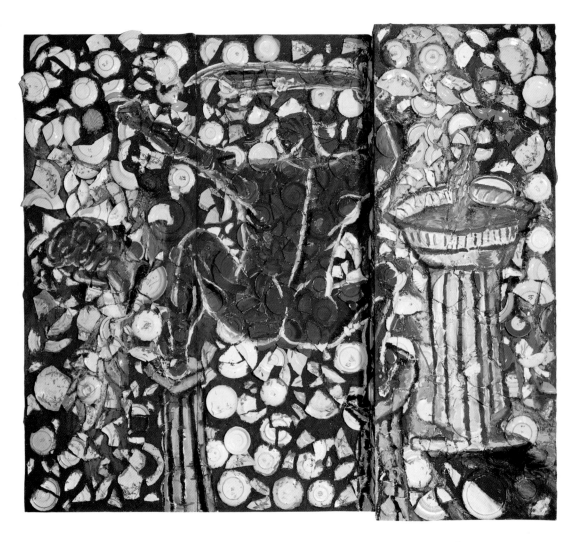

: 264 :
Julian Schnabel
Blue Nude with a Sword, 1979–80

Simon Rodia
ITALY,
ACTIVE
UNITED STATES,
1879–1965
:

Watts Towers
Los Angeles
1921–54
Mixed media in landscape
FIGURES 43, 178

Barbara Rossi
UNITED STATES,
BORN 1940
:

Brr'd and Baa'd
1972
Acrylic on Plexiglas with
satin and human hair in
painted wood frame
41¾ x 33½ x 2¼ in.
(106.1 x 85.1 x 5.7 cm)
Lois Craig and Stephen
Prokopoff
FIGURE 151

Sailing Stage
1975
Graphite and colored pencil
on paper
23 x 29 in.
(58.4 x 73.7 cm)
Barbara Rossi
FIGURE 157

Mumtric
1989
Colored pencil on paper
29 x 23 in.
(73.7 x 58.4 cm)
Howard and Helanie Greene
FIGURE 263

**Niki
de Saint Phalle**
FRANCE,
BORN 1930
:

La Maison de méditation
(House of meditation)
1978
Painted cast polyester
26¾ x 20 x 15 in.
(68 x 50.8 x 38.1 cm)
Niki de Saint Phalle
NOT ILLUSTRATED

Giardino dei Tarocchi
(Garden of the tarot)
Garavicchio, Italy
Begun in 1979
Mixed media in landscape
FIGURE 186

Italo Scanga
ITALY,
ACTIVE
UNITED STATES,
BORN 1932
:

Composite Deer
1981
Charcoal on paper, wood,
and blown glass
81 x 30 x 13 in.
(205.7 x 76.2 x 33 cm)
Italo Scanga
FIGURE 189

Transmitting
1983
Wood, antler, glass, and
oil paint
83 x 22 x 22 in.
(210.8 x 55.8 x 55.8 cm)
Italo Scanga
FIGURE 190

Clarence Schmidt
UNITED STATES,
1897–1978
:

Woodstock Environment,
or *House of Mirrors*
Woodstock, New York
1948–71
Mixed media in landscape
(destroyed)
FIGURES 44, 179

Julian Schnabel
UNITED STATES,
BORN 1951
:

Blue Nude with a Sword
1979–80
Oil, wax pastel, plates, and
Bondo on Masonite
96¹/₁₆ x 108¼ in.
(244 x 275 cm)
Courtesy of Galerie Bruno
Bischofberger, Switzerland
FIGURE 264

**Friedrich
Schröder-
Sonnenstern**
LITHUANIA,
ACTIVE GERMANY,
1892–1982
:

*Der einsame entsetzte
moralische Mondfrosch*
(The lonely horrified moral
moonfrog)
1952
Colored pencil on paper
28⁹/₁₆ x 20 ¹/₁₆ in.
(72.5 x 51 cm)
Collection of S. and G.
Poppe
FIGURE 88

*Die Praxis, oder die
Lebenszauberkünstlerin*
(The practice, or the artist
of the magic of life)
1952
Colored pencil on cardboard
28¾ x 20 ¹/₁₆ in.
(73 x 51 cm)
Galerie Brockstedt,
Hamburg
FIGURE 135

Der Mondmoralische Ziervogel
(The moon-moral
ornamental bird)
1956
Colored pencil on paper
28¾ x 20 ¹/₁₆ in.
(73 x 51 cm)
Collection of S. and G.
Poppe
FIGURE 84

*Mondelinchen, fortschrittliche
Rekordleisterin zu Land, Luft
und Meer*
(Little moon, progressive
record holder on land, by air
and sea)
1957
Colored pencil on paper
20 ¹/₁₆ x 28¾ in.
(51 x 73 cm)
Collection of S. and G.
Poppe
FIGURE 107

Des Teufels Himmelsfahrt
(Ascension of the devil)
1959
Colored pencil on paper
28¾ x 20 ¹/₁₆ in.
(73 x 51 cm)
Sam and Betsey Farber
FIGURE 45

Hélène Smith
SWITZERLAND,
1861–1929
:

Paysage martien
(Martian landscape)
1896
Watercolor, India ink, and
egg albumin varnish on
paper
8¹³/₁₆ x 12 in.
(22.4 x 30.4 cm)
Collection of Dr. Olivier
Flournoy, Geneva
FIGURE 221

Paysage ultramartien
(Ultramartian landscape)
1900
Watercolor, India ink, pencil,
and egg albumin varnish on
paper
9 x 11⅞ in.
(22.9 x 30.1 cm)
Collection of Dr. Olivier
Flournoy, Geneva
FIGURE 220

Lampe martienne
(Martian lamp)
Watercolor, India ink, and
egg albumin varnish on
paper
7¹/₁₆ x 3¹⁵/₁₆ in.
(18 x 10 cm)
Collection of Dr. Olivier
Flournoy, Geneva
FIGURE 46

Plantes extra-terrestres
(Extraterrestrial plants)
Watercolor, India ink, and
egg albumin varnish on paper
8¹¹/₁₆ x 11¹³/₁₆ in.
(22 x 30 cm)
Collection of Dr. Olivier
Flournoy, Geneva
FIGURE 65

Louis Soutter
SWITZERLAND,
1871–1942
:

Six personnages gesticulant
(Six personages
gesticulating)
c. 1937–42
Ink on paper
17⁵/₁₆ x 22¹³/₁₆ in.
(44 x 58 cm)
Galerie Beyeler, Basel
FIGURE 99

L'Ascension
(Ascension)
Ink on paper
25 x 19⅜ in.
(63.5 x 49.2 cm)
Galerie Karsten Greve,
Cologne and Paris
FIGURE 175

Fuite d'Egypte
(Flight from Egypt)
Ink on paper
29½ x 24⅜ in.
(75 x 62 cm)
Private collection, Vienna
FIGURE 47

Jean Tinguely
SWITZERLAND,
1925–91
:

Spirale I
1965
Metal, wood, and electric
motor
Height: 70⅞ in.
(180 cm)
Galerie Beyeler, Basel
NOT ILLUSTRATED

La Tête/Cyclope
(The head/cyclops)
Milly-la-Forêt, France
Begun in 1969
Mixed media
FIGURE 188

322

Check
list
of
the
Exhib
ition

August Walla
AUSTRIA,
BORN 1936
:

Religion-Christus
(Religion-Christ)
1983
Colored ink on paper on
wallboard
73½ x 55½ in.
(186.7 x 141 cm)
Sam and Betsey Farber
FIGURE 158

Planeten
(Planets)
1984
Pencil on paper
17⁵⁄₁₆ x 23⅝ in.
(44 x 60 cm)
Heike Curtze Gallery
FIGURE 166

Luluhonig/Naraka Batu
Enamel on tin can with
corners rounded and
clothesline
19¹⁄₁₆ x 10⅝ in.
(48.5 x 27 cm)
Neues Museum Weserburg,
Bremen
FIGURE 48

**Heinrich Welz
(Hyacinth
von Wieser)**
AUSTRIA,
1883–?
:

*Ideenkreis eines Mannes auf die
Aussenwelt projijiert*
(Circle of ideas of a man
projected onto the outer
world)
Pencil and ink on paper
13¼ x 9¹⁵⁄₁₆ in.
(33.6 x 25.2 cm)
Prinzhorn Collection,
University Psychiatric
Clinic, Heidelberg
FIGURE 49

P. M. Wentworth
UNITED STATES, ?
:

Untitled
1950
Pencil and colored pencil on
paper
14½ x 21½ in.
(36.8 x 54.6 cm)
Collection of Gregory
Amenoff and Victoria Faust,
courtesy Cavin-Morris
Gallery
FIGURE 50

*Floating Objects Down—
Threw Space Imagination*
c. 1950s
Mixed media on paper
29½ x 25½ in.
(74.9 x 64.8 cm)
Bryon J. Mollica, Baltimore,
Maryland
FIGURE 225

Moon
1952
Mixed media on paper
22 x 14 in.
(55.9 x 35.6 cm)
Barbara Rossi
FIGURE 152

*Imagination:
Mars—Full Moon*
Mixed media on paper
30 x 25½ in.
(76.2 x 64.8 cm)
Phyllis Kind, New York
FIGURE 226

Imagination: Serp
Mixed media on paper
30 x 25½ in.
(76.2 x 64.8 cm)
Roger Brown
FIGURE 148

H. C. Westermann
UNITED STATES,
1922–1981
:

Mad House
1957
Wood, glass, metal, and
enamel
39¼ x 17⅝ x 18⅜ in.
(99.7 x 44.8 x 46.7 cm)
Museum of Contemporary
Art, Chicago, gift of Joseph
and Jory Shapiro
FIGURE 122

Untitled
(Baja/Sincerely to Ann from
"Cactus Cliff")
1973
Watercolor on paper
11¼ x 15 in.
(28.6 x 38.1 cm)
Ms. Ann Janss
FIGURE 123

**Scottie Wilson
(Louis Freeman)**
SCOTLAND,
ACTIVE
ENGLAND,
1888–1972
:

Dream
c. 1930
Ink and pencil on paper
11⅞ x 8⅞ in.
(30.2 x 22.6 cm)
Gimpel Fils
FIGURE 70

Untitled
c. 1945
Ink and pencil on paper
10½ x 8¼ in.
(26.7 x 21 cm)
The Mayor Gallery, London
FIGURE 51

Fish Eater
c. 1950
Ink and crayon on paper
20⅜ x 10⅛ in.
(51.7 x 25.7 cm)
Antony Penrose
FIGURE 138

Untitled
c. 1950
Ink and pencil on paper
19⅛ x 13⅛ in.
(48.6 x 33.3 cm)
The Mayor Gallery, London
FIGURE 133

Adolf Wölfli
SWITZERLAND,
1864–1930
:

Juno, die Göttin der Neger
(Juno, the goddess of
Negroes)
1904
Pencil on newsprint
39⁹⁄₁₆ x 29⁵⁄₁₆ in.
(99.5 x 74.5 cm)
Adolf-Wölfli-Stiftung,
Kunstmuseum Bern
FIGURE 233
Los Angeles and Madrid

Schwefel = Beerg
(Sulphur = mountain)
1904
Pencil on newsprint
39⁹⁄₁₆ x 29⁵⁄₁₆ in.
(99.5 x 74.5 cm)
Adolf-Wölfli-Stiftung,
Kunstmuseum Bern
NOT ILLUSTRATED
Basel and Tokyo

Irren-Anstalt Band-Hain
(Mental asylum Band-Hain)
1910
Pencil and colored pencil on
newsprint
39¼ x 28⅜ in.
(99.7 x 72.1 cm)
Adolf-Wölfli-Stiftung,
Kunstmuseum Bern
FIGURE 239
Los Angeles and Madrid

Eissee = Hall, Riesen = Stadt
(Icelake = hall, giant = city)
1911
Pencil and colored pencil on
newsprint
39⁹⁄₁₆ x 28¹⁄₁₆ in.
(99.5 x 71.3 cm)
Adolf-Wölfli-Stiftung,
Kunstmuseum Bern
NOT ILLUSTRATED
Basel and Tokyo

*General-Ansicht der Insel
Nie3ohrn*
(General view of the island
Neveranger)
1911
Pencil and colored pencil on
newsprint
39⁵/₁₆ x 28 in.
(99.8 x 71.2 cm)
Adolf-Wölfli-Stiftung,
Kunstmuseum Bern
FIGURE 71
Los Angeles and Madrid

*Der Meider = Riesen = Käller
in Australien*
(The meider = giant = cellar
in Australia)
1911
Pencil and colored pencil on
newsprint
39¼ x 28⅜ in.
(99.6 x 72.1 cm)
Adolf-Wölfli-Stiftung,
Kunstmuseum Bern
NOT ILLUSTRATED
Basel and Tokyo

*Foliantten = Marsch. Stooss Nr.
4¹/₂–8¹/₂*
(Folio = march. blast no.
4½–8½)
1915
Pencil and colored pencil on
newsprint
28⁹/₁₆ x 40⅛ in.
(72.5 x 102 cm)
Adolf-Wölfli-Stiftung,
Kunstmuseum Bern
FIGURE 232
Los Angeles and Madrid

*Skt. Adolf = Broggahr =
Chat3li: Kat3en = Stok
und Skt. Adolf = Krohn =
Print3en*
(St. Adolf = brogghar =
kitten: cats = hill and St.
Adolf = crown = prince)
1915
Pencil and colored pencil on
newsprint
28¹¹/₁₆ x 41⁵/₁₆ in.
(72.8 x 105 cm)
Adolf-Wölfli-Stiftung,
Kunstmuseum Bern
NOT ILLUSTRATED
Basel and Tokyo

*Der Gross = Gott + Vatter =
Huht mit skt Adolf =
Kuss, Riesen = Founttaine*
(The great = god + father =
hat with St. Adolf = kiss,
giant = fountain)
1917
Pencil and colored pencil on
paper
15 x 19¾ in.
(38 x 50.2 cm)
Adolf-Wölfli-Stiftung,
Kunstmuseum Bern
FIGURE 235
Los Angeles and Madrid

*Riesen = Grand = Hottel
Daasen in Bern*
(Giant = Grand = Hotel
Daasen in Bern)
1917
Pencil and colored pencil on
paper
21¹³/₁₆ x 16¹³/₁₆ in.
(55.4 x 42.7 cm)
Adolf-Wölfli-Stiftung,
Kunstmuseum Bern
NOT ILLUSTRATED
Basel and Tokyo

Campbell's Tomato Soup
1929
Pencil, colored pencil, and
collage
27⁹/₁₆ x 19¹¹/₁₆ in.
(70 x 50 cm)
Adolf-Wölfli-Stiftung,
Kunstmuseum Bern
FIGURE 52
Los Angeles and Madrid

Kautschuk-Rad
(Kautschuk tire)
1929
Pencil, colored pencil, and
collage
39⅜ x 14¾ in.
(100 x 37.5 cm)
Adolf-Wölfli-Stiftung,
Kunstmuseum Bern
NOT ILLUSTRATED
Basel and Tokyo

Joseph Yoakum
UNITED STATES,
1886 (or 1888)–1972
:

*Lebanon Mts. near
Phoenicia Asia*
1964
Watercolor and ink on paper
12 x 18 in.
(30.5 x 45.7 cm)
Roger Brown
FIGURE 145

*Mt. Sadlerock near
Packard Maine*
1965
Watercolor and ink on paper
12 x 18 in.
(30.5 x 45.7 cm)
Roger Brown
FIGURE 130

Mt. Elberst in Elk Mtn. Range
1967
Colored pencil and pen on
paper
19 x 14 in.
(48.3 x 35.6 cm)
Ray Yoshida
FIGURE 124

*E. P. Leverest in Himilaya
Mtn. Range*
1968
Ballpoint pen, colored
pencil, and ink on paper
19 x 12 in.
(48.3 x 30.5 cm)
Jim Nutt and Gladys Nilsson
FIGURE 131

Iron Mtn. on Lake Kissimmee
1968
Ballpoint pen, colored
pencil, and ink on paper
12¼ x 19 in.
(31.1 x 48.3 cm)
Jim Nutt and Gladys Nilsson
FIGURE 132

*Mt. Makkah near Village
Mecca of Sudi Arabia*
1968
Ballpoint pen, colored
pencil, and ink on paper
14 x 22 in.
(35.6 x 55.9 cm)
Jim Nutt and Gladys Nilsson
FIGURE 125

*Mt. Mauna Kea in Volcanoic
Range in Central Hawaii
County of Hawaii Islands*
1968
Colored pencil and pen on
paper
14 x 19 in.
(35.6 x 48.3 cm)
Ray Yoshida
FIGURE 128

*Mt. Phu-Las-Leng in Plateau
near Xieng Laos*
1968
Ballpoint pen, colored
pencil, and ink on paper
19½ x 12³/₁₆ in.
(49.5 x 31 cm)
Jim Nutt and Gladys Nilsson
FIGURE 147

*Mt. Baykal of Yablonvy
Mtn. Range*
1969
Ballpoint pen, colored
pencil, and ink on paper
19¹/₁₆ x 12⅛ in.
(48.4 x 30.8 cm)
Jim Nutt and Gladys Nilsson
FIGURE 141

*Mt. Cloubelle Jamaca of
West India*
1969
Ballpoint pen, colored
pencil, and ink on paper
12 x 9½ in.
(30.5 x 24.1 cm)
Jim Nutt and Gladys Nilsson
FIGURE 142

*United Marine and Merchants
Ship*
1969
Ballpoint pen and colored
pencil on paper
12 x 18 in.
(30.5 x 45.7 cm)
Jim Nutt and Gladys Nilsson
FIGURE 53

*Mt. At3mon on Border of
Lebanon and Palestine*
Ballpoint pen and colored
pencil on paper
19¹/₁₆ x 24⅛ in.
(48.4 x 61.3 cm)
Jim Nutt and Gladys Nilsson
FIGURE 150

Ray Yoshida
UNITED STATES,
BORN 1930
:

Partial Evidences II
1973
Acrylic on canvas
49¾ x 45⅞ in.
(126.4 x 116.5 cm)
National Museum of
American Art, Smithsonian
Institution, gift of the S. W.
and B. M. Koffler Foundation
FIGURE 127
Los Angeles, Madrid, and
Basel

Froggy
1989
Oil on canvas
26 x 36 in.
(66 x 91.4 cm)
Courtesy of the Phyllis Kind
Gallery, Chicago and
New York
FIGURE 126

Acknowledgments

Ackno
wledg
ments

Researching *Parallel Visions: Modern Artists and Outsider Art* required stamina as well as vision and dedication. During the most difficult moments in the exhibition's development, we were buoyed by the assistance and encouragement of those who understood our thesis from the beginning and who shared our commitment to the material. We would like in particular to thank two very important benefactors, without whose support *Parallel Visions* might not have been realized. Frederick Weisman, through the Frederick R. Weisman Art Foundation, provided us with a generous planning grant that allowed us to travel, to procure research materials, and to hire a research assistant; his early advocacy of *Parallel Visions* was crucial. Gale Hayman's support allowed us to hold two scholars' conferences (one in Los Angeles in October 1989 and one in New York in February 1990) that were important watersheds in the shaping and planning of both the exhibition and catalogue. Many of those who participated in the conferences wrote essays for the catalogue, for which we thank the authors. Our special thanks go to Shiseido Co., Ltd., and to Nissha Printing Co., Ltd., for their generous support of *Parallel Visions*. We are also grateful to Maria de Corral of the Museo Nacional Reina Sofía in Madrid, Thomas Kellein of the Kunsthalle Basel, and Seiji Oshima of the Setagaya Art Museum in Tokyo, who have shared our vision. Their enthusiasm for *Parallel Visions* was of enormous importance in bringing the exhibition to fruition.

Numerous colleagues, collectors, dealers, and friends have been helpful, many not merely once or twice but repeatedly, answering our questions, making useful suggestions, providing constructive criticism. We extend our thanks to all those who were of assistance and particularly express our gratitude to Dennis Adrian, Gregory Amenoff, Vittorino Andreoli, Alexander Apsis, William and Paul Arnett, William Bengtson, Gregg N. Blasdel, Peter Boswell, Bettina Brand, Emily Braun, Andrew Braunsberg, Sam Carini, Brad Cebecci, Jeffrey Cohen, Jacqueline Cone, Dan Connally, Catherine Cottet, Didier Deroeux, Arne Ekstrom, Rosa and Aaron Esman, Sam and Betsey

Farber, Victoria Faust, Johann Feilacher, the late Dr. Gaston Ferdière, Michael Findlay, Marcel Fleiss, Waltraud Forelli-Wallach, Zac Freeman, John Gedo, Suzanne Ghez, Fay Gold, Michael Goldstein, N. J. Bud Goldstone, Robert Greenberg, Bonnie Grossman, Lynda Roscoe Hartigan, Franz Heller, Roger Herman, Andrea Honoré, Henry Hopkins, Inge Jádi, Jon Jerde, Phyllis Kind, Monika Kinley, Yukiko Koide, Dorothy Kosinski, Donald Kuspit, Susan Larsen, Elizabeth Legge, Phil Linhares, William Lipke, Judith McWillie, John Maizels, Roger Manley, Frank Maresca, Randall Morris, Richard Morris, Andy Nasisse, Peter Nathan, Barbara Nathan-Neher, Walter Navratil, Christy O'Hara, John Ollman, Suzanne Pagé, A. F. Petit, Dorothy and Leo Rabkin, William Rawlings, Jr., Theodore Reff, Roger Ricco, Seymour Rosen, Geneviève Roulin, John Sailer, Sheri Saperstein, Sal Scalora, the late Professor Gert Schiff, Mike Solomon, Branka Sondheim, Grace Spencer, Nancy Spero, Elka Spoerri, Michael Sweeney, Patricia Teter, Michel Thévoz, Judy Throm, Guy Tosatto, Martin Urban, Anne Vincendon, Wolfgang A. Waldner, Gabriele Wimmer, Grete Wolf, Myriam Yared, Deenie Yudell, and Pascale Zoller.

To organize an exhibition and catalogue of this magnitude required the dedication of many staff members at the Los Angeles County Museum of Art. We are grateful to Julie Johnston and Tom Jacobson of the museum's Development Department for their efforts on behalf of *Parallel Visions*. Elizabeth Algermissen and John Passi of the Exhibitions Department arranged for the exhibition's travel to three countries on two continents. We are thankful for their efforts. Renée Montgomery and Chandra King of the Registrar's Office coordinated the extensive shipping arrangements for the show smoothly and ably. We frequently depended on the expert advice of Pieter Meyers, Joe Fronek, Victoria Blyth-Hill, and Steve Colton of the museum's Conservation Department regarding the feasibility of loans and transport. Pamela Jenkinson and Anne-Marie Wagener disseminated information on *Parallel Visions* to the local and international press. Arthur Owens, with his usual good cheer, oversaw the installation of the exhibition, which was sensitively designed by Brent Saville. William Lillys and Lisa Vihos of the Education Department coordinated the many related events. We would also like to thank Eleanor Hartman and Anne Diederick of the museum's research library for their assistance on this project.

Managing editor Mitch Tuchman supervised the editing and production of the exhibition catalogue; his enthusiasm for the project was a pleasure to witness. The clear and readable text is due to Chris Keledjian's thorough editing, while Jim Drobka is responsible for the striking design. The astute eye of Sandy Bell, head graphic designer, is gratefully acknowledged. The high quality of the catalogue's reproductions is due to the talents and dedication of Peter Brenner and Steve Oliver.

We would particularly like to thank Sandra Kline in the Department of Twentieth-Century Art at the Los Angeles County Museum of Art for her enthusiastic and cheerful assistance on the project. We also wish to acknowledge the cooperation and support of our other colleagues in the department, Stephanie Barron, Howard Fox, Judi Freeman, Eric Pals, and Yvette Padilla. Rosalinde Leader, departmental volunteer *par excellence*, was an indispensable member of our team all along the way; to her we express our heartfelt thanks. We are especially grateful to director Earl A. Powell III for his immediate and continuing support of this project.

We spoke with many artists about this exhibition and extend to them all our gratitude for sharing their thoughts as well as, in many cases, works from their own collections. We are indebted to every lender to the exhibition; without their cooperation the show could not have taken its final form.

Finally we wish to thank our research assistant, Barbara Freeman. She has been an untiring, astute, and remarkable partner in this venture. Her efforts gave significant shape to *Parallel Visions*, and we are proud and delighted to offer her our gratitude.

Carol S. Eliel and Maurice Tuchman

Lenders to the Exhibition

Adolf-Wölfli-Stiftung, Kunstmuseum Bern
Berlinische Galerie, Berlin
Cavin-Morris Gallery
Collection de l'Art Brut, Lausanne
The David and Becky Anderson Collection,
 State University of New York at Buffalo
Didier Imbert Fine Art, Neuchâtel
Galerie Beyeler, Basel
Galerie Brockstedt, Hamburg
Galerie Bruno Bischofberger, Switzerland
Galerie Crousel-Robelin BAMA, Paris
Galerie de France
Galerie Karsten Greve, Cologne and Paris
Galerie Messine, Paris
Galerie Ulysses, Vienna
Galerie von Bartha
Gimpel Fils
Graphische Sammlung ALBERTINA, Vienna, Austria
Heike Curtze Gallery
Hirschl & Adler Modern
Institut Métapsychique International, Paris
Josh Baer Gallery, New York
Konstmuseet Malmö
Kunstmuseum Bern
Los Angeles County Museum of Art
Los Angeles County Museum of Art, Mr. and
 Mrs. Allan C. Balch Research Library
Marlborough Gallery, Inc., New York
The Mayor Gallery, London
The Metropolitan Museum of Art, New York
Mills College Art Gallery
Milwaukee Art Museum
Musée Cantini, Marseille
Musée d'Art Moderne, Saint Etienne
Musée de Béthune
Musée de l'Abbaye Sainte-Croix, Les Sables
 d'Olonne
Musée National d'Art Moderne, Centre Georges
 Pompidou, Paris
Museo Nacional Reina Sofía, Madrid
Museum of Contemporary Art, Chicago
The Museum of Modern Art, New York
National Museum of American Art, Smithsonian
 Institution
Neues Museum Weserburg, Bremen
Outside-in Gallery, Los Angeles

Passmore Edwards Museum Service, London
 Borough of Newham
Paul-Klee-Stiftung, Kunstmuseum Bern
Paula Cooper Gallery, New York
Peggy Guggenheim Collection, Venice
 (Solomon R. Guggenheim Foundation)
Perls Galleries, New York
Phyllis Kind Gallery, Chicago and New York
Prinzhorn Collection, University Psychiatric Clinic,
 Heidelberg
San Francisco Museum of Modern Art
Städtische Galerie im Lenbachhaus, Munich
Stephen Wirtz Gallery, San Francisco, California
Tate Gallery
Westfälische Klinik für Psychiatrie Lippstadt
William Beadleston Fine Art, New York
Yale University Art Gallery
:
Gregory Amenoff and Victoria Faust
Karel Appel
Donald Baechler
Eleanor and Max Baril
Timothy Baum, New York
Mark and Judy Bednar, Chicago
Jonathan Borofsky
James and Alexandra Brown
Roger Brown
Nancy N. Carroll
Richard D. Christiansen
Dan and Janis Connally
Lois Craig and Stephen Prokopoff
Edward F. Dragon
The Estate of Robert Duncan
Norris Embry Estate
Sam and Betsey Farber
Dr. Olivier Flournoy, Geneva
Mr. and Mrs. James R. Foster, Chicago, Illinois
Milly and Arne Glimcher
Robert M. Greenberg
Howard and Helanie Greene
Madame Jakovsky
Ms. Ann Janss
Patricia Kahane
Heinz Kammerer
Phyllis Kind, New York
E. W. Kornfeld, Bern

Ellen and Les Kreisler
Nathan Lerner
Jeanne and Richard Levitt
Kirk Edward Long
Edouard Malingue
Matthew Marks, New York
Hans and Christa Mennemann, Münster
Annette Messager
Bryon J. Mollica, Baltimore, Maryland
Dudley E. Morris
Andy Nasisse
Barbara Nathan, Zurich
Dr. Peter Nathan, Zurich
Claude Nutt
Jim Nutt and Gladys Nilsson
Claes Oldenburg and Coosje van Bruggen,
 New York
Barbara Orbison
Antony Penrose
Albert J. Petcavage
S. and G. Poppe
Dr. William Rawlings, Jr., Sandersville, Georgia
Richard S. Rosenzweig and Judy Henning
Barbara Rossi
Niki de Saint Phalle
Fayez Sarofim Collection
Italo Scanga
Mr. and Mrs. F. Simons, Montreal
Sonnabend Collection
Toni and Martin Sosnoff
Karel van Stuijvenberg
Maurice Weinberg, Paris
Frederick R. Weisman, Los Angeles
Jonathan Williams
Dian and Andrea Woodner
Ray Yoshida
Kristin and Helmut Zambo
and eight anonymous collectors

Contributors

Contr
ibuto
rs

Russell Bowman is director of the Milwaukee Art Museum and has written extensively on the Chicago imagists and American folk art.

Roger Cardinal is professor of Literary and Visual Studies at the University of Kent at Canterbury and the author of *Outsider Art* (New York: Praeger, 1972).

Carol S. Eliel is associate curator of Twentieth-Century Art at the Los Angeles County Museum of Art.

Barbara Freeman is a research assistant at the Los Angeles County Museum of Art.

Sander L. Gilman, Goldwin Smith professor of Humane Studies at Cornell University, is the author of *Disease and Representation: Images of Illness from Madness to AIDS* (Ithaca, New York: Cornell University Press, 1988), and *Inscribing the Other* (Lincoln: University of Nebraska, 1991).

Mark Gisbourne, who is currently completing a doctoral dissertation at the Courtauld Institute of Art, University of London, is visiting professor at the University of Bucharest and the Cleveland Institute of Art in France and is resident lecturer of the Stanley Picker Trust.

Reinhold Heller is professor of Art and of Germanic Languages at the University of Chicago and the author of *Edvard Munch: His Life and Work* (Chicago: University of Chicago Press, 1984).

John M. MacGregor, winner of the Ernst Kris Award in 1990, is the author of *The Discovery of the Art of the Insane* (Princeton: Princeton University Press, 1989), and *Dwight Mackintosh: The Boy Who Time Forgot* (Oakland: Creative Growth Press, 1992).

Donald Preziosi is professor of Art History at the University of California, Los Angeles, and the author of *Rethinking Art History: Meditations on a Coy Science* (New Haven: Yale University Press, 1989).

Maurice Tuchman is senior curator of Twentieth-Century Art at the Los Angeles County Museum of Art.

Allen S. Weiss, editor of *Art Brut: Madness and Marginalia*, a special issue of *Art & Text*, no. 27 (December 1987–February 1988), is the author of *The Aesthetics of Excess* (Albany: State University of New York Press, 1989), and *Shattered Forms: Art Brut, Phantasms, Modernism* (Albany: State University of New York Press, 1992).

Poet **Jonathan Williams** presides over the Jargon Society (which Hugh Kenner has called a "publisher of snowflakes"). His forthcoming book is *Walks to the Paradise Garden: Outsiders in the South*, with photographers Roger Manley and Guy Mendes.

Sarah Wilson, a lecturer in Twentieth-Century Art History at the Courtauld Institute of Art, University of London, has published extensively on art in France after 1945 and is the author of *Matisse* (Barcelona: Ediciones Poligrafa, 1991).

Photo
Sources
and
Credits

Photographs are reproduced courtesy of the lenders, except for **329**
the following figures:

Photo Schack, Lippstadt, 3
Photo Klinger, 4, 6–7, 21, 23–28, 33–38, 49, 58, 72–73, 79, 154,
 170, 173
D. James Dee, 5, 238
Outside-in Gallery, 12
Erbengemeinschaft Paul Goesch, Schweiz Berlinische Galerie,
 Berlin, 14–15
Ludek Holub, 17–18
Claude Thériez, 22
Walker Montgomery, 30
Bruce M. White, 41, 162, 194, 223, 236–37, 259
Seymour Rosen, 43
Gregg Blasdel, 44, 179
Olivier Flournoy, 46, 65, 220–21
Fotostudio Otto, 47
Joachim Fliegner, 48
Copyright © 1991 by VG Bild-Kunst, Bonn, 56
Copyright © 1992 by The Metropolitan Museum of Art, 59
Jim Strong, 60
Philippe Migeat, 68
David Heald, photograph © 1991, The Solomon R. Guggenheim
 Foundation, 76
Studio Grünke, 84, 88, 107
ARS, New York/ADAGP, Paris, ©1992, 87
Yves Bresson, 89
Anne Ferdière, 94
Henrot, 95 (rephotograph courtesy of the Courtauld Institute of
 Art, Witt Photographic Library)
Peter Lauri, 100, 137
Studio J. Coudray, 106
Studio Tom Haartsen, 108
Ellen Page Wilson, 111–12
Hans Namuth, 116
David Reynolds, 119
Richard de Liberto Photography, 120
William H. Bengtson, Chicago, 124, 128, 247
William H. Bengtson, courtesy Phyllis Kind Gallery, Chicago/
 New York, 126, 129, 149, 153, 156, 204, 226, 258
John Nienhuis, 136
Simone Gaensheimer, 165
Galerie Michael Werner, Cologne and New York, 168, 174
Marvin Rand, 178
Rogi André, 180
Ben Blackwell Photography, 181
Roger Manley, 184
Laurent Condominas, 186, 188
Kunstmuseum Bern, 187
Geoffrey Clements, 203
Annette Messager, 206
Jacques Gael Cressaty, 211
Dorothy Zeidman, 212
Pierre Battistolo, Lausanne, 217
Keith Fitzgerald, 227
Photoarchiv, Adolf-Wölfli-Stiftung, Kunstmuseum Bern, 234
Phillips/Schwab, 252
Paul Hester, 253
Peter Schäichli, 254

Index

Edited by Chris Keledjian
Designed by Jim Drobka
Photography supervised by Steve Oliver
Cover illustration by Jim Drobka

Text type set in Fournier and Times Roman by
Andresen Graphic Services, Tucson, Arizona
Cover art and display type produced using Adobe Illustrator
Printed and bound by Nissha Printing Co., Ltd., Kyoto, Japan

This book was printed in a first edition of 10,750 copies.

(continued from front flap)

watercolors recreating the landscapes, animals, and human-like inhabitants of her visions of Mars; Antonin Artaud, the poet, playwright, actor, theoretician, and artist who, after his estrangement from the surrealists, his year of living with the Tarahumara Indians in Mexico and taking part in their peyote rituals, and finally his notorious "Irish escapade," was confined to mental hospitals for much of the remainder of his life; and Henry Darger, a reclusive custodian who, in secret, wrote a fifteen-volume, fifteen thousand-page epic fantasy about a civil war fought over the question of child slavery.

Parallel Visions, with 264 illustrations (120 in color), offers penetrating, insightful essays by curators Maurice Tuchman and Carol S. Eliel and scholars Russell Bowman, Roger Cardinal, Barbara Freeman, Sander L. Gilman, Mark Gisbourne, Reinhold Heller, John MacGregor, Donald Preziosi, Allen Weiss, Jonathan Williams, and Sarah Wilson, essays that explore issues crucial to the formation of our aesthetic and critical judgments and our notions of what constitutes creativity.